NewYork NewYork

NewYork NewYork

GRIMALDI
FORUM MONACO

Fifty Years of Art, Architecture, Cinema, Performance, Photography and Video

Germano Celant and Lisa Dennison

SKIRA

Cover
Studio Cerri & Associati
Pierluigi Cerri
Alessandro Colombo
with Yuko Higashikawa
Jackson Pollock, *Drawing*,
1950 (detail)
Lee Krasner Pollock
Collection
© Adagp, Paris 2006

Design
Marcello Francone

Editing
Emma Cavazzini
Eva Vanzella

Graphic Coordination
Luigi Fiore

Layout
Enrico Alvarez
Veronica Bellotti

Translations
From German:
Stéphanie Buhmann
From English to French:
Denise Luccioni
Alice Petillot
Dominique Letellier
Francesca Gee
From French to English:
Douglas Herbert
From Italian to French:
Régine Cavallaro
Hélène Tordo
Julie Sibony
From Italian to English:
Sarah McLaren
Antony Shugaar

First published in Italy in
2006 by
Skira Editore S.p.A.
Palazzo Casati Stampa
via Torino 61
20123 Milano
Italy

www.skira.net

© 2006 Grimaldi Forum
Monaco
© 2006 Janet L.
Abu-Lughod, Germano
Celant, Lisa Dennison,
RoseLee Goldberg, Melissa
Harris, Kirstin Hübner,
Thierry Jousse, Herbert
Muschamp, Mario Perniola,
Fernanda Pivano, Robert
Rosenblum, Irving Sandler,
Nancy Spector, Bonnie
Yochelson for the texts
© 2006 The Clyfford Still
Estate for cat. nos. 54 and 55
© 2006 Skira editore

Printed and bound in Italy.
First edition
ISBN-13: 978-88-7624-864-1
ISBN-10: 88-7624-864-1

Distributed in North
America by Rizzoli
International Publications,
Inc., 300 Park Avenue South,
New York, NY 10010.
Distributed elsewhere in the
world by Thames and
Hudson Ltd., 181a High
Holborn, London WC1V
7QX, United Kingdom.

Photo Credits
© 2006 Erika Barahona-Ede
© 2006 Robert Bayer, Basel
© 2006 Bill Beckley
© 2006 Bert Burgemeister,
Pfullingen
© 2006 Christopher Burke
© 2006 Giorgio Colombo,
Milan
© 2006 Cosmos Savage
© 2006 Paula Court
© 2006 Cristopher Dawson
© 2006 Frédéric
Delpech/capcMusée
© 2006 Michel Denancé
© 2006 Kathy Dillon
© 2006 T.R. Du Brock
© 2006 François Fernandez
© 2006 Albert Fritz, Baden-
Baden
© 2006 Juan Garcia Rosell
(Archivo fotografico del
IVAM Institut Valencià d'Art
Modern, Generalitat
Valenciana)
© 2006 Al Giese
© 2006 Ane Gold
© 2006 Jeff Goldberg
© 2006 Carol Goodden
© 2006 Gianfranco Gorgoni
© 2006 Lois Greenfield
© 2006 John Groo
© 2006 David M. Heald
© 2006 Techching Hsieh
© 2006 Antonello Idini
© 2006 John Lamka, New
York
© 2006 David Lee
© 2006 Marcel Loli
© 2006 Attilio Maranzano
© 2006 Mary Ellen Mark
© 2006 Peter Mauss
© 2006 Robert McElroy
© 2006 Rob McKeever
© 2006 Leroy Mc Lukas
© 2006 Moderna Museet,
Stockholm
© 2006 MUMOK. Museum
Moderner Kunst Stiftung
Ludwig, Wien
© 2006 Hans Namuth
© 2006 Robert Neiman
© 2006 Paolo Pellion, Turin
© 2006 Hauser & Wirth,
Zürich
© 2006 Heinz Preute

© 2006 Kerra Quarles
© 2006 Micheal Raz-Russo
© 2006 David Regen
© 2006 Rocco Ricci
© 2006 Giovanni Ricci,
Milan
© 2006 Monika Rittershaus
© 2006 Roland Reiter, Zürich
& Werner Schnüriger,
Zürich-Wädenstil
© 2006 Tore H. Røyneland,
Oslo
© 2006 Kevin Ryan
© 2006 Uwe. H. Seyl,
Stuttgart
© 2006 Harry Shunk
© 2006 Steve Sloman
© 2006 SMK Photo
© 2006 Speltdoorn & sons
© 2006 Glenn Steigelmann
© 2006 Ezra Stoller
© 2006 Richard Stoner
© 2006 Jeff Sturges
© 2006 David Sundberg
© 2006 Tehching Hsieh
© 2006 TF1/Doc
© 2006 Jordan Tinker
© 2006 Frank J. Thomas
© 2006 Norihiro Ueno
© 2006 Ville de Marseille,
Photographic Department
© 2006 Ellen Page Wilson
© 2006 Stephen White
© 2006 Chris Winget
© 2006 Graydon Wood

New York New York

Fifty Years of Art, Architecture, Cinema, Performance, Photography and Video

Grimaldi Forum Monaco
14 July – 10 September 2006

GRIMALDI FORUM MONACO

10, avenue Princesse Grace,
MC 98000 Monaco
www.grimaldiforum.com

President
Jean-Claude Riey

Genaral Director
Sylvie Biancheri

Director of Cultural Events
Catherine Alestchenkoff

Building Director
Guy Caruana

Director of Events
Gérard Nouveau

Administrative and Financial Director
Marc Rossi
and their staff

Assistant to the Director of Cultural Events
Alfonso Ciulla

Editing assistant
Katia Montironi

Coordination of Workshops
Lætitia de Massy

Assistant
Christophe Mérigout

Director of Communication
Hervé Zorgniotti

Communication Manager
Nathalie Pinto

Counselors
Ruder Finn Arts & Communications

Monaco

Minister of State
His Excellency Mr. Jean-Paul Proust

Government Advisor for the Interior
Mr. Paul Masseron

Government Advisor for Economy and Finance
Mr. Franck Biancheri

Exhibition

Curators
Germano Celant
Lisa Dennison

Guest Curators
RoseLee Goldberg, *Performance and Video*
Melissa Harris, *Photography*
Thierry Jousse, *Cinema*
Greg Lynn, UNITED Architects, *Architecture*

Special Consultant
Otto Hübner, *Abstract Expressionism*

Scientific Research USA
Amy Brandt

Scientific Research Europe
Francesca Cattoi

General Coordination
Catherine Alestchenkoff
Amy Brandt
Francesca Cattoi
Katia Montironi

Exhibit and Graphic Design
Studio Cerri & Associati
Pierluigi Cerri
Alessandro Colombo
with
Paola Garbuglio
Maddalena Lerma
Francesca Stacca

Registrar
Thierry Vincent

Catalogue

General Editors
Germano Celant
Lisa Dennison

Scientific Research
Amy Brandt
Francesca Cattoi

General Coordination
Catherine Alestchenkoff
with
Francesca Cattoi
Katia Montironi

Essays
Janet L. Abu-Lughod
Germano Celant
RoseLee Goldberg
Melissa Harris
Kirstin Hübner
Thierry Jousse
Herbert Muschamp
Mario Perniola
Fernanda Pivano
Robert Rosenblum
Irving Sandler
Nancy Spector
Bonnie Yochelson

*This exhibition has been made possible
thanks to the support of*

Lenders

Vince Aletti, New York
American Contemporary Art Gallery, Munich
Thomas Ammann Fine Arts, Zürich
Astrup Fearnley Museum of Modern Art, Oslo
Tiqui Atencio, New York
The Richard Avedon Foundation, New York
Angelo Baldassarre, Bari
Marianne Boesky Gallery, New York
Louise Bourgeois, New York
The Broad Art Collection, Santa Monica
Trisha Brown Dance Company, New York
Christine Burgin Gallery, New York
CAPC, Musée d'Art Contemporain de Bordeaux
Carnegie Museum of Art, Pittsburgh
Castello di Rivoli, Museo d'Arte Contemporanea, Turin
Center for Creative Photography, The University
of Arizona, Tucson
Centre Georges Pompidou, Musée National d'Art
Moderne/Centre de Création Industrielle, Paris
Cheim & Read, New York
Attilio Codognato, Venezia
Gerard Cohen, Monaco
Collections of Christopher Rothko and Kate Rothko
Prizel
Commerce Graphics Ltd, Inc., New York
Lois Conner, New York
Paula Cooper Gallery, New York
The Cranford Collection, London
Daros Collection, Zürich
The Willem De Kooning Foundation, New York
Dimitris Daskalopoulos Collection, Athens
Electronic Arts Intermix, New York
Elliot Erwitt, New York
The Estate of Hans Hofmann, New York
The Estate of David Smith, New York
Donna Ferrato, New York
Fondation Mudima, Milan
Fondation Beyeler, Zürich
Fraenkel Gallery, San Francisco
Nanette Gehrig, Monaco
Sondra Gilman, New York
Gagosian Gallery, New York
Galerie Bruno Bischofberger, Zürich,
Galerie Gmurzynska, Zürich
Galerie Hans Mayer, Düsseldorf
Clay Hapaz, New York
Galerie Thaddaeus Ropac, Paris/Salzburg
Galerie Sprüth Magers, Munich
Galleria Salvatore + Caroline Ala, Milan
Galleria d'Arte Contemporanea Emilio Mazzoli, Modena
Galleria Nazionale d'Arte Moderna e Contemporanea,
Rome
Galleria Lia Rumma, Naples
Gladstone Gallery, New York
Howard Greenberg Gallery, New York
The Solomon R. Guggenheim Museum, New York
Philippe Halsman Archive, New York
Hauser & Wirth, Zürich and London
Hirshhorn Museum and Sculpture Garden, Washington
D.C

Hort Family Collection, New York
International Center of Photography, New York
IVAM, Instituto Valenciano de Arte Moderno,
Generalitat Valencia
Dakis Joannou Collection, Athens
Oliver Kamm 5BE Gallery, New York
Tomio Koyama Gallery, Tokyo
Sean Kelly Gallery, New York
Michael and Fiona King, London
Knoedler & Company, New York
Michael Kojaian, New York
Edward M. Lee, London
Kunstmuseum Liechtenstein
Kunstmuseum Wolfsburg
Little Bear Inc., New York
MACBA, Museu d'Art Contemporani de Barcelone
The Robert Mapplethorpe Foundation, New York
Matthew Marks Gallery, New York
Marlborough Gallery, New York
MART, Museo d'Arte Moderna e Contemporanea
di Trento e Rovereto
Barbara Mathes Gallery, New York
McKee Gallery, New York
Louis K. Meisel Gallery, New York
Susan Meiselas, New York
Metro Pictures Gallery, New York
Robert Miller Gallery, New York
David Mirvish, Toronto
Museum Frieder Burda, Baden Baden
Claes Oldenburg, New York
Museum of Modern Art's Circulating Film
and Video Library, New York
New Museum of Contemporary Art, New York
Reinhardt and Ute Onnasch, Berlin
Pace/Macgill Gallery, New York
PaceWildenstein, New York
Giuseppe and Rosa Giovanna Panza di Biumo
Sylvia Plachy, Queens, New York
PPOW Gallery, New York
Robert Rauschenberg Studio, New York
Eugene Richards & Janine Altongy, New York
Randolfo Rocha, Boston
Jeanne Greenberg Rohatyn and Nicolas Rohatyn,
New York
James Rosenquist and Richard Feigen, New York
Rubell Family Collection, Miami
Richard Schechner, New York
Bruce Silverstein Gallery, New York
Sikkema Jenkins & Co, New York
Sonnabend Gallery, New York
Reiner Speck, Cologne
Sperone Westwater, New York
Doug & Mike Starn, Starn Studio, Brooklyn, New York
Studio One, New York
Kustera Tilton Gallery, New York
The Andy Warhol Museum, Pittsburg
Frederic R. Weisman Art Foundation, Los Angeles
White Cube, London
The Whitney Museum of American Art, New York

Acknowledgments

Owing to its complexity and scale, this exhibition would not have been possible without the cooperation and generosity of the artists, museum directors, private collectors and art galleries who have been willing to devote their time and resources to the project. While we have thanked each individual lender in the list dedicated to them at the beginning of the volume, we would like to express our personal and heartfelt gratitude to all those who have contributed to the quality and comprehensiveness of the exhibition providing information and support in tracking down works and obtaining their loan, as well for their individual advice on specific aspects of the exhibition: Yaron Bruckner, Monaco; Anna Costantini, Genoa; Sanford Hirsch, President of the Adolph and Esther Gottlieb Foundation, New York; Mr. Royce Howes, New York; Jason Mc Coy, Jason Mc Coy Incorporation, New York; Meredith Lue, Mary Ellen Mark Studio, New York; Tobias Mueller, Galerie Bischofberger, Zurich; Giusepppe Pero, Galleria 1000eventi, Milan; Evelyn Pousette-Dart, The Estate of Richard Pousette-Dart; The Judith Rotschild Foundation, New York; Dr. Philip Rylands, Director of Peggy Guggenheim Collection, Venice; Susanna Singer, Riverside; Ileana Sonnabend, New York; Ron Warren, Mary Boone Gallery, New York.

Deep appreciation is also extended to Bruno Bischofberger, Director, Galerie Bischofberger, Zürich; Manuel J. Borga-Villel, Director, MACBA, Museu d'Art Contemporani, Barcelona; Markus Brüderlin, Director, Kunstmuseum Wolfsburg; John Cheim, Director, Cheim & Read, New York; Nanette Gehrig, Monaco; Marc and Arne Glimcher, Pace/Wildenstein, New York; Joanne Heyler, Director, The Broad Art Collection, Santa Monica; Antonio Homen, Director Sonnabend Gallery; Gunnar B. Kvaran, Director, Astrup Fearnley Museum of Modern Art, Oslo; Maria Vittoria Marini Clarelli, Soprintendente alla Galleria Nazionale d'Arte Moderna e Contemporanea, Rome; Pierre Levai, President, Marlborough Gallery, New York; Hans Mayer, Director, Galerie Hans Mayer, Düsseldorf; Reinhard and Ute Onnasch, Berlin; Giuseppe and Rosa Giovanna Panza di Biumo; Thaddaeus Ropac, Galerie Thaddaeus Ropac, Paris/Salzburg; Christopher Rothko and Kate Rothko Prizel; John Silberman, President and Amy Schichtel, Director, The Willem de Kooning Foundation, New York; Candida and Rebecca Smith and Peter Stevens, The Estate of David Smith, New York; Walter Soppelsa, Director, Daros Collection, Zürich; Christoph Vitali, Director, Beyeler Foundation, Zürich; David White, Robert Rauschenberg Studio, New York; James Yohe, The Estate of Hans Hofmann, New York.

We would like to include in our acknowledgments the catalogue authors whose contributions offer a new and original perspective on this artistic overview. We particularly thank the following artists who helped with lending of works and projects for the exhibition: Sol LeWitt; Tom Friedman; Tom Sachs; Julian Schnabel; Lawrence Weiner.

We would like to express our debt to: Nadia Forloni, Fondazione Giorgio Marconi, Milan; Barbara Tomassi, Soprintendenza alla Galleria d'Arte Moderna e Contemporanea, Rome; Davide Sandrini, MART, Museo d'Arte Moderna e Contemporanea di Trento e Rovereto; Brunella Bellini, Galleria Salvatore + Caroline Ala, Milan; Marcella Ferrari, Studio Celant, Genoa; Nicolas Boissonnas, Christine Cordazzo, Michel Denancé, Mario Lamparelli, Denise Luccioni, Véronique Martingay, Melchior Lussi, Sven Gehrke, Susanne Daniel.

The curators wish to thank, on behalf of RoseLee Goldberg, Lori Zippay, EAI director, and Rebecca Cleman and Josh Kline for their assistance in preparing materials for the exhibition, Paula Court and Jon Hendricks, as well as Mathew Sandoval for overseeing the many details of this project and for his enthusiasm in reviewing hours of archival video and performance material. On behalf of Melissa Harris, all of the artists for their generous and greatly appreciated participation; curatorial assistant Lauren Fabrizio for her thoroughness, attention to detail, ability to keep everything so organized, and grace under pressure; Diana C. Stoll for her ongoing collaboration, intelligence, and acute and sensitive editorial eye and ear. On behalf of Thierry Jousse: Christophe Bichon and Light Cone; N.T. Binh; Charlotte Garson; Vincent Godard, Sophie Latappy and Wild Side.

We wish to thank for their important professionnal contribution Pierluigi Cerri and Alessandro Colombo who designed the publication and the architecture for the show together with Paola Garbuglio, Maddalena Lerma, Francesca Stacca.

Finally, we wish to thank Otto Hübner for helping to shape the Abstract Expressionism section; all of the guest curators, whose contributions have added immeasurably to the presentation of this exhibition; Amy Brandt and Francesca Cattoi for their indispensable assistance in the realization of this project, to Gerard Cohen and Sylvie Biancheri for bringing us into this project, the staff of the Grimaldi Forum, Catherine Alestchenkoff and Katia Montironi, who coordinated all the crucial aspects of the exhibition, and Skira, specially Vincenza Russo, and Studio Ambrosio staff, Enrico Alvarez, Veronica Bellotti, Emma Cavazzini, Eva Vanzella, who have applied their professionalism and skills to the exhibition catalogue.

To all those institutions and individuals, even the ones who chose to remain anonymous, but have helped guide the project to fruition, we wish to express our deepest appreciation.

Germano Celant and Lisa Dennison
Curators

With "New York New York", the Grimaldi Forum is following up on the resounding success of its 2003 "SuperWarhol" exhibition, inviting visitors this time around on an in-depth exploration of vintage American art.

At the end of the Second World War, New York became a centre of gravity for creative energies of all kinds and the breeding ground of a plethora of artistic movements. From Abstract Expressionism to Pop Art, and from Minimalism to Conceptual Art and Postmodernism, the Grimaldi Forum is seeking to embrace the full range of movements and genres that were forged in the crucible of New York from the 1950s to the present day. To this end, its panoramic overview—the first of its kind in Europe—includes mediums such as architecture, cinema, photography, performance art and video, to name a few.

"New York New York" is also intended as a tribute to those artists who, in many cases, have achieved an iconic status on the international artistic stage.

I wish this exhibition every success and am pleased to see that thanks to events such as this, the heart of the Principality of Monaco is beating to the rhythm of a cutting-edge capital of artistic innovation.

H.S.H. Prince Albert II of Monaco

Contents

*The * next to the catalogue number
indicates the exhibited works*

New York: the Art & Communications Brand

Germano Celant

In August 1949, for the New York-based magazine *Life*, a round-table discussion was held to discuss and compare the meaning and value of "the strange art of today." Among the participants were the leading figures in the world of art, ranging from critics and museum directors to advisers, magazine publishers, professors of philosophy, and art dealers, including Clement Greenberg, Meyer Shapiro, Aldous Huxley, and James Soby. The intention was educational, but the informative promotional configuration toward American art, which counted among its heroes Jackson Pollock, Willem de Kooning, Franz Kline, and Robert Motherwell, was an early example of a process of media-driven exploitation of modern and contemporary art. This was a process of public 'consecration' and 'spectacularisation' of the avant-garde, which was introduced into the network of communications of the mass media, so that it could be consumed, like any other luxury goods. We are witnessing a first collaboration between artistic exploration and mass-market society, a collaboration that aspired to an integration of the subjectivity and the radicality of the creative ego in order to transmute it into the production of a value, both cultural and economic. No longer a frontal, alternative clash—art as opposition to power and to the institutions, a transgressive critique of reality—but instead an aspiration to an integrative dialectic, into which the artwork is sucked, absorbed, and diluted through the phantom-like evanescence of photographic, televisual, and filmic reproduction, losing itself and becoming transmuted into fiction, a weak superficial image. It thus enters a limbo that is triggered by a tenuous depth through which all images pass, on glossy paper or on the screen, and its non-sense and its uselessness, which represent its 'identity,' are transformed into an imaginary landscape, light and ephemeral. Its corrosive function gives way, making room for a theatrical aspect of the gesture of the artist, his performance, where moving in front of the still camera or movie camera, for Hans Namuth's *Pollock*, takes concrete form in an absence of meaning, and instead exalts the heroism of the cursed artist, the new van Gogh.

The intention was to render comprehensible the 'separate' vision of the artist, conveying its bourgeois values, which pass from the documentation of a being that in a familiar dimension produces abstract and informal gestures, such as Pollock's dripping, as accepted by the high bourgeoisie, in the person of Peggy Guggenheim. It is a reassuring game, which slides away, but also helps to make acceptable the idea of a process of creativity and imagination that does not constitute an infesting wound, but is instead the sign and symbol of a social status, both progressive and enlightened. At the same time, by entering the media-driven system, art is subjected to a process of informational consumption, that of a unique phenomenon which is translated into an ephemeral and temporary piece of news, and is thus absorbed into *fashion*. Here the creative structure functioned in a rapid and irregular manner, fed by the ebbs and flows of cultural reporting. Hence the linguistic and aesthetic research remains tied to the continuity of the history of art, but allows itself to be contaminated by the fever for the new, the celebration of the present that cancels the past. The theme of distinction and lived experience gives way to the dominion of the short-term evolution, where what counts is seduction and publicity, communications and the spectacular.

The explosion of the imaginary and the artistic, as symbols validating both the individual and society, in the 1950s was inevitably transmitted, again in New York, through the culturalization of art through curators and historians, museums, collectors, magazines, and gallery owners, such as Alfred Barr, Harold Rosenberg, Dore Ashton, the Museum of Modern Art, the Solomon R. Guggenheim Museum, and the Whitney Museum, Joseph Hirshhorn, the Rockefellers, *Art Digest* and *ArtNews*, Martha Jackson, Leo Castelli, and Sidney Janis, who by carrying out an intertwining between artistic interest and economic collaboration, have established a promotion and a revaluing of the pictorial and sculptural object. Their commitment on behalf of an individual or a movement have had the effect of assuring a consecration, immune from all and every ideological and political contamination.

Through the pursuit and exaltation of the research and their protagonists, through such exhibitions as "New Talent" (1950), "Ninth Street" (1951), "Artists of the New York School" (1957), and "Sixteen Americans" (1959), which were systematically covered and reviewed by magazines and journals, both positively and negatively, from *The New York Times* to *The Nation*, the mechanism of exploitation and acceptance was assimilated. One thus reaches a rationalization of the relationship between art, news, and market place that work in concert to create artistic 'fashions,' identified through definitions that become 'mythical,' because they wind up becoming a sort of aesthetic brand, which identifies a style of art: action painting and abstract expressionism, followed in the ensuing decades by New-dada and Pop Art. This universe, which aspires to construct a monopoly of art establishes itself and develops, from 1949 until 1969, encouraging contacts and exchanges of information, in the uptown area of Manhattan, from 52nd Street to 77th Street, where the headquarters of magazines and newspapers coexist side by side, along with the offices of patrons of the arts and collectors, while the artists continue to live downtown. A distance that with the passage of time becomes problematic and pushes the artistic system, around 1970, to bring together into a single block, SoHo, the production, exhibition, and promotion of artworks. The New York area becomes the central headquarters of the economic and cultural business of art, the place where all the currents and exchanges of the world of sculpture, painting, photography, and video, take place. With an exhibition structure capable of presenting to the millions of visitors and tourists that descend from Times Square to West Broadway some 280,000 personal and group shows and to produce revenues every year, through direct sales and allied activities, of more than six billion dollars, this artistic conglomerate has grown to overshadow the museums proper, which cannot move so quickly and relentlessly to present artists and movements and has transformed the critical and historic considerations, as well as the economic factors, of the work of artists and the behavior of collectors, so as to roil and redesign the universe of art.

The move to SoHo happened just as the dimension of art was becoming hyper-trophic, and exploration was spreading into the territory of advertising and the comic strip, consumer products and movie icons, from Rosenquist and Lichtenstein to Oldenburg and Warhol, introducing a growing coincidence between media-driven communications and visual language, or else taking on an environmental dimension, from Judd and Flavin to Morris and Andre, where what counted was the relationship between object and space, which could only be attested to in the large lofts of the industrial buildings that housed the galleries, such as 420 West Broadway, where in 1971 the leading merchants of Pop Art and Minimal Art, Leo Castelli, Ileana Sonnabend, Andre Emmerich e John Weber converged. By bringing together the territories, that of artistic production and that of its diffusion and marketing, the end use of art underwent a definitive inversion, defining itself as an area of consumption, a cultural mall, which was rapidly enriched by the arrival of luxury boutiques

and shops, where the hierarchies and the indications of power depend on belonging to the "stable" of a dealer which, with its social and journalistic, museum and commercial connections, was capable of ensuring a media "coverage" on all fronts, from business to fashion. In the enclosure of SoHo, the theatre of informational and communicative operations were run, concerning the consecration of one product rather than another, an exploitation that passed through the mass-media and political influence that sank its roots in the prize awarded to Rauschenberg at the Venice Biennale in 1964, and on up to the self-marketing and self-solemnization of Andy Warhol, who intuited before anyone else the process of convergence between art and business, making it into an industry, The Factory, which functioned as a productive facility for the "Warhol" brand. With its production, that extended from painting to the movies, from music to fashion, from journalism to cooking, the frivolity of existence or recording the lives of stars and prostitutes, aristocrats and transvestites, actors and singers, and ultimately attaining a value that exalted the power of the artist as a dominator and producer of images.

In the 1980s, following a decade of philosophical and environmental constrictions, Conceptual Art to Land Art, which with their iconoclastic fury had led to a 'dissolution' of the object and the produce in favor of a philosophy and sensory experience of art, with negative results on its marketing. The contrary wave of Neo-Expressionist and Neo-Realistic painting, contained within itself and in the tradition of painting, brought the market back to life. It led to the affirmation of a form of research that, by setting forth its most intimate and personal considerations, through a seductive style of painting, would once again become pleasant and understandable, free of all mental and theoretical lucubrations.

The consequence were a loss of the philosophical and critic 'mission' of art, upon which the entire modernist project was based, in favor of a romantic exaltation of creativity, and of the individual as protagonist. At the same time, with respect to 'artistic' thinking, the visible and the iconic were reaffirmed, though not exalted for their otherness, but instead for their pleasurable ease. Something irrational, but in the groove of the artistic tradition, both classical and historical, which might be accepted by the mass audience, unspecialized in any 'scientific' reading of art.

The return to a marketing approach was linked to a spectacular exaltation of the hero-artist and to a dizzying increase in the processes of the artworks, around which an international market flourishes as well. The investments and the collections expanded, and the cultural consecration grew in lockstep with the economic valuation. The fashion of painting created "idols," which validated and sanctioned the starring roles of such mythical art figures as Picasso and Dalí, while there began to appear on the scene of information and promotion the auction houses, with international branches, ranging from Christie's to Sotheby's. Art became a profession and the artist took on the standing of a professional or a successful person to whom newspapers and magazines, ranging from *The New York Times* to *Interview*, from *The Village Voice* to *Vogue*, dedicated pages and layouts. Warhol's hypothesis of fifteen seconds of fame came true and openings multiplied, from SoHo to TriBeCa, from the East Side to NoHo; at times *Time* and *The New York Times Weekly* devoted their covers to the old and new stars, Rauschenberg and Johns, Haring and Rothenberg. It was at this moment that the negative view of the artist as an unworthy person, sunk in laziness and unseemly activities, an antagonist of production, of business and commerce, made way for a professional, obliged to carry out an intellectual, but highly remunerative career, from Julian Schnabel to David Salle.

Against this proliferation of galleries, at the turn of the 1980s, there was an attempt by a generation of artists, from Peter Halley to Haim Steinbach who, with the creation of

alternative spaces, from "Nature Morte" to "Pat Hearn," attempted to shift to the focal point from SoHo to the Lower East Side, an area that was almost uninhabitable at the time because of the presence of drug pushers. All the same, the attempt to occupy shops and spaces, where the rent was affordable so that the artists could survive by selling their works directly, was a failure. At the same time, the costs of spaces in SoHo, which the gallery owners had foolishly failed to purchase, began to skyrocket, being pushed up by the arrival of furniture and fashion stores. The result was a growing awareness of the precarious conditions of the commercial settings, the galleries, which had become the lucrative space where outsiders and the misfits of society, the artists, found recognition, glory, and cash. As a result, in the 1990s, Chelsea, a midtown area, discovered in the 1980s by the Dia Foundation and by The Kitchen, where the buildings, from garages to lofts, could be purchased at reasonable prices and transformed into monumental exhibition spaces. Property ownership qualified the system, rendering it stable and secure. It also made a spectacular spatial definition possible, from Paula Cooper to Larry Gagosian, so that the artists could express their research to the greatest architectural degree.

The advent of a new arts neighborhood was preceded by the signals of an economic exploitation of art, as a worldwide field of investment. In 1990, in New York, Vincent van Gogh's *Portrait of Dr. Gachet* was sold at auction for 82.5 million dollars, and Renoir's *Au Moulin de la Gallette* went for 78.1 million dollars, so that the market of contemporary art was also swept by an extraordinary surge in rising prices, in which Sy Newhouse purchased Warhol for 6 million dollars, followed by 3 million dollars for a Basquiat. Sales amounting to billions of dollars in a single session were immediately echoed in Europe by the auctioning of a substantial portion of the collection of Charles Saatchi, an advertising tycoon who encouraged the rising prices and solemnisation of Young British Art, from Damien Hirst to Marc Quinn. The news of these prices created an international media wave, which spilled over onto the television networks and the news media, from Europe to Japan, sending a clear signal to investors and bankers that art was now, once and for all, a part of the economy. And so the media which previously functioned, in *Artforum* or *Art in America* as reflectors and amplifiers of ideas and images, now promote their mercantile values, with the result of giving the artwork, or any language, whether art or design, a 'speculative' representational quality. The myth of economic valuation intertwined with the myth of the artist-as-hero. Both become hyper-visible and their products clutter the theatre and the labyrinth of the media, the lives of their protagonists become the topic of films, from Julian Schnabel's *Basquiat* to Ed Harris's *Pollock*. And it is important to note that the system of the 'sanctification' of the artist passes not only through his economic exaltation, but also his value in terms of scandal, thus reaching the point of stabilizing the "van Gogh" effect of the cursed painter, with a stratospheric value. The diatribe over the nudes produced by Robert Mapplethorpe and his discussions of American cultural politics were both indicators of a dialectic between conservatives, who propose a censorship of the imaginary world, and a free society, that intended to focus attention not only on "all that is visible," without sexual or genre discrimination. All the same, the result of this controversy was a further 'spectacularisation' of art, which intended to continue to discuss social problems, from the AIDS epidemic to the problem of African Americans, from sex to ethnic placement, but inevitably it was restrained by the dizzying urgency of the news, which endowed both the radical declarations and the artistic fetishes, with elevated economic 'significance.'

And so New York, which had been the centre of Action Painting, Pop Art, Minimal Art, Underground Cinema, Happenings, New Modern Dance, Conceptual Art, Neo Patterns, Badpainting, and Neogeo, definitions of movements and trend-setting groups, entailing a par-

ticular and specific language, slowly retrenched, from 1990, into a city of 'personalities,' from Jeff Koons, Tom Friedman, Tom Sachs, Cindy Sherman, and Richard Prince to Matthew Barney, Kara Walker, and Gregory Crewdson, but without any definition and representavity of an idea or a theory, whether pictorial or sculptural, photographic or televisual, performance-related or creative. An exaltation of the monologue, which exalts the 'personality,' free of any and all 'definitions' save for that of his imaginary power as an individual and a solitary creature. Whether a damned or an angelic creature, the artist affirms himself as a 'producer' of objects or visions, which serve a system of 'exploitation,' repetitive and constant, from the media to the gallery and to the auction house, which no longer communicates a 'critical standpoint,' but instead merely an affirmation of the existence of a fetish, signed and dated, to be consumed. Once the iconoclastic fury had been completely reduced to zero, with the chaotic, anarchistic pursuit of artistic innovation, and the affirmation of an entity reflected upon itself and upon its informational vehicles—including the art fair that from Basel to New York and Miami, were established as mirrors of values and sites of frenetic collecting—where there was no longer the creation of an alternative reality or discussion of the present, but quite simply merchandise. If this is the informative spectacle that exists, subordinated to the media, as much as the consumption of the public, from visitor to collector, it was understandable why New York should once again have been the point of departure for a constellation of museums, linked to a 'trademark' or 'brand,' such as the Solomon R. Guggenheim Museum. It was an evolution of an institution whose primary task was the spread of modern art, beginning with non-objective art, from Klee to Kandinsky, which, in the wake of an economic globalization, attempted to expand its informative and patrimonial 'function,' considering that it already possessed one, in Europe, in Venice, pragmatically opening other branches around the world, from Europe to Asia. This was a further example of "cultural capitalism" (Rifkin) that witnessed the introduction into the sphere of economics and the market of social territories that had been excluded, as art, architecture, design, education, and information… The museum was transformed into a producer of macroscopic signs, such as the Bilbao Guggenheim Museum, designed by Frank O. Gehry, which in 1997 marked the end of a century of 'functional' architecture which made way for an artistic architecture, but above all determined once and for all the integration of art, museum, and business, tourism and real estate. Here the trademark has become the tool of persuasion par excellence and the consumer goods are those of history, from the modern to the contemporary; therefore, introducing the individual product does not matter, as do the galleries and auction houses, which actually sold, in the year 2000, in Europe and America, several billion dollars worth of art, one hundred times the values of the time SoHo, in 1970, but the system as a whole is an instrument of mass attraction, as well as cultural persuasion. And if the traditional instruments of art, such as the reproduction or the exhibition, the value at auction or the magazine cover, all still move within the context of publicity aimed at the individuality, the establishment of a chain of Guggenheim Museums, followed by the Museum of Modern Art of New York and the Hermitage of St. Petersburg, opens to art a self-referential position, publicizing itself and its own communications mechanisms, and it matters not at all what the product is that is being purveyed, it could be antique or modern, artisanal or industrial, artistic or architectural.

With the creation of such a kaleidoscope of instruments of diffusion and persuasion concerning the cultural commercial value of art, ranging from the mass media to the auction houses and the museums, the powerful network of art tended to bring down all possible psychological defenses against its consumption and acquisition, in all nations with developed economies, across the world, from China to India, from Russia to Latin America.

The final contribution came from the diffusion via Internet that makes it possible for images to appear in real time, with a circuit placement of 'fetishes' that, when simulated, become lighter, losing their physical weight, losing their incarnate presence, with a process that can become dangerous for the centrality of New York which, in order to remain the *centre* needs to remain a physical and clearly defined entity, not an indefinite and virtual territory, even if that territory is managed in its economic and cultural offices. We might conclude then with the statement that "New York" has become a brand that has symbolically appropriated all the products of the existing visual imaginary universe. It gives origin to recognitions, via museums or galleries, historians and experts, auction houses and institutions, of products that tend to become a universal language, assumable and consumable in any territory of the economy and of the circulation of cultural resources. It is a symbol, homogenized in the shared international language of all brands, of a centre of all trademarks, a centre that exists for the circulation of ideas and images, as well as for the density of the exchanges and transnational information, upon which all consumers and non-consumers of art can draw, depending on their resources: an *art and cultural brand*.

Painting and Sculpture from 1945 to the Present

Lisa Dennison

"If I can make it there, I'll make it anywhere
It's up to you, New York New York"
(*Theme from New York New York*)

Taken out of context, the lyrics from Frank Sinatra's legendary theme song *New York New York* speaks to the attraction that New York has been for generations of artists, who have found the "city that never sleeps" to be one of the most vibrant cultural capitals in the world.

As America became a world leader after World War II, New York replaced Paris as the capital of art, and would dominate the international scene for the next two decades. Even as a sweeping internationalism took hold of the contemporary art scene starting in the late 1970s, New York has remained at the vanguard for some of the most exciting developments of contemporary art.

This exhibition gives a broad overview of the years from 1945 to the present in art, architecture, photography, video and performance, and film, integrating these art forms into one comprehensive look at a time that has been sparked by tremendous innovation and creativity. The postwar period has been a complex one from a social and political perspective. Many of the essays in this catalogue capture the intertwining histories of politics, social history, and art.

The exhibition opens in the early 1940s with the artists of the New York School who charted a whole new course for America art. Influenced by the Surrealist émigrés who began arriving on these shores by 1940, Abstract Expressionism became the first important school in American painting to draw from European styles, yet ultimately declare its independence from them. Arshile Gorky, for example, absorbed the teachings Surrealism as filtered through Joan Miró and Pablo Picasso, in the development of his own language of free organic, biomorphic forms floating on indeterminate backgrounds.

The New York School was stylistically diverse, and can be characterized by a gestural mode, in which the canvas becomes an arena to enact the inner workings of the artist's subconscious, and a chromatic mode, whereby artists used large fields of pure color and monumental scale to evoke a sense of the transcendent, the spiritual, and the infinite. The practitioners of the movement were fiercely individual—as was their artistic expression. From the energetic brushwork and paint application of Jackson Pollock, Willem de Kooning, and Franz Kline, to the color abstractions of Ad Reinhardt, Barnett Newman, Mark Rothko, and Clyfford Still, the first generation of the New York School defined the artistic avant-garde.

The major American sculptor of this period was David Smith, who drew on the traditions of Surrealist sculpture, and the Cubist mode of drawing in space, of artists including Pablo Picasso, Alberto Giacometti, and Julio Gonzalez, to formulate a new mode of abstract sculpture marked by the use of industrial materials and the integration of open space. A second generation of New York School artists emerged, including an important group of woman artists such as Lee Krasner, Joan Mitchell, and Helen Frankenthaler. Frankenthaler and fellow color-field painter stained their color onto unprimed canvas, providing

an ideal of the truly flat picture plane and eliminating the emotional or mythic content of Abstract Expressionism. Frank Stella and Ellsworth Kelly practiced a more hard-edged variant of geometric abstraction. Stella's shaped his canvases into large scale geometric forms, whose interiors were painted with bands of strong, unmodulated, and sometimes fluorescent color, bringing abstraction and decorative pattern painting into a congruence. There was also a figurative school, including artists such as Alex Katz whose work was characterized by flat, schematized figures depicted in shallow space.

As America ascended to new artistic heights, Europeans had the ability to see this new art first hand, at festivals such as the Venice Biennale, and Dokumenta, as well as traveling exhibitions, most notably those organized by The Museum of Modern Art. The most influential of these was "The New American Painting", which traveled to eight European capitals in 1958 and 1959, and included artists such as Pollock, de Kooning, and Robert Motherwell. Europeans also began to collect vanguard American art, including Count Giuseppe Panza di Biumo, who amassed an extraordinary collection of Abstract Expressionism and Minimal Art (and is a lender to this exhibition), as well as Peter Ludwig, whose unparalled collection of American Pop Art is the centerpiece of the Ludwig Museum in Cologne.

The term Neo-Dada has been applied to a wide variety of artistic works and movements, including the combines and assemblages of Robert Rauschenberg and Jasper Johns; Happenings; Assemblage; and Fluxus. A reinvestigation of the precepts of Dada, in particular its irony, its rejection of traditional aesthetics, and its use of found objects as instruments of social critique, was among the hallmarks of these art forms. Happenings were loosely structured events of a theatrical nature that "happened" in public spaces. Characterized by spontaneity and improvisation, and encouraging audience participation, artists were searching for a means to establish more direct relationships between art and life. Among numerous artists involved in the early happenings were Red Grooms, Claes Oldenburg, Jim Dine, and Rauschenberg.

Fluxus explored connections between the visual arts, poetry, music, dance, theater, and the more radical forms of performance. It often was mixed with social and political activism. Fluxus artist Nam June Paik, a Korean born artist and student of avant-garde music, pioneered the use of video, creating eclectic sculptures that married technology and art.

Assemblage artists used found and scavenged objects and discarded materials in paintings and sculptures. John Chamberlain brought Abstract Expressionist painting into three dimensions in his sculptures composed of crashed automobile parts, welded together. Architecturally-scaled and spatially dynamic, Marc di Suvero's monumental steel sculptures, made from industrial I-beams, also spoke to the heroic qualities of Abex painting. Louise Nevelson set pieces of wood scraps inside open boxes, which were stacked to create evocative environments, painted matte black or white. In all cases, the works transcend the ordinary materials from which they are composed. Rauschenberg's combine paintings were created by collaging elements onto their support, which in the case of *Dylalby* is composed of an old tarpaulin, a skateboard, and rusted Coke sign. Jasper Johns took as his subject familiar generic forms which could not be distorted—letters, numbers, targets, flags, and maps—and renders them with built-up paint or lushly worked surfaces. He explores the paradox between an object and its representation, a legacy inherited from Duchamp.

The Pop artists of the 1960s explored the world of popular culture, and embraced its materialism. Building on the explorations of Johns and Rauschenberg, and the effort to bring art and life into intimate proximity, Pop artists took inspiration from the world of advertising, comic strips, television, movies, and billboards. These images, presented with hu-

mor, wit, and irony, can be seen as both a celebration and a critique of popular culture. Artists associated with Pop art include Roy Lichtenstein, Andy Warhol, James Rosenquist, Tom Wesselman, George Segal, Richard Artschwager, as well as Grooms, Dine and Oldenburg. Segal's figurative sculptures, cast in white plaster from the human figure, are rendered as ghostly and anonymous. They bespeak a sense of isolation and loneliness in their precisely constructed settings. Red Grooms, to the contrary, generates humor and hilarity in his constructed environmental sculpture, *Ruckus Manhattan*—a transformation of New York City's iconic monuments including the Brooklyn Bridge and the Statue of Liberty, rendered as garishly colored caricatures. Dine mounts objects onto his canvases—usually tools such as shovels, saws, and hammers—that were familiar to him from his family's hardware store business. Oldenburg transforms everyday objects in scale and material, violating their essential nature, as seen in this exhibition in the colossal hanging plug and twelve-foot high ice cream popsicle. Food is also a topic for Wesselman, whose mixed-medium still lifes incorporate items such as a turkey from a plastic supermarket display. He has also explored variations on the theme of the Great American Nude, imbued at once with eroticism, and a certain dispassionate coldness. James Rosenquist has channeled his experience as a billboard painter into canvases that share the mural scale of some of Wesselman's work, and presents a kaleidoscope of images drawn from the world of politics and advertising. Roy Lichtenstein not only appropriated icons of pop culture, but has also imitated the techniques used to reproduce these, adopting the Benday dots used in newspaper illustrations to create the appearance of mechanical reproduction. In works like *Little Aloha* and *Large Spool*, he simultaneously magnifies and simplifies, forcing us to reconsider the images that have seemed so familiar. Andy Warhol also uses the silkscreen process to eliminate the personal signature of the artist and further distance us from the familiar image. Like many Americans, Warhol worshipped movie stars, especially Marilyn Monroe, and paints her as the icon of a glamorous woman – a contemporary sex goddess, in a changing palette of brilliant colors. Warhol's painting of the Statue of Liberty mirrors the pictorial conventions of the celebrities in the cropped close up of the statue's head. Yet nothing is sacred in Warhol's world—the seemingly inviolate image is overlaid with a camaflogue pattern.

Another trend of the 1960s and 1970s that owed a clear debt to Pop Art, as well as to the popularity of photography, was Photorealism, which stressed the precise rendering of subject matter, often to the point of hyper-realism. Photorealist artists such as Chuck Close worked from actual photographs, transforming their scale into ten-foot gridded portraits that magnify every detail of the sitter's face. As you move closer to them, the image dissolves into abstract markings. Duane Hanson creates startlingly life-like sculptures of Middle America—housewives, tourists, shoppers—through a complex process of casting in Fiberglas resin that creates a realism reminiscent of Madame Tussaud's wax effigies. Richard Estes chronicles the urban landscape in meticulously executed works of extreme clarity. He chooses to eliminate people from his scenes, concentrating instead on the spatial dislocations created by reflections of the plate glass of store windows, or the shiny chrome of the diner, the car fender, and the telephone booth.

Reacting against the formal excesses of Abstract Expressionism, and the subjectivity of Pop Art, Minimalism refers to painting or sculpture made with an extreme economy of means, purged of metaphor. Forms were reduced to essentials of geometric abstraction. Repetition and seriality, the use of industrial or commercially fabricated materials, uninflected surfaces, were hallmarks of the artwork associated with this movement, by artists including Donald Judd, Dan Flavin, Carl Andre, Robert Ryman, Brice Marden, Robert Mangold, and Sol LeWitt. Judd's boxes, made of metal and plexiglas, rest directly on floor, or in the

case of his stacks, are hung on the wall according to a system that incorporates the intervals of space between the individual units into the overall work. Carl Andre's metal plates sit directly on the floor. The viewer is encouraged to walk on them, enabling a tactile connection with the work that is essential to Andre's concept of "sculpture as space." Sol LeWitt sought to bring his artwork into more direct engagement with its physical surroundings, bringing the wall literally inside the work in his wall drawings. His open cubes were based on mathematics and logic. Like much of Minimalist art, the phenomenological basis of the viewer's experience is key to understanding the work. Light is Dan Flavin's medium. He creates sculptures from readily available fluorescent fixtures and tubes, defining architectural spaces in the merging of light and color. His *"Monuments" for V. Tatlin* pay homage to the ideals of the famous Russian Constructivist. Minimalist painters also eliminated illusionism in their works, choosing instead to focus on the fundamental properties of the materials employed. In the case of Robert Ryman, he paints exclusively in white paint as a means of bringing one's attention to the other elements of painting, such as brushwork, and support. Mangold focuses on the relationship of the internal geometry, and external shape of his canvases. Marden eschews the cool neutrality of his contemporaries in favor of a more evocative style of abstraction that depends on color and lush encaustic surfaces for its effect. Martin's monochrome paintings rely on the grid, but are not based on mathematical systems. Meticulously hand-rendered, they radiate an organic quality, and often resemble woven fabric or textiles. Ellsworth Kelly, who is sometimes associated with Minimalism, abstracted his forms from the empirical world.

The Post-Minimalist artists such as Richard Serra, Bruce Nauman, Robert Morris, and Walter de Maria reacted against Minimalism and the authority of the single art object. They privileged process involved in the making of their art, used unorthodox materials like latex, molten lead, neon, mirrors, foam, and felt. Robert Morris articulated his aesthetic approach in a 1968 essay entitled *Anti-Form*. His felt sculptures exploit gravity, chance, and indeterminacy in their arrangement, whether hung on the wall, or scattered on the floor. Richard Serra's sculptures consist of sheets of steel or lead which are balanced or propped against each other, evoking a sense of threat and danger. Gravity is all that secures them. Artschwager's sculptures in Formica take on the morphology of furniture. Nauman's elongated writing, electrified in neon, becomes a meditation on identity, visibility, and legibility.

Another tendency, known as Conceptual Art, whose practitioners include Joseph Kosuth, Lawrence Weiner, Vito Acconci, and Walter de Maria, privileged the idea or concept of the artwork, rejecting the notion of originality and of the traditional art object as an end in itself. Text and language became important components of this art form, in order to investigate the meaning of a work of art, as well as how art functions are part of a social system. Kosuth's "definition" works include the dictionary definition of an object placed next to the real object itself. Lawrence Weiner's medium is language. His works are composed of language and the materials referred to. His approach to art making does not require that the piece need to be built, thus shifting the responsibility of the work's realization to the spectator. Vito Acconci's installation *Voice of America* is a seminal work of the artist, in which he was dealing with the particular location a work was to be located in, and the viewers who were part of that location. In his words, he was trying to turn "space," into "place."

Land Art, or Earthworks, was another manifestation of art that questioned the authority of the art institution and the idea of art as a commodity. Conceptual Art and Land Art often incorporate photographs, video, instructions, or maps. Robert Smithson's "nonsites" combine specimens of organic materials from locations into his sculptures made of

glass and mirrors. Performance Art, Body Art, and Video are another manifestation of Conceptual Art, whose tenets are discussed in another essay in this catalogue.

Although it was not the prevailing trend, traditional painting and sculpture, often figurative, and imbued with psychological content, continued to thrive in the 1970s. The term "Pluralism" was adopted to describe the varying tendencies of this era. Philip Guston, whose abstract work of the 1950s was characterized by centralized areas of overlapping brushstrokes in luminous colors, returned to figuration in the late 1960s, in works that are characterized by satirical, cartoon-like imagery. Cy Twombly's graffiti-like paintings contained allusions to mythology and classical literature. Susan Rothenberg was one of the artists included in the Whitney's seminal "New Image Painting" show of 1978. Reminiscent of Paleolithic cave paintings, her canvases of horses and body parts vacillate between abstraction and representation. Joel Shapiro abstracted from the form of the house, the ladder, and the figure, and demonstrated that scale and size are different concepts.

Another outcome of the pluralism of this decade was the new role accorded to photography. Moving away from the documentary function that it played in Conceptual Art, it became a medium in itself, both for fine-art photographers and for artists who used photography as a tool to make art. Artists such as Richard Prince and Cindy Sherman used photography as a vehicle through which to critique photographic representation itself. Richard Prince borrowed from the world of advertising to rephotograph images of American consumer culture, most notably the "Marlboro Man." Cindy Sherman explored stereotypes of female representation by using her own likeness for her photographs, albeit transformed by the personae she creates, which range from characters from b-grade movie film stills to portraits of gender-ambiguous figures. Barbara Kruger juxtaposes photographs from the media with pithy texts ("I shop therefore I am") to examine ways in which female stereotypes and gender difference is reinforced through the media. Robert Longo also deals with stereotypes, and how these can lead to alienation within our society. His large scale drawings based on photographs of contorted figures are both physical and psychological portraits.

The different artistic strategies that emerged during the end of the 1970s signaled a death knell to Modernism's utopian principles of innovation, authenticity, and individual expression. The "Postmodern" practices of the 1980s questioned the value of modernist enterprise through appropriation, through performative actions, through a challenging of the effects of commerce on the art world. Within the critical debate about the validity of painting and the status of Modernist ideology, new tendencies began to emerge, including a revival of Expressionism, often on a heroic scale, to counter the devaluation of painting by the Minimalist and Conceptualist artists. Neo-Expressionism had its roots in German Expressionism, and indeed Italian and German artists working in this vein also came to prominence in the early 1980s. The 1980s witnessed an influx of art from Europe, as Americans learned that vanguard art was no longer exclusively in the American domain. Julian Schnabel's figurative paintings constructed of broken crockery, or painted on velvet, tarpaulin, or theater backdrops, recalled the monumentality and brash confidence of Abex, while mining history and contemporary culture for their subjects. Eric Fischl's figurative paintings underscored the psychological tensions of life in suburbs in their erotically charged images of adults and adolescents caught in intensely private moments. David Salle's combinations of original and appropriated images, often from art history, were characterized by illogical juxtapositions of images, leaving the viewer to decipher meaning from these layered narratives.

Another kind of figurative expressiveness, defined by a new street sensibility, soon emerged in the work of the graffiti artists, Keith Haring and Jean-Michel Basquiat. Graffi-

ti Art was so named following an exhibition called the "Times Square Show." Keith Haring works with universally legible signs, including his signature barking dogs and radiant babies, in simple, flatly colored, cartoon-style line drawings. Basquiat often painted on crudely constructed canvases, merging a deliberately naïve, child-like drawing style, with language and with images from African culture, and American popular culture. In the realm of public art, Jenny Holzer uses electronic signage to flash provocative messages, ranging from pithy one-liners to more lengthy meditations on society, on the human condition, and the role of art in society.

Pop Art provided a model for many artists in the 1980s, perhaps none as much as Jeff Koons, who took consumer goods and transformed them through alterations of scale and material, extending the lineage of Dada. The *Banality* series, created by highly skilled woodcarvers, adopted images from the world of kitsch (a three-dimensional version of a found photograph of a couple holding eight puppies; a bear hugging policemen) which test the limits between popular and elite culture, and challenges notions of taste. Koons seeks to heighten our awareness of art as a commodity that cannot be placed within the hierarchy of conventional aesthetics.

Artists in the 1990s have continued to explore in many different and often contradictory directions, looking outside the frame of the institution for validation of their work. Cultural identity is an issue for Kara Walker, whose powerful wall-scale cutouts retell the history of slavery in the United States. The silhouetted forms of slaves and masters from the antebellum South draws attention to the stereotypical abandonment of individuality. Identity also figures in the work of Felix Gonzalez-Torres, who died of AIDS in 1996. He reinterpreted the aesthetic of Minimalism in his ephemeral work, made of replenishable stacks of paper, candy spills, and light strings, yet imbued them with a depth of meaning and emotion absent from the art of the 1960s and 1970s. Robert Gober's nonfunctional domestic objects, like sinks and playpens, also reference the forms of Minimalism, but are handmade, and project a strong human presence. His haunting works suggest that the ordinary and the recognizable is never what it appears to be.

Christopher Wool's reductive patterned imagery, created with decorative rollers, and his stenciled word paintings, broken up so as to confound their meaning, speak to the failure of meaning in language, and, ultimately, in art. Sue Williams has also used texts in her paintings. In the mid-1990s, she began to create allover compositions of body parts, often sexual organs, that recall the gestural painting of de Kooning and Pollock, yet explore issues of the body, gender and identity in an almost caricature style. Kiki Smith's sculptures also refer to human anatomy and body functions. Through their materials they communicate vulnerability, fragility, and ultimately, decomposition. Louise Bourgeois's highly personal work of the 1990s continues to be autobiographical. Her bronze and steel spiders are associated with childhood fears, and the protective instincts of her mother.

Matthew Barney's *Cremaster* cycle consists of five visually extravagantly feature-length films that explore the processes of creation. The title refers to the muscle that raises and lowers the male reproductive system. Barney creates an intensely private universe—a complex fantasy of densely layered personal symbols and images. Filmed out of sequence, *Cremaster 2* explores the life story of convicted killer Gary Gilmore, who was executed in Utah in 1977, and has since been famed as Harry Houdini's grandson. Tom Sachs creates an equally bizarre universe in his *Nutsy's* world, which links the idealistic Modernism of Le Corbusier with another icon of the modern age—McDonald's—encircled by a giant race car track. Everything is fetishistically rendered through a bricolage technique—Sachs' work has been described as "handmade pieces from ready-made goods." Tom Friedman obses-

sively crafts poetic objects from non-art materials to create astonishingly meticulous forms. What is ordinary becomes extraordinary—a self-portrait carved onto an aspirin, for example—and always engenders a dialogue between material and image. Video artist Tony Oursler also brings a handmade sensibility to his "talking heads." He creates bizarre psychodramas by projecting image and sound onto sculptural objects that are sometimes figural, and sometimes abstract.

While the exhibition has been deliberately selective, and only representative of some of the currents in contemporary art, the future is suggested in the work of artists like John Currin. Currin examines the tradition of painting, synthesizing historical and contemporary styles from the Renaissance and Mannerist periods with images from fashion magazines. He depicts a very American world of aging women with sagging breasts, to full-breasted pin up girls in a contrarian spirit that reflects a kind of Postmodern irony.

The art that is being created in New York today continues the spirit of vitality, energy, and innovation of the last fifty years. As for the future, in the words of Frank Sinatra, "It's up to you, New York New York."

1950-1975

Producing, Displaying, Commodifying:
Art in New York's Volatile Financial and Real Estate Context

Janet L. Abu-Lughod

European Roots

Just as New York City was emerging from the Great Depression of the 1930s, it mounted its most ambitious World's Fair, not in crowded Manhattan but on more than 1,200 empty acres in the sparsely settled Outer Borough of Queens. The fair opened on April 30, 1939, amid great fanfare heralding the "dawning of a new Utopia." Its theme was "Building the World of Tomorrow," whose progress would be propelled by a uniquely American technological revolution in transportation and communication. But the exhibitions were displayed in sleekly designed, if simplified, "modern" buildings derived from European models that had been introduced by earlier exhibits. In 1932, the Museum of Modern Art's International Exhibition of Modern Architecture showed the works of Le Corbusier, Walter Gropius, and Mies van der Rohe, among others. Their 1934 exhibit of "Machine Art" was followed in 1938–39 with a retrospective exhibit, "Bauhaus, 1919–1928."

Three of the best-attended exhibits in the World's Fair were: "Democracity" (depicting an industrialized garden city that Ebenezer Howard and Patrick Geddes could have embraced); "Futurama," which promised to transport the viewer into 1960, an exhibit sponsored not surprisingly by General Motors (depicting the auto manufacturer's wish dream of a vast national highway system, equipped with overpasses and cloverleaves, that would facilitate the ultimate disengagement between center city jobs and residential suburbs); and the most realistic, "The City of Light" sponsored by New York's electric company Con-Edison, a panorama – as long as a city block and three stories high – exalting the city itself as a dazzling aesthetic achievement, complete with Manhattan's skyscrapers and its subways in motion, lit 24 hours a day (a tribute to the city that never sleeps).

Many of New York City's admirers view the city, with its enormous diversity of the built environment and of its teeming inhabitants, as the ultimate "work of art." That truth remains valid, long after the World's Fair closed abruptly on October 27, 1939, its bankrupt demise of hope signaled by Germany's invasion of Poland and sealed by the fall of Paris in 1940. New York's art scene went dark as well, although it served as a safe heaven for European luminaries such as Dali, Mondrian, and Chagall, among others. When the lights went on again (literally, since blackouts had been enforced), New York emerged with vital non-derivative creativity.

Cycles of Change

The artistic history of New York over the last half century, roughly between the late 1940s and the late 1990s, can be conveniently divided into two cycles of 25 years each—breaking in the 1975 fiscal crisis when the city literally had to be rescued from bankruptcy. These cycles paralleled changing economic conditions of boom (1950s-late 1960s), recession (1970s-early 1980s) and recovery (late 1980s and, with a brief interruption, the later 1990s). The city's population mirrored its economic health: rising to a high point of 8 million by 1970, slipping to 7.5 million ten years later, and not recovering to its earlier peak until 2000. These cycles were reflected in New York's turbulent real estate market that alternated between overbuilding, neighborhood blowouts, and gentrification. All three trends provide the backdrop for changing artistic production, consumption, and display.

Prosperity

The United States emerged from Europe's ashes of World War II as the richest and most powerful country in the world, and New York, the city that Kenneth Jackson called in 1950 "The Capital of Capitalism," dominated the United States. Untouched by the destruction that had devastated the physical environment and exhausted the fiscal resources of Western Europe, the city had prospered. Its moribund port had revived at first through Lend-Lease and then through massive shipments of men and materiel to Europe. Its weak industrial base had boomed through aircraft production in large decentralized plants throughout its region. And its banks and stock markets, on solid economic ground thanks to the loans to be made both at home and abroad where the dollar was the "gold standard" of the incipient global economy, increased their tentacles of control and their profits to investors.

The city's population had grown from the migration of African Americans from southern states stimulated by increased labor demands, fueling a revival of the Harlem Renaissance in the arts. In the postwar period they were joined by the arrival of adventuresome white migrants from distant cities and small towns, drawn to the "City of

Lights" by the magnet of opportunities promised in the now-relit Broadway, by the expansion of schools and universities offering training and teaching jobs in architecture, literature, film making, music and drama, and by the freedom of painters to experiment with new media and new modes of expression. But they were also drawn by the prospect of finding companionship and mutual inspiration in communities of others with whom they could share the "deviant" interests that had isolated them "back home." Their synergism created new "schools" of artistic expression, which found their base in Lower Manhattan: in Greenwich Village, the Cedar Tavern, Andy Warhol's warehouses, and eventually in the bargain priced abandoned vertical loft factories in SoHo, in which, at first, only "certified" artists were authorized to inhabit and work.

Mobility

It was the dominant theme, not only for artists but for the churning of real estate. Spaces for art production were opening up in the older crowded quarters as young middle class families decanted to new mass-produced suburbs idealized by Democracity, which were now reachable through freeways that had been built according to Futurama designs. Government policies made these possible, not only guaranteeing low-rate mortgages for veterans, heavily subsidized loans for builders, and direct costs for highway construction, but through tax benefits to "consumers" of art.

Money

It was the second theme. Just as the new fortunes generated in New York during the American Civil War had led to a "Golden Age" of museum construction and a demand for the symbols of elegant living, including investments in "Art," so the new fortunes made in the World War II were invested not only in private consumption but in competitive bidding for acquisitions of artworks (still mostly from Europeans) by an explosion of new collectors. Although many might have preferred to buy the works of old masters and French impressionists, some few collectors (newly rich as well as the children of old money) competed to sponsor younger artists and to invest in their works. Peggy Guggenheim, among others, led the way to new tastes, supporting innovative painters experimenting with different media and forms. Once the work of these younger artists (for example, Kline, Rothko, de Koonig, Motherwell, and especially Jackson Pollack) gained greater, albeit at first reluctant, acceptance in the exuberant 1950s, the investments began to pay off in museum acquisitions and resales.

By the early 1960s, this first generation of abstract expressionists of the "New York School" was joined by a group (including not only Andy Warhol but Jasper Johns, Roy Lichtenstein, and Robert Rauschenberg, among others) who were producing in the even more salable "pop-style." The number of galleries exploded from 150 to 300, and astute dealers took advantage of the boom in disposable incomes of consumers to market their still-affordable products, desired not only for their undeniable merits also for the tax savings they promised. Just as in 14th-century Florence, the wealthy stimulated the demand for artworks and fine artifacts because wealth accumulated in goods, rather than in money, escaped taxation, so donations of paintings, sculpture, and other "priceless" artifacts to the rapidly increasing number and variety of museums in the city gained the donors significant tax deductions. Here was a way to save money, keep the prestige of ownership, while still advertising the name of the donor.

Needless to say, the financial returns to the producers of art lagged considerably behind those that accrued to consumers and donors. As had always been the case, most artists lived on the edge of poverty, even those few who enjoyed patronage and occasional sales. Their works were not marketed through the prestigious auction houses where buyers still competed for works of recognized provenance, increasingly the paintings of French impressionists, Van Gogh, Modigliani, Picasso, and sculptures of modernists such as Brancusi and Henry Moore, which were acceptable to museum curators or suitable for the growing number of sculpture gardens. (New York artists whose works most closely resembled theirs, such as Childe Hassan's, rode on their coat tails.) The ordinary would-be winners in the struggle for acceptance as creative artists, in the meantime, were struggling in the competitive housing market to find interstices of affordable space in which to live and to work.

Scarce Space

For the burgeoning number of artists it was the third theme of the period. Such accommodations, however, were rapidly being destroyed. The fiscal exuberance of the postwar period had led to what economist Schumpeter had called "creative destruction." Beginning in the late 1940s, the city engaged in a massive clearing of many of its dense tenement districts, most of which had been constructed in the later 19th century. Under its housing czar, Robert Moses, and with financial assistance from the federal government (the Public Housing and Urban Renewal programs), the City engaged in the country's largest program of building subsidized public housing projects for low-income tenants. Large swaths of land scattered throughout Manhattan, the Bronx, and Brooklyn were cleared and replaced by monolithic high rise projects—downscale Le Corbusier structures, except that they lacked workplaces and com-

mercial facilities—and would gradually be filled not by artists but by minorities blessed with children. Creative destruction was also taking place in midtown Manhattan as old-style office buildings were cleared and replaced by corporate headquarters designed by geniuses like Stone and, unfortunately, by many of lesser talent.

There was one source of underutilized center city land that was a legacy from the decentralization of large-scale industrial plants during and after the war, promised by Democracity, and the massive construction of super highways to connect distant point promised by Futurama. New York's older industrial base, which had been characterized by small, vertical factories, and its abandoned port areas that were flanked by expansive warehouses, were concentrated in Lower Manhattan and were failing, emptying out, and, most significantly, were drastically under priced, despite the real estate boom. What stood in the way of their destruction was a legal problem which, when solved, would have the serendipitous effect of simultaneously preserving them from destruction and opening them to transitional "recycling" as low-cost production and residential sites reserved for artists. The problem was that they had been zoned not for residential but exclusively for the industrial uses that were fleeing the area.

The most famous of these became SoHo [South of Houston], with its distinctive metal clad loft factories which in 1962, in a uniquely imaginative New York solution much copied later in other American cities, were opened to the exclusive use of "city-certified" artists who planned to produce large-scale paintings and sculpture in their undivided space, in return for which they would be allowed to live in them at nominal rents. But the door was opened to recycling and eventually gentrification, when residual owners began to recoup their losses by selling upper floors for bargain prices that in the beginning had been as low as $5,000. The potential profits to be made were irresistible, and soon, subterfuge resulted in illegal occupancy by non-artists and investments by speculators, until the City gave up and the boom began. By 1970, some 2,000 artists were living in the area, supplemented by "faux" artists. Galleries flocked to the zone, taking advantage of cheap space and the caché of sophistication associated with New York's "Left Bank." (In the meantime, Greenwich Village had fallen victim to gentrification, institutional expansion and recycling.) This was the first in a series of nomadic artist colonies, in which creative artists have subsequently served as "shock troops" to open other undervalued zones whose sites would multiply in the recession soon to come.

Hard Times - Retrenchment
In the meantime, New York City's efflorescence was beginning to falter. Its population, that had peaked in 1970, was in decline and bifurcating into greater class and racial inequalities, due to stagflation, loss of good jobs, and evisceration of the middle class that had increasingly opted for suburban and even exurban regions. City revenues were declining as owners of deteriorated buildings milked their properties, failed to reinvest in maintenance, and eventually stopped paying their real estate taxes entirely. Thousands of these properties, by default, came into city ownership. By 1975, with declining tax collections and increasing expenses, the city was on the edge of bankruptcy. This marked the beginning of the "Fiscal Crisis," solved only by the issuance of new bonds.

One area in Manhattan that experienced massive disinvestment was the East Village, an area shared uncomfortably in the 1960s by poor Puerto Ricans and members of the Counter-Culture (the equivalent of San Francisco's Haight Ashbury district). By the mid-1970s, this hippie haven of run-down tenements experienced devalorization and eventually abandonment, as tax arrears mounted or owners burned their buildings for insurance compensation. The serendipitous effect was to open up space, not only for squatters, but for a profusion of artistic innovations: new musical forms at places such as CBGB, exciting large-scale street art (murals that covered whole walls), poetry readings, experimental theater, communal gardens, and strange outdoor sculpture using found objects. In the interstices created by abandonment and tax forfeiture, artists moved in, grateful for low cost housing in buildings taken over by the city in default and reassigned to communes, art collectives, and for free work space in closed public school buildings and social service facilities no longer needed by the declining number of tenement families. Some galleries followed them, but the lucrative market had dried up in the recession. There was therefore not only space in which to live and work cheaply but a new freedom from the tyranny of the market to innovate.

Booming 1980s and 1990s - Global Markets
In the early 1980s New York's economy began to recover from its nadir and in the following decades, with only slight setbacks in the stock market, enjoyed a sharp upturn in its fortunes as the City assumed an unrivaled position in the evolving global system. Once again it had proved its resilience. Massive immigration from 169 foreign countries led to filling in the empty spaces created in the recession and put pressure on the market for land. The East Village benefited by an extension of Chinatown to its south but was largely ignored by foreign immigrants who flocked to the Outer Boroughs, notably Brooklyn and Queens, or settled in northern Manhattan flanking the established core of Harlem, not yet in recovery. The South Bronx, destroyed in the 1960s

and 1970s, and Brooklyn's farthest reach, East New York, remained the highest crime areas of the city, which made them unattractive to artists, despite their bargains.

The East Village, which had nurtured collaborative projects and mixed media "on the cheap," was subject to unstoppable gentrification. Rents rose as speculators and then developers rehabilitated old buildings or constructed new ones on the many vacant lots. The city withdrew its license to artists to use the vacant schools and warehouses, and sold off its city-owned properties.

Globalization fueled new fortunes, as headquarters of command and control global corporations were offered tax incentives to remain in Manhattan, often putting up iconic towers, using airspace borrowed from their lower neighbors. The thriving stock market, after two setbacks, yielded bonuses to bankers and investment firms and demanded the high paid services of legal and accounting firms skilled in international business. These tended to drive the wedge between rich and poor even farther. The "new" money, combined with favorable tax incentives to construct new living quarters for the rich, whether on cleared land or on landfills such as Battery Park City, led to the proliferation of protected enclaves, not all of them built by Trump. Gentrifiers recycled deteriorated brownstones and even 19th-century co-op apartment buildings.

Globalization also infused the art market with international capital from Asia and Europe. The number of galleries rose from about 150 in the 1950s to some 800 by 1990, and auction houses such as Sotheby's and Christie's, by then turned into public corporations, were selling at prices never before seen. In November 1989, for example, over 300 artworks sold at prices of more than one million dollars each. Even a handful of New York artists from the two earlier schools (Warhol, followed by de Koonig, Rothko, and Lichtenstein, with Pollack lagging behind) have broken through this ceiling, although the highest prices still go to the European "greats" such as Picasso, who recently commanded $104 million for a single painting. Breaking the traditional monopoly of the Upper East Side, larger and more exciting galleries in recycled warehouses were opening in Chelsea on the far west side, which remains the outlet for innovative, often multimedia, artworks.

In the interim, with rising real estate values and the gentrification of their former redoubts, producing artists, whose numbers defy counting and whose future fame remains unpredictable, have again been forced to flee. SoHo has long been turned into an overpriced trendy mall. The East Village, although not as upscale, has lost the subsidized performance and atelier spaces. CBGB has just lost its lease, as have many other promising spots for "The New." The murals and graffiti have been washed away from the walls or been replaced by advertising

From highly concentrated locations where artists cross-pollinated their innovations, the younger generation must seek refuge in any residual crevice still undervalued. The sequence of their flight has moved them off the island of Manhattan itself—the incubator that had nurtured the "New York School." Just as Greenwich Village gave way to SoHo, and then to the East Village, so the trail has led producing artists across bridges and tunnels: to Jersey City and Hoboken on the western shore of the Hudson, to Brooklyn zones near the East River: at first to Dumbo (Down Under the Manhattan Bridge), where galleries and gentrification have followed them, then to Williamsburg, then to Greenpoint, and finally to Red Hook. The irony is that wherever they have gone, they have planted the seeds of their own displacement. The most recent settlement to be doomed is formerly "out of the way" Redhook, whose docks have now been opened for tourists aboard cruise ships, including the *Queen Mary*. Artists are now in flight to the last frontiers, East New York at the city's easternmost border, and the South Bronx, north of northern Manhattan.

The Future

It would be inaccurate, however, to claim that synergism by proximity was ever the sole cause of New York art's rise to glory in the second half of the 20th century. Individual talent, supported on a firm base of prosperity and world power, must count for something. And in the digital world of instantaneous international cross-pollinization, the synergism once enabled by "the boys" drinking together upstairs at the Cedar Tavern (now replaced by a Mexican restaurant) may yet bring together not only New York's diverse and scattered artists but also a wider range of physically distant producers and consumers. Whether this disembodied assembly, coordinated by an international art market, will not reduce art to a manufactured commodity, remains to be seen. Also unpredictable is the general prosperity and peace of the global system itself, upon which patronage has always depended.

New York New York: Then and Now

Robert Rosenblum

If today, in 2006, time travelers from the New York art world we now live in were suddenly rushed backwards half a century to the New York art world of the 1950s, when I first connected with contemporary art, they would be dumbfounded by the difference. To begin with, we were inspired by the thrilling faith that, by some almost mythical miracle, all the excitement of modern art's pioneering history had crossed the Atlantic during the traumatic years of World War II. From the moribund ashes of the great European tradition, an American phoenix seemed to emerge. Looking at works by the then controversial masters of what got to be called "Abstract Expressionism"—De Kooning, Motherwell, Pollock, Still, Rothko, Kline, Newman—it seemed clear that a new era of art had begun, a Book of Genesis that was no longer being written in Paris, but in New York. In 1958–59, the Museum of Modern Art circulated in eight European countries an exhibition boldly and boastfully titled "The New American Painting," implying that there had been a major shift in international art power. It was an assumption further confirmed in the title of the first serious historical study of Abstract Expression, Irving Sandler's *Triumph of American Painting* (1970). At the time, at least, these young and often startling paintings looked like no art ever seen before, thrilling heresies that could persuade many spectators how a picture made of nothing but a poured chaos of paint or a single vertical line bisecting a field of color could be a mesmerizing work of art. And that many sneering responses to these unfamiliar images equated them with chimpanzee scrawls and laughable hoaxes of course contributed to the fervor of those who defended them. But time changes everything, including art. Today, these works are historical treasures, assumed to be museum-worthy, historical icons that looked not only forwards to the art of younger generations who had to reckon with this ancestral achievement, but backwards to venerable traditions (De Kooning, for example, to Rubens, Hals and Rembrandt; Rothko, to Monet and Turner). Fifty years ago, however, it was only their heretical excitement that was visible. And with this feeling of rebirth and gigantic challenges to history also came strong chauvinistic prejudices that made most of the New York art world think that, with the possible exceptions of Dubuffet and Bacon, European art no longer mattered, buried by history. Nationalistic pride dominated the perception of this new American painting and blinded most viewers to what European contemporaries were doing.

The excitement of the New York art world in the 1950s had a lot to do with the continued belief in what could be seen as a kind of Darwinian vision of the history of modern art, an evolutionary progression in which only the fittest could survive. It was a myth always oriented to the future, in which the art of the present would absorb the art of the past but move it forward in new, unpredictable directions. Above all, it was the writing of Clement Greenberg that supported this faith in an onward-march of art, a relentless progression in which there was a major highway to follow that left little or no room for any deviant sidepaths. The world of abstract art, of ongoing distillations to greater degrees of pictorial purity, was the true religion; and those artists who ignored this were doomed to irrelevance and mediocrity. In truth, thinking back to the awesome power of Abstract Expressionism, it is easy to understand how for years, even for decades, it could eclipse the work of other artists in the 1950s and even the 1960s who worked in entirely different modes, especially artists who had any penchant for dealing with the visible world, whether working with old-fashioned kinds of realism, painting real people and real things (e.g., Alex Katz) or with more complex reinventions of realism (e.g., Rauschenberg's *Combines*, Johns's *Flags*, *Targets*, *Numbers*, and soon after, Warhol's absorption of silk-screen photography into the fields of painting). Greenberg's vision, in fact, went on to validate what seemed to be the next step after the heroic achievements of Abstract Expressionism, namely, the extraction of such pictorial essences as disembodied stains of color, exemplified in the work of Morris Louis and Helen Frankenthaler. For some, at least, a new genealogical table was being created in New York. But history, including art history, is always far more disorderly than the minds of those who would impose clear patterns of major and minor, right and wrong. By the 1960s, it was obvious in New York that there was no single truth or inevitability. While Newman and Kelly could go on painting pristine fields of opaque color, other artists would celebrate what lay outside art's ivory towers, embracing a world that had been censored out of the universal language of abstraction, a specifically American anthology that

included everything from junk food, automobiles, and pin-up nudes to comic strips, billboard ads, and Hollywood celebrities. And as an opposing counterpart to this enthusiastic acceptance of the ugly but very real facts of urban American life, another kind of purism emerged, this time under the banner of Minimalism, which offered another approach to reducing art's vocabulary to an indivisible core, whether in two dimensions, as in Stella's paintings, or in three, as in the sculpture of Andre, Judd, and Morris. Presumably, this new version of abstract essences was vacuum-packed, unpolluted by the aggressively democratic imagery so loved by Pop artists. But looking back from the early 21st century, Minimalism seems more a complement than an enemy of Pop art, sharing its distaste for handmade art stamped with the craft and passion of individual artists, and preferring lucid, repetitive structures that seemed to mirror an industrial environment, whether of machine-made modules or grids of soup cans in supermarkets. Flavin's fluorescent light tubes seem to bridge the gap perfectly. They offered both a geometrically pure sculptural unit, a cylinder as perfect as a cube, but this ideal form came straight from a factory and provided the most commonplace source of artificial light familiar to every kind of American interior.

But even in the 1960s, art in New York seemed far tidier than it does today. At the time, the world appeared to be divided into two enemy camps, one continuing to worship at the shrine of abstract art, the other sullying these high-minded traditions with the trash of popular culture. It was a civil war that in many ways perpetuated the almost religious fervor of modern art's early evangelists. In 2006, however, all of this seems like ancient history, so much so that a new word, post-modernist, had to be coined in order to accommodate the sense that, at some point in the 1960s, the heroic era of modern art had expired. And what has replaced it? The New York art world now would be unrecognizable to a time traveler from the 1950s and 1960s. Where, oh where, is the true path to the Holy Grail? Almost every assumption about the relentless course of modern art has been turned upside down and what was repressed has returned with a vengeance. Who would ever have guessed, for example, that the number-one enemy of modern art, realism, would emerge again, alive and well, in countless new and old forms, or that pictorial narrative, the bane of abstract art, could be revived? Would anybody have noticed Eric Fischl, Chuck Close, or John Currin had they been painting in the 1950s? And new art changes our views of old art. Duane Hanson, for example, once scorned, now emerges as the venerated ancestor of artists who, like Robert Gober, make body doubles. All certainties, all faiths have crashed, and today, gallery-goers expect to see not the cutting edge of the next great "ism" in the history of modern art, but the most all-embracing diversity of styles, images, media. Photography, video, installation have equal time with painting and new varieties of three-dimensional art that no longer fit comfortably into what we used to call sculpture. No kind of art, whether made of graffiti or light-emitting diodes, is in or out, right or wrong, advanced or retrograde. And this openness extends as well to the rest of the world. The chauvinistic, often xenophobic character of the New York art scene half a century ago is a thing of the past. We now expect that art from Iceland, Iran, Nigeria, or Taiwan can demand as much attention as the local American product. Although we may no longer have a clue about where art is going, a future we felt so sure of back in the 20th century, we do at least know that we have to keep our eyes open far beyond the reaches of Manhattan Island. These days, the pilgrimage route from one New York gallery to another is like a trip to the United Nations of Art.

New York, New York

Fernanda Pivano

Oh, New York, New York. Here I am, after fifty years or so that I have been searching for happiness, discovering its stories, its never-ending stories. They make me happy when they are thrust towards future hopes; they make me despair when they disappoint my dreams that are too full of science fiction and push me back to everyday life. But New York is still there, the "thousand lights" that have taught us to keep its king in our hearts, still matchless, surrounded by dozens of writers who have created, according to the rhythm of his pages, the new century, our century, opened by him exactly in 1984, with *Bright Lights, Big City*.[1] He lit up that decade gaining the favor of the youngsters, and soon a whole audience of readers. He was the great surprise, followed immediately by Bret Easton Ellis with his *Less than Zero* in 1985, launched in Italy by Tullio Pironti with his usual enlightened bravery. So my New America was there, forever, in the memory of my dearest friends overcome by now, maybe, by the disaster of their dreams of peace. Jack Kerouac with his immortal *On the Road* in 1957, Allen Ginsberg with his enlightened, enlightening *Howl* in 1956, Gregory Corso with his unforgettable *Bomb* in 1958, William Burroughs with his perserve *Naked Lunch* that put too much to question in 1959. New York seemed specially made to welcome, with its far-sighted love, those children who introduced Buddhist pacifism for the future and the not necessarily anti-capitalistic literature. It also accepted the non-violent Black revival, led by Martin Luther King, John Kennedy's geniality, and Bill Clinton's more or less empty attempts, but paid at an exorbitant price.

Those were the years that could be considered to have been lived under the triumph of the war-mongering lobbies based on the organization and reconstruction of all the houses destroyed by the war in the East and on massive weapon production less concerned about cost than the armies coming out unhurt.

Very soon the alliances' games took place, maybe with tiny European regions almost unaware of these real organizations. The efforts made, right or wrong, to reorganize our country after decades of Fascist dictatorship, had to work out the relationships with an America that represented no longer the image of freedom many of us had dreamt about, but of a victorious country that wanted to take into its system our naive hope of being able to live together peacefully, disguised by political experiences hard to understand. We had our anti-fascist dreams that were actually dreams of peace and, at last, of efforts made to live without the nightmare of weapons and uniforms, without regiments being sent to the Greek mountains wearing cardboard shoes, and coming back home to have their frozen feet amputated with their heads deafened by the victorious anthems of the lunatics who had sent them to be massacred.

This poor Italy, disguised by heroism that had decimated above all the souls of the younger generations swept away by the political disaster, lived, when it managed to keep away from political intolerance, making the children study, maybe with the hope that, once they had grown "older," they would be able to cope with dictatorships which did not always coincide with their dreams. And we studied, we got drunk studying, while more impatient children were playing pranks that looked like, and in a certain way they were, efforts to gain independence. The intolerance of war was connected to the ungained independence; and to most of us the war continued to be a mysterious disaster.

Everything I am talking about is based only on my memories, my autobiography. My brother, a handsome young man in his early twenties, was recalled and spent eight and a half years in the artillery. He had studied to become a lawyer. Then after having spent nine years in the mountains, he got ill and died. He passed away when he got back home, during a one-month leave (may God look after him in heaven and forgive those who took his life and did not give him the chance of getting better by being looked after by own his mother).

It was with this mother that I realized the horror of war, when I was five or six. My extremely handsome, smart and young father had been recalled before he was thirty and would come home every now and then, when he had a twenty-four-hour leave. My mother, in tears, used to sit at the table with my father, who had left at the beginning of his adulthood, and would listen to all the trouble he was having in the mountains, somewhere in the Veneto. My father would tell her to be patient, because, once again, he had heard about a probable peace. But one day I, still a child and a bit naive, asked him: "But if they keep on promising you peace and they don't give it to you, why don't you get by yourselves?"

After a brief moment of silence, my mother burst out crying. My father gave me one of the tiny things he always carried. He would usually give it to my mother, but that time he gave it to me without answering my question. In the meanwhile my mother had dried her tears and told me just to wait a little bit more, because peace would have definitely been granted.

My sweet, dear, handsome daddy. They did not give him peace, not even after having waited far too long. However everyday I kept on asking my mother if peace had been given or not. She would reply "not yet." My mother also taught me to knit for the poor boys trapped in the war. She used to give me four knitting needles I could barely hold. I have a feeling that every evening my mother would undo what I had knitted during the day, without me finding out, and redo it herself so that nobody would realize how helpless I was.

My sweet, beautiful, dear mummy. She belonged to one of the most unlucky generations. She went from one war to another; from one war that was crueler, more contradictory and useless than another. In the meanwhile she made me study, study, study. Once my young publisher told me: "I've got a lovely daughter and, to distract her, I make her do loads of sport. I hope it'll do her good." The publisher must be very proud, because his daughter grew up really well. Luckily she studies the least possible and she is beautiful. Instead I did nothing else but study; luckily I studied the piano too. I played a beautiful old Pleyed, which was said to have been Chopin's. I could study for hours on end, without feeling tired and well enough to get a good diploma from the conservatory run by Giorgio Federico Ghedini with Sandro Fuga and Benedetto Mazzacurati in the commission. The piano was probably the study I took most seriously together with the grammar school and the university. I used to study with two Russian teachers, refugees from Stalin: Maria Wataghin, a gentle therapist, who I will never honor enough, who ran away from Italy at the time of Togliatti; and Raissa Liftschitz Kaufman, who was Paderewski's pupil and Borowski's school-friend. She was not sweet at all with me: she would make me study to such an extent that I even ended up saying nice things about the solfeggio.

When I was not studying, I used to write letters to cheer up the boys (who knows why), who had been sent to the mountains or around the world. When the bombing was over, my beautiful childhood house was destroyed and we took shelter in Mondovì. My father could barely recall his name and my brother, who could not get out of bed, was waiting for his death.

That world was entirely different to the one I discovered in 1956, when I was thirty-nine, in New York. I managed to get there with an American scholarship. I was enchanted by the city's monumental beauty and its sense of independence (probably false), which I misunderstood as New York's real independence that I was seeing for the very first time.

But there was something extraordinary that I was seeing for the first time, after having endlessly read Edmund Wilson's reviews and having learnt that, with an ocean in between, it was really the reviews that gave a sense to the book. But in this case it was not any old kind of book: it was actually James Branch Cabell's book, published in Italy by Alberto Mondadori with the title L'incubo. Alberto, with his usually sharpness, had put three of Cabell's books into one. Edmund Wilson had actually written an enthusiastic review of this type of contamination and had got me involved in this attention that was given to this surrealist writer much more than its real meaning.

My first arrival in New York coincided with this incredible recognition and, during the whole time I spent there, I was received with Edmund Wilson's acknowledgment in the New Yorker. Hannah and Matthew Josephson came to pick me up at the airport and from far away I could see them waving a copy of the New Yorker opened at the very page so magical for my American welcome. Edmund Wilson had asked Hannah Josephson, librarian of the American Academy, to invite me to talk about Alberto's idea, who back in Italy probably had not realized what type of solemn American welcome had been granted without any hesitation by Wilson. I felt stunned when I read that famous comment and the day after the Josephsons took me straight away to Wilson's, to the house where he had lived until a few weeks earlier with Mary MacCarthy. In the wonderful living-room that looked directly onto the beach, enchanted by my first encounter with the American sea, Wilson had welcomed together with me a Northern European literary critic. They immediately set off a discussion. I just listened to them slightly stunned by the journey, but above all by the discovery of this America so long dreamt about and so difficult to understand at first glance. Almost immediately I realized that Wilson would get up, go mysteriously to a staircase and return holding a bottle. Obviously it was a bottle of whisky, but it took me a while before I realized. The European criticism was talking about Zola's biography that had made Josephson famous both in America and in Europe. The times still presented Matthew's Academy as a precious proof of international success. Josephson accepted the complements as if due to the renowned fame that had put him at the top of the critical tributes at that time. What a pity that Matthew did not stop to look at his acknowledgment; so he would have been moved once again by that admiration without borders. It was Hannah Josephson, I was convinced that she had quite a lot to do with the

biography, who had made Zola's known to her husband; he had welcomed it into his international heart and above all into his incredible knowledge without borders of a life still connected to his discovery and to Hannah's, as it had been for many years.

We stayed there until late, when the smell of the sea was united with the smell of the sky.

But this America, that was the America of an intellectuality without compromises, would have accompanied me for the rest of my stay in the country. It was the America of my dreams that was turning up in all the splendors of its discoveries. Oh, New York, New York. How much love, how much joy, for so many years, without ever being betrayed.

The first-time love, in that airport. The 1950s, the legendary names: Dorothy Parker, an American reality; Stella Adler with a green chiffon dress as long as New York's dream; Arthur Miller and Marilyn Monroe, an unusual engaged couple; Norman Mailer famous for an extraordinary book (1967) and also for his beautiful wife stabbed for a drop of whisky instead of for love; Edmund Wilson in his seaside house and gallons of whisky with Mary MacCarthy full of dreams of glory. Even Norman had drunk a glass or two to celebrate the beginning of the column of his *Village Voice*; or joking with Adele he had "threatened" her with a penknife, or probably "wounded" her (so to speak) with a penknife, setting off a drunkard's row, that had caused a flock of armed policemen to arrive. I did not quite understand if it had happened to protect him or her. Norman was imprisoned and Adele was stupefied by a depression for too long left without being cured. A few months later there was Kerouac in Charlie Parker's arms, Ginsberg on Neal Cassady's mattress, Henry Miller at Daisetz Suzuki's lessons at the Columbia. Everything was like a dream, the dream of American democracy, still unaware of defeats, still on a president's dream. Oh, his speech on the four liberties held ten years earlier, three liberties taken for granted, but the fourth liberty from dictatorship. Here was the American democracy of our nostalgia and streams of love films for a romantic decade for romantic dreams for the romantic splendor of an American dawn still unaware of decline.

That day on the way from the airport, I had looked at the endless lanes. America, a dream through Sherwood Anderson's soul; the highway wound as far as the crosses, price of liberty, and then the real vision, the real dream: the pinkish skyscrapers with the illusion of a future of peace. Oh, New York, New York, my frail fame through Fitzgerald's face powder and fox-trot, my burning anarchy through Hemingway's "separate peace," my dreams of the clouds of trouser suits and Coca-Cola: "May I have a Coca-Cola?" Oh, what a lesson of modesty: "What language do you speak, darling?" But above the clouds the dreams were intact; that was the new world, the democracy, democracy, democracy. There is still someone who remembers the wardens, the spies, the border, the respectable salons during the recreation hour, the black shirts, the ambiguous hellos, the ambiguous promises, the ambiguous futures.

Oh, New York, New York, where the promises were kept, where democracy was perfumed, where cinema offered jelly breasts and platinum blonde hair, and books were more spoken about than read; where tips were still ten per cent; where there were Russian chauffeurs running away from other dictatorships; dreamt splendors, dreamt romances, futures much more beautiful than anybody could have dreamt about. The 1950s, a blooming civilization, a blinded reality, Harlem forewarner. Oh, New York, New York.

The years flew by in that democracy. The lobbies were set up, the presidents changed. There was a young, strong and handsome president, who was loved so much that he was assassinated. There was another young, strong and handsome president humiliated for having remembered he was a man, the rigged elections. Oh, New York, New York, where have the flowers gone? Where have the "Peace Corps" gone to tell the troops about the peace, the troops of the guys who, like in Italy, where conscientious objectors? Where has nuclear peace gone to introduce the word "peace" to the collective imaginary? The "Food for The Peace of People" to give the food as a prize to those who did not make war? The terrible Bay of Pigs handed back to the uniforms that had planned it, Nikita Krusciov's atomic missiles taken back to Russia from Cuba with the best wishes.

Everything ended up in what censorship would not allow us to say, or even in a more obscene word, that, however, would not bother anybody: it all ended up in blood. White blood, black blood, blood on the uniforms, on television, at the cinema, in the hearts.

The value that was far from the dreams and close to violence. Petroleum was no longer underground as God had wanted it or as Timothy Leary would have wanted it, that is between one type of acid and another. It was instead in the right-wing and left-wing corrupted purses; and blood, blood, blood, to conquer them, foodless people, children massacred in the schools, women raped without any dreams, handsome and wealthy terrorists full of violence, born with a machine-gun on their laps, maybe killed with a machine-gun on their laps, who knows, who knows, who knows.

In the meanwhile, sweet Asia had become a land of hunger and war, a religious war, but war, an ideological war, but war, a just war, but war, a wrong war, but war. It was as if we had fallen

asleep in a dream of peace and woken up in a nightmare of death.

In this bewildered America there were dreams, but they were dreams of power, of false wealth, dreams of blood, blood, blood.

Maybe I am too old to dream about the reality of blood. Maybe I kept on dreaming about freedom from dictatorship, freedom from violence. Maybe I kept on dreaming about the freedom promised by the old wheel-chair that had manoeuvred the world.

Maybe the horrors of blood had been collected in the Vietnam nightmares, the never-ending horrors. The girls that had started to work in the offices, the women that no longer wanted to have children, the mothers that no longer wanted to give up their identity as women; the men that considered wedding an abuse of power; and all kinds of offices that give salaries to the newly employed women. And then, almost all of a sudden from San Francisco, Bob Dylan created a new world of youngsters, of songs that talked about the young guys' lives, the "sandwiches" that took over the lunches, the love stories, the lofts full of mysteries searched for the grey uniforms of the defeated and yet victorious army. In San Francisco, that very first evening, there were grey jackets of the generals left with their dreams, fields cultivated by the former ladies, with their parasols, former women slaves of slaves experiencing their first real humiliation by not knowing anymore whether they were slaves or free, leftovers of all kinds of defeats. There were the youngsters who looked after the slaves that had brought them up. But time flies! Soon the former slaves had become the new middle-class with their qualifications and their professions, getting into the city and sometimes staying on at "home" without any type of social qualifications, dressed like their former lords to go to church with them. Dear sweet South that had become head of the computers in the whole world, the mansions of the South inhabited by the former slaves who would get changed for dinner every evening.

This is how one lived, in the North with nostalgia for the South, in the South with nostalgia for the North, but with the computers that had swallowed the steel-plants and the buses that had replaced the first trains.

But the clothes worn at Bob Dylan's first evening were like costumes, pre-bellum 19th century lace (Southern), with their enormous skirts; clothes opened at the crucial points, furs, embroideries, touching the floor. These were clothes one could find at exorbitant prices in New York's trendy shops, almost certainly with the label: "second-hand clothes worn by a real Beat."

Because right from the beginning the condition of these transformations had been led by clever friends, who had overtaken the blood war images using the image of a new young generation inspired by numerous volunteer nurses, who would line the wounded up in front of the stations and cure them as if they were in a hospital camp.

Maybe this time the shift from a bloody defeat to a young people's attempt to find a way out was carried out by the so called Beat. During those years they had conquered the North and the South. The dates are well-known. The most brilliant of all, who in my opinion was Jack, had invented everything. When Allen Ginsberg had joined him, thanks to a scholarship, at the Columbia University, he had found him absorbed in his dream for another type of reality, that he had called "New Vision." Ginsberg had joined him at once to spread their invention.

They managed to do it. However they would not have managed it, if they had not played their "trump card," that was Daisetz Suzuski's Buddhist outburst who had spread his extraordinary *An Introduction to Zen Buddhism* during his lectures at the Columbia University. Suzuski had started lecturing in 1952 and Henry Miller, who had been interested in Zen since the 1920s, had been amongst the first people to attend the lectures together with avant-garde intellectuals. At the beginning Ginsberg had not been intellectually or sentimentally attracted by this type of philosophy, probably because he had been put off by a history of Zen Buddhism full of ideas, characters and dates that Suzuki would never stop talking about. After he had felt that the Buddhist texts Suzuki presented were far too vague to be interesting, above all because they did not given enough details about the various dynasties, the artistic periods and tautological features in the complicated Buddhist history.

One afternoon, while Ginsberg was in the public library, was looking at a 12th-century painting by Liang Kai and was studying the story of an ascetic, probably Buddha, in one of his appearances, while seeking the enlightenment (*satori*), he realized that sanctity existed in the imagination. Ginsberg accepted this while he was studying William Carlos Williams' poems written in triadic form. Ginsberg decided to break up his longer verses into three shorter one, giving to poetry a nicer aspect than the one offered by the page.

Ginsberg liked this poetry and many years later he would have realized that his three main ideas (the collapse of imagination, the negation of an ethereal vision and the acceptance of the real world) reflected the evolution of his visionary quest which took place from 1948 to 1961 and was outlined in his poems such as *Metaphysics*, *Ode to my Twenty-fourth Year* and *The Transformation*.

Prompted by the success of the poetry, Allen immediately made a plan to compose a longer and more ambitious poem connected to his love affair with Neal Cassidy. At the beginning he want-

ed to entitle the poem *The Green Automobile*, because symbolically green was the color of hope and the color of the clothes worn by gay prostitutes in ancient Rome; the car symbolized not only the ephemeral character of that experience, but also Cassady's permanent movement.

Allen Ginsberg wanted the poem to be a personal step forward, a way towards the experience of mental loneliness, and a lack of action expressed in *Empty Mirror* and his new creed, that blessing that exists in enlightenment. In a letter to Neal Cassady he wrote: "I have discovered that life is so unsatisfactory that I'm starting to use my imagination to find alternatives."

Therefore *The Green Automobile* became Ginsberg's way of making his past perfect, to overcome his relationship with Neal Cassidy and make it work as he had supposed it would have done when he had met Neal.

Kerouac's influence was crucial and ironic in this activity, and *The Green Automobile* had become Allen Ginsberg's way of making his past perfect, to examine his relationship with Neal Cassady and make it work as he had supposed it would have done at their first date. The reality of poetry does not lead to a negation: because from the beginning actions are presented as fantasy. But these were mostly Jack Kerouac's years, the ones that struck our hearts and our actions. His influence was enormous: from the first brave lifestyle presented in *The Town and the City* published in 1950, but written many years earlier, to our *On the Road* finally released in 1957, introducing the young generation's type of life; and *The Subterraneans* that came out a year later in 1958. In the same year *The Dharma Bums* was published; it was a warning that his Buddhism had become real and would have developed through the almost symbolic *Pull my Daisy*, where Kerouac wrote the script for Robert Frank's film in 1959.

Big Sur, published only in 1962, was full of Buddhism and so was *Visions of Gerard* in 1963; so even precedent the proposal of his "New Vision" that came out in 1959 soon after *Mexico City Blues*, already connected with the excerpts of *Visions of Cody*. Then with less uncertainties in 1960 *The Scripture of the Golden Eternity* with *Tristessa*, a story full of matchless sweetness and desperation. And in those so called Kerouac's years other books were published that adopted the same style of writing that only Kerouac could use: this continued, after *Tristessa*, in the *Book of Dreams* of 1961, in *Desolation Angels*, a charming tiny autobiography, then in *Vanity of Duluoz* and then, after eleven books published between 1971 and 1995, in the outburst of *Some of the Dharma* which enthralled us all in 1997.

One book would never be enough to talk about all the works published by the numerous people inspired by Kerouac. I would only like to recall his friends' memories that everyone will remember for one reason or another, such as Tom Clark's in 1984 and Carolyn Cassady's *Art Beat*. Hundreds of bibliographies have been published, amongst which the most famous and the longest is Allen Ginsberg's: not to talk about the critical essays that would take three full pages.

One could give three pages full of titles and memories of these so called "Jack Kerouac's years." I am fairly proud to say that my opinion was published by Mondadori on 16th September 1957, which thus ended: "maybe this 35-year-old writer will actually become the symbol of the new generation."

After many years of silence on behalf of both American and Italian publishers, thanks to the personal action of Arnoldo Mondadori, the book was published in Italy for the joy of thousands of young people not necessarily drugged, not necessarily alcoholics, not necessarily bad: they were only sharp guys who wanted to celebrate their youth.

[1] The author is referring to Jay McInerney, whose book was a huge success when it was published (translator's note).

Abstract Expressionism

Kirstin Hübner

Abstract Expressionism was the most important American art movement of the 1940s and 1950s, and led the contemporary art world to shift its center from Paris to New York. Its two major types were Action Painting and Color Field Painting. Whereas the Action painters expressed themselves through the texture of paint and the movement of the artist's hand, Color Field painters employed color and shape to create peaceful and spiritual paintings with no representational subject matter. During World War II, when war refugees and immigrants populated the city, New York became a vibrant melting pot of diverse cultures, many of which were of European and Russian origin. This gave rise to a dialogue about different art movements, in which American painters and founding members and disciples of Cubism, Surrealism, and German Expressionism, for example, began to exchange their theories on art. In addition, a widespread fascination with Tribal Art and the murals of the Mexican painters had a significant aesthetic impact. Most of the first generation Abstract Expressionists, such as Arshile Gorky, Jackson Pollock, Willem de Kooning, Robert Motherwell, David Smith, Lee Krasner and Philip Guston, met during the Depression in the 1930s when they were employed in the mural and easel divisions of the publicly-sponsored WPA (Works Progress Administration) Federal Art Project. This government initiative supported hundreds of artists by commissioning projects for schools, post offices, and other public buildings. As early as 1935, Mark Rothko and Adolph Gottlieb organized "The Ten," a collective of both figurative and abstract artists.

In 1933, a year after his arrival in the United States, German painter Hans Hofmann established his own art school in New York (which in the following year included a summer school in Provincetown, Massachusetts), where he taught, among many others, Lee Krasner, Joan Mitchell (albeit briefly), and Louise Nevelson. Thanks to his earlier contact with Picasso, Kandinsky, and Matisse, Hofmann was able to introduce many young American painters to the ideas of the European avant-garde and hence significantly to strengthen the exchange between European and American art.

The Armenian artist Arshile Gorky, who emigrated to the United States in 1920, is widely considered the most significant bridge between European and American painting. There is still debate about whether he should be regarded as the last Surrealist or first Abstract Expressionist. While he spent years in the 1930s analyzing Cubism, as well as the work of his idols Miró and Kandinsky, he discovered his unique style during the last years of his life. In Gorky's abstractions, biomorphic forms seem to hover in an uncertain world between being and not being. Gorky stated: "I don't paint from nature but through nature."[1] During the 1940s, a group of artists emerged, later to be known as the "New York School," whose ideas were based on similar ideologies and views on art, which they exchanged in frequently held meetings. It was often through the introductions of John Graham, a Russian immigrant, that younger artists such as Pollock, Gottlieb, Smith, and Gorky got to know each other and began to articulate their ideas on contemporary art to each other. Soon, friendships and various organizations developed based on a shared disapproval of tradition and a longing for a new way of giving expression to spontaneous freedom which would address contemporary concerns in a contemporary manner. They believed in the necessity of emancipating themselves from the past in order to formulate a new world view, rooted in the rejection of materialism and mass culture. To achieve these goals, they began to identify themselves with non-objective, abstract art.

An avid supporter of Abstract Expressionism, art critic Harold Rosenberg wrote in 1952: "The new American painting is not 'pure' art, since the extrusion of the object was not for the sake of the esthetic. The apples weren't brushed off the table in order to make room for perfect relations of space and color. They had to go so that nothing would get in the way of the act of painting. In this gesturing with materials the esthetic, too, had been subordinated. Forms, color, composition, drawing, are auxiliaries, any one of which—or practically all, as has been attempted logically, with unpainted canvases can be dispensed with. What matters always is the revelation contained in the act. It is to be taken for granted that in the final effect, the image, whatever be or be not in it, will be a tension."[2]

Soon, young artists began to organize cooperative galleries, as there was almost no outside commercial support. By the end of the 1940s, one of the first of these, the Tanager Gallery on 10th Street, functioned as a public extension of the

artists' studios. Aiming to garner recognition from the established art world, the Tanager Gallery was considered a "barometer for the New York art scene," as it was frequently visited by museum directors, curators and critics, amongst them Alfred Barr and Dorothy Miller both of the Museum of Modern Art, Harold Rosenberg and Clement Greenberg. In addition, various neighborhood bars and cheap restaurants provided informal gathering places for the artists living downtown. Until 1963, the most famous of these was the Cedar Tavern on University Place near West Eighth Street, where artists met to maintain professional contacts and to exchange ideas.

This exchange was a fundamental necessity, as the artists were in the problematic position of having no access to traditional exhibition spaces nor even potential buyers of their work. Addressing this situation, Smith explained: "We had no group identity in the 1930s. In the 1940s it developed when Pollock and Motherwell and Rothko were showing and seemed to become a kind of group [...]. We were all individuals, sort of expatriates in the United States and New York [...]. Nobody I knew made a living from sales. Artists showed their work to other artists."[3]

The continuing need among the Abstract Expressionists for a place to talk about art led in 1949 to the founding of The Club: a group of artists, who met in a rented loft at 39 East Eighth Street. Franz Kline, de Kooning, Jack Tworkov, and Ad Reinhardt were among its initial members, which ultimately included Guston, Elaine de Kooning, and Rosenberg among others. Not limited to discussion of painting, The Club also featured presentations by the leading New York poets of the day, such as Frank O'Hara, John Ashbery, and James Schuyler. The Club set out to provide the artists with a welcoming atmosphere, in which they could encourage each other at a time when the public and local art scene still ignored them. Whereas at the beginning discussions revolved around the influence of European art, attention soon shifted to the independent qualities of the new American work. Tworkov summarized this awareness of something new when he stated: "Suddenly we realized that we were looking at each other's work and talking about that and not about Picasso and Braque. We had created for the first time a milieu, in which American artists could talk to American artists about their art and consider, what was said 'important.'"[4]

A growing number of art critics, such as Rosenberg and Greenberg, and art dealers joined The Club and began to visit the artists' studios. The results were groundbreaking solo exhibitions, held at the Betty Parsons, Samuel Kootz, and Charles Egan galleries. Much earlier, in 1942, Peggy Guggenheim had opened her museum/gallery Art of This Century on 30 West Fifty-seventh Street.

At first, Guggenheim had primarily shown European artists who had arrived in New York as immigrants fleeing World War II, including Ernst, Mondrian, Duchamp, as well as work by other Europeans such as Picasso, De Chirico, Malevich, and Klee. But in the following years she became a vehement advocate of the Abstract Expressionists, such as Hofmann, Motherwell, Pollock, Clyfford Still, Rothko, Richard Pousette-Dart, Gottlieb, Reinhardt, and William Baziotes. Guggenheim provided both an impressively futuristic exhibition space designed by Frederick Kiesler, and sales opportunities. Pollock first exhibited there in 1943, as did Baziotes and Motherwell. His early recognition is in particular due to Guggenheim, who devotedly supported the Abstract Expressionists between 1943 and 1947 when their fight for acceptance was the most crucial.[5]

Through his radical writings on art, Clement Greenberg lent a powerful voice to Abstract Expressionism. He resolutely rejected everything objective and functional. To him, art was not a window on imaginary realities. Instead, he focused on how and of what physical materials an artwork was made.[6]

Around 1950, the member count of The Club had increased from twenty to over two hundred, including Motherwell, Gottlieb, Baziotes, Barnett Newman, and art dealer Leo Castelli (Still, Pollock, and Rothko were not members though they often attended meetings). In order to create another forum for their ideas, Motherwell, Rothko, and William Baziotes (together with sculptor David Hare) had established the "Subjects of the Artist" school in 1948 at 35 East Eighth Street. While short-lived, it nevertheless provided the impetus for Studio 35 (in the same location) where, before it closed in 1950, de Kooning, Gottlieb, Motherwell, Newman, Reinhardt, Rothko, and Rosenberg lectured on art. Rather than discussing politics (as they did not want to be confused with the Social Realists), they mainly elaborated on art itself. In 1950, Studio 35 closed after a three-day conference. The results were published in *Modern Artists in America* (1951) by Motherwell, Reinhardt and Robert Goodnough.

After this conference, Alfred Barr, the founding director of the Museum of Modern Art, encouraged the artists to find a name for themselves before others would. After several options, including "abstract-symbolists" and "intra-subjectives," they decided on "Abstract Expressionists."[7] While this term had originally been used to describe a body of work by Vasily Kandinsky, it was art critic Robert Coates who in 1945 had first employed it to describe contemporary American art.[8]

Over time, the Abstract Expressionists began to rebel against the art establishment. In 1948, several artists met at the Museum of Modern Art to criticize the Boston Institute of Contemporary

Art, which had released a statement against the new avant-garde. In 1950, at the above-mentioned conference at Studio 35, Gottlieb (with the support of Newman, Motherwell and Reinhardt) drafted a public letter, addressed to the president of the Metropolitan Museum of Art, to protest a juried exhibition intended to increase the museum's collection of contemporary art. The letter accused director Francis Henry Taylor and curator Robert Beverly of forming a jury with critics hostile to "advanced art," particularly Abstract Expressionism. It was signed by eighteen painters and supported by ten sculptors. Barnett Newman delivered the letter to *The New York Times* and it was published immediately. *The Herald Tribune* named the artists "The Irascible Eighteen," which led to the famous abbreviation "The Irascibles." As a reaction, the Museum of Modern Art, the Whitney Museum of American Art, and Boston's Institute of Contemporary Art formulated a response, which commented on the "continuing validity… of Modern Art" and promised that in the future, "avant-garde art would be treated fairly."

In 1951, Leo Castelli and some of the founding members of The Club organized an exhibition in an old, rented store at 60 East Ninth Street, where the legendary "Ninth Street show" was held. Though they did not expect a favorable response, this project became a landmark for the movement, and Motherwell and Reinhardt noted in *Modern Artists in America*: "[…] by 1950, Modern Art in the United States has reached a point of sustained achievement worthy of a detached and democratic treatment."[9]

The same year, *Life* magazine published the famous photograph by Nina Leen of fifteen members of this group, with the title "The Irascibles." They were: Theodoros Stamos, Jimmy Ernst, Newman, James Brooks, Rothko, Pousette-Dart, Baziotes, Pollock, Still, Motherwell, Bradley Walker Tomlin, de Kooning, Gottlieb, Reinhardt, and Hedda Sterne.

Unexpectedly, times had changed. Artists who formerly had to fight for recognition now became famous through extensive media coverage and art world attention. By the late 1940s, Abstract Expressionism possessed a significant matrix of intellectual ideas, a coherent body of mature work by numerous artists, venues for public display, and meaningful critical reviews. Whereas in the beginning they had supported themselves and received help from a only few art dealers and collectors, they suddenly found themselves the focus of the public admiration they had craved. The growing number of publications that highlighted Abstract Expressionist works enhanced this recognition. By the end of the 1940s, little magazines such as *Possibilities I* and *The Tiger's Eye* included statements by the Abstract Expressionists along with illustrations of their work. In 1948, Thomas

Hess became the editor of *ArtNews*, a magazine widely read by art professionals and interested amateurs. Under Hess's direction, *ArtNews* featured numerous articles on the Abstract Expressionists. Furthermore, a *Life* magazine article of August 8, 1949 on Pollock spread the notion that artists of this generation made interesting stories. In the early 1950s, *Life*, *Time*, *Look*, and *Vogue* for example published several feature articles on artists affiliated with Abstract Expressionism. Around 1950, after years of despair, Abstract Expressionism triumphed as the primary American art movement. Despite the various meeting points and shared activities, the Abstract Expressionists were never an official group, as they never formulated a program or published manifestoes. Each artist wished to be understood as an individual with independent beliefs. In fact, their work never had a continuous stylistic aesthetic; some painted with seemingly uncontrollable spontaneity; others with absolute self-control. Each artist slowly withdrew into his or her own cosmos as a reaction to the grim political reality of the time: the aftermath of World War II, the Holocaust, and nuclear destruction. What they did share was the search for a new language to process contemporary feelings.

Due to the immense success of some members, the general urge to exchange ideas lessened. By 1956, the concept of The Club, as a forum for Abstract Expressionism was steadily dissipating. Irving Sandler took over The Club's leadership until its closure in 1962. The same applied to the other meeting venues in New York City, and before long their concentration in downtown Manhattan was fractured into smaller divisions, formed by artists living in South and East Hampton, Suffern, or Bolton Landing for example. Nevertheless, thanks to the success of the most notable members and their significant influence on the following generations of artists, the lasting importance of Abstract Expressionism was guaranteed—as the first independent American art movement and a groundbreaking force in contemporary art in general.

Willem de Kooning

In 1926, Willem de Kooning (1904-1997) left Rotterdam and emigrated to the United States. He had studied at the Rotterdam Academy of Arts and Technical Sciences from the age of twelve and had graduated as a certified artist and craftsman in 1925. In 1927, he moved to New York City, where he soon met Stuart Davis and John Graham, as well as Arshile Gorky, with whom he shared a studio. In 1935, he joined the WPA Federal Art Project. In the early 1940s, he also became acquainted with Franz Kline, Robert Motherwell and Jackson Pollock, among others. By the late 1930s, his compositions inspired by landscape and the human figure became increasingly abstract. However, his style never embraced

pure abstraction as he continued to incorporate figurative elements. Some of his most famous works are portraits of women, such as that of his wife and fellow artist Elaine de Kooning. Begun around 1953, these paintings, which are based on the tension between figurative elements in the foreground and abstract forms in the background, reveal the strong influence of Surrealism and Cézanne, as well as of Gorky, on de Kooning's visual vocabulary. In time, these compositions became increasingly abstract and his palette moved from radiant colors to the simplicity of black, white, and gray. *Montauk II* (1969) depicts a female figure in a landscape, transforming this traditional subject matter into an abstracted symphony of color and form. Though the figure is placed in the lower left of the composition and the background embodies the landscape, both elements appear interlocked. In other words, the landscape invades the figure and vice versa. As a result, both are transformed into a unique fusion, rich in gestural expression and dynamism. The palette ranges from pastel pinks and yellows to shades of green and blue. *Untitled XLI-II* (1983) is a good example of de Kooning's late paintings. Compared to earlier paintings, the overall structure, brushwork, and shape of this composition have been drastically simplified and seem almost minimal. Set against a white background, the colorful shapes are of a translucence that radiates with strong light. In five years, from 1969 to 1974, de Kooning completed twenty sculptures. These were initially inspired by a trip to Rome in 1969, when a friend and fellow artist let him use his sculpture studio. Whereas his first sculptures of every-day-objects, such as Co-ca-Cola bottles, revealed Cubist and Dadaist influences, his later large-scale works were more abstract. The bronze *Large Torso* (1974) shows how closely de Kooning's paintings and sculpture relate to each other. Here, the painterly fusion of figure and landscape has been translated into the gestural forms of sculpture, in which mass provides a strong sense of weight. In addition, the lack of a central axis, as well as the overall twisted pose, add interesting tension. De Kooning did not use preliminary sketches for these sculptures; instead, he worked directly with small amounts of clay that he combined spontaneously into larger structures (sometimes with his eyes closed). While their rich texture might bring works by Matisse and Rodin to mind, de Kooning's clay sculptures and bronze casts have a strong organic quality and embody the physical characteristics of their materials. They appear to be frozen in time.[10]

Helen Frankenthaler

Born in New York in 1928, Helen Frankenthaler studied at the Dalton School and Bennington College, Vermont (1945–49), where she received a thorough introduction to Cubism from her teacher Paul Feeley. However, her main interests were in the works of Arshile Gorky and Vasily Kandinsky. In 1950 the critic Clement Greenberg introduced her to contemporary painting. During that summer, she studied with Hans Hofmann in Provincetown, Massachusetts. The following year, Adolph Gottlieb selected her for an important "New Talent" exhibition, and she was given her first solo show in New York later that year. In 1951, Frankenthaler visited Jackson Pollock's studio in East Hampton and his work proved highly influential on the development of her signature style. Inspired by Pollock's practice of pouring paint directly onto raw unprimed canvas, she thinned her paint with turpentine to allow the color to penetrate and bleed into the fabric, rather than have it build up on the surface. Clement Greenberg referred to this style of painting as Post-Painterly Abstraction. As in *Walnut Hedge* (1971), the resulting "stains," which allow the light ground of the canvas to shine through, resemble watercolor, in which the luminosity of color and the brilliance of light dominate. Here, biomorphic shapes held in saturated nuances of orange, red, and green, overlap and intertwine freely, blurring the division between fore- and background. The resulting effect of light and airiness is as characteristic of Frankenthaler's compositions of this period as their poetic and ethereal quality. Frankenthaler was married to Robert Motherwell from 1958 to 1970.

Arshile Gorky

Born in Turkish Armenia as Vosdanig Manoog Adoian, Arshile Gorky (1904–48) escaped the genocide of his people during World War I and settled with his sister in the United States at the age of sixteen. His mother did not survive due to starvation and her death impacted many of Gorky's later works. He stayed with relatives in Watertown, Massachusetts, and with his father, who had left the family in Armenia when Gorky was a child and that time lived in Providence, Rhode Island. By 1922 he was teaching at the New School of Design in Boston. In 1925 he moved to New York and changed his name to Arshile Gorky, adopting the last name of the Russian writer Maxim Gorky. He entered the Grand Central School of Art in New York as a student but soon became an instructor of drawing (1926–31). Throughout the 1920s Gorky's painting was influenced by Cézanne and above all by the Cubist works of Braque and Picasso. In the following years, he associated closely with Stuart Davis, John Graham, and Willem de Kooning, with whom he shared a studio late in the decade. Until 1941, he worked on the WPA Federal Art Project, painting murals at Newark Airport (1935–37). By the early 1940s, he had turned towards biomorphism and Surrealist ideas as ex-

pressed by Miró, Masson, and Matta. In 1944 he met André Breton and befriended other Surrealist emigrés in New York. From 1942 to 1948 he worked for part of each year in the countryside of Connecticut and Virginia. *Landscape Table* (1945) reveals Gorky's strong interest in Surrealism at this time. Though completely abstract, some of the shapes evoke floral forms and are certainly rooted in nature. While these appear as delicate line drawings, large color patches of yellow, black, white, green, and red add a contrasting force. Rich in movement, the overall composition is as dynamic as it is lyrical, creating an aura of mystery. A succession of personal tragedies, including a fire in his studio that destroyed much of his work, a serious operation, and an automobile accident, led to his suicide in 1948, in Sherman, Connecticut. At the end of his career, Gorky had established a unique approach to his painting that placed his work in the Abstract Expressionist movement.

Adolph Gottlieb

Born in New York, Adolph Gottlieb (1903–74) received a rigorous artistic training. In 1919, he enrolled in the Art Students League in New York, where he studied with John Sloan and Robert Henri. Two years later he traveled to Europe and was one of the first artists of his generation to go abroad. In the course of a year, he traveled to Berlin and Munich, as well as attending drawing classes at the Académie de la Grande Chaumière, Paris. He returned to New York in 1923 and studied at the Parsons School of Design, Cooper Union, and the Educational Alliance Art School. Along with Mark Rothko, he was a founding member of The Ten, an artists' group that advocated abstract and expressionist painting. Gottlieb was particularly influenced by non-western art, above all the tribal art of American Indians and their myths. Both Gottlieb and Rothko were moved by the atrocities of World War II and their frequent discussions of this topic influenced their work. To them, "in times of violence, personal predilections for niceties of color and form seemed irrelevant."[11] Gottlieb and other artists felt the need to disassociate themselves from conventional themes and genres of European art. As a result, he began to explore tribal cultures as an important source of inspiration during this violent time. *Pictograph* (1944) belongs to Gottlieb's series of the same title, which he began in 1941. These works represent his goal of creating an emblematic and mythic symbolism. As is the case in this painting, all *Pictographs* are based on abstract grids that contain hieroglyphic forms, primal figures, triangles, and decorative signs that were intended to address directly the viewer's mind. They were painted in a flat frontal manner, evidence of Gottlieb's ambition to "kill the old three-dimensional space."[12] In the 1950s he developed his *Imaginary Landscapes*, in which two contrasting forces, such as sun and moon, or night and day, oppose each other on two horizontally divided planes. From 1957 on, Gottlieb worked on a series entitled *Bursts*, which are based on a disc symbolizing the order of the cosmos, and an abstract form below, which refers to the chaos of existence. *Charcoal* (1971) is an exceptional example of one of these *Burst* paintings. A disc in the upper half of the composition represents tranquility. It is painted red, and a series of brown circles radiate from it throughout the visual plane. Functioning instead as a symbol of uproar, a conglomerate of small white and restlessly drifting shapes is placed in the lower half of the canvas. Like an afterthought, two fine brushstrokes on the lower right complete the overall emotional content of the work.

Hans Hofmann

Hans Hofmann (1880–1966) was born in Weissenburg, Germany. In 1898 he studied painting in Munich, where he later met members of the "Blue Rider" group that included Wassily Kandinsky and Franz Marc. During a long stay in Paris, he became acquainted with artists of the French avant-garde, such as Robert Delaunay, Georges Braque, Henri Matisse, and Pablo Picasso. After moving to New York in 1932, he taught at the Art Students League, before opening the Hans Hofmann School of Fine Arts in 1933. Though the school moved several times, Hofmann's reputation as a unique teacher, who could convey to American students what he had learned from Picasso, Braque, Matisse and Delaunay, spread quickly. He became known as an instructor who encouraged his students to develop their own technique while still using the natural world as their source of inspiration. Originally a figurative painter, Hofmann had moved towards abstraction by the late 1930s. To him, it was essential to capture an intuitive impression of nature rather than a literal translation of it. He often stated that in nature light created color, but that on canvas color described light. In 1941, Hofmann came in contact with the younger "New York School." His student Lee Krasner introduced him to Jackson Pollock and soon both men engaged in an inspiring exchange of ideas, sharing a strong interest in automatism as well as the dripping and pouring of paint. As *Oriental Design* (1945) reveals, the tension between spontaneous elements and premeditated structure is a dominant theme in Hofmann's work. Completed only a few years after his first contact with the younger generation painters of the New York School, *Oriental Design* documents the impact of this encounter on Hofmann's style. Vivid and spontaneous, his thick brushwork is full of movement and expression. He used the wooden point of the brush to mark relief-like signs into a large

white shape in the lower half of the composition. Through each of these "scars," underlying colors, ranging from deep blue to a fiery red, can be glimpsed, endowing the composition with a mythic quality. Motifs drawn with black lines, suggestive of eyes and floral forms, add to the overall surreal quality. Painted over a decade later, *Homage to White* (1956) is more simple. A few freely brushed strokes in the primary colors plus green are set on a white background and partially unprimed canvas. Crisp and of radiant translucence, these shapes are transformed into energetic color accents that despite being abstract seem to function as protagonists of a poetic narrative. Hofmann finished *Red Parable* (1964) two years before his death. This work explores the relationship and tensions between the two complementary colors red and green, as well as the contrast of loose and crisp forms. Whereas a brownish red has been poured directly onto the canvas, seeping into the fabric, a thin layer of dark green rests on top. The latter was applied with a large brush, which left light streaks where the hairs touched the canvas. Creating a stark contrast against these light color fields, fine lines of thick red paint define the surface layer and appear as delicately spare line drawing. Overall, *Red Parable* translates as an homage to freedom of gesture.

Franz Kline

Franz Kline (1910–62) was born in Wilkes-Barre, Pennsylvania. He studied painting at Boston University (1931–35) and at Heatherley's School in London (1937–38) before settling in New York. He began by painting figurative compositions and views of New York in the tradition of Sloan and Glackens. In 1943, Kline met Willem de Kooning at Conrad Marca-Relli's studio and within the next few years he also came to know Jackson Pollock. Kline's interest in Japanese art began at this time and led to his mature abstract style, developed in the late 1940s, which is characterized by bold gestural strokes of fast-drying black and white enamel. His first solo exhibition was held at the Egan Gallery, New York, in 1950, quickly leading to his recognition as one of the leading Abstract Expressionists. His work moved towards abstraction in the second half of the 1940s, and around 1950 he began to create abstract paintings in black and white. *Mahoning II* (1961) is an example of these dynamic gestural works. The thick paint layers were partially applied with a decorator's brush, providing the composition with a distinctive raw quality. Set against a white background, monolithic black forms reminiscent of enlarged fragments of Chinese calligraphy dominate the picture plane. While best known for this particular body of work, Kline began to use extensive color from the mid-1950s on.

Lee Krasner

Lee Krasner (1908–84), the wife of Jackson Pollock, was born Lena Krassner in 1908, to Russian emigré parents living in Brooklyn. She attended the Cooper Union for the Advancement of Art and Science, and later the National Academy of Design. Krasner's early artistic influences included Giorgio de Chirico and Joan Miró, but it was under the tutelage of Hans Hofmann in 1937 that she began to acquire her own artistic voice and to develop a keen interest in Matisse, who remained a life-long source of inspiration to her. She began working abstractly in the mid-1930s. She did not paint "non-objectively" like her colleagues, but retained a connection to nature as a starting point in her compositions. Her palette in the decade of the 1950s varied from pure optical colors to different shades of umber and white. Referring to the somber tones of her so-called *Umber-Paintings* or *Night Journeys*, begun in 1959 in East Hampton and concluded in 1962 in New York, Krasner recalled: "I painted a great many of them because I couldn't sleep nights. I got tired of fighting insomnia and tried to paint instead. And I realized that if I was going to work at night I would have to knock out color altogether, because I couldn't deal with color except in daylight."[13] In the late 1950s, Krasner returned to complementary hues like red, orange, blue and yellow as an affiliation to landscape. *Sun Woman II*, painted in 1957 and reworked in 1973, is a fine example of these works. Here, the two complementary colors red and green dominate the composition. Whereas red is employed to render both loosely brushed and meticulously outlined forms, the deep green shapes are opaque and relatively linear. Set against a neutralizing cream background, a vivid dialogue based on color characteristics and form is initiated. Compared to earlier works, *Sun Woman II* is simplified and the paint application is smooth and free of impasto.

Joan Mitchell

Born in Chicago, Joan Mitchell (1926–92) belongs to the second generation of the American Abstract Expressionists. Between 1942 and 1944 she studied art with Hyman George Cohen and in 1947 graduated from the Art Institute of Chicago with a Bachelor's degree in Fine Art. In 1950 she met Franz Kline and Willem de Kooning and became an active member of The Club and the Cedar Tavern meetings. Her prevailing subjects were light and color, and their interaction on a painterly field. These were captured through energetic physical gesture and were infused with an overt romantic sensibility. Separated by areas of blank canvas, which were sometimes overpainted with white, the colors of Mitchell's works succeed in capturing dazzling light effects. The paintings frequently allude to landscape, though

they are not of nature nor of things seen, but rather an expression of sensations and felt emotions. In *Untitled* (1956) various shades of lush greens and earth tones are set against a white background. Applied with thick, staccato brushstrokes, the paint is transformed into a luminous composition of an almost explosive energy. *Untitled* (1947) involves a more complex palette, of greens, blues, reds, and yellow. The composition is denser than the later canvas, but traces of the white ground still generate a sense of three-dimensionality. Thick, muscular brushwork, that while concentrated in the composition's center seems to spiral outward, providing the work with a grounding verticality.[14] European art, especially that of Cézanne, Matisse, Renoir, and Van Gogh, strongly influenced her work. She had a profound affinity for France, dividing her time between Paris and New York from the mid 1950s until 1967 and after, living near Giverny until the end of her life. Jean-Paul Riopelle was her companion for about twenty-five years.

Robert Motherwell

Robert Motherwell (1915–91) was born in Aberdeen, Washington. He was awarded a fellowship at the Otis Art Institute in Los Angeles at the age of eleven, and in 1932 he studied painting briefly at the California School of Fine Arts in San Francisco. He received a B.A. from Stanford University in 1937 and enrolled in graduate work later that year in the Department of Philosophy at Harvard University. In September 1940, Motherwell settled in New York, where he entered Columbia University to study art history with Meyer Schapiro, who encouraged him to become a painter. In 1941, Motherwell traveled to Mexico with Roberto Matta for six months. On his return to New York, he met William Baziotes, Willem de Kooning, Hans Hofmann, and Jackson Pollock. In 1944, Motherwell became editor of the *Documents of Modern Art* series of books, and contributed frequently to the literature on Modern art of that time. The same year, a solo exhibition of Motherwell's work was held at Peggy Guggenheim's Art of This Century gallery. In 1946, he met Herbert Ferber, Barnett Newman, and Mark Rothko, and spent his first summer in East Hampton, Long Island. That year, Motherwell was given solo exhibitions at the Arts Club of Chicago and the San Francisco Museum of Art, and participated in "Fourteen Americans" at the Museum of Modern Art in New York. From 1971, Motherwell lived and worked in Greenwich, Connecticut. He died in 1991 in Cape Cod, Massachusetts. Featuring large black shapes on a white background with rare color accents in orange, brown and yellow, *Elegy to the Spanish Republic* (1970) is bold in its structural simplicity. Though completely abstract, it is through their dominant position on the rectangular plane

that the expressive black shapes are transformed into mysterious symbols and bearers of larger truths. Completed in 1963, *Untitled (Iberia)* is further simplified. Here, the same black shapes almost entirely cover the picture plane. Only in the lower left corner does the white of the primed canvas remind the viewer of fore- and background relationships.

Louise Nevelson

Louise Nevelson (1899–1988), a Russian immigrant, moved with her family to the United States in 1905. She studied art with Hans Hofmann in Munich in 1931 and worked as an assistant to Diego Rivera in 1932. She experimented with wood, terracotta, marble, steel, bronze and plexiglas. Her most famous works are labyrinthine wood sculptures, built from individual wood parts that are combined into artistic forms and painted in monochromatic black, white, or gold. From the end of the 1950s, she created "wall reliefs," complex assemblages of abstract shapes and found objects, such as chair legs and bits of balustrades. While these works provoked the expression "Junk Art," they reflect Nevelson's interest in integrating daily-life elements into her art to create a universe all her own. Navigating between Constructivism and Surrealism, she considered her art a continuing search for a new consciousness and inner life. Very often she reconfigured existing sculptures into new ones, thinking of them as subject to a never-ending cycle of transformation and rebirth.[15] In 1959 Nevelson created a monochromatic white painted group construction, made of single wood pieces. These sculptures and wall reliefs of a monumental size were called "environments" and titled *Dawn's Wedding Feast* on the occasion of her participation in a group show, "Sixteen Americans," organized by the Museum of Modern Art in New York in the same year. One wall was called the "Wedding Chapel" consisting of several sculptures. The individual pieces were not nailed or screwed together, in order to enable her to rearrange the composition at will. After some years the whole group was divided into a number of smaller sections and sold to separate collectors. *Wedding Chapel IV* (1959), in the exhibition in the Grimaldi Forum, is a pair of two-part totemic columns, which show the typical features of Nevelson's construction in putting together found objects. The artist described her art as a "wish fulfillment, a transition to a marriage with the world."[16] *Homage to the Universe* (1968) is a monumental all-black wall relief. It consists of strong geometrical elements in the form of an accumulation of similar wood pieces, minimal in character, which gives an impression of an altar painting. This geometric regularity can be compared to architecture, but can also be seen as metaphor for natural environments. The scale of this mono-

chromatic sculpture inevitably confronts the viewer's eye with the play of light and shadow.

Barnett Newman

The son of Polish immigrants, Barnett Newman (1905–70) is known for his austerely reductive canvases. He studied at the Art Students League (1922–26) and attended New York's City College, from which he graduated in 1927 with a major in philosophy. Believing that a completely new art was needed to capture his time, Newman formulated a set of ideas in various drafts of an unpublished "monologue," *The Plasmic Image* (1945). In this he explained that, between the time of the Impressionists and the 1940s, modernist painters had resolved the technical concerns of the language of painting and should now go on to transcend such decorative aspects of art to formulate larger concepts. To him, Western art had lost its ability to relate directly to absolute emotions, due to its disorienting search for beauty and formal perfection. He felt that an art of the sublime was both necessary and possible, but that to achieve it artists would have to free themselves from the past and paint as if painting had never existed. Newman's thinking was influenced by the writings of the Russian anarchist Peter Kropotkin, who believed in the responsibility of the individual to free himself from all dogma, as well as by the Kwakiutl art of the Northwest Coast, in which abstract shapes were understood to have their own reality and convey ideas and feelings directly. It was in the mid-1940s that Newman created his first works employing his signature vertical "color strips" to articulate the single-hued fields of his canvases. The slim vertical composition *Now I* (1965) is a fine example of Newman's ability to transform elementary vocabulary into a powerful image. A thick black stripe set against a white background divides the canvas into three vertical parallels. Though these shapes are confined to the size of the canvas, they seem endless and give the impression of infinite extension. The same quality can be found in *The Name I* (1949). The horizontal canvas is divided into vertical segments by red stripes that are set against a gray background. However, there are no straight lines and the artist's hand can be traced in the red lines of varying thickness, as well as in the loosely brushed background.

Jackson Pollock

Born in Cody, Wyoming, Jackson Pollock (1912–56) is considered to be the central figure of Action Painting. He lived first in Los Angeles before following his brother, painter Charles Pollock, to New York in 1930. There he enrolled in the Art Students League to study with Thomas Hart Benton (1929 to 1931). From 1935 to 1941, he worked on the WPA Federal Art Project with Mexican artist David Alfaro Siqueiros, among others, and his early figurative compositions show a strong influence of Benton, the Mexican muralists, as well as the Native American art of the Southwest. Early on, he experimented with automatism, which was sparked by psychological and philosophical theories formulated by Freud, Jung, and Nietzsche. Automatism's plea for spontaneous creativity allowed for the dominance of the subconscious mind to manifest itself in Pollock's work. *Square Composition with Horse* (1937) is an early work by Pollock, in which the Cubist influence of Picasso, as well as the impact of the Mexican muralists, in particular that of his teacher and fellow artist José Clemente Orozko, are very apparent. Devoid of any figurative elements, this all-encompassing, semi-abstract composition is dominated by an array of forms, ranging from muscular, mechanical, and biomorphic, to almost skeletal structures. It celebrates the freedom of gesture in a time when most American abstractionists still explored a geometric approach. Only through associative forms, does this composition suggest distinct images, such as horse legs, while a rhythmic pattern of color provides it with a unique sense of dynamism. *Square Composition with Horse* is an exceptional example of Pollock's all-over compositions and functions as precursor of his works of the 1940s. In 1943 Pollock had his first solo exhibition at Peggy Guggenheim's Art of This Century gallery. In 1947, Pollock made the first of his densely layered large-scale all-over compositions. *Composition No. 16* (1948) is a good example of these completely abstract works utilizing Pollock's unique method of applying the paint by dripping and pouring directly onto the canvas. Within this process, he used sticks of wood instead of brushes, and preferred liquid enamel and aluminum paint or a heavy impasto mixed with sand or broken glass to traditional materials. In *Composition #16* multiple layers of poured paint, with a palette ranging from white to ochre and dark blue to black, are transformed into a visual symphony of dynamic movement and color textures. Due to the "all-over style," there are no points of emphasis in the traditional sense. All parts relate to the larger whole.

Richard Pousette-Dart

Born in Saint-Paul, Minnesota, as a son of artists. His mother, Flora Louise Dart, was a poem and his father, Nathaniel Pousette, a painter. Richard Pousette-Dart (1916–92) studied art at Bard College in Annandale-on-Hudson, New York. Soon after finishing his studies, Pousette-Dart began to create small sculptures, filling his notebooks with poems, drawings, and little oil paintings. His main influences were Eastern philosophy and religion, as well as archaic forms. Abstract art provided him with the possibility of moving away from reality towards a new, mystical world. He set out to cap-

ture the energy of the universe on canvas, and at times incorporated Surrealist elements. He represented the universe in asymmetrical, unpredictable and spontaneous kaleidoscopes. In the 1940s, he increasingly deployed allegory, metaphor and symbol to reflect his distaste for war. In the 1950s, Pousette-Dart developed many paintings in shades of white that were based on biomorphic forms and calligraphic fields. The artist was devoted to the French Impressionists, whose ideas he translated into pointillist abstract paintings. For example, a circle in the center of the canvas provided the effect of a magical light source. Beginning in 1960 he specialized in vivid colors and in the 1970s and 1980s he experimented with varying thicknesses of paint, multiple layers of color, and a variety of dominant geometric forms. He taught at several New York Art institutions, most notably Columbia University (1968) and the Art Students League (from 1980). Completed in the mid-1940s, *Presence No.10* is one of a number of paintings that were critical of war and the Atomic Bomb. The white circular center of the picture represents the Mushroom Cloud, while the surrounding black embodies death and pain following the explosion. *Hieroglyph (White Garden)* (1971) is one of Pousette-Dart's pointillist paintings. Whereas a cursory glance shows only a white surface with little spots, closer inspection reveals a lyrical layering of vibrant color, evocative of the night star-studded sky. Arguably it is a great example of "American landscape painting" in that it captures a mysterious view through a window, in which no borders prevent the composition from expanding in all directions.

In 1947, Pousette-Dart had a solo exhibition at Peggy Guggenheim's Art of This Century gallery.

Ad Reinhardt

As a painter and writer, Ad Reinhardt (1913–67) is considered a pioneer of Conceptual and minimal art. He was born in Buffalo, New York, and studied art history under Meyer Schapiro at Columbia University. He went on to study painting with Carl Holty at the American Artists School, and then at the National Academy of Design under Karl Anderson. Between 1936 and 1939 he worked on the WPA Federal Art Project, and soon became a member of the American Abstract Artists group. Having completed his studies at the New York University Institute of Fine Arts, Reinhardt became a teacher at Brooklyn College (1947 to 1967) and later at the California School of Fine Arts in San Francisco, the University of Wyoming, Yale University, and Hunter College, New York. Reinhardt was given his first solo exhibition at Columbia Teachers College in 1943, and by 1946 was showing regularly with the Betty Parsons Gallery, New York. Reinhardt was one of the first to work with hard-edge compositions. In the mid-1950s

he began to limit his palette to a single color, moving from red to blue and then to his final stage, the so-called *Black Paintings*. *Untitled* (1952) is a precursor of these geometric abstractions. The palette is reduced to only a few hues, such as pink, turquoise, light blue, and ochre. Though still containing traces of gestural expression, the overall compositional structure, based on several rectangular shapes that float freely on a monochrome background, is rigorously simplified, yet rich in visual lyricism.

Mark Rothko

Marcus Rothkowitz (1903–70) was born in Dvinsk, Russia, and moved with his family to Portland, Oregon, in 1913. Largely self-taught, he took up painting after moving to New York City in 1925. His early realistic style culminated in the *Subway* series (late 1930s). The semi-abstract forms of his work in the early 1940s developed by 1948 into a highly personal, contemplative form of Abstract Expressionism. Unlike many of his fellow Abstract Expressionists, Rothko did not employ dramatic brushstrokes to create compositions of forceful gesture. Instead, his paintings achieved their powerful effects by juxtaposing large areas of bleeding colors that are rich in psychological meaning and seem to float parallel to the picture plane in an atmospheric space. Rothko spent the rest of his life refining this basic style through continuous simplification. In 1965–66 he completed fourteen immense canvases, whose somber intensity reveals his deepening mysticism; they are now housed in a chapel in Houston, which was named the Rothko Chapel after his suicide in 1970.

David Smith

David Smith (1906–65) was born in Decatur, Indiana. In 1921, he moved with his family to Paulding, Ohio, where he graduated high school and attended one year of college at Ohio University. During the summer of 1925, he worked at the Studebaker automobile factory in South Bend, Indiana, as a riveter and spot welder. In 1927, Smith moved to New York where he studied painting at the Art Students League with the American realist artist John Sloan and the Czech modernist painter Jan Matulka.

During a trip to the Virgin Islands in 1931–32 Smith experimented with photographing tableaus of found objects that he incorporated as elements in his first painted and constructed sculptures, made after his return to New York. During the early 1930s, inspired by welded steel sculptures by Picasso and Julio González and surrealist works by Giacometti that he saw in European art magazines, Smith created a series of painted and welded iron and steel heads and reclining figures as well as more abstract constructions influenced by synthetic cubism. His first solo ex-

hibition of sculptures and drawings was presented at Marion Willard's East River Gallery in New York in 1938.

In 1940, he settled permanently in Bolton Landing and worked as a locomotive welder and a machinist. A few years later, Smith taught at Sarah Lawrence College, Bronxville, New York, (1948–50) and at Bennington College in Vermont (1950s).

Besides continuing to paint and draw, Smith is widely considered as the leading American sculptor who translated the different influences of European art into Abstract Expressionism. He created individual sculptures and various series in his oeuvre like the *Agricola*-series, the *Tanktotems*, the *Sentinels*, the *Zigs*, the *Voltri*, and others.

The exhibition shows a selection of five sculptures completed between 1946 and 1962.

Euterpe and Terpsichore is named after two of the Greek muses of lyrical poetry and dance.[17] It was completed in 1946, a time when the discovery of new forms sparked Smith's imagination. Since his European travels in 1935, Greek mythology was a recurring theme in his oeuvre and this particular work explores the topic of creativity, music, and dance as the positive side of human nature. It is more abstract than earlier works and reveals Smith's focus on geometry, weight, volume and light as well as on balancing positive and negative space.

In *Construction on Star Points* (1954) Smith made the dialogue between formal and poetic devices explicit by increasing the scale of the work. This sculpture is substantially taller than previous works. In addition, it is made of stainless steel instead of bronze, which had been Smith's preferred metal during the 1940s. The base resembles the shimmering image of a spiraling galaxy and creates a visual counterbalance to the upper part of the sculpture, a delicate iron construction painted in earth tones. This inversion is typical of Smith's desire to make each work unpredictable.

Smith said: "American machine techniques and European cubist tradition both of this century are accountable for the new freedom in sculpture making. Sculpture is no longer limited to slow carving of marble and long process of bronze. Here I'm talking about direct metal construction […] the new method is assemble the whole by adding its unit parts […] is also an industrial concept, the basis of automobile and machine assembly in the steel process."[18]

Between 1953 and 1960 Smith completed ten works titled *Tanktotem*, which included parts of commercial boilers. In *Tanktotem VI* (1957) tank lids are incorporated into vertical structures that evoke associations with the human figure. This sculpture is one of the most complex and delicate examples of the series. The arching line that ascends from the base and connects the work's upper and lower portions provides this piece with a lyrical sense of motion. A small right angle that rests squarely on top of the sculpture re-enforces the work's strong sense of gravity.

Dida's Circle on a Fungus (1961) and its companion *Rebecca's Circle* are titled after Smith's daughters Candida and Rebecca and belong to the *Circle* series. *Dida's Circle on a Fungus* is painted mustard yellow over red enamel on one side and blue over red and gray enamel on the other. Seen from one side, the sculpture suggests a bright and airy cross between a figure and a large flower. The irregular notches cut into the circumference of the two large forms allow air and light to penetrate into the sculpture and animate its profile. On the orange and yellow side Smith accentuates this effect, adding a brightly colored vertical element to create a central core of light that unites the lower and upper portions of the sculpture in resplendent harmony. The other side of the sculpture, stippled with dark blue, evokes the mystery and introspective calm of evening. The balancing of its two halves seems more tenuous, braced by much smaller vertical element. Like day and night, the sculpture presents two distinct experiences of the interplay between color and form.

In 1961, Smith began his *Cubi* series of twenty-eight monumental sculptures (1961–65), made of hard stainless steel. *Cubi II* (1962) is an excellent example of these large geometrical forms that include cubes, cylinders and cuboids. They are highly polished so that they adopt the different colors of nature, depending on the varying lights of its original surroundings, the fields next to Smith's home and workshop at Bolton Landing. In such a setting, seen against "sky, land or sun, this sculpture manifests as a solitary protagonist of impressively heroic stature."[19]

Clyfford Still

Born in Grandin, North Dakota, Clyfford Still (1904–80) attended Spokane University in Washington and later spent many years in California. It was around the time of his first solo show at the San Francisco Museum of Art that Still met Mark Rothko in Berkeley. In 1945, Rothko introduced him to Peggy Guggenheim and in the following year Still was given a solo exhibition at her Art of This Century gallery. Whereas his early work included figurative paintings and landscapes, his signature style abstractions are compositions based on heavy impasto and vertical, uneven strokes of color, which seem to reach beyond the edges of the canvas. To Still, each work marked a deeply personal reflection of the artist's life which, not unlike a journal entry, captured a distinct emotion in a moment in time. The titles of his paintings, which involve dates, letters, and numbers that signify the order in which they were created, support this notion. Still wanted his paintings to be under his personal control, and

did not wish them to be separated from one another or exhibited with other artists' work. He felt that his paintings could only be understood as a whole; as a group they could reflect the true evolution of his entire *oeuvre*. These special concerns resulted in his rejection of offers to buy his paintings, in his refusing awards and honors and declining invitations to exhibit both in individual and group shows. After a period in New York, Still settled in Maryland as a signal of his rejection of the politics that defined the New York art world at the time.

[1] H. Honour, J. Fleming, *Weltgeschichte der Kunst*, Munich 1983, pp. 626ff.
[2] Published in *ArtNews*, vol. 51, no. 8, December 1952, pp. 22–23, 48–50.
[3] Catalogue: *New York School*, Los Angeles County Museum of Art, 1965, p. 242, original interview by Thomas Hess for the David Smith catalogue, Marlborough-Gerson Gallery, New York 1964.
[4] I. Sandler, *A Sweeper-up after Artists*, New York 2003, p. 32.
[5] S. Davidson, P. Rylands (eds.), *Peggy Guggenheim & Frederick Kiesler, The Story of Art of This Century*, Venice and Vienna 2005, p. 288.
[6] C. Greenberg, *Die Essenz der Moderne*, Karlheinz Lüdeking, ed., Amsterdam and Dresden 1997, p. 11.
[7] I. Sandler, *op. cit.*, p. 29.
[8] *Art and Artists*, Oxford University Press, 1996, p. 3.
[9] I. Sandler, *op. cit.*, p. 29.
[10] Catalogue: *Willem de Kooning, Retrospektive*, Munich/Berlin 1984, pp. 241ff.
[11] D. Anfam, *Abstract Expressionism*, New York/London 1990, p. 78.
[12] *Ibid.*, p. 82.
[13] R. Howard, "A Conversation with Lee Krasner," in *Lee Krasner Paintings 1959-1962*, Pace Gallery, New York 1979 (exhibition catalogue, n.p.).
[14] J.E. Bernstock, *Joan Mitchell*, New York 1988, p. 52.
[15] L. Nevelson, *Structures Evolving*, Whitney Museum of American Art, New York 1998.
[16] Catalogue: *Louise Nevelson, Atmospheres and Environments*, Whitney Museum of American Art, New York, 1980, p. 107.
[17] R. Sautner, *Lexikon der Mythologie*, Salzburg 1984, p. 106 and p. 281.
[18] S.E. Marcus, *David Smith, The Sculptor and his Work*, New York and London 1983, p. 117.
[19] D. Anfam, *Abstract Expressionism*, New York, London 1990, p. 181.

Selected Bibliography
American Vision: Epic History of Art in America by Robert Hughes, Alfred A. Knopf, 1997.
American Abstract Expressionism of the 1950s: An Illustrated Survey by Marika Herskovic, New York School Press, 2003.
Amerikanische Kunst im 20. Jh., Malerei und Plastik 1913-1983, Munich, London, Berlin 1993.
D. Anfam, *Abstract Expressionism*, New York and London 1990.
Art and Artists, Oxford University Press, 1996.
ArtNews, vol. 51, no. 8, December 1952.
Art-as-Art: The Selected Writings of Ad Reinhardt, by Ad Reinhardt, Barbara Rose, ed. University of California Press, 1990.
J. Bernstock, *Joan Mitchell*, New York 1988.
Catalogue: *New York School, Los Angeles County Museum of Art*, 1965, orginal interview by Thomas Hess for the David Smtih catalogue, Marlborough-Gerson Gallery, New York 1964.
Catalogue: *American Contemporary Art Gallery*, Yearbooks, 2002–05.
Catalogue: *Peggy Guggenheim and Frederick Kiesler, The Story of The Art of This Century*, Venice and Vienna 2005.
Catalogue: *Willem de Kooning Retrospective*, New York, Berlin, Paris 1984.

Catalogue: *David Smith*, Hrsg. Jörn Mengert, Munich 1986
De Kooning: An American Master, by M. Stevens and A. Swan, Alfred A. Knopf, 2004.
Helen Frankenthaler, by E.A. Carmean, Fort Worth Museum, 1989.
From a High Place: A Life of Arshile Gorky, by M. Spender, Knopf, 1999.
C. Greenberg, *Die Essenz der Moderne*, K. Lüdeking ed., Amsterdam and Dresden, 1997.
S. Hirsch / M. Davis MacNaughton, *Adolph Gottlieb: A Retrspective*, New York 1981.
Hans Hofmann, by S. Hunter; essays by F. Stella, T. Dickey, ed. James Yohe, Rizzoli, 2002.
R. Hobbs and J. Kuebler, *Richard Pousette-Dart*, Indianapolis 1990.
H. Honour, and J. Fleming, *Weltgeschichte der Kunst*, Munich 1983.
Franz Kline: 1910-1962, by D. Anfam *et al.*, Skira, Milano 2004.
Lee Krasner: A Catalogue Raisonne, by E.G. Landau, Harry N. Abrams Inc, 1995.
S.E. Marcus, *David Smith, The Sculptor and His Work*, Ithaca and London 1983.
Robert Motherwell, by D. Ashton; J. Flam; introduction by R.T. Buck, Abbeville Press, 1983.
Catalogue: *Louise Nevelson, Atmospheres and Environments*, Whitney Museum of American Art, New York 1980.
Jackson Pollock: The Irascibles and the New York School, by Kirk Varnedoe *et al.*, essays by E.G. Landau, P. Rylands, W. Liebeman, Skira, Milan 2002.
Richard Pousette-Dart: the New York School and Beyond, by S. Hunter, Skira, Milano 2005.
Mark Rothko: A Biography by James Breslin, University of Chicago Press, 1993.
I. Sandler, *A Sweeper-up after Artists*, New York 2003.
I. Sandler, *The Triumph of American Painting*, New York 1970.
R. Sautner, *Lexikon der Mythologie*, Salzburg, 1984.

My City

"I was asking for something specific and perfect for my city…"

is how Walt Whitman opens his joyful poem *Mannahatta*. Later in the verse, he writes:

"The mechanics of the city, the masters, well-form'd, beautiful-faced, looking you straight in the eyes,
Trottoirs throng'd, vehicles, Broadway, the women, the shops and shows,
A million people—manners free and superb—open voices—hospitality—the most courageous and friendly young men,
City of hurried and sparkling waters! city of spires and masts!
City nested in bays! my city!"

Although long predating the works in the exhibition "New York New York" (the earliest images here were made in the 1940s), Whitman's words evoke the boundless vitality of the city, the energy that was clearly already buzzing in 1860 when his poem was penned. They later underwent a kind of metamorphosis when Paul Strand and Charles Sheeler collaborated to make the experimental film *Manhatta* (1921, originally called *New York the Magnificent*), in which images of the city are interspersed with lines from Whitman's poems *Crossing Brooklyn Ferry* (1856) as well as *Mannahatta*. The film was a multimedia celebration, by a photographer/filmmaker, a painter/photographer, and a poet (contributing in spirit)—all paying loving homage to New York City.

My city! First-person possessive. "I'm from New York," "I'm a New Yorker"—those words really *mean* something. We are a city that not only tolerates difference, but revels in it. We are comprised of remarkable subcultures—political, artistic, cultural, ethnic; I like to think that we all believe in evolution and in the separation of Church and State; most of us believe in a person's right to privacy and to make decisions about whom he or she wishes to marry, and about his or her own body. On September 11 and in the following weeks and months, we came together as a city in an unprecedented way, having experienced together an unprecedented horror. Later, many of us protested an unjustifiable war in Iraq. We have been known to be convivial during a blackout and a transit strike. We are wild for animals (mine, a lhasa apso named Ella), and will go to extreme lengths on behalf of all creatures—from displaced hawks to escaped coyotes—as well as dogs and cats who find themselves in less than ideal circumstances. We are independent, don't like being told what to do or think, and safeguard our personal space and lives—and yet we are in a state of constant communication.

Like people in other places, we suffer from poverty, joblessness, homelessness, and brutalities of all sorts. We have gratuitous rules, appalling gentrification, an ever-increasing disparity between the rich and everyone else, and avenues once characterized by grand idiosyncrasies that are now as bland as strip malls. But we are always working on ourselves, always changing, hopefully for the better.

My city, which is enchanting after a big snowfall: deceptively clean and eerily silent. Then there are the first daffodils at the end of March. (A gym teacher, taking my third-grade class out to play dodge-ball in Central Park, suddenly hushed us all and, in a manner that would have made Miss Jean Brodie proud, invoked Wordsworth's "host of golden daffodils." Recalling this to a friend one day years later in Greenwich Village—and speaking just a little too loudly—I'd barely uttered "lonely as a cloud," when that line, and the entire rest of Wordsworth's poem, was completed by the poet Rene Ricard, who happened to be walking a few paces behind us. My city boasts pick-up basketball games, and apparently pick-up poetry, too.) And the Bradford Callery pear trees that soften the streets with fuzzy-white in early April, all trees pale-green, and animated by birds in May, and then June—*I like New York in June*, as the song goes.

Cinematically: Judy Garland and Fred Astaire take to the New York streets in *Easter Parade*; Jerome Robbins choreographs an impassioned street life to Leonard Bernstein's score in *West Side Story*; and Gene Kelly, Frank Sinatra, and others dance through the avenues in *On the Town*. Then, among so many, we have Woody Allen's *Annie Hall*, Martin Scorsese's *Goodfellas*, and Bob Fosse's *All That Jazz*. And of course, there *is* all that jazz—all that music in the clubs and concert halls, on the streets: from Lincoln Center to CBGB's to the Kitchen to the Knitting Factory; from the rhythms of Earl Hines's jazz to Charlotte Moorman and Nam June Paik performing a piece by John Cage at Café Au Go-Go; from Juilliard students flooding the Upper West Side on warm

evenings with their music to the drummers in the 42nd Street subway station, infusing the tiled walkways with their fever. Absolute synergy. Art forms easily touch one another and mix here: there's Duke Ellington's take on Tchaikovsky's *Nutcracker Suite*, performed by the Dance Theatre of Harlem; George Balanchine's classic extravaganza for the New York City Ballet, and Mark Morris's anti-classic version of the same tale, *The Hard Nut*. And performers are not always bound to the proscenium: there's Merce Cunningham's troupe dancing in the Armory, lit by a car's headlights as it comes driving in, or Trisha Brown's company moving along rooftops and down the sides of buildings. There are all the churches that have opened their doors—Judson, St. Mark's, St. Ann's, St. John the Divine—becoming democratic spaces for everything from the most avant-garde dance to poetry to experimental theater. And of course there are the extraordinary sculptors and painters who have found such inspiration in the scale, light, movement, materials, and absolute electricity of this city, and who are so well-represented in this exhibition.

These are just some of the ways my mind wanders, free-associating "New York New York". There are more visions, more experiences here than could ever be considered, let alone categorized. Ask for "something specific and perfect" about New York, and you will end up with all the answers in the world.

These meanderings about my city suggest just some of the images comprising the photographic section of "New York New York." Many of the city's artists, working in all media—poets, writers, musicians, and performers—are represented, in portraits by Richard Avedon, Chuck Close, Peter Moore, Allen Ginsberg, Peter Hujar, Arnold Newman, Gordon Parks, Philippe Halsman, and Bruce Weber. Their photographs provide a kind of "open sesame" into New York's supercharged arts community.

"Isms" that are so often used to codify creative endeavors tend to prove fairly useless when considering photography. Of course, photography comes with its own baggage—especially the objective and literal expectations that viewers often bring to the medium. But we are being neither literal nor linear here, instead choosing to riff on the oft-sung "New York state of mind." The photographic section of "New York New York" is a freewheeling evocation, revealing something of the remarkable spirit of my city: its generosity as a home base; its cultural, social, and political engagement; its infinite style. It is, in a way, the most fitting approach to such an unfettered subject.

Still, we might group these photographers loosely into various configurations, recognizing that there will be much overlap, that the process is by its very nature reductive, and that all categories are fungible. We have a perfect metaphor for this flux in New York's primary boundaries—our rivers—fluid, adaptable, like the city's psychic and emotional hold on its people. This is simply a way of rounding up, of finding a place for the photographs included in "New York New York."

Consider, for example, photography's inherent ability and longstanding mandate to bear witness, manifested in everything from Weegee's 1940s crime-scene photographs to the more narrative reportage of W. Eugene Smith, and later Bruce Davidson, Mary Ellen Mark, Susan Meiselas, Eugene Richards, and Donna Ferrato. These photographers bring unflinching eyes, and remarkable empathy and integrity to the often difficult subjects before them, whether at home or afield.

Indeed, New York is a city that is easy to leave, because one is so secure about returning home to it later (perhaps one of the reasons for the iconic status of some of its bridges). It is this very openness that beckons the intrepid photojournalists who have always populated this city. Nothing is too "other;" there is no "other" here. And such photographers are part of a larger community, sharing convictions about the possibilities for social and political and cultural change here and elsewhere, and a desire to explore places not their own. They often turn their lenses outward with the openhearted sensibility of my city.

Many photographers work in a way that is not grounded in reportage, but is fully as provocative and effective when it comes to addressing and challenging social injustice, or offering a window onto the "fringes" of society. Barbara Kruger, Nan Goldin, David Wojnarowicz, Robert Mapplethorpe, Brian Weil, and Lorna Simpson are such seminal witnesses, as are groups such as Gran Fury and the Guerrilla Girls, among others. Whether taking on gender, race, sexuality, our rights to make decisions about our own bodies, AIDS, or politics—or a combination of all these interrelated issues—, their work provides a profound, often incendiary, riveting consideration of concerns and lifestyles viewers may or may not share, but to which attention must be paid.

And the focus moves in other directions as well, of course: Lucas Samaras and Cindy Sherman obsessively and brilliantly take on issues of self and identity, often in a performative manner, while Laurie Simmons utilizes her playful, ironic humor to explore notions of the feminine, and the relationship between people and objects—often domestic. Gregory Crewdson and Duane Michals both delve into narrative, psychologically and poetically; and Andres Serrano, Doug and Mike Starn, and Andy Warhol have brazenly touched the untouchable, deploying in their separate ways such icons as Jesus Christ and the Statue of Liberty among many other images.

Acutely sensitive to the subconscious dynamics at play beneath the human surface, and teasing those dynamics out with her camera, Diane Arbus brings an exacting and at times disquieting—though never sentimental—quality to her portraiture, both posed and (apparently) candid. Irving Penn's elegant portraits and still lifes, often made for *Vogue*, are orchestrated with exquisite precision. Robert Frank's intense and often idiosyncratic vision of America, both the people and the place, gets at the essential nature of his subject with incisiveness and respect. Philip Lorca diCorcia often looks to the streets, exercising keen control in his depictions. With wit and intelligence, Sylvia Plachy, Elliott Erwitt, Mitch Epstein, and Garry Winogrand grace the city streets with their cameras, poised for the happy synchronicities and accidents that they communicate with such nonchalant eloquence. And Helen Levitt, Louis Faurer, and William Klein perceptively capture the faces and gestures and street life of my ever-changing city as well.

More formal investigations into the environment of the city and elsewhere—attending to pattern, architecture, and the shapes of things—are undertaken by André Kertész and Lois Conner, while James Casebere constructs his environments with a surreal lilt. Lee Friedlander, too, focuses on the compositional arrangement of elements in the world, paying close attention to at times disjunctive, at times humorous juxtapositions—with an almost choreographic eye.

While not immersed in the natural world, these and many other New York photographers have a deep appreciation for it, and the photographs made here often reveal a fascination with the intrinsic coexistence of the natural and the man-made that is such a common paradox in the urban setting. Once, at a Manhattan Community Board meeting, I took part in a debate about the proposed use of an office building's atrium (designated for public use) as a large-scale-sculpture environment. The argument against this transformation was that in the process, some of the bamboo plantings that were deemed "natural" to the space would have to be removed. Of course, bamboo is about as natural to New York City as a giant gorilla on the Empire State Building—which begs the question: what *is* indigenous to my city? In this case, the artists prevailed. It was decided that large-scale sculpture was more endemic to New York City than bamboo. And at last look, sculpture and bamboo (just slightly fewer plants than before) are happily cohabiting on Madison Avenue.

In considering the images that make up the photography section of "New York New York," what becomes marvelously clear is that, like the city itself, the work is a confluence of convictions, beliefs, desires, ideas, concepts of art, of life, of self, at once sensuous and pragmatic, evoking causality and randomness, nothing stagnant, always in flux. An *isness*: specific and perfect.

As for this city, my city, let's close with the words of architecture critic Ada Louise Huxtable, who knows it as intimately as anyone: "New York, thy name is irreverence and hyperbole. And grandeur." All that, and more.

Rethinking the New York School in the 1950s

Irving Sandler

Historians of American art since World War II have tended to focus their attention on the 1940s and/or the 1960s. In the 1940s, the originators of Abstract Expressionism, notably Jackson Pollock, Willem de Kooning, Franz Kline, Hans Hofmann, Clyfford Still, Mark Rothko, and Barnett Newman, "broke through" to their radically new styles. The 1960s saw the arrival of the initiators of Pop Art—Andy Warhol, Roy Lichtenstein, and James Rosenquist—and of Minimal Sculpture—Carl Andre, Dan Flavin, Donald Judd, and Robert Morris.

Abstract Expressionism on the one hand and, on the other, Pop Art and Minimal Sculpture are very dissimilar. The Abstract Expressionists aspired to reveal their subjective feelings and private visions. In contrast, the Pop artists aimed to depict the objects in the world or representations of them in an objective or factual way, and the Minimal sculptors, in a related literal manner, were intent on articulating the unique, tangible qualities of sculpture, that is, its "objecthood." A radical change in the sensibility of American art had occurred.

But in jumping from the Abstract Expressionism to Pop and Minimal Art, scholars have overlooked for the most part the seminal contributions made by artists in the 1950s. Those artists who have continued to command art-world attention have been treated out of context. The result is a distorted perception of the development of American art. In sum, the decade of the 1950s deserves to be dealt with its own right, as an innovative period that gave rise to significant post-Abstract Expressionist artists and to competing aesthetic theories justifying their work.

By 1950, the group of pioneering Abstract Expressionists, termed Action Painters (Harold Rosenberg), Painterly Painters (Clement Greenberg), and Gesture Painters (the author), had spawned a second generation. Among its leading figures were Helen Frankenthaler and Joan Mitchell. Although their work was influenced by their forerunners, it was different in attitude and feeling. First-generation artists, at least those who achieved the greatest art-world recognition at the time, such as Pollock and de Kooning, seemed scarred by the psychic wounds inflicted by World War II, its Cold War aftermath, the revelations of the Holocaust, and the threat of nuclear devastation. In the 1940s, these older Abstract Ex-

pressionists were in the grip of a "crisis" mentality, a view put forward by Rosenberg. He maintained that the then-existing styles could no longer express contemporary feeling and had to be jettisoned. In order to be relevant, artists would have to begin a picture with "nothingness." In an anxiety-ridden, improvisational dialogue with the painting—the movement of the brush dictated by what Wassily Kandinsky had termed "inner necessity"—, the artist would add paint mark to paint mark until no further brushstroke was required. The picture was then "finished." The result would be an image of the artist's individual artistic identity, which, it was hoped, would express the tragic mood of the time. With an eye to newly emergent Existentialist metaphysics, Rosenberg also said that the Action painters, confronted by innumerable choices while painting, were engaged in a difficult struggle to make genuinely "felt" choices.

Like Rosenberg, the art historian Meyer Schapiro maintained that the artist's direct experience was the mainspring of Gesture Painting: "The consciousness of the personal and the spontaneous [...] stimulated the artist to invent devices of handling, processing, surfacing, which confer to the utmost degree the aspect of the freely made. Hence, the importance of the mark, the stroke, the brush, the drip, the quality of the substance of the paint itself, and the surface of the canvas as a texture and field of operation—all signs of the artist's active presence. [...] The impulse [...] becomes tangible and definite on the surface of the canvas through the painted mark." But the spontaneous was not all, for the "elements of so-called chance or accident [are] submitted to critical control by the artist who is alert to the rightness and wrongness of the elements delivered spontaneously, and accepts or rejects them." Schapiro then extended the personal into the social, asserting that "art in modern society requires for its life the artist's spontaneity."[1] Consequently, in Schapiro's view, Gesture Painting was providing an antidote to the conformism and stifling mass culture that were engulfing the Western world.

Rosenberg's emphasis on angst in what Auden termed the "Age of Anxiety" seemed very suited to the temper of the 1940s. However, in the course of the 1950s, World War II receded increasingly into the past. And despite the continuing threat of nuclear devastation and the Kore-

an War, the Cold War had cooled. Moreover, the United States was becoming a prosperous consumer society, and artists were beginning to partake of the burgeoning affluence. In short, the mood of disquiet that had pervaded life in the 1940s dissipated in the 1950s (even for first-generation artists).

Such younger artists as Mitchell and Frankenthaler were not as troubled by the crisis mentality as their elders. As if responding to the changed social situation, they adopted the formal innovations of the first generation but painted more lyrical pictures. Mitchell looked to de Kooning for inspiration, but unlike him, her poetic images call to mind amalgams of bridges and trees: man-made architecture and nature. Influenced by Pollock's poured images, Frankenthaler encountered her luminous abstract landscapes in poured pigment, but unlike Pollock's linear meshes, her images are based on the interaction of color areas. The work of Mitchell and Frankenthaler tended to be attractive and appealing, certainly compared to that of their heroes. Of the younger artists generally, Robert Goldwater wrote that they "like the materials of their art: the texture of paint and the sweep of the brush, the contrast of color and its nuance, the plain fact of the harmonious concatenation of so much of art's underlying physical basis to be enjoyed as such."[2]

Both Mitchell and Frankenthaler created highly personal styles that continued to command art-world attention, but most of the myriad Gesture painters who came later were servile mimics who churned out hand-painted illustrations of illustrations in *Art News* and other art magazines. Their painting looked contrived, mannered, and predictable, deficient in intelligence and ambition. The very number of followers indicated that Gesture Painting was becoming an outworn dead-end, and in fact, after 1958, growing numbers of artists and art professionals came to believe that it had become academic.

Since then historians have often taken Gesture Painting to typify New York School painting in the 1950s. They are wrong. Seminal new tendencies emerged in the 1950s, among them Assemblage, New Perceptual Realism, Stained Color-Field and Hard-Edge Painting, and at the very end of the decade, Minimal Painting. In the 1960s, these innovative styles would lead to even more radical developments.

Much, if not most, of second-generation Gesture Painting was figurative. Just as the abstract variants went into eclipse by the end of the 1950s so did the representational. Fifties-figurative artists focused on the relationship between the realistic image and the act of painting, that is, the tension between the portrayal of a subject and the signs of the painting process. Most figurative painters of the time chose to make their paint-

ing process visible. Not Alex Katz. In order to accentuate likeness in his images, he suppressed rough, overlapping, and scumbled brushwork. By concentrating on the factual description of what he saw, he originated what would be termed the New Perceptual Realism. Most of Katz's paintings were specific portraits, but, with an eye toward Henri Matisse and Milton Avery, he adopted their modernist mode of composition, namely, the interaction of shapes of flat color, to render the subjects. One of Katz's major contributions to realist painting was the enlargement of his format so that his canvases compete in visual impact, muscle, and grandeur, with the "big" abstractions of his contemporaries. Katz's expression-through-color and his large scale would be enormously influential on later generations of realist artists.

In the middle 1950s, Robert Rauschenberg and Jasper Johns deflected Gesture Painting in a new direction by turning from looking inward to looking outward—at the American environment. In 1955, Rauschenberg introduced found materials of city origin into his de Kooningesque Gesture paintings, creating a new kind of urban realism. In 1957, Johns began to exhibit pictures of commonplace objects or signs—flags, targets, numbers, letters--depicted in free brushwork resembling that of Gesture Painting. In emphasizing the literalness of his ordinary subjects Johns diverged from Gesture Painting, but his painting technique, nonetheless, seemed related. In actuality, Johns's brushwork was not as impulsive as it looked. Carefully "crafted" in a dispassionate manner, Johns's facture called Expressionism into question and challenged its Existentialist maxim that a painting could not be made but had to be found in the anxious act of painting. The work of Rauschenberg, and particularly Johns, laid the foundation for the development of Pop Art in the early 1960s.

Rauschenberg's and Johns's works were informed by the thinking of John Cage. Cage is recognized as a composer of avant-garde music but not as an art-critic and/or art-theoretician. Nevertheless, he was arguably the single most influential art critic/theoretician of the second half of the 20th century. His aesthetic was in direct opposition to Rosenberg's Existentialism (as well as the art-for-art's sake rhetoric of Clement Greenberg and Ad Reinhardt, as I will show). Cage rejected the Abstract Expressionist requirement that the artist's subjective experience be the primary source of art. Instead, he maintained that art ought to break down all barriers between art and life. In this, he was influenced by the example of his friend Marcel Duchamp's *Readymades* and his use of chance. The purpose of art, as Cage viewed it, was to open up one's eyes to just seeing what there was to see, and one's ears to just attend to the activ-

ity of sounds.[3] He rejected any hierarchy of sounds in music or of materials, forms and colors in the visual arts. Each element, as it occurred, was to exist only for itself, allowed to come into its own rather than being exploited to express emotions or ideas of formal picture-making. Consequently, any sound or material, by itself or in any combination, whether intended or not, *is* art. Noise is music and so is silence, which Cage denied could even exist, since in nature sound is always to be found. In short, he maintained that art should make people mindful of their surroundings and induce them to enjoy everyday life. In Cage's opinion, his thinking found its most cogent expression in the works of Rauschenberg and Johns.

Until the middle 1950s, the Gesture Painting of de Kooning and Kline was most influential on younger artists. However, another group of first-generation Abstract Expressionists received growing art-world attention, namely the Color-Field Painters Clyfford Still, Mark Rothko, and Barnett Newman. Unlike the Gesture painters, whose work tended to be based on painterly drawing, these artists explored the expressive possibilities of expansive areas of color, that is, the visual and emotional potential of color in its own right.

During the second half of the decade, younger painters, prominent among them Morris Louis, looked to these older colorists for inspiration, while embracing Pollock's and, particularly, Frankenthaler's technique of pouring color but they eliminated the signs of the hand found in her pictures. The result of soaking thinned paint into unsized canvas, as Clement Greenberg wrote, was that the fabric became "paint in itself, color in itself, like dyed cloth," producing a textural uniformity of both the polychromed and the bare canvas, akin to that created by the Impressionists' allover brush dabs or Newman's color fields.[4] But Louis's stained color is optical—disembodied—immediately inundating the eye, producing a fresh kind of chromatic expression.

Greenberg was Louis's art-critical champion. He was attracted to Stained Color-Field Painting because it was based primarily on the "opticality" of color, that is, color that was purely visual and had none of the brushy signs of the "tactile" touch of the artist, associated with Gesture Painting. Sheer visuality was important to Greenberg because of his formalist theory of modernist or avant-garde painting. What made any art modernist was its quest for "purity," and this was achieved by developing what was unique in the nature of its medium and separate from every other art. Painting, for example, was to "confine itself to the disposition pure and simple of color and line, and not intrigue us by associations with things we can experience more authentically elsewhere."[5] Consequently, painting had to be purged

of such impurities as "literary" subject matter. Because painting was identified primarily by its two-dimensionality, the artist was obliged above all to be panel conscious and to squeeze out "fictive" deep space. Hence, Greenberg's attack on brushwork, whose unevenness produced illusionistic effects that destroyed flatness.

Louis's stained canvases shared certain pictorial elements with Ellsworth Kelly's paintings: simplicity and clarity, lack of surface incident, and generally large scale. However, whereas Louis stressed the optical color-field, Kelly drew attention to the tactile color-shape. Enlarging on the idea that "a shape can stand alone," Kelly even created sculptures.[6] He developed a new geometric style that rejected Mondrian's intricate Cubist-inspired relational design in favor of the Matisse's elemental shapes of color, hence the label Hard-Edge Painting to differentiate it from earlier geometric abstraction. Moreover, unlike the latter, there are subtle references to visual reality in Kelly's pictures, namely the silhouettes of natural phenomena or the spaces between them.

Ad Reinhardt was generally included among first-generation Abstract Expressionists. But he stood opposed to everything they painted or professed. At a time when their work—with its romantic rationales—was at the forefront, he embraced a formalist art-for-art-sake aesthetic, related to that of Greenberg. Renouncing all extra-aesthetic associations in art, he wrote: "Art is art-as-art and everything else is everything else."[7] To Reinhardt, the antithesis of art-as-art was life-as-art. To distill the artness of art he programmatically purged painting of all signs of life, among which he listed varied shapes, painterly textures, and colors. At the end of the 1950s, Reinhardt arrived at his "ultimate" painting: a five-foot square abstraction trisected on the vertical and the horizontal into nine equal squares of an almost homogenous dark gray. Reinhardt's purist approach was rejected by the Abstract Expressionists, although his "black" paintings were admired.

Frank Stella followed Reinhardt in the embrace of art-as-art. In 1958, he was painting Gesture paintings consisting of horizontal swaths of pigment, but in the following year he hardened them and began to paint symmetrical, concentric configurations of black stripes, that seemed to refer only to themselves. In these abstractions, Stella rigorously subverted Gesture Painting. Direct improvisation was replaced by preconception. As Walter Darby Bannard wrote: "Abstract Expressionism was repudiated point by point: painting within the drawing replaced drawing with paint; overt regularity replaced apparent randomness; symmetry replaced asymmetrical balancing; flat, depersonalized brushing or open, stained color replaced the smudge, smear and spatter. [...] The entire visible esthetic of Ab-

stract Expressionism was brutally revised."[8] Inspired by Reinhardt's purist aesthetics, Stella challenged every angst-ridden, romanticist justification of Gesture Painting, brushing aside all subjective, psychological, and social interpretations. As Stella put it succinctly: "My painting is based on the fact that only what can be seen there is there. [...] What you see is what you see." He was the first artist to make the transition from Gesture Painting to Minimal Painting. Stella's abstractions would soon influence the Minimal Sculpture of Carl Andre, Donald Judd, Dan Flavin, and Robert Morris, which they claimed was the "next move" in avant-garde art.

In retrospect, it is clear that as Gesture Painting was becoming outworn in the 1950s, there was a growing rejection of ambiguous painterly painting. Any signs in the finished work of the creative process of the artist, of improvisation, exemplified in visible brushwork became taboo. The "hot" Expressionist look of Gesture Painting gave way to finished surfacing that was impassive, distanced, and seemingly objective, whether in New Perceptual Realism, Stained Color-Field Abstraction, Hard-Edge Painting, or Minimal Painting. Art criticism followed the development of post-painterly styles. Younger critics rejected Rosenberg's "angst" and embraced either Greenberg's and Reinhardt's purist art-for-art's-sake aesthetic or Cage's art-for-life's sake approach. And this "cool" attitude in art and art criticism would grow even more pronounced in the 1960s.

[1] M. Schapiro, "The Liberating Quality of Avant-Garde Art," *Art News*, Summer 1957, pp. 38–40.
[2] R. Goldwater, "Reflections on the New York School," *Quadrum 8*, 1960, p. 30.
[3] J. Cage, *Silence: Lectures and Writings* (Cambridge, Mass., and London: Massachusetts Institute of Technology Press, 1967), p. 10.
[4] C. Greenberg, "Louis and Noland," *Art International*, May 25, 1960, p. 28.

[5] C. Greenberg, "Abstract Art," *The Nation*, April 15, 1944, p. 451.
[6] W. Rubin, "Ellsworth Kelly: The Big Form," *Art News*, November 1963, p. 65.
[7] A. Reinhardt, "Art-as-Art," *Art International*, December 1962, p. 37.
[8] W. Darby Bannard, "Present-Day Art and Ready-Made Styles," *Artforum*, December 1966, p. 30.

The Pop Freezer

Germano Celant

In the United States, beginning in the 1930s, the artistic avant-garde transformed itself into a metaphor for morality, an ideal language to which one turned to understand a new set of values. After the stock market crash of 1929 and the ensuing depression, which rendered meaningless all traditional ethical canons, the only field in which American virtues could survive was the field of art. A symbol of criticism and negativity, art alone could transform into a positive image the face of the crisis, as well as interjecting into its own humanistic component the idea, incomprehensible after the onset of the Great Depression, of freedom achieved. People turned to art, trusting in its appearance of elusive existence, and set it up as a gauge of progress and transformation, with which to establish a different hierarchy of values. In fact, with the collapse of the reliable certainties of an ethic that had long been thought of as unassailable because of its Calvinist and puritan roots, the decision was made to turn to and cling to another absolute—art—whose positive assessment could stand in clear opposition to the collapse of order and existential certainty. This then, constituted the laying of the foundation, in ideological terms, of the prerequisites of an avant-garde as a weapon of moral pressure and expression of the behavior and conduct of a country. Here began the rhetoric of the avant-garde, whose unbridled liberalism was intended to serve, on the interior, in a curative role and, on the exterior, as a "banner" function. It was during this period that the great museums were established as institutions, and that the groundwork was done for the establishment of national funding for experimental arts research. The desire was to fall back onto an ideal in order to restore a whole, an entity that had been undermined and shattered by economic and political events. The entire history of Modernism was informed by this process and any artistic movement should be tempered in such a context of relentless idealism. In the name of that idealism, on all fronts, struggles would be waged to devour, and thus eliminate, European art, present on the arts scene since before 1929, and the avant-garde would become a rear-guard in order to establish itself on the international stage as a milestone of the new ethics.

In the brief course of a few decades, the anarchistic disorder of creative experimentation would be transformed into a therapeutic entity, which the terrifying hyperbole of the World War II would endow with increased efficacy. In a process of na-tional redemption, American art would employ any and all shock effects in order to pose itself as a simulacrum of life, capable of denouncing the malaises of a society that was moving quickly into the realm of galloping consumerism and technology. And rather than openly displaying its function as a pacifying treatment and cure, this art became the language embodying the libertarian lie, against whose illusory wall Davis would hurl himself, much as Gorky, Pollock, and Kline after him. If we look carefully, we can see that their sacrifice would serve only to deepen and enhance the reverence for a doctrine that set itself the goal of supporting and defending the hypothesis of an autonomous form of action, the ideal stereotype of an absence of restrictions and conditions. At the same time, given its faculty of self-determination and self-reproduction, art lent itself ideally to being presented as a process in a continual state of modification, and therefore as a notion of humanistic progress. If we wish to find a political equivalent of this conception, we should turn to the idea of "do what you feel like," without restrictions or limitations, in the name of a worldwide pseudo-wellbeing. The various parts coincide so neatly and are so nearly equivalent that, from the end of the 1940s to the present writing, the exchange attained the status of synchrony. Thus, whenever the American image began to wobble and sway in the realm of its social strategy, art would emerge as a moral force to help rectify the situation, covering over with its spectacular aspects all and any negative disturbance of its cultural values. As a result, each and every new crisis would trigger a new trend that we should no longer interpret as a critical meditation, but rather as an ideological underpinning and as an injection of renewed faith in its own virtues, and it little matters whether those are virtues of life or death. The reassuring form of art, the tragic quadrant of a language that is inadequate to things themselves, functions because it calls into question the reliance upon reality and upholds the mirage of a future civilization, with a reassuring character. Instead of accepting its unreality, it exists within the obscure and gratuitous abode of the right choice, in horror and scorn of external events, believing primarily in exorcism—not the exorcism of practice, but that of the revolutionary consciousness. In this context, after claiming for itself the territory of a break with the past, art survived all the political and economic crises of a world disenchanted, without realizing

that it was being used as a "cast" to ensure their reproduction. The head-on impact of the overall effect of the Action painters was utilized in this exact sense: internally, it became a process of levelling the atoms, of dripping as well as of components of a democracy based upon the exaltation of the individual gesture; externally, as a monolith that, with its homogeneity made up of disarticulated signs, could attest to the unequivocal and one-dimensional determination of social agglomeration, capable—given the potentialities of its individual elements—of opposing the lacerations that were shredding the social fabric, at the time, of the "distant" lands of Europe and China.

This method of treating the problem of the functionality of the American avant-garde to those tools that were considered useful in managing or prompting the changes and developments in a positive direction of a culture is clearly not meant as an attempt to obscure or undermine its significance within the context of art history; rather it is meant to pose the question of historic recognition, which sees art as a moral power, inasmuch as it is an abstract capacity of existence in terms of an attainable utopia. Why then, its deification, which reduces Pollock to a star and O'Hara to a hero? Or else, what explanation can we give to their unrestrained industrialization, unless it is the public sense of a pointer for the psycho-social attitudes of a majority that glimpsed in the behaviors ritualized by the media the desire for an ethics and a morality of their own, constructed however in keeping with the interests of a restricted apparatus in order to become dominant, that is, shared by one and all? As we retrace the path that led to the new artistic frontier, we might well be able to identify a series of coinciding factors. In the period of political apathy under the Eisenhower administration, when the security issues were set in the context of a repressive atmosphere that culminated, in 1950, in the passage of the Internal Security Act and the witch-hunts of Senator Joe McCarthy, Action Painting was recognized and supported by the enlightened bourgeoisie of New York City. At the same time, when the expansionistic drive, already at work in military terms in Korea, went looking for further international space and required a wedge, if possible, a radical wedge, with which it could camouflage its real nature and step onto the stage as a peer, alongside the revolutionary turmoil that was besetting the hemisphere controlled by its allies, from Chiang Kai-shek to Adenauer, this was identified in the field of cultural rebellion, from Action Painting to the Beat Generation, which served to vigorously wave the banner of civilization. And considering that, in this period, all events and facts were posited and imposed by the deforming pressure of the mass media, the ultimate proofs of this osmosis, which reconciled the avant-garde with a moral and ideological governance, can be deduced by reading them. In July of 1949, *Life* magazine, the highest circulation weekly in the United States, set out to investigate, for the good of its readership, at the time tens of millions of people, toward what ethical and moral horizons American culture was hurtling. The first investigation, published on 12 July, explored the "pursuit of happiness," and it was followed, almost on the same wavelength, by the themes of satisfaction with oneself and of free self-expression, in the context of a round-table on modern art. The function of such discussions, which filled some twenty glossy pages of the valuable real estate of the magazine's content, was to determine—this was a period of scandals over the immorality of politicians and committee hearings on the spread of administrative malfeasance—whether the development of a humanistic culture was possible that could be understood and loved for its "joyful" objectives by a mass audience. In order to help grasp the level of importance assigned to the resolution of these questions, whose diffuse solution would necessarily have elevated the identity of all the strata of society, let us point out that, among the fifteen experts who took part in the discussion[1], there were the philosophers Aldous Huxley and Theodore Greene, the art historians Meyer Schapiro and James Soby, the directors of museums such as the Victoria and Albert Museum in London, The Metropolitan Museum of Art and The Museum of Modern Art in New York, as well as such militant critics as Clement Greenberg and James Sweeney. This is clearly a sampling of the public firmament of experts in the field. This impressive constellation of celebrities was asked, not so much to explain in linguistic and historical terms the avant-garde of the 20th century, but rather to establish whether it was "symptomatic of the moral values of our age," or whether it could be viewed as a "great obvious truth of human life." And since it was impossible to analyze the entire corpus of modern art, it was decided to explore only works by the great masters. And this led to the dramatic moment. Among the visual therapeutists, whose degree of communicability and whose level of understandability and ethical acceptability were deemed to be appropriate for the American readership, alongside Poussin, Rembrandt, Cézanne, Matisse, Rouault, Picasso, and Miró, there were also Pollock, De Kooning, Stamos, and Gottlieb, then the leading figures in American experimental art. The juxtaposition was no accident. It helped to inculcate, on top of an official recognition and accreditation of values, also a substitution of moral reference points. Since the protagonists of the historic avant-garde are genuine and recognized, likewise their contemporary counterparts must also be authentic. And since for many decades European art has been held forth as a shining example of civilization and since "morality and truth" were not considered to be separate from the work of art, here we had the presentation of a new set

of idols, with respect to whom these same contents could be transposed, along with "the Classical-Christian tradition we wish to retain in our attitude toward art." In brief, the circle was unbroken. A way of making art that posed the irrational and subconscious manifestations as the true motives for human behavior, that exalted expressivity and subjective judgement, which could be transmitted through action, and which believed in the spontaneity of the individual experience, became the American standard of "the struggle of freedom," while in "insisting upon the highly individual experiences that have been emphasized today, is fulfilling a very valuable function: it is preserving something that is in great danger, namely our ability to remain individuals."[2]

The goal of converting the destructive energy and the drama of rejection, triggered by the Action painters, in a sense of trust in individual stability. The period of anguish and fear, silence and consent was transformed into a process of training toward absolute integration. Only the state of crisis, it was stated, could temper reality, and all the better if it involves a phase of self-destruction. Moreover, the despairing cynicism of the world of the gesture should not be rejected, but rather reconciled with ideal values. Indeed, it can be subjected to motivational research and exploration, embarking it into the flat consumerism of the images of the popular press.

The insufficiency of the existential rebellion, then, entails a simple spectacularization of the critical attitude, as if the artist, rather than launching an image against an image, were attempting to extract value and dignity from a previously existing image. A molecular investigation, carried out on the same material, thus becomes a quest for an approvable behavior, which immediately becomes the model for all the metaphysical and subjective art theories. There is a continuous back-sliding, a return to the domain of morality, to which all the ideological forms of American experimental art are ultimately linked, while the theme of emancipation, instead of conferring a disruptive and explosive form, offers instead a mystifying coverage, which preserves unchanged the authoritarian quality of culture, both visual and non-visual.

To emphasize the contradictory ambivalence of art may be useful in this context for a revised view of the "Pop" apparatus that, based on the situation of the 1960s, could be interpreted as a further instance of moralistic solidification.

It is clear that the two-faced physiognomy has to do with the presence of two phases, the artistic phase and the political and social phase; as these phases crossbreed, they render simultaneous autonomy and heteronomy, liberty and illiberty. Social practice, in fact, strikes at the very roots of art, entailing a subordination of the creative mind to contents assigned by others, in such a way that those contents form the true nucleus of the will to

transformation. All the same, the game of liberty, as social illiberty, continues, though distributed throughout its specific sphere. This establishes an existence all its own, enclosed in itself, and it is assigned a territory that is "authentic," because it is separate and unreal. And the other hand, there is another History, which the world of art considers to be fundamentally negative—hence its morality—because it is "dominant" over any practice.

In order to describe the characteristics of the "Pop" apparatus it would be important to discuss the breadth of both the activity of their participants and their organization. Considering the limited space available, we shall limit ourselves to a narrow contextualization of the years from 1959 till 1963, the period of the birth and expansion of Pop Art, both in "artistic" and "ideological" terms. As a function of separation, the frame of "art" is a chapter in the larger historical art gallery that serves, later, to provide a setting for Pop Art as the *memento mori* of the avant-garde.

Since we have to compress that history of a contemporary period that is still historically in the process of creation, it is not acceptable to forget that the trajectory from Action Painting to Pop Art did not necessarily take place without a series of gradual intermediate transitions, which included artists and groups, isolated and not amenable to codification, as well as the parallel and intersecting languages of theater, cinema, and dance. All right then, the years from 1959 to 1963, the period of the Pop explosion, correspond to an incorporation into the sphere of art of a totality of conditions and languages, capable of elevating to the level of communication the totality of reality. The orientation is inclusive in nature and helps to push art to "swallow" the greatest possible volume of communicative data, with an open and aware approach and stance. The proposal is to "open wide" in order to incorporate the world to the point of identifying with it. The idea is to place art in a total condition, open therefore to an acceptance of all the potential cases of expression and tension toward reality and toward art. Therefore, the artists that found themselves working in these years did not use art as a hypothesis of salvation or as a screen on which to project, but rather as a cold and crystallized "area," in which to isolate all the components of existence, both social and artistic. One chooses a sample of the art of life and one presents it. Any utopian discourse that affected the discourses of the artists working in the post-war years was eschewed, and instead one faced, with eyes wide open, the reality of one's own act of creation, in its empirical prosaicness and in all its vital banality.

The need, then, is to hurl oneself into the world and into art, in order to take on its banal conditions and to question the logic of everyday events as well as the logic of artistic events. Art and life become interchangeable poles in an investigation that oscillates between the aesthetic and the sociological,

the anthropological and the artistic. In the same way, the boundaries between languages tend to fall with the affirmation of an interlanguage that, since it can avail itself of all the media, is the only language capable of expressing this status of communications.

Clearly, this process of prosaicization and reliance upon the banal, along with the "con-fusion" of languages, has its roots in general in the historic avant-gardes of Futurism and Dadaism.[3]

All the same, while it is possible for the years in question to write a history of the linguistic and behavioral influences, relying upon the information available from our knowledge of the most representative artists, in all their fields of operation, it is not possible to ignore the attention-catalyzing effect of Marcel Duchamp. In fact, if we follow the individual stories,[4] from Johns to Klein, from Cage to La Monte Young, from The Living Theater to Kaprow, from Cunningham to the Judson Group, from Maya Deren to Markopulos, from Rauschenberg to Oldenburg, and from Dine to Warhol, it is easy to note, as you compare the various chronologies,[5] the way that the basic content of what they were doing changed as soon as they became aware of Duchamp. In particular, it was in the two-year period of 1957/1959, a period that corresponded to the publication and international diffusion of Duchamp's works and writings,[6] as well as the first monograph on his body of work,[7] that we begin to see a clear operative change. But first of all, let us explore schematically just what made Duchamp's attitude so different, since what we are interested in here, more than the actual, is a different way of being.[8] Marcel Duchamp was an individual who decided to abandon the visual lucubrations on the relationship between life and art, and instead emerged from the world of art and decided to enter directly into life. Rather than continuing to develop techniques well suited to keeping active the phantom of life in art, he chose to adopt a simpler solution. He gave art the "sense" of his life and in a certain way he affirmed its dissolution into his own persona and his choices in the world. In fact, he establishes himself as an "homme comme un autre,"[9] that is, as a person who acts and has an immediate contact with things, i.e., with "ready-mades." His intention is to satisfy his own needs, without having any idea of revealing truths: "in the first place," he states, "never believing in truth"[10] or social messages. " Je ne considère pas que le travail que j'ai fait puisse avoir une importance quelconque au point de vue social dans l'avenir."[11] He therefore follows primary impulses, and does not offer solutions ("there are no solutions because there are no problems"),[12] he simply lives his life and finds fulfilment as a person.

All this distinguishes his work from those who seem to want to demand answers about work or life, without following its course: "si vous voulez," he also said, "mon art serait de vivre; chaque seconde, chaque respiration est une œuvre qui n'est inscrite nulle parte, qui n'est ni visuelle ni cérébrale."[13] And since there is a spatial and temporal uniformity between a person and art, the manifestations of the Duchampian being are rendered equal to his body, his external choices to objects, and his states of awareness and unawareness to his paradoxes and witty bon-mots.

For Duchamp, then, it is possible to "reflect oneself" in a ready-made or in a "non-artistic" element, or else to "comprehend oneself" on a continual basis in the ambiguous changes of the body and in the vitality of a pun or play on words. And at the moment when the biologic need for self-expression has free access to all materiality, self-expression becomes unique and total, inasmuch as it, through the Duchampian choice, is an entirely material particularization, which determines it and gives it existence.

But if reality unfolds itself and forms itself in keeping with personal limitations and determinations, it no longer offers itself as an area of speculation, but rather as a field for the satisfaction of the needs of life. As a result, art, placing itself within the context of the satisfaction of individual needs, can make use in its practice of all the instruments and tools that allow an individual to attain satisfaction. At this point, in order to manage to affirm what is wanted and what is needed, all of the media are identical or, if you like, all languages will do fine. That doesn't mean that Duchamp does not set himself linguistic limitations and that he refuses to accept specifics, but rather that he chooses, as "materials in interiority," any sign without providing reasons or linguistic justifications. His was of proceeding and his way of being therefore have the effect of elevating to the status of sign the materialized totality[14] of reality, as well as proposing the insignificant as significant.

His engagement in favor of the sign-based elevation of reality attests once and for all his determination to flee from the sector-specific and mythic discourse of art. The objective is the annulment of art in the context of life, or if we choose to consider the problem from another point of view, a recognition of the arbitrary nature of art. However we decide to look at it, art loses value, because the Duchampian experience proves that art is useless and "odious" to life. It should come as no surprise then that his form of expression, whose entire purpose was to satisfy his own life, should have been called "anti-art" and should have been passed over in "silence." A silence concerning this material of being and making that was finally broken in the 1950s, when musicians, filmmakers, dancers, and artists were able at least, with the publication of his works, to "know" Duchamp and all the aspects of his work that entailed the obsolescence of the Neo-Surrealism of the Action painters and of the Neo-Concretism of the logic color painters.[15] The vastness of the behaviors induced by a re-read-

ing[16] of Duchamp is difficult to define[17] with any precision, and so, remaining within the context of the period we have identified, I will attempt to adduce an array of linguistic and behavioral data, capable of identifying analogies, which can then be extended also to the work of the 1960s. As we proceed historically, the intelligibility of Duchamp can be traced first and foremost to a crucial figure of the 1950s: John Cage, a close friend and a pupil, in the game of chess, of Marcel Duchamp.

Much like that of Duchamp, whose Cagean debt can be summed up in this phrase: "a way of writing music: study Duchamp,"[18] music for Cage is close to life[19]. He was convinced, in fact, that everyday life is capable of providing, if we pay close attention to it, if you listen to it, an enormous quantity of musical elements. At the outside, the musical array can be constructed with the passive attitude of listening. And if at any moment it is possible to hear sounds and noise proceeding from known and unknown sources, the musician has no other task than to facilitate and discern its musical aspect. More than a producer of sounds, he is a "listener"[20] who can, logically and illogically, cause music to emerge. That music, of course, instead of being constructed, has to be allowed to be or, as Cage wrote, "let sounds be themselves rather than vehicles for manmade theories or expressions of human sentiments."[21]

In this way, music, like the Duchampian readymade, is, in fact, "ready made." All that is needed to recognize it is to choose it, objectify it, and name it; this process of elevation ensures that every motif derived from real life will become music, so that it is possible to understand, on Cage's part, the musical introduction of silence, spoken stories, and noises. On the interior of this totalizing system, all sorts of sources can thus be used to "produce" music, and thus in his performances we begin to see such musical instruments as film, the voice, the body, and objects, as well as the invention of such modified instruments as the "watergong" and the "prepared piano."

In short, there is no need to "create" anything musically new in order to express oneself. Vital forms can be introduced into any element of an artwork, that is to say music develops progressively as the musical experience proceeds. It changes from one moment to another; indeed, musical events are, like life, "essentially unintentional."[22] A term that, to Cage, offers the possibility of emphasizing the random chance and indeterminacy of his music, which, like theater, "takes place all the time, wherever one is."[23] This contributes to determining, along with the adaptation of the "chance method," an attitude of "inertia" which, in the face of the composer's exaltation, allows to emerge the reality of objects and events, whose musical "representation" is thus achieved through self-evidence. The "achievement" of music, as a total manifestation, takes place in *4'33"* and in *Untitled* (1958), cru-

cial works for the future of music and performances[24]. The experience of silence and of vital sounds, as music, appears in the piece, whose duration and whose title are both four minutes and thirty-three seconds: the pianist, David Tudor, seated at a piano, does nothing, and in fact he opens and closes three different times (without playing) the key cover, in order to indicate that the music of silence and of sounds from the audience is divided into three phases.

A description of the work, however, does not permit its reconstruction: the place, the people, the noises, the objects, the silence, and chance occurrences, in fact, all take on a fundamental character, not included in what is stated. Everything becomes music, a cough as well as the sound of breathing. There is nothing in the interstructure of the performance that does not have a certain musical value. Every moment of the action and of the inaction takes on significance. The musical experience thus becomes more intensely significant and the reality of every individual, as well as the reality around that individual, establishes itself as music. The "comprehension" and the "reciprocity" of the sounds become complementary operative indications that Cage interiorized in the closed and untitled work, performed in 1952 at Black Mountain College. The "event"[25] was based on a system of a-logical and random reactions of dance, theater, music, art, and poetry. The Happening, which can be explored on various levels and all at once, constitutes an authentically radical "departure" in the method of conceiving of the linguistic components of the various arts. Cage's organizational liberty produced, in fact, an accumulation of actions in which the subject (Cunningham for dance, Cage for music, Rauschenberg for art, Richards and Olsen for poetry, Tudor for performance), while remaining objectively free to act, while still constrained by a common temporal restriction, is at the same time both a unity and a plurality. Since no shared reason can be delineated, the accumulation of materials tends to liberate the various languages from their reciprocal states of subjugation, in the same way in which it aspires to demonstrate a possible dialogue between them as autonomous and self-signifying entities.

The process of "confusion," whose Duchampian and Dada matrix is quite evident, was destined to exert a profound influence on the entire development of artistic expression. It also tended to check all other musical, theatrical, and artistic concepts in favor of an aesthetic "totalization." The backlash to this yielded its first results right in the years from 1955 to 1963, when Happenings, New Dada, The Living Theater, Fluxus, underground cinema, Pop Art, the Nouveau Realisme, and the Judson Group all began working on the shared material of the multiplicity reality and of its media.

The flattening and zeroing out that are found in the work of Cage can also be detected in the dance of

Merce Cunningham, when he emphasizes the fact that every gesture and each dancer are "first among equals."[26] For Cunningham as well, in fact, "all is dance" and "dance is all." And since everything at every instant is significant, it is not possible to establish a hierarchy among things, nor bring order to them, nor overlay subjective interpretations, nor depict them. In order to recognize their expressive properties, suffice it to live them and let them act. Dance was thus transformed, from a receptacle of passive practices, into an active practice that renewed, connected indissolubly as it was to the vital process, the material conditions and the inert significances of its components. These component parts, liberated in their autonomy, "declared themselves," and as a result, the space, the stage design, the music, the audience, the dancers, the lights, the costumes, and so on, all emerged into the open and self-determined. Above all, as was the case with sound and silence in Cage, there was no longer a major difference between a banal gesture and a choreographed gesture, indeed, those heterogeneous materials, together with other instances of chance in corporal movement, formed the dance. In the end, dance manifested itself only as an "immersion" in the reality of the common body. In practical terms, in Cunningham's *Suite* from 1957 to 1963,[27] every gesture, from walking to leaping, from running to stopping, self-determined as a sign of dance and every performance was founded with the idea of a person capable of capturing the identity of body and the body's gestures, as dance.

The sense of the urgency to recognize self-expression as an act indivisible from one's own existence and from one's own experience, in the cinema of those years, can be observed in the work of Maya Deren. This forerunner of independent cinema was in fact the first to adopt the idea of an identity between camera and body and use it to make cinema, in which the idea of the persona links filmmaker and film. The experience of her moving body was lived through the camera held on the shoulder, while the concept of equivalence between individual and filmic object is set forth in her films, including especially *Meshes of the Afternoon* (1943), which involves the "reversal," much like Duchamp, her actor in that same year,[28] or Cage and Cunningham, that is, of how "the intimate experience of a person," Deren herself, was poured "onto the outside world, to the point amalgamating itself almost indistinguishably."[29]

An exaltation of the worldly choices of the individual which, in the films of Anger and Markopulos, pillars of underground cinema of the 1950s, becomes dramatic when the filmed product was nothing more than an objective "reflection" of the filmmakers themselves[30].

Duchamp's decision and choice were widely recognized as positive and there came about a general confluence to his "protest against the physical aspect of painting."[31] This tendency toward a "re-reading" of Duchamp, with the consensus on reality that it entails, manifested itself differently in the United States and in Europe. The real dimension to which the members of the American community fell prisoner was based on a marriage between object and individual and in this continued collusion, the caesura between subjective action and the objectual sign is impossible. Objects are incarnated and coexist with individuals, while the individuals identify with and withdraw into objects. The result is a decorative whole that leads to a reciprocal coordination and exchange of roles. This coexistence, based on a love-hate relationship, was established, in the 1950s, by the moulds created by Johns, by the environment Happenings of Kaprow, and by the *Combine Paintings* of Rauschenberg; in the 1960s, by the portraits of objects and persons done by Warhol, by the bourgeois settings of Oldenburg, and by the cartoon stills of Lichtenstein. In the degree to which a sensitivity to reality, encouraged by the Dadaists, led to a reexamination of (one's own) objective reality, these artists seem to demand explicitly to know what is the essence of their own reality. This knowledge necessarily takes on, in each of them, different objectifications, due to the differences in interaction and harmony with Dadaist practice. The contemplative stance thus comes into conflict with the active stance in Kaprow, while Rauschenberg seems to waver, as he himself stated,[32] between the two. In truth, in order to keep Duchampian liberty from dying entirely, we might say that the free movement of life continued through Kaprow. Naturally, public opinion admired Johns.

Johns, instead of "subsuming himself" in the first person and "sacrificing himself" like Kaprow, intellectualized the Duchampian vital choice and made it into a problem of perception; he undertook, that is, a negative movement toward life, the positive movement giving a content to the action. His "revolt" became abstract, indeed equivocal. And it was precisely on the visual "equivocations" and on the prejudices of fixed significance that Johns worked, though without providing and answers. Object stability, first endangered by Duchamp, was thus transmuted into a mere doubt. "I think," Johns said, "the object itself is a somewhat dubious concept…"[33] He did not enjoy feeling that he was in danger, nor did he like to overturn the objective certainties, at the very worst he recreated objects in order to integrate them into a system of measurement: art. In contrast with Duchamp's purging of art in life, Johns counterpoised the purging of reality in art. In a certain sense, the inert materiality of art was transformed into a mediation for the analysis of the functioning of images and objects, and established itself as a reciprocity between reality and painting and sculpture. Instead of being, Johns reexplored, once again, the meanings of being. "I am interested in things which suggest the world, rather than suggest personality."[34] And in

fact, when he executed a neutral cast or copy of an image or an object, his problem was not so much a new awareness of the objectual signs as much as their recovery in terms of artistic objectivity. The purely impressionistic and realistic nature of dissolving and reexploring flags, numbers, maps, and targets in painting and neutralizing beer cans or flashlights in sculpture is heralded in the realistic and technical reference to Medardo Rosso, who represented, more than Duchamp did, his historic precursor. In fact, the relevance of Johns's objects has a sensualized character. The wax-painted images or the cast bronze objects are intelligible in their diversity only through their sensual content. I would venture to say that they have a double face, they seem to be offered as inert signs, but they are then rendered organically. This "organic" way of being of each of these objects entails a considerable component of ambiguity, upon the warranty of which both art and reality can newly survey one another, dependent and independent of one another. Johns does not make a statement in favor of either of the two, and, even if he ventures very close to art, the doubt persists.

If one does not wish for the art object to absorb human activity, it is necessary to restore to the context of the discourse of the individual as material reality from which the art object receives human functions. In this sense, the passive unity of the "organic" object is contracted from the active whole of Happenings and environments. These forms of communication, whose basic affirmation was the work, in 1958, on Kaprow, are in fact capable of unleashing themselves, through reliance on the use of the body, as object and as persona, from the danger of the intellectualization of reality.

Everything changes insignia and returns to the sphere of practice and being or, if we like, the visual material is not separated from the other materials, for instance, the olfactory and auditory ones. If, indeed, artistic communication were to be limited, as in the work of Johns, to a single level, we would have a fossilized image of reality and inert matter would prevail in the end over practice. The Happening and the environment avert this danger and tend, instead, to establish, with their physical and corporal situation, that the explication of individual experience must return to act and preside over art, so that it is defined increasingly as a way of doing, rather than a way of representing and recreating. In the final analysis, there was a new attempt, in the wake of Duchamp and the Dadaists, to further reduce the space of art with respect to life. For this reason, Kaprow, Whitman, Oldenburg, and Dine adopted in their creations, much like the Judson Group in dance,[35] all of those linguistic dispersions, from the non-professional performers to the movements without matrix[36] which rendered the action random and indeterminate. The need for a loss of linguistic identity is supported also by the skill that these total manifesta-

tions entailed. It often happened that the experience of the Happening and the environment came about while moving through "spatial wholes," such as apartments, meadows, skyscrapers, streets, and in some cases, entire cities. The practice of walking and operating within is indeed a "placing in movement" that obliges art to expand as an architectural, urbanistic, and territorial organism.

The spatial dispersion has as a consequence the possibility of integrating into all sorts of materials (animals, automobiles, trees, newspapers, subways); indeed, the process of chance inclusion often became the very reason for the Happening and the environment. But in order to define the complex array of rules that governed them, it would be best to allow Kaprow to take the floor; in his book on the subject, he described them as follows: "A) The line between art and life should be kept as fluid, and perhaps indistinct, as possible. B) Therefore, the sources of themes, materials, actions and the relationships between are to be derived from any place or period except from the arts, their derivatives and their milieu. C) The performance of a Happening should take place over several widely spaced, sometimes moving and changing locales. D) Time, which follows closely on space considerations, should be variable and discontinuous. E) Happenings should be performed once only. F) It follows the audience should be eliminated entirely. G) The composition of a Happening proceeds exactly as in Assemblage and Environments, that is, it is evolved as a collage of events in certain spans of time and in certain spaces."[37] The conditions of a Happening are prescribed as overcoming the material results that were obtained by Duchamp and the Dadaists, inasmuch as they include in their overview of their reciprocal objectives the elimination of the public representation and the disappearance of all aesthetic content, elements of the social mythification of the product, results that were fatal to the Dadaists. In other words, the significance of these events resides in the aesthetic experience of the performers, whose expression of action is of itself, leaving no traces that might later be interpreted or commodified, or in any case manipulated of "other" discourses.

Evidently, the "social" future of Happenings was relatively limited, but within the context of their historicization, we should distinguish in terms of their radical objectives of a struggle on behalf of life, which were taken up again, ten years later, by the Body artists. Between the inert being of Johns and the active being of Kaprow there exists, of course, a throng of artists, from Rauschenberg to Dine, from Maciunas to Brecht, who identified from case to case with the respective poles of contemplation and action on the object, whether artistic or not. For them, the action as negation of the object of Kaprow and the object as alienation of action in Johns, there exists a dialectical relationship, and it can take concrete

form in a combined array of "action object."[38] The action informs the object and the material is transformed into a personal practice, that is to say it protracts the artistic dialogue between objectuality and individuality. The "Pop" conception subscribes to an opposing theme, even in its rejection of that very denomination: "Pop is a word invented by somebody to describe some sort of situation, a handy term that has nothing to do with art"[39] (Rosenquist). The criterion of destruction is between the subjective and the objective. For Warhol, Segal, Lichtenstein, and Wesselman, the image and the object do not have a uniquely individual scope. Their attitude excluded all arguments aimed at the rhetoric of immediate action, which leads one to think of a utopian "movement." Instead, the Pop artists preferred a metaphysical profundity, linked to death more than to the life of the objectual phantom. The abyss of industrialism was not filled in but merely skirted. The guiding concept of Gesturalism needed to be interrupted by a policy that transplanted into art the conditions of the present. The mistrust of spontaneity is replaced by the decision to identify oneself—the period was being swept by the figure of Elvis Presley—with the subculture of the street. There was a general assumption of a cynical and despairing attitude toward personal reality and the horizon focused on urban topics. These can be found in the beauty of the industrialized landscape, where profit is king. Aware that opposition to industry is an a-historical and romantic way of operating—the country in question continues to be America—the artist is willing to accept its waste, indeed he makes that waste return to life. In this manner, artistic research dries up everyday expression and immerses itself in it. It chooses the seduction of the monster that is "within," without the ingenuousness of wishing to create an anti-society, which would become the arena of a new and future market. The colors of Hollywood, television, comic strips, advertising posters, the non-verbal communication of the body, the star system, and all the still lifes that make up the squalid setting of the city are experienced once again, but no longer with a destructive energy, but instead with a necrophiliac approach. Because in a consumer culture the oasis of liberty is a mirage of hardships, the attachment—or better the hook—should be attempted in the sense of commodification and profit. It is therefore pointless to circumscribe the activity to an undervalued ambient, devoid of all power, better to be absorbed and to work in favor of the absorption, because if the artistic rebellion is a commodity, then that commodity is revolution. The "Marx" of Pop is Andy Warhol, who exalts the figure of the foul character, the opportunist, the star, the businessman, the model, the boxer, and the rock singer and inserts into the conformist system of art the disturbance of non-engagement and glamour. At the same time, Oldenburg, by this point completely lacking in faith in the artistic image, decided to move into the realm of the "fake," where things are not distinguished by their quality and originality, but by their quantity, number of copies, and scale. Artistic research, rather than becoming an argumentation on behalf of existence, is transformed into a demonstration. The expectations are far more limited: the interpretation of the figures is no longer open, there exists a consensus and therefore an unequivocal quality. It is believed that the iconic elements (*Marilyn, Campbell's, Blam, Seven Up, Dollar, Nude*) were understood by everyone in the same way, thanks to the systems of collective awareness, that is to say quantitative, and there was thus a reduction of ingenuousness, as well as ambiguity, of life lived "in opposition." This is too easy to profane— let us think of Duchamp and Pollock—because it was considered true—and thus unreal in any absolute sense, preferable to sacrifice it with suicide to the dominant ideology of the mass media.

The vision is openly pessimistic, the Pop artists do not believe in liberation and are suspicious of any image that claims to rescue art from the culture industry. Having moved past the phase of protest, Lichtenstein, Rosenquist, Dine, and Segal chose the banal of the petit bourgeoisie. Since "the star of avant-garde," as Dine put, "right now has become too popular, lawyers act as avant-garde artists,"[40] why not just take their place, or even better, choose the images and products that most fascinate them? In opposition to the overweening ambitions of the critics and the protesters, they did nothing to attempt to escape the ideological subjugation of the system, nor did they focus on an interpretation that would connote the phenomenon with a degree of abstraction, instead attributing to it an importance and a prominence, without pushing it into the shadows.

The attempt is to rise to the level of mass communication, to eliminate all "distinction," the subterranean process of the consumeristic game. The idea was to liberate the artistic practice from one-way pretext of the antithetical transgression to the discourse of industry, in an attempt to establish a contact, indeed an osmosis, between the transformations of society and the modifications of the visual experience, in order to observe all that they have in common. The hypothesis of elsewhere does not reside in exorcising the real but in an acceptance of its catastrophe. Instead of imposing new icons, and discarding others, they unfurled their knowledge of existing icons. All inspiration was taken from the colony of industrial dreams and from the capillary and molecular system of television waves and films, where the ectoplasms of sex, war, food, and violence were formed. No longer a learned humanism, but instead the archaeology of large numbers, where the incest of TV channels was equivalent to the mental fracture of the anarchoid and intellectual action. The shatterings upon canvas by Rosenquist originated from the amorous ef-

fusions of both canned peas and heroes of the Westerns, while Warhol's star system was fed with the projection upon the invisible, but live body of art, of the stars of the glossy, electronic fatherland. The choice of the sites of inspiration was now qualified by the quantity of degradation and alienation, where the experience of living was formulated as an anonymous form, subject to fascination and petrification. By opposing the gesture and the assemblage that still make appeals to the ego, one linked oneself to the impersonal notion ("the impersonal look is what I wanted to have," said Lichtenstein), where the technological mantra levitates the body of painting and sculpture and increases their power. The art that supported the power (of the images) seemed not to refer only to it, in order to keep from being occupied with its human, yet inhuman and artificial rules. All was decided in terms of anonymous considerations, anonymity became the site of responsibility. Segal discarded his own existence in the presence of another, non-individualized being, and his own expression into the coldness of a plaster construction: all bodies can agree with a mould, no reason to attempt to invent new things. Individuality was always established in relation to a standardizing logic, in which the formula replaced the form (Wright Mills), "creation tends to become production"[41] (E. Morin), and where "the reason I'm painting this way is that I want to be a machine" (Warhol).[42]

On the painted surface, the phenomenon of the concentration of industry took place. The presence of the negative occasion, in Warhol, was overturned and reversed into an infinite repetition, converging upon the suicide of art. It is an attempt to rid oneself of the sign, through the lightness of print, television, and movies, so that a personally unequivocal quality can be established so as to give a sense to the infinitely reduced quality of artistic research. The Pop cultural value is determined precisely by its own industrial character, neither refined, nor filtered, nor influenced by art. The snobbery of the demiurge is violated by the recourse to forbidden things, or those that are scorned by aristocratic culture. The immersion is in the totality and the protection of the consumer, so as to link the propagandistic moment with the moral conception of art. Thus, if at first the realms of billboard art and cartoons had been the last refuge of failed painters, today these are the linguistic techniques that designate the educated, refined artist. The profession of display window designer and graphic designer, typical positions out of commercial culture, are no longer in opposition to aesthetic value, indeed they orient it through the experience of images of detergents and washing machines.

Standardized fabrication through silk-screening, spray painting, photographic enlarging, plaster casts, "mixage," or sewing machines, to cite once again Segal, Warhol, Lichtenstein, and Oldenburg, is not however incompatible with the identification of the artwork. With respect to the chaotic and material-based agitation of the Action painters, the flattening and the limitation of the creative rule "substantiates," while the major mass-market operators (Coca-Cola, margarine, flag, airplane, lipstick) "distinguishes" from the isolated particle or clot of color. In contrast, while it increases the presence of the star, it also drives away the individuality of the artist, who seems almost afflicted with shame at his way of working, withdrawing as a person, while the art is reinforced, eliminating the personal in a larger, collective identity. It is possible to react to this degradation, but not in the mystical and humanistic sense of the "persona," which bases its trascendency on the cliché of "one" sign, but rather with the quantitative recourse to the repellent presence of the stereotype. By feeding into the realms of standardization and payment, Warhol superindividualized himself.[43] He achieved, that is, the two-fold goal of scorning both art and consumption. With a cynicism and an aggressivity that were typical of the most vulgar commerce and atypical, perhaps, of aesthetic experimentation, he treated art as a function of its retribution and its success. He established a different linguistic and economic relationship, because he laid down the law, almost as if to state that, if art is to consider itself as well established, it must at least attain the firmament of Hollywood. In a country of virulent capitalism, the "critique" is chained, and therefore overpaid. The factors of conformism act, therefore, not in this restriction, but as an impulse toward the increased open discussion of this subjugation. One made use of the lack of culture to measure the scope of a survival in the age-old sector of art. The right to folly and suicide, which was so characteristic of the historic and contemporary avant-garde, was transmuted into an invitation to degradation and failure. Since the apparatus secretes its own antidotes, seeking them in the positive and the negative of artistic ethics, it was necessary to impede its therapeutic effects, by injecting a gangrene. The idea of converting to become spokespersons of current interest sharpened and accelerated the mediocrity of art, and therefore its degree of opposition. And so we see interactions in the Olympus of the *New York Times* or Channel 13, the *Ed Sullivan Show* and *Interview* between the champions of art and the movies, fashion and industry. They all forgathered there, because there they can crossbreed with the comic strip and advertising, the TV movie and the image of the president, all the insignia of the brutality of the human condition that need not be attenuated or covered over, but instead put on display. The face of art is not diverse, it appears therefore on the screen, which is a canvas, monitor, and film, with its collapsing make-up.

The make-up conceals the clown. The spectacle of art is due to the vocation of its acrobats who blend the risk of life with the hobby of travelling through

a universe of landscapes made up of highways, Picasso, hot dogs, Dick Tracy, atomic mushroom clouds, posters of Mao, electric chairs, sexual monuments, spaghetti, and other objects that can be visually collectable, during a trip as an aesthetic tourist. Pop lives in a total manner this circus condition. Moving from one trampoline to another of the image, it attempts to halt, in its memory, to the greatest degree possible. But its eye is weak, it cannot see because it has been taken over by the muscle of stomach or sex, there remains nothing more for us than to depict it all with a Polaroid, the Pogo and the monument of canvas and pigment, traces all done by "hand," souvenirs of a touristic and intellectual excursion into the context of the culture industry. To collect gadgets of this sort means to render extraordinary the ordinary and to take it out into the open, so as to take on toward it "a double view, both for and against" (Oldenburg).[44] The gadgets are stupid, and so to collect them reveals an ironic and mystical attitude: devotion and a laughable accumulation are devoted to it. The parody of the museum could not have been any more blatant.

This is the information that can be deduced from Oldenburg's *Ray Gun Wing* and *Mouse Museum*,[45] museums designed in the shape of pistols and mouse heads, in which the artist has collected hundreds of small objects made of rubber, sugar, tin, marzipan, canvas, gelatin, and plastic, a collection assembled over the course of the years. The inventory includes insignificant fetishes and miniatures of animals, food, monuments, clothing, landscapes, and money. Created as indifferent vectors, the figures of the everyday arrive on the far shores of art, where, instead of heating up, they are frozen. Celebrity is cadaverous, and so Segal exhibits mummies and skeletons of the city and Warhol portrays that ghosts and Draculas of business society. With them, death enjoys liberty and horror is transformed into a lucky love. They emerge from the Lower East Side and are served at table or exhibited on the wall in the world of the jet set.

If the illicit and the obscene is available from the first to the thirtieth channel on television, much like the first or the hundredth object collected, why not consume the protagonists of the same, in the form of the figures of industrialists, actors, artists, and other wealthy members of the bourgeoisie, such as the antagonists, who can be found among the filth and garbage of the city? It was the Bowery, the avenue with the least dignity in New York, that inspired all the Pop artists. The violence experienced in this area full of cut throats and shattered stores was the other face of the tribute paid to the relaxed accounts of the same episodes of violence, broadcast over the television set or the newspaper. It matters little where urban death lives, the living dead are everywhere, in the corners of the sidewalks or of a framed canvas.

The recovery of the theme of death, which manifested itself in the configuration of the frozen nature and the cadaverous appearance of the objects and figures used in art, was also a reminder to its artists that the flow of images, collective and personal, underlies a process of irreversible annihilation. Paintings and sculptures over the course of the decades grow old as a comic strip, or they have ephemeral nature of a postcard. By burying art under a mountain of icy clippings, the Pop artists attempted to chip away at its last cowardly resistance. They were planning its disaster. Every one of their works tended to take on the appearance of a tombstone, an effigy not only of sex, style, advertising, and interior design, but also of art, and it was the commemorative stone and the *memento mori* of the individual avant-garde, swept away by the collective avant-garde. The quicksand, identified by the Pop artists for art in their scorn and their misunderstanding of the vital worth of images, can indeed express the intention of a definitive sacrifice of visual research to the mediocrities of industry and capital, but through a normal process of reversal they also risk supporting the very opposite: the *memento mori* of the avant-garde runs the risk of transitioning into the avant-garde of the "memento mori," that is into the moral and mystical rear-guard.

Considering the context of the apparition and the socio-economic locus that defines the research, the probabilities of such an end are not few. In the United States the survival of art, as we saw at the beginning, seems to stand at the final stage of public manifestation, as an allegory of moral survival. The transition is not difficult even for Pop Art that, aside from the struggle over iconic pollution, stakes all its success on the presence of the objectual fetish. Now, by tradition, since the 17th century, paintings of objects served to suggest the fragility of the person with respect to death. Considering the times of the plague, the reference to the *Vanitas*[46] of life hardly comes as a surprise, just as it is no surprise that, if we consider what is happening in the social period, since the birth of Pop Art, one might use the same analogy. In the five year period in which the Pop artists first appeared on the scene, the utopian programmes of American society were overwhelmed by internal and external events, which pollute the "purity" of the neo-capitalistic colossus. Though surrounded by a great wall of illusion to the progress of welfare and prosperity, the American paradise was not ready for the reversal of values produced by democratic, also known as popular movements. Between 1956 and 1963, the level of dissatisfaction could not be measured by the number of dishwashers and refrigerators, but with the sense of insurrection that ran through ethnic and racial minorities.

The sit-ins were mixed with political protest, while the wall of conformism began to crack under the hammerblows of the "howls" of the Beat Generation and the attacks of a generation of dissent that

had no more trust in the decisions taken at the highest levels, the traditional sources of authority, a silent apparatus, that is systematically violent in its treatment of all criticism and standpoints of the left. Alongside the genuine attempts at protest and rebellion from the new radicals, who gathered considerable forces, capable of shaking the administrative and police gelatin, there were also the blows struck by the political situation, national and international. Let's remember a few of them. When Eisenhower's military apparatus was re-elected once again to run America, prompting suicides among those accused by the anti-Communist committees, Mao launched in Beijing his "Hundred Flowers" policy, stimulating free intellectual activity. In Africa and in the Orient, the mercenaries of colonization were isolated and expelled, while in America the struggle against racial segregation continued, with the rise of the charismatic image of Martin Luther King. In Cuba, the tropical island of New York speculators and businessmen, the dictator Batista was overthrown, and Fidel Castro conquered Havana. Against the declaration of *détente*, the "good" president Kennedy proposed an invasion. At the same time, the Japanese-American treaty was shot out of the sky, much as had been the U-2 spy plane in the skies over the Soviet Union, which was also attempting to seize control of space with the lightning-fast construction of the Berlin Wall and with the launch of the artificial satellite, flown by Gagarin. The spread of such catastrophes and plagues seemed without end for America, and finally it developed an addiction, and, even though it emerged crippled from the Korean disease, the country began to inject doses of Vietnam. The erosion of the country's sense of security could not have been any more dramatic: the revolt of the "subalternate forces" threatened to overturn the transcendental structure of well-being, based on the proclamation of happiness for one and all, while the explosions of self-determination for the second and third world damaged and undermined the monopoly of the dollar. After a survival without risks, the civilization of comfort found itself surrounded by the phantoms of insecurity and irreversible decadence. Death seemed right around the corner.

The time was one of tightened belts but, in an attempt to uphold the "happy days" of the past and to reassure everyone that this was a passing crisis, the pedal of superconsumerism was pressed to the floor, so as to allow for the circulation of those symbols that were used to measure the era as transitory. By placing the public in the face of an avalanche of objects, designed at random for unknown functions, it was intended in fact to bring to mind the uselessness of all conditions and to zero out the awareness of any value.[47] The bombardment of images and objects further denounced the scorn for information that derived from it, whether one was talking about jelly or happiness, drugs or rock music. All of the tension was aimed at the pace of emission and expansion of the flow that, by temporalizing production, committed itself to transmit a message of a metaphysical order,[48] the irreversible race toward the consumption of the body, understood as a product and a persona. The Pop artists shared with the mass culture the heartbreaking aspect of conventional stereotypes and the passion over their circulation. They configured "still lifes" with tomato cans and dressing gowns, golf balls and ice cream, almost as if to oppose a pleasurable expression and symbolize, during a time of technological leprosy, the fragility of existence. The transition, through which it was possible to neutralize the energy field of the sensual and spontaneous field, took place between 1960 and 1962, when the Pop artists stopped producing Happenings and environments, and began to devote themselves to simple depictions of things, whether effigies or not. The fixation on appearance was the result of an accelerated reconciliation. The critical energy had cooled and the important thing was to remain tied to the context, because it was the context that assigned to the work its function and its significance. By injecting "unpleasant" objects that were reminiscent of death, the alternative revealed its fragility and its simulation: *The Crash* by Jim Dine was made as a commemoration of a car crash in which a friend of his had lost his life[49] and the image of *Ray Gun*, Oldenburg's phallic pistol, was chosen to become, in the artist's own words, "the metaphor of a new kind of art, one dedicated to spiritualizing American sensation."[50] If we look carefully, the Luna Park that was erected by Pop artists on the terrain of art in favor of an unbridled proliferation of banal figure well suited to gobble up the sublime presences, actually concealed a strong sense of aversion. Lichtenstein and Wesselman, Segal and Dine were interested in technological adornments, but they were afraid of their mortal embrace. In order to conceal this repulsion, their works adorned themselves in mysticism and religious transports for the culture industry. When all was said and done, Warhol and Oldenburg gloried in the game that had been started between their creations and the public. When they designed giant cakes that blocked the intersections of Manhattan or when they managed to sell their personalities to promote travel with TWA, they produced syndromes of sadomasochism. It was they who became the "religious gun men,"[51] that is the future "sex pistols," upon whom it would be possible to unload violence and the desire for sublimation. The Pop artists absorbed the sensation of death and digested it without questions; they became its drivers. They were satisfied with recalling repression and they gave it surfaces and volumes. The match, then, was played on two fronts. Thus, Wesselman's nudes seemed to gleam with their ice-cream colors, but in fact they moved in the shadows. Any gaze cast upon them or by them (they are eyeless) is blind,

where existence is a memory of a vision and a life which can no longer be perceived. Even the nonrepresentative arrays, where fragments of bodies are in motion, and which refer to mutilations, crystallize the privileged sites of the display of corpses, conducted by the cut[52] of fashion, sex, and art. In Wesselman and Segal, the enunciation of lipsticked mouths and laughing vaginas, whole or fragmentary nudes, abolished all the dignity of the person and liquidated all and any sensuality. Rationalizing the parts and sanctioning their molecularization, that is the programming of the struggles of consumerism. What benefits is morality, which judges and condemns, to life or to death, this or that other part. Profit, therefore, flows in one direction only. In concert, the removal and the serialization of the same elements render visually legitimate the quantification of the martyred body, exchanging sensual violence with security in its shiniest and most repetitive form. Aside from vindicating the death of the avant-garde, Pop Art encouraged its reappropriation. It claimed a quality and made it collectable, transporting it in this way into the universe of bourgeois exchange, interested in all new markets. The rule of dying thus became an alternative in which to redeem the collapse of security, both social and national. If death was besieging the system, the system gave itself death, even in the form of art. It built itself an aesthetic catafalque that is a capital that can be displayed around the world: a giant sepulchral arch, paid back for its spectacular nature. The vertigo of burial was also sought in the scanning on a macroscopic scale of surfaces and rooms, brought to the stage by Pop artists. In order to obtain effects of macabre resonance, capable of terrifying the audience, the aspect of canvases and sculptures grows to such a point that it annihilates any relationship. The formula is the one developed and tested by advertising techniques, where the fig-

ure and the objects painted on outsized billboards cannot be controlled, but instead vanish into the giantism that only an aerial view can control. Banality is not satisfied, but instead demands an additional sacrifice: in order to approach it, one must vanish as a person. The redundancy of Rosenquist's *F-111*, of Oldenburg's *Giant Iceberg*, of the big head of Mao as silk-screened by Warhol[53] all overshadow the costar to the point of exterminating it: necessarily, the body of a human being is rigid, while the theater of bourgeois consumption is elastic, expanding according to demand and success. The expansion of the surfaces and the volumes moreover multiplies the circulation of industrial waste and ensures that nothing survives of the hand-made drafts. We work, therefore, for an authorized death, which offers moral security, and for which cutting and "mixage" become pleasurable procedures of suicide and homicide of the persona.

Finally, the Frankenstein of Pop renders fascinating the *dèja-vu* effect, confiscating its most alive parts and transplanting them into the "monster." In this way, the spectre of death is recycled with the acceleration of the combinations between mutilated parts and, expurgating its own horror, it confers an inoffensive aspect, becoming a good monster. The condolences for American society is thus rapidly reinjected into the productive process. The "delightful" relationships with the cadaver are reestablished, allowing it to continue to live and flourish, reproducing itself over time. The interaction among the snippets also offers the hypothesis that the fragments, through a process of order, here imaginary and creative, are easily integrated into their social functions. The artistic milieu is kept alive for this purpose: it must operate as an undertaker for visual experimentation and for an emergency room and intensive care unit for a character also known as Society.

[1] The round table that was organised by *Life* in order to "clarify the strange art of today" included: Clement Greenberg, avant-garde critic; James Fosburgh, advisor to *Life*; the moderator, Russell Davenport; Meyer Schapiro, professor of art history, Columbia University, New York; Georges Duthuit, editor of the magazine *Transition Forty-Eight*, Paris; Aldous Huxley, author; Francis Henry Taylor, director of The Metropolitan Museum of Art, New York; Leigh Ashton, director of the Victoria and Albert Museum, London; Kirk Askew, art dealer, New York; Raymond Mortimer, British author and critic; Alfred Frankfurter, editor of *Art News*, New York; Theodore Greene, professor of philosophy at Yale University; James Sweeney, author and critic; Charles Sawyer, president of the School of Art at Yale; H. Janson, professor of art and archaeology at Washington University, St. Louis; Hyatt Mayor, curator of prints, Metropolitan Museum, New York; James Soby, chairman, Department of Painting and Sculpture, The Museum of Modern Art, New York. R. Davenport (ed.), "A Life Round Table on Modern Art", in *Life*, New York, August 1949.
[2] All quotes *ibid.*
[3] M. Calvesi, "Un pensiero concreto II", in *Il Marcatré*, no. 16-18, Rome, July-September 1966, pp. 241-251.
[4] For the individual artists and groups, see M. Kozloff, *Jasper Johns*, Harry Abrams, New York 1967; R. Kòstelanetz, *John Cage*, Praeger, New York 1968; J. Biner, *The Living Theater*, Editions l'Age d'Homme, Lausanne 1968; A. Forge, *Robert Rauschenberg*, Harry Abrams, New York 1969; P. Wemser, *Yves Klein*, Du Mont Schauberg, Cologne 1969; A. Kaprow, *Happenings*, Harry Abrams, New York 1969; La Monte Young and M. Zazeela, *Select Writings*, Heiner Friedrich, Cologne 1969; M. Cunningham, *Changes: Notes on Choreography*, Something Else Press, New York 1968; G. Celant, *Appunti per una cronologia critica dei lavori, progetti, idee, scritti e manifesti di Piero Manzoni*, Galleria Nazionale d'Arte Moderna, Rome 1971; R. Wedewer, *Uber Beuys*, Droste Verlag, Dusseldorf 1972. In general, concerning the intermediate research bridging music, dance, theater, and cinema in the 1950s and 1960s, see M. Kirby, *Happening*, De Donato Editore, Bari 1969; *Happening & Fluxus*, Koelnischer Kunstverein, Cologne 1970; A. Leonardi, *Occhio mio dio*, Feltrinelli, Milan 1971; D. McMonagh, *The Rise and Fall and Rise of Modern Dance*, New American Library, New York 1971; G. Celant, *Musica e danza in USA*, Jabik, Milan 1974.
[5] Concerning Marcel Duchamp, we have followed the most recent chronology in *Marcel Duchamp*, The Museum of Modern Art, New York 1973.

[6] M. Duchamp, *From the Green Box*, Ready Made Press, New Haven 1957 and M. Duchamp, *Marchand du Sel*, Edition Le Terrain Vague, Paris 1958.

[7] R. Lebel, *Sur Marcel Duchamp*, Trianon, Paris 1959.

[8] For him, his art and the art of the Dadaists, "s'agissait de mettre en question le comportement de l'artiste tel quel l'envisageaient les gens." Quote from P. Cabanne, *Entretiens avec Marcel Duchamp*, Editions Belfond, Paris 1967, p. 100.

[9] *Ibid.*, p. 19.

[10] Quoted from J. Tancock, *The Influence of Marcel Duchamp*, in the catalogue *Marcel Duchamp* cit., p. 165.

[11] P. Cabanne, *op. cit.*, p. 135.

[12] J.J. Sweeney, *Interview with Marcel Duchamp*, NBC, New York 1955 (Italian translation by A. Nosei, in *Marchand du Sel*, Marcello Rumma Editore, Salerno 1969, p. 35).

[13] P. Cabanne, *op. cit.*, p. 135.

[14] The totalizing vision and the expansion of signs of Duchamp found in Italy, aside from Arturo Schwarz, other careful scholars, such as Alberto Boatto and Ermanno Migliorini. His aesthetic pantheism was subjected to analysis in various essays by them; in particular, let me mention: A. Boatto, "Approssimazione Duchamp", in *Senza Margini*, no. 1, Rome 1969; E. Migliorini, *Lo scolabottiglie di Duchamp*, Edizioni Il Fiorino, Florence 1970; A. Boatto, "Un Hercule sans Emploi", in *Critica in Atto*, Rome, March 1972.

[15] In this connection, here are the words of Duchamp: "I wanted to change the status of the artist or at least to change the norm used for defining an artist. Again to de-deify him [...] The idea of the artist as a superman is comparatively recent. This I was going against. In fact since I've stopped my artistic activity. I feel that I am against this attitude of reverence the world has. Art, etymologically speaking, means to 'make.' Everybody is making, not only artists, and maybe in coming centuries there will be the making without the noticing [...]" in "I Propose to Strain the Laws of Physic" (interview by F. Roberts), in *Art News*, vol. 67, no. 8, December 1968.

[16] The element of Duchampian liberation "falls" with its recognition and mythification. It was Duchamp himself who said that "the fact that the readymades are regarded with the same reverence as objects of art probably means I have failed to solve the problem of trying to do away entirely with art" (*ibid.*). Indeed, if a "re-reading" of Duchamp allows the intellectuals to take on new expressive modes, that signifies, however, its "death." By discovering its conscious game, the artists, filmmakers, musicians, and dancers provide a cultural deciphering of his desires and this, like all interpretations, is a negation. By not accepting him as he is, they demonstrate a refusal of the annihilation of art in life. They adapt, that is, the cultural trap to emerge from life and return to art, performing what could be called, by paraphrasing Reich, "the murder of Duchamp."

[17] The influence of Duchamp has ramifications in all areas; for the most recent analysis of this problem, see R. Pincus Witten, "Theater of the Conceptual: Autobiography and Myth", in *Artforum*, New York, October 1973, pp. 40-46; J. Tancock, *op. cit.*, pp. 160-168.

[18] J. Cage, *Silence*, Wesleyan University Press, Middletown 1961 (Italian translation by R. Pedio, Feltrinelli, Milan 1970, p. 132). This notion of liberated sound proceeds osmotically with the notion of "action music." The gesture does not merely "accompany" the music; for Cage it is the music itself, as we can see from the exact words of his definition: "It is simply an action the outcome of which is not forseen. It is therefore very useful if one has decided that sounds are to come into their own, rather than being exploited to express sentiments or ideas of order. Among these actions the outcomes of which are not forseen, actions resulting from chance operations are useful. However, more essential than composing by means of chance operations, it seems to me now, is composing in such a way that what one does is indeterminate of its performance. In such a case one can just work directly, for nothing one does gives rise to anything that is preconceived. This necessitates, of course, a rather great change in habits of notation" (J. Cage, *op. cit.*, p. 69).

[19] As he himself puts it, "we are trying to identify life with art." In *John Cage* (edited by R. Kòstelanetz), Praeger Publishers, New York 1970, p. 14.

[20] R. Kòstelanetz (ed.), *John Cage, op. cit.*

[21] *Ibid.*

[22] *Ibid.*

[23] *Ibid.*

[24] We are using this term because of its generalized character, so as to include under it the Happenings and the events of theater, music, and dance.

[25] I take the description of the creation of Cage's work from my own *Musica e danza in USA*, Jabik, Milan 1974, p. 6.

[26] Quoted from D. McDonagh, *op. cit.*, p. 57.

[27] For a chronology and a detailed analysis of these performances, see M. Cunningham, *op. cit.*

[28] In 1943 Marcel Duchamp played a part in a sequence of the unfinished film by Maya Deren, *The Witch Creole*.

[29] A. Leonardi, *op. cit.*, p. 18.

[30] *Ibid.*, pp. 32-37 and 41-58.

[31] J.J. Sweeney, *op. cit.*, p. 146.

[32] Rauschenberg aspired to move osmotically between art and life, or better, "in relation both with art and life. Neither of the two can be held in the hand. I am trying to operate in the vacuum between them." in *The Art of Assemblage*, The Museum of Modern Art, New York 1961, p. 116 (Italian translation by A. Boatto, *op. cit.*).

[33] D. Silvester, *Jasper Johns at the Whitechapel*, BBC Third Programme, London, 12 December 1964.

[34] *Ibid.*

[35] G. Celant, "Musica e danza americana", in *Domus.*, no. 513, Milan, August 1972, pp. 41-43.

[36] M. Kirby, *op. cit.*

[37] A. Kaprow, *op. cit.*, pp. 188-198.

[38] The dialectic action between the action and the object is present in many *Combine Paintings* by Rauschenberg and Dine, in particular those in which the participation of the public is involved, encouraged to sit on chairs and open doors that form part of their assemblage. A similar situation is present for many works by Brecht and Maciunas; the postal works in particular are exemplary.

[39] J. Rosenquist, Whitney Museum of American Art, New York 1972.

[40] T. Kerns (ed.), *Conversation with Jim Dine*, in *Jim Dine, Prints 1970-1977*, Harper & Row, New York 1977.

[41] E. Morin, *L'Esprit du temps*, Grasset, Paris 1962.

[42] A. Warhol, *The Philosophy of Andy Warhol*, New York 1976.

[43] *Ibid.*

[44] C. Oldenburg, The Museum of Modern Art, New York 1969.

[45] C. Oldenburg, *Mouse Museum—Ray Gun Wing*, Museum of Contemporary Art, Chicago 1978.

[46] B. Lamblin, "Vanitas, la symbolique de l'object", in *Pour l'objet*, no. 3–4, Paris 1979.

[47] For a complete analysis of the processes of avoidance of death, see W. Fuchs, *Le immagini della morte nella società moderna*, Italian translation by G. Dore, Einaudi, Turin 1973 (original edition Frankfurt 1969).

[48] The literature on the subject is limited; a few references to Pop mysticism can be found in B. Rose, *American Art Since 1900*, Praeger, New York 1967.

[49] J. Dine, Whitney Museum of American Art, New York 1970.

[50] B. Rose, *Claes Oldenburg*, The Museum of Modern Art, New York, September 1969.

[51] *Ibid.*

[52] Concerning the principle of the "cut" as a mortal inscription, one fundamental work is J. Baudrillard, *L'échange symbolique et la mort*, Gallimard, Paris 1975 (Italian translation by G. Mancuso, Feltrinelli, Milan 1979).

[53] M. Tucker, *James Rosenquist*, Whitney Museum of American Art, New York 1972; R. Crone, *Andy Warhol*, Hatje, Stuttgart 1970 (Italian translation by C.B. Ceppi, Mazzotta, Milan 1972) and C. Oldenburg, *Proposal for Monuments and Buildings 1965–69*, Big Table, Chicago 1969.

Louise Bourgeois
Willem de Kooning
Helen Frankenthaler
Arshile Gorky
Adolph Gottlieb
Philip Guston
Hans Hofmann
Franz Kline
Lee Krasner
Morris Louis
Joan Mitchell
Robert Motherwell
Barnett Newman
Jackson Pollock
Richard Pousette-Dart
Ad Reinhardt
Mark Rothko
David Smith
Clyfford Still

Photography

Cinema

Architecture

Jasper Johns
Louise Nevelson
Nam June Paik
Robert Rauschenberg
Cy Twombly

Photography

Architecture

Performance and Video

Cinema

Richard Artschwager
John Chamberlain
Jim Dine
Red Grooms
Roy Lichtenstein
Claes Oldenburg Coosje van Bruggen
James Rosenquist
George Segal
Andy Warhol
Tom Wesselman

Louise Bourgeois

*1. *Quarantania*, 1947-1953

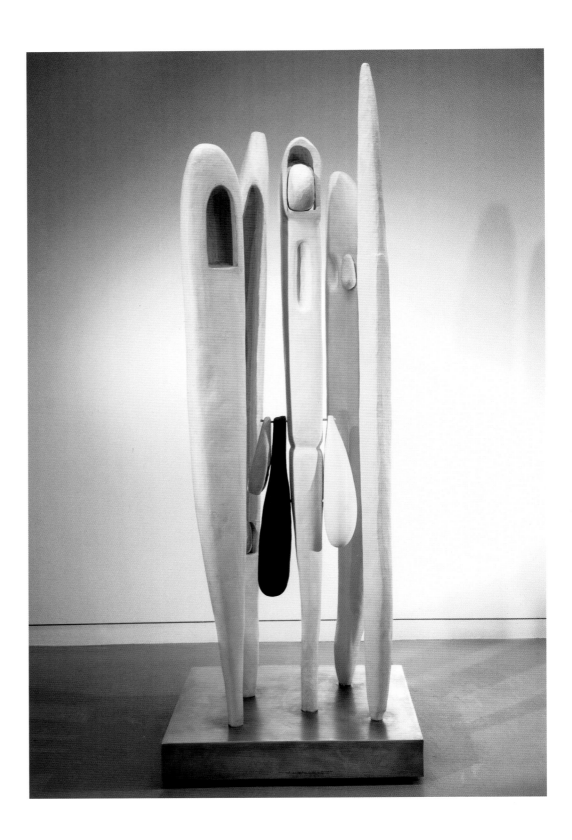

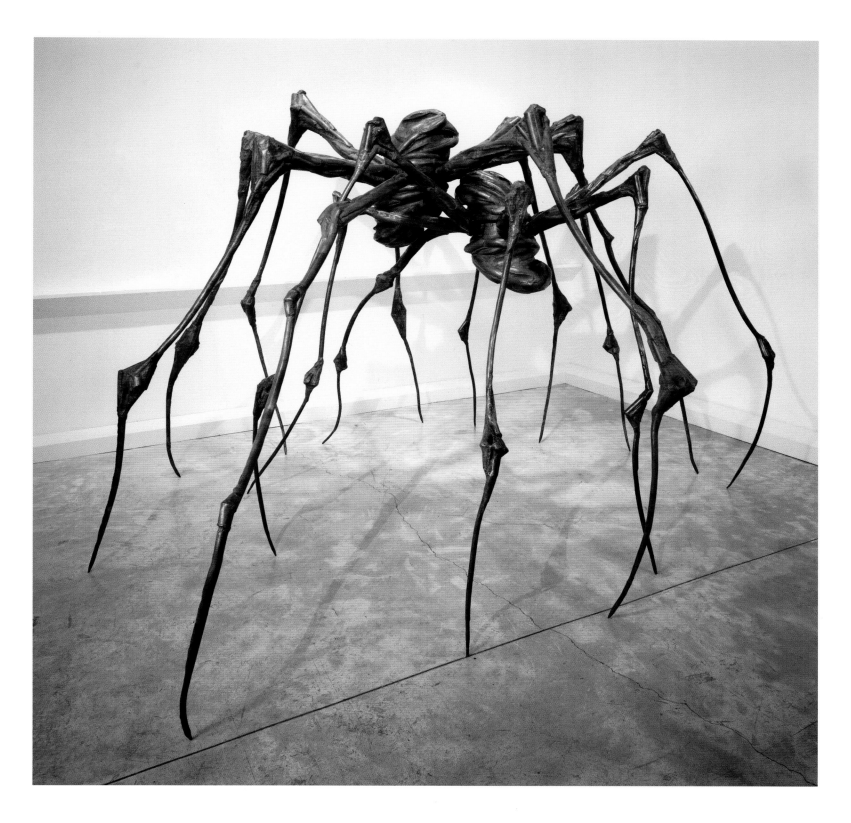

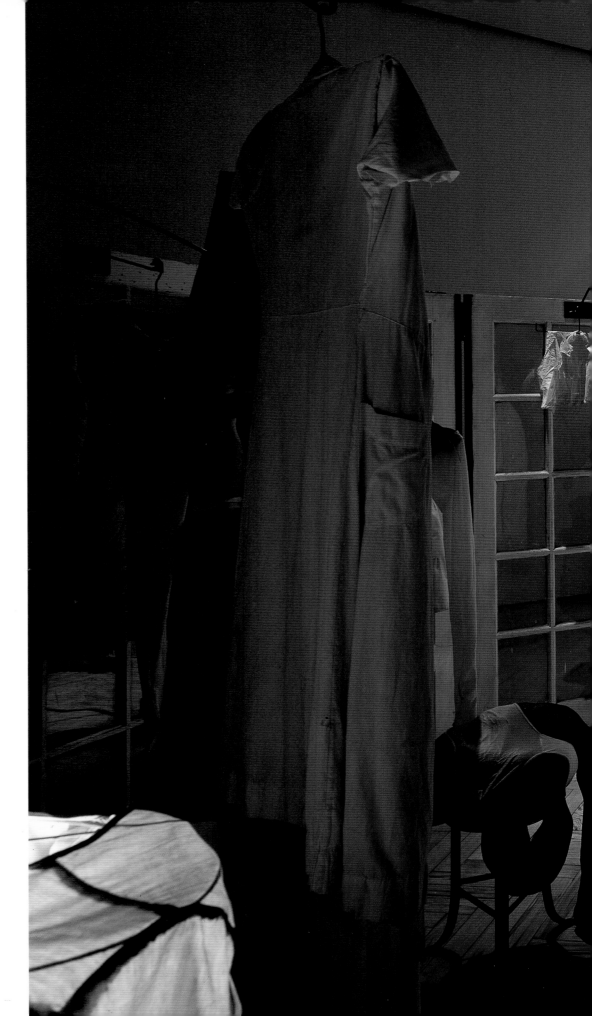

3. *Cell (Clothes)*, 1996

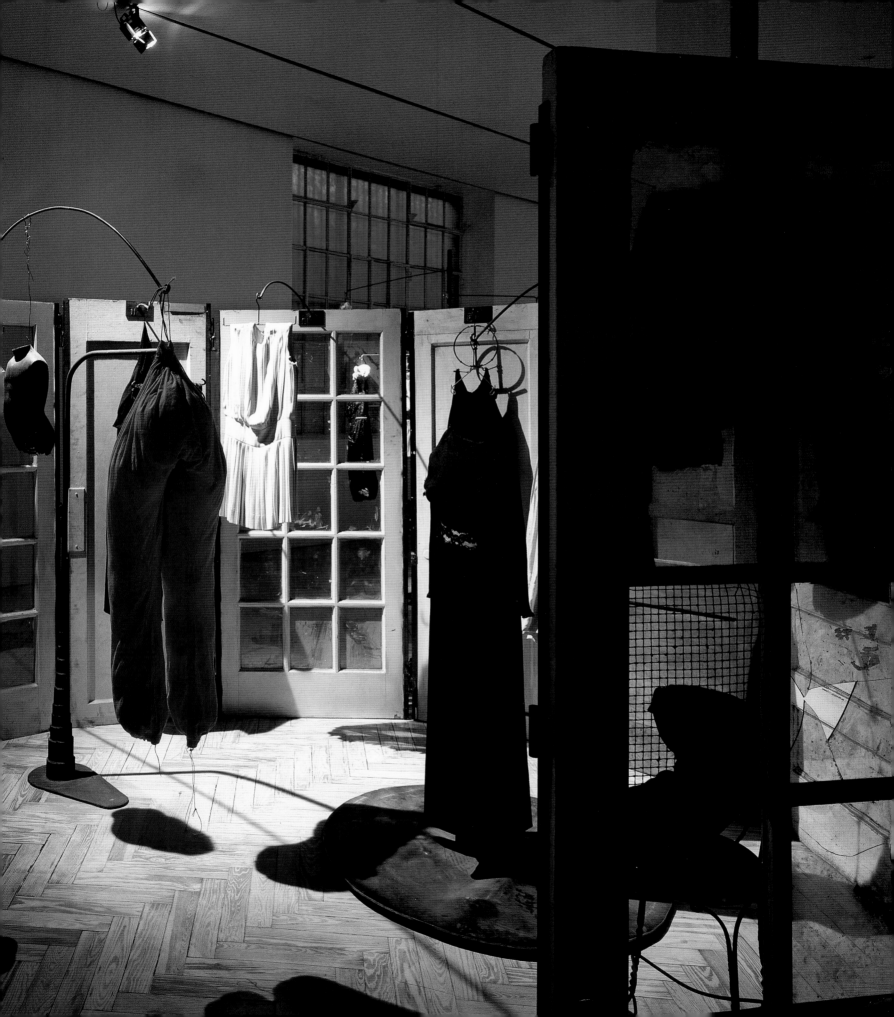

Willem de Kooning

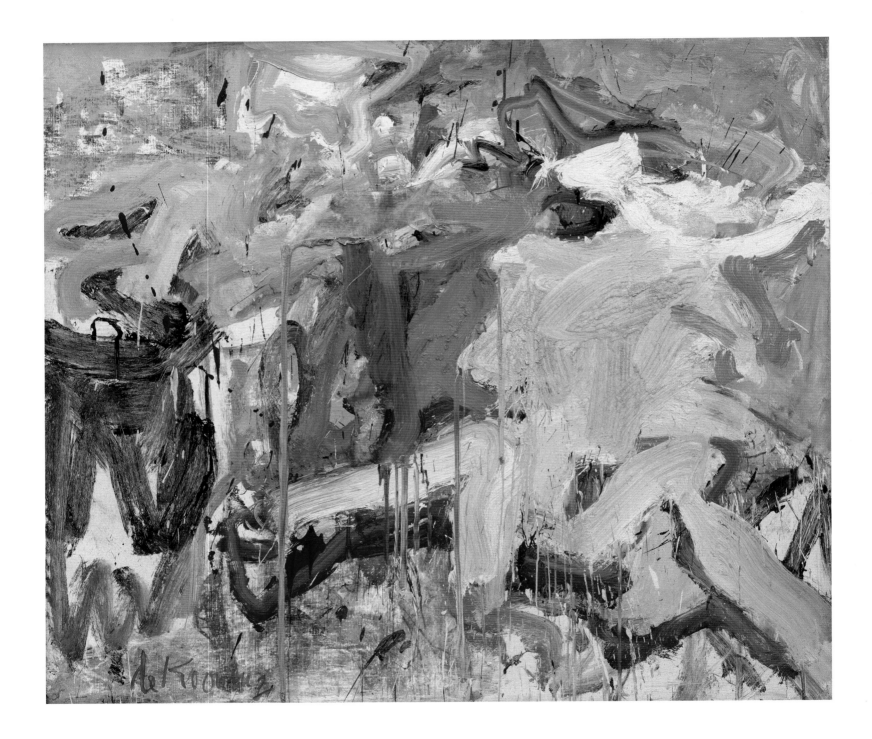

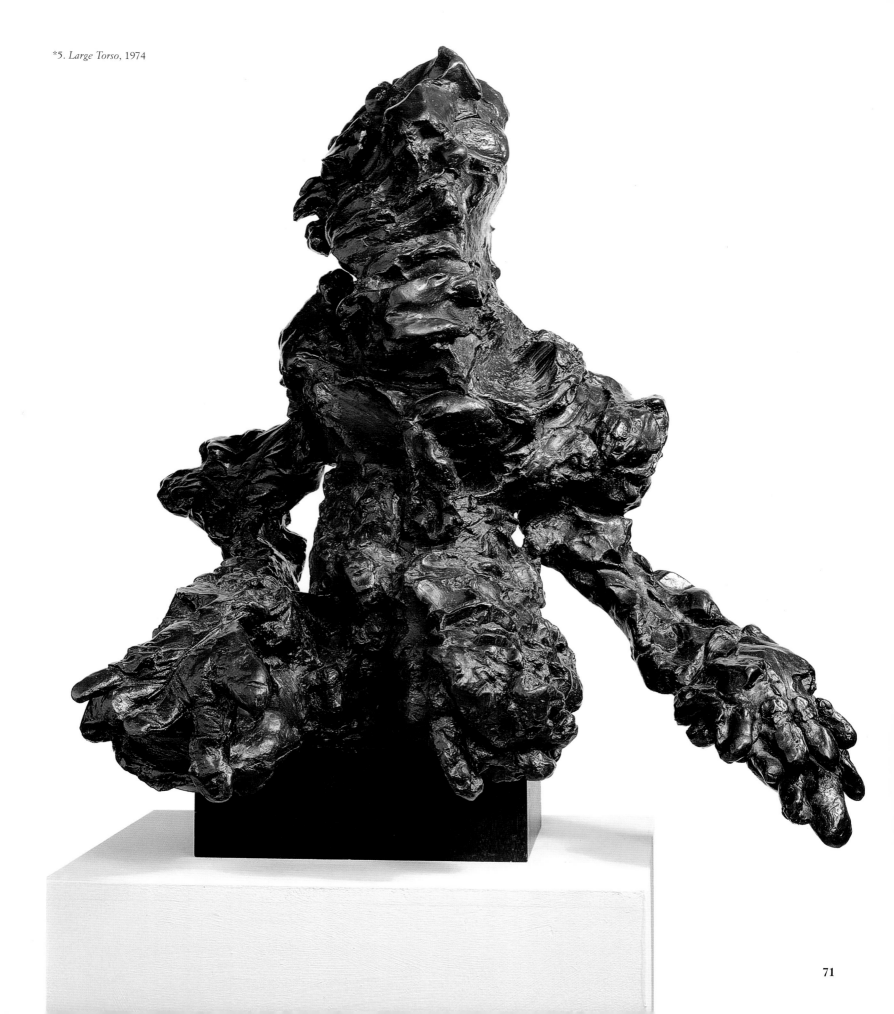

*6. *Untitled*, 1971

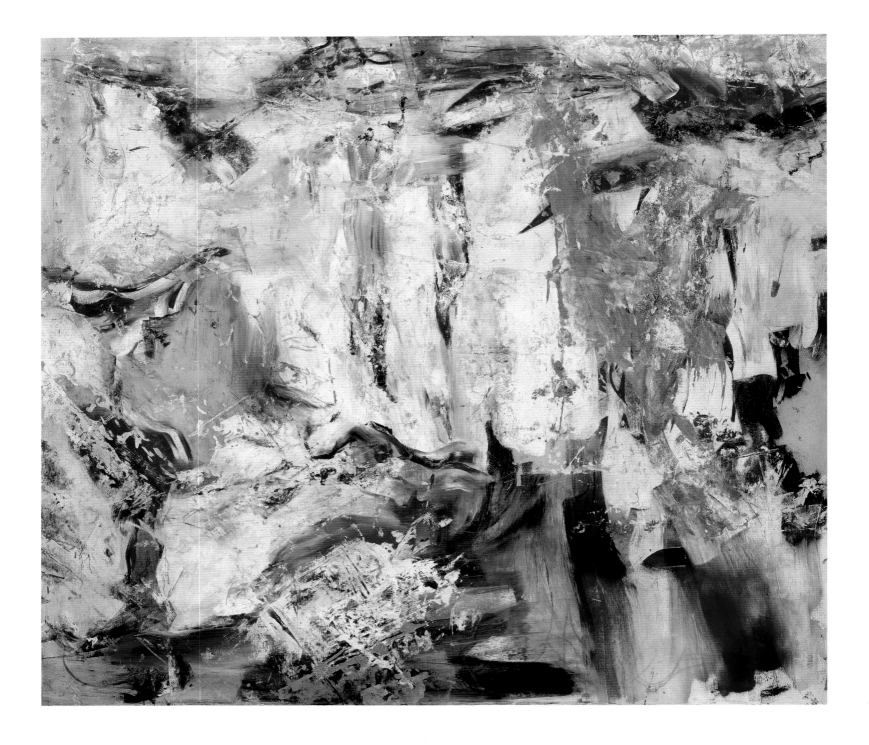

Willem de Kooning

Helen Frankenthaler

*8. *Walnut Hedge*, 1971

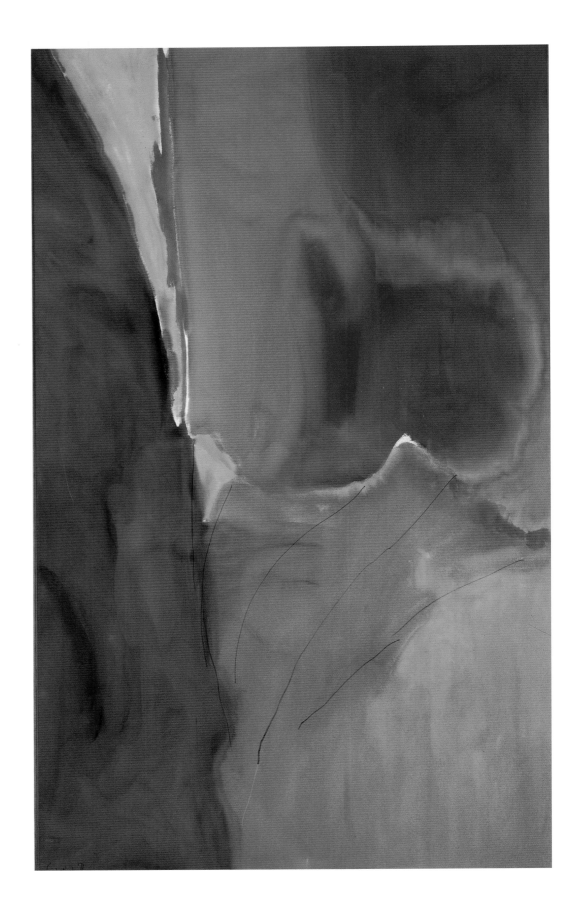

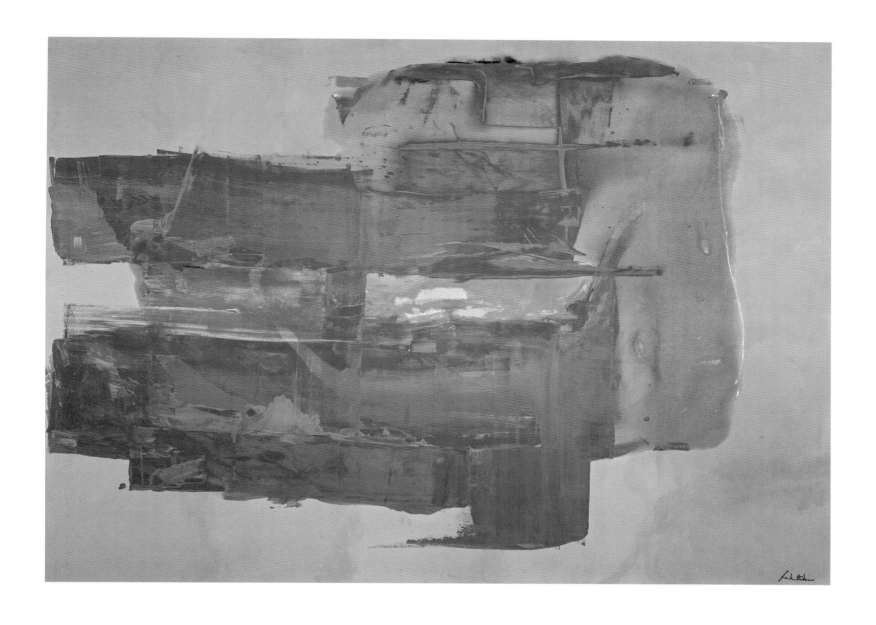

Helen Frankenthaler

Arshile Gorky

10. *Waterfall*, 1943

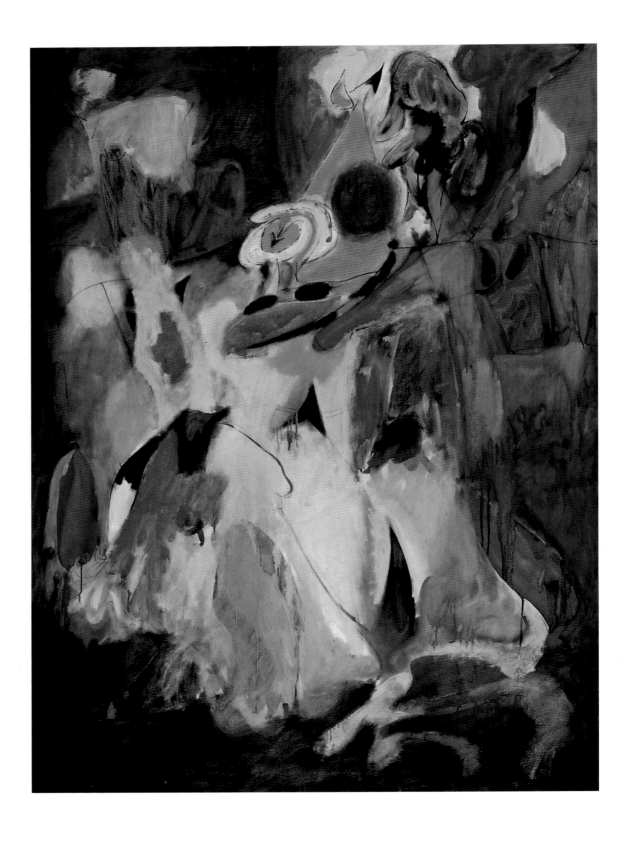

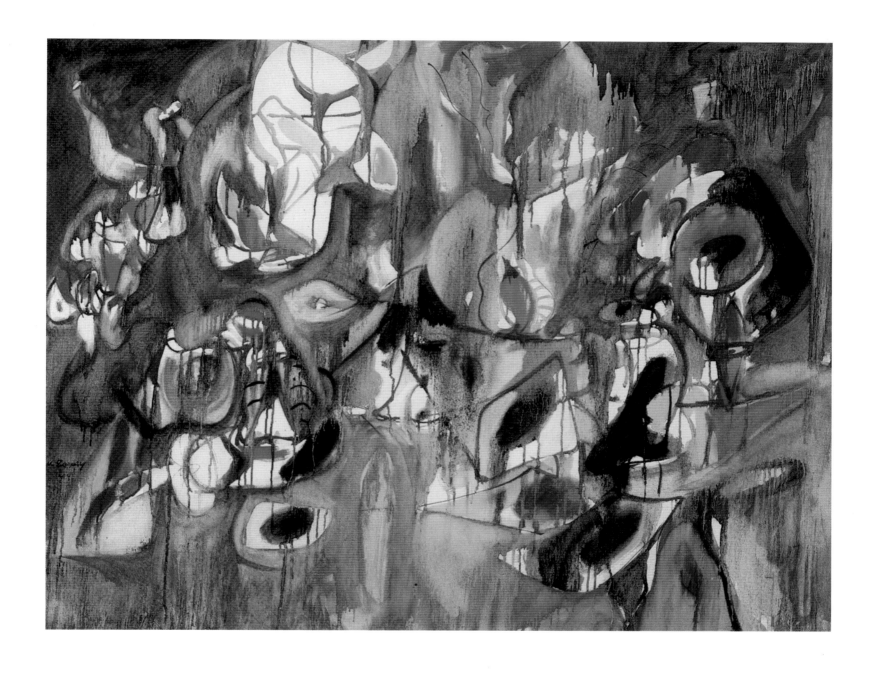

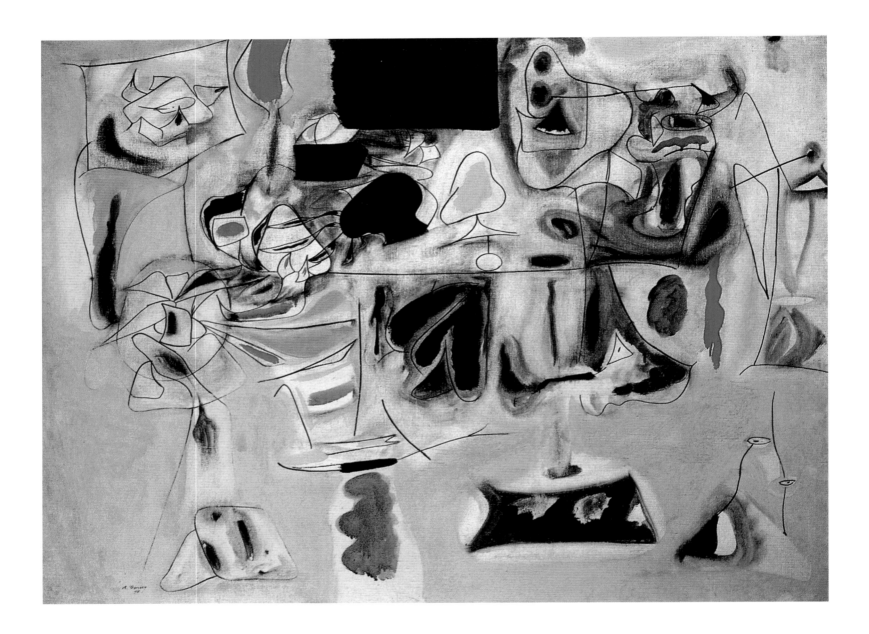

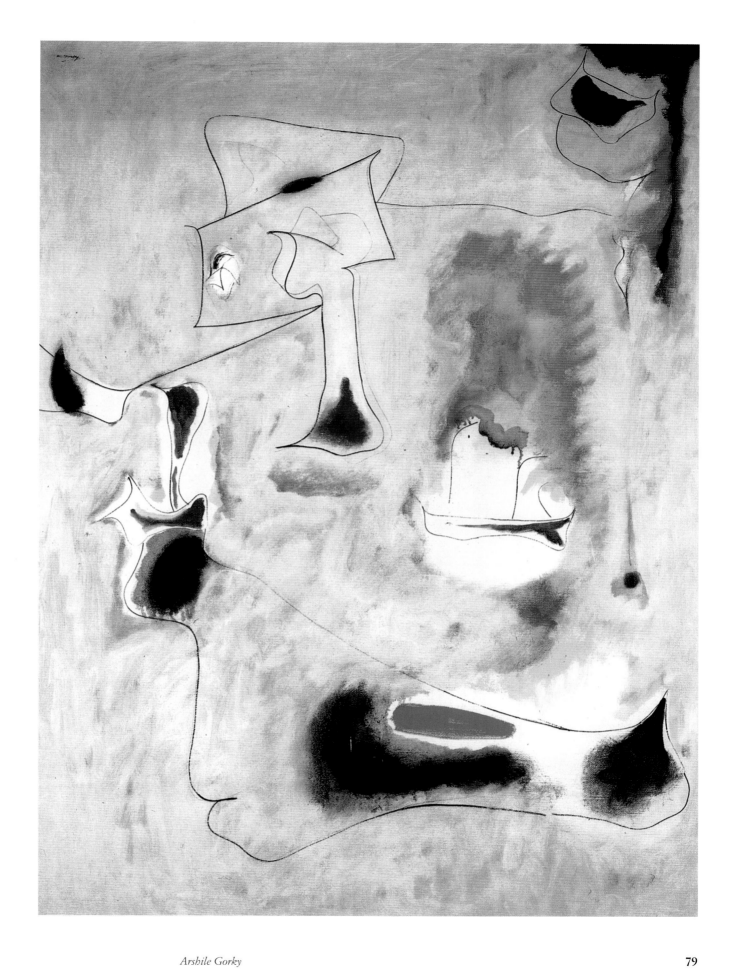

Arshile Gorky

Adolph Gottlieb

14. *Pictograph*, 1944

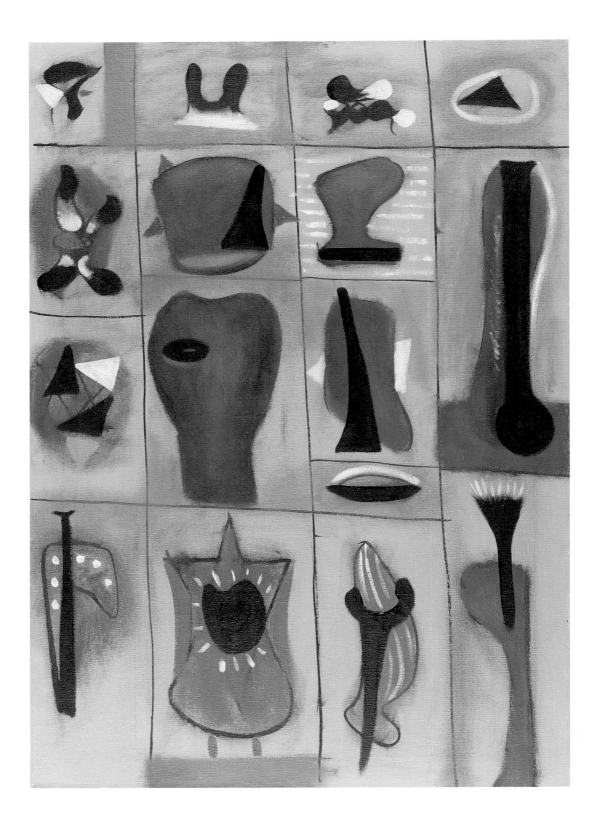

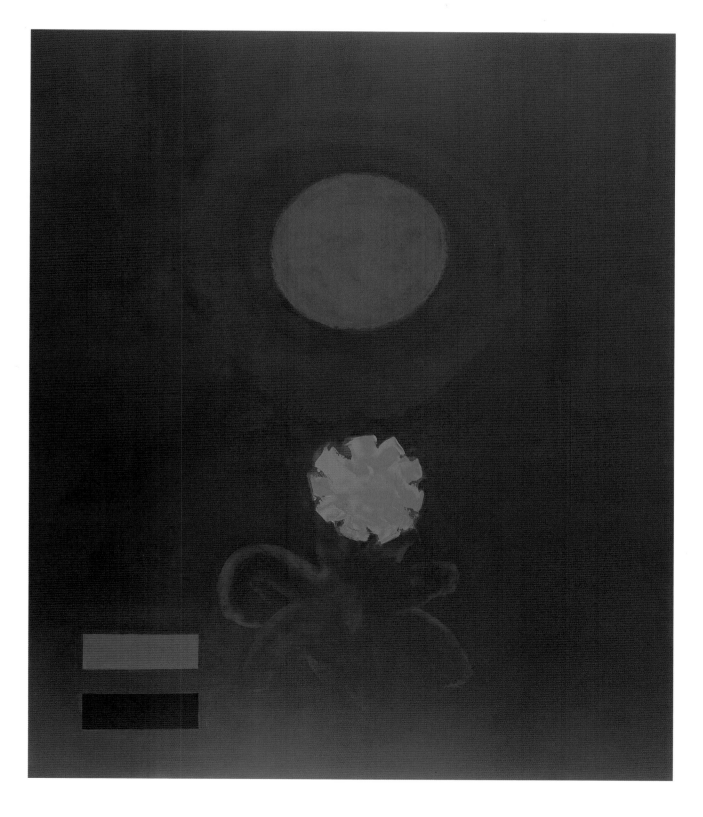

Adolph Gottlieb

Philip Guston

*16. *Traveller II*, 1960

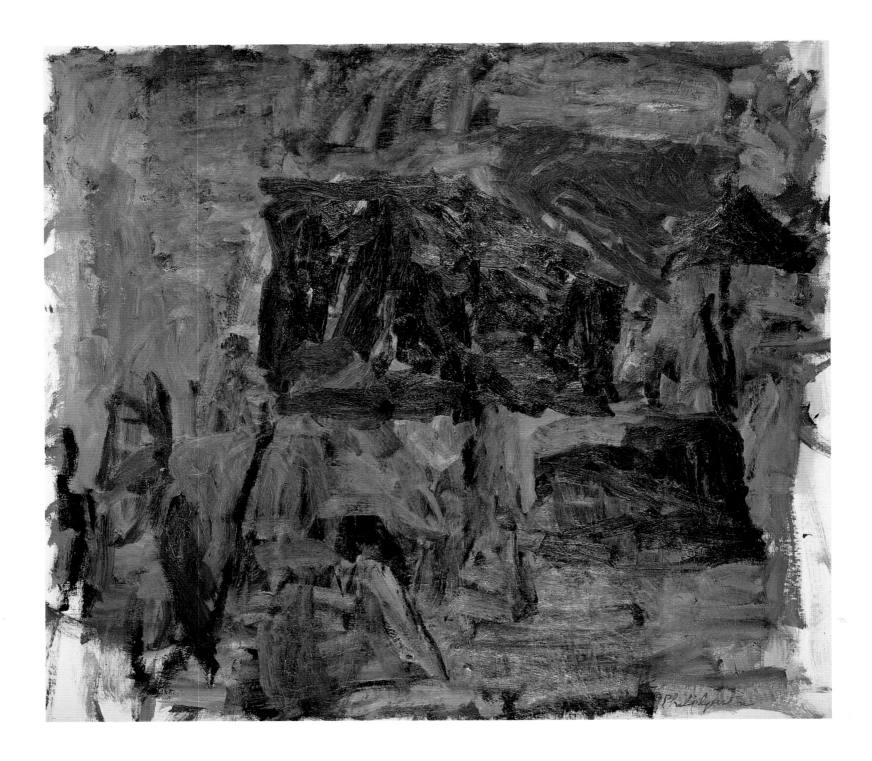

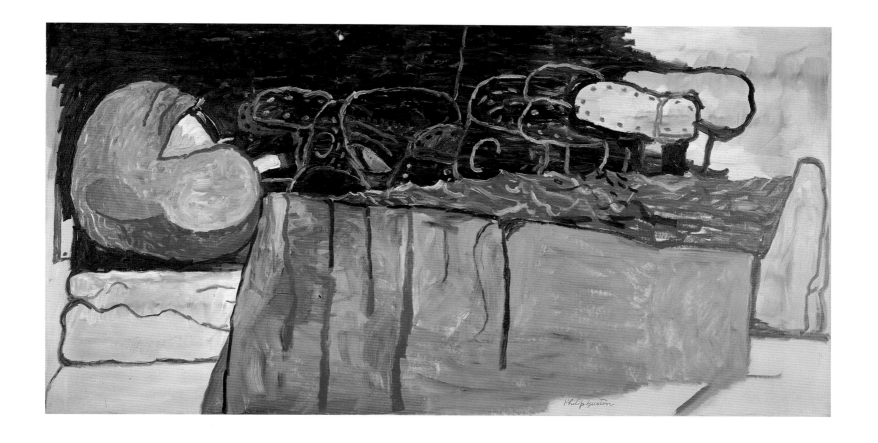

Hans Hofmann

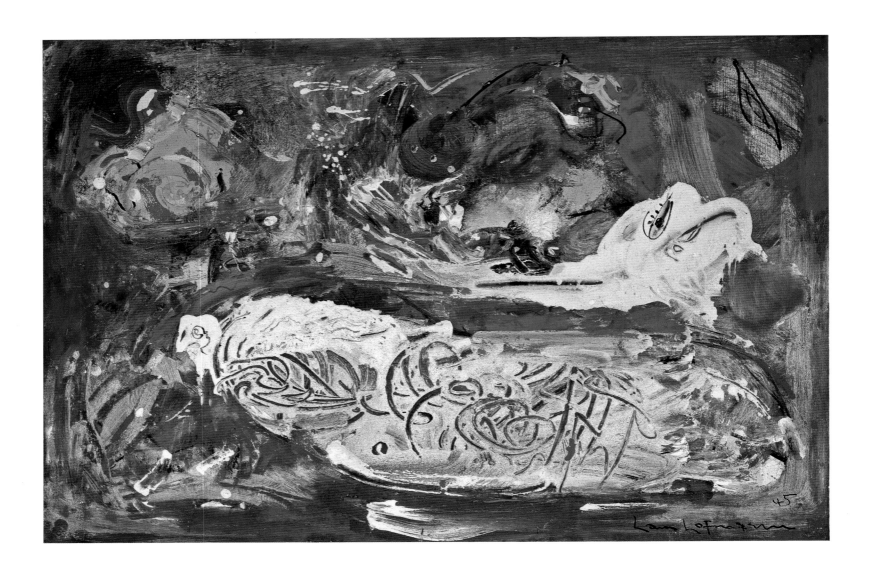

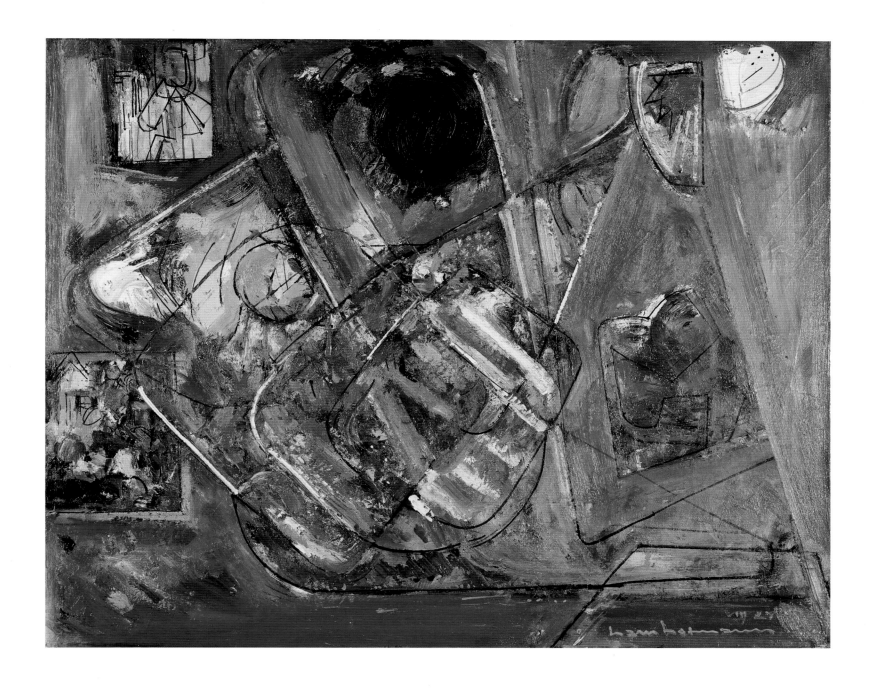

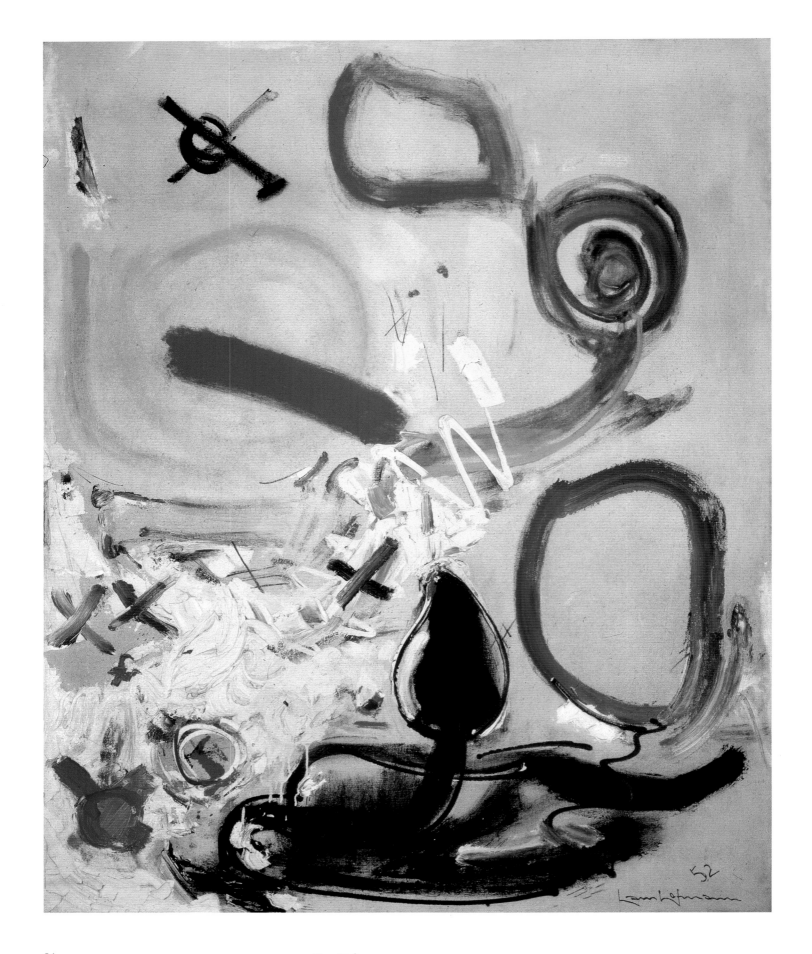

Hans Hofmann

20. *Jubilant*, 1952

*21. *Homage to the White*, 1956

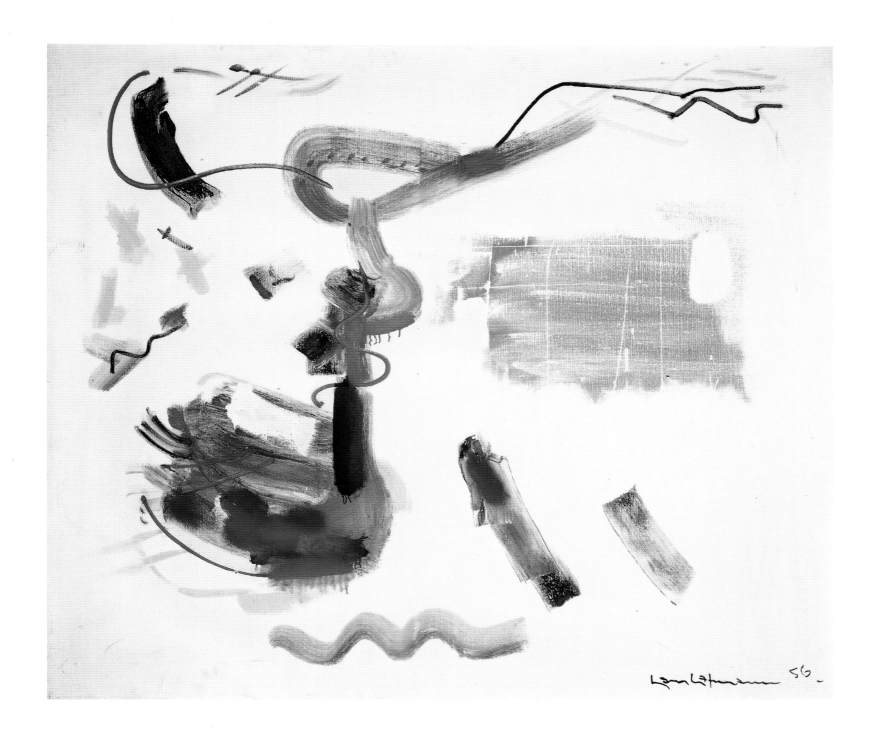

Hans Hofmann

Franz Kline

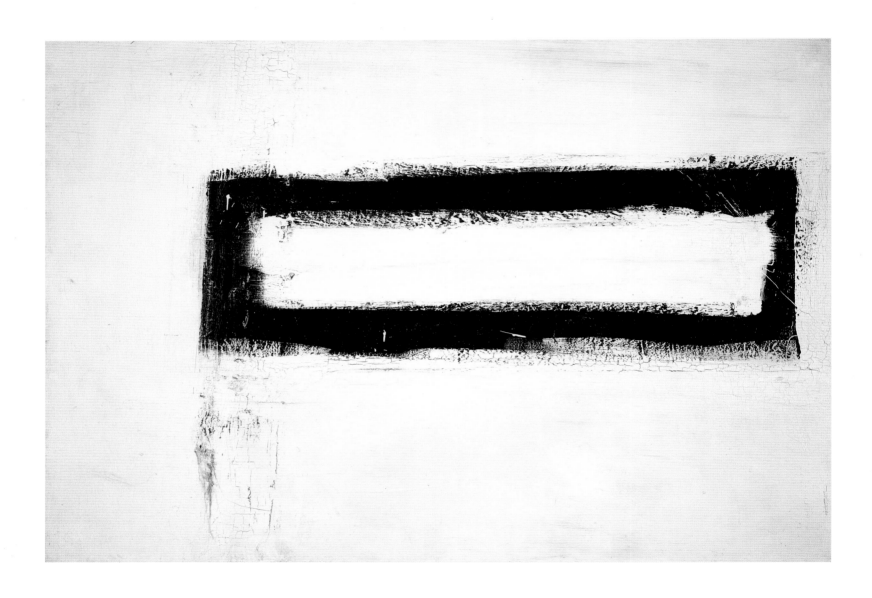

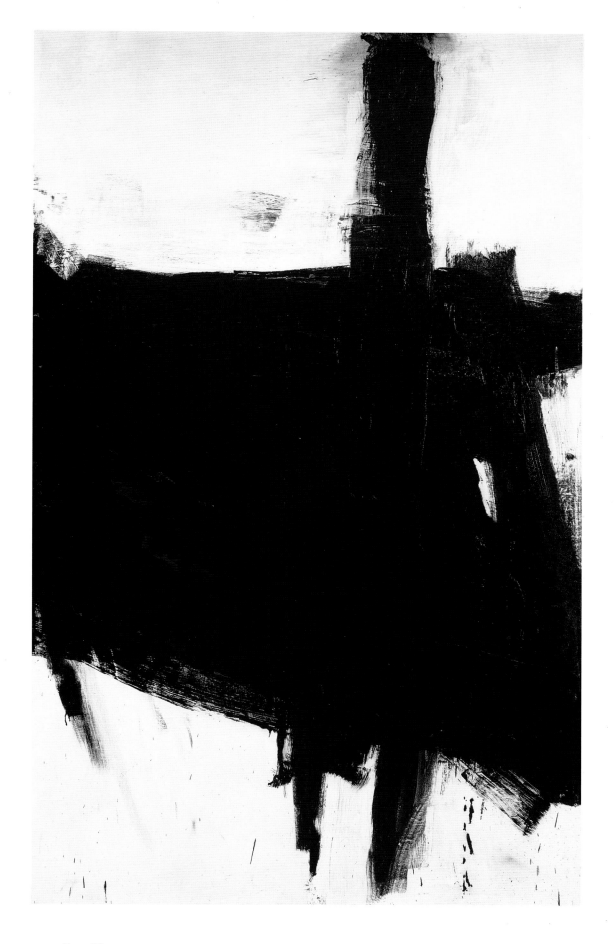

Franz Kline

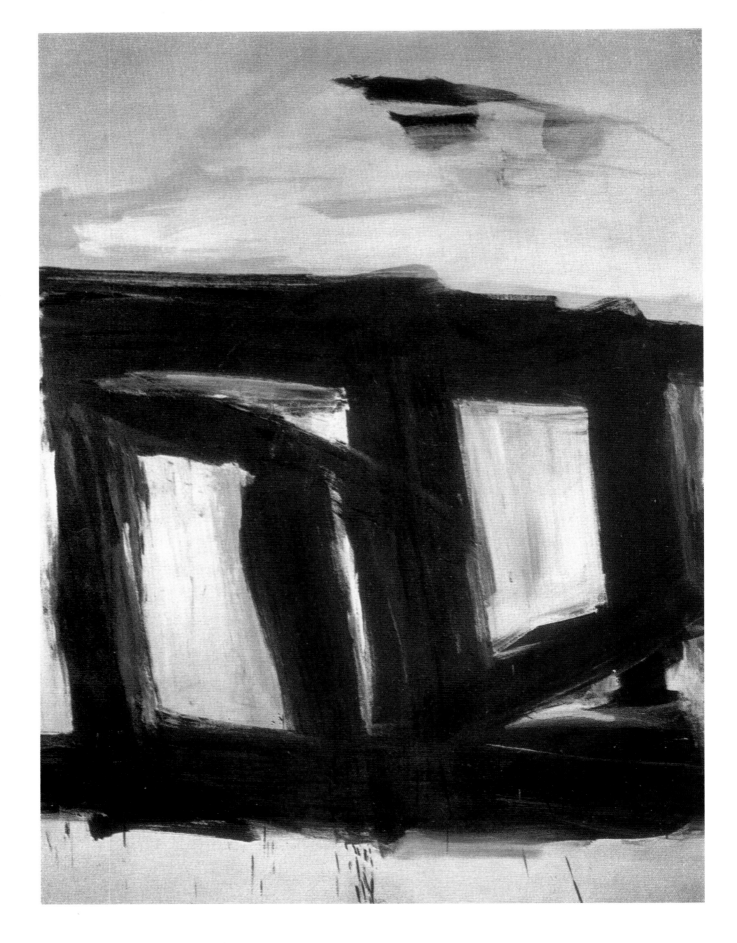

Franz Kline

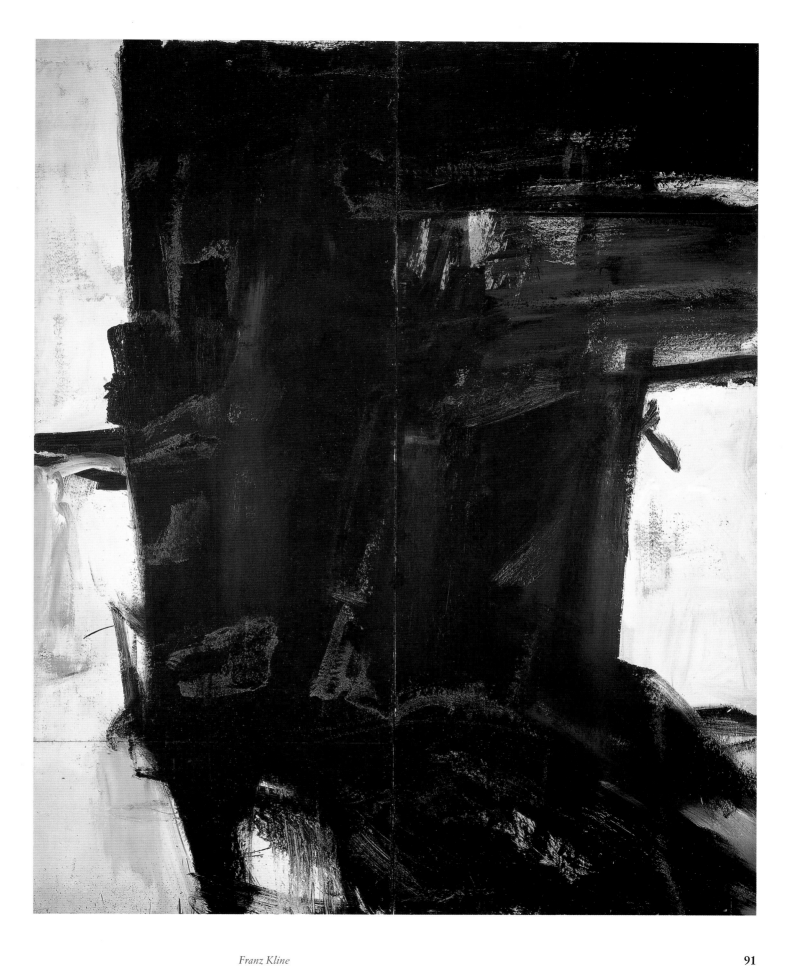

Franz Kline

Lee Krasner

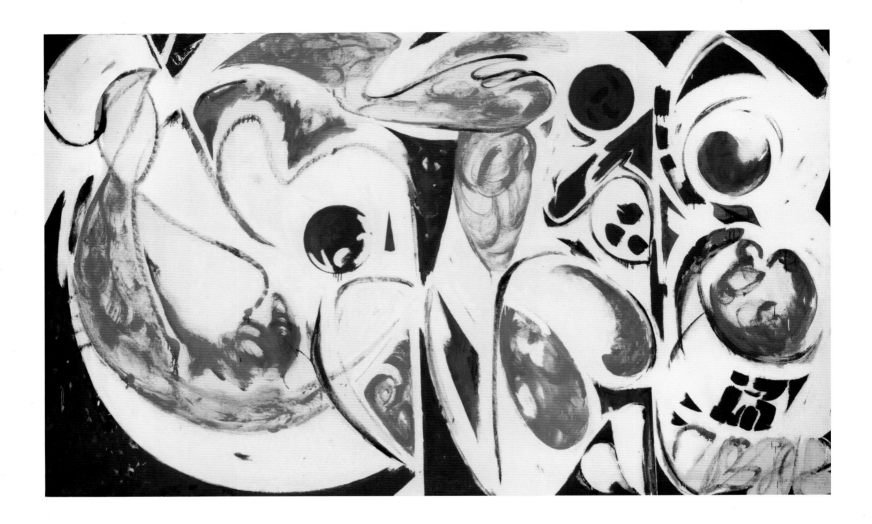

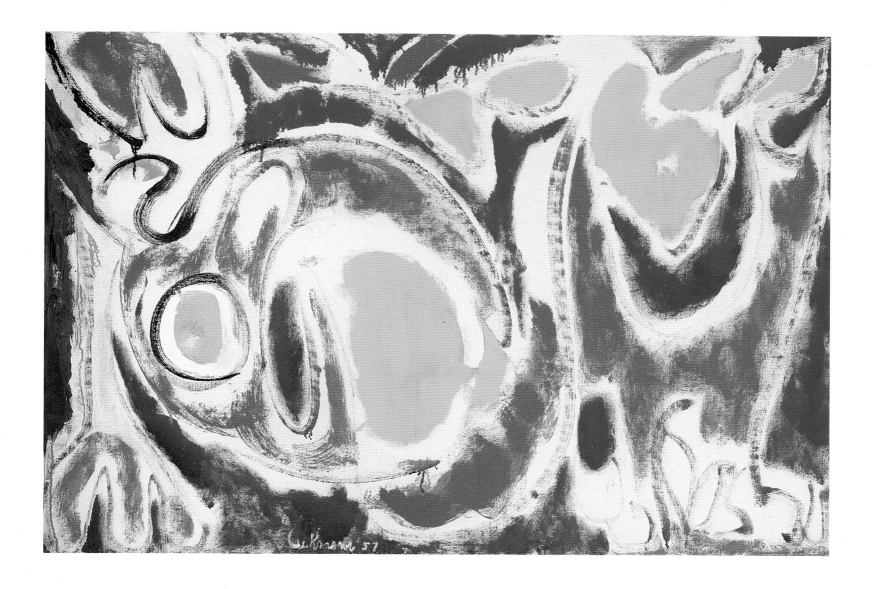

Morris Louis

28. *Burning Stain*, 1961

Joan Mitchell

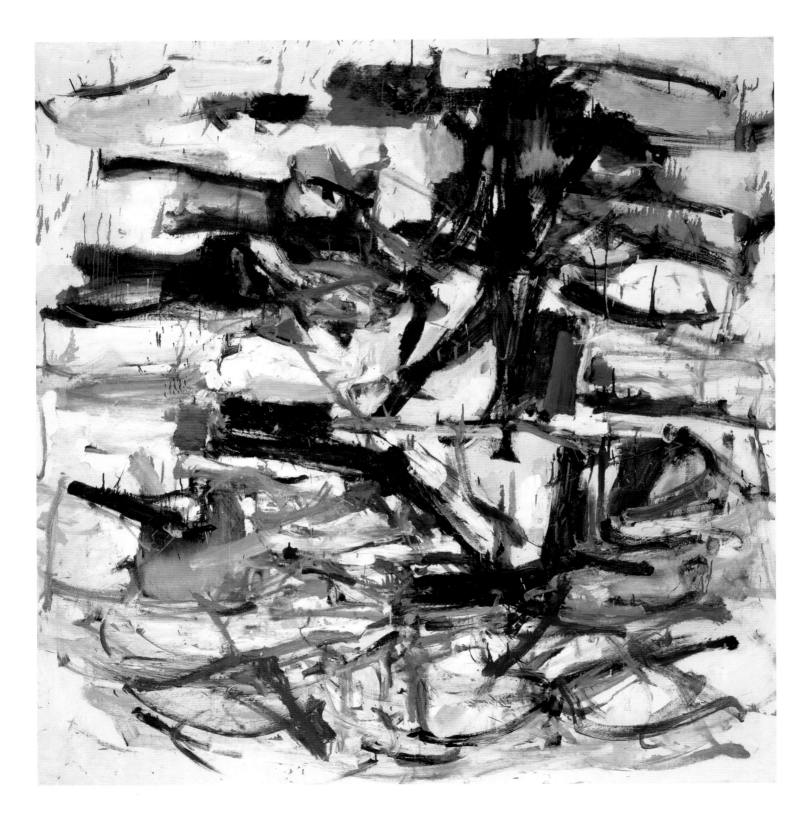

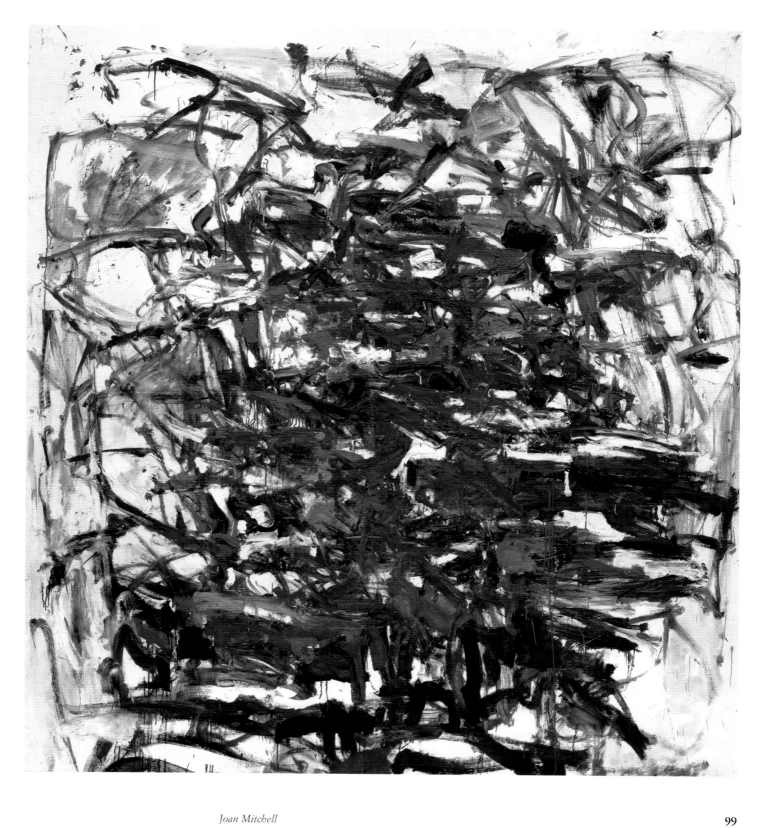

Joan Mitchell

*34. *Wall Painting n. III, 1953*

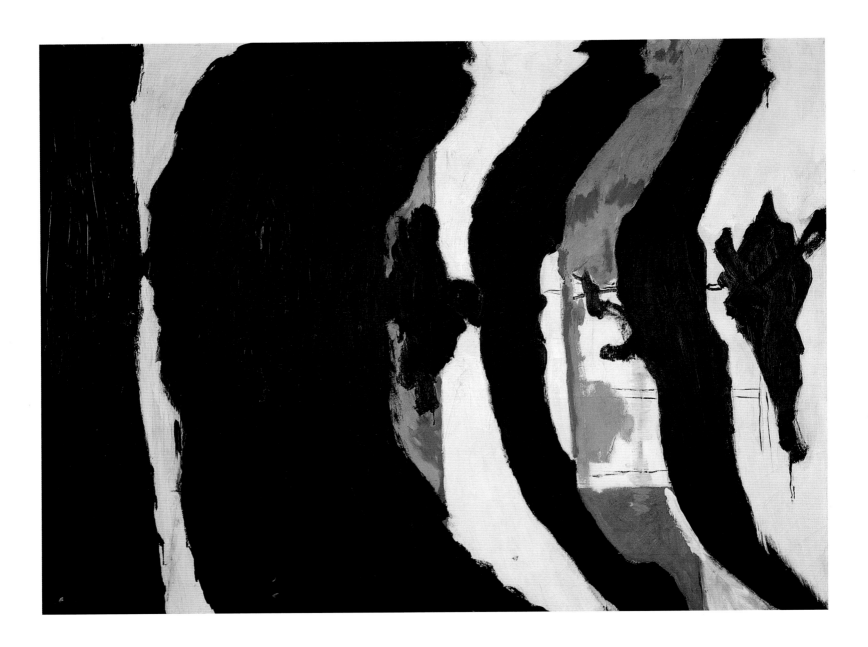

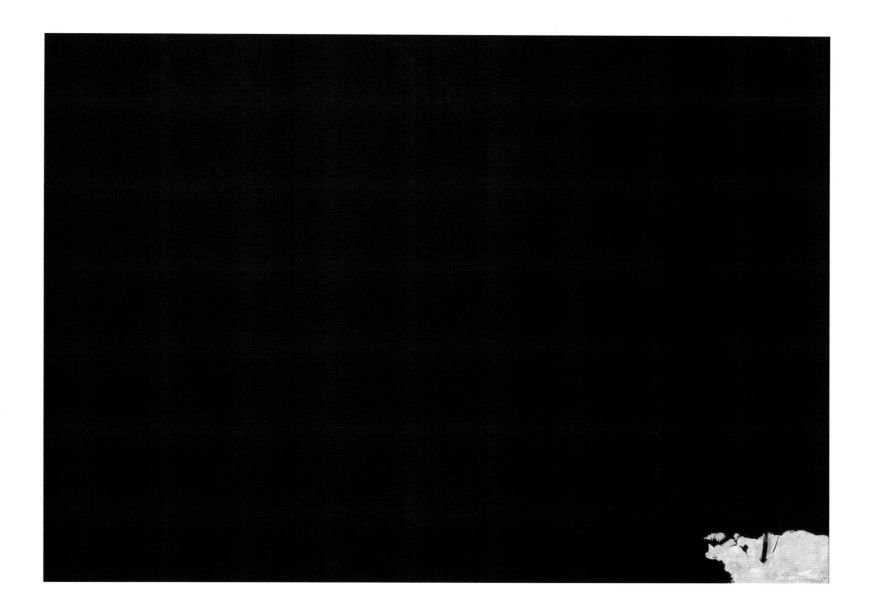

Robert Motherwell

36. *Uriel*, 1955 37. *Dionysius*, 1949

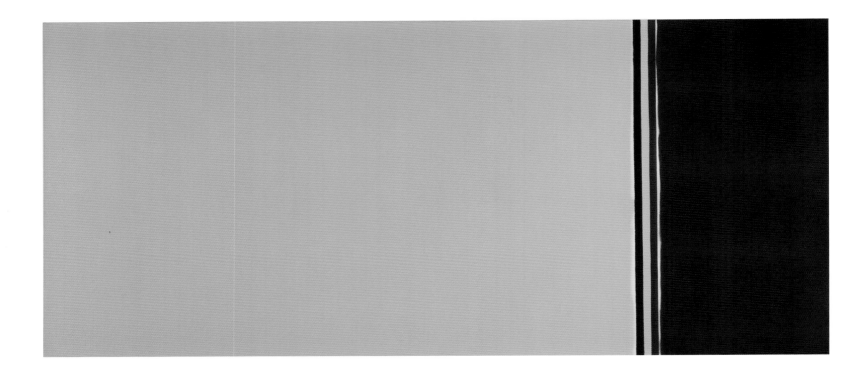

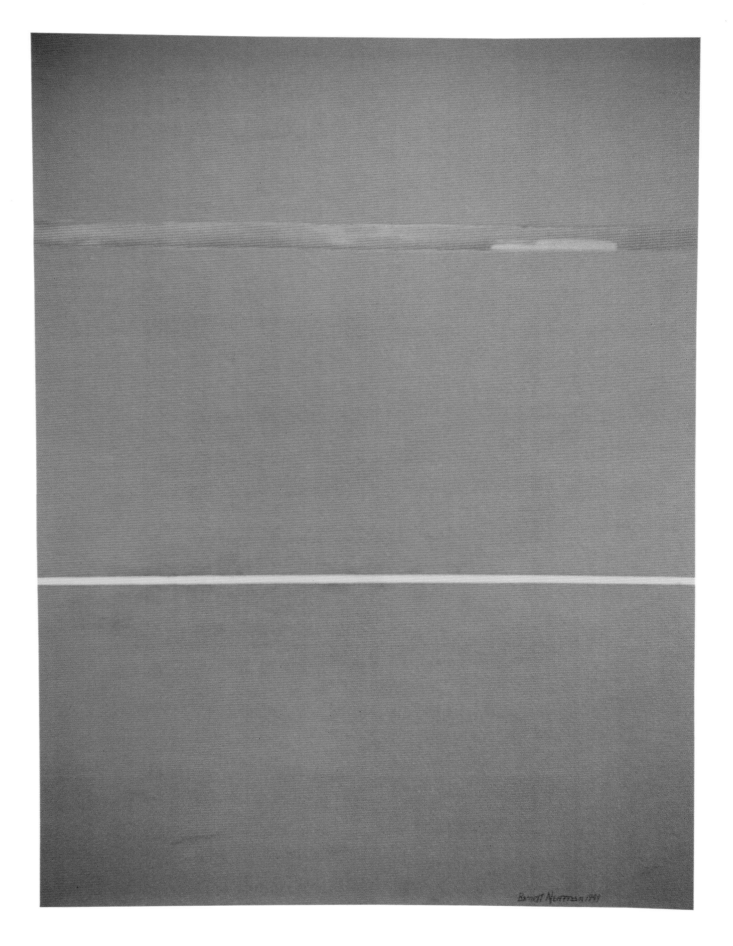

Barnett Newman

Barnett Newman

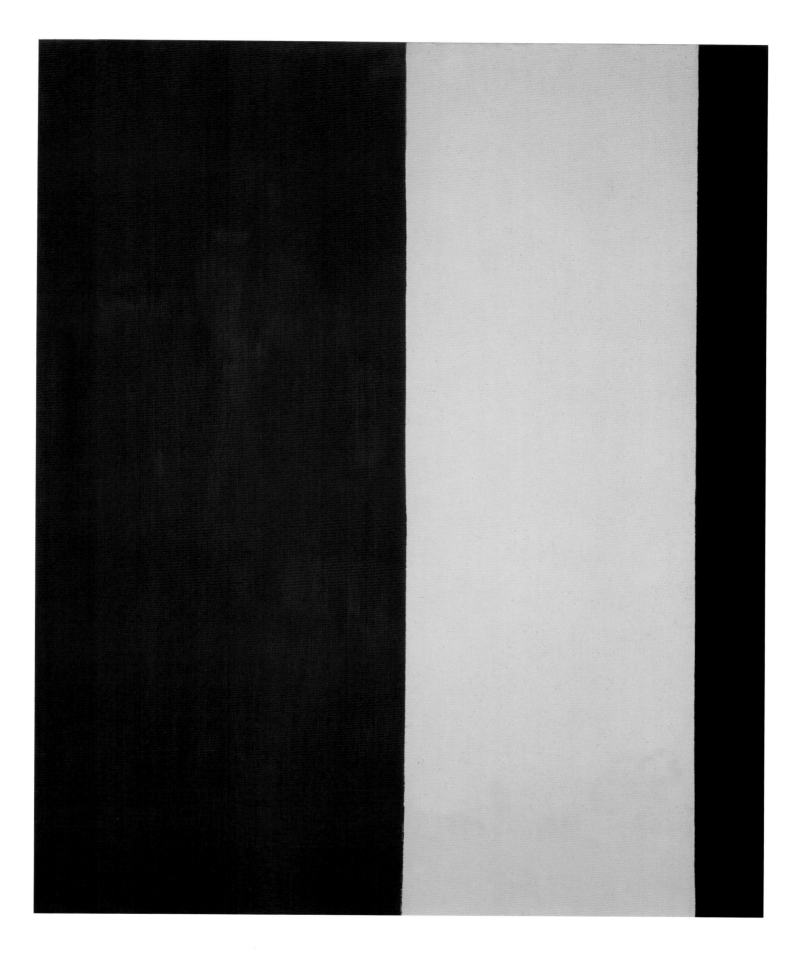

Jackson Pollock

*40. *Square Composition with Horse*, 1937

41. *The Tea Cup*, 1946

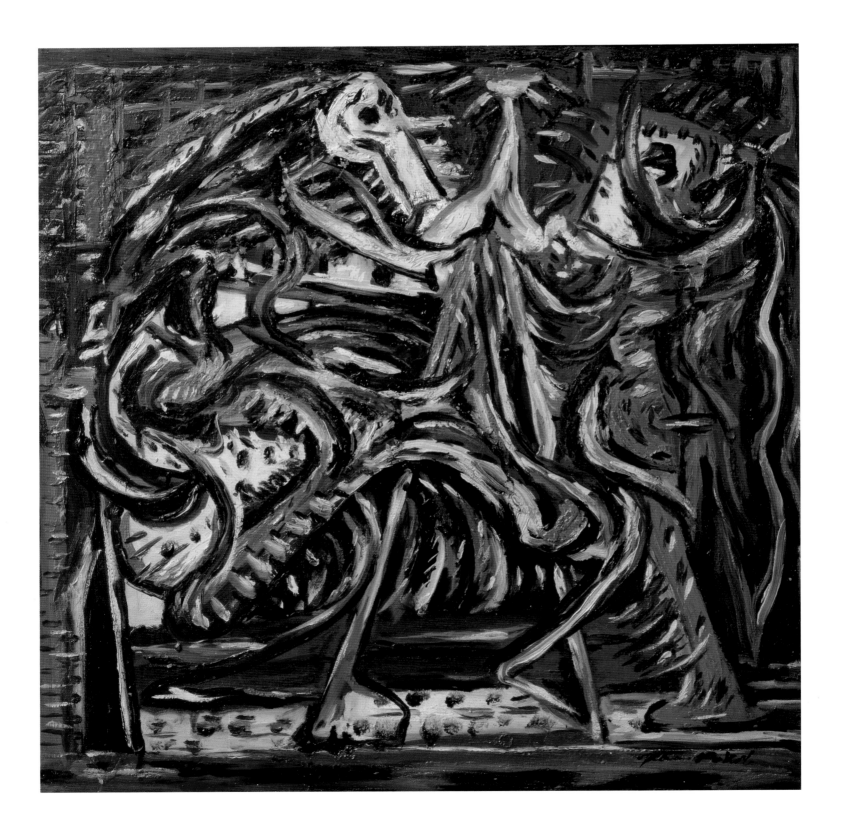

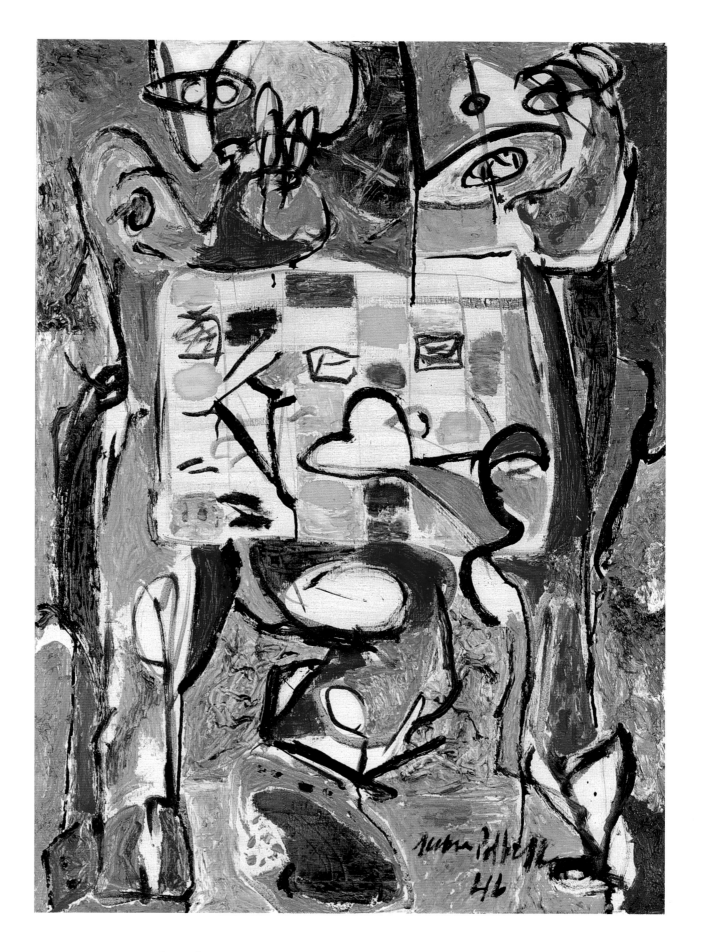

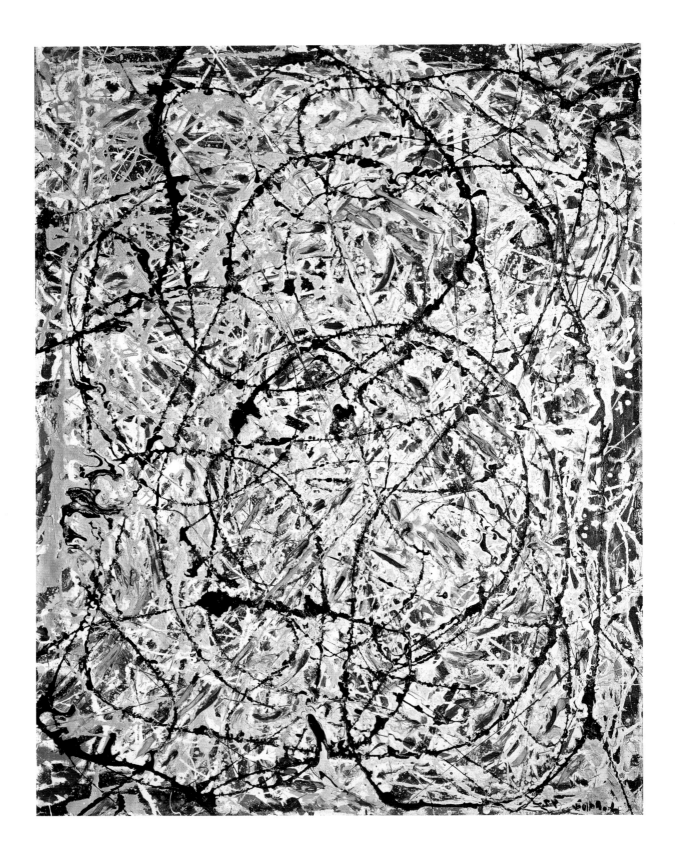

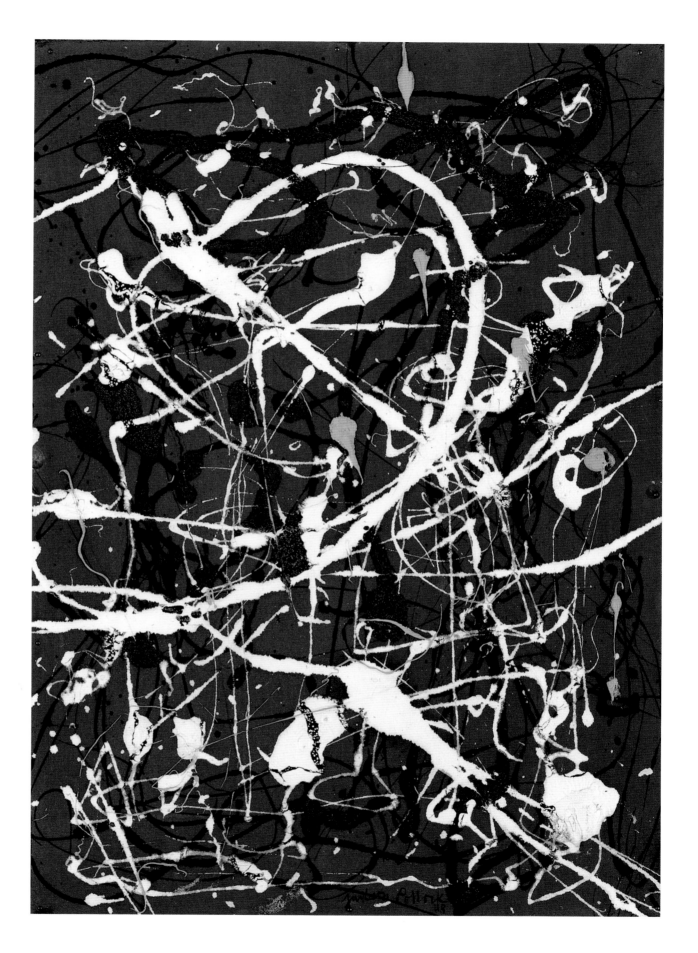

Jackson Pollock

Richard Pousette-Dart

44. *Presence #10*, 1949

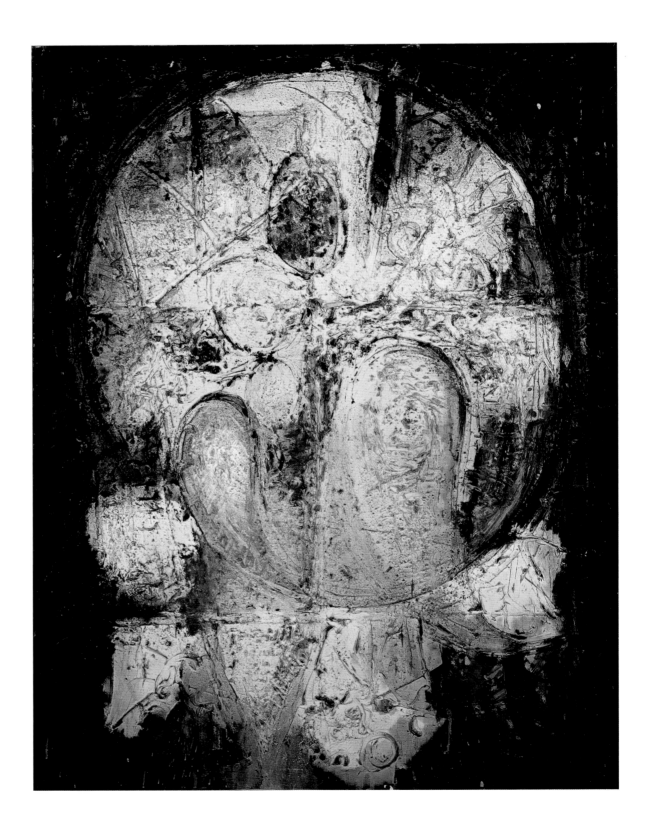

*45. *Hieroglyph (White Garden),*
1971

Ad Reinhardt

*46. *Untitled*, 1952

*47. *Abstract Painting*, 1956

Ad Reinhardt

Mark Rothko

*48. *Untitled*, 1959*

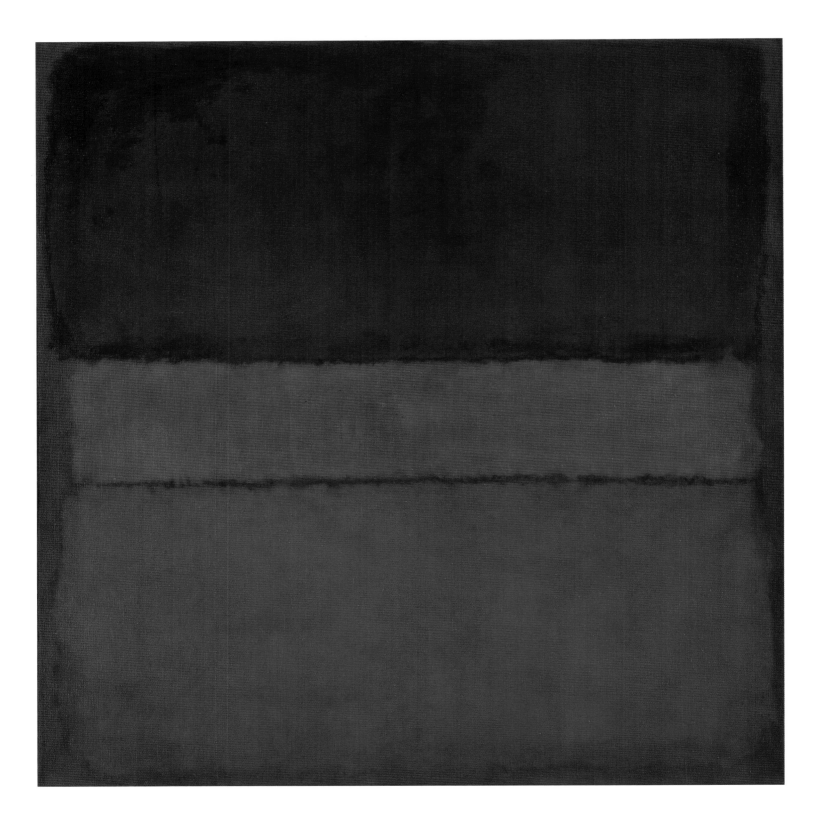

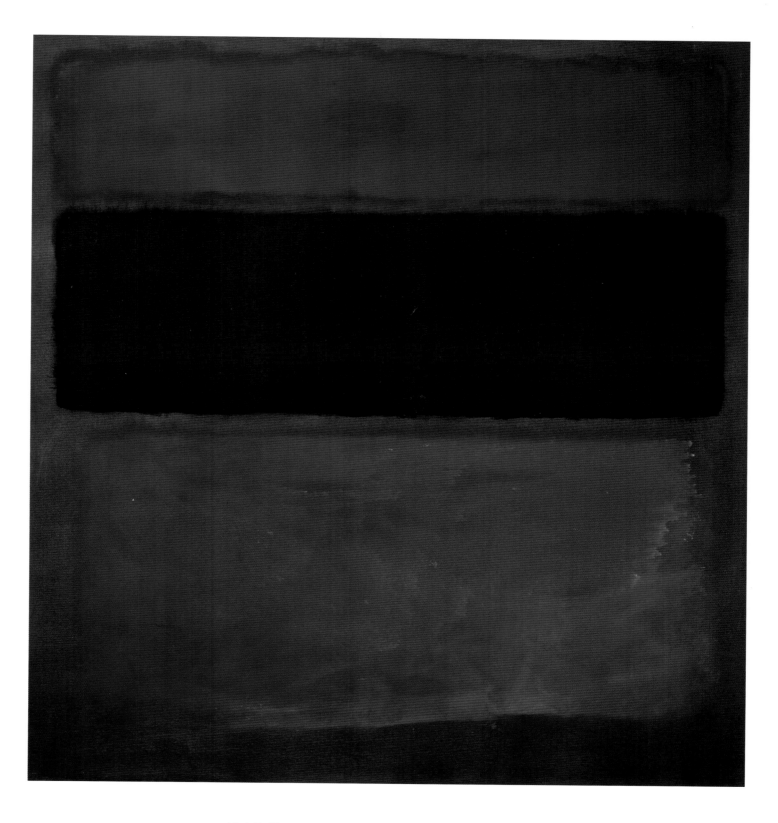

Mark Rothko

David Smith

*50. *Construction on Star Points*,
1954-1956

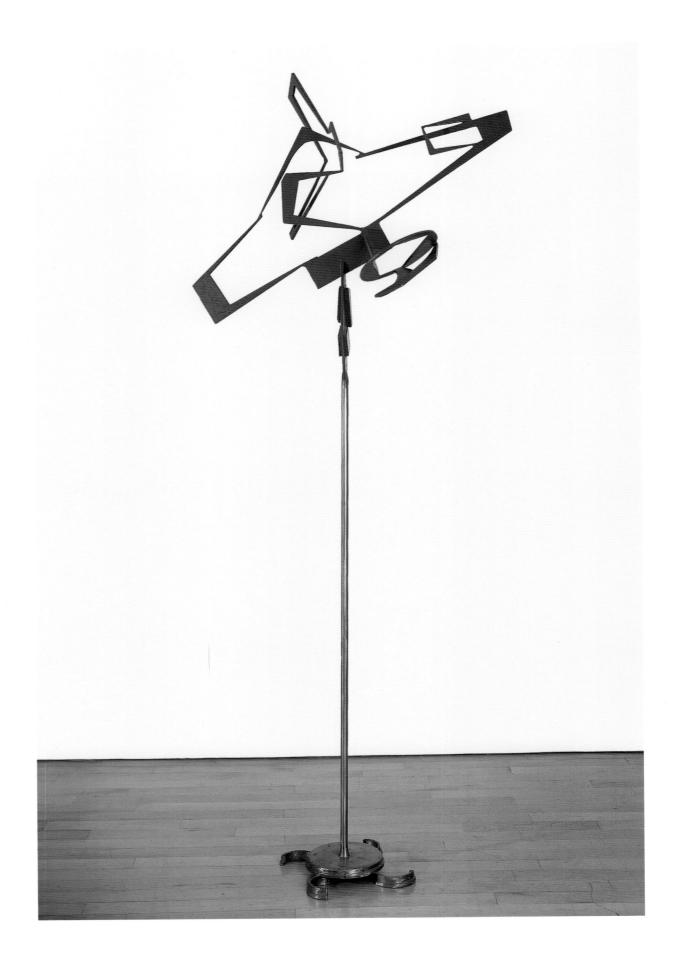

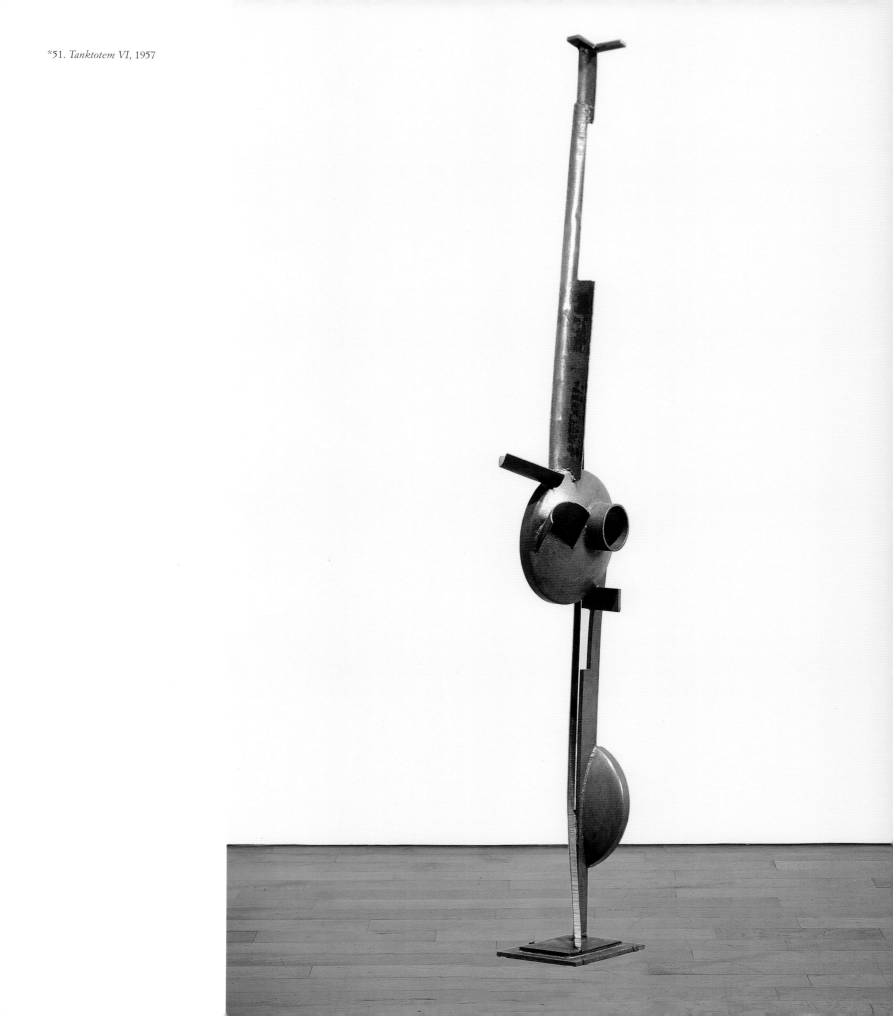

*51. *Tanktotem VI*, 1957

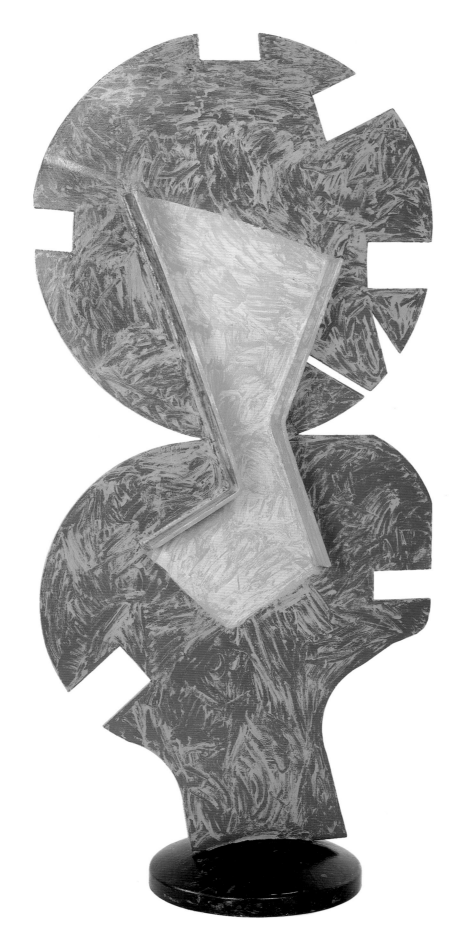

David Smith

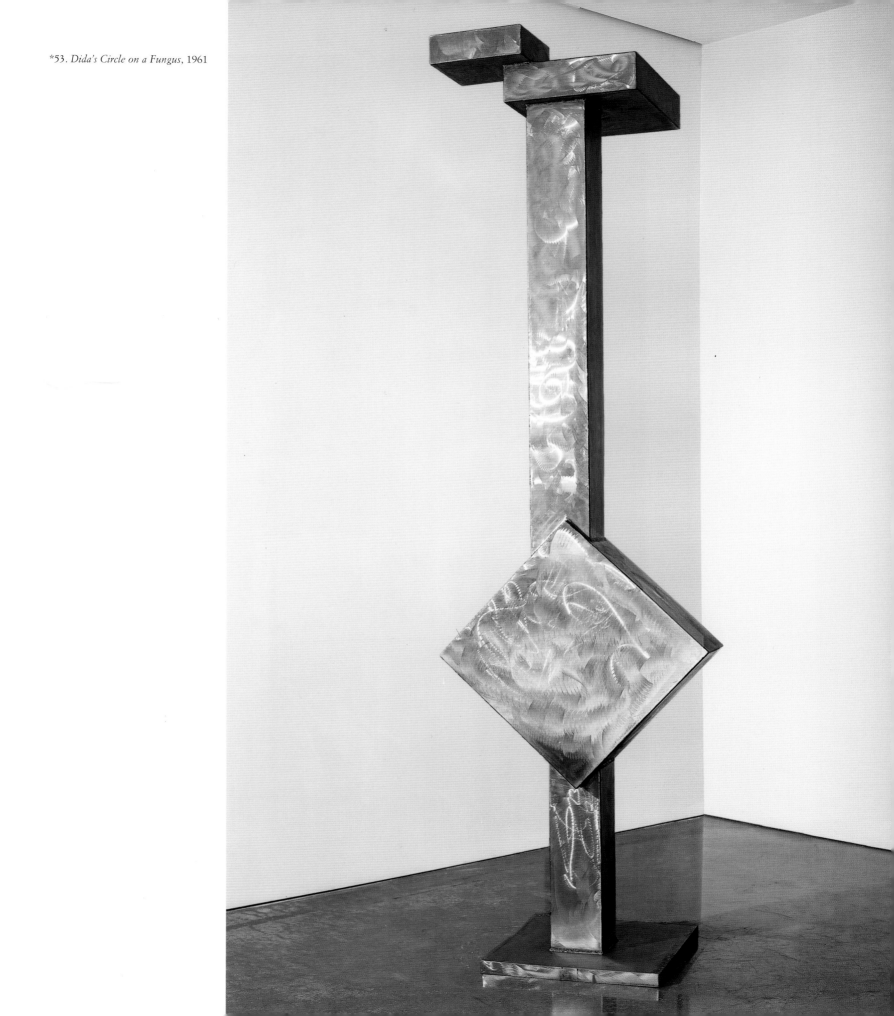

*53. *Dida's Circle on a Fungus*, 1961

Clyfford Still

54. *Untitled*, 1964

55. *Untitled*, 1964

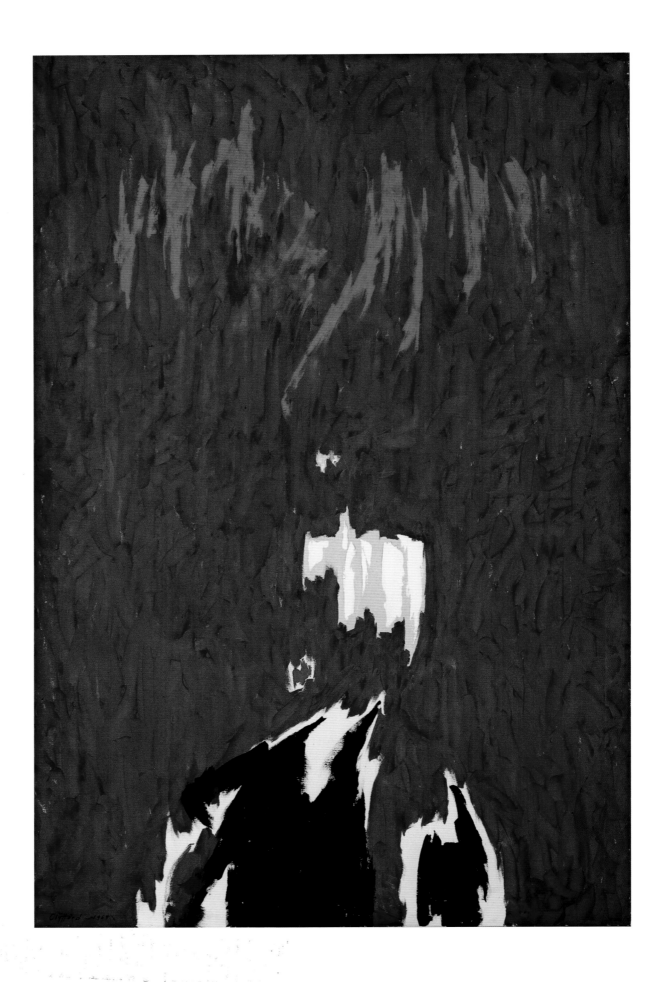

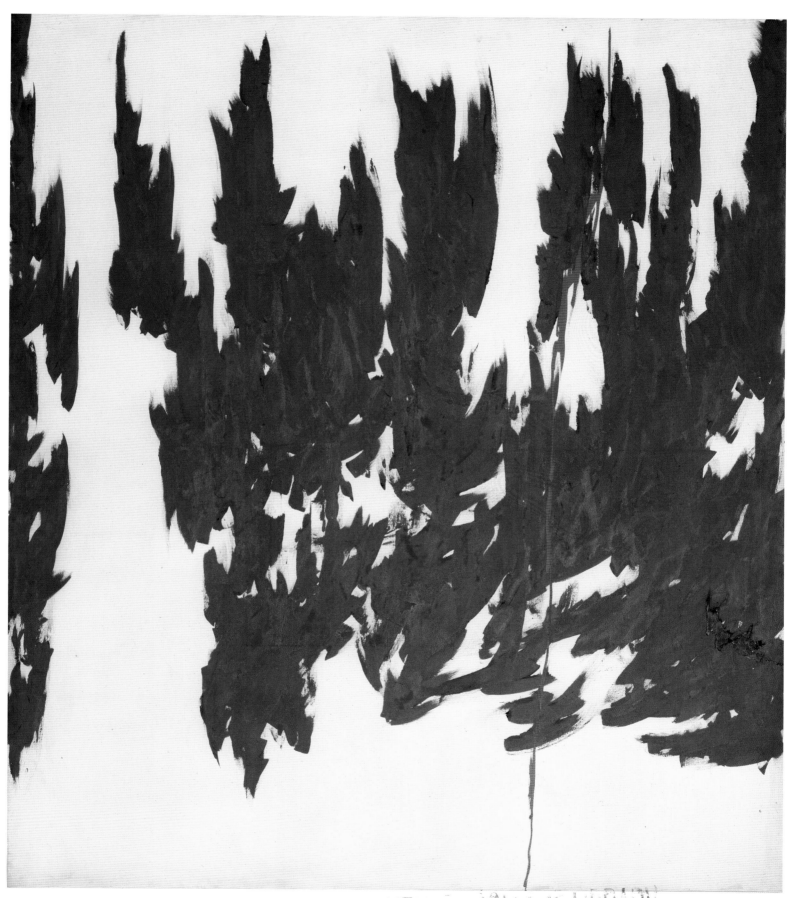

Clyfford Still

121

Bruce Davidson

*56. Untitled (from "Brooklyn Gang"), 1959

*57. Untitled (from "Brooklyn Gang"), 1960

*58. Untitled (from "East 100th Street"), 1966-1968

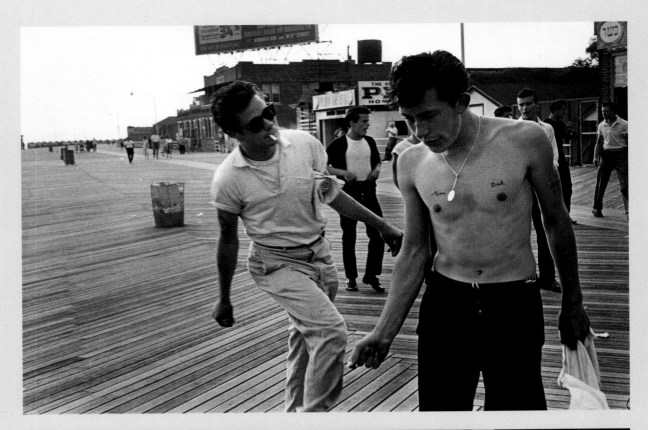

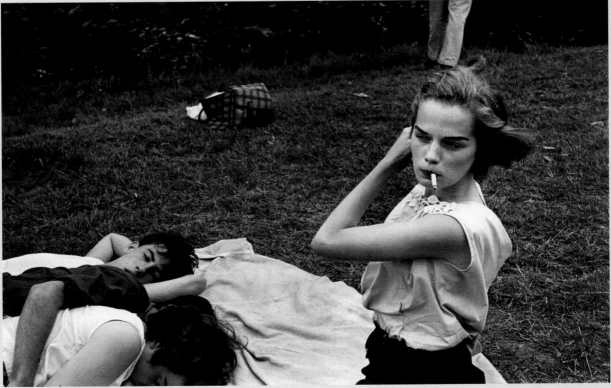

Photography

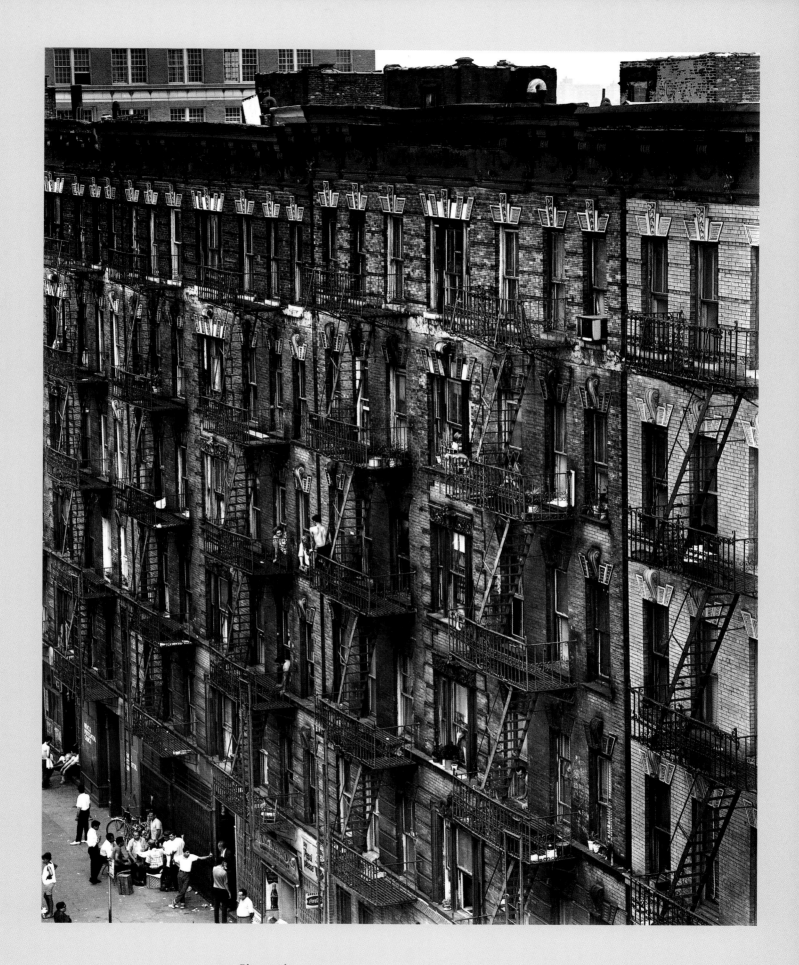

Elliot Erwitt

*59. *California*, 1955

*60. *Pasadena, California*, 1963

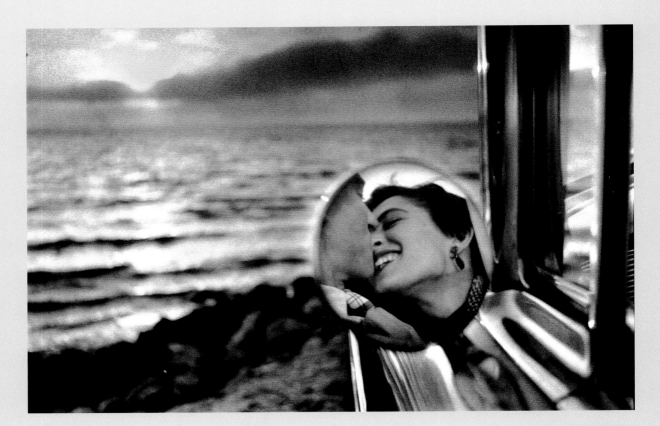

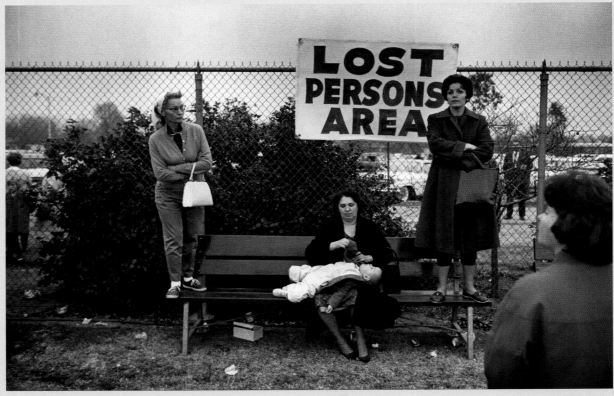

Photography

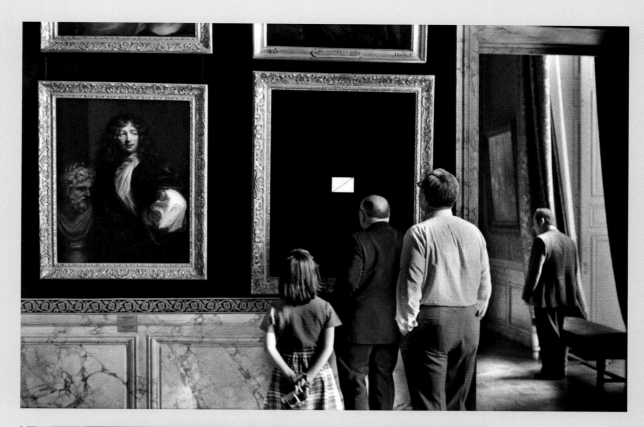

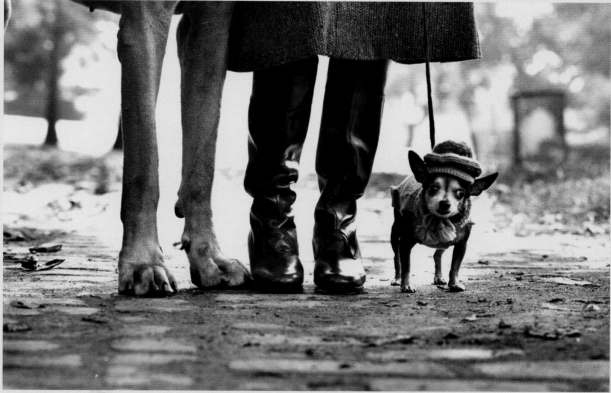

Louis Faurer

*63. *Ritz Bar, New York, NY,*
1947-1948

*64. *Broadway Convertible,* 1950

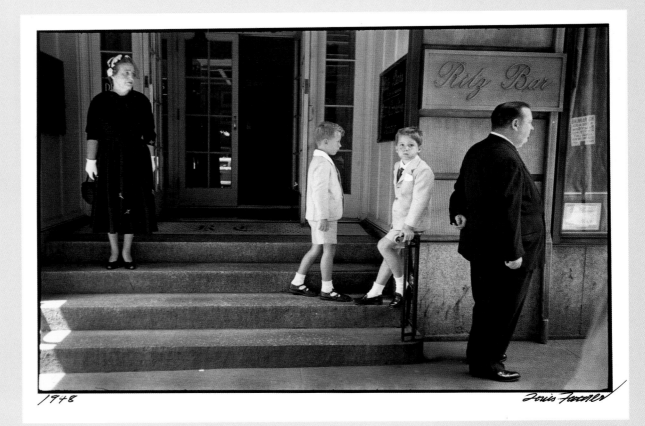

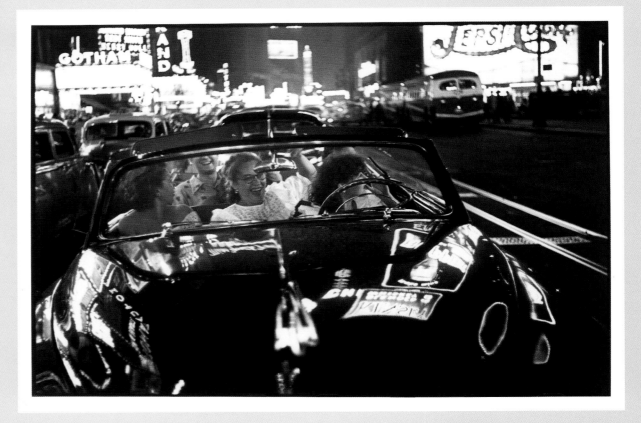

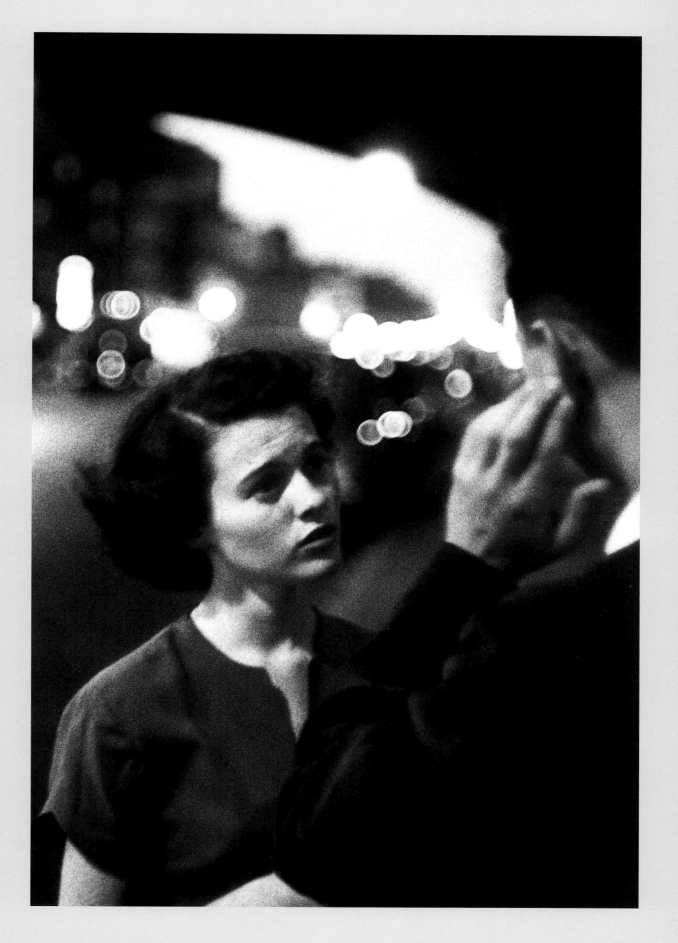

Allen Ginsberg

*66. *Jack Kerouac, Staten Island
Ferry dock, New York, Fall,* 1953

*67. *Rene Ricard, poet art
critic,* 1986

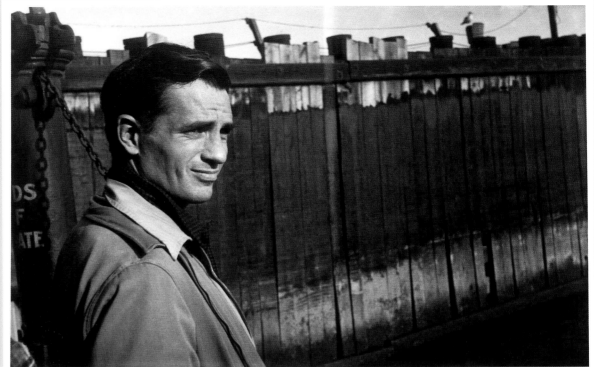

Jack Kerouac at Staten Island Ferry dock, we used to wander thru truck Parking
lots near waterfront under Brooklyn Bridge singing rawbone blues & shouting Hart Crane's
Atlantis to the traffic above. Time of Dr. Sax & the Subterraneans, Fall 1953. Allen Ginsberg

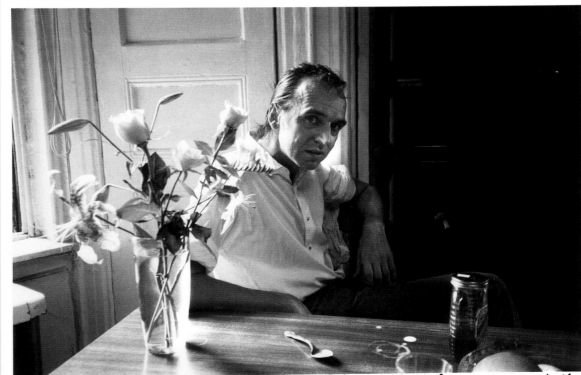

René Ricard, outrageous faggot poet art critic, visiting from across the hall.
same floor on East 12th St. apartment house we live in (his windows opposite mine
visible from my kitchen window), July 29, 1986. Two years later fire drove him out on the
street hallucinating murder basements.
 Allen Ginsberg

*68. William Burroughs & Jack
Kerouac in mortal combat with
snaky Morocan dagger and
broomstick club on my couch,
206 E. 7th. Street, Fall, 1953

*69. Robert Frank at Kiev
restaurant, 7th Str. and Second Ave.,
March 7, 1984

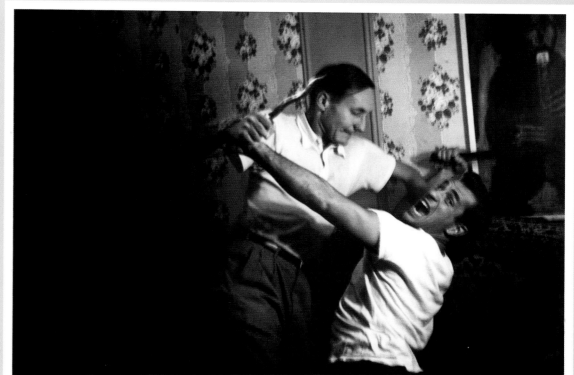

Bill Burroughs & Jack Kerouac in mortal combat with snaky morocan dagger & broomstick club on my couch 206 (Street, East Seventh) Manhatten - Jack came in weekends from Richmond Hill, Bill was staying with me in little East Village Apartment editing Yage Letters, Jack engaged in The Subterraneans love affair, Fall 1953.
Allen Ginsberg

Robert Frank at Kiev Restaurant, 7th Street & Second Avenue March 7, 1984 — inquisitive Private look not unkind — patient: "Maybe I could show you something too."
Allen Ginsberg

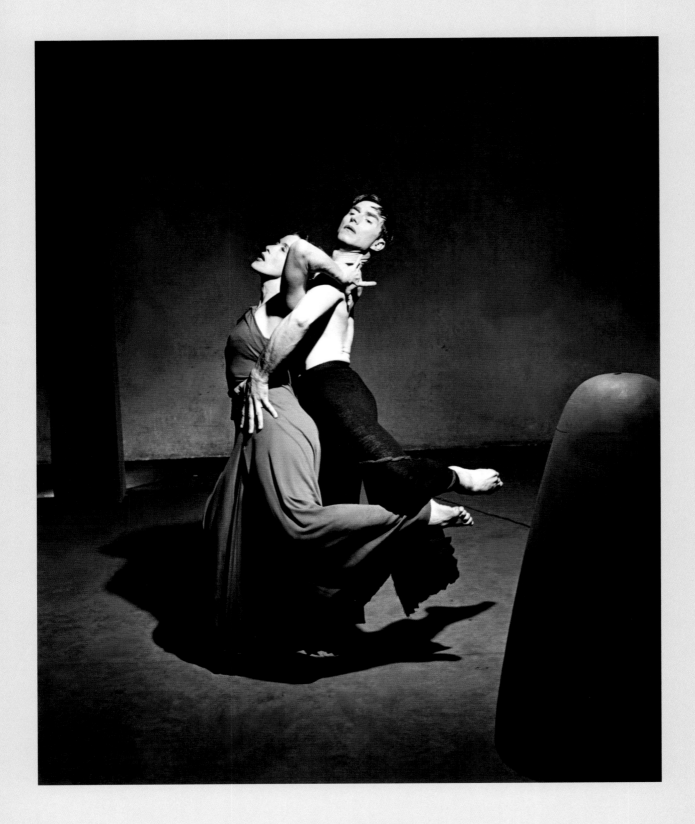

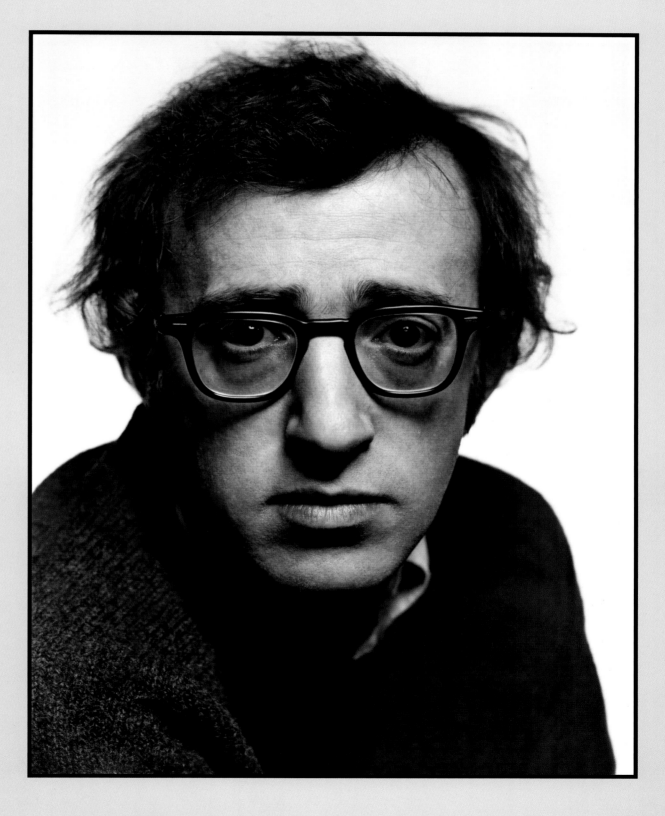

*72. *Disappearing Act*, 1955

William Klein

*74. *Group & Top Hat, Harlem,*
1955

*75. *Boys & See-Saw, Harlem,*
New York, 1955

*80. *Emerging Man, Harlem*, 1952

Eugene W. Smith

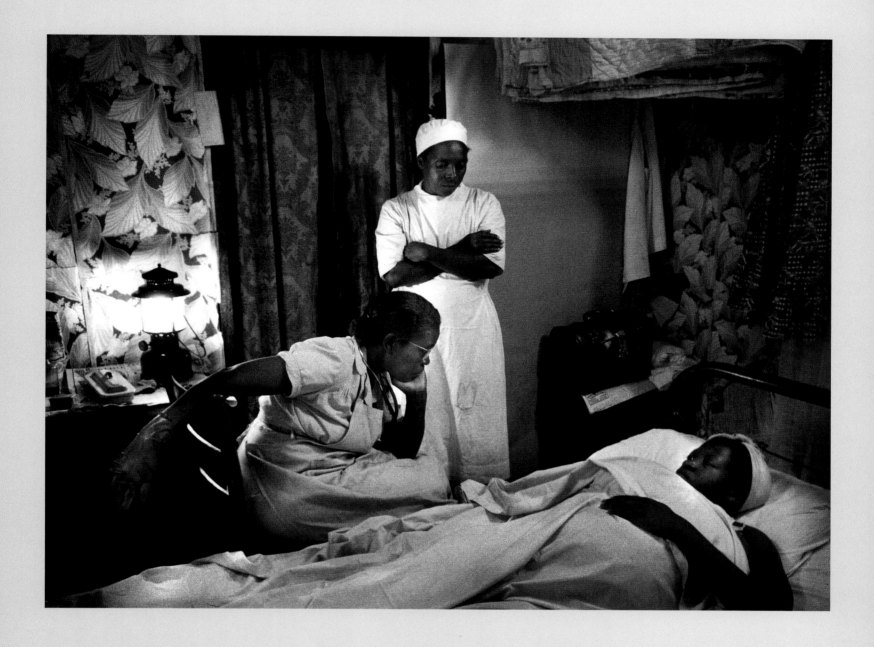

Weegee (Arthur Fellig)

*85. *Fire Lieutenant rescues woman
from fourth floor of burning
building,* January 13, 1941

*86. *Fireman holding Torahs,
saved from a fire,* c. 1943

*87. *Madam Swift,* 1941

*88. *"Bandit",* August 11, 1941

Helen Levitt

Photography

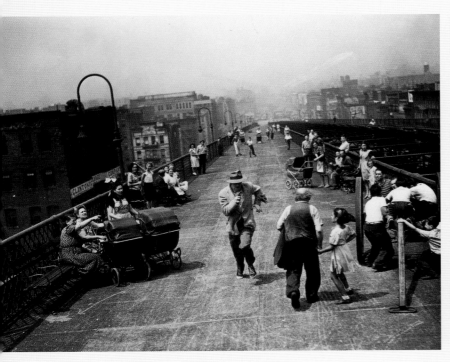

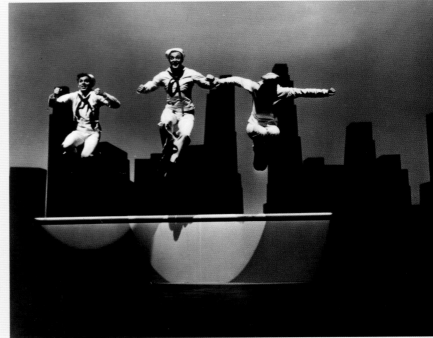

*92. Jules Dassin
The Naked City, 1948

*93. Stanley Donen, Gene Kelly
On the Town, 1949

*94. Samuel Fuller
Pick up on South Street, 1953

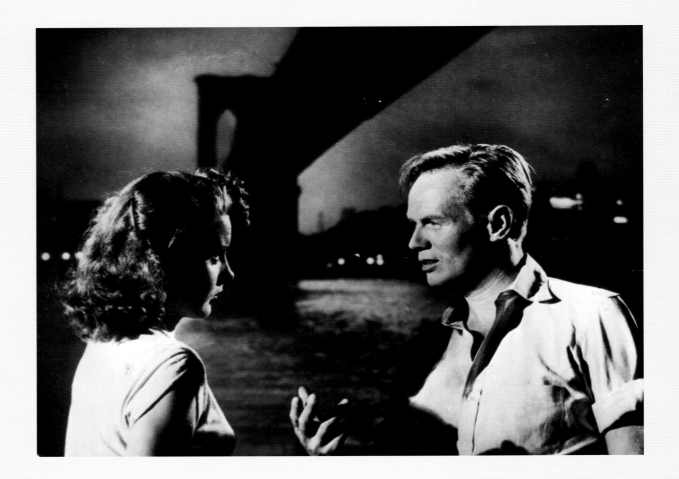

95. Elia Kazan
On the Water Front, 1954

96. Vincente Minnelli
The Bandwagon, 1953

97. Alfred Hitchcock
Rear Window, 1954

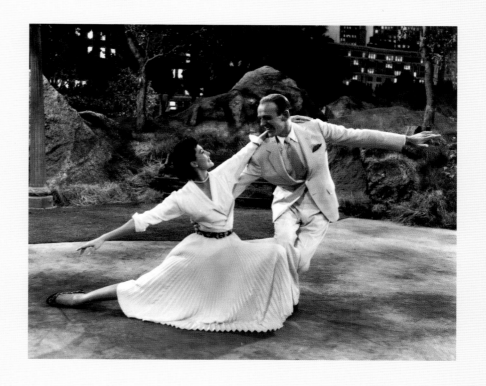

*98. Billy Wilder
The Seven Year Itch, 1955

*99. Stanley Donen, Gene Kelly
It's Always Fair Weather, 1955

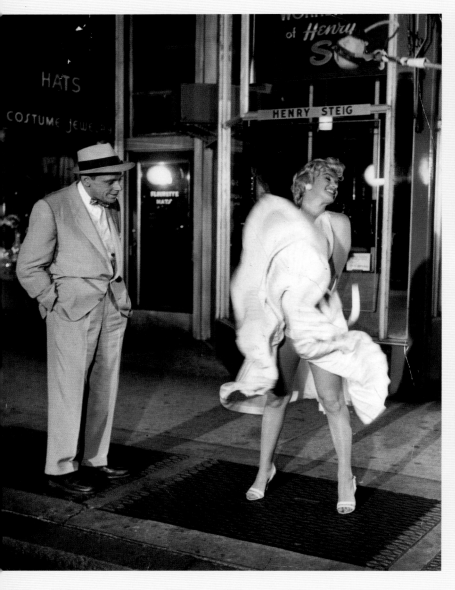

Cinema

*100. Alfred Hitchcock
The Wrong Man, 1957

101. John Cassavetes
Shooting of "Shadows", 1959

*102. Blake Edwards
Breakfast at Tiffany's, 1960

147

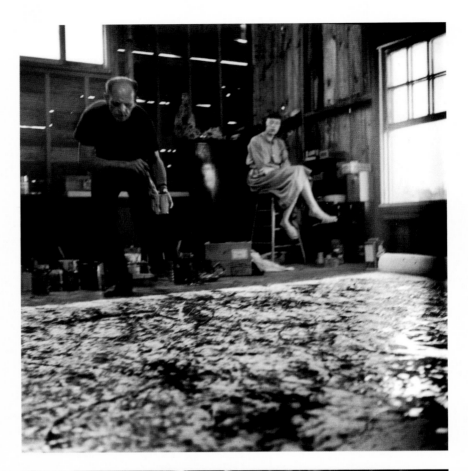

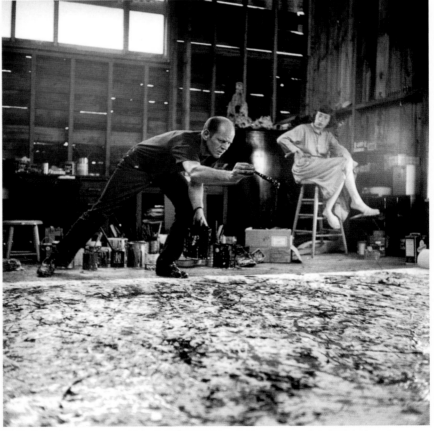

105. Claes Oldenburg
Ray Gun Theater, 1962

106. Claes Oldenburg
Sports, 1962

107-109. Jim Dine in *Vaudeville Collage: "An Evening of: Sound-Theatre-Happenings"*, an evening of performances held at the Reuben Gallery, New York, June 11, 1960

107-109. Jim Dine in *Vaudeville Collage: "An Evening of: Sound-Theatre-Happenings"*, an evening of performances held at the Reuben Gallery, New York, June 11, 1960

*110. Carolee Schneemann
Meat Joy, 1964

*111. Nam June Paik, John Godfrey
Global Groove, 1973

*112-114. Allan Kaprow
Comfort Zone, 1975

115. Skidmore, Owings & Merrill,
Gordon Bunshaft
Lever Building, New York, 1952

116-117. Skidmore, Owings
& Merrill, Gordon Bunshaft
*Manufacturers Hanover Trust
Building, New York*, 1954

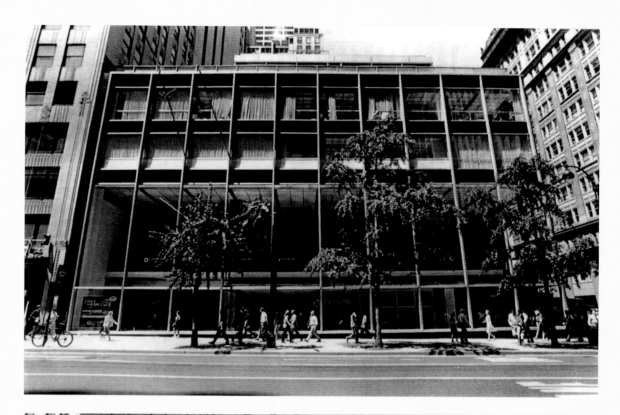

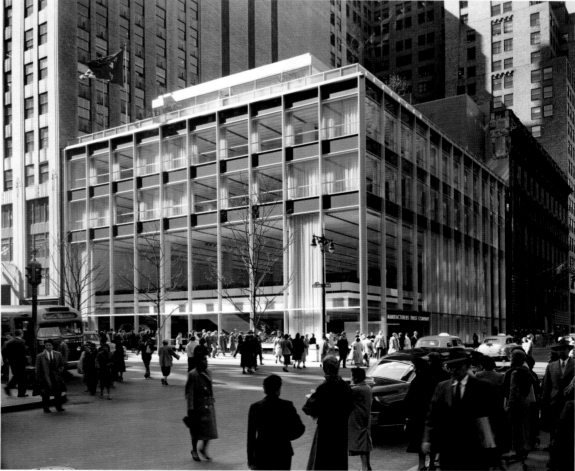

118. Frank Lloyd Wright
Solomon R. Guggenheim Museum,
New York, 1956-1959

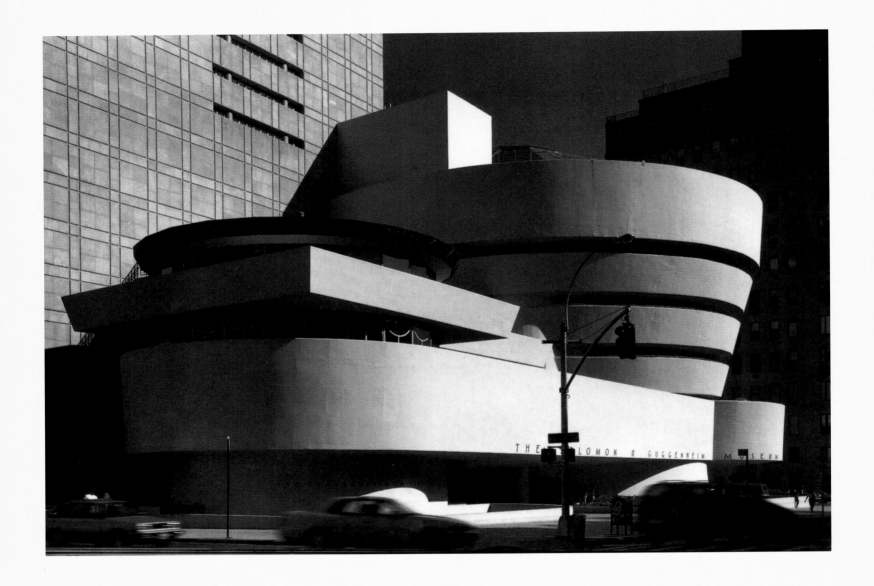

119-122. Ludwig Mies van der Rohe
Seagram Building, New York, 1958

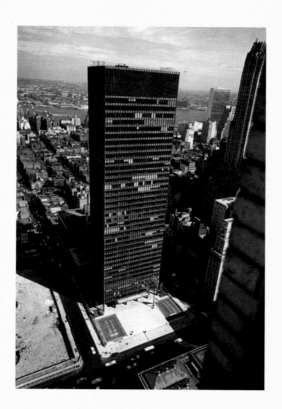

Jasper Johns

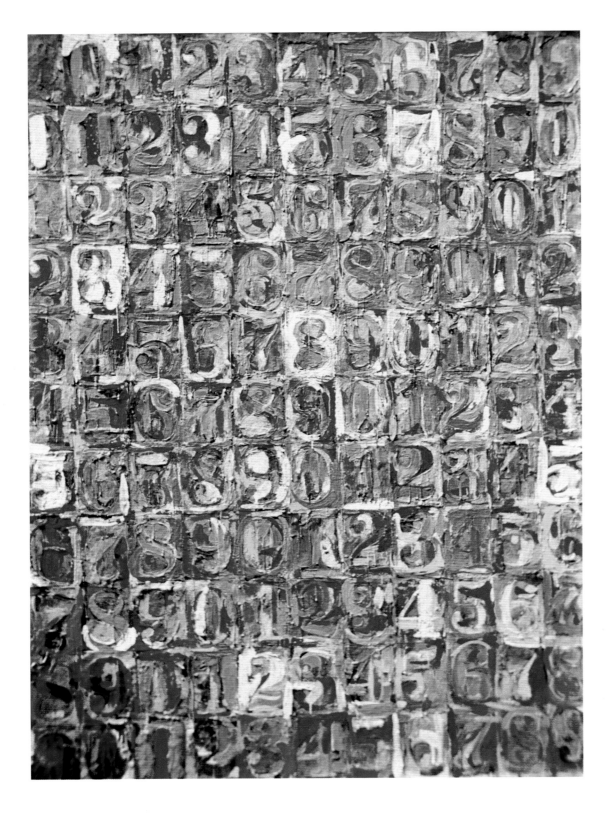

*124. *Number 8*, 1959

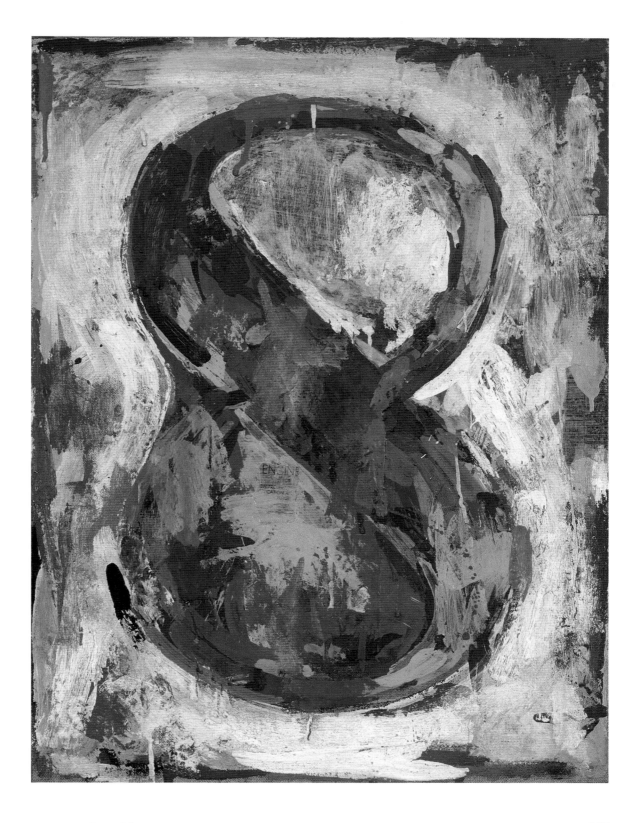

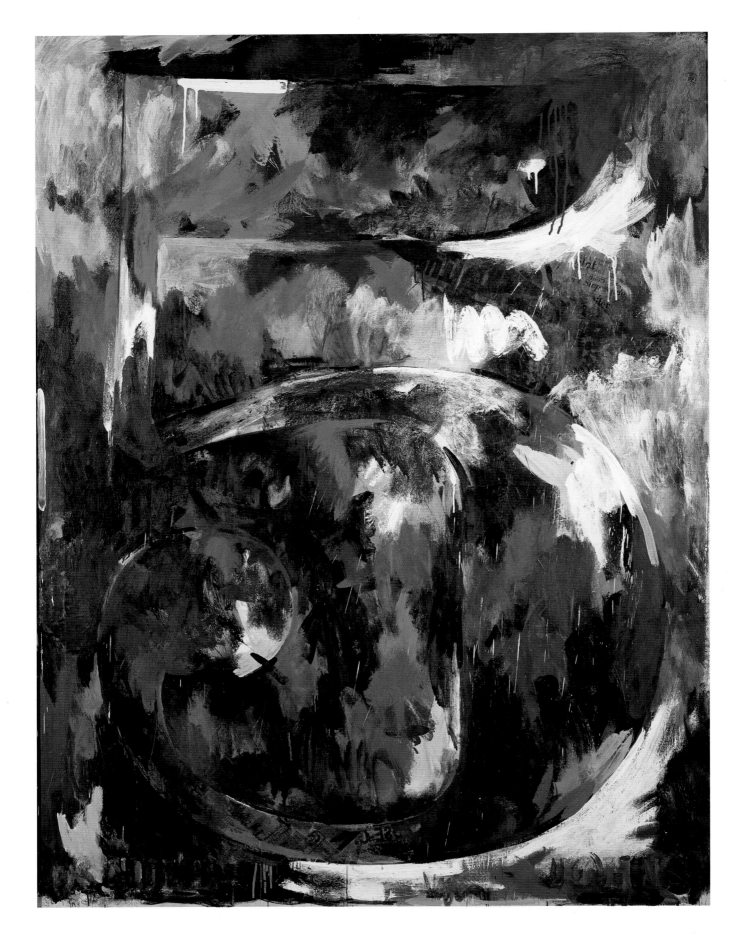

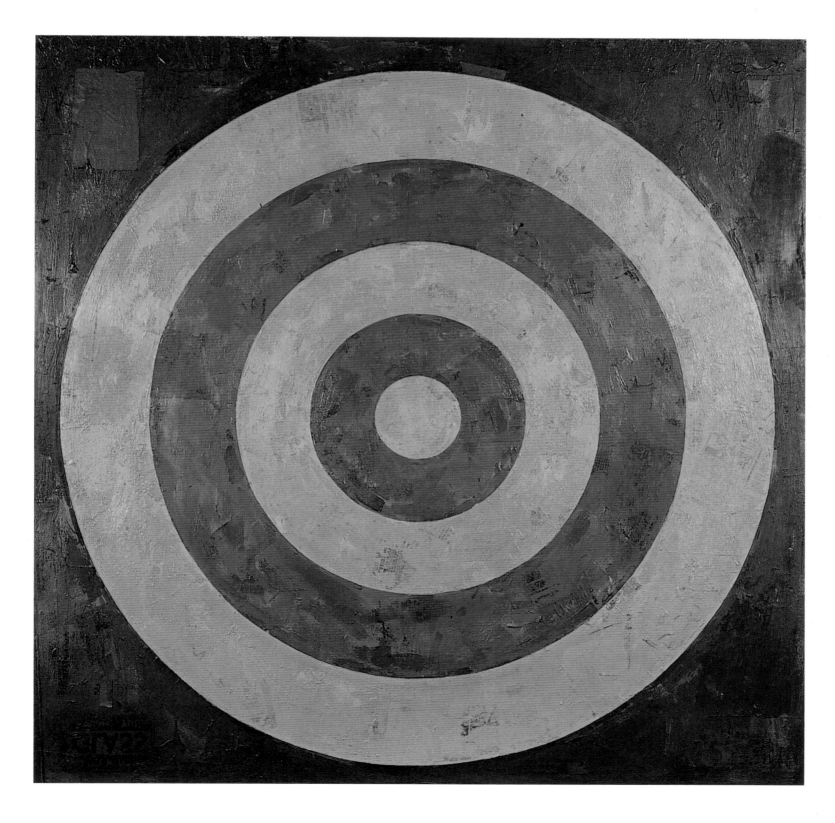

Jasper Johns

Louise Nevelson

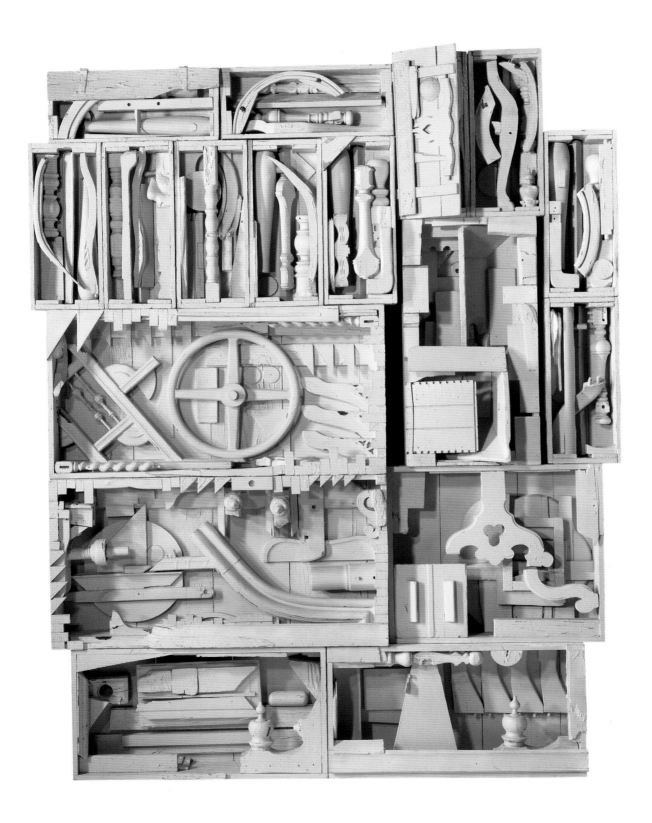

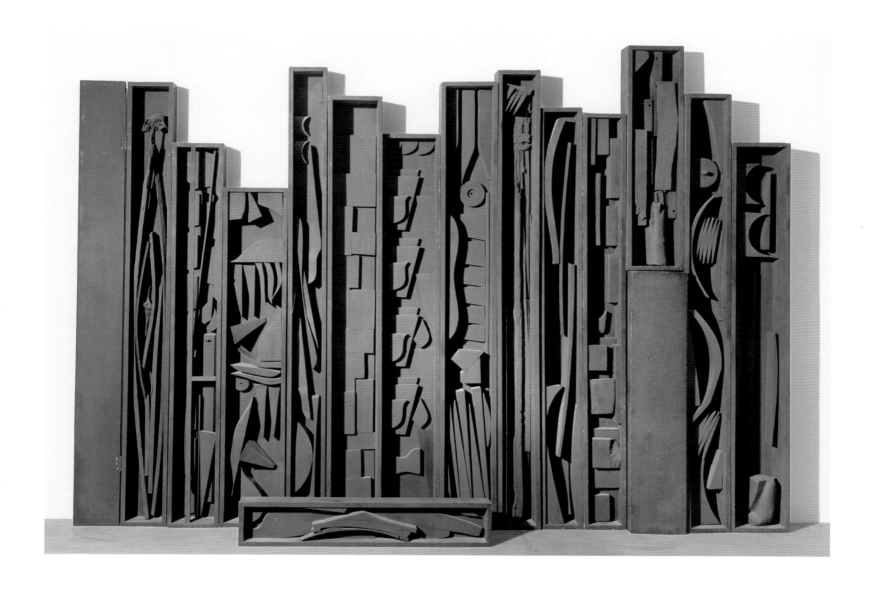

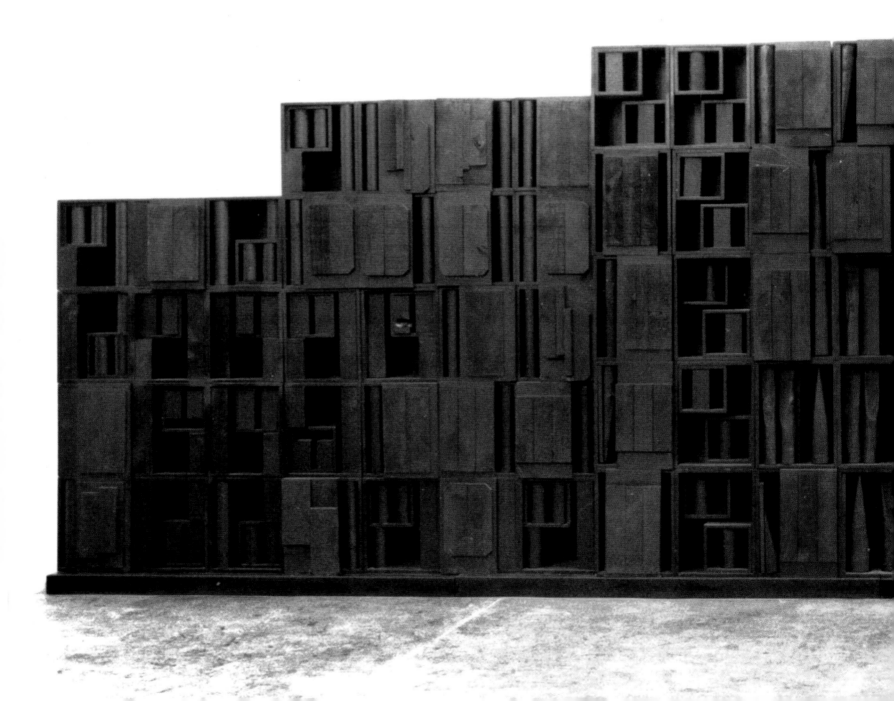

129. *Homage to the Universe*, 1968

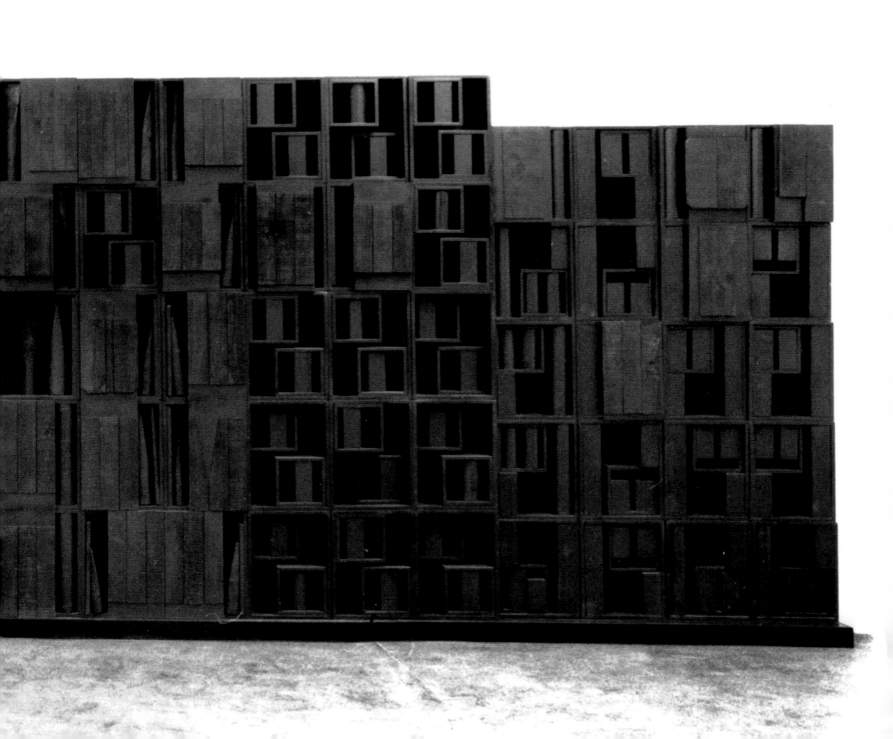

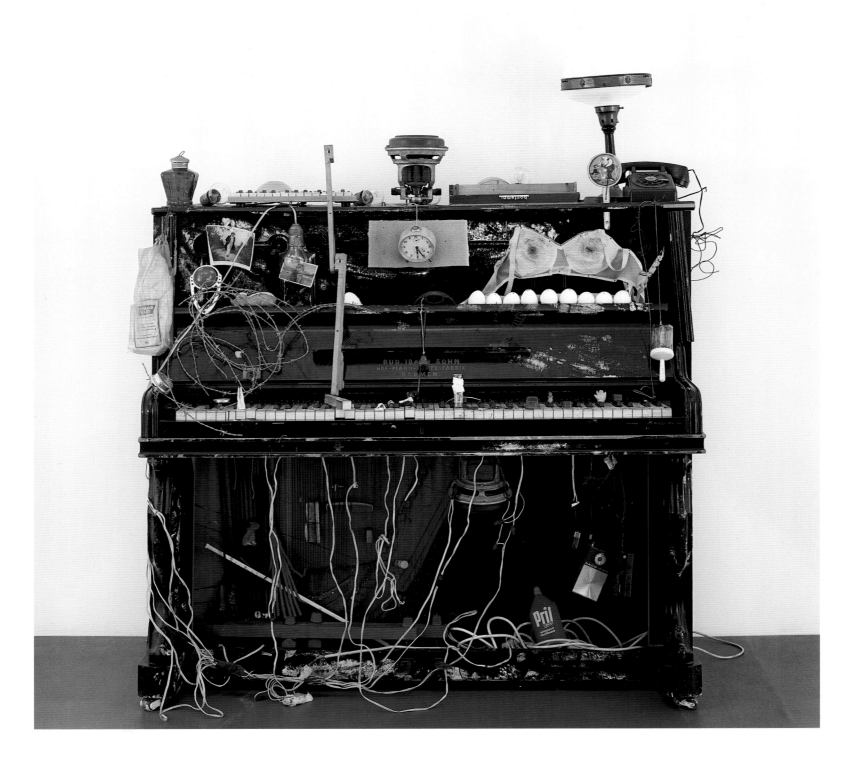

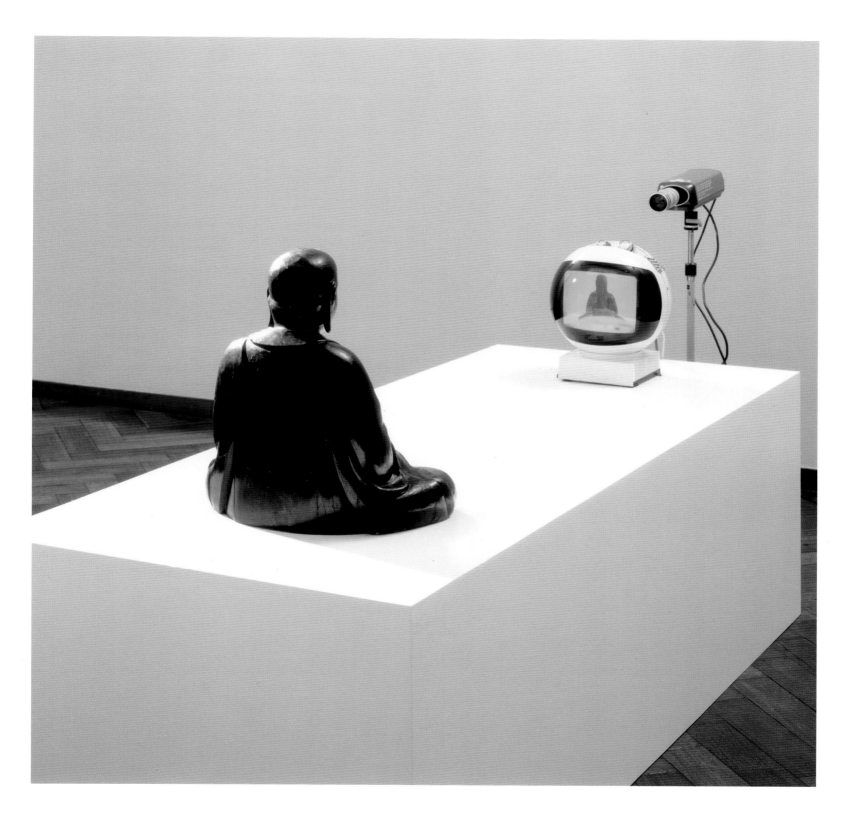

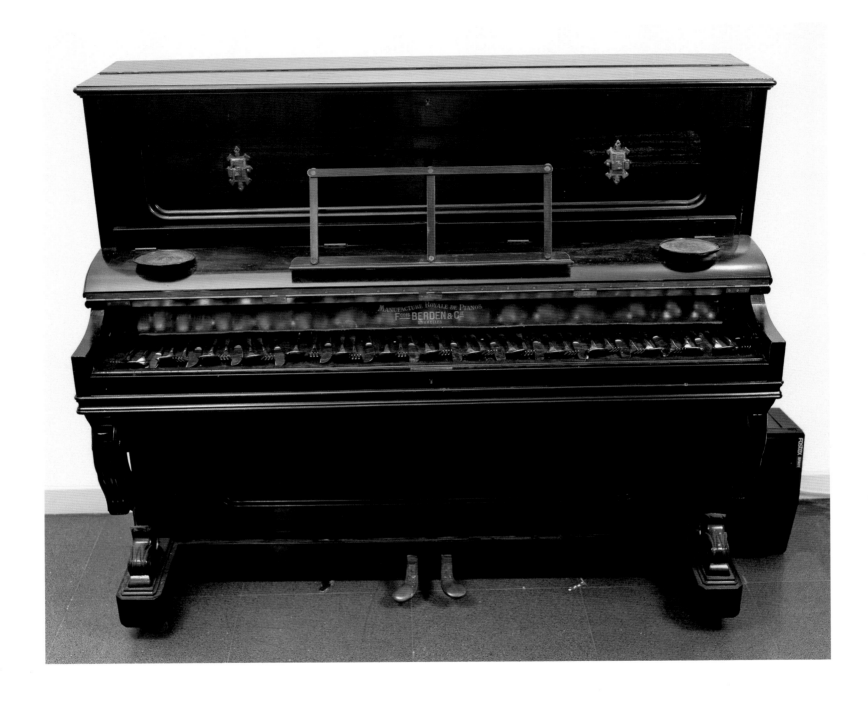

Nam June Paik

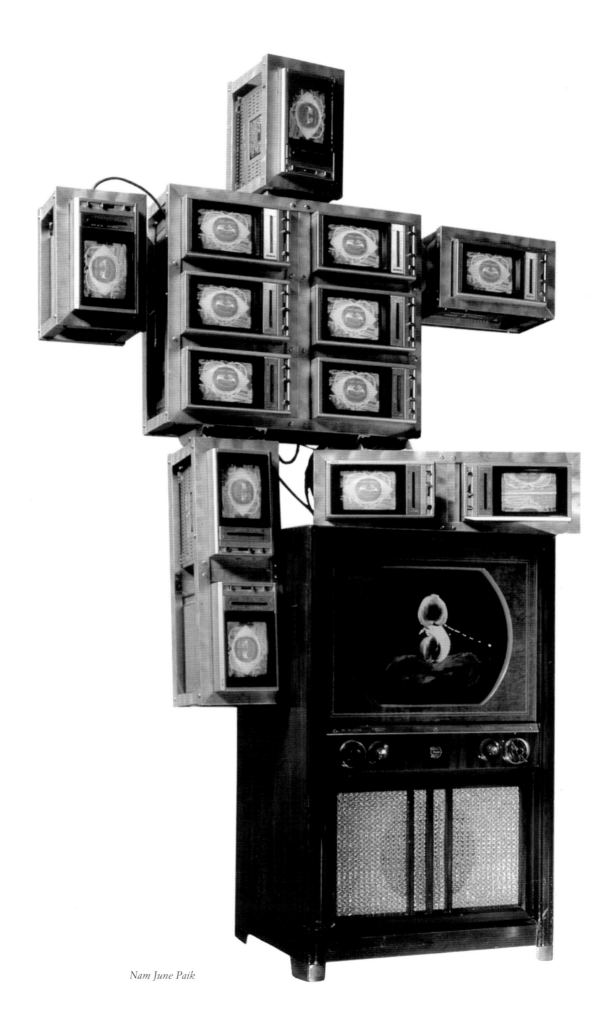

Nam June Paik

Robert Rauschenberg

134. *Kite*, 1953

135. *Tideline*, 1963

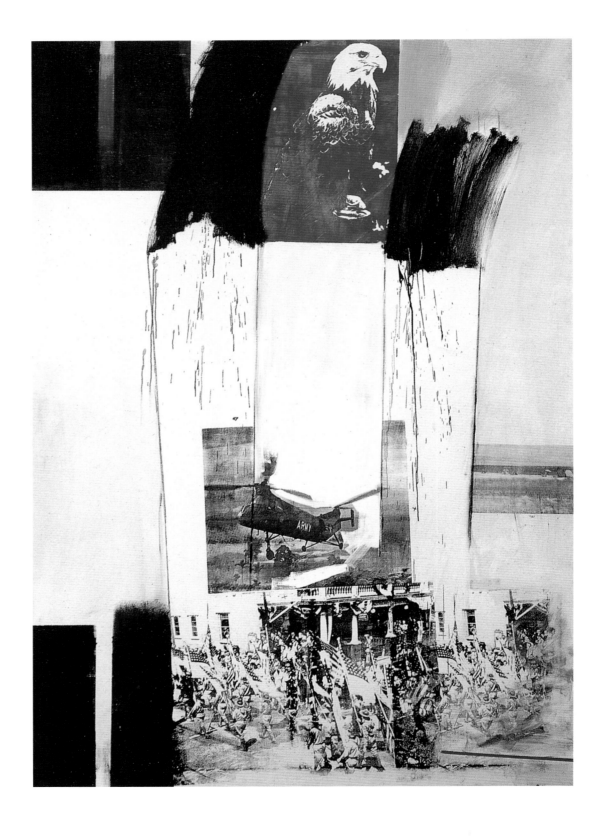

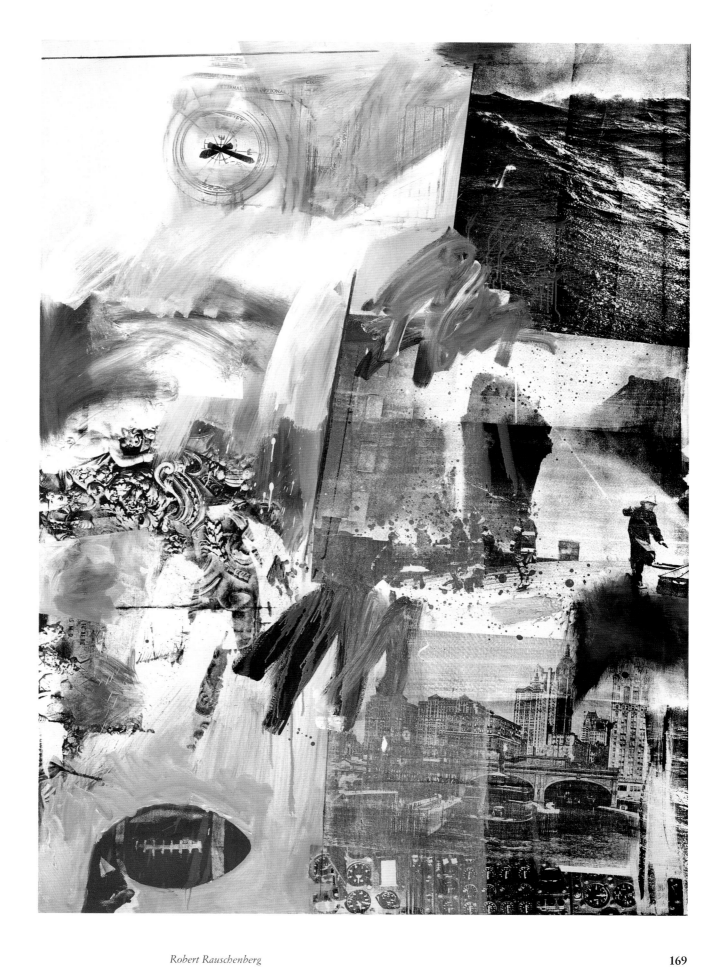

*137. *Balcone Glut (Neopolitan)*,
1987

Cy Twombly

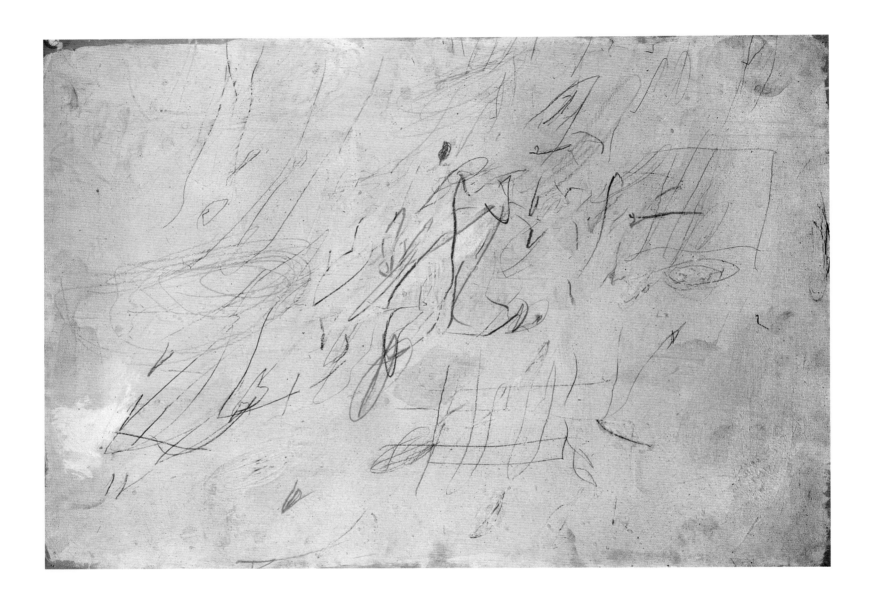

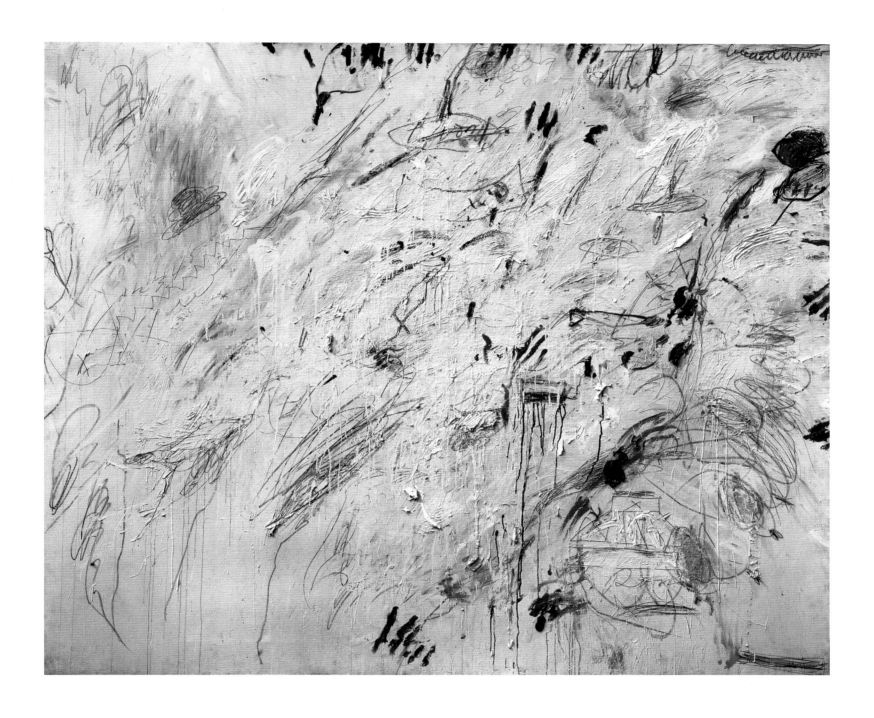

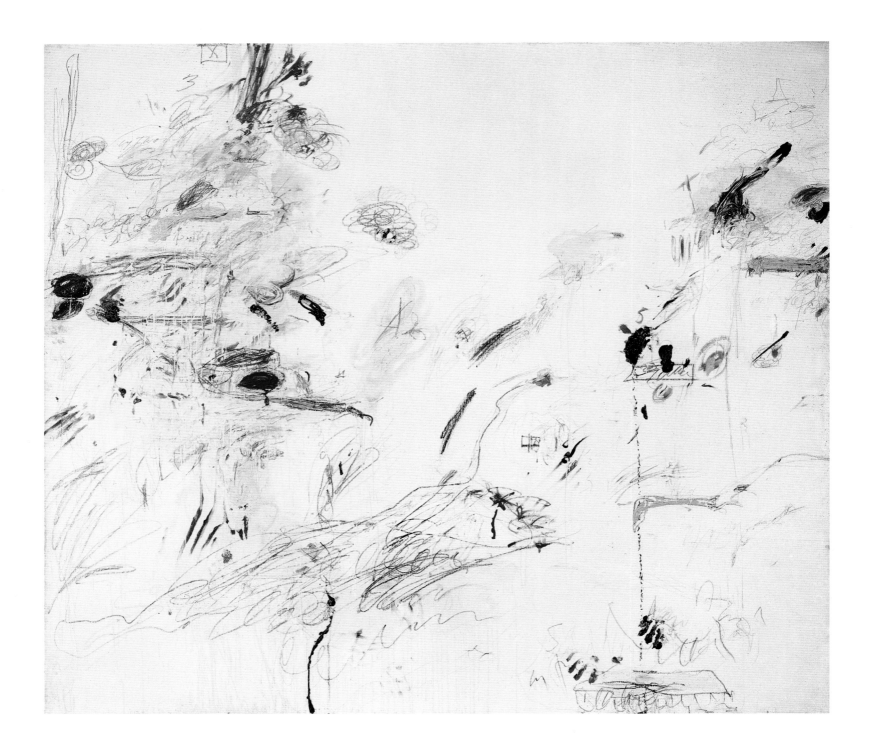

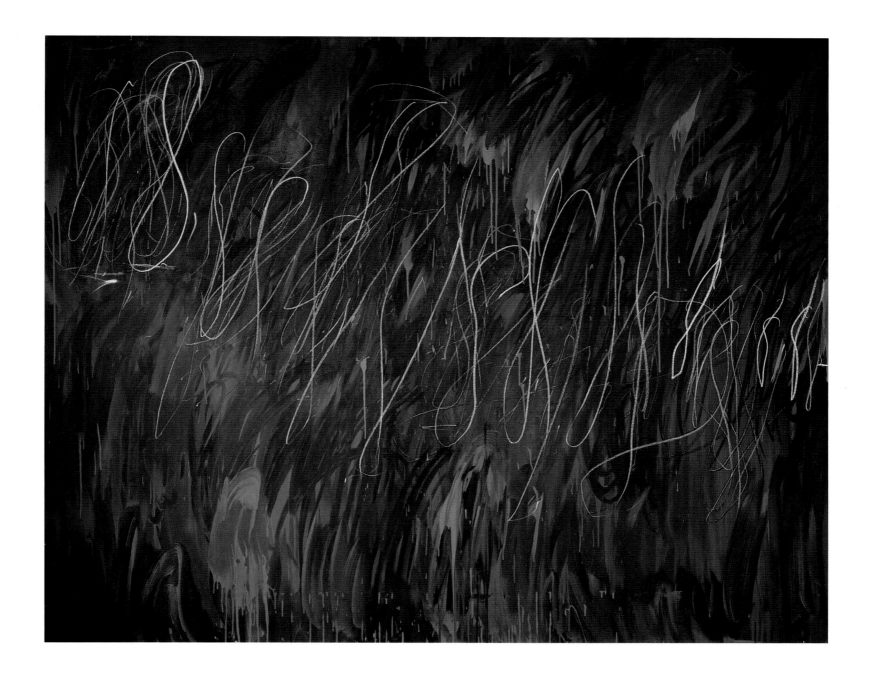

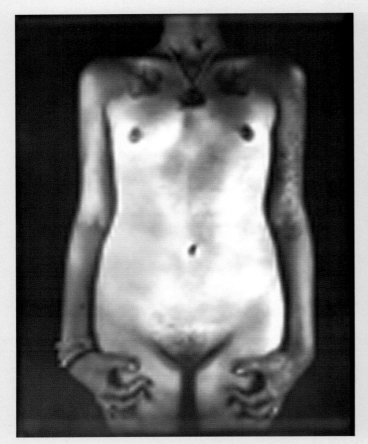 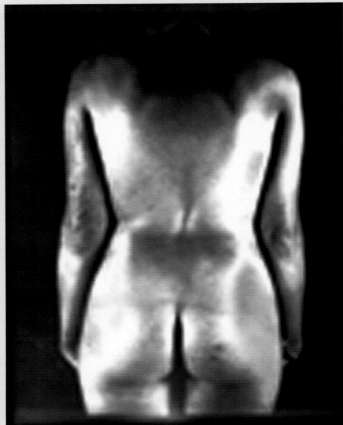

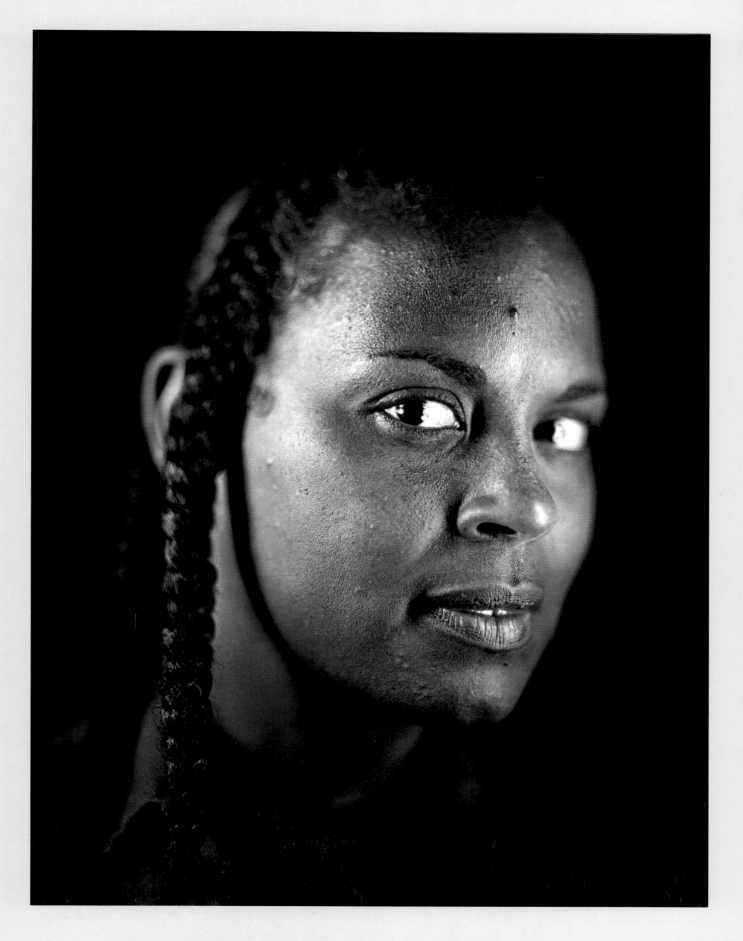

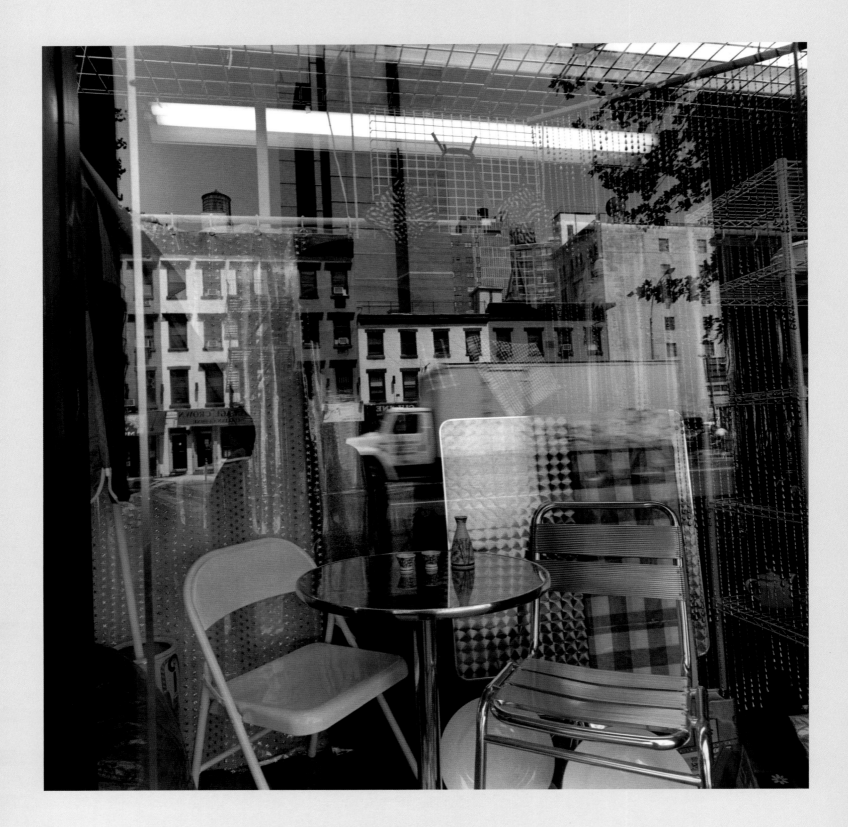

Andy Warhol

Photography

Garry Winogrand

*152. *Central Park Zoo, New York,* 1967

*153. *Political Demonstration, New York,* 1969

*154. Robert Wise
West Side Story, 1963

155. Shirley Clarks
Shooting of "The Cool World", 1963

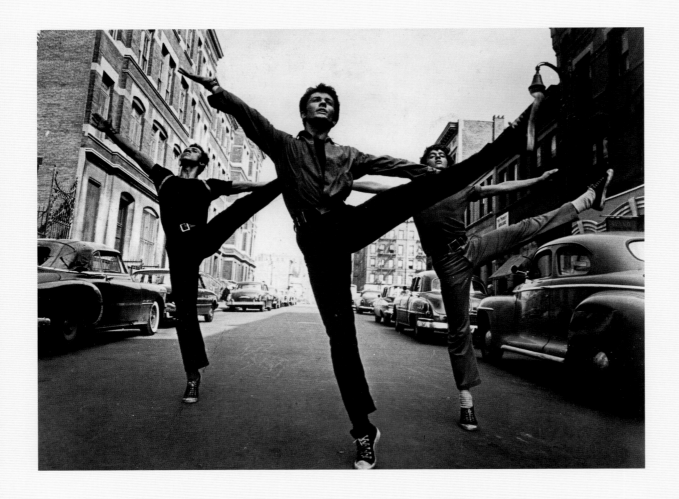

156. Andy Wahrol
Empire, 1964

157. Jonas Mekas
Shooting of "Guns of the Trees",
1964

Cinema

*160. John Schlesinger
Midnight Cowboy, 1968

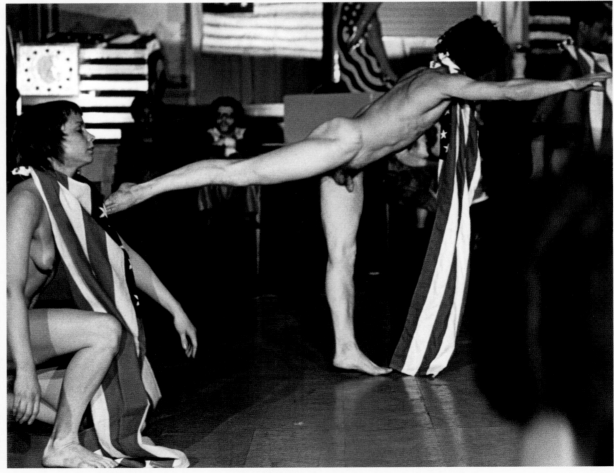

Performance and Video

163. Bruce Nauman
Flesh to White to Black to Flesh,
1968

164. Robert Morris
Slow Motion, 1969

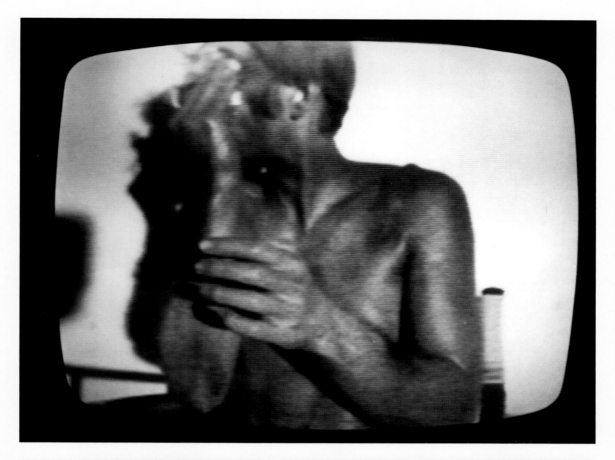

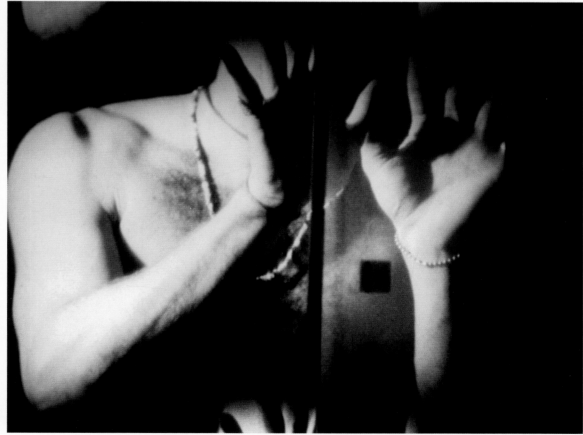

*165. Bruce Nauman
Slow Angle Walk (Beckett Walk),
1968

*166. Trisha Brown
*Man Walking Down the Side
of a Building*, 1970

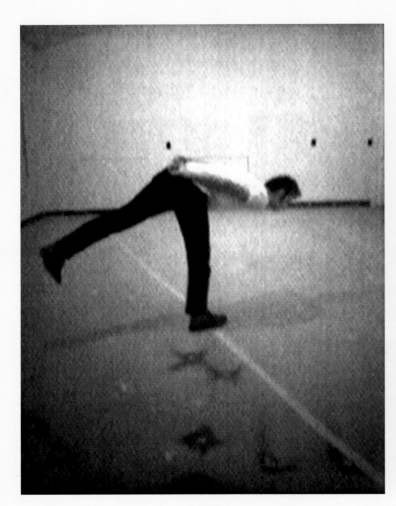

*165. Bruce Nauman
Slow Angle Walk (Beckett Walk),
1968

*166. Trisha Brown
*Man Walking Down the Side
of a Building*, 1970

167. Steve Paxton
Contact Improvisations, 1968

168. *Dance*, 1979
Choreograph by Lucinda Childs,
music by Philip Glass

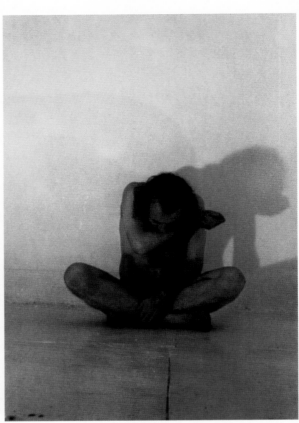

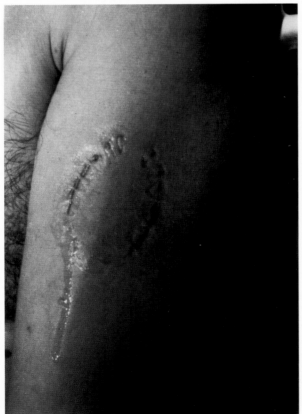

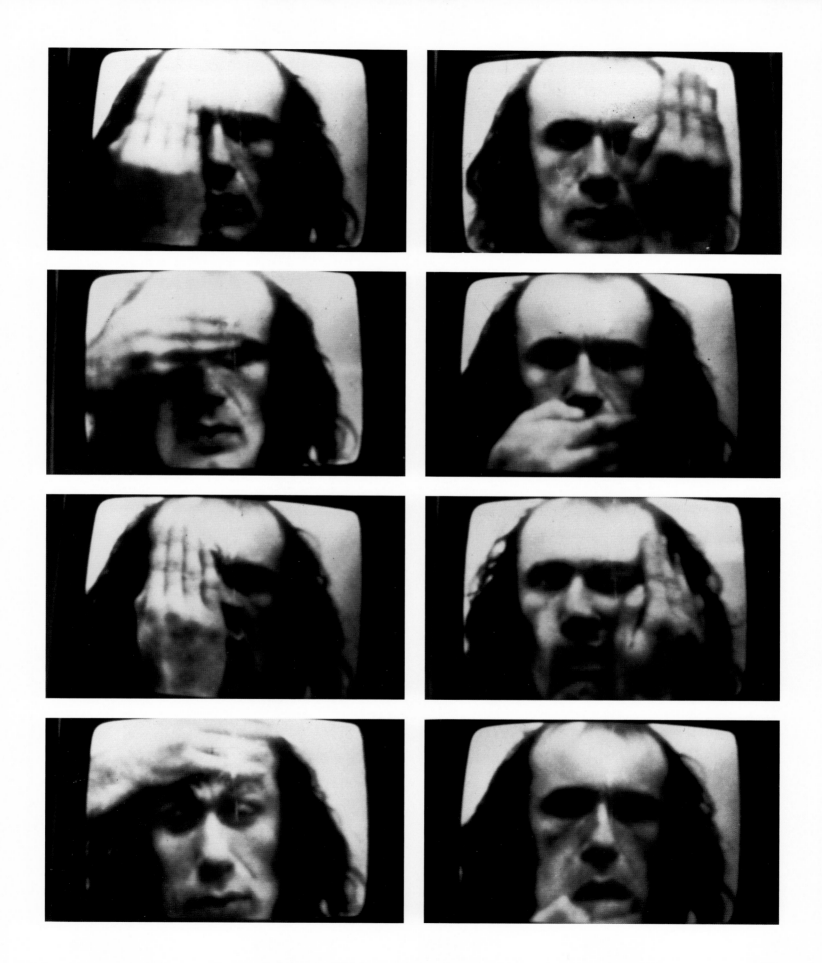

*181. Gordon Matta-Clark
Clock Shower, 1973

*182. Hannah Wilke
Gestures, 1974

Performance and Video

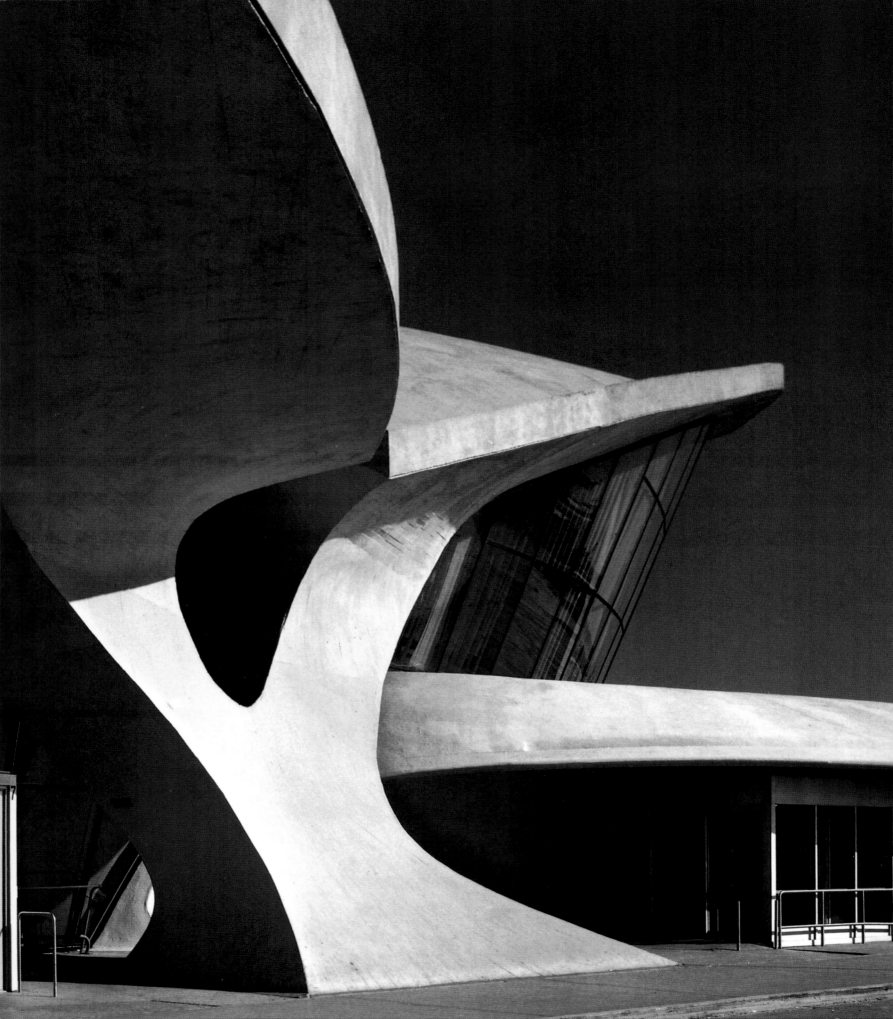

185. Eero Saarinen
TWA Terminal, New York,
1956-1962

186. Skidmore, Owings & Merrill
Pepsicola Building, New York, 1960

187. Morris Lapidus, Harle
& Liebman Architects
*Summit Hotel (Doubletree
Metropolitan Hotel), New York,*
1959-1961

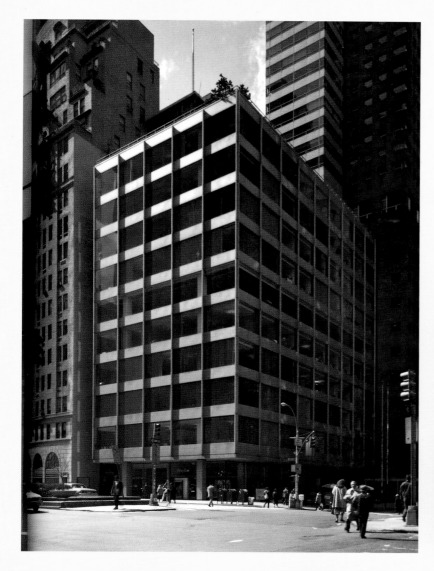

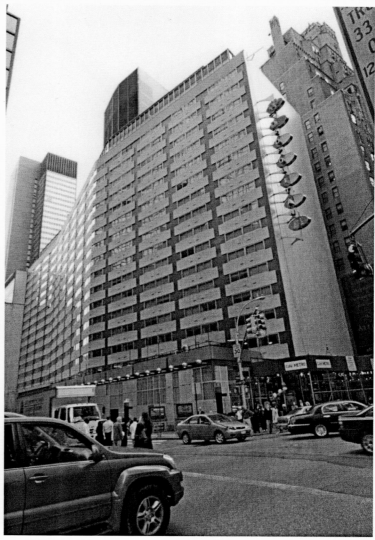

188. Edwards D. Stone
Gallery of Contemporary Art,
2 Columbus Circle, New York,
1964-1965

189. Kevin Roche, John Dinkeloo
& Associates
Ford Foundation Building Location,
New York, 1967

190. Eero Saarinen
CBS Building, New York, 1961-1966

191. Marcel Breuer
Whitney Museum of American
Art, New York, 1966

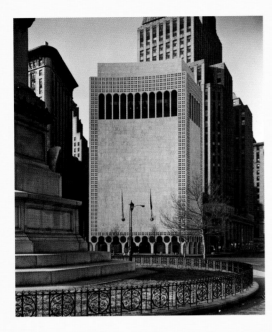

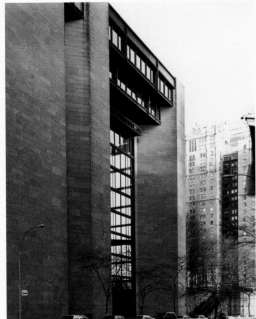

Architecture

192. Emery Roth & Sons, Pietro
Belluschi & Walter Gropius
*Pan Am Building/Met Life,
New York, 1958-1963*

193. Davis Brody Bond
*Waterside Plaza, New York,
1963-1974*

194-195. Daniel Libeskind
Collage Rebus, New York, 1970

*197. *Chair/Chair*, 1965

198. *Piano II*, 1965-1979

John Chamberlain

199. *Trixie Dee*, 1963

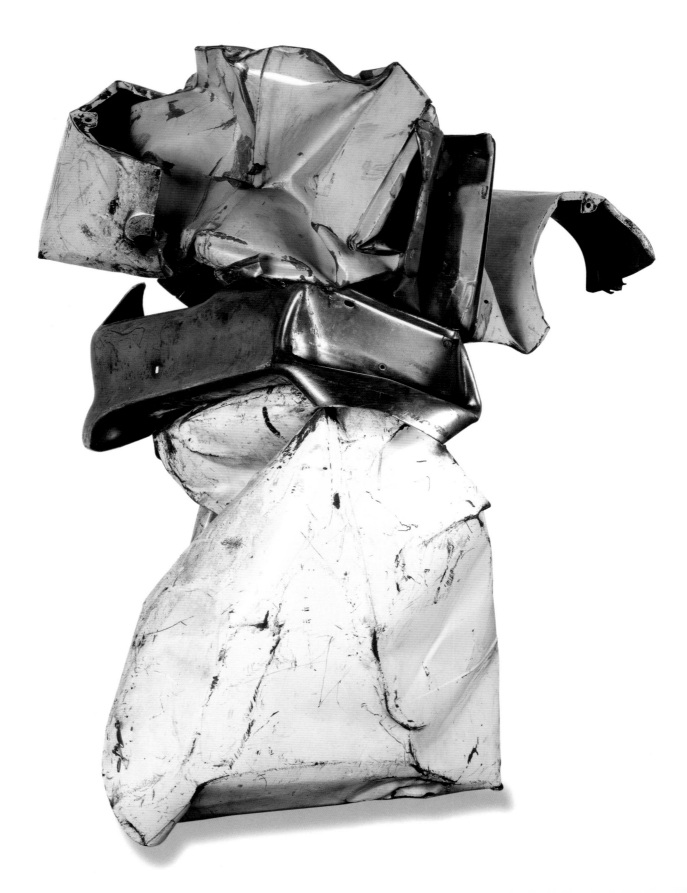

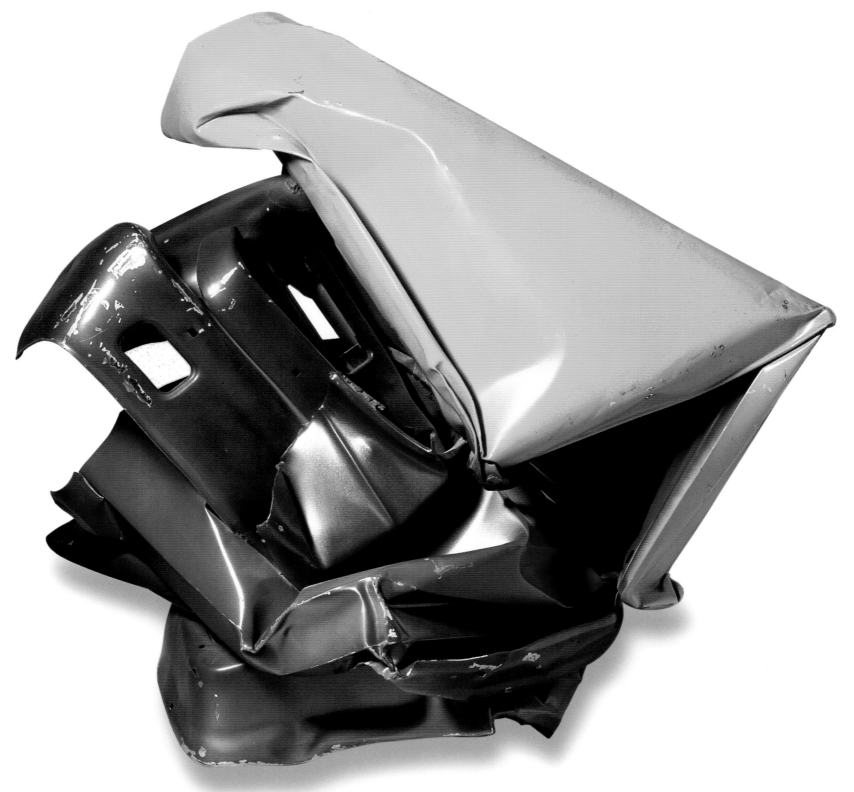

John Chamberlain

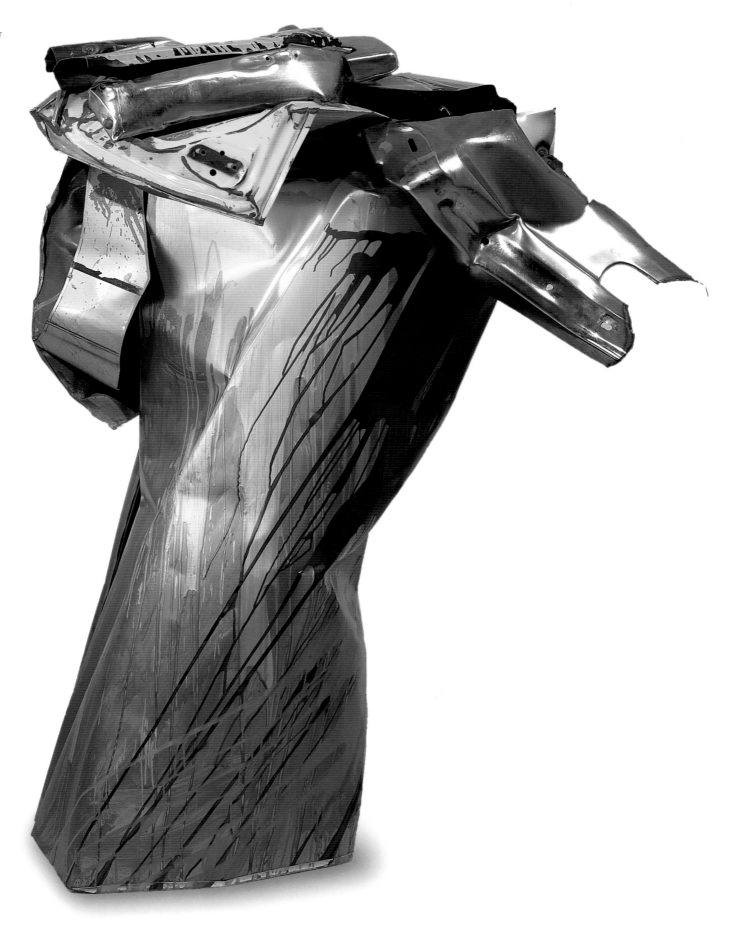

John Chamberlain

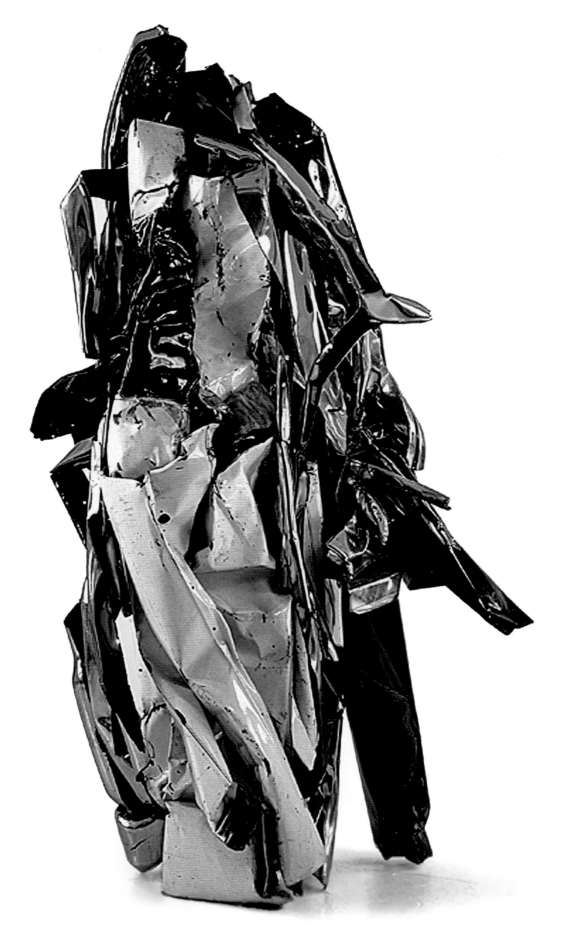

Jim Dine

*203. *Car Crash*, 1959-1960

*204. *Flesh Chisel*, 1962

Pages 212-213

*205. *Two Shovels*, 1962

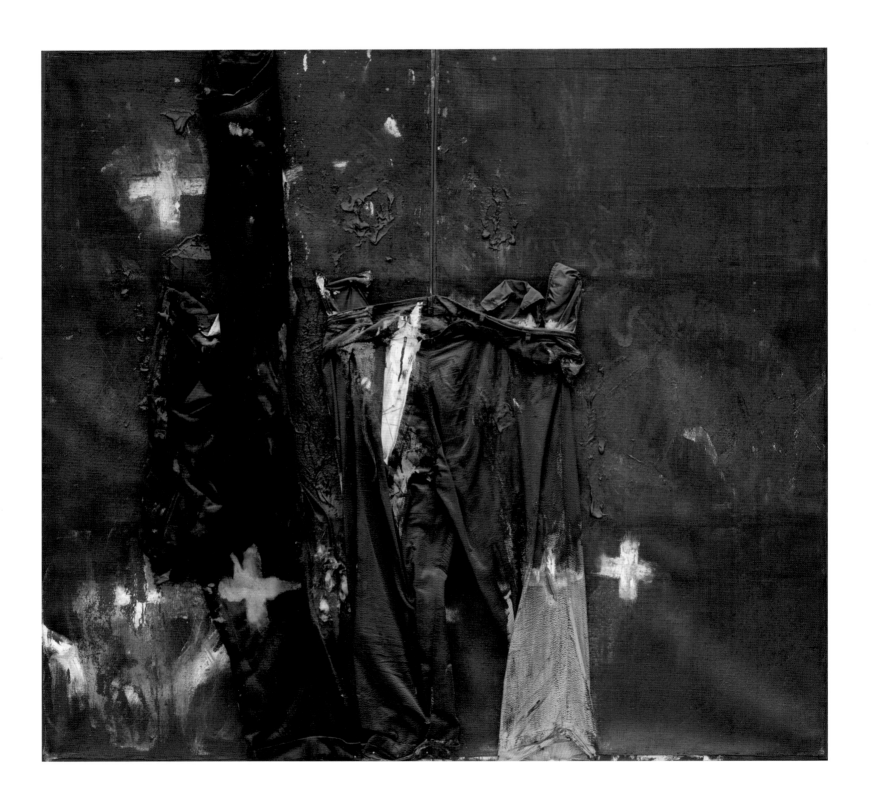

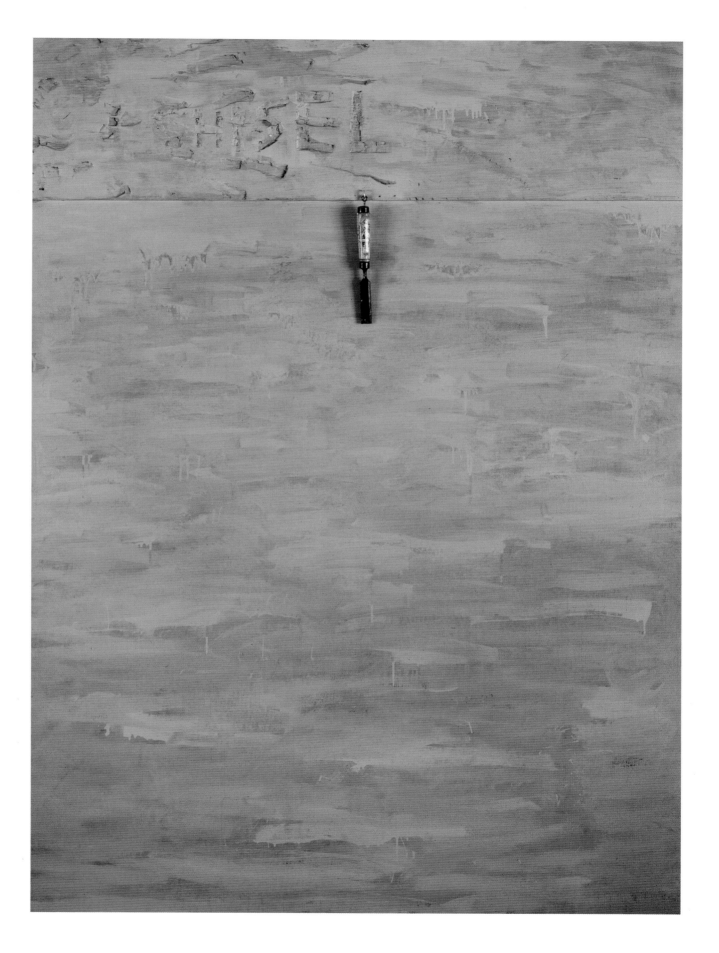

Jim Dine

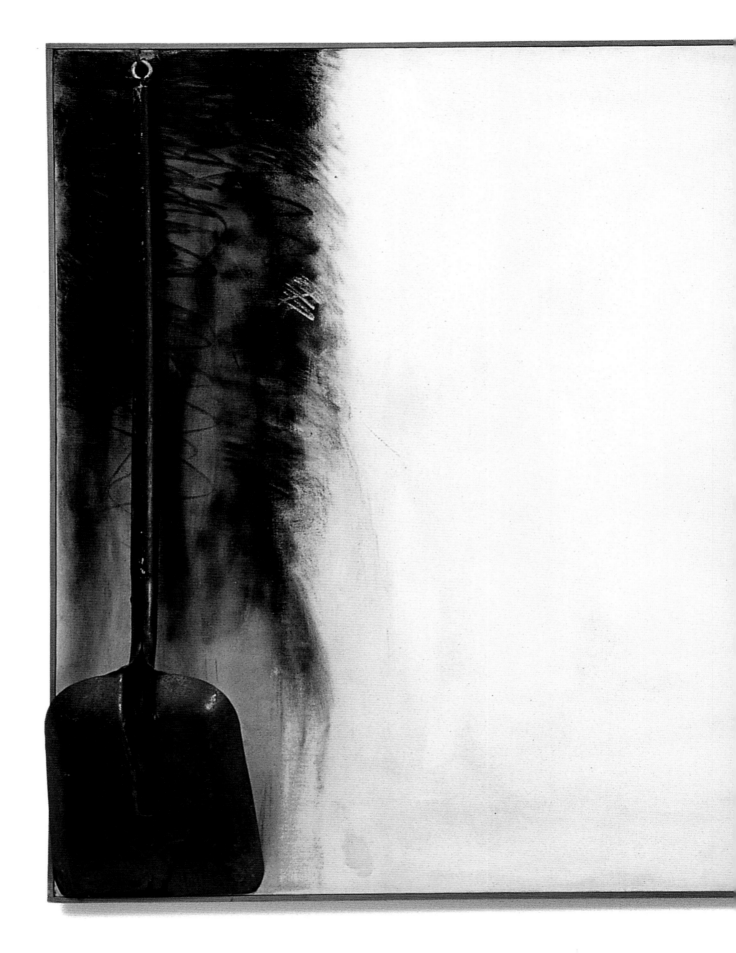

Jim Dine

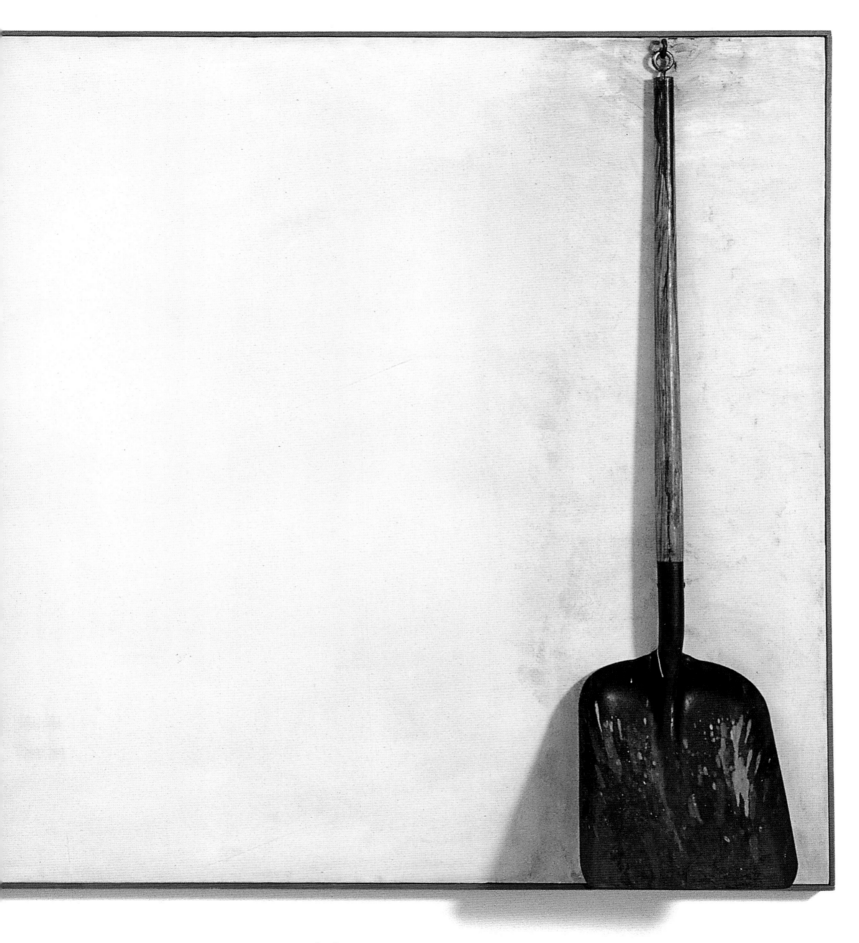

Jim Dine

Red Grooms

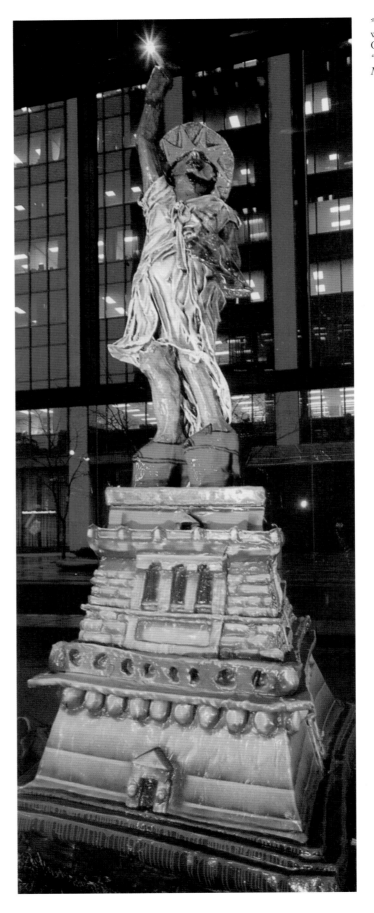

*206. Red Grooms in collaboration with Mimi Gross and the Ruckus Construction Company
"Ms. Liberty" from Ruckus Manhattan, 1976

207. Red Grooms in collaboration
with Mimi Gross and the Ruckus
Construction Company
*"Brooklyn Bridge", from Ruckus
Manhattan*, 1976

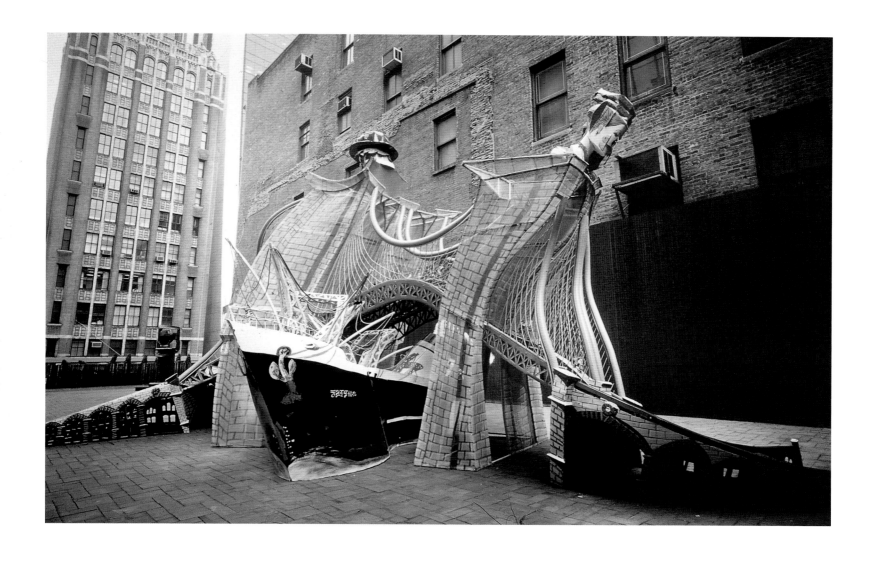

*208. *Little Aloha*, 1962

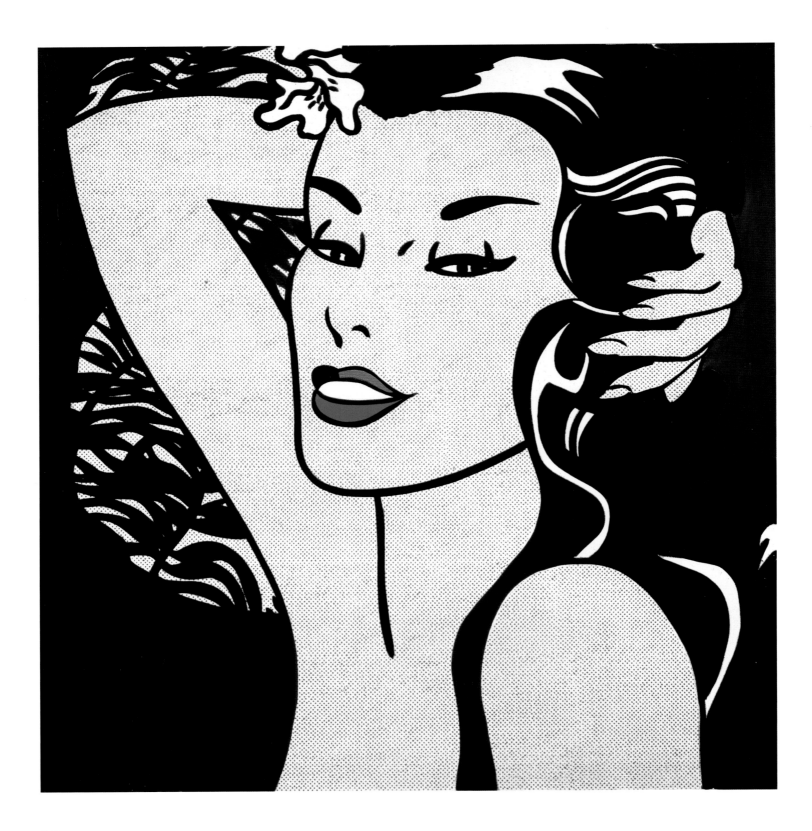

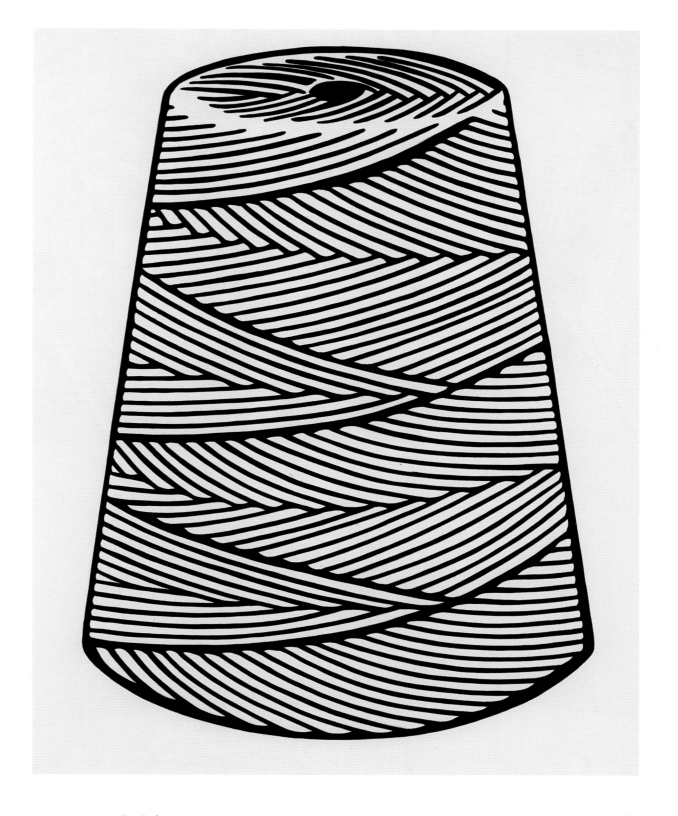

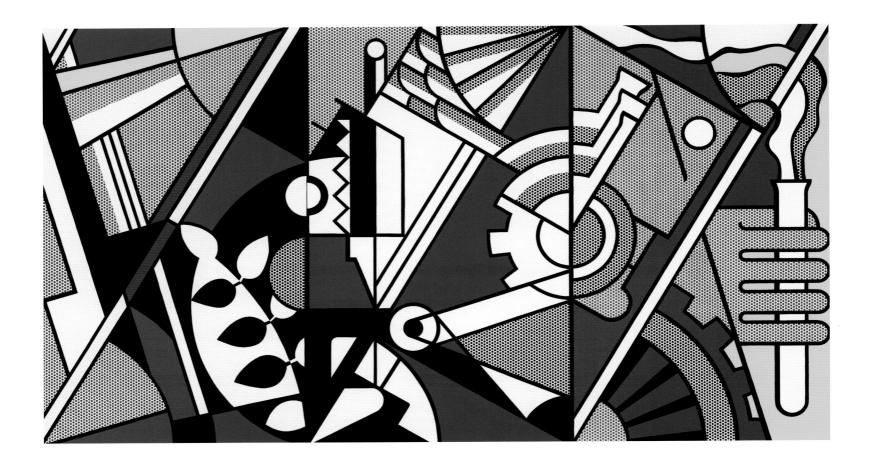

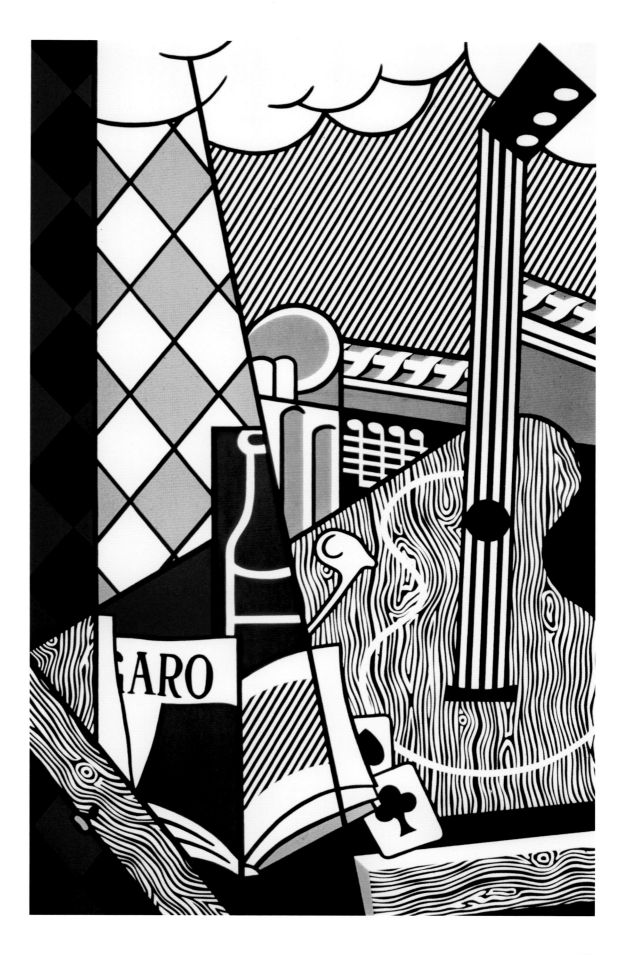

Claes Oldenburg,
Coosje van Bruggen

212. Claes Oldenburg
Three Way Plug, 1966

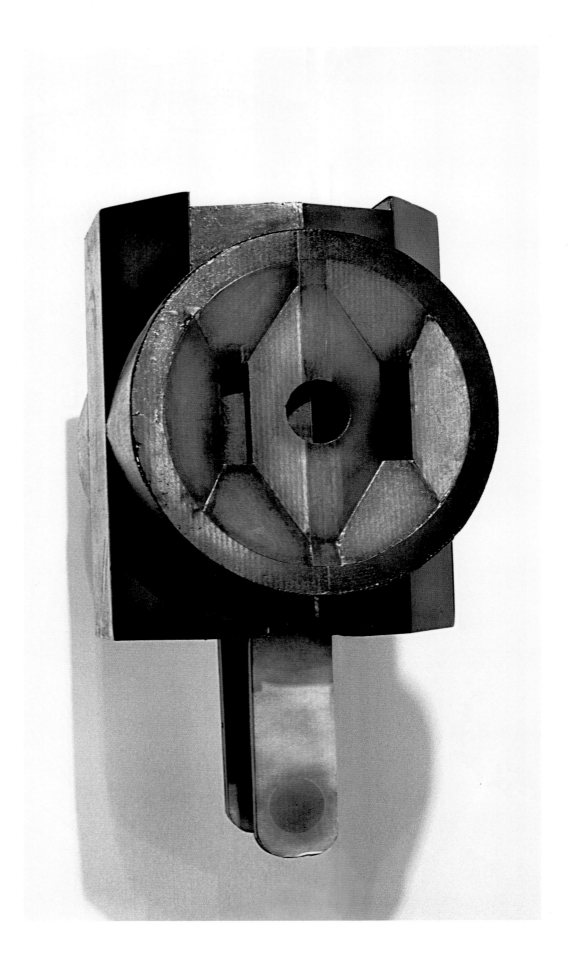

*213. Claes Oldenburg
Alphabet/Good Humor Bar, 1975

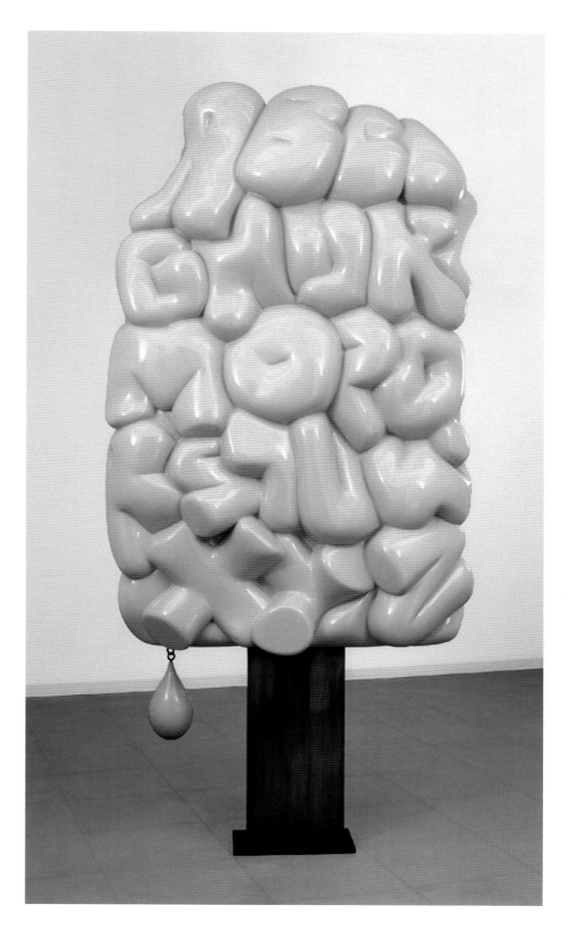

214a-b. Claes Oldenburg,
Coosje van Bruggen
Spoonbridge and Cherry, 1988

215. Claes Oldenburg,
Coosje van Bruggen
Monument to the Last Horse, 1991

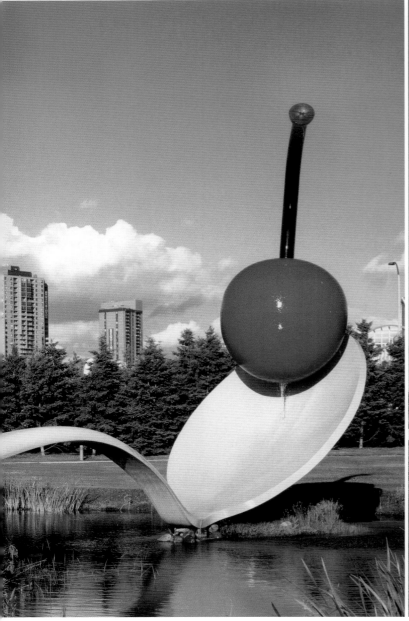

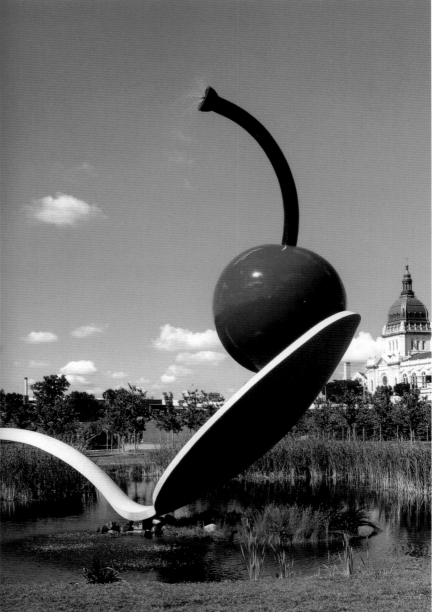

Claes Oldenburg, Coosje van Bruggen

ANIMO ET FIDE

James Rosenquist

*219. *Slipping off the Continental Divide*, 1973

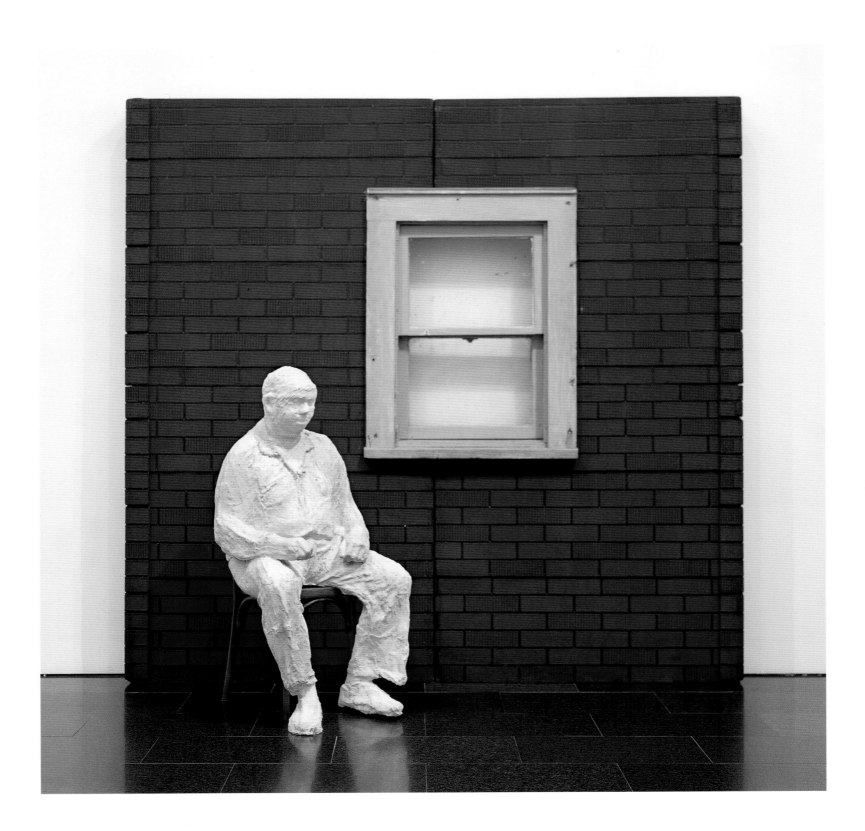

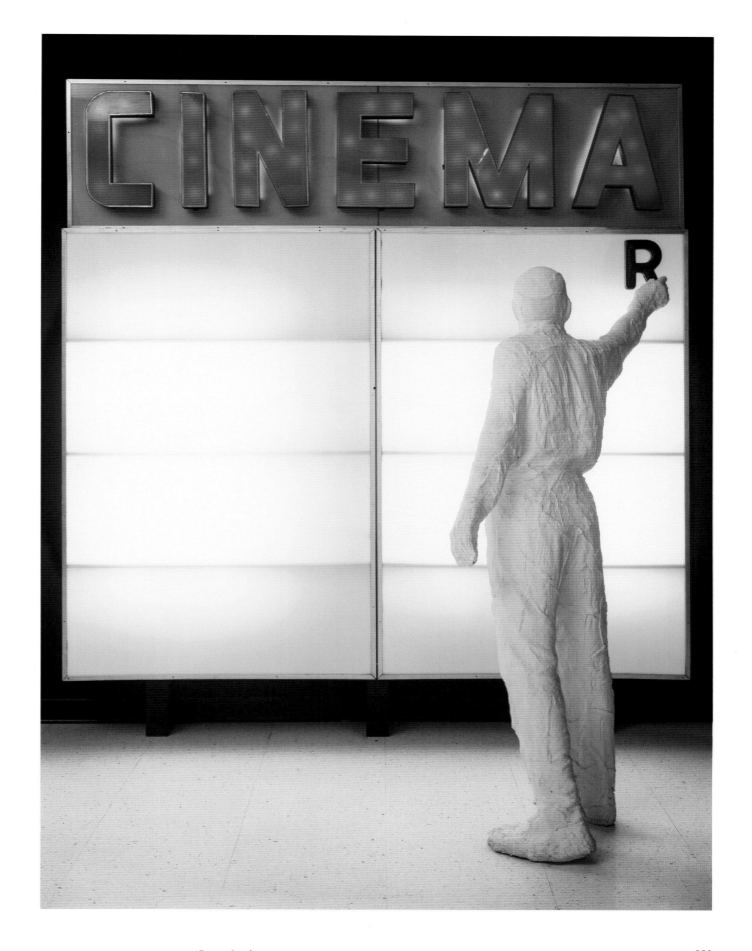

George Segal

222. Cherry Marilyn, 1962

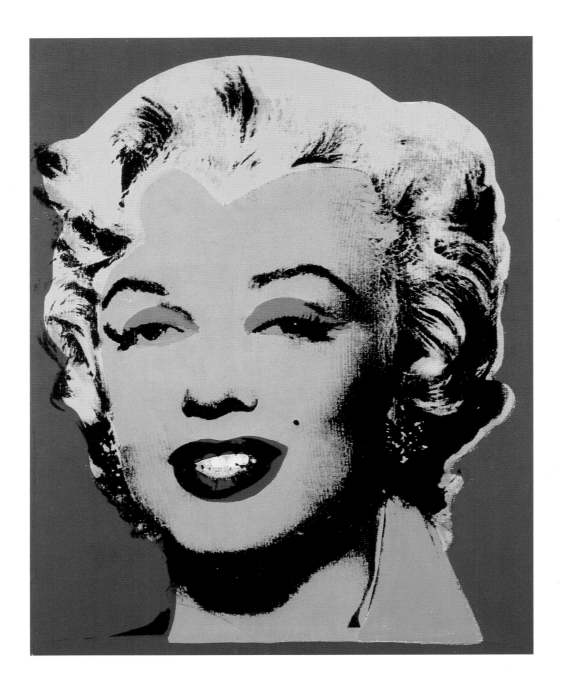

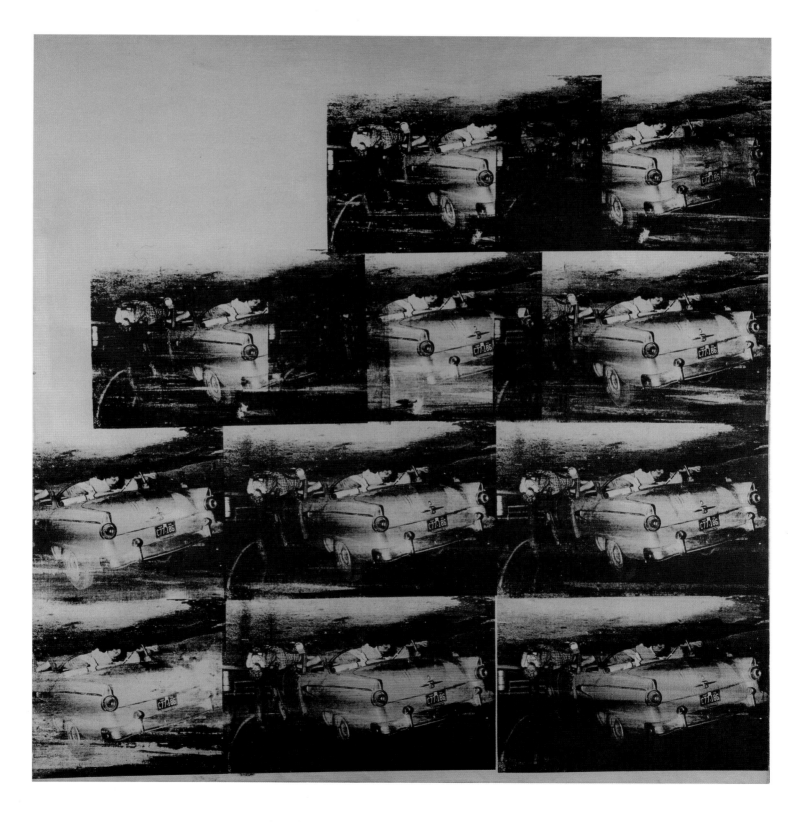

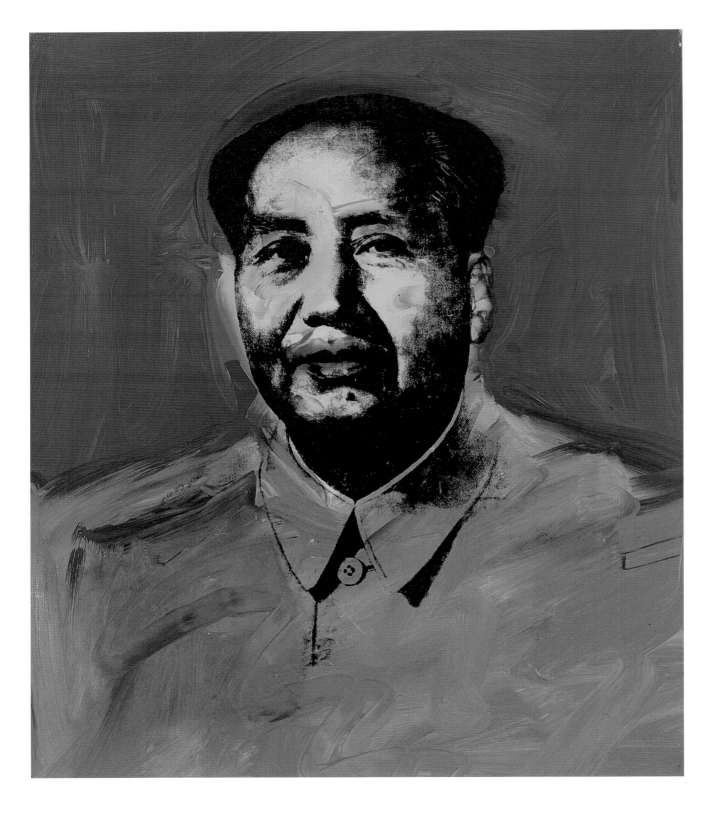

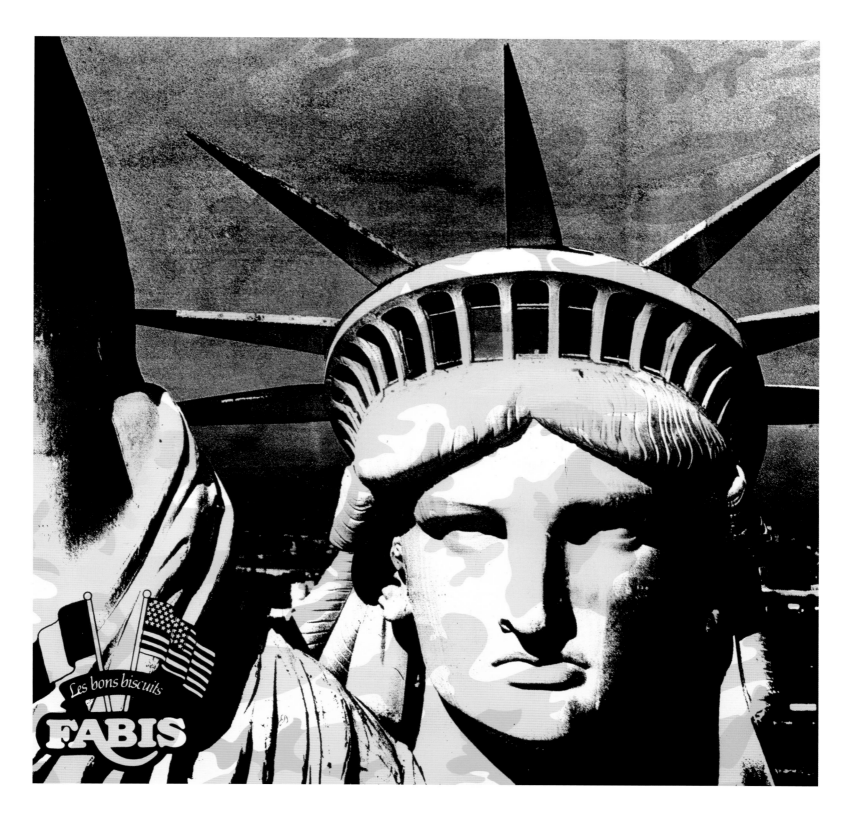

Tom Wesselman

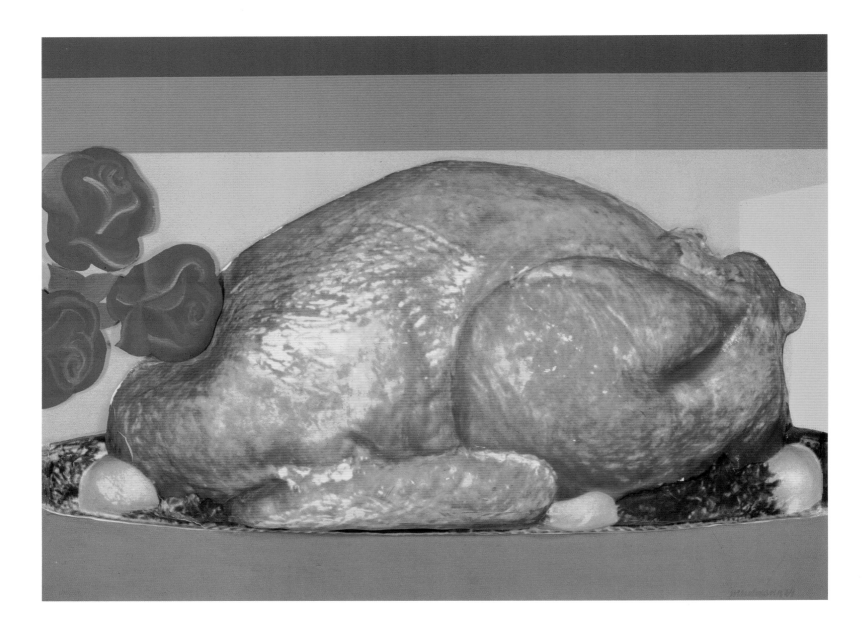

228. *Great American Nude #44,* 1963

1975-2000

New York, Vamp City

Mario Perniola

Gotham City

The idea that there is a close connection between New York and the so-called Gothic subculture might, at first sight, seem unlikely for many reasons. In fact, firstly this subculture was born in England between the end of the 1970s and the beginning of the 1980s, and sprung from the Punk movement. At the time it was even called Post-Punk. It seems that in those years its effects in the United States were felt more in California than on the East Coast. It reached its peak a decade later, above all in Germany and the Northern European countries, where a controversy developed regarding its ideological orientation towards the extreme right. Moreover, regarding youth fashion and rock music, the Gothic subculture does not seem to have any relationship with Postmodernism, that in the 1980s was the main cultural movement of the American universities (unless one can find a link between the re-evaluation of the notion of the "sublime" carried out by Postmodernism and the experience of fright and horror). However, within the field of humanistic culture, Neo-baroque and even Neomanierism have gained a lot of attention, whereas not the same can be said about a Neogothic trend containing novel elements as regards to the past.

The relationship between New York and the Neogothic is instead more reliable. As is well-known, New York was called Gotham City since the end of the 18th century. This was connected to a legend that since the Middle Ages had been ascribed to the inhabitants of an English town bearing the same name. The inhabitants in fact were alleged to behave weirdly and extravagantly, but not without being cunning so as to avoid paying their taxes by pretending to be stupid. It seems that it was the American writer Washington Irving who gave this nickname to New York at the beginning of the 19th century, when the city was starting to gain a great economic and commercial importance, which however was not matched by its low intellectual life. It is an 18th century cliché the opposition between the eccentric and chaotic New York and the tidy and rational Philadelphia.

If we turn from legends to architecture, the relationship between New York and Neogothic is not less original. Anticipated by the construction of Trinity Church (1846) and the pillars of Brooklyn Bridge (1869–83), the profusion of Neogothic architecture in New York seems a late and epigonic phenomenon in contrast with the European Gothic Revival which took place in the first half of the 19th century. In fact most of the Neogothic buildings, amongst which the Trinity and U.S. Realty Buildings (1904–07), Liberty Tower (1909–10), the renowned Woolworth Building (1913–30), the New York Life Insurance Company Building (1926–28), were built in New York between 1905 and 1930, therefore much later than in Europe and with entirely different aesthetic intentions from the European ones. In Europe two completely diverse interpretations of Neogothic lived side by side and in opposition to one another: the moral one, that sees in this trend the architectural expression of good, truth and religious transcendence (developed by Augustus W. Pugin and John Ruskin); and the cursed one which sprung up in literary Romanticism (already set forth in the 18th century by Edmund Burke in the feeling of "delightful horror," which found its main American literary contribution in Edgar Allan Poe). Regarding Neogothic architecture in New York, neither of the two interpretations seem suitable, because it is the expression of a commercial culture inspired by the will to power that is neither institutional nor alternative. Even though in the 18th century the painter Erastus Salisbury Field had already depicted in his colossal work *The Historical Monument of the American Republic* (1876–88) a fantastic city inspired by Babel Tower, made of enormous buildings decorated with statues and sculptures, this gigantic artwork—as Sarah Maclaren has maintained—belongs more to the aesthetic category of magnificence than to the Neogothic one. In fact the American institutional architecture continued to be profoundly linked to a neoclassical model until the 1930s; public buildings prefer horizontal positions to vertical ones, that are considered the expression *par excellence* of the industrial and financial power. In this regard, William R. Taylor quotes the 1931 Regional Plan that prescribed a horizontal position for buildings designated to offer public services. However in the 1930s Lewis Mumford and other progressive town planners had already expressed extremely negative opinions on Manhattan considering it as a cemented chaos, a chaotic accidentality, a den of dirt and obsessive advertising competition; this opinion was later on resumed and developed in the classic work on American town-planning, *The Death and Life of*

Great American Cities (1991), by Jane Jacobs. After 1930 the allure for the Gothic ends up in cinema and in Pulp journalism, of which it is quite a prominent aspect. Many films belonging to the horror genre take place in New York from the renowned *King King* (1933) until today. Neogothic goes from pulp, cinema, comics and architectural culture of the early 20th century to mass culture production for which the term "subculture" is not suitable, because it implies the idea of social marginality, whereas it creates products that are widely spread. I would like to coin the word "paraculture," in its double meaning implied in the Greek preposition *para* that means "next to, near," but also "from" thus suggesting coexistence, derivation and origin.

Goth City

Before the Neogothic turned into a "subculture" or better into a "paraculture," a further interpretation of Gothic culture was developed in Europe at the beginning of the 20th century. This can be seen as a fourth original idea of Neogothic, which is different from the first three (the institutional, the alternative and the commercial). The fourth interpretation, which I would define with the term "inorganic," seems the most appropriate one in order to see New York as a Goth City. The author is the German art historian Wilhelm Worringer and the cultural environment where German Expressionism was born. The work I refer to is *Formprobleme der Gotik* (1911). According to Worringer, Gothic is a step forward in the inorganic experience, because it does not stop to give a static, geometric representation of form; Gothic is full of a mysterious pathos, which confers dynamism to the inorganic, producing a type of artificial "life," a "living" mechanics provided with much more intensity than natural life. With Gothic, abstraction celebrates its own triumph, because it gets hold also of its opposite, the empathic dimension. However this kind of appropriation does not mean a harmonic synthesis at all. On the contrary, it is rather a troubling mixture of materiality and sensitivity, which looks like an "excess of dissoluteness" to an organically moderated vital feeling. The perversion of Gothic consists in breaking the boundaries of organic mobility: in fact as soon as the energy flows into the dead lines of the stone, it gains such a force that it overcomes any obstacle. Thus Gothic leads us into an experience of form which dissolves the very notion of form seen as a determined shape provided with a specific identity. One may wonder what type of "form" still exists in such an experience: I believe it is important to underline not only the feature of "transcendence" which all the founding fathers of the aesthetics of form have in common, from Wölfflin and Riegl to Worringer, but most importantly the aspect of exteriorization, which is opposed to any type of organic-vitalistic subjectivity. The energy that Gothic buildings seem to have is totally autonomous and independent of us, moreover it challenges us. The excitement it gives us has nothing to do with pleasure or play. Indeed it is something we would willingly do without, if only we could! Therefore the will of art (*kunstwollen*) does not belong to the subject, to the artist, but it is imposed on him as something alien and despotic. The feeling that goes beyond the senses of the Gothic experience must not be seen as a yearning for a dematerialized spirituality, but as something strange, the enigma of a vibrating stone. Once again the aesthetic experience is different from the religious experience, because it is indissolubly linked to the *res*, the thing, the mass. Gothic art is asymmetric and without a center: whereas classical art tends towards symmetry and the determination of a center, Gothic art throws itself on the endless repetition of one motif, on a restless strengthening. It suffers from a sort of "sublime hysteria," that allows it to find a convulsive and unnatural satisfaction only by being stunned and inebriated.

The result of the inorganic aesthetic experience described by Worringer is a different perception of the body, that loses its dimension of a living autonomous organism so exalted in the classical Greek nudes. In Gothic art clothing counts more than the body; the former gains an existence and an importance which is independent of what it covers. The victory of the inorganic over the natural reaches its climax in dealing with drapes, when these gain a movement that has nothing to do with life. Once again it is the combination of the abstract and the material that causes the emotion to be stronger and troubling.

Moreover the connections between Gothic and inorganic have been underlined by others even from a strictly building point of view. The Gothic church seems to be an organic building only at first sight. For instance it has been observed that the Gothic building system has always been pure plastic and that the ribs and the flying buttresses do not "carry" or support the structure. What Gothic buildings would have in common with the baroque ones is a meticulously realistic ornamentation, thus explaining a possible and logical connection between the two styles such as in the case of the Cathedral of Toledo in Spain. In Worringer's text we can find clearly outlined the main ideas of that type of experience which I have described in my book *The Sex Appeal of the Inorganic* (1994), where the most realistic sexual experience is removed from vitalism and held in abeyance in an intermediate and abstract space, similar on the one side to philosophical abstraction and, on the other, to those typical states caused by drug addiction.

Therefore we have a fourth type of Neogothic which is neither institutional nor alternative nor

commercial, even though it does share something with all three of them; it has something in common with religion (particularly Catholicism being the most institutional), with transgressions (above all sexual perversions); it uses the same devices as advertising and media (with which it has the same attitude of distance towards whatever is absolutely pure and originary). However it cannot be identified with any doctrine or ideology; it is different from the perversions studied by psychoanalysis; it is against the show business and the methods employed by the cultural industry, when they make everything alike and merely quantitative. In fact—and this is the main feature—it is a culture and not a "subculture" (or a "paraculture"), namely the effect of a creative activity that expects to be considered and recognized as such, while the "subcultures" (or "paracultures") are parasitic and second-hand.

Vamp City

This is the fourth type of Neogothic that I have found in New York through the lenses of a director who was born, lived and shot most of his films in this city, Abel Ferrara. One of his most interesting "neogothic" films is undoubtedly *The Addiction* (1995). At first sight it looks like one of the usual films on vampirism, a theme *par excellence* of Gothic subculture. The plot is fairly straightforward: a New York philosophy student is assaulted by a woman who bites her on her neck. From that moment onwards, the student falls into a state of uneasiness and cannot stop vampirizing other people, with whom she has deeply philosophical and religious relationships. During her graduation party she bites the rector's neck and sets off a bloody orgy. Taken to hospital, she dies after having been visited by the woman who had vampirized her and a friend who, even if she had been bitten on the neck, managed to escape her tragic destiny.

I was struck by the film, because even my book *The Sex Appeal of the Inorganic* (published in 1994, the year before Ferrara's film) acknowledges that vampirism has a paradigmatic meaning to understand today's life. This is characterized by a type of experience which is between life and death, focused on a sexual neutrality and an impersonal and posthuman sensitivity, that is exactly the same type the legend attributes to the vampire, *Nosferatu* (in Romanian, it literally means "has not passed away yet"). This type of pathology, that still has not been studied greatly by psychoanalysis, is deeply related to that part of modern philosophy, phenomenology, that gives a crucial importance to the state of abeyance, of *epoché*: by putting the subject in parenthesis, it introduces a dimension connected to things, but not to animal or to God. The focus on the things (on blood in the specific case of vampirism) unfolds an irresistible attraction to those extreme experiences that are the ones Ferrara's films deal with. The image of New York's culture, shown by Abel Ferrara, is therefore entirely different from the one provided by a director who is far more renowned than him, Woody Allen. Whereas the latter's work is focused on neurosis, i.e. on those pathologies that have always been greatly taken into consideration by psychoanalysis, Ferrara's films are obsessed by perversions and addictions, that, in my opinion, have a deep relationship with philosophy, even if this is simply due to the fact that these share an irresistible attraction towards radical and extreme things. Woody Allen's New York is a neurotic city, while Ferrara's one is "goth," namely a city where we have far more serious psychic pathologies that are almost always fatal. These pathologies present features that swing between perversion and addiction. While in my book and in other essays I have tried to analyze these within the framework of perversions (even drawing on the influence of the psychoanalytic developments on the topic given by Jacques Lacan, Robert J. Stoller and Masud Khan), for Ferrara the starting point of the inorganic Neogothic is already in drug addiction. All the imaginary and symbolic world, with its complicated mediations and enigmatic transits, is annulled and turned simply into craving, into the impossibility of waiting, into the compulsive need to take something or do something. Therefore even if the world of perversions can provide a space of happiness, it is extremely difficult that this can take place in the world of addictions, because they are felt as absolute constrictions which are impossible to get away from. In the film *The Addiction* only the master vampire, who quotes Baudelaire and Nietzsche, manages to dominate dependence!

It is also significant that Ferrara still sees vampirism as the addiction *par excellence*. Therefore he discovers the reasons why Gothic subculture has lasted for decades, whereas many other paracultures turned out being ephemeral. Firstly there is the postsexual character of the phenomenon that, even though it does has strong sexual implications, goes beyond the difference between masculine and feminine and towards a sex appeal of the inorganic experience: in fact the friar Ludovico Maria Sinistrari, consultor of the Santo Uffizio in the second half of the 17th century, claimed that the people who had had a sexual intercourse with a vampire used to find any other lover poor and incapable. However the main feature is its metaphoric aspect: this is referred to the fact that the vampire's need for blood is never satisfied and will keep on drawing it from his victims until they are weakened. But vampires would not be so popular, if in the unconscious of today's society there were not such an unconscious desire to be vampirized.

New York has been the vampire city *par excellence* in the world for the last fifty years. It is the city

that has sucked the whole world's blood, feeding itself on the cultures, knowledge, styles, information, material and spiritual goods coming from all over and turning them into values, wealth and resources suitable to circulate across the globe. In philosophy, the so called French Theory is exemplary: post 1968 French thinkers have been vampirized by New York and then sent to American universities.

The issue that Ferrara's film addresses regards the opportunity of resisting vampirization: in any case, the vampirized, starting from the chief character of the film the *The Addiction*, could resist the mortal bite, if they were strong enough to fight it off firmly. The vampire says to the chief character: "Look at me and tell me to go away," but this does not happen. Ferrara believes in free will: the addicted in his films are always questioned and are guilty because they do not give the right answer. Someone manages to get away from New York: for example, in the film *Bad Lieutenant* the nun's rapers are forced by the policeman to get a coach that will take them far away from New York. In *Mary* the chief character ends up being so involved with the role she is acting, that she goes to live in Jerusalem. Nevertheless she gets tracked down by the journalist of a New York television talk show and takes part in the programme via telephone with a performance that puts the director in the shade, who realizes with the utmost concern that he is no longer the star of the show. The thing is that nowadays there are too many people who offer their blood free and without any feeling of guilt! In the film *New Rose Hotel*, a plan set up in New York by a secret agent and a prostitute, expresses the former's abstract will to power and the latter's capacity of seduction. Not much later, however, there will be neither one of them. In fact Abel Ferrara's addiction is still full of immoral tension, that weakens due to the continuous banalization of today's life.

So this is how the myth of New York ends along with the Gothic myth. Myths in which the great New York novel writer William Gaddis never believed. In his two great novels *The Recognitions* and *Carpenter's Gothic*, he started a fifth type of Gothic which following the institutional, the alternative, the commercial and the inorganic could be called derisive Neogothic; a type of gothic which in a certain sense paradoxically summarizes all the other ones, vampirizing them and turning them into the best antidote to trash in Gothic subculture.

Bibliography

G. Baddeley, *Goth Chic: A Connoisseur's Guide to Dark Culture*, Plexus, London 2002.
F. Cusset, *French Theory. Foucault, Derrida, Deleuze & Cie et les mutations de la vie intellectuelle aus États-Unis*, La Découverte, Paris 2003.
S. Danese, *Abel Ferrara*, Le Mani, Genoa 1998.
W. Gaddis, *The Recognitions* [1955], Penguin, New York 1993.
W. Gaddis, *Carpenter's Gothic* [1985], Penguin, New York 1986.
J. Jacobs, *The Death and Life of Great American Cities: the Failure of Town Planning*, Penguin, Harmondsworth 1965.
S. Maclaren, *La magnificenza e il suo doppio*, Mimesis, Milan 2005.

V.L. Parrington, *Main Currents in American Thought: an Interpretation of American Literature from the Beginnings to 1920*, Harcourt, Brace and Company, New York 1930.
M. Perniola, *Art and its Shadow* [2000], Continuum, New York-London 2004.
M. Perniola, *The Sex appeal of the Inorganic,* [1994], Continuum, New York-London 2004.
A.W. Pugin, *Contrasts or a Parallel between the Noble Edifices of the Middle Ages and the Corresponding Buildings of the Present Day Shewing the Present Decay of Taste*, Charles Dolman, London 1841.
T.R. William, *In Pursuit of Gotham: Culture and Commerce in New York*, Oxford University Press, Oxford 1992.
W. Worringer, *Formprobleme der Gotik*, R. Piper & Co., Munich 1911.

"Bubble in the Wine"

Herbert Muschamp

In the first fifty years after the end of World War II, New York architecture passed through two distinct phases and lurched fitfully into a third, a chapter that is now unfolding in the shadow of September 11. The impact of that event has proved uncontainable, in time as well as space. Perhaps inevitable, it has affected our view of the entire postwar period, when New York seized its moment to become the world's most culturally energetic city. The World Trade Center was a product of that energy. Its destruction, and the confused efforts to rebuild on the site, helped to illuminate the ebbing of the progressive spirit that animated the immediate postwar decades. The aftermath of September 11 also brought to the surface profoundly unresolved conflicts over the criteria New Yorkers have brought to the evaluation of their buildings for the past half century.

This confusion was evident in efforts to affix a consensus of opinion about the merit of the toppled towers after they'd been destroyed. For a long time, the World Trade Center was assumed to be a critical failure. For many, the buildings were thought to represent the brutal insensitivity of modern architecture to urban context. Their height shattered the scale of the Lower Manhattan skyline, obliterating what had previously resembled a crystalline formation. Worse, the Trade Center's "superblock" approach to urban planning erased the scale, diversity, and liveliness of the traditional Manhattan street grid, opting instead for an overscaled open plaza, a public space that was shunned even by workers in the towers.

Yet by 2001 this view had been eroded by the perceptions of several overlapping audiences. Younger architects, many of them not even born when the towers were completed, looked to the complex as a symbol of a time when optimism in the city's future was reflected in its willingness to embrace innovative urban forms. Faced with the evident shortcomings of so-called "contextual" architecture, and unwilling to accept its reactionary dogmas as self-evident truths, this group wished to claim as its inheritance the progressive outlook of the immediate postwar years.

Tourists were the largest group of dissenters from the critical consensus. Whatever their aesthetic or urbanistic merits, the towers were inaugurably a New York City icon, perhaps the most prominent the city possessed. Thanks to their Egyptian scale, the towers made ideal targets for the September 11 attacks. But tourists had selected the towers years before as an image for photographs, postcards, tee shirts, and souvenirs. In the court of public opinion, the towers were winners.

Office workers and residents in Lower Manhattan—theoretically the people most likely to be negatively effected by the superblock configuration—had mixed feelings about the buildings. For office workers, the underground shopping mall was a popular lunch hour destination. The shops were affordable, the concourses pleasant to stroll around. The Borders bookstore was a particular magnet for downtown residents. But many of us had also grown fond, if at first reluctantly, of the over-towering perspectives from close up. And we could see with our own eyes that the World Trade Center plaza was scarcely the barren wasteland depicted by its critics. Programming had made all the difference: lunchtime concerts, winter skating, and evening performing arts events drew sizable crowds year round.

Those who tried to reassert the conventional negative view found themselves in an uncomfortable position. Not only did they reveal themselves to be out of touch with changing taste, they also gave the appearance of dancing on the buildings' grave. In the weeks that followed, this impression was reinforced by plans that sought to restore the old street maps to the site, as if fate had created an opportunity to turn back the clock to some pre-modern dispensation. But was that the response New York wanted to make to September 11? This scarcely seemed like the ideal moment to escape into a theme park fantasy of prewar New York.

But why should there have been a consensus of opinion about the Twin Towers? What was so disconcerting about the evident lack of one? Call it the residue of historicism, the 19th-century belief that it is the business of a historical period to build in a particular architectural style. This idea persisted well beyond the 19th century. Indeed, historicism was underlying ethos of New York's architecture in the immediate postwar decades.

Though Modern architects may have broken with the use of period styles, the ethos driving them was the Victorian view of style as the embodiment of a period. As Mies van der Rohe put it, "Architecture is the will of an epoch translated into space." In the postwar years, the Miesian translation became the defining form of the Manhattan skyline. Commonly known as the International Style, it might be more accurately termed a Ger-

man style: it epitomized the aesthetic promoted by the Bauhaus, and the philosophy that informed the Bauhaus approach to design. Nieue Sachlichkeit—the New Objectivity—this philosophy was called. A reaction against the obscure symbolism of Expressionism, the movement toward objectivity manifested itself in a stoic refinement of material essentials. Instead of treating architecture as applied ornament in the 19th-century manner, modern architects proceeded to "make architecture out of building," in Neil Levine's phrase, "by developing the esthetic potential of structural engineering."

It was common in those days to say that modern design proceeded from the inside-out: it began with the structural frame, worked its way through the program of required spatial enclosures and the circulation systems for moving between them, and in some cases the technologies for controlling temperature, light, and air. In the theory, the appearance of the building was strictly determined by the outcome of this analytic. The outward of the building's internal causes was free from the architect's personal expression.

Yet it could be argued with equal merit that this method actually proceeded from the outside-in. In selecting objectivity as the chief criterion of architectural value, modern designers invested their authority in a system of thought that commonly signified the reality of the world "out there." By suppressing subjective perception in the name of objectively verifiable truth, they held the building accountable to methods associated with the field of science. They also availed themselves of the aura of benign progress that was enjoyed by science in those optimistic years.

This was an undeniably powerful combination, so long as it held. After the war, and the Great Depression that preceded it, these ideas fully embodied the myths in which most Americans wanted to believe. It also fit naturally into the mythological scheme New York had constructed itself as the capital of the arts and intellectual life in the postwar years. And I doubt that anyone who grew up in New York in those years was immune to its spell. The appeal was partly the allure of unity. The organic consistency of those buildings appeared to leave nothing out of the picture. They presented themselves as ideal containers for whatever subjective experiences individual inhabitants might care to pursue. And they endowed postwar national power with an admirable lightness of being: they were Apollonian in this sense. The self-containment of the Seagram Building is purely magnificent. And it's not easy to let go of Apollo, even when you know that the demands of Dionysus will not be denied.

Indeed, for a period of years, International Style buildings served those demands with considerable flair. They did so by providing aggressive novelty, a quality dramatized by the stark contrast they ini-

tially presented to their aging masonry surroundings. Yet the attitude of modern architects toward the concept of novelty was highly ambivalent. On the one hand, they did not hesitate to exploit the moral aura of "the new" as the inspired opposition to a status quo that they held to be socially as well as artistically obsolete. But the emotional appeal of novelty was strenuously denied. Modern architects were not promoting newness for its own sake, as they saw it, but for the sake of progress: for the purpose of advancing from an inferior to a superior model whose benefits in physical and psychological well-being could be objectively measured. Notwithstanding the International Style label, modern architecture was not a style. In theory, it represented the elimination of style; it pitched design above the subjective level of taste.

This rhetoric was not false, merely incomplete. As you might suspect, the denial of novelty's value indicated the power of its appeal, not only to the public but to modern architects themselves. Indeed, pace Mies, novelty was no small part of the "will of the epoch," and why should any epoch settle for being translated into space by a single architect and those content to follow his example? Why should it settle for becoming monotonous, or for losing the charm of contrast, the pace of change? And, if reason should prevail, where is the evidence that architecture should restrict itself to satisfying rational needs?

The idea that buildings of an era should aspire to speak a common language is not ignoble. And the attainment of consensus about what language that should be was one of the glories of postwar New York. But cities are discussions and often arguments. Their material forms embody periodic disagreements over the use and adornment of space. This is an ideal also, for an open democratic society, one that came to the fore in the 1970s in the field of city planning. Since unity of expression necessarily extends beyond the isolated building, it was inevitable that this field would become a ground of contention. In 1960, Jane Jacobs had framed the terms of debate with her pioneering book, *The Death and Life of Great American Cities*. By the end of the decade, modern aesthetics as well as modern planning principles had come under strong attack from many quarters. Like other aspects of the liberal consensus culture, modern buildings fell prey to 1960s attitudes of provocation and dissent.

For many, the Ford Foundation Building remains a pivotal work in the shift of opinion away from modern aesthetics. Completed in 1967, the Ford Foundation was designed by the New Haven firm, Dinkeloo and Roche, heirs to Eero Saarinen's practice. From its scale, proportions, materials, and detailing, its play of solid and void, it was instantly recognized as a work of exceptional quality. The leafy green canopy of the enclosed garden intro-

duced a note of delight comparable to the soaring rotunda of Frank Lloyd Wright's Guggenheim Museum.

But that same note struck some as false, for though the garden looked enticing, it did not reward those who allowed themselves to be enticed. A little walkway led through it, but there was no place to sit down, or linger comfortably; indeed, a small sign expressly forbid sitting. The garden only worked when you were outside it, and that is not how an oasis is supposed to work.

The semiotic analysis of urban form was not then in widespread use. Even the term was scarcely known in the United States. So it was hard to find the language to describe why some were unsettled by the building's effects. It was noted that the foundation's president had been an advisor to President Lyndon Johnson and was therefore implicated in the nation's policies in Vietnam. This hardly qualified as architecture criticism, yet the connection seemed, in a general way, to illustrate the shortcomings of the liberal consensus that had governed cultural matters in the postwar decades. Political consciousness had been invaded by images of the defoliation of Vietnam's jungles by chemical weapons like Agent Orange, and it was hard to divorce those images from the leafy foliage of the building's garden. The strategically negligible destruction of plants and the visual deployment of them to convey a bogus arcadian image: both pictures seemed to be drawn from the same reservoir of bad faith. How was it possible to go on overlooking the dubious ethos of technological mastery when appraising its architectural artifacts?

The building was a beautifully made shoe that fit a foot that had taken a wrong turn. I am not suggesting that this ethos discredited the building. The point is that it embodied the anxieties provoked by this ethos and in doing so helped conscientous observers to become more aware of them. In hindsight, it appears that this was one of the principle functions architecture was called upon to play in the postwar decades, increasingly so as the 1960s unfolded. Eero Saarinen's office performed this function with consummate flair. To his clients and the public, Saarinen virtually epitomized progressive architecture in the early part of the decade. Yet, perhaps in part because of his evident popularity, some adherents of orthodox modernism regarded his later projects with increasing suspicion and alarm.

The TWA Pavilion aroused particular anxiety among these observers. The building's great soaring roof conveyed the idea that the expressive possibilities of structural concrete had been fantastically unleashed. In fact, as critics pointed out, the roof's structure was made of steel, with the concrete slathered over it almost like frosting on a cake. This violated the well-established canon of the "truth to materials."

Yet why should we deprive ourselves of the pleasure of a soaring surface of smooth concrete simply because metal has been used to hold it up? What is the point at which this self-imposed deprivation becomes pathological, a form of moral masochism displaced onto pieces of the city where guilt is out of bounds?

Saarinen's posthumously completed CBS Building also caused a stir when it was revealed that there were no structural piers beneath some of the tower's black granite sheathed columns. An image arises of New Objectivity inspection squads groping around on hands and knees at the base of the building, tap-tapping to see which of the columns were hollow. But who wants to watch people converting our pleasure into their pain? Why couldn't they do this in private?

Anxiety about pleasure also shaped critical responses to the new Summit Hotel, designed by Morris Lapidus and completed in 1961. One much-repeated comment—that the hotel was "too far from the beach"—registered the design's libidinous content only to swat it down with grim Puritan disapproval. The Gallery of Modern Art, designed by Edward Durrell Stone and completed in 1965, aroused similar displays of contempt. "A die-cut Venetian palazzo on lollypops" was Ada Louis Huxtable's memorably withering comment.

But the biggest orgy of moral masochism arrived with the opening of the 1964–65 New York World's Fair. Here, the disapproval was focused on the Belgian Village, a full-scale replica of a Flemish town square and the crooked little streets around it. With the added lure of the Belgian Waffle, a nauseating concoction of fried dough, sweetened cream, and strawberries, the Village was the Fair's most popular attraction. Critics were less dismayed by the pavilion itself—there wasn't much fun in dismissing as kitsch a design that didn't try to be anything else—but on the public's enthusiasm for it. Disapproval also fell on the fair's organizers for creating a spectacle from which an architectural vision was conspicuously absent. The whole event added up to a Belgian Village so far as most critics were concerned. In this carnival atmosphere, Saarinen's IBM Pavilion, designed in association with the office of Charles and Ray Eames, who were responsible for the multi-screen media presentation inside) stood out as a model of modernist rigor.

Hierarchy is built on the capacity to deny responsibility for the undesirable effects of one's own causes. That is true of top-down approaches to art as well as corporate institutions. "What went wrong?," a dismayed Mies van der Rohe was once heard to exclaim, when architects began to pull away from his example. "We showed them how to do it." Mies had indeed shown how the ideal of objectivity could be beautifully realized for a 20th-century city. But he had also shown, inad-

vertently, that the city stood for other ideals that were also in need of realization.

It is against this background that we gain an insight into the role architectural preservation began to play in the 1960s. The appeal of buildings like Grand Central Terminal was only partly derived from the contrast of "oldness" to the prevailing dictates of newness. Of perhaps greater importance was the impression of irrationality that such buildings offered in contrast to the ethos of reason. A rationalist would never come up with the idea of putting a statue of Mercury on top of a train station. Pagan gods had no place in the grids that objectivity had devised for correlating structural and programmatic functions with architectural forms. This displacement gave Mercury great gaiety. In fact it is arguable that Mercury finally came into his own in the era of rational grids. Hermes, the Greek God incorporated into the Roman Mercury, represented the transgression as well as the setting of boundaries, the mobility of minds as well as bodies, the bearer of dreams. Never before had the need for such a deity been as clear as it was in the years when architecture aspired to the condition of graph paper.

Preservation followed the Hermetic logic of dreams. And once this logic had disclosed itself, it seemed logical to expect that new buildings would follow it as well. For a time, it seemed that this might happen. For example, Aldo Rossi's *Architecture of the City*, published in Italy in 1966, introduced the concepts of introspection and memory as potential generators of contemporary urban form. Scholars, meanwhile, were uncovering other paths that modern architecture might have taken and in some cases did take before the New Objectivity took control. Expressionism, virtually eliminated from conventional histories like Pevsner's, reemerged as a source of formal and ideological inspiration. So did Constructivist designs of the Soviet avant-garde. Pop architecture—roadside tourist attractions, theme motels, gambling casinos, futuristic coffee shops—was revaluated by Robert Venturi and Charles Moore.

This mix of ideas seemed to portend an era of richer artistic imagination. This prospect did not immediately materialize in New York, however. Disillusionment with modernism certainly set in. But the historicist ethos underlying modern architecture was retained its grip. That is one of the lessons that emerged with New York's variant of Post-Modern architecture in the 1980s. Instead of a wider aesthetic latitude, architects increasingly subject to stringent design guidelines. Typically, the guidelines were based on generalized impressions of Manhattan prewar architecture. Though usually described as "contextual," they were highly selective in their models of what a proper context should be. Often, the guidelines bore little or no coherent relationship to the actual surround-

ings of the new buildings that were guided by them. In the case of Battery Park City, where this approach was pioneered, guidelines based on prewar architecture were applied to ninety-two acres of new landfill separated from the rest of the city by a six lane highway.

In theory, this approach was supposed to represent a return of or to tradition, though there was seldom any discussion of which tradition was to represented and what other traditions were to be ignored. We also heard a lot about the return to or of Classicism, but it was never made clear why a post-modern design by Michael Graves was more entitled to wear that label than, say, that little steel and glass temple, the Pepsi Cola Building. But this wearing of fancy labels held evident appeal for the developer clients who found themselves treated by their architects to slide shows in which it would be demonstrated that the next post-modern eyesore was nothing less than a direct discendent of the Parthenon, and perhaps the Pantheon, too.

If not great for architecture, the period at least generated rich social comedy. And it was a time that needed all the laughs it could get. New York in the 1980s was still in shock from the fiscal crisis of the previous decade. Corporate headquarters were still decamping to suburban office parks. Manufacturing jobs had all but disappeared. At a time of insecurity about the future, some found it reassuring to recreate architecture from the past, when it seemed that New York had known better days. Art Deco became a favored design motif. The concept of "appropriateness," otherwise known as aversion to risk, acquired signal virtue. In such an atmosphere, strong artistic convictions proved a definite handicap. No one understood this better than Philip Johnson, an architect who found himself cast in the role of the period's unofficial regent. No one else had Johnson's knack for injecting social comedy into the actual forms of his buildings. Hopping promiscuously from period style to geometric abstraction, Johnson and his partner John Burgee appeared to practice architecture as a hysterical form of polymorphous perversity. Mies van der Rohe, Johnson's former mentor, had insisted that "you cannot invent a new architecture every Monday morning." Then how about a different old architecture every other Tuesday?

Johnson's flirtation with historical styles, if perverse, illustrated that historicism's 19th-century framework had completely collapsed, leaving nothing behind but memories of ornamental gestures. These now drifted aimlessly through the cityscape like the decorations floating on the sea above the grave of a sunken liner. As the the International Style's most ardent champion, Johnson had extended historicism into its grand, 20th-century finale. No one was better equipped to understand that the parade had finally passed by. In this sense, Johnson's motley approach helped to prepare the

"Bubble in the Wine"

way for the broad diversity of individual voices that would later begin to make themselves heard. There was another meaning, too. Why not hysteria? Why not a state of mind? Reason is not the only legitimate framework for mental activity; emotion also has valid claims on the lives of city-dwellers. Already, as the man who chose pink glass for the Seagram Building's curtain wall, Johnson had subverted Objectivity with a libinous tint. In his later years, the subjective dimension took over completely. It was as if, having taken architecture down to the bare minimum of Mies's "almost nothing," there was nowhere to go but into the depths of the architect's psyche.

The results of such excavations might even resonate with others: this should be kept in mind by those would like to dismiss Johnson as a mere personality with little of substance to contribute to architecture per se. Personality—including the subconscious architecture of personal fantasy—would hold the key to architecture future's as a socially communicative medium. One day, architects more latently gifted than Johnson would learn how to turn it.

I have a fondness for I.M. Pei's Four Seasons Hotel. While Pei distanced himself from the postmodern movement, he was able to exploit it here for romantically expressive ends. Others tried, but Pei managed to pull it off. On a certain level, Post-Modernism stood for the idea of good taste, but you can't invent that on a Monday morning, either. Pei was born with it, and this quality shows as clearly in the Four Seasons as in his remodeling of the Louvre. The hotel shows one of the paths Post-Modernism might have taken if it had subjected its fascination with Art Deco to rigorous modern standards.

If the building has been undervalued, that is partly because not everyone believed that this path was worth taking in the first place. For the most part, Johnson's follies notwithstanding, these were years of exile for New York architecture. Committed modernists, like Charles Gwathmey and Norman Jaffee, found most of their work in the beach resorts of the Hamptons or their West Coast equivalents. Richard Meier retreated to a mountaintop in Los Angeles to build the Getty Center, a complex regarded by many local architects as an alien East Coast landing. Peter Eisenman sustained almost entirely on unbuilt projects and as director of the Institute for Architecture and Urban Studies, an ivory tower outpost in mid-Manhattan.

John Hejduk attained distinction as an educator, while directing the architecture program at Cooper Union, and as a visual artist whose drawings helped to reintroduce the concept of narrative as a generator of urban form. An element of masochistic retaliation pervades Hejduk's work: the lament of an artist who rejects the world for refusing to recognize his genius. But, for many architects born in the so-called Baby Boom years immediately following World War II, Hejduk's example proved irresistible. "Paper architecture," graphic representation of unbuilt and in many cases unbuildable projects, became an end in itself. Lebbeus Woods, Daniel Libeskind, Bernard Tschumi, Elizabeth Diller and Ricardo Scofidio, and Henry Smith Miller and Laurie Hawkinson were among those who attracted prominent notice with works in this genre. Rem Koolhaas's Delirious New York, based on the Dutch architect's impressions on his generation.

This age group had been profoundly influenced by the student upheavals of the 1960s and the rejection of authority they represented. It was also led by the example of Conceptual Art to embrace the idea that architecture works primarily through consciousness and is therefore not contingent on the manipulation of material reality on the urban scale of enduring built form. Work by Europeans like Archigram, Constant, Yona Friedman, and Cedric Price also served as models. Gallery installations, theatrical design, and other ephemeral events; portfolios of drawings; teaching assignments; and an increasing reliance on distribution through the media: such activities became the basis for alternative forms of architectural practice. Interior spaces also offered refuge. Here, too, architects followed the lead of artists. Warhol's tinfoil lined studio on East 47th Street, and the ephemeral environments he created by projecting movies on walls were among the most memorable places of the 1960s. The environments Alan Kaprow created for performance pieces also enlarged the domain for spatial intervention. By the 1970s, the term "environmental design" had supplanted interior design in schools and professional practice. Nightclub design, in the 1980s, became a popular medium. Arata Isozaki and Massimo Iosa-Ghini were among those who worked in this genre. Philippe Starck's hotel designs for Ian Schrager helped to define the period.

The introversion of paper architecture was dismaying, at least for those who believe that architecture resides in large part in the process of extending metaphors into the public sphere of material reality. But this process can take a long time, even in the most congenial circumstances. What seems clearer in retrospect is that the withdrawl from conventional practice allowed ideas to develop in times that were relatively hostile to ideas. It became possible, and eventually natural, for young practitioners to develop a personal voice, for example, and in doing so to create a field in which individual subjectivisms were seen to be part of a collective whole. You might not want an entire city to be built according to the principles inherent in the work of any one of these designers, but that possibility was scarcely in the cards. But the

field generated by them projected a complexity any city lover could admire.

Conceptual projects also enabled architects to establish relationships with the audience for contemporary work. This was especially evident in the Art on the Beach program sponsored in the early 1980s by Creative Time, an independent group dedicated to staging art events in unexpected locations. For Art on the Beach, Creative Time secured several dozen acres of landfill on the Hudson River, the future site of Battery Park City. (It is worth noting that the landfill site was initially created with earth removed from the future Ground Zero: the site of the World Trade Center prior to the construction of the Twin Towers.)

Each summer, the group invited artists, architects, and performers to collaborate on projects, in effect creating an ephemeral Club Med for the avant-garde. Architects without clients in the Hamptons had an alternative beach to play on. But the projects themselves were less important than event's creation of public access to them. People not only got to see original work by promising designers. They also got to see one another in the act of paying attention to it. As such, Art on the Beach became a symbolic staging ground for the audience that would eventually change the climate for architecture in New York.

In the 1980s and 1990s, this audience continued to swell. It was evident in the turn-out at art museums and private galleries (most notably that of Max Protetch) where architecture and design shows were held. Before long, it became evident that one of post-modern architecture's pivotal tenets was a dubious myth. You couldn't rouse an audience to see a show of post-modern historical pastiche. So where was this famous public that was supposed to be clamoring for it?

You could get a big crowd for old buildings. You could get a crowd for designs that revealed some dimension of contemporary life. But the only people who wanted these ersatz old-fashioned clunks carved out of processed American cheese were the sort of people who can't relax on holiday because they're too busy complaining about the folks with the loud radio that they deliberately chose to sit beside on the beach.

A popular misconception holds that the redevelopment of Ground Zero has been beneficial for architecture in New York. It happens that the reverse is true. The New York audience for contemporary architecture had emerged long before then. It represented something far more substantial than the swelling of numbers at museum design shows. It reflected the rejection of the prevailing post-modern notion that the public abhors buildings conceived with a high level of creative ambition. As the attendance figures at museum shows made clear, a substantial portion of the public had a robust appetite for new ideas. And this very real segment made it more difficult to use an abstract, chimerical "public" as a cudgel against artistic values.

Naturally, some elements of the architectural profession felt left behind by this turn of events. They had built, in some cases, substantial careers on their willingness to curb whatever creative imagination they possessed. As a result, they had achieved a high degree of competence on the level of the "executive architect"—the figure responsible for carrying a design through to physical realization. On the level of conceptualization, however, they had little to show. And a more educated public was now demanding performance on precisely this level. It had begun to resurrect, and to rethink, the principle of discrimination. Architectural ideas are not merely different but equal. Some, when examined against the international field, are better than others.

This was the worst possible news for those corporate firms that had gambled heavily on the prior dispensation. For these firms, September 11 represented an opportunity to regain the ground they had lost in the preceding decade. Patriotism, an emotion then in full artificial flower, became a rationale for organized efforts to maximize job opportunities that seemed to open up. Though the physical damage inflicted by the terrorist attack scarcely extended beyond the sixteen acre World Trade Center site, the professional organizations became all a-tizzy with the prospect of "rebuilding New York." Far from improving the climate for architecture in New York, this self-aggrandizing trade campaign released a cloud of bad faith over good and bad work alike. Again, as in the 1990s, pressure to withstand such special interest group tactics has come from the increasing local awareness more enlightened methods used elsewhere: juried competitions, support for younger architects, and, not least, the tradition of social housing that remains in relatively good repair outside the United States.

The Austrian Cultural Institute, completed in 2002, was the most substantial piece of architecture to be realized in New York in decades. Designed by the Austrian-born architect Raimund Abraham, the slender tower resembles a wedge, and that is how it will be symbolically remembered. This project pried open a space in Manhattan for contemporary architecture to occur. In short order it was followed by LMVH Tower, designed by Christian de Portzamparc; The New York Presbyterian Church, designed by Greg Lynn, Doug Garofalo, and Michael McInturf, and the American Craft Museum by Tod Williams and Billie Tsien. Two highly publicized international competitions, for the Museum of Modern Art and the *New York Times* headquarters, also signified the revival of architectural values in New York. From this point, we would see the pressure of energies directed

from the inside-out. Subjective visions of the city began materialize in public space.

But perhaps no building had greater impact on the future of architecture than Frank Gehry's design for the Guggenheim Museum in Bilbao, Spain. Though designed by a Los Angeles architect for a site on the far side of the Atlantic Ocean, the Guggenheim's Bilbao branch exerted an international influence from the moment its doors were open. The influence, soon named "the Bilbao effect," was not one of style. Rather, the building made strikingly clear that a single building of distinction could help transform a city's image of itself.

Bilbao was scarcely the first city to adopt contemporary architecture toward this use. Paris and Barcelona, most notably, had benefited from major programs of public works. Nor was the Guggenheim's the sole building in Bilbao's campaign for a new urban identity. Still, the museum rapidly acquired the status of a cathedral, a pilgrimage site for international connoisseurs of the newest thing. This aura was only partly due to the building's intrinsic sculptural qualities, dazzling as they are. It also derived from the building's relationship to its time.

There was a need, in the years after the Cold War, to resist the pressures toward cultural implosion in the United States. The world and America's position within it were changing rapidly. Bilbao came to symbolize the emergence of a new cosmopolitan ideal within the context of global history no longer frozen by Cold War symmetries. Cultural intelligence—the acquisition of regional as well as global perspectives—was seen as fundamental to the realization of this ideal. Urban identity began to take its cue from the tensions between local and international relationships.

Civic infrastructure, especially transportation systems, assumed symbolic importance as connective urban tissue. This helped to alleviate the pressure on architects to aim for homogeneity of style. Instead, as with new buildings proposed for the High Line project on Manhattan's West Side, they have been encouraged to create a diversity of individual voices. Architects, some of them, have things to say, songs to sing, gestures to try out. There was a time when this concept would be automatically condemned as the mere expression of ego at the public's expense. In fact, it was the public that lost out in the years when the architect's voice was stifled. New Yorkers were denied the opportunity to see their own moods, perceptions, memories, and attitudes projected into the cityscape. Urban chords could not be struck.

The picture has changed. From my window, I can see Jean Nouvel's new residential building in SoHo nearing completion. Blue, a residential tower designed by Bernard Tschumi, is rising on the Lower East Side. To the west, the glass will shortly be installed on an office building Frank Gehry has designed for Barry Diller. In Brooklyn, Gehry has designed a twenty-two-acre office and residential complex anchored that includes a stadium for the Nets basketball team. Santiago Calatrava has designed a residential tower and a rail hub for Lower Manhattan.

A new dormitory for Cooper Union, designed by Thom Mayne of the Los Angeles firm Morphosis, is about to go into construction. Work is proceeding on two projects by Renzo Piano, a remodeling of the Morgan Library and a new headquarters for the *New York Times*. Ground has been broken for a new building for the New Museum, designed by the Japanese office SAANA. Work on Diller and Scofidio's design for remodeling the Juilliard School and other areas of Lincoln Center is also underway. In Midtown, Norman Foster's design for Hearst Publications opened last year. Residential projects by Lindy Roy, Wolf Prix, Neal Denari, and Winka Dubbeldam are in design development.

By any standard, this represents a remarkable flowering of talent. It has even produced something of a backlash. The term "star architects" is often used pejoratively to caraciture talented architects as flashy, superficial souls driven by a mad lust for fame. As yet another attempt to discredit the value of discrimination, this usage partly reflects the resentment of less talented architects who benefited in earlier years. Practitioners of other art forms, and the journalists who cover them, have indulged in crude equations between architecture and materialism, as if to suggest that the creative energies now at work in the design of building signifies the immorality of contemporary society.

It is to the good that such objections be raised. They signify that architecture is once again performing a robust civic function. One feature that distinguishes cities from suburbs is that city dwellers are less conflict-averse. If architecture still enjoys the stature of a public art, that is because buildings invite public ridicule and doubt. They expose us to arguments latent within ourselves as well as those that arise between us.

Minimal Art, Conceptual Art, Land Art

Germano Celant

Minimal Art

New York City has an urban life in which dirt plays a preponderant and active role. The city is practically a cloaca that sets its biological clock by the daily consumption of objects and waste which, day after day, are 'retained' in an almost animal manner on sidewalks and at streetcorners. All the same, the art is produced in the city's territory seems to repress the social impulses toward dirt and refuse, substituting a coercion to cleanliness, almost as if that art were obliged to pay its final respects to the ceremonial of a culture as a dazzling blinder, both puritan and moral. According to this vision, art should not be besmirched, but instead should remain clean and pristine, because it is free from the accumulation of corruption and obscenity that circulates through all the gutters of Manhattan. In that art, excremental contortions and ornamentations are not permitted, because it must represent an economics and a politics relieved of everything that hobbles and fattens, everything that befouls. Moreover, dirt is incompatible with the social order, and since art sets itself up as a producer of symbolic models, capable of acquiring social value, it cannot reinforce such a concept; it can merely critique it and call it into crisis. At the same time, since we are talking about purity, it brings to light the city's contribution in the form of expiation, whose secretion is totally impure and unclean.

At the same time, while dirt may be asocial and art supports a progressive conception, no aesthetic exploration can exalt the monster of refuse and disorder. Rather it will tend to reinforce the credibility of rigid and stable values, normally associated with cleanliness. Pop Art sings its hymn to "junk culture," and thus belongs to the realm of the asocial and operates in the territory of the malign. It should be opposed and critiqued and no operation can be seen as more effective that "reflecting on dirt," since it entails "a reflection between order and disorder, being and non-being, the formal and the informal, life and death" (Douglas). The only action in favor of this policy is the reaction against it, so as to eliminate it. In order to obtain this outcome, artistic work must return to the state of the uncontaminated, where the forms and the materials, presented in their purity of volumes and surfaces, either simple or made up of unfinished metals or woods, would no longer be besmirched by the intrusion of consumeristic materials, and would instead continue to live autonomously in a field of aseptic purity.

The minimalist religion, while it identifies the linear, elementary, and smooth with cleanliness, also divides the universe of art into things that are subject to being reduced and flattened and others that, because of their internal chaos and disorder, cannot be. The former objects correspond to the innocent element, subordinated to the social order, while the latter objects correspond to disintegration and crisis. And since art, in America, expresses a moral judgment, the orderly is the correct evolutionary pathway, since it presupposes a programme and a plan. At the beginning of the 1960s, Minimal Art, hoping to establish itself as an antithetic value to Pop Art and Fluxus, chose to venerate order, rules, and norms. The works of Judd and Flavin were, therefore, full of references to integrity and the entirely perfect. In them, the materials of the world, from the fluorescent tube to steel, from light bulbs to plexiglas, conformed to the elementary structure and became monolithic entities that tautologically represented the independence and the power of a system whose values are based in the area of limitation and order. In Judd, the spatial and chromatic autonomy of the volumes is total. The pure parallelepiped rejects all referential values, while the materials introduce into the interior the fusion of surface and color. The result is therefore a whole made up of solid entities such that "each is dependent upon the other and can be that which it is in and through its relationship with the others" (Lalande).

The conception of the volumetric phenomenon led Judd to consider sculptural work as a whole consisting of autonomous units, which manifest an internal solidarity and which possess their own laws. In this way, a sculpture exists as a self-determining entity, conditioned only by its internal relationships and by the elements that govern it. In an attestation to this way of working, sculpture always presents wholes of separate entities, which are not however separable, which differentiate and limit one another on a reciprocal basis in order to constitute an indivisible whole. Because the entities are interactive, the relationships are multiple and dynamic and each and every sculpture is never closed, because it establishes a continuous dialogue between the solid and empty. At the same time, the possibilities of position and progression are infinite: the position-

al arrangement can make use of the three-dimensional and two-dimensional coordinates, vertical and horizontal, while the progression can be geometric and can proceed in accordance with the Fibonacci series. In addition to this, the materials that make up the whole can be of various depth, refraction, color, finish, transparency, and weight. It therefore follows that Judd excludes, from sculpture, all hierarchic value between the solid and the hollow, between the beginning and the end, between the front and the back, above and beneath, between material and immaterial; and therefore on the interior of a single element, the choice is always binary. In this way, the sculpture will be autonomous in and of itself, and the act of privileging one datum over another will be only a question of environmental position.

Flavin, too, set out from an imperative toward a chilly and rigid element; his work set itself the task of placing the spectator in the presence of the entity of "light," in order to underscore that entity as an "iconic" affirmation. An assertion that, implemented without any participation in inventive or imaginative—that is, expressively "dirty"—terms, would concentrate the ensuing analysis upon the isolated and isolatable phenomenon of light. For Flavin, that phenomenon is identified as the fluorescent tube which becomes, for him, a technological totem that, by its very availability in all the marketplaces of the world, establishes itself as a perfect example of aspatiality and atemporality.

The composition, in the early works, is elementary, in such a way that no visual "noise" intervenes to disturb the "cleanliness" and the spareness of the fluorescent light, in the primeval stage of its technology. The tube, in fact, lives on an autonomous plane, as a signless and non-iconic element, since the only sign resulting is the actual light emitted, which varies according to the spectrum of colors in the sampling. The importance of information became therefore the discovery of light as information in the pure state (according to McLuhan's hypothesis), so that all of Flavin's work is developed in this analysis and visual development of combinations or diagrams of light. Around 1966, the fluorescent light was no longer satisfied with a "side" role, in a corner or on a wall, and it now "invaded" the space, conditioning various architectural passages, the actions and movements, the routes followed by the spectator, becoming an intrusive presence and totally invading the environment. Here light took on a manifold substance: light exists as a value per se, as the light of the tube; the light reflected off the walls, on the combined and neighboring lights, on the architectural whole; the light created forms and space as a result of the arrangements and colors employed.

Sol LeWitt also worked on "scores" of elementary signs, but, instead of making use of the tech-

nological icon, he focused on hand-made "construction." His works are visual "scores" to two- and three-dimensional signs, "unconscious and intuitive exercises" in calculation, in which the execution is nothing more than the volumetric and superficial translation of conceptual processes. In this sense, LeWitt's works are "scores" that are based on reciprocal relationships between concepts and processes, cognitive events that communicate an idea and sacrifice to that idea all the intentionality of the material and the subject. It is the idea that informs and gives significance to his work, and it is upon the idea or the concept that he works, tending to hollow out to the greatest degree possible his expressive media of their materiality. In this sense, Sol LeWitt can define himself a "musicians of concepts and volumes," on the hunt for an increasingly ideal score, a musician who already sees, in the translation from idea to practice, a contamination and experimentation with extreme consistency, the negation of the visual "appreciation" in favor of a structural reading. LeWitt's bi- and tri-dimensional paintings and sculptures are therefore formulations of an idea, so that they proceed in accordance with a mechanical rationalism that does not admit will and chaos. Once the idea has been formulated, what follows is beyond any and all material and subjective control. The artwork is in fact a conceptual operation that randomly deposits itself in a material or in a form. The object, however, and the trace that derives from it, are irrelevant with respect to the idea or the concept chosen. In this sense, as LeWitt says, "even a blind man can make art," because it is the idea that designs the work, while the implementation is nothing more than a procedure of visualization of the same, or it need not go beyond those limits, through the media employed. It is not, therefore, fundamental to choose an idea that has an artistic and aesthetic implication in order to make art. All that is needed is to assume an idea and verify its objective assertion, transcribe it, not interpret it, "offer it as it presents itself" in order to communicate something that only the idea and with the idea can be communicated. In this logic system of conceptual procedure, it is evident that the experimentation should be aimed at non-characterized forms, such as volumetric and geometric forms, and to materials, eliminated by the non-colors, white and black, which in their simplicity serve to keep from altering the conceptual "whole," indeed, with their flatness and insignificance, they tend to concentrate upon the intensity of the process.

After an experience as a painter devoted to Abstract Expressionism and an interest in music and dance performances, which led him to create "portals" and "platforms" that could be used by the performers, Robert Morris around 1964 devoted himself to the construction of works in

wood, enhanced by a pale gray color, whose characteristic feature was to appear as simple volumetric elements, such as boards, corner angles, squares, parallelepipeds, and cubes, structures reduced to primary forms. These were artworks made of an industrial material, flat and smooth, but with an extremely refined color which revealed their essence as simple structural and volumetric entities, arranged in relation to the environment, both spatial and temporal. But in comparison with the impersonal nature of other Minimalists, these artworks presented an interesting trait: in their appearance of smoothness and perfection, they always concealed an "irregular" and "unstable" intervention by Morris. They are not totally elementary structures, taken and enlarged, rather they include a moment of complexity and disorder. By checking them over, in fact, it is possible to notice a number of "improprieties," the huge beam or the enormous cube has a rounded corner, or else the squared-off polyhedron appears as parallelepiped missing one side, as if there were a desire to open to discussion or problematize the certainty and the dogmatism of the minimalist affirmation.

Last of all, Carl Andre in whose work we seem to see the emergence of a critical hypothesis, directed toward a rescaling of minimal art, with a view to recognizing only the working presence. If we retrace, in fact, the history of his way of working, we cannot find any division between material work and intellectual work, but everything that appears and is perceived is "work," an activity linked to the context of a productive and economic reality. His art, or rather we should say, his work, does not accept the historic and utopian tasks that the culture of cleanliness and order wishes to attribute to him, but it is bound up with the instability of productive spaces and sites, with the result of being linked more to the "politics of things" than to any artistic experimentation, in the pure sense. In this context, Andre subjects to criticism the most important lines of the artistic ideology. He rejects the traditional conception of art as a stable and sublimating form and accepts the consequences of a work with only a relative degree of autonomy. The affirmation of a "work" as an artistic process is a political and ideological assumption of position with respect to art and work itself. They are rendered comparable and socially equivalent, and therefore have no reason to be the causes of separations between the intellectual and the non-intellectual class, which distinguish them.

All of this reveals in Andre an attempt to eliminate all differentiation among "workers"; his way of working, however, does not attribute different values to itself, nor does it accept "tasks" that cannot be performed by one and all, nor does it use materials that are not in common production. What follows is that his works develop out of elementary arrangements of material elements that can be found on the market. The elements that are ordered and organized into structures are in fact, bricks, styrofoam, planks, ceramic magnets, cement blocks, and wooden beams, standard construction products that can be found in all social contexts. The motivations that guided the choice of these materials can be numerous: first of all the "promotion" of entities linked to the world of proletarian work, then the requalification of materials, determined according to the "periodic table." These, in fact, much like work, have lost their significance, and so Andre seems interested in reproposing their importance, through an analysis of their conditions and their significance in terms of mass, molecular volume, weight, constant structure, thermodynamic and electrical properties of conduction, which vary from element to element. Thus, his work, from the "floors" to the "alignments," attests to his dialectical awareness and self-consciousness, as a whole and a unit, materialistic and political, as well as continuously keeping its role present as an ideological and economic value. In short, he is concerned with the "management" and the "objectives," which are extremely limited and restricted, in a situation where dirt dominates.

Conceptual and Post-minimal Art

According to the historic definition of Lippard and Chandler, Conceptual Art attempts to emphasize a "dematerialization" of art, which is recognized in the gradual disappearance of the object in favor of the idea and the concept, the ephemeral and immaterial material. This dematerialization demonstrates the loss of interest in the formalist evolution of the work and the tension toward transforming all matter into energy and mental process. In particular, taking Conceptual Art into consideration, its operative content is an emphasis upon the philosophical and cognitive process concerning the materialist operation and the subjectivism of the artist, whereby forms become irrelevant and intrinsically equal. The artist can use all sorts of forms, from physical reality to the written and spoken word, but he will attempt to emphasize the concept with respect to them, the concept which accepts only a rational and linear approach, with a great methodological precision. By adopting the concept or the idea as an operative model, Conceptual Art rejects all expressionism of the materials and the actions of the individual "artist." All entities external to the analysis of the concepts and ideas that inform art is considered as a subvalue. The discourse on the aspect of process, both mental and theoretical, of art thus becomes, in other words, no longer a manifestation of critical literature, but of art. An art that can use the printed page, mathematics, numbering, writing, the essay and the book, as well as all the instruments of

philosophical and process-oriented communication. Artists who are often presented as Conceptual artists include: Robert Barry, Lawrence Weiner, Douglas Huebler, Joseph Kosuth, who had formed the first nucleus of the exhibitions held by Seth Siegelaub. Later, their ranks swelled, and came to include also Hanne Darboven, On Kawara, Jan Dibbets, Vincenzo Agnetti, Stanley Brown, Victor Burgin, Ian Wilson, Hamish Fulton, and David Tremlett. An attitude in the radical sense of Conceptual Art was represented by the group Art & Language, whose career as a group was troubled and chaotic. They rejected the use of artistic language in a dematerializing and ephemeral sense, and instead proposed a scientific use of the use of the concept and of politics in art. Art & Language, at least at the beginning, rejected the visual and literary components in order to reduce the conceptual operation to pure philosophy, and then to an active political practice, of the language of art. The reduction to a pure concept abolished all interest in the object and in documentation and a renunciation of aesthetics by adopting an exclusive use of idiom and language, in keeping with a logic that harks back to the latest theorizations of the Anglo-Saxon linguists, from Wittgenstein to Moore, and then on to Marx and Lenin. In the individuals as in the group, the books and essays thus become works of analysis on the language of art, and they are therefore art, just as art is talking and discussing (Ian Wilson) the educational or esoterical relationship with relation to the theme of art. By making use of the channels of information, Conceptual Art has no need, in general terms, of exhibition spaces since often the information takes the place of the exhibition and can be conveyed by newspapers and magazines as well as discussions. The documentation serves in place of the object and what predominates is an effort on the invisible: Robert Barry works on the minimal variations of energy systems or else on the indeterminacy of the "object"; Huebler's *Durations* are based on cognitive and perceptual processes structured upon a preordained duration, which focuses the attention upon events or elements that are not preordained; Lawrence Weiner informs us of the removals or persistences of physical and non-physical events; while Kosuth, more analytically and theoretically, presents linguistic "categories" and "definitions," extrapolated from the dictionary. Appearance is considered to be of no particular importance because art becomes "art theory," a way of working on the statements and assertions of art as upon art inasmuch as an idea.

Among the names mentioned, Joseph Kosuth, together with Art & Language, seemed the most extremist in his offering of problematic directives with respect to the identity of the context of "art." His production, from 1965 till today, shows how his attention to use and function manages to eliminate the "form of the presentation" of the artwork. His discussion of the nature of art proceeds, in fact, through "groups of meaning" and not by "taste" or "sensitive reaction." The groups of meaning translated into "investigations" underscore all the complex properties of the relationships between language and art. The definitions that make up his *First Investigation* initially had to do with the concepts of materials such as "water," and "air," and offer themselves as abstractions of a particular entity, devoid of form and color. Thereafter, the "definitions" had to do with such abstract terms as "meaning," "empty," "time," "universal," "object." That is, they became abstractions of abstractions. Their presentation demonstrates in many cases that the linguistic entities in common use in the language of art have no properties that can be defined a priori, so that a word is not a definition of a single phenomenon, but rather the connotation of a class of an indeterminate number of meanings. The principle was verified during the artistic exhibition, held in 1968 at the 669 Gallery in Los Angeles, putting on exhibit many definitions of the word "nothing," taken from various dictionaries.

Art reflects upon its own "physiognomy" and on the "measure" of its own communication structures, and this can take place through writing, as reinvented in the first person by Hanne Darboven, as well as the "disorientation" of the discussion, through which Ian Wilson carries out a specular retrenchment on the territory of art history and history. As for Darboven, likewise for On Kawara the work springs from the coexistence of idea and personal experience. In a very explicit form, he always makes reference, in the "dates," to references that concern him directly, whether they communicate the time of his awakening or they list the people that he meets on a daily basis. An interpretation of his work should therefore be constantly associated with his existence, and it moves, that is, along a bilateral channel whether the conceptual identification does not exclude his social and individual being. In this sense, each of his works should be understood as a contingent, and thus everyday, form or trace, of a physical or intellectual activity, whose time of existence coincides with the very existence of On Kawara. All traces are reasons and documents of life, they can remain single or fit into an historic nexus, capable of presenting it as the member of a whole, both personal and impersonal. What is intended to be stated with respect to his work is that his way of working offers different possibilities of knowledge: it can be established as a whole or as a specific trace, whereby taken as a whole it pursues understandings and experiences that are, at the same, both intersubjective and abstract and rational.

The specific temporal and local aspect reappears as well in the photographic sequences created by Dibbets and Fulton, with a special focus upon the landscape setting, in such a way that the transforms itself into a "horizon," an ideal line of territorial and topological abstraction. The images contained are thus future remains of a natural archaeology, as it was experienced by the human, that is photographic, eye.

The reference to nature becomes macroscopic in the work of the land artists, from Long to De Maria, from Smithson to Heizer, who make use in their work of deserts or snowy prairies, craggy mountains and the sea. Their works are in fact judged by the ton of earth or rock moved and are calculated in terms of caterpillars, trucks, and steamshovel-scoop used to undertake monumental gestures that mark the face of the earth with mega-hieroglyphics.

The signs left on the terrestrial crust seem, then, to establish themselves as so many hieroglyphics created in a natural environment, whether meadow or desert expanse, river bed or hill. These are the marks left by "primitives" who still see in nature a "remote" space, into which the human being can project himself, as into prehistoric eras, in order to produce their menhirs of earth and stone. Architecture and artistic manifestations, rough and massive, consisting of macroscopic excavations or microscopic collations that underscore a primary and elementary intervention. In particular, the art of Richard Long reveals his Anglo-Saxon character, especially in the poverty of the figures and in the dose of love added to the figure, distinguishing him from the tendency toward technological violence, so typical of Americans. His signs, scattered around the world, lose all memory of their natural substance and their organic nature, becoming abstract signs, ideograms, images of Anglo-Saxon art, whose ancient meanings remain unknown, but whose content of magic, almost of exorcism, can be guessed at.

The tendency to simplify and to reduce, so dear to the Minimalists, also emerged in the generation that followed Judd, Flavin, LeWitt, and Andre, but here the rigidities and dogmatisms, both formal and volumetric, were resolved by their debt to anti-form and process art. The rules of the combinations leap and skip, and the materials, from iron to lead, bend in order to negate their value of absolute surface or volume. Instead of producing "finished" constructions, Serra, Nonas, and Highstein capture and work with the materials and the weights "in situation," as if the provisional completion in a room or in a meadow were more important than the reductive and geometric modalities. The ephemeral designs their installations, so that the value of the work is distributed in the chain of the effects on floor and wall, without remaining autonomous and isolated, as was the case with the Minimalists. At the same time, the promotion—as an elementary material value—of latex, pig iron, lead, and wood worked more on the absence of security and on an affirmation of softness than on the stiff and the hard, and with that they place themselves at the passage from the intensive of minimal art to the extensive of Body and Land Art.

Land Art

Working in a megalopolis such as New York can mean that one is obliged to solve a two-fold problem: either communicating one's own individual, conceptual, and physical demands, or else symbolizing, through one's own work, the "monumental" that is intrinsic in every aspect, with the configuration and the structure of the megalopolis itself. In the first case, the individual tension entails an exaltation of the artisanal or the spectacular, intrinsic in the human subject, and an ostentation of the philosophizing and the communication through signs, both written and spoken, typical of all human subjects. In the latter case, the demand of a signifier for a macrodimension leads to the utilization of supertechnological tools, typical of a superindustrialised civilization that finds in the megalopolis its symbol, and the testimonial of immense spaces in vast quantities, so typical of major urban clusters.

Utilizing great means in order to achieve "monumental" and spectacular gestures is in fact one of the distinctive traits of the work of the land artists. Every depression or displacement, every excavation and cut into the earth's crust is the macroscopic sign of a human being who wants to testify to a quantitative culture and who uses all of the supertechnological resources that a megalopolis places at his disposal, in order to give a greater significance to ritual art, that is representative of a massive industrial civilization.

Its aesthetic "traces" are technological "artifacts" that tend to establish themselves as future archaeological "remains" capable of revealing thousands of years, a pre-galactic and terrestrial culture. Its achievements are the testimonials of a "primitive" that still sees in nature a "remote" space into which man can project himself, as in the prehistoric times, to produce menhirs of earth and stone.

"Architecture," rough and massive, consisting of macroscopic excavations or single blocks of stone that have been removed, are the works of art that Heizer began to undertake in 1967, when, in a great open space in the Sierra Mountains, he produced a large cubical excavation: a primary and elementary intervention of a man from the megalopolis, who was shifting his energy from inside to outside of his urban bluster, in order to affirm his power and liberty, which remains, however, quantitative and massive. A primitive gesture, which leads to the rendering concrete of an "artifact," the excavation, the significance of which is unknown, because the work is close to the "be-

lief" in human action. A belief in one's own traces, revelatory of a violent and technological culture, that the ceremony of the motorcycle hurtling at high speed underscores by leaving, as it breaks, an abstract, yet extremely incisive sign; a concentrate of technology and energy, translated into an iconic gesture, present in *Circumflex*, an excavation done at Massacre Dry Creek Lake, in Nevada, which "figuratively" recalls the remote image of the sign produced by the technological machine, the motorcycle, being sublimated into a "monument," 120 feet long and 18 feet deep, capable of a ritual and human significance of a pre-galactic culture. The expansion of the sign takes place through the utilization of other technological media, earthmovers and trucks, dynamite and caterpillars. The parallel media do not strip away any content of significance from the signal created, and instead they exalt their power and physical and visual poignancy, which in the limitless space of the Great Salt Lake is further enhanced.

The acceptance of one's own condition as a supertechnological citizen thus led Heizer to replace the microscopic media (photography, canvas, writing, oral communication, materials), so typical of a village culture, with macroscopic media, typical of an extraterrestrial civilization, in the moment when it accepts nature as the only space for action. An action that, again in 1968, continued in the Mojave Desert, and on the mountains that surrounded it, with the impression into the earth of a series of depressions, small in size, but symbolic of a need to operate in a macrodimension.

A macrodimension that solidifies in the *Munich Depression* (1969), an artwork that consisted of the shifting of one thousand metric tons of earth to form a crater thirty-five meters across and four meters deep. A great telluric event that was steeped in a magical and archaic significance, and which seems to elude all classification, both artistic and aesthetic, a megalomaniac gesture of a citizen of the megalopolis. A work that seems to have been produced by an enormous meteorite that has fallen to the surface of the earth, an act of cosmic violence that annihilates the human presence, just as the city erases with its discharges of pure energy the dimension of the human being. A physical balancing, or squaring of accounts, between nature and that industrial and lunar civilization that Heizer sought continuously in order to attain dissolution and exaltation, at the same time, in a way of working that signified both himself and his world, without necessarily therefore following the two polarities. The works that he accomplished do not correspond either to a requirement of personal communication nor a productive stimulus; they are not commodifiable nor can they be transported; they exist, therefore, as the "tribal" signals of a tribe made up of hundreds of millions of men and women. Upon them, nature works to render

them uniform with the actual disposition of the territory; water invades them, turning them into large-scale puddles. Every "universal" event, in fact, forms part of the work, which thus winds up "instrumentalizing" the entire macroscopic dimension of the earth, from the artificial medium to the natural manifestation.

A belief in the "*natura naturata*" of the 20th century that brings Heizer back through a telluric process of shifting rocks that are brought from the high summits of the mountains of Silver Springs, Nevada, back to their original earthly level, as hypothesized by Heizer. They are great granite boulders, ranging in size from eight meters by four meters by one meter to six meters by two meters by one meter, erected or placed in gently sloping excavations, depressions, in the form of parallelepipeds, obtained with cement walls in the vast plain at the base of the mountains, which range in size up to fifteen meters by four meters by three meters.

Dimensions rendered insignificant by *Double Negative*, an enormous excavation produced, in 1970, on two opposite slopes of a mountain on the Virgin River Mesa, in Nevada, so as to create a huge isthmus some 560 meters in length, ten meters in width, and fifteen meters in depth. A cyclopean sign that led to the movement and shifting of 240,000 metric tons of earth, requiring eight months of labor and the use of dozens of earthmovers and trucks. All of this to create an "artifact" that, even if the precision of the walls reveals the intervention and decision of man, tends to blend into the panoramic appearance.

In this work as well, the intention of leaving a trace that was neither codifiable nor significant, but only energetic and massive, manifested itself in the grandiosity of the work which, in its "apparent" gratuitousness and banality took on a great force of sign cultural imprint. It is an action "without meaning" that acquires meaning in its display of power, possible only in a society of terrestrial, but also galactic superpowers. In these works, the man Heizer disappeared to make way for an apparatus of energy that annulled any presence that is not power and energy. Like a pyramid, *Double Negative* is the symbol perhaps of a death or a life in limitless development. The interpretation of this sign, however, is not possible today, because the condition of the judgement is to vital and implicating, too critical and ideological, too ephemeral and contingent, with respect to a time of hundreds of years, which tends to cancel and nullify all traces, even the most macroscopic and megalithic.

And yet Heizer's challenge continued, he took on ever larger spaces and signs, his motivation, even as he ran against human impotence to think and create in a galactic condition, drove him continuously to render concrete his gestures of a primitive man of the megalopolis who, after act-

ing, now designs on the earth's surface a series of circles with a diameter ranging from one hundred forty to seventy meters. After cutting first of all into the earth and shifting its elements, Heizer's work became more refined, as in all the historic developments involving the transition from a primitive culture to a more tribal culture. The circles overlapped and intersected, and from an aerial view they take on the meaning—in opposition to the pseudonatural events of *Munich Depression* and *Double Negative*, of a sign that does not believe only in energy, but also in the mental process.

Beginning in 1972, Heizer undertook a major project of a city in the desert, consisting of constructions and plains of sand and cement, extending into the void to create lofty canals and architectural passages. The work was to take many decades, because the artist intended to link each and every element to form a megalithic whole, created with the most advanced contemporary high technologies, but located in the desert heart of America. It seemed that the intention was to begin a spiral that, by arriving at abstraction and the primary sign, would bring the artist to a primitively advanced urban vision. In contrast, Walter De Maria, even though he took on the challenge of the macroscopic dimension of such natural events as lightning and earthquakes, adopted himself—"I am only interested in myself"—as his sole system of awareness, living by chance in a randomly operating world, finding it intolerable to continue to consider art as a bearer of values ahead of their times and models of behavior, and so he went into the Sahara to build a one-mile-long corridor and then filled the Galerie Heiner Friedrich in Munich with dirt. De Maria no longer believed in the cultural management (artist, intellectual, critic, etc.) that suggests to the consumers (spectator, audience, user, etc.) a model of value, no longer accepts the list of cultural heritage and resources, denies the moralistic fallacy of the product which has created an illusionistic dimension of life and reality, and believes only in his own personal experience. Thus, his availability is total, it rejects perhaps only classification and judgement and enriches itself continuously with will, choosing and not choosing, passing or remaining on this side of the wall of death (*Death Wall*, 1965), being in a life that bypasses the formulation of a thousand lives. Taking himself as the sole instrument of questioning and knowledge, he enters into a world that is at the very least classifiable, adapting in order to keep from being assimilated, he leaps outside of his own "naturalness" and emerges continually from his acquired dimension, learning once again to perceive, to feel, to understand, and to use himself. Naturally, learning to move himself, to experience his own being there, does not mean producing movements, but rather learning to use

ourselves as a material upon which new developments and imprints are exercised. Consequently, impossibility of believing in the linguistic models, in the code that correspond to a regularity, a syntax, a social and moral-industrial necessity. "Tabula rasa," therefore, of the existing archetypes and of history, a quest for linguistic and communicative death, total aversion to discourse and aspiration to aphasia for a progressive identification of awareness and praxis.

The first discoveries of this perusal are time *(High Energy Bar*, 1966) and the dimension of duration without limit, the repetition of gestures, signs of a temporality; being still in order to emerge from circumstances and immerse oneself into infinite time; the explosion of the temporal dimension as an ecstatic communion with individuals and nature. The subconscious as a system of awareness, the stimulus to lose and recover continuously an equilibrium with the surrounding world, the quest for anxiety and a plurilinear life, as the sole possibilities of estrangement; the loss of identity with ourselves for an abandonment of the reassuring and restrictive recognition imposed by the outside world; a changing physical presence, which becomes discontinuity, chaos, liberty, space, and time, in which the work is continually suspended and infinite. The problem now is to realize and help others to realize our own existence, to feel the totality of becoming, chased and never attained, perhaps unattainable. With the end of the time of answers, it is necessary to offer only questions, confuse our ideas, raise contradictions, and remove energy by adding it. *High Energy Bar*, a bar of energy fourteen inches long, is nothing other than a segment of steel that can be produced in countless copies, during the existence of De Maria; the product is never finished, completed, or unified, it always depends on the previous and the following ones, it is linked to the duration of the artist's life, it develops energy until his death. It is an appendage to his flesh, his thought, his body. It is offered only in its temporal dimension, a dimension that we can scarcely recognize because it is inconsistent, impersonal, personal, consistent, finite, and infinite. The bar is a complex entity like all works produced by man, the only security: it is in the world.

Like our very being, the object springs from a series of sensations, of equilibrium and disequilibrium, of charges and discharges, it is *entrusted* to a single opportunity of life, our internal experience. The artwork thus becomes 'plurisensory', acquiring as many meanings as there are people to experience it, denying itself to each of them, self-signifying itself as an absolute object and as an infinite entity. A fragment of a work, expanded and expandable, which speaks referring to other matters. Thus, De Maria, aware of the circular and labyrinthine character of the work he is doing, teaches a new dimension of existence,

continual time and space that he does not recognize in order to better know himself, an "other" dimension that lives only on individual relationships, where the work is nothing more than a pause in life and the apprehension one of the countless ways of acquiring it and experiencing it. Product and apprehension thus wander through the mental infinity.

Thus the products not only can be seen, but they can also merely be thought, such as the natural disasters, the art yards, and the meaningless works, of 1960. The character of the practical expression of these works is based, in the first case, on the use of concrete circumstances such as earthquakes, tornados, floods, and sandstorms. To the degree that they produce "asesthetic" effects upon the earth's crust, they are considered, by De Maria, "the highest form of art possible to experience."

The principle of their aesthetic quality can already be found in such natural examples as the Niagara Falls, the Grand Canyon, and the Petrified Forest and therefore by treating them as works of art, De Maria does nothing more than to "free them" from their catastrophic aura in order to recognize them as "expressive actions" In other words, it is to allow nature to express itself, much as an individual might, with a "strong" aesthetic sense, so that the transformations that are carried out by natural events become works of art.

The expansion reaches out and the object is translated into potential material. The "1,600 cubic feet of level dirt, pure dirt," installed in the rooms of the Galerie Friederich in Munich, experience their own objectivity, but they can also be conceived and experienced internally, they are dirt, earth, region, world, and universe. The 50 cubic meters of earth contains within itself an infinite quantity of significances, demanded by De Maria himself, with the expression: "The dirt (or earth) is there not only to be seen but to be thought about." A source of mental energy, the earth is experienced directly, it pulsates in time and outside of time, its duration is limited and limitless, repeatable and unrepeatable, being and nothing. Isolated in a closed space it enters into an almost metaphysical dimension, it transcends itself, triggering countless mental and physical stimuli.

Transcendence is instead avoided in the works, also completed in 1969, that require the use of broad territories, deserts and whole continents. The corridor in the Nevada desert, a project from 1962, was preceded by the laying down of two parallel straight lines one mile long. The two lines, each twelve feet wide, are the traces upon which the cement walls were to be built, framing a cement corridor one mile long. The work is linked to the totalizing experience of the implication of the desert and the specific experience of someone walking along that mile, enclosed between two very tall white walls.

A transition from void to solid, from the closed to the open, from the finite to the infinite, which will depend only upon the person's attitude and emotional disposition. Real knowledge can only occur as a result of that experience of insertion and desert. In parallel with this project in the desert, which also includes a large cross, De Maria is currently working on an artwork that will entail the use of three continents, the *Three Continent Project*, and the employment of a satellite to document the artwork, which is described in the following words: "In this project a square shape will be made on the land in the desert of the United States! A horizontal line in the Sahara; and a vertical line in India! When all of the lines are photographed from the satellite, the photos are placed on the top of each other, the image of a cross within a square will appear! To create this image three continents will be used! A satellite could photograph all in its journey around the world!"

This attempt at stereovisual vision embraces the total surface of the earth and manages to take concrete form in an ample portion of wild and deserted crust such as the *Lightning Field*, a work that took over five years to create, from 1973 to 1979, and is planned as a permanent work.

In order to begin to understand it, it is necessary first of all to describe the trip which, according to Walter De Maria, is already a part of the artwork. One leaves New York, after agreeing with the Dia Foundation on the period of the visit, and one reaches Albuquerque. The airplane flight, several hours long, helps to adapt one psychologically to the encounter and to attempt to make predictions. Influenced by the expectations of an enormous bed of steel spikes, while leaving Manhattan, one sees the skyscrapers transforming themselves visually into a "field of industrial grass," while Albuquerque, upon one's arrival, appears as a "vast desert plain," occupied by a shantytown. Once one reaches New Mexico, at the wheel of a car (another filter of deculturation with respect to the variations of the local landscape), one travels in four hours the distance that separates the urban setting from the desert plain where the *Lightning Field* is located.

This is an enormous desert expanse, situated at an elevation of about 2,000 meters above sea level, surrounded by mountains that, at least to the eye, seem dozens and dozens of kilometers away. Almost at the centre of this flat surface, covered only by bushes and shrubs, suddenly following a glint of sunlight reflected from a steel surface, one notices the presence of a metal rod. If you look more carefully, you will discover more of these rods, until there are so many that you cannot count them. There are in fact four hundred of them, arranged in a grid, each two hundred twenty feet from the next one, and they form a rectangle one mile by one kilometer. As you draw

nearer, you begin to perceive it as an "object," and, considering our tradition of seeing, it seems like a megasculpture, whose exhibition framework is constituted by the flat plain. When you walk around the entire perimeter (whose sides are formed by 25/16/25/16 rods), the relationship alters. The walk around the entire field takes from two to three hours, and during that time the relationship with the work becomes more personal. The height of the body "measures" itself in relation to the height of the rods, while the length of the sides becomes the gauge for theorizing the size of the plain and the distance of the mountains. If we continue to remain on the outside of the field, we try to imagine how to photograph it. First we consider an aerial shot, but this clearly appears to be unworkable, since any view from above would cause the presence of the rods to disappear. If we persist with this sculptural approach, stepping away several miles, we notice other characteristics. The colored surface of the earth corresponds to the transparent and invisible surface that joins the tips of all the rods: it is a rectangle in the air that finds its counterpoint in the surface of the sky. The interferences between *Lightning Field* and nature are thus revealed gradually and make a separation of the data impossible. Solid and void, tangible and intangible, surface of the earth and surface of the sky, vertical and horizontal images, light and reflection, empty and polarized plain, observer and object observed, natural and artificial rods form the whole of the artwork. Since it is impossible to remain outside of it, we return to *Lightning Field* to walk through

the grid of rods, so that we can perceive their details. And, as we proceed, the "object" is transformed into a "situation."

Because the surface formed by the metal tips is, with respect to the surface of the plain, the highest point for many dozens of miles around, and in case of a thunderstorm any lightning will tend to hit the *Lightning Field*, it is necessary to keep track of atmospheric conditions and keep an eye out for cloud formations that, from time to time, suddenly block out the sun. On the day of our inspection, the temperature oscillated from 17 degrees below zero to 21 degrees above zero, with sudden burts of snow and rain, but no lightning, so it was possible to perceive the danger of the situation, without visualizing it, as can happen, between May and June, when lightning strikes the rods, to the point of rendering their tips incandescent. Noting, however, the reflections of sunlight on the rods, it was possible to have an idea of lighting as a light that is reflected, with greater power, on the field.

The experience of the lightning bolts came the next day. In the late afternoon, the clouds condensed and the entire field darkened. Electricity was in the air and the vision from the cabin became intense. It was possible to hear the first distance rolls of thunder, then suddenly lightning arrived, joining the sky to the earth, cracking down to the tips of the rods, which became incandescent. It was a dramatic vision, it seemed that the sky was a bed of electric thorns, overturned on our head, to which an artwork responds from the earth.

New York New York: Fifty Years of Photography

Bonnie Yochelson

In the wake of World War II, New York emerged as a world art center. Abstract Expressionist painting and Beat poetry, both rooted in Bohemian Greenwich Village, were signature manifestations of the new cultural mecca, but the excitement of New York permeated all the arts, and photography was no exception. At mid-century, opportunities to exhibit photographs in galleries or museums were meager, but assignments for illustrated magazines, which reached millions of American homes, were abundant. By the early 1970s when the magazines went into decline, galleries featuring photography began to emerge, and New York's Museum of Modern Art played a critical role in cultivating an elite audience and a modest market. A decade later, an increasing number of conceptual artists took up photography, breaking open the insular world of fine art photography and challenging its aesthetics. At century's end, photographs—many large and printed in color—commanded the wall power and commercial clout of painting in New York's burgeoning gallery scene.

The careers of the photographers who are celebrated in "New York New York" follow this path from printed page to gallery wall. The tendency to recast yesterday's magazine freelancers into old masters and to turn expendable press photos into high-priced vintage prints has obscured much of this story. It has equated the work of a 1950s photojournalist with that of a 1980s art star. A brief sketch of photography in New York since 1950 shows the different means and ends of these very different photographic artists.

At mid-century, the most prestigious job for a photographer in New York was a staff position at *Life* magazine. Founded by Henry Luce in 1936, *Life* was a mass-market weekly that featured photo-essays in which captioned photographs formed extended narratives, and photographers—not writers—received by-lines. Luce himself elevated the camera's interpretive role, claiming that "a photographer has his style as an essayist has his." After World War II, *Life* operated lavishly, sending photographers all over the globe and publishing a fraction of the freelance stories it commissioned.

Among the select corps of *Life*'s staff photographers were Gordon Parks and W. Eugene Smith. Both born in Kansas, Parks and Smith typified the small-town adventurers who were drawn to New York in search of an arena large enough to fulfill their ambitions. At *Life*, they found that arena. Despite the need to submit to the company's bureaucratic procedures, each became a celebrity photojournalist with ample opportunities to develop his art and exercise his social convictions. In 1948 when he received his first *Life* assignment to photograph a Harlem street gang, Parks was already a seasoned documentary photographer. For several years he had worked for Roy Stryker in Washington, D.C., at the Farm Security Administration and in New York for the Standard Oil Company. *Life* capitalized on Parks' race, assigning him numerous stories on black culture and the civil rights movement, and Parks stayed on staff until 1970, when he turned to filmmaking.

Smith started at *Life* in 1939 at age twenty-one and never fully accepted the strictures that the magazine business required. In 1954, while in his prime and at the height of *Life's* influence, he quit the magazine and joined Magnum, a photo agency founded seven years earlier as a cooperative for photojournalists. In its early years, the now legendary agency provided more moral than economic support, and many photographers departed when it became clear that the agency's membership fee exceeded the job opportunities it provided. Magnum lost money on Smith, when he turned an assignment on the city of Pittsburgh into an endless ordeal. Help came from the Guggenheim Foundation, which in 1956 awarded Smith a fellowship. (The Guggenheim provided vital career sponsorship to a number of photographers in the 1950s and 1960s, including Roy DeCarava, Robert Frank, Helen Levitt, Lee Friedlander, Bruce Davidson, Diane Arbus, and Garry Winogrand.) Despite his acclaim and the support of Magnum and the Guggenheim, Smith floundered for the remainder of what was a troubled life. His productivity depended upon the structure of *Life's* photo-essay format that he so bitterly opposed.

While photojournalists were using small flexible cameras to capture ongoing events, fashion photographers were fabricating fantasy images in the studio with large cameras and elaborate lighting. For these photographers, the competing publishing empires of Conde Nast and Hearst provided a profitable battlefield at *Vogue* and *Harper's Bazaar,* respectively. Irving Penn led the *Vogue* phalanx and Richard Avedon emerged as *Harper's Bazaar's* precocious star. Both were locals;

Penn was born in New Jersey and Avedon in Manhattan. Their artistic sensibilities, however, were honed by two Russian émigré artists, *Vogue*'s Alexander Liberman and *Harper's Bazaar*'s Alexey Brodovitch, who were among the exodus of artists fleeing Eastern Europe for Paris and then New York between the World Wars. Brodovitch's legendary photography workshop nurtured many talents, including Louis Faurer, Robert Frank, and Garry Winogrand, photographers better known now for street photography than fashion. Another Eastern European émigré who adapted well to the commercial conditions of American photography was Philippe Halsman, whose journey from Latvia to Paris and New York ended with thirty years at *Life*, where he produced 101 cover portraits. Other émigrés, however, found the transition from Europe to New York more difficult. Hungarian-born André Kertész, for example, left Paris in 1936 for a short-term commercial assignment in New York, where he found himself stranded as Europe fell into war. Kertész freelanced for American magazines, and from 1949 to 1962 worked for Conde Nast's *House and Garden*. Although his commercial work paid the bills, his art never flourished in New York as it had in Budapest and Paris. His best New York photographs are of his Greenwich Village neighborhood and were made in his spare time.

Staff jobs or steady work from a single magazine were not the norm for most New York photographers, who worked freelance and often valued freedom more than security. Although there were no commercial galleries devoted to photography, a variety of institutions supported their ideals if not their pocketbooks. From 1936 to 1951, the Photo League offered classes, darkrooms, lectures, and exhibitions to anyone interested in photography. The League was originally a leftist political organization, but after the war it was largely apolitical and nurtured a sense of community among professional and amateur photographers alike. The transformation of Arthur Fellig, better known as Weegee, from a *déclassé* crime scene photographer into a respected artist was due largely to the Photo League, which gave him his first exhibition in 1941. Paul Strand's rave review of Weegee's 1945 book *The Naked City* in the League's newsletter *Photo Notes* cemented his reputation. Support for photographers also came from the New School for Social Research, a Greenwich Village haven for European émigrés, which offered courses and regularly sponsored exhibitions. A third gathering place for photographers was the Limelight, a Greenwich Village coffee house run between 1954 and 1961 by Helen Gee. Featuring exhibitions by photographers as diverse as California landscapist Edward Weston, New York portraitist Arnold Newman, and Magnum photojournalist Elliot Erwitt, the Limelight made its money more from coffee than photographs. From 1941 to 1970, critic Jacob ("Jack") Deschin avidly chronicled all these photographic goings-on for the *New York Times*. Surpassing these downtown venues in influence was the Museum of Modern Art (MoMA) in midtown, which had taken up the cause of photography as early as 1937 and established the first photography department in an American art museum in 1941. The department's first director was Beaumont Newhall, a photographer and Harvard trained art historian whose scholarly survey exhibition "Photography 1839-1937" became the foundation for his classic *History of Photography*. Newhall left MoMA to serve in the U.S. Army in World War II, and Edward Steichen ousted him from the directorship in his absence. A powerhouse in American photography since the turn of the century, Steichen had the ability to continually reinvent himself, from painter and pictorial photographer to fashion and celebrity photographer to curator extraordinaire. He remained at MoMA from 1947 to 1963, retiring at the age of eighty-four.

New York's photography havens nurtured many talented photographers who could not find or did not want regular magazine work. A prime example is Lisette Model, a musician-turned-photographer who was born in Vienna and fled Paris for New York in 1938. Model's sensibility was perfectly suited to New York, and she produced many of her best works—her Lower East Side street portraits, her shop window reflections, and her "running legs" series of midtown pedestrians—within a few years of her arrival. She found immediate support among photographers: in 1941, Ralph Steiner, photo editor of the short-lived illustrated newspaper *PM*, published her street portraits of Nice under the incendiary title, "Why France Fell," which led to an exhibition at the Photo League. Brodovitch offered her assignments for *Harper's Bazaar*, and both Brodovitch and Steiner introduced her to Newhall, who purchased a group of her photographs for MoMA's collection. It was not until she secured a teaching position at the New School in 1950, however, that Model attained a modicum of financial security.

When a younger generation of photographers came of age in the 1960s, they first entered the magazine world. Robert Frank, William Klein, Diane Arbus, Lee Friedlander, Garry Winogrand, and Bruce Davidson all began their careers working for the printed page, relying on the network of institutions established by their elders. For example, when Swiss-born Frank arrived in New York in 1947, he began working at *Harper's Bazaar*. After five years in fashion, Frank shifted to photojournalism, making valuable allies along the way. With letters of recommendation from Brodovitch, Liberman, Steichen, and Walker Evans (an editor at *Fortune*), he won a Guggen-

heim Fellowship in 1955. The award stipend freed him from commercial assignments and yielded *The Americans*, the 1958 *succes de scandale* that established his international reputation. The legendary status of *The Americans* was unique, but Frank's ambition to produce a photographic book was typical. Klein's *Life is Good and Good for You in New York* (1956), Winogrand's *The Animals* (1969), and Davidson's *East 100th Street* (1970) demonstrate the desire of ambitious magazine photographers to achieve artistic autonomy on the printed page.

In the mid-1960s, the aesthetic climate began to change, in part due to John Szarkowski, Steichen's successor at MoMA. Steichen's aesthetic model was the photo-essay, exemplified in his monumental "The Family of Man" exhibition of 1955, which used 503 photographs by 273 photographers to preach a timely sermon: if the nations of the world recognize their common humanity, they can avoid nuclear holocaust. Brilliantly designed by modernist architect Paul Rudolph, the exhibition was a walk-in photo-essay, in which the viewer was enveloped in mural-sized photographs. Szarkowski, by contrast, avoided thematic exhibitions and featured simple, matted and framed prints by photographers whose aesthetic goals challenged the audience. In the tradition of MoMA's founding director Alfred Barr who sought to explain European modernism to an American audience, Szarkowski cultivated an audience for modernist photography. An elegant writer, he convincingly advocated for an aesthetic particular to the medium of photography and consolidated a canon of photographers who he believed had a unique photographic vision. Like Newhall and unlike Steichen, Szarkowski focused on acquiring high-quality photographs to build a definitive collection.

As Szarkowski was establishing a critical voice at MoMA, commercial galleries opened to market photographic prints. Previous attempts to sell photographs as fine art in New York had met with little success. In the 1930s, Alfred Stieglitz showed photographs by Ansel Adams and Eliot Porter at An American Place, his gallery devoted primarily to modernist painters, and Julien Levy briefly showed photographs at his gallery before shifting to Surrealist painting and sculpture. A curious effort to sell photographs was "American Photographs at $10", a 1941 MoMA exhibition organized by Newhall, which offered limited-edition prints by Alfred Stieglitz, Edward Weston, and Ansel Adams, among others. The Limelight was an influential venue for exhibiting photographs during the magazine era, but it too failed commercially. Times began to change, however, when the Witkin Gallery opened in 1969, followed shortly by Light Gallery; both were commercially viable businesses devoted solely to photography. A few years later, blue-chip painting and sculpture galleries, such as Marlborough, Sonnabend and Robert Miller, began to show photography as well. In 1974, a museum dedicated solely to photography opened in a mansion on upper Fifth Avenue. Founded by photojournalist Cornell Capa, the International Center for Photography (ICP) provided exhibitions, public programs and classes for a diverse audience of professionals, amateurs, and collectors.

As a result of these developments, many magazine photographers began to refocus their energies toward museum and gallery shows. Diane Arbus' career typifies the change. Arbus started out in fashion and shifted to photojournalism in the 1960s, developing her own off-beat ideas for stories, like one on the celebrated Baltimore stripper Blaze Starr, which appeared in *Esquire* (July 1964), and another on a nudist colony, which remained unpublished. In 1963 and 1966, she won Guggenheim Fellowships, and in 1967, she was featured, along with Lee Friedlander and Garry Winogrand, in Szarkowski's controversial exhibition, "New Documents". In 1969, Arbus began a book project and a limited edition portfolio of ten prints. The former was the expression of her photojournalistic ambition; the latter, a response to the growing interest in her work as fine art. Both projects were cut short by her suicide in 1971. Szarkowski's 1972 retrospective, which gave no hint of her magazine background, established Arbus' reputation as a major artist.

During the 1970s, well-established magazine photographers recast their earlier work for gallery and museum wall. The Witkin Gallery, for example, showed prints by photojournalists Gene Smith and Margaret Bourke-White, and Marlborough Gallery exhibited works by fashion photographers Penn and Avedon. In 1974, MoMA exhibited Avedon's portraits, and in 1978 the Metropolitan Museum gave him a retrospective. This reinterpretation of magazine assignments for the emerging market brought renewed fame and fortune to these photographers (or their estates) but blurred an understanding of their most productive years.

The shifting photography scene of the 1970s presented a variety of options to young photographers, who often entered the field with master's degrees in fine art or journalism. Although the glory years of photojournalism were past, many photographers continued to ground their careers in magazine and advertising assignments. Foremost among them were Eugene Richards and Susan Meiselas, who joined Magnum and have carried on its tradition of humanitarian photojournalism. Richards has brought a new intensity to reportage of the American underclass, and Meiselas has garnered attention for her passionate coverage of human rights struggles in Latin America. Both have used book projects as a springboard for museum exhibitions and gallery rep-

resentation. Also straddling the publishing and gallery worlds is Annie Leibowitz, the foremost celebrity portraitist of her generation. Leibowitz began as a magazine photographer—for *Rolling Stone* in the 1970s and *Vanity Fair* in the 1980s—and was honored with a one-person exhibition at the National Portrait Gallery in 1991.

In the 1980s, many photographers rebelled against the restrictive aesthetic of John Szarkowski, MoMA's influential photography director until his retirement in 1991. Szarkowski eschewed most commercial, color, and studio photography, and his faith in the authenticity of "the photographer's eye" ran counter to the tastes of art school graduates for postmodern aesthetics and conceptual art. Robert Mapplethorpe, Cindy Sherman, Barbara Kruger, and Nan Goldin were among the photographers who chose artifice over authenticity as their photographic muse. Mapplethorpe borrowed the style of 1930s fashion photography to glamorize gay eroticism. Sherman adopts the imagery of film and television to explore the effects of the media on her own identity. Kruger appropriates not only media style but media content, using magazine illustrations to propagate feminist ideology. And Goldin heightens the emotional impact of her intensely autobiographical work by employing the scale and intense color of advertisements. These photographers entered the art world on an equal footing with painters and sculptors. They paved the way for younger artists like Gregory Crewdson, whose elaborately staged tableaux of everyday American life have achieved instant critical and commercial success.

By 2000, the vogue for constructed photographic images was supreme. Since September 11, 2001, however, photographers have left the studio for the street with a renewed sense of urgency. Which of these two paths—the studio or the street, the gallery or the internet—will inspire the next generation of New York photographers remains to be seen.

The City Revealed

Thierry Jousse

It is undoubtedly in the immediate post-war period that New York truly emerged as a major cinematic city on a par, it might even be said, with Paris, the cinematic city *par excellence*. Not that New York had never been present on the screen in the past—to the contrary. But previously, the city had almost always been a mock-up, recreated in the West Coast studios nestled within the Hollywood Hills that had become the capital of the American movie industry starting around 1910—*in lieu* of New York, as the case may be. It is in the years 1947–48 that we really start to see New York being filmed for its own sake, in its essence as a Big City that is both cosmopolitan and profoundly American, with its own rhythm, its own beat, the geometric grid pattern of its streets and the bustle of its residents. It is a city that begins to breathe through the screen and which, thanks to this metamorphosis, acquires a mythological dimension that had hitherto remained embryonic. Two *films noirs* shot around the same time mark a decisive phase in this respect: Jules Dassin's *The Naked City* and Abraham Polonsky's *Force of Evil*, one of Martin Scorsese's favourite films. Two movies directed by a couple of left-wing filmmakers who would be forced into exile just a few years later under the hammer-blow of McCarthyism. Two works that were deeply influenced by Italian neo-realism, a seminal event in modern filmmaking that will forever signal the sudden development of an urban space left derelict by the war, notably in Rossellini's *Rome, Open City*. The spoken credits at the start of *The Naked City* announce the films' shooting in real-life settings, like a world premiere inaugurating us to a striking new blend of documentary and fiction. This on-location filming in the heart of New York marks a breakthrough in a new representation of the city or, more generally, in American cinema's conquest of a multifaceted, complex and polyphonic space. New York is in fact the main character in Jules Dassin's film as its very title—*The Naked City*—immediately indicates.

New York, of course, was not directly affected by the World War II. But like all big cities, and perhaps more so than any other, it is pervaded during the 20th century by a mythology of seediness, corruption, and the underworld that is going to combine in the 1950s with that heightened sense of realism linked to the real presence of the city.

In actual fact, during these years shooting in the studio is still the norm, though one finds remarkable examples of sequences shot on location in the middle of the city, as in Stanley Kubrick's second film, *Killer's Kiss*, full of over-the-top urban high jinks such as the early-morning roof chase, or the famous subway scenes in Samuel Fuller's *Pickup on South Street* in which a pickpocket played by Richard Widmark rummages through a young woman's (Jean Peters) bag on a jam-packed train, not to mention the too often ignored *Sweet Smell of Success* by the Scottish-American director Alexander Mackendrick. This is an indoor film shot in splendid black-and-white, superbly punctuated by several nighttime glimpses of Broadway and intensely redolent of New York's atmosphere, that of the city's bars and theaters, in which journalists and young hoodlums rub shoulders and corruption coexists alongside intellectual pretension. Conversely, in 1954, Alfred Hitchcock reconstructs an entire apartment building and its inner courtyard in a studio for the famous *Rear Window*. Yet he still manages to produce a film that is indisputably tied to a city he will return to film three years later, in black-and-white, in one of his most documentary-style works, *The Wrong Man*, with Henry Fonda.

The other major genre responsible for New York's image overhaul is musical comedy which occasionally turns into just plain comedy, full stop. It is *On the Town*, the first film directed by Stanley Donen and Gene Kelly, in 1949, that opens up the genre to an incipient modernity. Combining natural settings and studio scenes, *On the Town* is an ode to New York as experienced through the exploratory strolls of three sailors who, fresh from the front just after the World War II, rediscover the big city with undisguised pleasure. New York is here portrayed as a space of diversion, chance encounters and cases of mistaken identity, a choreographic stage that reveals the city in all its luminous splendour. Even if musical comedy remains heavily associated with artifice, it often succeeds in conveying a truly unique sense of New York, as is the case with *The Band Wagon*. Despite being shot entirely in the studio, like all of Vincente Minnelli's films, it nonetheless exudes an aura of unrivalled poetry, notably in the famous nighttime ballet scene in Central Park in which Fred Astaire and Cyd Charisse

share a rare moment of intimacy. It is in the early 1960s that two films finally attempt to offer a portrayal of New York as it exists in reality, albeit with some highly stylised touches: Robert Wise and Jerome Robbins' *West Side Story* and Blake Edwards' *Breakfast at Tiffany's*, a comedy full of Henry Mancini music numbers, even though it was not strictly a musical. The city becomes a veritable dramatic stage in these two New York classics. The locations are seamlessly integrated into the action, whether we are talking about the neighborhood around 110th Street in *West Side Story*, or the corner of 57th Street and Fifth Avenue—filmed early in the morning in a totally empty city in the opening sequences of Blake Edwards' movie—where the world-famous jeweller, Tiffany's, stands to this day. Further uptown, the film takes us to 71st Street, on Manhattan's Upper East Side, where *Breakfast at Tiffany's* main characters all live cheek by jowl. These films present two aspects of a multi-faceted city: that of the gangs who have long been a not inconsiderable part of New Yorkers' daily reality and that of the urban bohemian as unforgettably personified by Audrey Hepburn in the role of Holly Golightly.

But in these agitated 1960s, it is a different side of the city that is seeing a real revolution in New York cinema being played out in the sudden development of an independent, underground and experimental scene that often intersects with the worlds of modern art and the avant-garde. By the end of the 1950s—1957 to be precise—the shooting of *Shadows*, the first full-length feature by John Cassavetes, a budding actor-turned-director, is a seminal event, an inaugural act that leaves a deep and lasting impression in the popular imagination. Cassavetes adopts a semi-improvisational approach, firmly rooted in the city, to tell his story of three brothers and sisters beset with problems tied to their black identity. Filming live in a fast-moving, almost documentary, style, he captures Central Park, the Museum of Modern Art and 42nd Street as they had never before been seen on the screen. Parallel to this founding experience, the Lithuanian-born immigrant Jonas Mekas, armed with a Bolex 16mm camera, begins in the mid-1950s to keep his video diary. Through the end of the 1960s, and even well beyond that, he builds up an invaluable and highly personal collection of archives that are as much an inside look at the emergence and rising fortunes of an independent cinema, as they are fully-fledged films in their own right with notable titles such as *Lost, Lost, Lost*, *Walden* or *Scenes from the Life of Andy Warhol*. Extraordinary documents in the most literal sense and the birth of an intimate, rugged and quintessentially New York aesthetic that explores the limits of cinema and often resurrects silent film—an ex-

plosive mixture of primitivism, and sophistication. The entire underground scene parades past, under the keen and impressionistic eye of Mekas, historian of the present, beat poet, experimenter with the pen-camera, one-of-a-kind filmmaker. It is an entirely new cinema that is taking shape here on the sidelines and, simultaneously, a hitherto unseen city that reveals itself during this dazzling period. One may find forerunners of these two trailblazers, such as *In the Street*, co-directed in 1952 by Helen Levitt, Janice Loeb and the essayist James Agee, a magnificent 15-minute urban documentary that trains its lens on the children of the Upper East Side without dwelling on the sordid side, most memorably in an extraordinary scene in which the children parade down the street wearing face masks. And then there is *Daybreak Express*, a brief ballad shot in 1953 in the New York subway and set to the music of Duke Ellington by the legendary documentary maker, Don Allan Peennebaker. But it is with Mekas and Cassavetes that we see the creation for the first time in the history of American cinema of a true alternative to Hollywood, however marginal it might have been. An alternative that opens up the possibility, in the decades to come, of a genuinely independent cinema.

A handful of figures emerge from this 1960s scene, including some who have since achieved mythical status such as Andy Warhol obviously, most famous for his artistic pursuits, yet whose films are firmly rooted in this experimental era and which make his Factory a thoroughly cinegenic laboratory of figures, postures, gestures and experimentation. On a slightly less exalted level, there is Michael Snow, a true leading light of experimental American cinema, with his fascinating inquiries on space and duration, as well as lesser known figures such as Stan Vanderbeek, inventor of a cinema form that playfully mixes animation and real-life filmed shots in a completely novel way, or Warren Sonnbert, a homosexual poet and filmmaker who pushed the envelope on extreme intimacy. We are no longer simply talking about films that use New York as a backdrop or as a subject matter but films—those made by Jack Smith, Ron Rice or Ken Jacobs—that are *of* New York, veritable pagan ceremonials (in particular, Jack Smith's cult classic *Flaming Creatures*, produced in 1963 and banned at the time on the grounds it was too pornographic) that no longer simply film the city, but literally emanate from it, from its freedom of spirit, its inner movement, its profound difference from the rest of the country. In this abbreviated overview, we need to mention yet other filmmakers who, while not part of the experimental vein evoked earlier, contributed greatly to the spirit of independence initiated by Cassavetes and Mekas. I am thinking of Shirley Clark who, in her masterpiece, *The Cool*

World, captures Harlem on film in a way that is incredibly lively and particularly poignant; Peter Emmanuel Goldman, author of a handful of films among which one in particular stands out, *Echoes of Silence*, a silent movie in the form of an urban poem in which a profoundly tragic dimension suddenly materialises out of the New York space and which films the street as a realm of extreme solitude; Paul Morrissey, whom Andy Warhol uses as the basis for his trilogy *Flesh*, *Heat*, *Trash*, which is illuminated by the presence of Joe Dallessandro in the role of a man who prostitutes himself; or Jim McBride who, in 1967, before subsequently going on to pursue a career in Hollywood, directs *David Holzman's Diary*, the fake intimate journal of a laugh-out-loud narcissism, a film that engages in a long-distance dialogue with those of Godard.

It is not until the end of the 1970s and of 'no wave' cinema that we rediscover a period of creative ferment in the underground scene akin to that of the 1960s. This exciting era is obviously dominated by the personality of Jim Jarmusch, whose first two full-length feature films—*Permanent Vacation* and *Stranger Than Paradise*—are vehicles through which he imposes a minimal aesthetic, tinged with melancholy and fantasy, and directs a host of quirky characters drifting aimlessly in an often phantasmal Lower East Side. Nor should we neglect to mention, during this same period, *Downtown 81*, directed by photographer Edo Bertoglio and only finished at the end of the 1990s. Straddling the fault line between fiction and documentary, Bertoglio captures on celluloid the artist Jean-Michel Basquiat, who left this world much too soon, along with the entire contemporary musical scene of downtown New York, from Kid Creole and The Coconuts to DNA, the punk trio created by Arto Lindsay, Tim Wright and the Japanese Ikue Mori. The result is an exceptional document on this pioneering period in New York culture. *Downtown 81* also reveals one of the abiding features of this independent scene, whether in the 1960s or the early 1980s: the intersection between the arts, music, painting and cinema… From the presence of Velvet Underground or the style icon Nico in Andy Warhol's orbit or the films of Mekas, to the contributions of the minimalist musician Tony Conrad to the works of Jack Smith or Ron Rice, not to mention the link between Jarmusch and saxophonist John Lurie (the founder of the Lounge Lizards, who composes music for Jarmusch's first films and plays one of the leading roles in *Stranger than Paradise* and then *Down by Law*), or that which unites the experimental filmmaker Henry Hills with another figure from this downtown scene, John Zorn, there is no shortage of examples in the independent and experimental cinema to attest to the widespread circulation of styles and ideas in a city whose artistic worlds, often very segmented elsewhere, were undoubtedly more easily influenced than in any other city.

But let us all the same turn back the clock a little bit, to around the end of the 1960s, to the advent of what has come to be known as "the new Hollywood" and such seminal figures as Martin Scorsese or Woody Allen. A true synthesis is occurring at this time, between the independent, indeed experimental, spirit evoked above and a fascinating reworking of the major Hollywood genres, *film noir*, or comedy, not to mention the influence of French New Wave. This 1970s decade is a golden age for a kind of independent filmmaker that frees himself from constraints, among whom we find Spike Lee (*Do The Right Thing*), with his early films completely rooted in the black community, and the fiercely independent Abel Ferrara (*Bad Lieutenant*), a native New Yorker who fires the imagination with the mystical darkness of his vision. They will carry on in the 1980s and 1990s. With this new generation of filmmakers—to which we must add Sidney Lumet, who begins his career at the end of the 1950s but enjoys his most fruitful period in the 1970s with such notable films as *Serpico* and *Dog Day Afternoon*, two great detective thrillers illuminated by the presence of the young Al Pacino, William Friedkin (*French Connection*) or Alan J. Pakula (*Klute*)—it is yet another New York that unfurls before the spectators' eyes. A dirty, violent, corrupt, disturbing, trivial, nocturnal New York, a sick yet oh-so-alive city that Scorsese will heat to incandescence in inimitable style, first in *Mean Streets* and then in *Taxi Driver*. The filmmaker from Little Italy, who spent his entire childhood in this neighborhood teeming with mafia and bands of hooligans, is without doubt the person who succeeded in getting the most up-close-and-personal with this magical and menacing city whose fall and redemption are his favored themes. Conversely, Woody Allen is the exception that confirms the rule since his New York is an intellectual, chic and cosy town diametrically opposed to the nightmare depicted by Scorsese, as clearly demonstrated by the famous prologue of *Manhattan*, a magnificent reverie in and around Central Park, Lincoln Center or Fifth Avenue, traditional New York neighborhoods filmed nostalgically in black-and-white. In the late 1960s to early 1970s, New York is a city that is endlessly and aimlessly surveyed, as in a couple of films made by two temporary exiles: *Midnight Cowboy*, by the British director John Schlesinger, who tells the story of a naive cowboy's (Jon Voight) discovery of the big city after moving there from small-town Texas and, to an even greater degree, Polish director Roman Polanski's sardonic *Rosemary's Baby*, which offers an oblique and thoroughly haunting vision of a metropolis that seems suddenly

transformed into some Eastern European burg. It is also a city of chases, as in William Friedkin's early-1970s classic, *French Connection*, featuring an endlessly varied series of manhunts and shadowings across a New York that is filmed illicitly, with an amazing naturalness and incredible energy, and which comes to define the canons of the modern urban detective thriller. At the same moment, Don Siegel and Clint Eastwood are doing much the same thing on the West Coast, in San Francisco to be precise, in *Dirty Harry*. As this golden age of New York cinema recedes further into the past, we begin to realize just how much classics such as *Taxi Driver*, *French Connection* or *Annie Hall*, not to mention the films that came before them, have shaped a perception of New York. These perceptions, while certainly multifarious and full of contrasts, are henceforth etched into the imagination of the city's residents and, even more so, its visitors, whose numbers swell with each passing year. It is no longer possible to film New York innocently, because the stock of images and representations that the city has spawned is too extensive to be erased from either our memories, or that of the filmmakers.

From the 1990s, New York evolves, and so too does American cinema. The mayor, Rudolf Giuliani, decides to clean up the city which, at the time, is no longer the focal point of an American film industry that is increasingly fragmented across every region of the country. The city is often used as a shooting location for television series, perhaps more than for films. In this period, which extends to the present day, it is the superhero films that in the end make the most skillful use of New York,

undoubtedly because they succeed in casting a new spell over a city that is showing signs of reaching a figurative breaking point under the weight of all the films that built its myth. For the past two decades, the city has been under continual siege from movies such as *Superman*, *Batman*, *Spiderman*, as well as *Men in Black*, not to mention *King Kong*, which was recently brought back in a third revival, by Peter Jackson. These films occasionally transform New York into a fantastic metropolis as in the first two *Batman* films directed by Tim Burton (*Batman* and *Batman Returns*) which repaint New York in the somber hues of Gotham City in order to lend it a hybrid retro-futuristic vision that is it at once dark, playful, and operatic. As for Sam Raimi's *Spiderman*, while often a fallible superhero, his super powers nonetheless enable him to bound over New York skyscrapers and bring the subway to a grinding halt. The preternatural powers of *Batman* or *Spiderman*, however, did not manage to prevent the September 11, 2001 terrorist attacks. These obviously left an indelible mark on the city of which the cinema is yet to take the full measure, with the notable exception of *The 25th Hour*, one of Spike Lee's latest films, which offers a beautiful meditation on the gaping hole in Manhattan, or the final image in Martin Scorsese's *Gangs of New York*. We will of course have to await Oliver Stone's *World Trade Center*, due for release at the end of summer 2006, in order to see the first real fictional film directly inspired by the September 11 attacks and to observe that New York and its cinema have undoubtedly not had their last word, however haunted they may be by the worst disaster the city has ever seen.

Live from New York! Five Decades of Performances and Events that Shaped the Art of a City

RoseLee Goldberg

The dazzling art world that was New York City during the second half of the 20th century was the result of a vital scene of artists, film makers, dancers, musicians, poets and writers who lived, worked, and played together "Downtown," below 14th Street, in an area made up of Greenwich Village (in the 1950s and 1960s), SoHo (the 1970s), the East Village (the 1980s) and the Lower East Side (the 1990s). Like Paris in the 1920s, the creative drive of individuals who comprised this non-stop scene erupted in the gaps between disciplines, the spaces between buildings, the intervals between people. Whether John Cage and Merce Cunningham, Yoko Ono and George Maciunas, Robert Rauschenberg and Andy Warhol, Cindy Sherman and Matthew Barney, the art of this extraordinarily rich, remarkably long period of avant-garde activity that shaped New York City's cultural history was the result of a continuous combustion of personalities and ideas, and of artists working side by side, in a broad range of disciplines and media.

Viewed through the lens of the lives lived by artists and the events they organized, rather than by the objects they produced, including close attention to the bars, lofts and fire-escape landings that hung inelegantly down the fronts of turn-of-the-century industrial buildings, from where the non-stop movement of the city could be observed, a more accurate picture of the art world and the source of the ideas that fueled it emerges. From the late 1940s, at the Cedar Bar on 10th Street and University Place in Manhattan, brawny men including painters Jackson Pollock, Willem de Kooning and poet Jack Kerouac, and talented, intellectually astute painters Joan Mitchell and Helen Frankenthaler, frequently in sweaters and pearls, as well as cravat-wearing art critic Clement Greenberg, and stylishly turned out art dealers John Bernard Myers and Richard Bellamy, amongst many others, argued into the night about the rigors of abstraction or the politics of the latest power plays that shaped the American 1950s in the aftermath of the World War II. Half a decade into the 1960s, in December 1965, Max's Kansas City on lower Park Avenue, close to Union Square, picked up where the Cedar Bar left off, and brought together an entirely new generation that would mix Conceptual Art and Rock'n Roll, Pop Art and Fashion, Ridiculous Theater and Minimalist Music, in two floors of an establishment run by the irrepressible Mickey Ruskin. Described by its proprietor as his "living room, where each night I throw a party," Max's was the centerpiece of New York art life for close to a decade. Stopping by late at night in 1971 or 1972, one might be greeted by Robert Smithson holding court at the long bar near the entrance while Carl Andre, Nancy Holt, Lawrence Weiner, Jackie Windsor, or Vito Acconci might be seated in booths along the walls, each table dotted with its customary bowl of chick peas. In the back room, Andy Warhol, Lou Reed, David Johansen, David Bowie, Iggy Pop, William Burroughs, Candy Darling, Robert Mapplethorpe, and Patti Smith might be at a large round table, while upstairs, seven nights a week, the Velvet Underground, Iggy, and the Stooges or Debbie Harry and Blondie would play to a packed and smoky room.

In walking distance, only eight blocks down Broadway, at the corner of Prince and Mercer Streets, beyond the Mercer Art Center (1971–73) where the New York Dolls launched American 'glitter rock,' stood the bar Fanelli's, with its dark wall-paneling, photographs of boxers who convened there long ago, and its tables covered in red and white checked tablecloths. Choreographers including Trisha Brown, Lucinda Childs or Simone Forti, composers Steve Reich, Philip Glass and Meredith Monk, theater directors Richard Foreman or Robert Wilson, film diarist Jonas Mekas, or video artists Nam June Paik, Shigeko Kubota or Joan Jonas, neighbors all in the nearby floor-through lofts with their banks of tall windows and high ceilings in buildings recently vacated by sweatshops that were the light-industry backbone of Manhattan for almost a century, would meet for early dinners or late beers to exchange conversations about performances seen or soon to be presented at the alternative artist-run spaces that dotted SoHo from the early 1970s through the end of the decade. At 112 Greene Street, The Kitchen, Franklin Furnace, Artists Space, or in the parking lots below Canal Street or on the sand covered embankment of the West Side Highway, they would perform for or with one another, lending a hand to make work that might begin on the rooftop of a nearby warehouse and end at water's edge on the Hudson River. Later in the 1970s, the after-midnight route wound from The Kitchen on Broome Street to CBGB's on the Bowery, where musicians Alan Suicide,

Patti Smith, and Richard Hell and his band the Voidoids as well as Television, The Ramones or Dead Boys played to standing crowds. Further south, at The Mudd Club, on White Street, Eric Bogosian performed on a small stage, impersonating leering suburban males in monologues that mimicked 1950s Borscht-belt comedy and that drew on the spirit of Bogosian's hero, the famously foul-mouthed Lenny Bruce. Before strolling West for an early morning cocktail at Puffy's Tavern as the sun came up, detours might include the Ocean Club where art-school graduates David Byrne, Tina Weymouth and their newly formed art-music group, Talking Heads, played, or Tier 3, where artists Robert Longo and Richard Prince and composers Rhys Chatham and Glenn Branca blasted rock-anthems and noise music for an enthralled art world who, it seemed, could not get enough of the art-as-punk-music adventure. In the 1980s, as rents in SoHo increased a thousand fold, nighttime geography shifted east of Broadway to small storefront bars and clubs along First and Second Avenues, Avenues A and B; at the Pyramid Club, WOW Café, 8BC, Limbo Lounge, Club 57 with artists as polished and stylish as Ann Magnuson, as extravagant as Ethyl Eichelberger, or as eloquent as David Cale, John Kelly, Sanghi Wagner or Steve Buscemi. Audiences comprised Alphabet City residents (named for the avenues "A", "B" etc.) and those on stage were determined to 'blow the minds' of their friends with surprise combinations of projections, music, drawings, paintings, constructions, street graffiti and detritus that did away with all barriers between art, camp or cabaret, and thriving on their combination. The exuberant, compact East Village scene created a cultural cacophony that would reach far beyond lower Manhattan to Tokyo, Paris, London, Beijing and Johannesburg.

The restlessness, over five decades, of intensely creative New Yorkers (transplants from other States, other countries) was punctuated by events and performances that continuously altered ideas about art and the manner in which it was made. They ignored boundaries between disciplines, disregarded the gallery as exhibition space, and, as members of a like-minded conglomeration of widely different sensibilities, generally encouraged each other to think in many media at once. Each new New York generation, from the 1950s onward, metaphorically carried the proverbial *baton* from one watering hole to the next where it was unceremoniously passed to newcomers as license to take off in entirely new directions. Shifts in aesthetic viewpoints would have a far-reaching effect; when Jackson Pollock went public with his painting technique in 1949, allowing photographers (first Arnold Newman and Martha Holmes in 1949 and then Hans Namuth in 1950) to witness up close his slow dance as he bent low over canvases laid out on the floor, he not only revealed an entirely personal invention and his own powerful physicality as the driving force behind his paintings, but he also opened the way for an approach to the medium of painting that critic Michael Fried would later describe with some concern as becoming perilously close to theater. Or, as Harold Rosenberg wrote in 1952, "what was to go on the canvas was not a picture but an event." Pollock's method-painting would be interpreted by other painters as a directive to break the limitations of the canvas, and to open pictorial space to include the artist's corporeal gestures and surroundings. In contrast to Pollock's well-known comments about a trance-like inward focus that gripped him during his unusually athletic painting process, Robert Rauschenberg described his own approach as a strong reaction to Pollock's cogitation. "There was something about the self-assertion of abstract expressionism that personally always put me off," he told an interviewer in 1965, explaining that his focus was "as much in the opposite direction as it could be." He was intent on finding ways "where the imagery and the material and the meanings of the painting would be not an illustration of the artist's will," but would be "an unbiased documentation of my observations and [...] excitement about the city," he said of his *modus operandi*, and of his home base New York City. For Allan Kaprow, whose installation, *18 Happenings in Six Parts* (1959), took the form of a series of constructed rooms through which viewers at the Reuben Gallery on Fourth Avenue would move when instructed to do so by the artist, and that spawned the term *Happening*, Pollock's energetically constructed canvases suggested an end to painting as it was known. For Kaprow, Happenings were an expression of his resolve to participate directly in the world around him: "I simply gave up the whole idea of making pictures as figurative metaphors for extensions in time and space," he said of his shift from being an 'action painter' to an 'action artist.' Painter Carolee Schneemann was to take the radical step, in 1963, of placing herself, naked at the center of a huge-three dimensional painted construction in her loft. Of this private performance, *Eye Body*, which was captured in photographs, Schneemann said that she wanted her body to be combined with the work, as "an integral material, a further dimension of the construction."

Such determination to create events that would entirely reshape perception and that engaged the viewer as much as the artist in a particular experience became a central interest of many artists working in New York in the late 1950s, especially for a small circle who had graduated from John Cage's classes in experimental composition

at The New School for Social Research (1956–60). Dancers, musicians, composer, poets, and visual artists responded to Cage's inventive teaching methods, incorporating into their own work his notions of chance and simultaneity as a creative strategy, as well as his instructions on how to perform that were informed by tenets of Zen Buddhism. Heightened consciousness, whether of ambient sound and silence or of actions in space made by artist and audience, was integral to Cage's notion of the 'finished work' that was, paradoxically, always in process. Artists such as Kaprow, Al Hansen, George Brecht, Dick Higgens and Jackson MacLow, applied Cage's various 'non-intentional' systems to a range of disciplines expanding on a famously untitled work from 1952, that Cage, Rauschenberg, Cunningham, composer David Tudor and others had produced as part of a summer program at Black Mountain College in North Carolina. As Cunningham ran down aisles between chairs arranged in four diamond-shaped seating areas in the college dining hall, followed, the story goes, by an excited dog, poet M.C. Richards pronounced from the top of a ladder, Cage read a lecture on music and performed 'a composition with a radio,' while films by Rauschenberg were projected overhead onto broad swatches of white-painted canvas. Memory of the event would be written into the future activities of all participants, and the thrill of improvisation as a means to shake new ideas from the very bottom of creative psyches became a frequently utilized escape-hatch for avant-garde experimentation from that time on.

Anti-historical, anti-academic and irrepressible, the many hundred events of the 1960s were brash and brazen, and conceived for entirely unexpected places. Rauschenberg's one-time-only *Pelican* (1963) was presented in a skating rink (actually in Washington), Claes Oldenburg's *Washes* (1965) in a swimming pool, Robert Whitman's *Prune Flat* (1965) in a movie theater, while Red Grooms's *Burning Building* (1959) was constructed in the Delancey Street Museum (Grooms's loft) where it remained as an installation over several days. These actions, which took place off the beaten track, were created mostly for an intimately connected group of New York artists who cared less about the products of art than about the intensity of their engagement with the work, and with one another. For them, the real measure of success or failure was based on how much these productions changed their minds and how each new event upped the ante of the last performance for doing so. Interestingly, *épater le bourgeois* was not the driving motive; rather these artists were intent on creating vehicles for the continuous unfolding of radical ideas and fiery imaginations. The result was a fluid matrix for argument about the avant-garde that gave New York City its pulse and which erupted in more festivals, Happenings, Events, private performances and loosely associated collaborations and acts of experimental theater, than any time before or since. Fluxus artists George Maciunas, Nam June Paik, Yoko Ono, George Brecht, Alison Knowles, Al Hansen, Jon Hendricks, Tom Watts or Ben Patterson, to name a few, created combinations of whimsical yet formally serious concerts involving recorded sound, classical instruments, objects and spoken word that might take place in Ono's loft on Canal Street, often joined by musician Ornette Coleman or Japanese artist Ay-O, at the Filmmaker's Cinematheque on West 41st Street, or under the marquee of the First Avant-Garde Festival organized by Charlotte Moorman at Carnegie Hall in 1963 (and thereafter through the following two decades). Judson Dance Theater, begun in 1962 as an informal consortium of activist and forward-thinking choreographers including Trisha Brown, Lucinda Childs, Yvonne Rainer, Steve Paxton, Deborah Hay, Robert Dunn, Jill Johnston, Simone Forti among many others (several of whom had apprenticed with West Coast movement teacher and guru Anna Halprin who encouraged performers to consider dance as a form of critical thinking), frequently included collaborations with many visual artists including Robert Morris, Robert Rauschenberg, Bernar Venet, and Carolee Schneemann. The Living Theater, with its indomitable leaders Judith Malina and Julian Beck, The Performance Group, founded by Richard Schechner, Mabou Mines with JoAnne Akalaitis and Lee Breuer, and wave upon wave of creative individuals in every imaginable combination of media, in various spaces up and down Manhattan's island and further afield, for example to Robert Delford Brown's farm, where the Yam Festival (May spelled backwards) took place. Each person in this constantly expanding group of original inventors fed the others' ideas; they refused to categorize their activities as dance or music or poetry or sculpture, but rather considered all of these equal yardsticks for taking the measure of new concepts. It seemed that no field of human endeavor was left untouched by their adventurous thinking: in 1966, M.I.T. engineer Billy Klüver organized *Nine Evenings of Theater and Engineering* at the 69th Regiment Armory, a collaboration between more than twenty Bell Laboratories engineers and ten artists who worked together on performances incorporating new technology; John Cage, Lucinda Childs, Yvonne Rainer, Öyvind Fahlström, Alex Hay, Deborah Hay, Steve Paxton, Robert Rauschenberg, David Tudor, and Robert Whitman produced startling collaborations with their partnering scientist. Later that year, Klüver, along with Rauschenberg and Whitman, founded Experiments in Art and Technology (E.A.T.), an or-

ganization that would foster continuing relationships between scientists, artists and industry in the form of conferences and exhibitions, for several years afterwards.

The continuous combustion of New York's artistic life took place against a backdrop of increasing political ferment, which these artists were quick to absorb into their work. In just one month, March 1965, on a day that would go down in Alabama history as Bloody Sunday, when 600 black and white protesters were viciously attacked by local and federal police, setting the country on edge and launching the burgeoning Civil Rights Movement, U.S. combat troops arrived in South Vietnam. That month also, in downtown New York, the mood was pervasively austere. The Judson Church Theater provided a gathering place for somber protest in the form of 'democratic' performances involving non-trained dancers, in events that articulated a social and cultural critique. A pared down aesthetic that refused and refuted décor of any kind (of the body or of setting), evolved out of a fast changing political and social consciousness. Yvonne Rainer's now seminal work, *Parts of Some Sextets*, in which dancers went through the motions of ordinary, everyday motions as dance, perfectly illustrated the tenets of a manifesto that was published under the same name: "no to spectacle, no to virtuosity, no to transformations and magic and make believe." These instructions articulated the general ethos and aesthetics of a generation, which were as much a response to the horrific events of Selma, Kent State, Chicago, or Memphis, they were an expression of their serious purpose in altering the nature and form of dance. For this generation, art was an intellectual endeavor with philosophical and moral consequences, and, although not always accessible to every audience, content, context and communication mattered.

The Portapak, the first commercially available video equipment outside the TV studio, introduced by Sony in the United States in 1965, was quickly thought of as a 'democratic tool' that would exponentially extend communication to form a 'global village' of endlessly linked parts. In the hands of Nam June Paik, who apparently exited a store with his new purchase in October of that year, filmed the Pope's cavalcade on Fifth Avenue, and showed the results that evening at the Café Au Go-Go, video was about instantly capturing time. It was also a means to fragment and replay it and to delve into a broad range of conceptual territories, having to do with ritual, the body, psychological or 'topological space,' the relationship between performer and viewer, or the innate properties of video technology itself, such as 'snow' or 'vertical' and 'horizontal' holds on TV monitors. For Paik and fellow artists

Steina and Woody Vesulka, Beryl Korot, Richard Gillette, Shigeko Kubota, Peter Campus, Hermine Freed, Dan Graham, Vito Acconci, Richard Serra, Kit Fitzgerald or Joan Jonas the video camera and its companion playback machine and monitor were a closed circuit for giving visual form to entirely new thought processes. In 1969, at the Howard Wise Gallery, the exhibition "TV as a Creative Medium", with Nam June Paik and Charlotte Moorman, Ira Schneider, and Frank Gillette among others, reprised Marshall McLuhan's notion of the medium as the carrier of content, pointing to a distinct 'video maker' aesthetic, while a decade later at The Kitchen, originally founded by the Vesulkas, video was shown continuously in a dedicated viewing room, as one medium among many used by artists to indicate the symbiotic connections between visual art of the art world and the visual language used by the mainstream media.

By the mid-1970s, SoHo had the feel of a newly settled frontier village as artists who had previously squatted illegally in their large lofts were now entitled to do so through newly introduced loft laws protecting their right to inhabit, if proof were presented of an individual's status as an artist. In those days, a 2,000 square foot loft in the heart of SoHo cost just 200 dollars a month. Streets were empty and dimly lit at night, trucks and truckers hogged sidewalks by day, and rummaging through bins outside electrical stores along Canal Street constituted a shopping expedition for those living and working in the cast-iron buildings, usually one or two per floor, in buildings recently vacated by small businesses and factories, where the possibility of so much space was inspiration in itself. Performances and exhibition might take place in any number of these personal spaces, and their generous architectural volumes gave the simplest gesture, the least pretentious construction, a grandeur all their own. Cheap rent generated a particular aesthetic in the art of the 1970s, and the extraordinary spaces that it made available to a large and immensely talented community provided the model for exhibition spaces for years to come, including the new museums with their cavernous halls that would be built at the turn of the millennium.

The galleries that opened at 420 West Broadway, and along Greene and Wooster Streets, had the same proportions and construction as artists' lofts, so that workspace and exhibition space were interchangeable. Attending a rehearsal with Laura Dean dancers spinning in a loft on Lower Broadway or a Simone Forti and Charlemagne Palestine performance at Sonnabend Gallery had essentially the same feel; close proximity to the work in both venues forced viewers to watch and

listen carefully, to weigh the propositions before them as attentively as they might memorize directions through a maze. Such concentrated mental tracking of instructions to notice a myriad of clues, both physical and conceptual, was part of the plan of many a performance in those days: Richard Foreman's Ontological-Hysteric Theater was set in a long and narrow space that stretched away from the audience like the rings of a telescope, his specially constructed stage emphasizing the pictorial aspect as much as the rhetorical energy driving his intensely intellectual theater, while early drafts of Robert Wilson and Philip Glass's *Einstein on the Beach* (1976) also showed that this brave new work had as much to do with the vast, dreamy spaces of Lower Manhattan as with Wilson's ferocious imagination. A trained architect, Wilson envisaged drama on the scale of city blocks which performers traversed in slow motion as though giving actual form to time. When he and Glass rehearsed at Westbeth (a huge building on the corner of West and Bethune Streets on the West Side, converted from Bell Telephone Laboratories to artist studios), it was as though the entire ethos of an era were contained in one very large room. In a bold collaborative gesture, Wilson brought together the talents and intelligence of the neighborhood. Glass, fellow traveler with Wilson in conceiving and developing *Einstein* into an extraordinary visual opera without a narrative, sat at his electric piano, while slides of drawings of proposed backdrops were projected onto a wall behind him. Choreographers Lucinda Childs, Andy deGroat, Grethe Holby, and Dana Reitz, the musician Connie Beckley and many other performers highly regarded in their own right added their idiosyncratic design to Wilson's whole. *Einstein*, when it opened at the Metropolitan Opera House in New York, was called a total artwork for the way it combined an entire gamut of disciplines. Yet it was also a tally of the totality of inventions and influences of performers, including Meredith Monk, Robert Ashley, the Performance Group and Mabou Mines, those having nothing to do with the opera itself, but whose essential and pivotal work could be said to have provided touchstones for it.

The moment of *Einstein* coincided with the arrival of a new generation in town: the students of the Conceptualists who poured into New York from art schools where some of the best had been teaching—CalArts, Nova Scotia College of Art and Design, the Rhode Island School of Design, the University of Buffalo. They came to witness first-hand the artist-run 'alternative spaces' that served as exhibition and performance outlets for the areas enormous artistic production: 112 Greene Street, Franklin Furnace, 3 Mercer Street, Anthology Film Archives, Global Village, Artists Space, The Kitchen. They were the media generation who had grown up on rock'n roll, B movies, twenty-four hour television, and fast food, and who focused at art school on the mechanics, both perceptual and emotional, of the media as ubiquitous cultural and experiential filter. The work of John Baldessari, Joseph Kosuth, Marina Abramovic, Michael Snow, Vito Acconci, Chris Burden, Dan Graham, Joan Jonas, Rebecca Horn, Dara Birnbaum, Laurie Anderson or Dennis Oppenheim was second nature to them, and Andy Warhol reigned supreme in this firmament for his utter disregard of the boundaries between commerce and fine arts and his incomparable success in combining them. The media generation's sophistication was palpable, as was their ambition and their experience of New York life, much edgier than that of their elders, made no distinction between the intellectual high of conceptual art and the gut-wrenching low of Punk, the ingenious experimentation of artists' video or the ironic absurdity of late-night TV: *The Gong Show, Mary Hartman, Mary Hartman*, or *Saturday Night Live*, on the one hand, and videotapes (and live performances) by Michael Smith, Julian Heyward, Mitchell Kriegman, Bill Viola, Kit Fitzgerald, and Jill Kroesen on the other were the flip sides of a mirror that reflected the United States as a vast media landscape stretching from coast to coast. With one foot in high art and its historical legitimacy and the other in the mire of popular culture and celebrity acclaim, the media generation dreamed up an entirely new look for the art of the 1980s that would fit together the nuanced sensibilities of the one and the not-so-nuanced pronouncements of the other.

Making direct connections, both conceptual and aesthetic among all media, was built into the ethos of the artists who would lead the way in the early 1980s, including Cindy Sherman, David Salle, Robert Longo, Matt Mullican, Troy Brauntuch, Jack Goldstein or Sherry Levine, each of whom had their first solo shows in the small gallery at The Kitchen, between 1978 and 1980. For artists of this new generation, The Kitchen's multidisciplinary approach reinforced the media-oriented explorations of their artwork, adding a sense of motion and mediation, even when the artwork was still. It revealed as well how cleverly this group examined the mechanics of spectacle; its repetition of bold images, its obliteration of the backgrounds that transformed such images into solid iconic legends, its use of veils of brilliant light and technicolor to seduce visitors. For this astute group and their peers beyond The Kitchen, including intuitive and articulate image makers such as Gretchen Bender, Sarah Charlesworth, Nancy Dwyer, Barbara Ess, Laurie Simmons, Louise Lawler, BethB, Jenny Holzer, and Barbara Kruger, The Kitchen maintained an ongoing critical con-

versation about medium and content, about pictures that speak and words that don't (but that function as visual signs instead), and about how their artworks which explicitly critiqued the media, were nevertheless quickly co-opted by advertisers on Madison Avenue. The Kitchen was a unique platform for such debate and an active reminder that art can and should set serious arguments in motion. Its team of curators, in dance, music, performance, video, and visual arts, most of whom were artists themselves, were in continuous discussion in their determination to provide up to the minute reporting on cultural shifts as they occurred.

The Kitchen's dedication to all media all the time helped launch waves of new material that shaped the 1980s across disciplines. Choreographers Bill T. Jones, Arnie Zane, Molissa Fenley, Karole Armitage and Ishmael Houston-Jones, to name a few, were seen as extending the high-low dialogue as was the music program with its new jazz, serial rock, art music and hip hop by performers as varied as Rhys Chatham, Ned Sublette, "Blue" Gene Tyranny, Sonic Youth or John Lurie. Films by Amos Poe, Eric Mitchell or the painter and performer James Nares swung between narrative styles that referred to French Nouvelle Vague and American TV fare. Any of the above named artists was just as likely to be in the audience as to be showing work at The Kitchen where Afrika Bambaataa manned the turntables or when Rock Steady Crew gave its first institutional performance of break-dancing in 1981, the same year that Laurie Anderson's single *O Superman* topped the British pop charts, breaking the "high-low" barrier in the most public way. By the time that she presented *United States* (1983), an eight-hour opus of storytelling, music and projections of hand-drawn pictures, blown-up photographs and film fragments onto an opera-sized backdrop at the Brooklyn Academy of Music (BAM) other artists were also finding ways to present their material to a much broader audience. Robert Longo, Cindy Sherman, David Salle, and Julian Schnabel would each create feature-length films in the 1990s.

The end of the 1980s would be marked by economic and political shifts brought about by the stock market crash, as well as by the fall of the Berlin Wall and the end of totalitarian Communism, and with it a gradual awareness that the decade of excess also carried the somber signature "Silence=Death" used by activist groups to focus attention on the ravages of AIDS and the rampant world epidemic that it would become. Multi-culturalism, first as an academic concept, raised in departments of African-American history in high profile universities and, as measure of ethnic identity, also shaped the thinking and

aesthetics of the decade, highlighting as it did the roots of New York City's rich human tapestry, and opening windows onto global cultures as well. Performance, as always, provided an expressive platform for protest and was a means to articulate nuanced viewpoints about how the multitude of nationalities within one city, a conglomerate of five boroughs, co-existed and also enriched one another. The art of the 1990s would absorb all of the above as well as appropriations from a broad historical menu that 'post-modernism' permitted and encouraged. Its content of a pervasive international media culture, that looks to the future each day as the very latest technologies are projected directly from computer screen to production line, would generate material of the highest level of sophistication. High density digital imagery—collaged, layered and perfectly re-imaged—created a level of sophisticated picture-making never seen before, that could be spliced through with techno music or outtakes from vast banks of collected and re-arranged sounds. Perhaps no artist better represented this *fin de siècle* apotheosis of visual history and aesthetic desire than did Matthew Barney, whose talents as an inventor of visual spectacle, as *imagist par excellence*, made his work the measure of new art and media for the new century. The boldness of his sculptural vision, which has produced voluptuous projectiles that seem to ooze from his own body and freeze on the museum floor, is translated into films whose deliciously textured pictures become lodged, indelibly, in the psyche and continue to throb in the bloodstream ever after. Only the Brothers Grimm similarly intertwined creatures of the imagination with an insidious and yet abstract commentary on their times.

Contemporary art is so riven through with shards of performance history that it is impossible to view the story of visual art of the past five decades in New York City as anything but an integrated history of the two. Indeed, performance, as provocation, as social milieu, and above all as a breeding ground for developing original concepts and new forms is central to the unfolding story of the avant-garde over five decades in our town. New York, New York, from the 1950s until now, is an extraordinary adventure, a continuous period of change and invention. New York is a state of mind that remains forever radical.

New York Stories

Nancy Spector

The story of contemporary art in New York is the story of contemporary art. That is not to say that absolutely everything that happened in the development of contemporary art took place here, but it does imply that just about anything of any critical importance either evolved in or had an immediate impact upon the city's artistic milieu. Pop Art, Minimalism, Post-Minimalism, and Conceptual Art—the true forebears of what constitutes the most radical art of the present—were all deeply rooted in New York. Certainly there have been foreign iterations of all these movements, but New York has been the nucleus, the ur site, where artists have gathered to test their ideas, prove their ground, and make their mark. This is a place of great density and compression, where artists rarely work in isolation and ideas flow freely. While the history books may segregate artists according to their respective movements—i.e. Robert Rauschenberg practiced Pop, Donald Judd was a Minimalist, and Lawrence Weiner pioneered Conceptualism—the reality is otherwise. The story of New York's contemporary culture is a story of cross-fertilization, overlapping influences, and a creative energy that can only be described as promiscuous and polymorphous. To revisit the names just cited, Rauschenberg was active as a choreographer with the Judson Church dancers during the 1960s; Judd was an architect and designer in addition to being a sculptor, and Lawrence Weiner was actively engaged with the behaviors and processes of materials even though he reduced everything to the written word. This essay will relay just one (unlikely) story of interconnections and influence—between the artists Richard Prince and Felix Gonzalez-Torres—that, in turn, begins to unpack some of the overlapping principles behind the art of the 1970s, 1980s, and 1990s in this city.

During the early 1970s, no one artistic style dominated in New York. Artists working in Post-Pop, Post-Minimalist and Conceptual veins were exploring the entropic nature of materials (Robert Morris, Robert Smithson), the ontological status of art itself (Joseph Kosuth, Bruce Nauman), the limitations of the body (Vito Acconci, Dennis Oppenheim, Dan Graham), the built environment (Gordon Matta-Clark, Richard Nonas), the status of women in society (Martha Rosler, Hannah Wilke), the cult of celebrity (Andy Warhol, Robert Mapplethorpe), and so on. This is hardly an exhaustive list, but it indicates the plethora of investigations underway at the time and how a number of artists' works could also be easily cast in a different category, such as "those exploring new technologies like video" or "performance" or "environmental art."

Every once in awhile in the long history of the visual arts something singular happens that shatters all existing paradigms, that changes the rules, that makes it impossible to go forward without considering the astonishing implications of what just happened. Kasimir Malevich's *Black Square* (1915), Marcel Duchamp's *Urinal* (1917), Jasper Johns' *Flag* (1954–55), Robert Rauschenberg's *Bed* (1955), Dan Flavin's *The diagonal of May 25, 1963 (to Constantin Brancusi)* (1963), and Joseph Beuys' *Fat Chair* (1964) all represent such discrete moments of rupture. Tradition was fractured again in 1977 when Richard Prince rephotographed four advertising images from the *New York Times Magazine* and presented them as his own. Kidnapped from their mass-media source, these photographs are shown devoid of any ad copy, logo, or signifier of their derivation. The quartet of pictures shows four different living rooms, all cropped to emphasize a similar, horizontal expanse of plush sofas, perfectly appointed coffee tables, designer carpets, and decorative accoutrements. The serial nature of the photographs and their humid, over-stated depiction of bourgeois lifestyle read like a meditation on consumer desire, on the aspiration for material goods, and the lust for luxury that permeates late-capitalist culture. While all this is relevant to the work, the real radicality in Prince's deceptively simple act of rephotographing already existing commercial images lies in the technique itself. By purloining utterly contrived pictures designed to represent the "real world"—to sell us an image of what we think we want the real world to be—and showing us seamless copies of them, Prince puts into play a dizzying strategy that challenges the distinction between truth and fiction. He creates photographs that when matted, framed, and hung on a gallery wall seem more real, more authoritative, and certainly more precious than their reproduction in a magazine, which is only on the newsstand for a week or month at best. In a way, Prince's photographs return the mass-produced images he appropriates back into the "original" pictures used for the advertising layout. In an early interview with David

Robbins, Prince explained the concept behind his rephotography (in his albeit deliberately cryptic way):

"Sometimes I think all my work got sent away for. You know, like I saved up my box tops, sent them off to Battle Creek, Michigan, and this is what I got back in the mail. 'Baking soda makes the submarine go under water and propels it!' But I'm not just making another fiction. That wouldn't interest me at all. I'm interested in the fiction becoming true. You know what I mean?: it wouldn't surprise me if the day came when the Earth really *did* stand still. I'm interested in the idea of making non-fiction art. In other words, I'm interested in making a fiction look true. It seems to me that trying to present something believable might be about *asking too much*. I'm interested in my photographs asking too much."[1]

While Prince may have been the first to appropriate an existing photograph, he did not create this groundbreaking work in a vacuum. By the end of the 1970s, a number of young critics and artists influenced by Post-Structuralist theory began to question conventional assumptions about visual representation and rejected Modernism's faith in the singular author/singular masterpiece model. Manifest as a crisis in cultural authority, Postmodernist thinking exposed the legitimizing narratives of Western thoughts—such as religion, philosophy, and psychology—to be ideological constructs designed to maintain the presumed hegemony of Western civilization. In the visual arts, Postmodernist theory was translated into a widespread suspicion of representation itself. For representation also promoted a "narrative of mastery," a legitimizing myth of man's capacity to mimetically reproduce his environment and, thus, to guarantee his place as subject in the world. This privileged position of man as subject has historically been constituted through and protected by cultural ideologies. The alleged unitary, dominant, and incessantly masculine nature of this socially constructed subject—as well as the ideologies necessary to keep it intact—came under interrogation during this period by artists who felt compelled to challenge inherited representational and discursive strategies. Questions regarding the mechanisms of power inherent to systems of modern-day representation—fine art, advertising, television, film, print media, fashion, and architecture—emerged as operative aspects of the most provocative and enduring art created during the late 1970s and 1980s: to whom is representation addressed and whom is excluded from it? In what ways does representation define and perpetuate class structure, sexual difference, and racial difference? What does representation validate and what does it obstruct? In what ways does representation foster desire—on both the erotic and the economic levels? And, ultimately, can the mechanisms of representation—like those of ideology, which are seamless, transparent, and always present—be policed, dismantled, or transformed?

For the artists most publicly and effectively engaged with these issues—including Troy Brauntuch, Sarah Charlesworth, Jack Goldstein, Barbara Kruger, Louise Lawler, Sherrie Levine, Cindy Sherman, Laurie Simmons, and James Welling, among others—photography provided the perfect means with which to interrogate mass-cultural representation. Appropriation or rephotography became the technique of choice in that it functioned as both an analytical and formal tool. In 1977, the year Prince created his *Untitled (Living Rooms)*, art critic Douglas Crimp organized the exhibition "Pictures" for Artist's Space in Manhattan, which provided the first occasion to witness this Postmodernist strain in the visual arts and the role of photography as a theoretical tool.

While Prince was certainly conversant in Postmodernist theory, peppering interviews with comments about the falsity of history and fictions of the media, his sense of rebellion is rooted elsewhere. A student of 1968, Prince's references are Woodstock and Dylan not Baudrillard and Lyotard. His rephotography stems from an attempt to aestheticize the world as he sees it, to make things present that are otherwise invisible, and to tease out the uncanny, sometimes poetic, side of reality as it is pictured for us in the media. "What's unreal for most is an official fiction for me," he explained in an early interview with Peter Halley:

"It's pretty much what chimneys were to the industrial revolution. They were familiar but still, they looked unreal. They had very little history to them. Someone like de Chirico recognized this and was able to additionalize another reality onto them. The look of his chimneys ended up having a virtuoso real. So it's somewhat the same for me. I don't have any memories of earrings hanging on a tree or of three women looking to the left, [description of two of his photographs] or even of the Eiffel Tower next to the Empire State Building next to Taj Mahal! And if I do have any memories of these scenes, they come from other pictures."[2]

Prince has always cultivated an outsider's mentality. During the 1980s, his subject matter subsequent to the appropriated advertising images flew in the face of iconography deemed acceptable by an art world increasingly involved with identity politics, AIDS, feminism, and Postmodernism's critique of the canon. With its deadpan detachment, Prince's work also appeared in opposition to the overwrought heroics of Neo-Ex-

pressionist painting and sculpture. His *Cowboys*, *Girlfriends*, *Entertainers*, and *Sunsets* photo series, *Joke* paintings, and *Car Hood* sculptures exist on their own terms, in dialogue with no one, daring to be different. This is not to say that Prince's work wasn't influential at the time. To the contrary. Though he often claimed to be "practicing without a license,"[3] Prince gave permission to a younger generation of artists to freely sample from existing source material, to disregard the need for a signature style or technique, and to jettison any aesthetic resistance to popular culture. While there is no "school of Prince," in the way that artists like Luc Tuymans or Gregory Crewdson spawned circles of followers who emulated their style and/or technique, his attitude to art-making has resonated widely to many different effects. Prince's machismo themes and outlaw sensibility can be sensed in the work of Cady Noland, Pruitt and Early, Damien Hirst, and Piotr Uklanski among others.

For Felix Gonzalez-Torres, who studied with Prince at New York University's Masters Program in Photography in 1987, it was the artist's subversive attitude toward originality and authorship that inspired him to devise a form of portraiture that eschewed any representational imagery. In other words, in the midst of his graduate studies in photography, he stopped taking pictures entirely (for awhile at least).[4] Gonzalez-Torres was specifically responding to Prince's *Entertainers* (1982–83) series, for which he collected aspiring actors' and actresses' publicity photos—gathered from theater and nightclub managers—and rephotographed them to create individual portraits. Prince's motivation was, he claimed, to create a "'look' that looked 'bought,' 'produced,' 'managed.'"[5] This body of work reflects the seedier side of New York theater and the desperation for fame among its countless two-bit players. "The beauty of Richard's work," Gonzalez-Torres explained, is that "you can just go to one of those discount, dollar stores and get your photo made, your photograph, your portrait. That's it. They're great portraits." He went on to explain that he asked himself "at this point in history how can I do portraits."[6] The answer for Gonzalez-Torres was not to perpetuate more imagery, but rather, to simply provide information, to capture the points at which the depicted lives intersected with the cultural and political events occurring around them. He thus created "linguistic" portraits—lists of events and their dates that enumerate the lives of specific individuals (or couples or, in some cases, institutions) filled with unforgettable incidents both great and small, juxtaposed and intertwined with recognizable public milestones. When read together, these listings of intimate and communal occurrences demonstrate that virtually everyone's life can be graphed by such an open-ended narrative structure.

The strategy behind Gonzalez-Torres' word-portraits is truly democratic. Their owners are free to add or subtract any entry from their own biographical indices at any time. And their life-stories are recounted without the use of any conjunctions, prepositions, or verbs that usually serve to anchor meaning. Like run-on sentences, these works break grammatical and syntactical rules. Because of the potential for endless transformation, meaning is never completely secured, but neither is it denied.

Prince's radical gesture of rephotography and its subversion of the sacrosanct Modernist values or originality and authorship reverberates in Gonzalez-Torres' art on every level. The "linguistic portraits" are just one easily traceable indication of Prince's influence. His groundbreaking act of photographic appropriation and its attendant denial of the original object as a unique and integral entity gave license to Gonzalez-Torres's concept of the give-away, endlessly replenishable artwork—which is in itself another paradigm-shattering gesture in the history of contemporary art. The emphatic multiplicity of Gonzalez-Torres's stacks and candy spills directly contradicts the notion of the singular, self-contained work of art. Premised on ideal heights and weights (determined, in part, by the particularities of the site in which they are displayed), the stacks and spills shrink each time an individual sheet of paper or sweet is removed by a visitor, but swell again when their elements are replaced. Viewed as static objects, these pieces mimic the solidity and singularity of sculpture, but, metaphorically, they closely resemble the photographic edition. In essence, the candy spills and paper stacks are copies of objects for which there is no original. Until realized, they exist as conceptual prototypes, manifest only as certificates of authenticity that function as contracts for their owners. These contracts operate like photographic negatives, from which an infinite number of reproductions can be made. And like the photographs in an edition, these sculptures can be installed in several different locations at once. When this occurs, they are less exhibition copies than coexistent reproductions of the same thing.

A student of the late 1970s and 1980s, Gonzalez-Torres formulated his own approach to the issues of originality, subjectivity, and identity that surfaced with Conceptual Art and Postmodern theory. While his project, at the time of its execution, was largely understood to be a direct response to artists working in these veins—he cited Prince, Kruger, Lawler, Sherman, and Kosuth as critical influences—his practice, in retrospect, can now also be understood as a bridge to the Interrelational Art of the 1990s. In fact, his work has become profoundly important to a generation of younger artists investigating methods of distribution, audience participation, and process-oriented aes-

thetic strategies. His generosity as an artist is manifested most obviously in the give-away stacks and spills, but it is also intrinsic to the incredible open-endedness of his entire *œuvre*. Meaning is never predetermined, and owners of the individual objects—stacks, spills, portraits, billboards and light strings—are invested with the responsibility to determine the execution and installation parameters of their works. Gonzalez-Torres gave his audience extraordinary agency in the realization of his project; without them much of the work would remain inert. One could argue that the work of Rirkrit Tiravanija, who gained recognition during the early 1990s by cooking Thai food for gallery visitors, and Tino Sehgal, who more recently has garnered attention for his temporal "situations" involving the interaction between gallery guards and viewers, would not have been possible without the example set by Gonzalez-Torres. But that is a separate (New York) story.

[1] D. Robbins, "Richard Prince: An Interview," *Aperture* 100 (Fall 1985), p. 9.

[2] P. Halley, "Richard Prince: Interviewed by Peter Halley," *ZG Magazine*, no. 10 (May 1984).

[3] D. Robbins, *op. cit.*, p. 10.

[4] In my monograph on the artist I argue that all of Gonzalez-Torres' work—in particular, the paper stacks, light strings, and billboards—engages with photography. It contemplates and exemplifies the very conditions of the photographic medium—its technology, its semiotics, it socioeconomic implications, and its cultural mythologies. See N. Spector, *Felix Gonzalez-Torres*, exh. cat. (New York, Solomon R. Guggenheim Foundation, 1995), in particular the chapter, "The Trace," pp. 89–133. A majority of the discussion of Gonzalez-Torres' work in this essay is derived from my book.

[5] D. Robbins, *op. cit.*, p. 13.

[6] N. Spector, *op. cit.*, p. 146.

From Inexpressionism to Post-Realism

Germano Celant

If painting belongs to the traditional body of extravagances until the 19th century, filmic, photographic, typographic, and television reproduction are the novel of the 20th century. For a generation of Americans who were born in a technological era, when the control of images and what is known is entrusted to the screen, the depth of color and pigment, the lack of precision of outlines and the static quality of the narrative appear as archaic elements, marked by errors and imprecisions. And that is not to mention the private experience, which does not exist, since for millions of spectators the screen of the mass media is at the same time without affect or effect. Any drama or event is in fact necessarily projected into the realm of the impersonal; as a result of the spatial and temporal distancing, the narrative becomes static and devoid of values, and so nothing is isolated or exceptional, as if the quality of uniqueness or imagination no longer existed. Originality is only a commercial entity and is often derived from a previously broadcast originality, because the screen flourishes on memory and repetition. It is possible to define, then, the territory of the remake, where the world of imagination no longer exists, but is only derived.

Now, for most Americans, the world is photographed and filmed in order to be broadcast via television or in newspapers. Everything is reproduced and the reproduction refers back to an impersonal technique and an unreal world. We might therefore state that an image exists only to be produced and recreated and that its remake is the true subject of American seeing. What one learns and what one sees does not refer back to anything real, save for the image itself, and it speaks coldly about itself. It represents through its abstract qualities, without any links to an emotional point of reference. The private appeal is absent, and when it appears it is without expression. There then appears the extreme authority of the inexpressive and the totemism of the anonymous image.

With respect to obviousness and absence, determined by the "void" of reproduction, the emotional and fantastic resistance of the "New Dandies" is interesting, but it does not involve the identity of "screens:" it transfers art into a "reservation" and it keeps it "free" in its enclosure. The development was perceived, by many artists, as a sort of corralling, in which resistance translates into passivity and an experiment in control.

And so we see a reason to emphasize the possible contents of a ghettoization, attempting not so much isolate oneself, as much as to infiltrate oneself and to declare the reproduced image the site of isolation and research. In this last phase, art is capable of identifying and distinguishing a culture that loses its expressive function and establishes itself as a blocked and absent process, where the absence is always imaginary and should be compensated by external participation, as in film and photography.

In order to endow that "void" with significance, it is necessary to focus attention not so much on the expression of oneself, as much as on the "inexpression" of the image, known and pre-existing. Among the artists who have dedicated to this field of pursuit are Sherrie Levine, Cindy Sherman, Troy Brauntuch, Robert Longo, Jack Goldstein, Matt Mullican, Richard Prince, Jenny Holzer, Dara Birnbaum, and Barbara Kruger, and the subjects designated in their artworks seem to have to do with a comparative investigation between Pop Art and Conceptual Art. The parallel positions in fact have to do with the logic of the artistic and photographic culture, no longer understood as avant-garde, but instead as the "product of a mass consumption and education." By needing to be associated with the "already known," their works are based on the law of simultaneity and identity to an investigated subject, adding a minimal linguistic disparity.

More than a contrast, the work is contagion and coincidence, because for them the disturbance cannot be produced with differentiation, but instead with the "reproduction of the reproduction." Considering this, it is clear why Sherrie Levine rephotographs the photography of Edward Weston and Lee Friedlander: rather than creating, she wants to work in the realm of the extremely narrow difference of the remake. Comparably, Robert Longo works in the realm of the juxtaposition of "already made images" in Westerns or Fassbinder movies. For these artists, in fact, nothing is replaced, it is only possible to redo, and every image and technique is only a "mirror" of the same image and the same technique. And since each and every figure is derived from a previously existing model, it is equally valid to seek out the subjects and processes of mass communication. It is illusory to think, then, of alternative images, inasmuch as those suggested by the mass media are "primary." The dominion be-

longs to them, and so we might as well observe them once again, but without any expressionistic anguish, and let us take them up, because in their impersonality and inexpressivity they are matrices of the private and public thinking of one and all. At the same time, the works of Goldstein, Sherman, Prince, and Brauntuch show that it is not possible create any sign unless one avails oneself of a prototype. Resemblance, if not repetition, thus becomes the explicit assertion of an impossibility, as well as a critique of the illusion of neocreation. If culture is a mass-produced product, then all that exists are copies. For this reason, Levine "describes" photography with photography, Mullican appropriates an array of signals, remaking them into flags, banners, and posters, Prince moves through advertizing with the advertizing techniques of enlargement and serialization, while Longo renders static, in drawing and in relief, the dynamics of film. At the same time, the subjects of the reproductions belong to well-known stories that cannot be misunderstood: these are the feminine stereotypes of the 1950s of Sherman, as well as the scenes of war, the post-war heroes, of Goldstein. It is important to underscore that in the works of these inexpressionists there is never either a person or a story, but instead the image of the story and the person: identity likes in appearance, not in actual participation in reality.

The appearance of the system, cultural and noncultural, is an objective state and even if the protagonists of art hope that all that is noticed is the production of images, different and distinct, that are so dear to romantic ideology and to consumption, it is not possible to forget that the system of "art," much like the system of photography and film, by sustaining a false idea of image, wants to conceal that they are actually the real image. Therefore, if the intention is to unmask, it would be wise to mirror the systems in their twofold roles of experiment and product, taking them up as "still lifes," indistinguishable from the materials that pollute our eyes. In this sense, the operation of these artists seems to be allied with the optical pollution but, as in the times of Pop and Conceptual artists, the stance is ironic and analytical.

Doubling an image in order to devour it into a system proper means that the active becomes passive and the artist puts himself in place of the object. Identification with an indifferent and recognizable entity, to the point of losing oneself within it, can be considered the norm in mass society, where an abandonment to the factual nature of consumption and the fetishism of the signals does not amount to losing oneself or denying oneself, but only "staying within time." And since the cadences are accelerated, it is necessary to condense images, rather than rarefying them. That process of condensing entails a disturbance of identity and the individual, who will sense the anguish of negation, and yet remains "outside of time" to become unsettled at the accumulation and the repeated performance, since a phobia points to a fragility. Being there is simply no longer enough, it is necessary to be there in the form of "merchandise," desirable and negotiable, since it is only thus that it is possible to render evident a mass identity and dignity. Now, there is nothing more obvious than Warhol's identification with the camera, with silk-screening machinery, with musical equipment, printing machinery, and film television equipment. He understood what, in our century, an artist is "lacking" and, rather than negate his existence, he counterinvested his being in the fetish of technology and consumption. If in fact today the object is freer to circulate than is the person, the concern of an artist is to allow himself to be devoured by it and by its production equipment, so that he may circulate. Moreover, since the human being is rigid, dead things become soft and dynamic. That this is true is clearly determined by others, so that, according to Warhol, in order to participate it is necessary to abolish one's own pseudo-identity, of romantic origin, and join the "repeaters." Taking into consideration a real integration with equipment serves to expel fear, so as to purge oneself of the humanistic pollution. At the same time, assuming the amorality of losing oneself amounts to not showing any devotion for art, as well as for other languages. To infect it, then, is to induce it to think of oneself as mask and illusion. It is only by disturbing identity and order, through the very ambiguity and duplicity of economic and social criminality, that one can violate and sabotage the fragile myths of the cultural devices and truly create the possibility of self-determination. For this reason, Warhol, as early as 1963, shifted the boundaries of his territory increasingly further along, moving away from the enclosure of art, and entered into the realm of the turbid and the hybrid, where prohibition and passivity are active processes. The goal was to strip oneself of everything that the artist has that is fatal and humiliating and to convert fatality and humiliation not into a practice of ruin, but of success. The first step consisted of discovering the threshold over which one could pass from one to the other, so as to circulate freely in the diversified fields of the star system, as well as the area of bourgeois begging. And the first transition came in the form of penetration into the world of film. In it he succeeded in overcoming any absence of subtlety and any presence of luxury, so that nothing appeared excessive, but only normal. Time, subject, waste, falsehood, abjection, doubles, and duration all appeared to be crossable boundaries. Everything was linked only to demand and supply. According to these, everything can be fabricated, including art, which cannot

have been left intact in the game of perversion. All this leads to the Factory where Warhol attained the acme of dehumanization, where the artist is the tool of the conditions of work, that is to say, the fact that he is exploited in order to produced "signed" images, including filmmakers, photographers, and musicians such as Paul Morrissey, Malanga, Lou Reed, the Velvet Underground, Viva, Joe D'Alessandro, and Nico. Like all factories, Warhol did not perform a single task, nor did he consume himself in a single performance, but instead found his existence only on the market. In it, he narrowed his achievement: the artist is real, when he possesses a machine-like function. He is a subhuman whose "dexterity" lies in his skill in accommodating the "fashions" for which imagination is only a warehouse from which one extracts "deals."

Until Warhol, no artist had dared to make so complete a rejection of his being, as the one from which sprang all his operations of restaurants with frozen foods, or television programmes. In comparison with the intentions of the avant-garde, he violates all the purist and moralistic aspirations, which he denounces as linguistic and processual prisons. Certainly the purpose is also to insist on the area between the rigidity of art and the vulgar filth, whose contrast and separation form the authentic sentiment of any being. All the same, the heterogeneous whole that Warhol managed to construct with his greed and detachment is almost "unheard-of," and that is why the entire operation enters into the realm of the unreal and the metaphysical.

In terms of the morale of the artistic world, the match would clearly seem to have been lost by now, and it is ridiculous to blame Warhol for having emphasized it. But let us not misunderstand the issue. The indifference of American artists to any *eidos* reveals their obstinate determination to pursue the "destiny" of performance, so typical of machines, precisely because Warhol took the machine as a model for his "alterations." By renouncing the possibility of taking oneself as a unit of measurement, he placed his reliance on the movie camera, the printing press, the still camera, and the tape recorder, as if to ecstatic lovers. In the final analysis, renunciation is an act of auto-elimination and auto-humiliation that takes to its extreme logical consequences the question that society poses for the "feminine." On the other hand, auto-degradation taken to an excess is "surprising," and especially so that of a star. And it was here that the hybrid and the impure returned in all their arrogance and re-evaluated the condition of the alienated: an ecstatic passage through the feminine produces security and myth. Indeed, modelling oneself in accordance with "defects" is tantamount to reinforcing oneself. Moreover, if an artist comes to terms with the machine, he expands and becomes more long-lived, because a machine is capable of competing with time and death. All that counted for Warhol was duration and his struggle was against time and death, and so he used them, to reincarnate himself in them. And since the external is an unstable identity, he would devour it, he would perform, that is, a ritual of warding any identity of otherness. In a certain sense, the use of portraits was justified because, through them, Narcissus murders Narcissus. The war is always twofold, in reproduction, whereby living amounts to reincarnating oneself in a new object and as long as the idea of Narcissus and the object exists the process continues. Certainly, the continuous "industrial reproduction" is not to the credit of the person, but instead of the "product," and it was in this context that Warhol loved the virtues of being inexpressive and perfect, repeatable and replaceable.

The transformation of the New York artist into an inexpressive product has already been achieved, his or her image is available to the advertising world and his or her behavior is corporate. In empire of images, whose proportion and intensity is uncontrolled, Warhol was the only artist who established for himself a small domain. His was a test of the power of art and it was for this reason that his unbearableness is today considered to have been a unique quality, a point of reference for the young American artists who are working in the context of Inexpressionism. What interests them is in fact the possibility of emerging from the reservation of the emotional and the decorative in order to acquire a multiple and multiplied existence. In this direction, photographic copies find a parallel in sound recording copies: both of them satisfy the lust for devouring and being devoured, as well as that of affirming oneself while obliterating the shame of imprisonment, restriction, expanding into the field of society like all other mass products. The absence of an expressive interpolation that characterizes the "Inexpressionist" approach from Warhol to Levine and Brauntuch is unsettling for those who feel a sense of horror towards multiplication and reproduction, but instead is exciting for those who are interested in the perfection of the "transmissions" inasmuch as an absence of interpretation serves to obliterate the difference between direct experience and indirect information.

For a generation educated via cable and satellite, systems that provide data and configurations, narratives and chromatics directly to the home, what counts is the reception, and so the proposition transformed into image and sound must be perfect, since perfection determines the attention, more than content. Passion, in fact, focuses on the quality of the engraving and the reprint, and it is upon these that the eye as well as the ear issue their judgments. All information inasmuch as they are set forth are evaluated there-

fore for their reproductive qualities. What one consumes, sitting in front of the television and movie screen or else walking or skating while wearing ear-buds, is to an increasing degree less and less of a judgement and a narrative and more and more of an image and a sound that have been technically super-controlled. We might even state that the "real" stereotype travels through the photographic and musical camouflages. It is they that are deserving of faith, inasmuch as they are "objective," to a greater degree than the narratives of the human eye and ear.

The exasperating minutiae in which these new realities were formed are extremely interesting today. With respect to the silence and opacity of painting and sculpture, photography and music seem sensational, because of a high-society glare that fascinates us, because they correspond to reality, even if it is a false reality. Every photograph, like every sound, is an absolute entity, they emerge out of fixed schemes but they render the world "unheard-of." The unusual qualities that once emerged from the picture frame and the pedestal now issue from loudspeakers and projectors, and it is for this reason that greatest measurement of the contemporary artist is to succeed in articulating himself or herself to become a painter, photographer, filmmaker, and musician, like Robert Longo and Mayo Thompson, Alan Vega and Laurie Anderson, Jack Goldstein and Eric Bogosian. Their needs in fact are regulated according to an imprint left on the impressions on a sheet of paper, a film, or a disk, upon which it is possible to engrave a perfect visual and acoustic image.

Moreover, blank, virgin films and disks shape the world itself, because it is from their matrix that hundreds of thousands of copies derive, and therefore millions of images and sounds, which circulate everywhere, entering the eyes and ears of anyone. Now, since artists have always been interested in shaping reality, or at least in influencing it, what better process that reproducing their ideas in unlimited quantities? If we consider carefully, after the spread of the media over the past twenty years, all artists have armed themselves with cameras and tape recorders (Warhol's lover and wife); for them, taking pictures and recording is a normal process, which serves to relax them, because they can take with them any image, in a short time. The identification between trace-effigy and the real world renders the real world a surface of sounds and images, it is there that its existence lies, the rest does not count.

It is therefore perfectly logical that today artists react to their restricted existence and set out to wander on a tramp's voyage through electronic and filmic images. On this terrain, the location is not restricted, but instead expansive because the panoply of figures and noises are poured out through giant founts of emission. It should come as no surprise that, in the wake of the historic ex-

ample set by the Velvet Underground, artists at the end of the 1970s should have decided to shatter the alienation of art and should have decided to shift from personal shows in galleries and museums to the musical show and to show business, in clubs and on television. The list of artists, or individuals emerging from the world of art, who formed groups is now a very long list indeed, ranging from the Red Crayolas (close to Art Language) to Martha Wilson's Disband, from Cabaret Voltaire to Alan Suicide, from Brian Eno to Glenn Branca, from Rhys Chatman to David Byrne. To them, imagination or the conceptual process made everything usable, to the point of stimulating any cosmos of products. The attitude is a bellwether of a change in the artistic system as well as in the world of music, almost as if the intention were to carry out a spectacular calibration or fine-tuning of the avant-garde. It is no accident that the Talking Heads used the poetry of Hugo Ball and that the Cabaret Voltaire used the sound poems of Marinetti, or that Philip Glass was translated into the Polyrock. Moreover, music is an industrial sector, and it allows an expansion toward the mass audience and a direct monitoring of that public's reactions. In comparison with the graveyard silence of exhibition spaces, the actions induced by music are explosive, practically an exorcism against the dead object. All sounds, in fact, uproot the knowledge of the body, so as to revitalize the blind, dead pupil of the spectator of exhibitions. Can the mechanism that was established in recent years with the musical excursion already be defined as an "inversion," that is to say the substitution of one system for another? One would say no, rather it is an equivalency, whereby industry has entered into art and art, instead to standing by as a passive witness to its own plunder and despoliation, entered into the creative industry.

In addition, if musicians allow themselves the luxury of being artistic, they do so because art "acts" on the public, and can therefore be staged. The musical rite is complementary to the artistic sacrifice, except that the artist conceals herself behind the object and does not transcribe herself, remaining separate from the "senses," in contrast with the situation of the singer or the musician. In some sense, if all the artists around the world constitute a band, from Peter Gordon and Arto Lindsay to the Pere Ubu and the UJ3RK5, this means that art aspires to the destruction of the limitations that condition the non-systems of "reception." He attempts to sacrifice himself, sweats and shouts, in order to be accepted and adored by thousands of spectators, to whom the "diversity" of the rite gives pleasure. They all forget in fact that the aspiration of any artist is to penetrate into the castle of the socially enjoyable and to be recognized, now in the last decade, with the mortification due to commitment, this occasion has

come to lack, if not making "recourse" to the tragic aspect of decoration. Today, no one wants to being ejected from the world, and the artists, who seem no longer to have anything to offer, have infiltrated the world of entertainment, first with performances and later with theater, and now with concerts. Since the spectacle is made to be seen, the leap from visual arts is not entirely unnatural, and in addition the event happens for one and all, so that it replaces the solitude of art with a mass audience, which increases even more when you add in the circulation of the disk.

And so exchanges and collaborations between artists and filmmakers, musicians and photographers were extremely welcome; they would foregather at the Mudd Club or the Rock Lounge, to record and plan projects with Blondie and Lydia Lunch, Amos Poe and Michael Oblowitz, Steve Pollack and the Untouchables. They did not seem capable of renouncing anything, because in an explicit manner they tended to dethrone one another reciprocally and it was in this match for survival that we find the difference from the preceding generation. The new experience never derived from inanity and separation, but rather from the fact of believing in the catastrophe of order. And therefore the dissolution of art into music and vice versa restores magic to each of the two, ritualizes the one and illuminates the other. The intertwining was however already detectable in the linguistic approach of many performers, such as Joan Jonas and Yvonne Rainer, who had for many years adopted music as cohesive. No one can deny that the soundtrack changed the nature of listening and seeing: music is seductive, in part because it underscores the fact that there is no distinction between execution and product, a fundamental equivalence for all performers. Naturally, the landing on the new land of music was not easy. And so it easy to understand the degree to which they relied upon chance and improvisation, so typical of the musical products of the New York New Wave. The tramp-like wandering of individuals who had been educated to the avant-gardes of Futurism and Dada, could not be directed, but only found, like a ready-made. Many artist-musicians do not know music, nor do they know how to use traditional instruments, they often rely on toys and objects which, together with their actions, lights, and films become sound instruments comparable to the drums or the guitar. The horizontal convergence of "diverse" sound equipment always tends toward immaterial effects. The revelation therefore should be offered on the stage, as if on a wall, and the same thing seems to be true for those artists who work in the realm of photography. For Incandela and Kruger, the images are shown by moving from a fresco by Veronese to a painting by Pollock or else they are petrified, for Mapplethorpe, as in a sculpture by Verrocchio or by Duane Hanson.

If we choose to use an irreverent term, it seems that everyone is ashamed of being tied to a single language, whether that be art, music, dance, or photography. The idea to which they aspire is to reduce it to an infinitesimal minimum, so as to take it to the level of a metaphysical existence, capable of joining itself with other existences of the same nature, so that in the complex and articulated whole that comes to be, the inexpressive and the impersonal become the maximum form of the expressive and the personal.

In the 1960s, artist and artwork grew together, one intertwined with the other, and the artwork offered itself as a global object, in which it is possible to justify all personal and social motivations, to embrace and include all levels, motivations, and reasons, as well as treating the extreme degree of abstraction and naturalism, so that the artefact winds up including every aspect of time and space, void and solid, mental and carnal, material and immaterial, and original and virtual. We live in an ear when, through conceptual art and Arte Povera, Body Art and Land Art, what is desire overwhelms what is real, and there do not seem to be any limits to the world of the imaginary: art takes on the challenge of the impossible and the undefinable, it pursues an extreme range of implementation, which extends from the disappearance into the abstraction of word and philosophy to the appearance in nature, from deserts to rivers. The hope is to draw upon a new synthesis of visual thought, no longer relegated to the restricted condition of painting and sculpture, but instead open to a multilinguistic and multimedia dimension, where what counts is the transmutation of what exists in artistic terms. It is a shift toward a cognitive and experiential stance that calls into discussion the sacrificial and haloed solemnity of the events involved in the heroism of Action Painting and Informal Art. The intention is to bring art into a society of information and communications, as much as in the planetary context, which consists not only of metropolises, but also countless territories and unknown ethnic groups. A field of research aimed at an intersubjective processuality that brings it closer to scientific, semiological, philosophical, and technological activities, so that it can establish connections between aesthetics and politics, between participation and experimentation. It is an emergence from the production of "things" in favor of an investigation on the significances and the reasons of a way of creating as an intervention in the world. This immersion into totality is also an indicator of a retrenchment into one's own territory, while art expands to the greatest degree possible, intended to question itself on the political and social significance of its activity. It means to discover what relevance it can acquire, fully aware that it can no longer follow the path of ideology and utopi-

anism, and so it commits itself to defining its world. And so it sets itself up as an autonomous power, which expands politically across the territory, through events no longer aimed at representation, but instead at facts. In this it coincides with the dissolution of politics into a cultural action, which was accompanied by the rebellion of 1968, when criticism and critics were radicalized in opposition to the virtual spectacle of social commitment. A denunciation and a clear stance in opposition to the theater of politics which, inevitably, entailed the disappearance of the image that exalted commitment and revolution.

Aside from a number of recordings of the revolutionary dream, represented by the depiction of a number of historic street events, the art of 1968 seemed to purge the political subject, and no longer believed in the subversion induced by a "portrayal" of the social struggles, thinking rather that action should be set on its own terrain. It accounts for its ephemeral and precarious dimension, as well as its inability to provide orientations that are anything but aesthetic, so that, aside from certain individualities, such as Joseph Beuys, there is a renunciation of moralistic perspectives, becoming sceptical and disillusioned. Aware of its political uselessness, art removes all good intentions and resolutions, "figurative" and "realistic" from its process, and detaches itself from the romantic and idealistic tradition of art in favor of an engaged and aware connotation, where what counts is the entrance into reality, not its mimesis.

All the same, this conceptual and behavioral harshness that tends to underscore a way of proceeding that lacks purpose and foundation, to the point of becoming senseless and purposeless, is such a perfect model that, over the course of time, the approach is transformed into a hard and inflexible abstraction, with a resulting rigidity that serves only to maintain the communication, which per se communicates less and less, except perhaps for the survival of the language, which is as equivocal as it is unreal, and leads to mannerist products, entering into an anti-creative "metaphysics" that excludes existence. In this interstice, in the 1980s, there was inserted an imaginary world that allowed the unsettling world of individuality and its expressivity to erupt into art. An "obscure" background, neither purified nor intellectualized, that found in Neo-Expressionism a degree of visibility, giving form to visions that seem to be relics of dreams and nightmares. They are paintings in which we see angels and demons, whirling through primitive and dramatic chromatic spaces. They are stories in which love and hate, narcissism and sex form a "whole," which is a mirror of the detritus of life and death. It is a kaleidoscopic vision that presents no unity, if not that of individual indeterminacy, which in order to survive the pressure of mass society folds

back into the history of painting and a return to traditional styles. Retro tendencies are developed that reject radicality and entrust themselves to the indissoluble tie between artistic form and persona. The historic and social anchorage gives way and the expression of one's own time takes concrete form in the meta-historical form of the subjectivity of the artist. All the paintings that are produced move, in this case, within a sphere that is extraneous to history, almost as if they were so many satellites orbiting in a mystical extraterrestrial hyperspace. There is no longer a centre, save that of the self, which leads to the production of enormous quantities of self-portraits, in which the obsession of self-contemplation certainly provides evidence of a total haemorrhaging of political and social energy. A crepuscular moment, in which the world of art seems to hang suspended within itself, overwhelmed by a narcissistic calamity, in which the significances fall into disgrace, in favor of a pictorial and sculptural formalism that has the effect of erasing all references to the real. Everything is identifiable only in terms of color and figure, atmosphere and personal effects, in which the message is arrested: an "unrealism" of painting where what counts is the quiver of the surface and the fascination of the hallucination. There was an exaltation of art as solitude, because in the face of the dramatic quality of a media-driven world, made up of spectacle and superficiality, the only response seems to be the obsession with life.

We are in a climate of absolute silence that becomes untenable, especially considering that beginning in the 1990s a new generation shatters this regressive relationship and attempts to relaunch the conception of art as a re-evaluation of realistic "documentation", which can no longer be concealed by a technical and linguistic process, nor set aside in favor of an emotional and expressive marginality, but rather shared, as a mirroring and testimonial value of the world. And even though the generational may have been quite limited, artists such as Damien Hirst, Barbara Kruger, Andreas Gursky, Thomas Hirshhorn, Andres Serrano, Tom Sachs, Jeff Koons, Nan Goldin, Steve McQueen, Santiago Sierra, Sherin Neshat, and Kara Walker, in the fields of art, photography, installations, and film, re-established a relationship with the social and political malaise, that concern the negation of being of various ethnicities and ages, male and female, exploitation in all the countries of the world. The avowed purpose was to return to a reality that is not "merely" a representation of reality, so as to re-evaluate the stance of the old realism, but instead "presenting" it as no longer fictitious and illusory, because camouflaged in painting and sculptures, but rather as a real reality: "Post-Realism".

And even if this reality almost always passes through the virtual language of photography, the

From Inexpressionism to Post-Realism

"document" is real, it is no longer the expression of a manipulation and concealment, but instead it is an ostentation, as neutral and impersonal as possible, of what exists. It is a search for an "effectual" dimension, where the utopia and the chimera of the "other" world are erased, yielding the floor to the knowledge of the gaze which can direct itself to the brute energy of the machinery of production and consumption. In this sense it is interesting to note how the artistic document takes on the dimensions of a vast panoramic image, an enormous format photograph or picture, nearly ten meters by three meters, in which the artist—photographer or painter—seems to depict himself on an infinite scale, leaving the spectator at the perspectival centre. A radical reversal that does not intend to make use of the manipulative stance, from Cindy Sherman to Gregory Crewdson, of the image, but which sets itself practically as guarantors of the narrative, from McQueen to Sachs, which speaks of slavery and poverty, human mechanization and militarization of labor and consumption, in China as well as in India, in the United States as well as in Brazil, just as it takes a critical stance on the political distancing by art, which has made images into commodified products, corrupt and unprincipled, forgetful of the universal tragedies, such as wars and invasions. The documents that then come to light are the figures of a mastery of the artistic illusion which, having forgotten the social community, had taken refuge in the code of languages and the secrecy of the personal dimension. In this situation, art brings onto the stage the evil and the obscene in reality, which the artifice of painting and mimesis can no longer obscure. A visible antagonism which it is difficult to exorcise, in part because the counterpoint between positive and negative, between reality and utopia, collapsed in 1989, along with the Berlin Wall, leading to the intolerable scandal of an undifferentiation between extremes. A cancellation of the opposite scenes that eliminated distances and led to a mixture that renders everything meaningless. In the territory of art, then, we see a reappearance of the unsolvable enigmas of obscenity and death, tragedy and the apocalypse, with their mourning and their massacres: everything has been restored to visibility, without filters or mediation. Here the conflictuality between art and reality seems to dissolve, not in the sense of an absorption of one into the other, as proposed by the explorations from New Dada to Body Art, but in the direction of a journalistic and documentary surveying of their relationship. A greater closeness in terms of news and present history, which approaches the film-verité of Vertov, opposed to representation and imagination. A way of moving devoid for purpose and norms, where what counts is the factuality of the events recorded, which can indeed assume political and philosophical viewpoints, but which are, all the same, recordable as social occurrences. The reproduction of events and factual action intertwine and this may perhaps lead to a dissolution of the artistic research, where what counts is the experience of the real and the truth of its existence, and in that direction the subject no longer counts, while the process of manifestation may count, which is not alternative, nor critical, but simply is.

Photography

Vito Acconci
Walter De Maria
Mark di Suvero
Joseph Kosuth
Bruce Nauman
Richard Serra
Robert Smithson
Richard Tuttle
Lawrence Weiner

Chuck Close
Richard Estes
Duane Hanson
Alex Katz

Cinema

Carl Andre
Dan Flavin
Donald Judd
Ellsworth Kelly
Sol LeWitt
Robert Mangold
Brice Marden
Agnes Martin
Robert Morris
Robert Ryman
Frank Stella

Performance and Video

Architecture

Photography

Architecture

Laurie Anderson
Matthew Barney
Jean-Michel Basquiat
John Currin
Eric Fischl
Tom Friedman
Robert Gober
Felix Gonzalez-Torres
Keith Haring
Jenny Holzer
Jeff Koons
Robert Longo
Tony Oursler
Richard Prince
Susan Rothenberg
Tom Sachs
David Salle
Julian Schnabel
Joel Shapiro
Kiki Smith
Haim Steinbach
Kara Walker
Sue Williams
Christopher Wool

Cinema

229. *Cross*, 1978

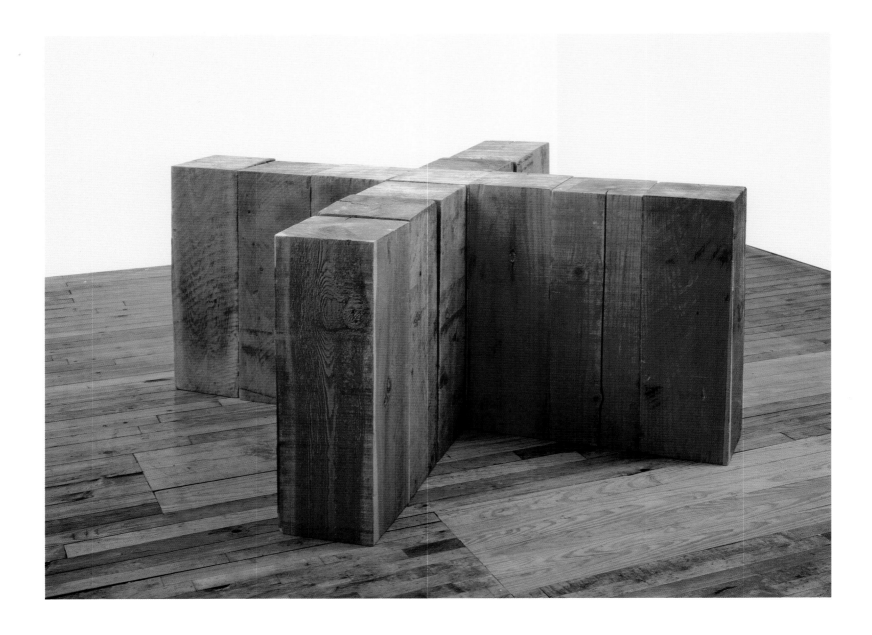

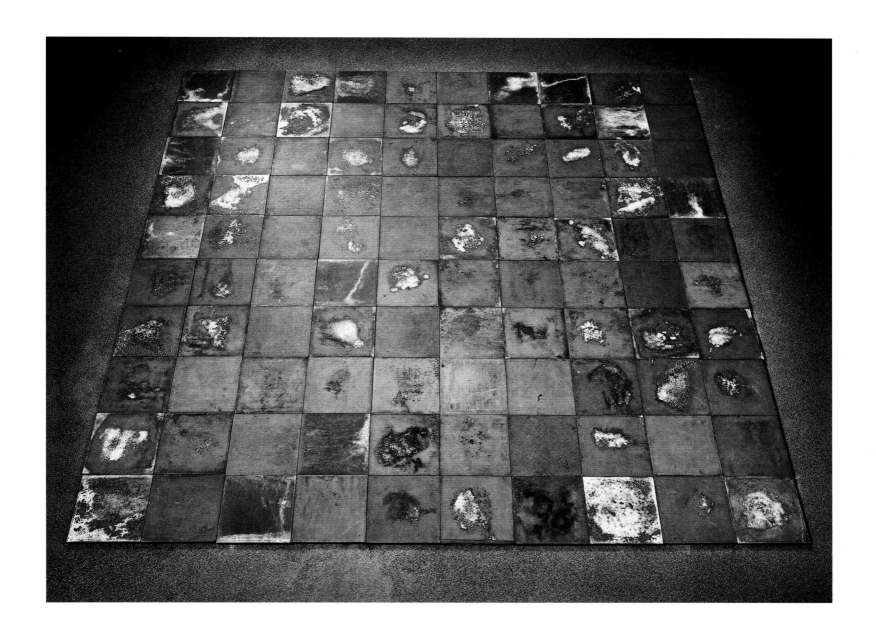

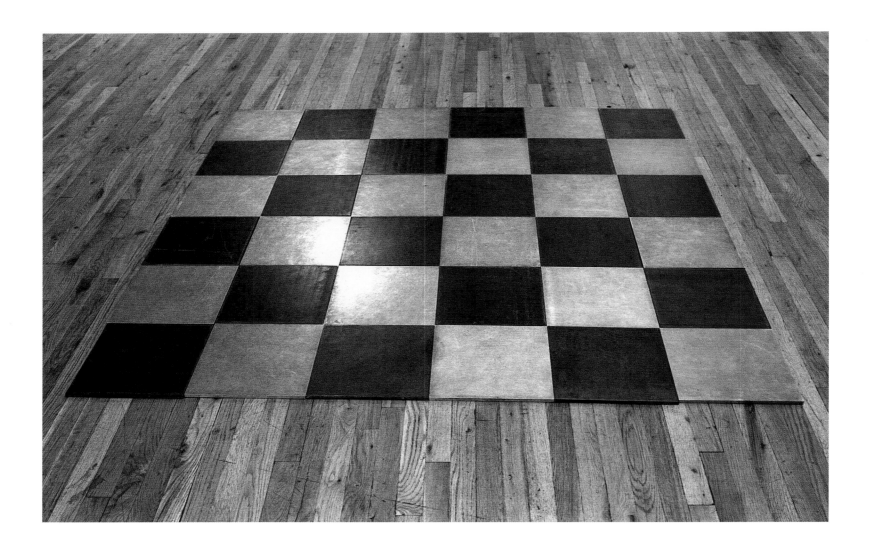

232. *Steel Peneplain-Kassel-Cold Rolled Steel*, 1982

Carl Andre

Dan Flavin

*233. *Monument 12 for V. Tatlin*, 1964

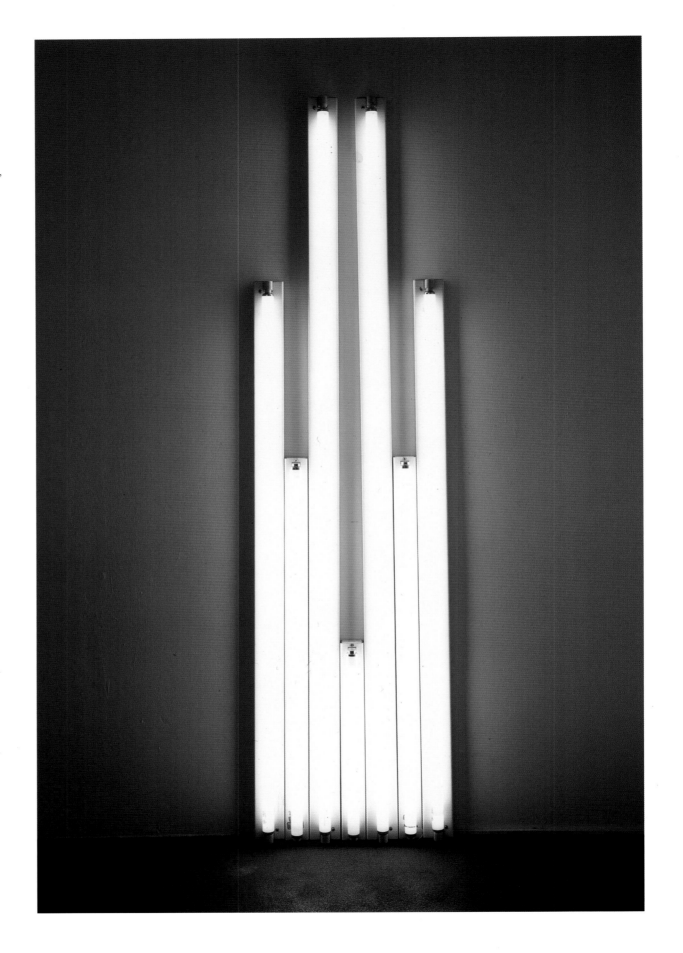

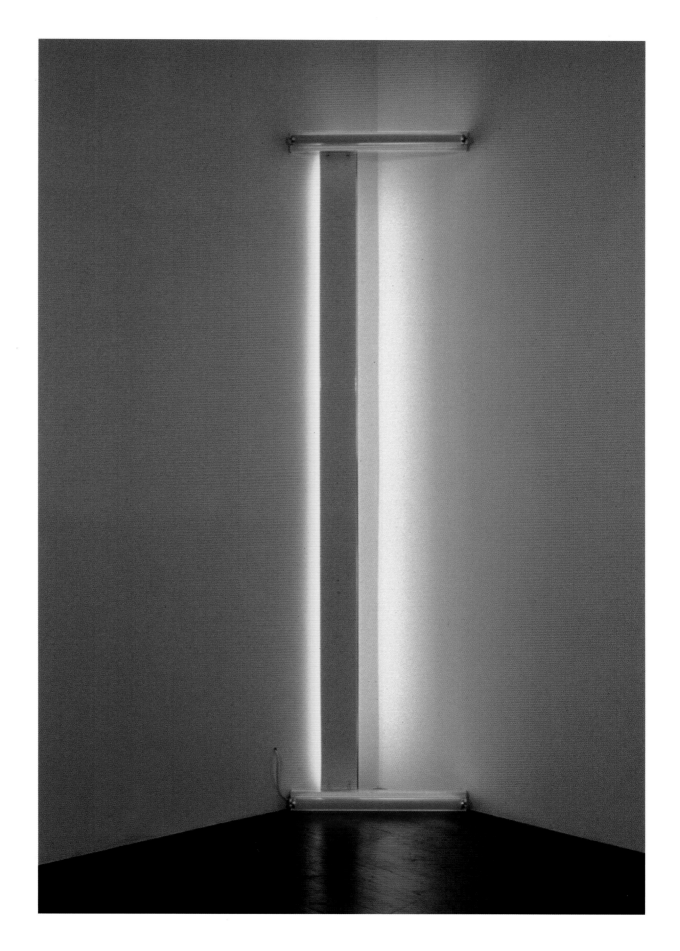

234. *Untitled (to Pat and Bob Rohm)*, 1973

Pages 296-297

*235. *Untitled (To Don Judd, Colorist) 1*, 1987

*236. *Untitled (To Don Judd, Colorist) 2*, 1987

*237. *Untitled (To Don Judd, Colorist) 3*, 1987

*238. *Untitled (To Don Judd, Colorist) 4*, 1987

*239. *Untitled (To Don Judd, Colorist) 5*, 1987

Dan Flavin

295

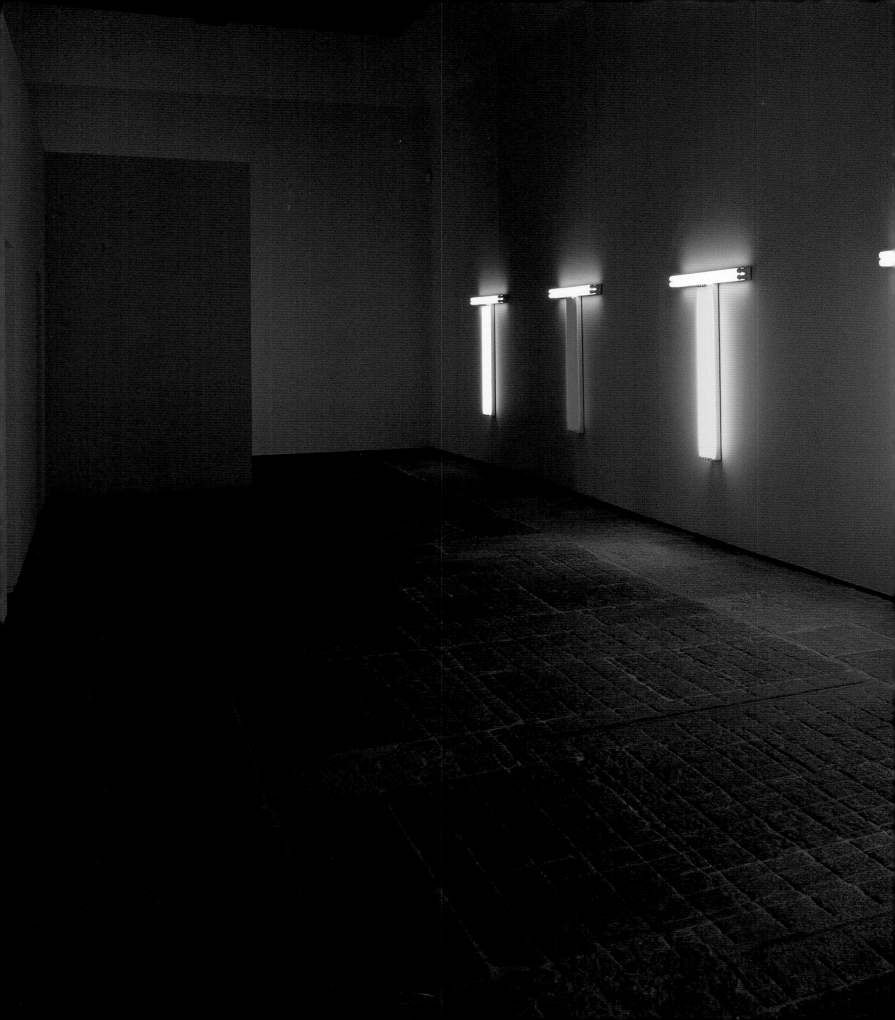

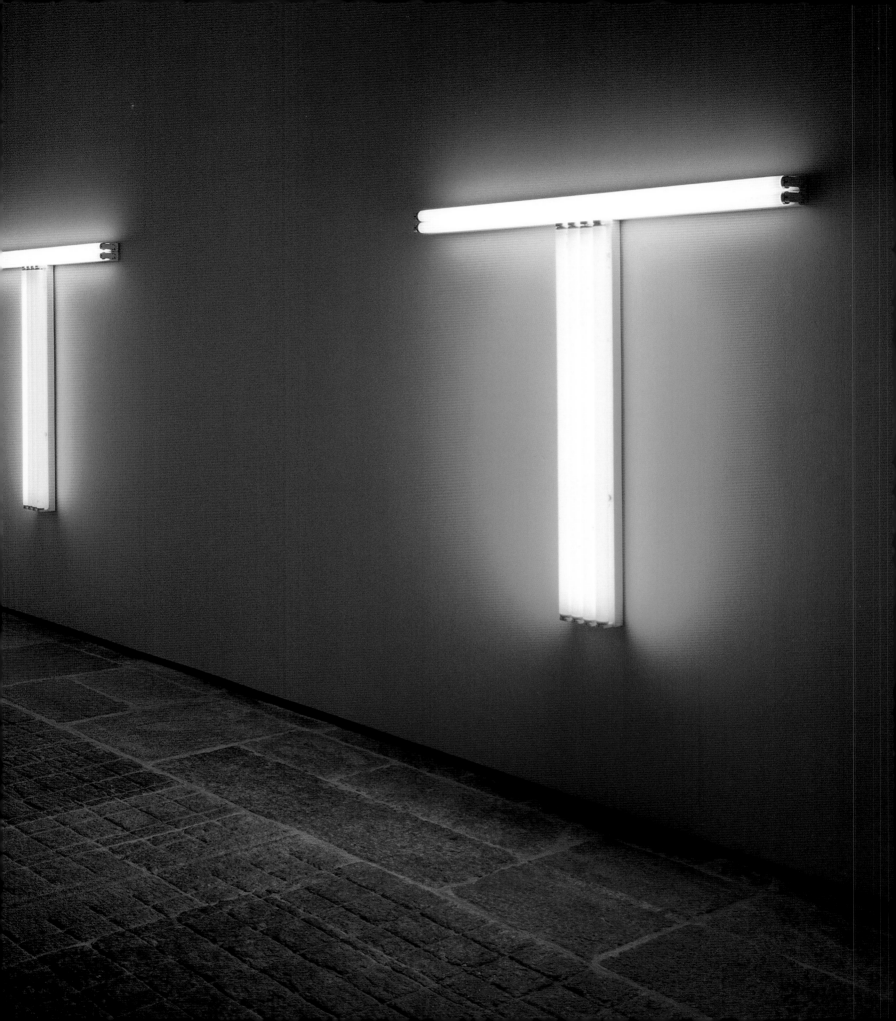

Donald Judd

240. *Untitled*, 1966

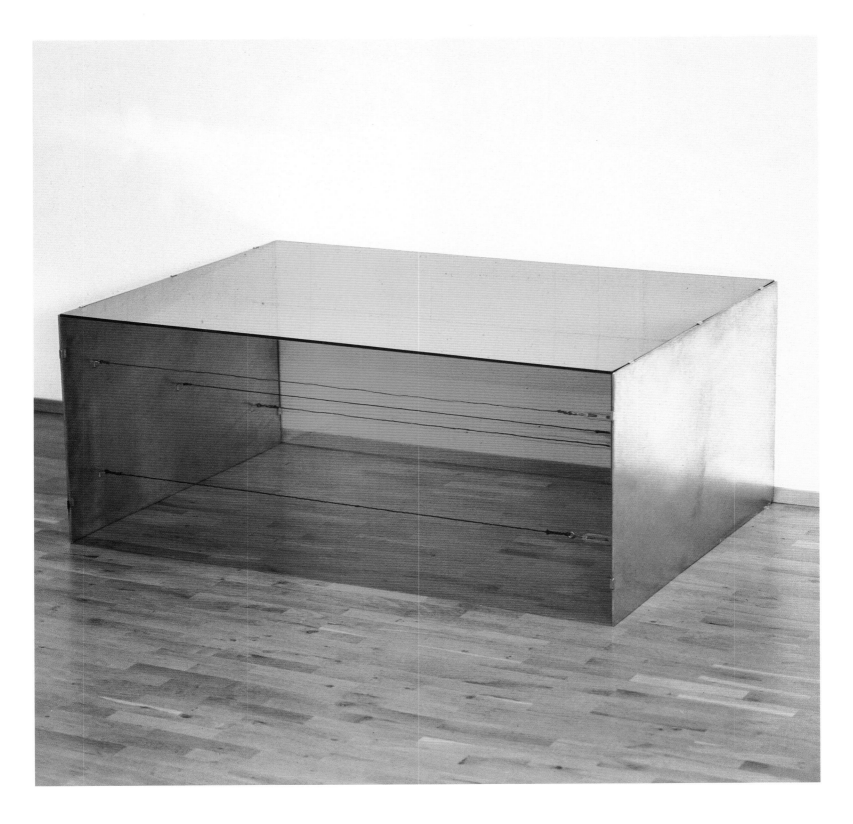

241. *Untitled*, 1968

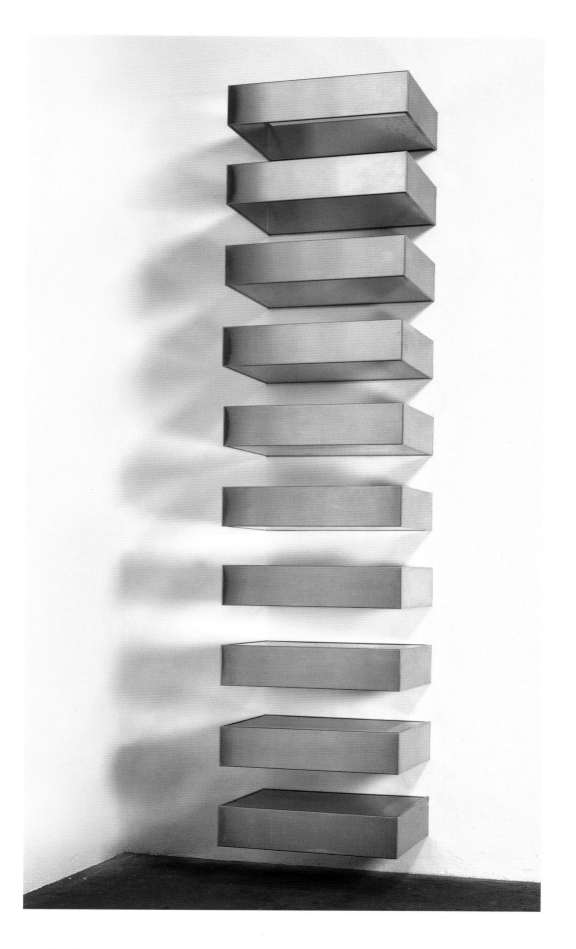

Donald Judd

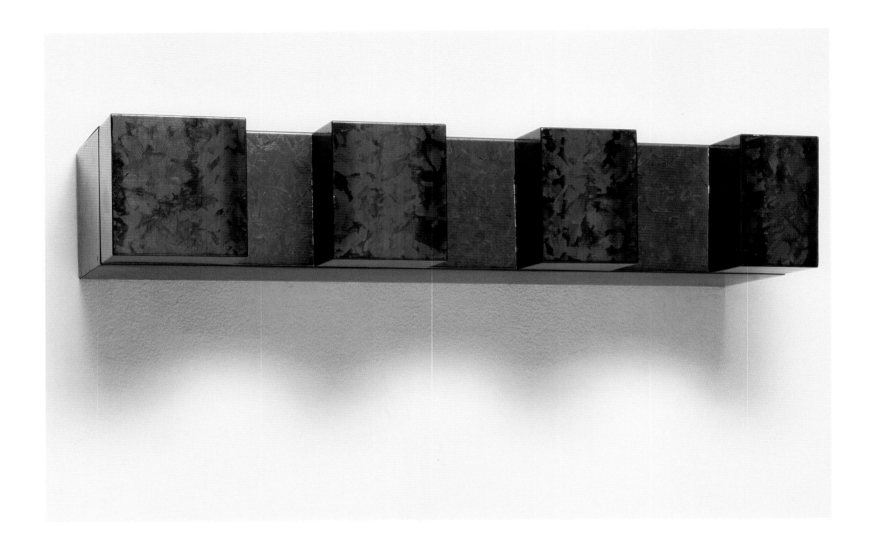

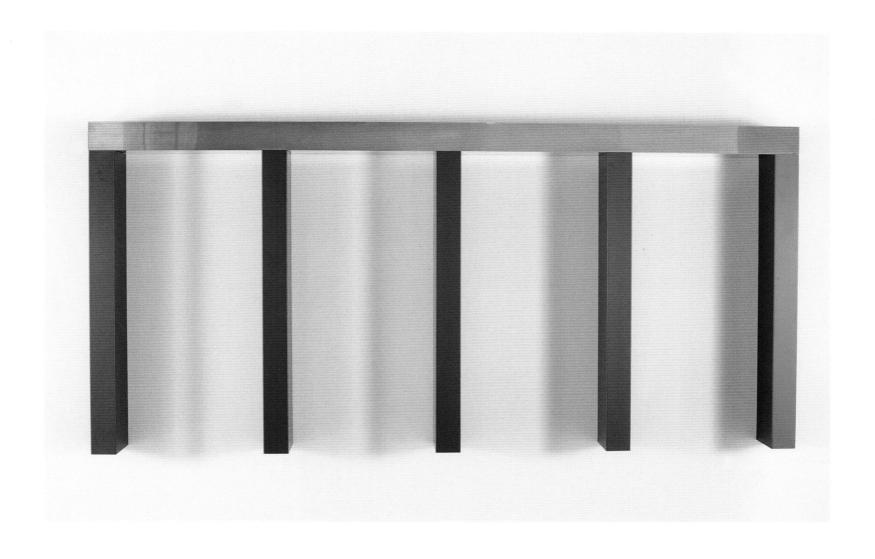

Ellsworth Kelly

*244. *Two Panels: Black and White,*
c. 1970

Ellsworth Kelly

*247. *Serial Project A1 5 9*, 1966

*248. *11 × 11 × 1*, 1989

Pages 308-309

249. *Wall Drawing n. 260*, 1976

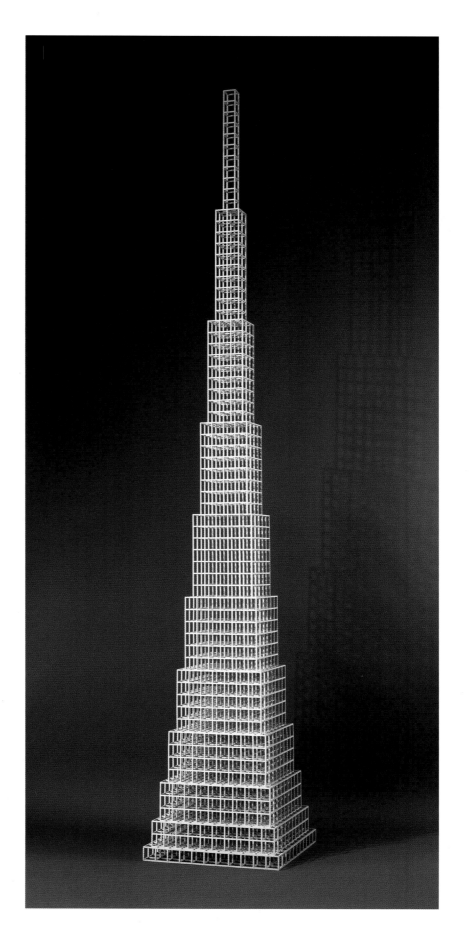

Sol LeWitt

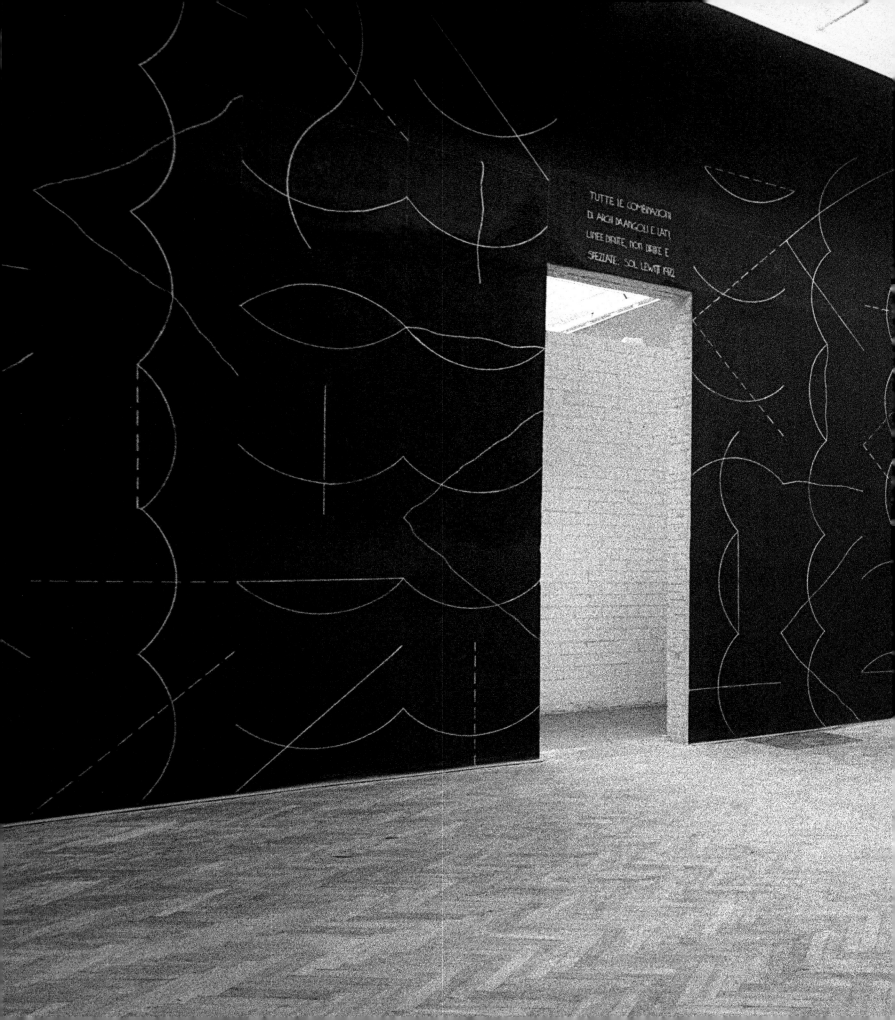

TUTTE LE COMBINAZIONI
DI ARCHI DA ANGOLI E LATI
LINEE DIRITTE, NON DIRITTE E
SPEZZATE. SOL LEWITT 1972

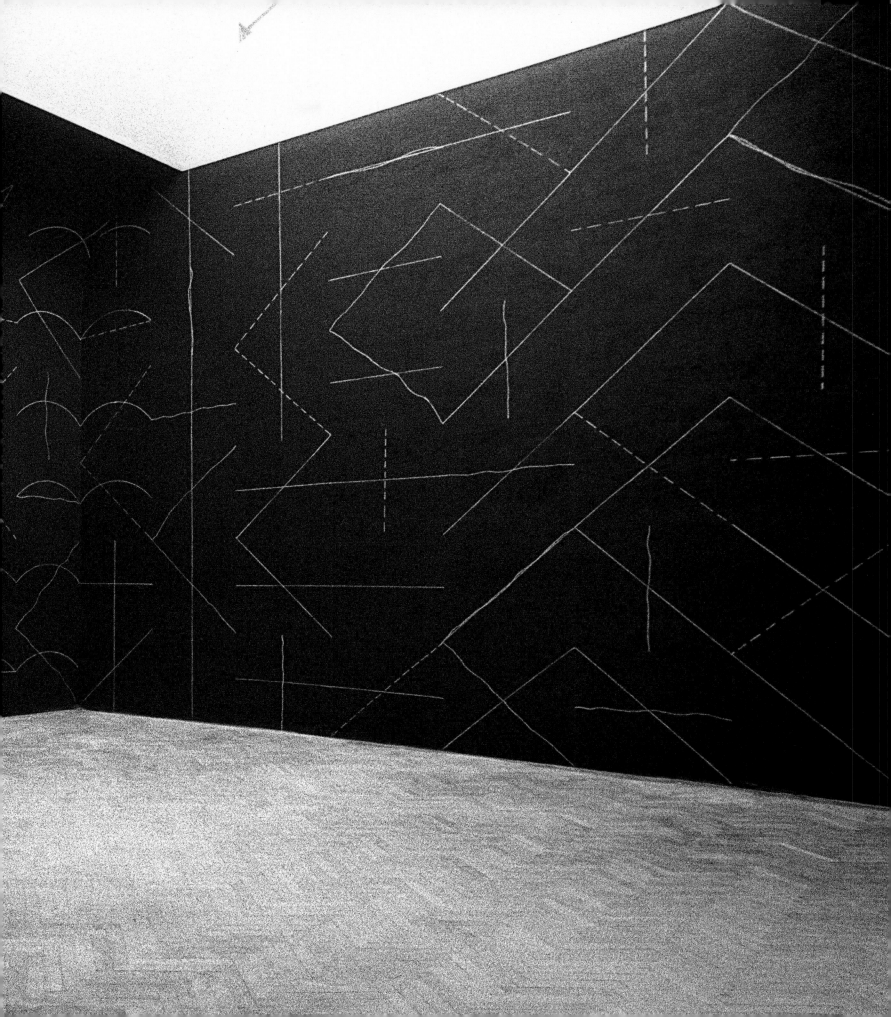

Robert Mangold

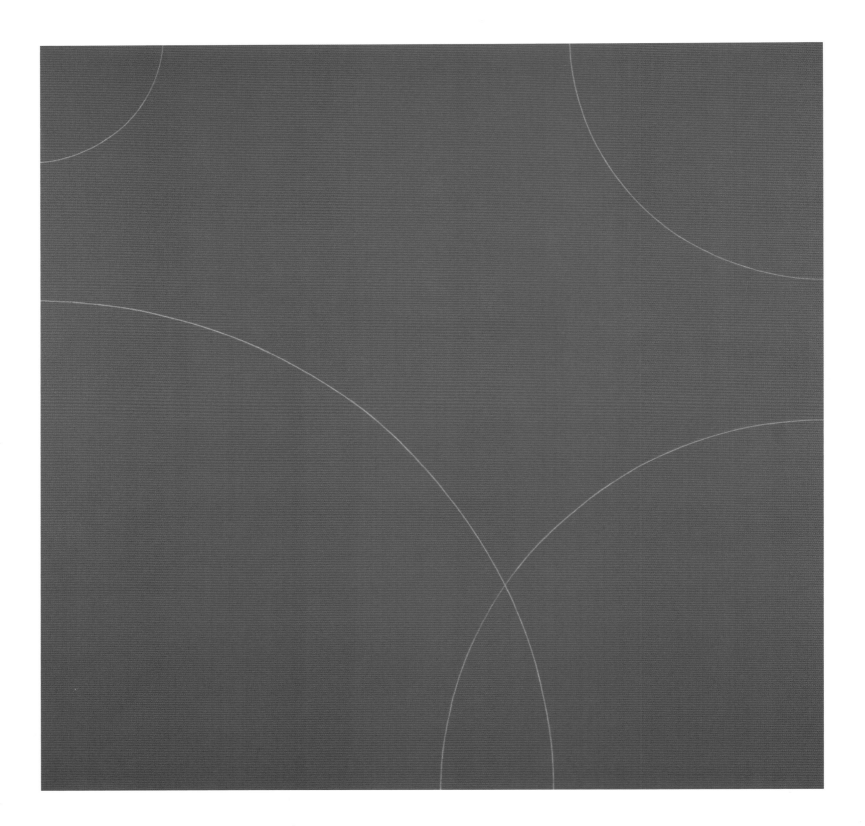

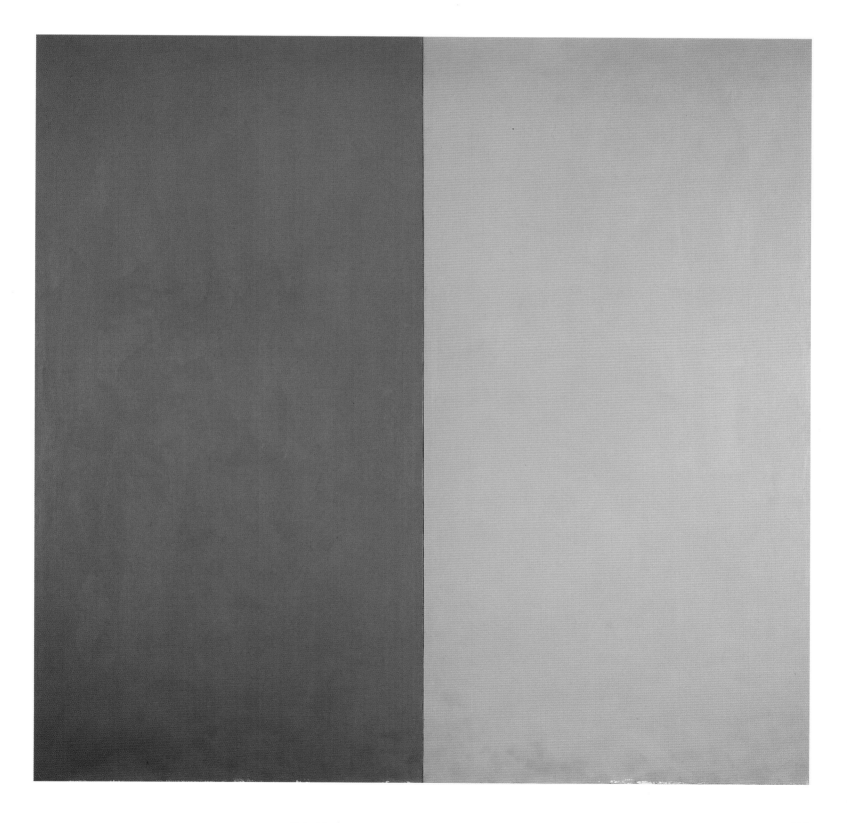

Brice Marden

Agnes Martin

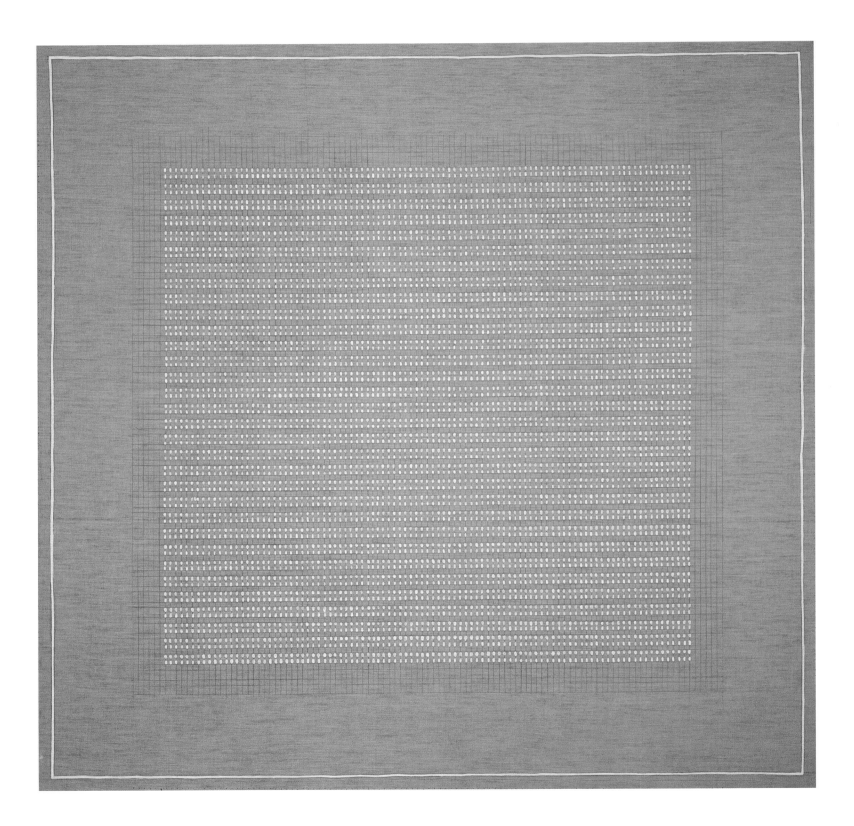

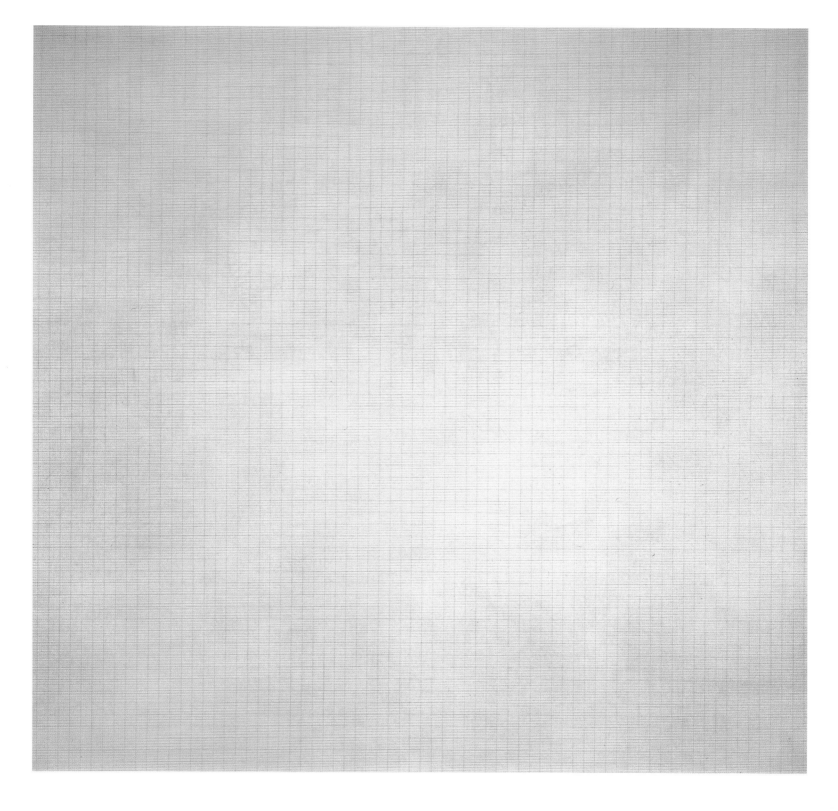

Agnes Martin

258. *Untitled*, 1967

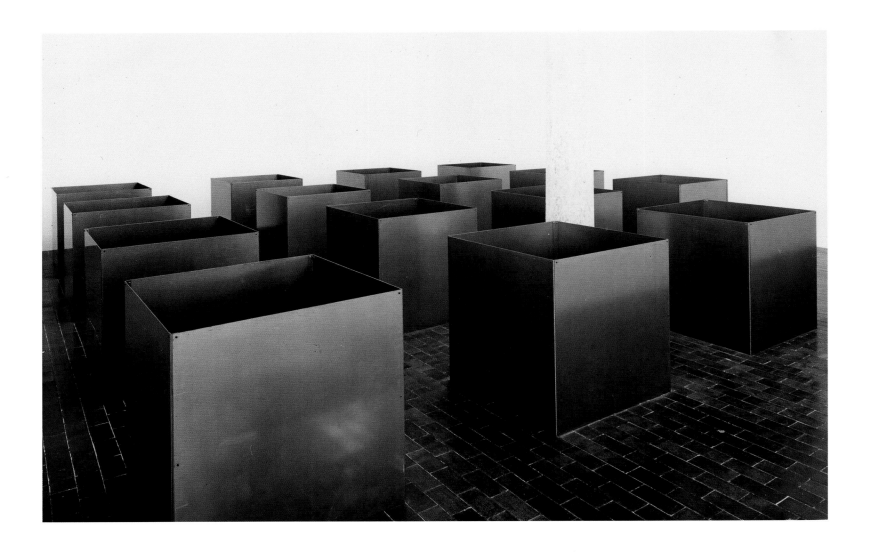

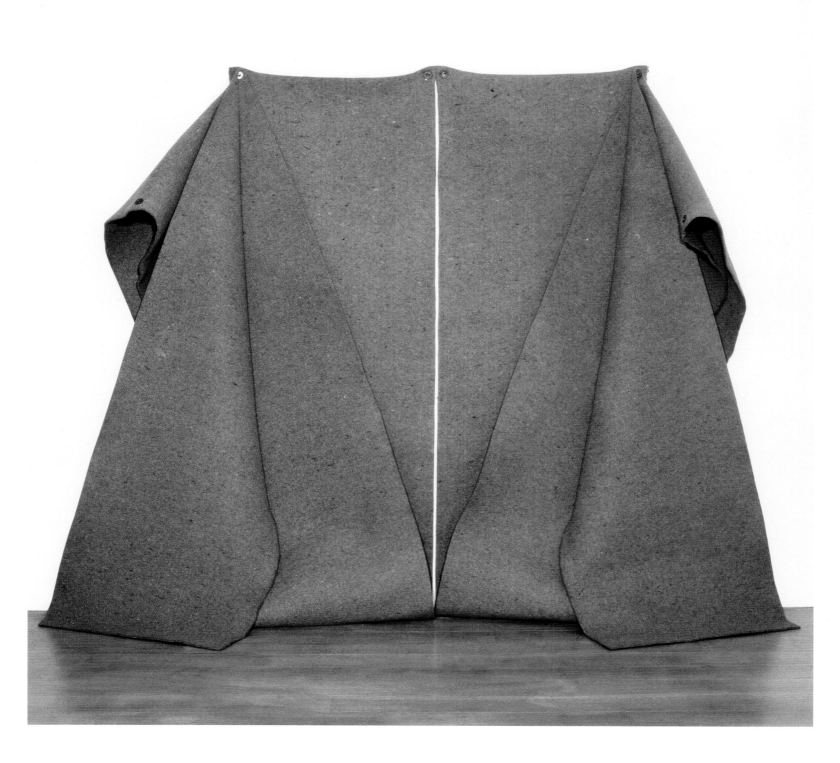

Robert Morris

Robert Ryman

*260. *Untitled*, c. 1961

262. *General*, 1970

263. *Untitled (Surfeice Veil)*,
1970

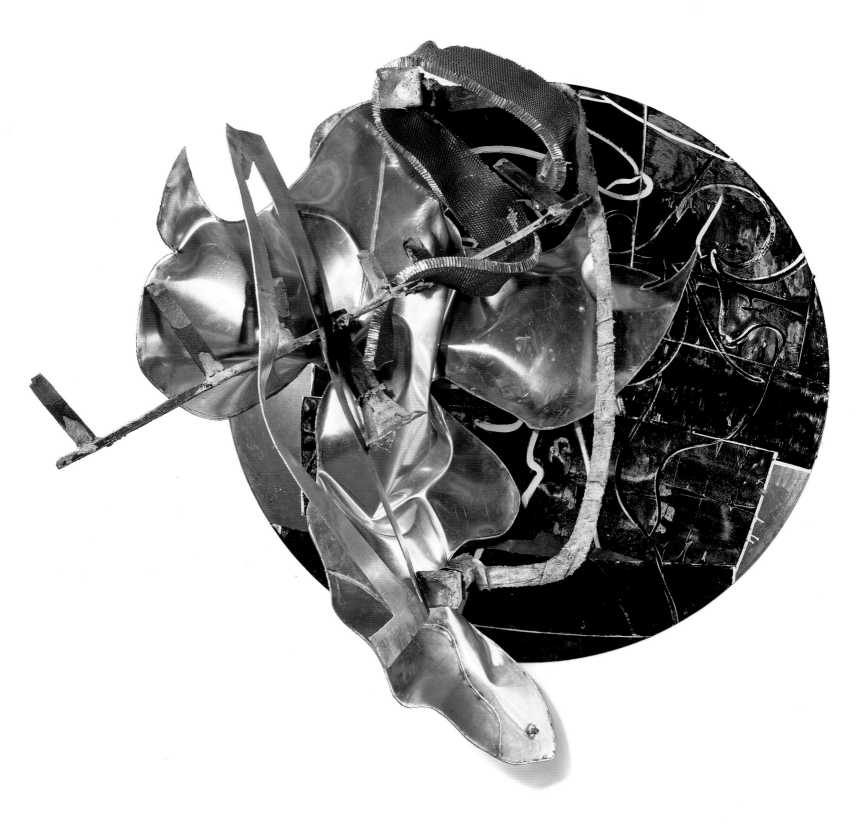

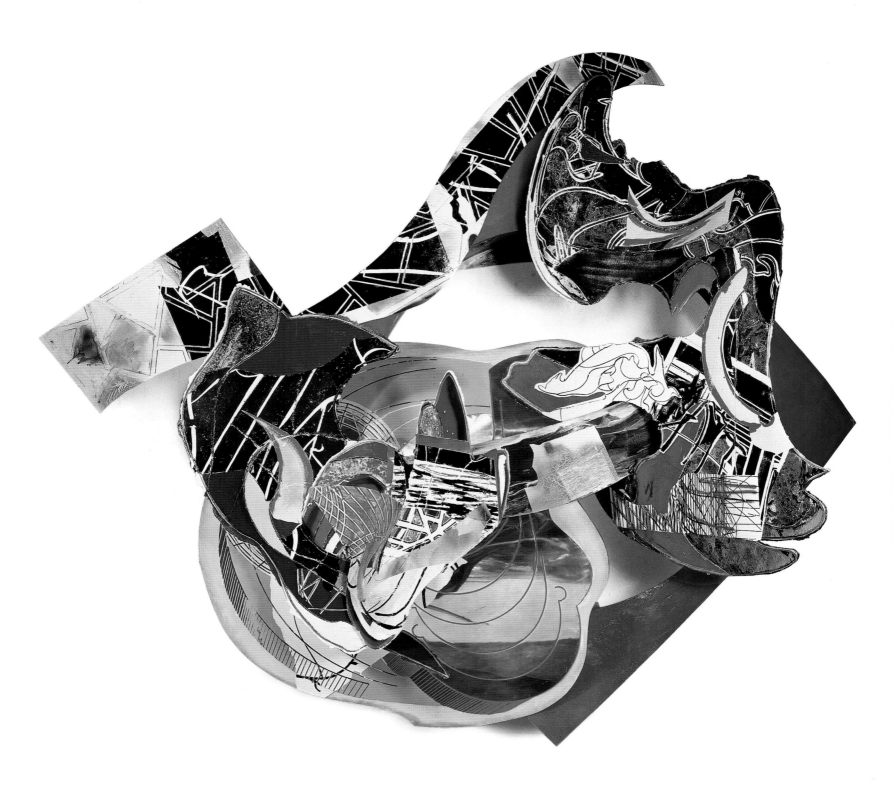

Frank Stella

Nan Goldin

*268. *Cookie at Tin Pan Alley, New York City*, 1983

*269. *Nan one month after being battered*, 1984

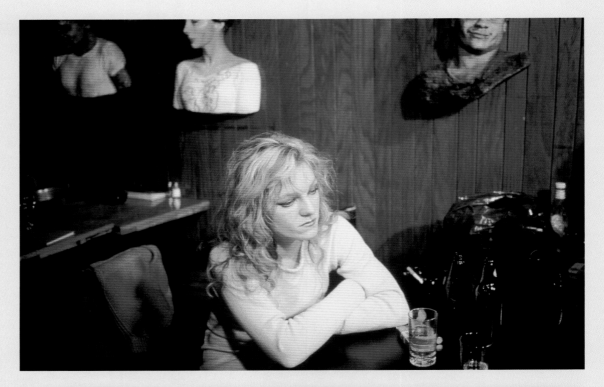

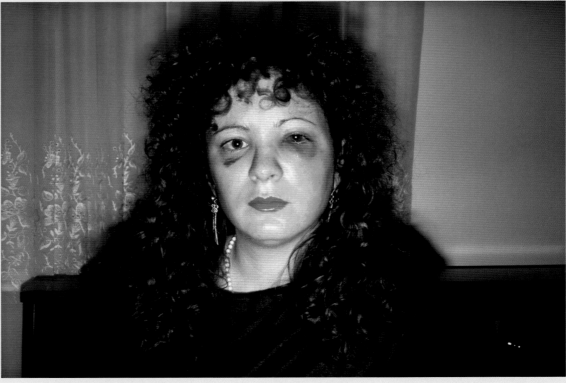

*270. *Jimmy Paulette and Tabboo!
In the Bathroom*, 1991

*271. *Cookie and Vittorio's wedding,
New York City*, 1986

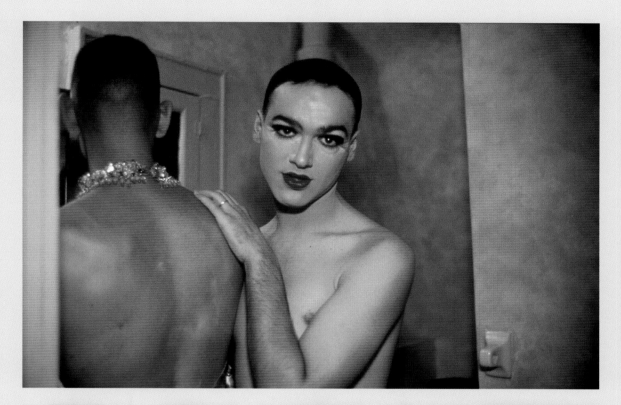

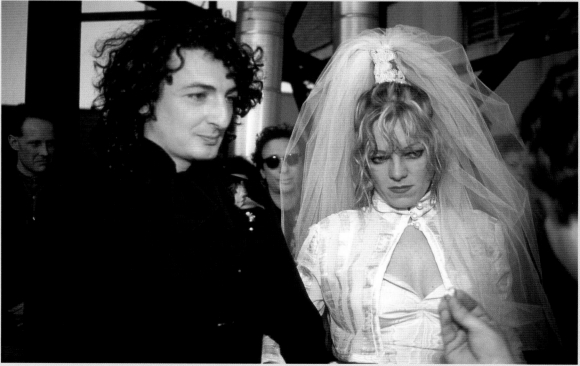

Peter Hujar

*272. *David Wojnarowicz Reclining,*
1981

*273. *Peggy Lee,* 1974

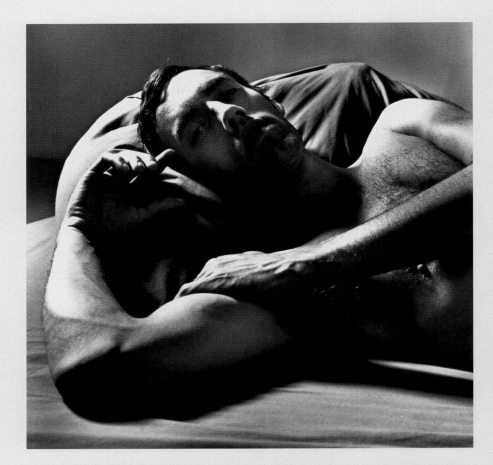

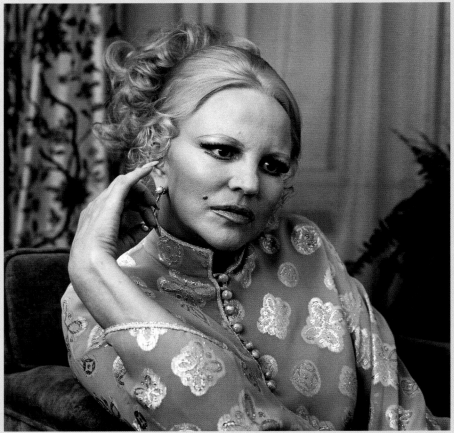

Photography

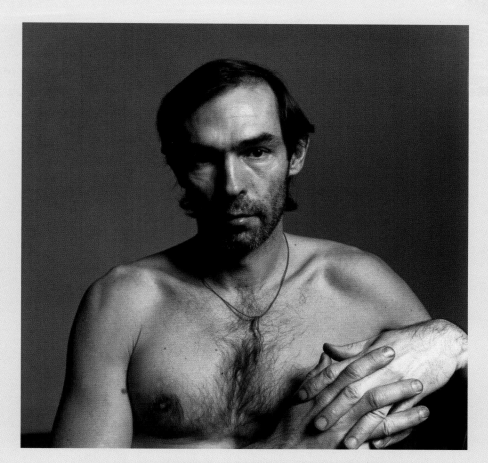

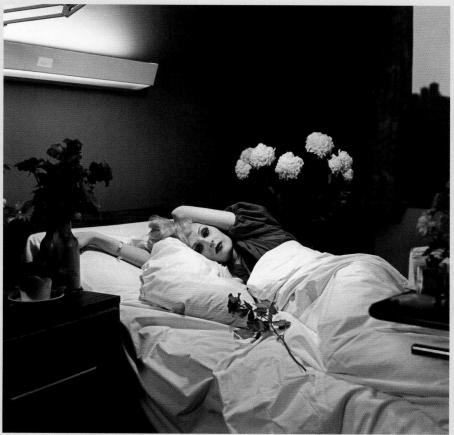

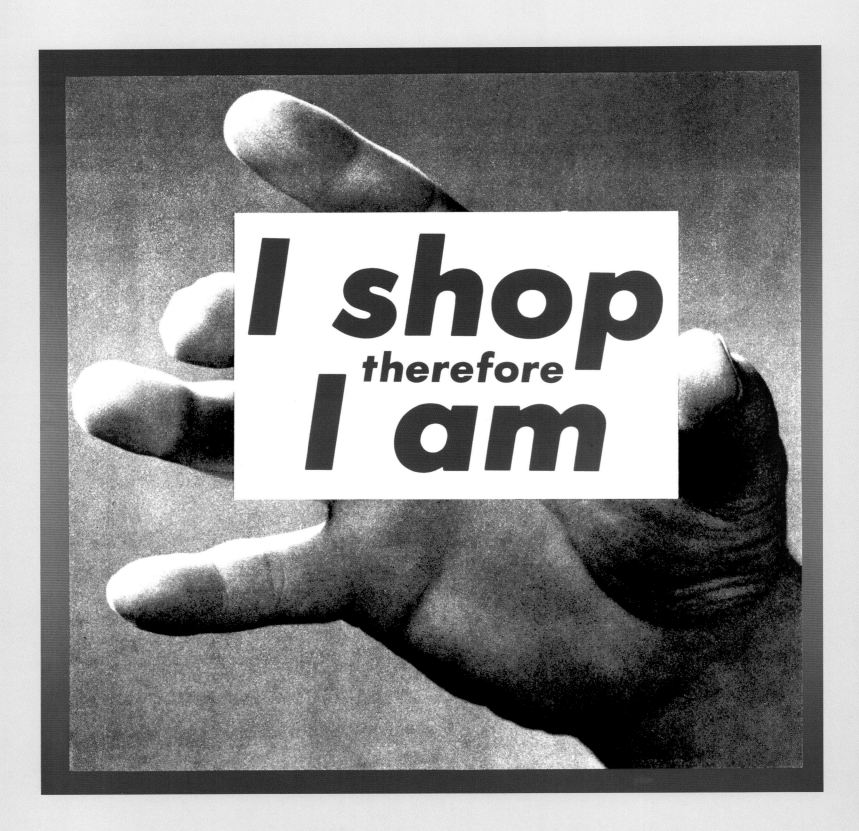

Photography

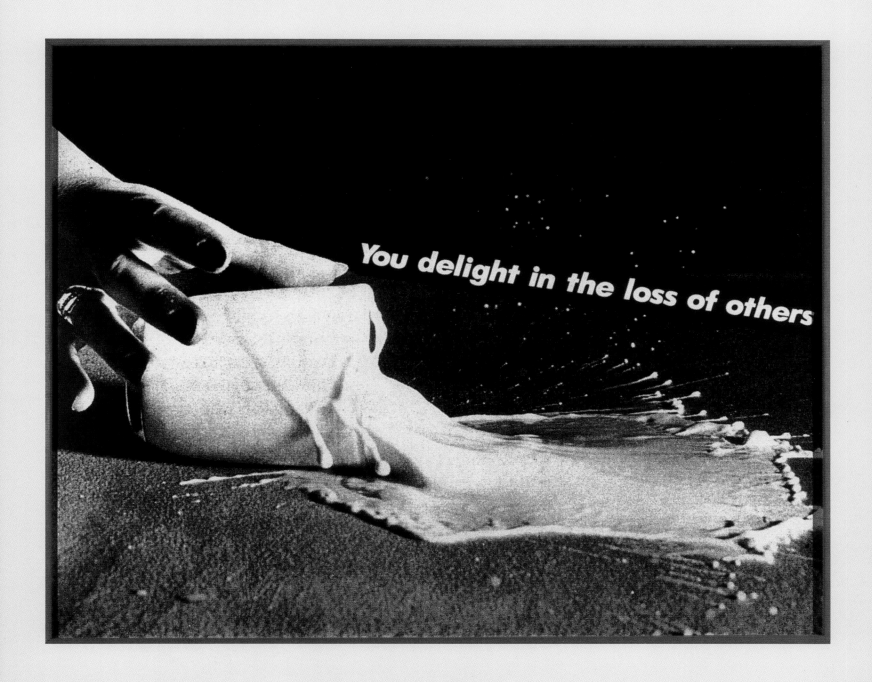

Robert Mapplethorpe

278. *Patti Smith*, 1979

*279. *Brian Ridley and Lyle Heeter*, 1979

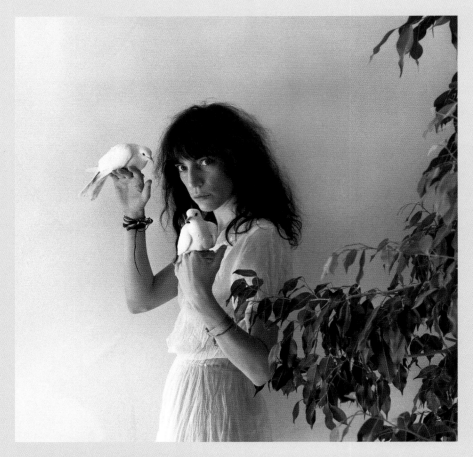

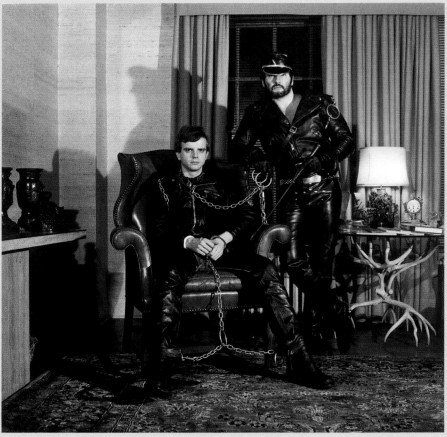

280. *Larry and Bobby Kissing*, 1979

281. *Lisa Lyon*, 1980

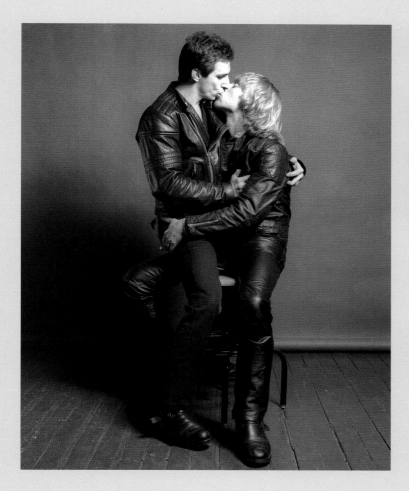

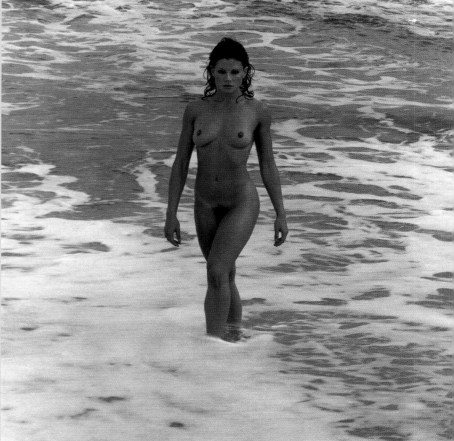

Mary Ellen Mark

*282. *Putla on her bed with a crushed rose, Bombay, India, 1978*

*283. *The girl who is being made up was brought to the brothel by the people of her village because her husband had left her, Bombay, India, 1978*

*284. *Falkland Road "cages". Madam: "Cage girls are the lowest - they only charge two rupees" (Seven ruppes equaled one dollar), 1978*

*285. *Champa, a transvestite, with his pet goat, getting dressed for the night, Bombay, India, 1978*

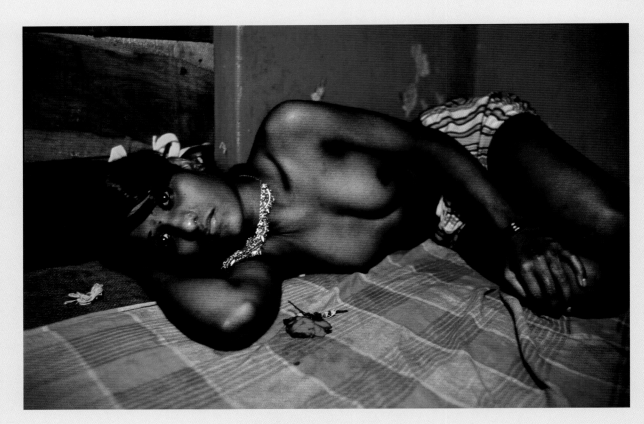

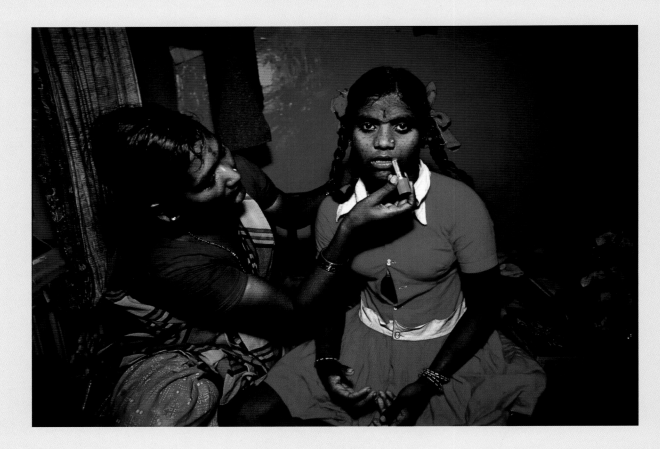

Photography

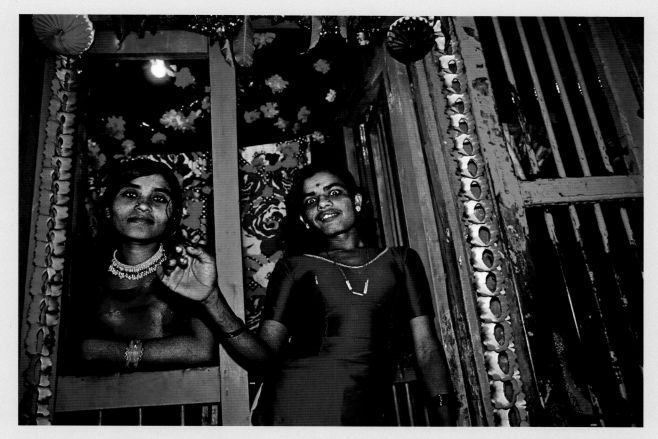

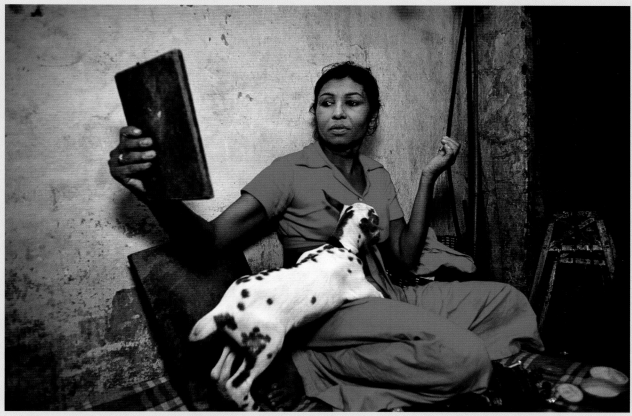

Susan Meiselas

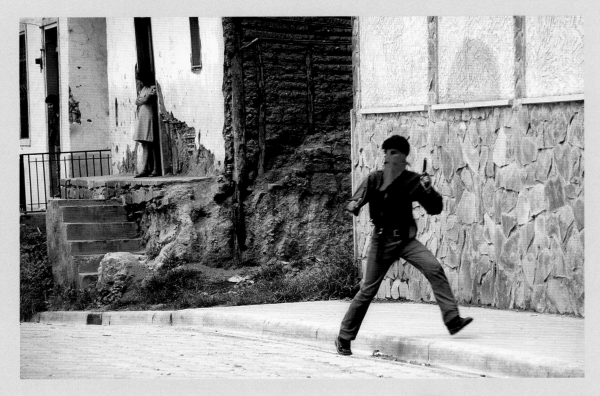

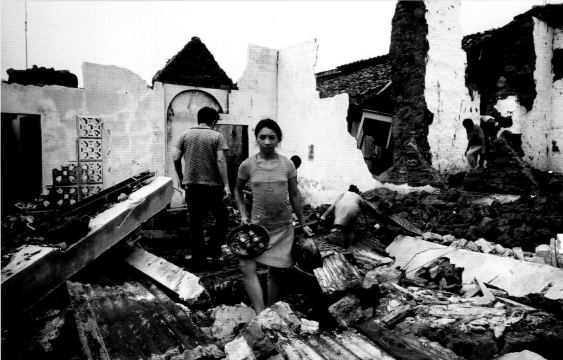

*286. First day of popular
insurrection, Matagalpa, Nicaragua,
August 26, 1978*

*287. Returning home, Masaya,
Nicaragua, September, 1978*

*288. Market place, Diriamba,
Nicaragua, 1978*

*289. "Cuesta del Plomo", a well-
know site of many assassinations
carried out by the National Guard,
where people searched daily for
missing persons, Managua,
Nicaragua, 1981*

Photography

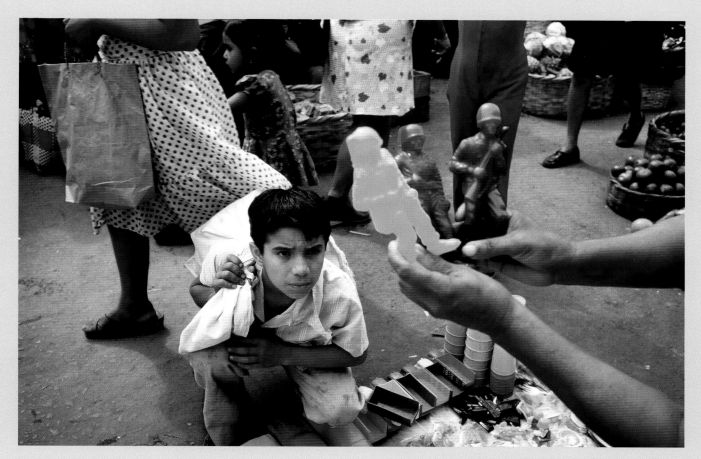

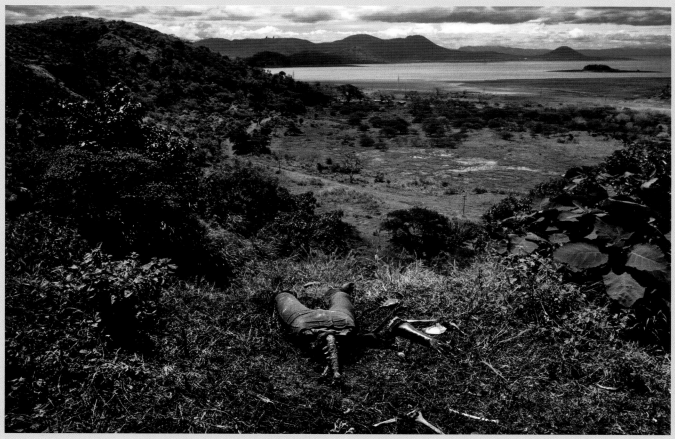

*290. The Poet Decorates His Muse
with Verse, 2003-2005*

The poet decorates his muse with verse

CRIST IN NEW YORK

Christ is sold on television by a religious hypocrite.

Christ cries when he sees a young woman who has died during an illegal abortion.

Christ eats dog food with an old Ukrainian lady in Brooklyn.

Christ is beaten defending a homosexual.

Christ sees a woman being attacked.

Christ is killed by a mugger with a handgun. The second coming had occurred & no one noticed.

Sylvia Plachy

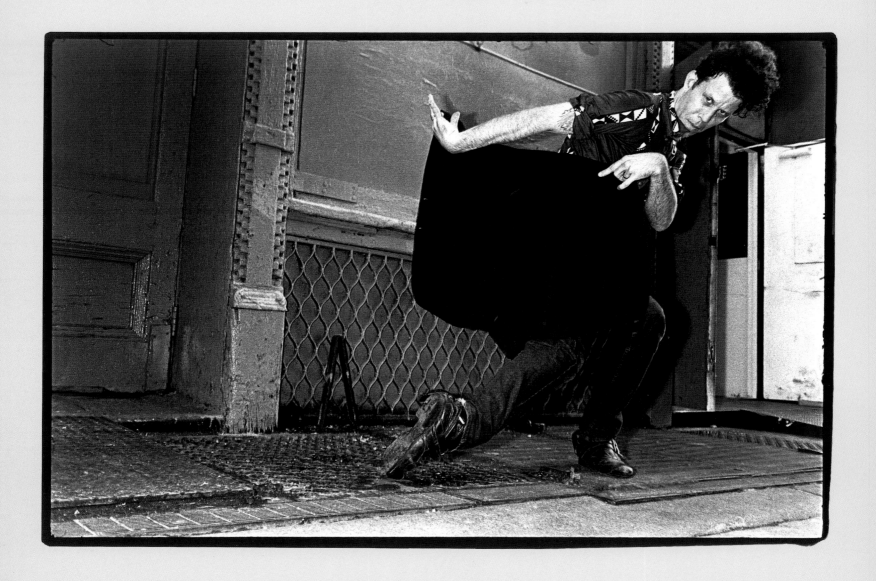

Photography

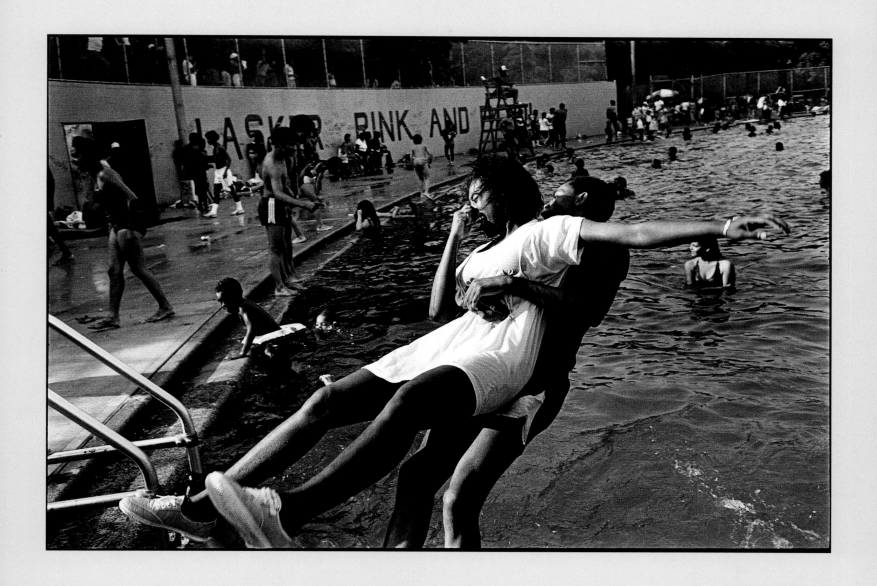

Eugene Richards

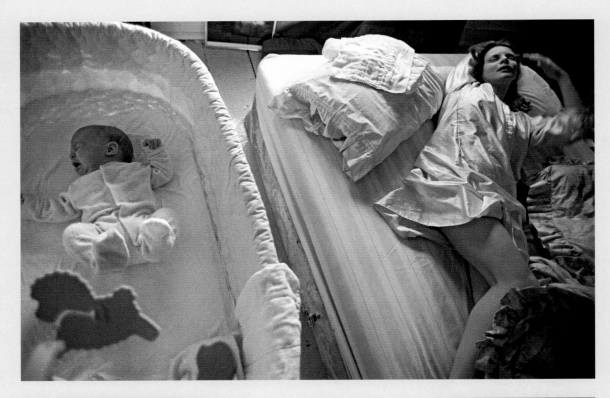

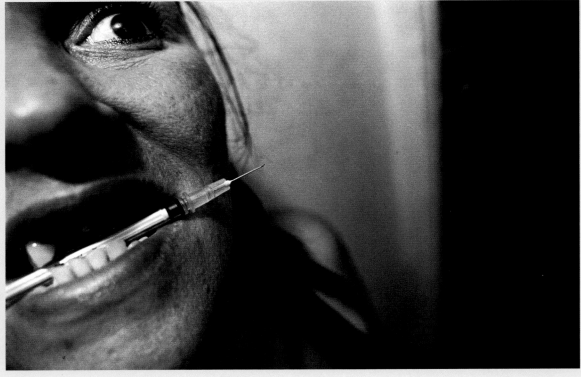

*294. *Janine and Sam, Brooklyn, NY*, 1988

295. *Shooting Cocaine, Brooklyn, NY*, 1992

Photography

*296. *Young addicts in the early
morning, Brooklyn, NY,* 1988

*297. *Tom, New York City,* 1988

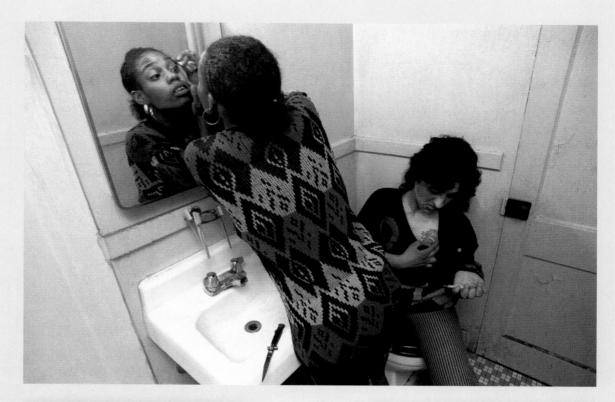

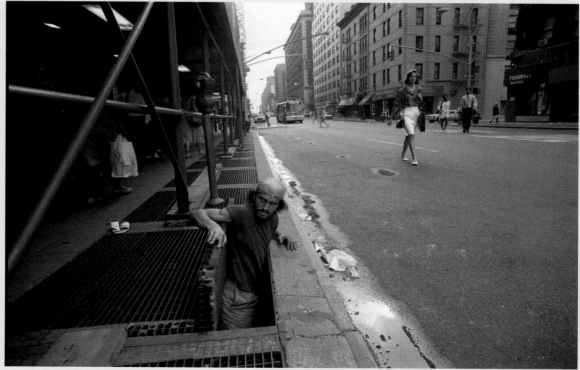

Lucas Samaras

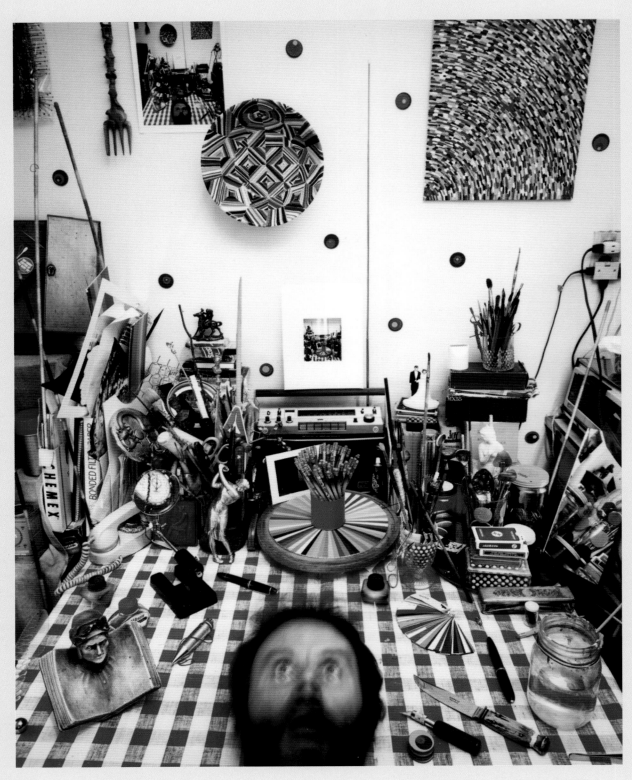

Cindy Sherman

303. Untitled #97, 1982

Photography

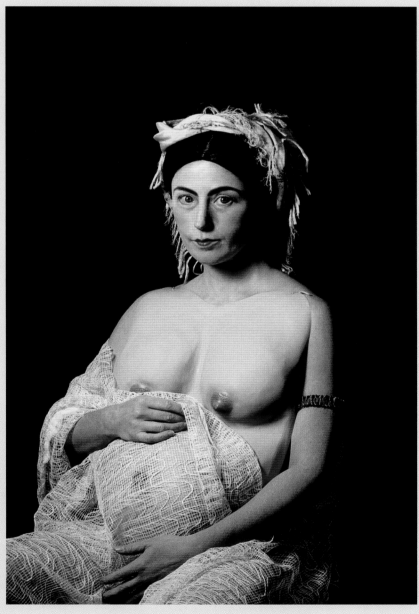

Mike & Doug Starn

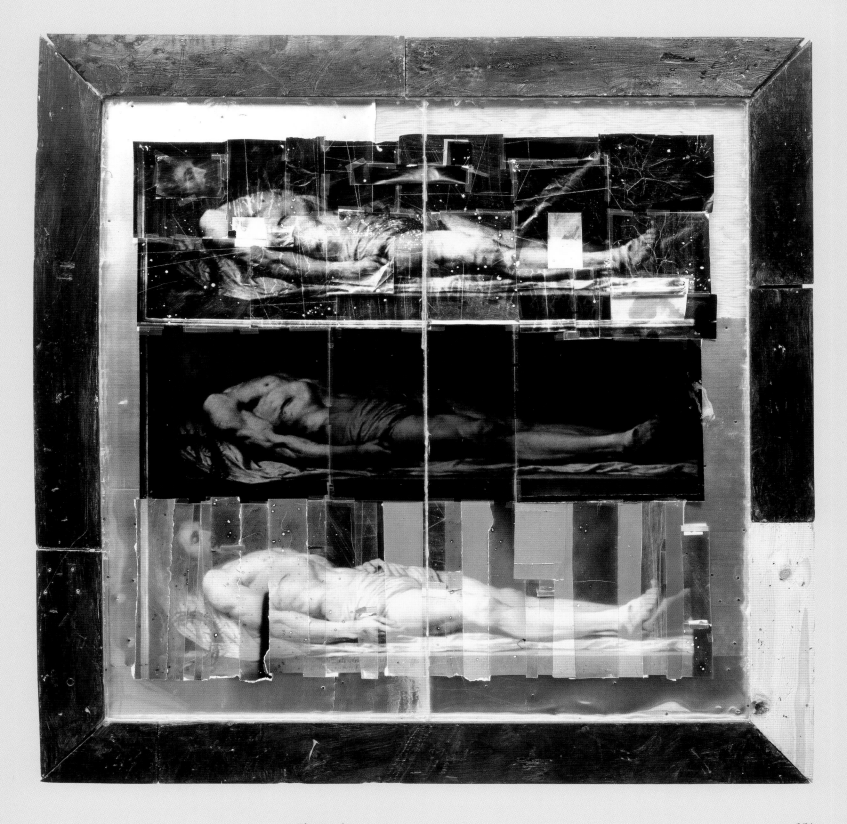

Brian Weil

*307. Prince, Two-Year-Old With
AIDS, New York City*, 1986

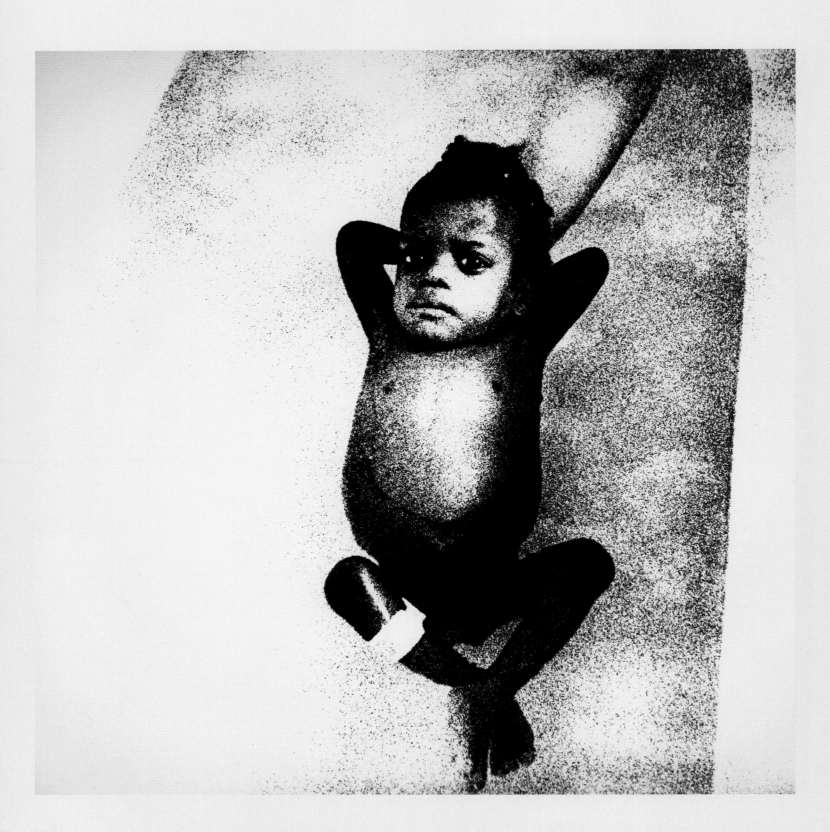

Photography

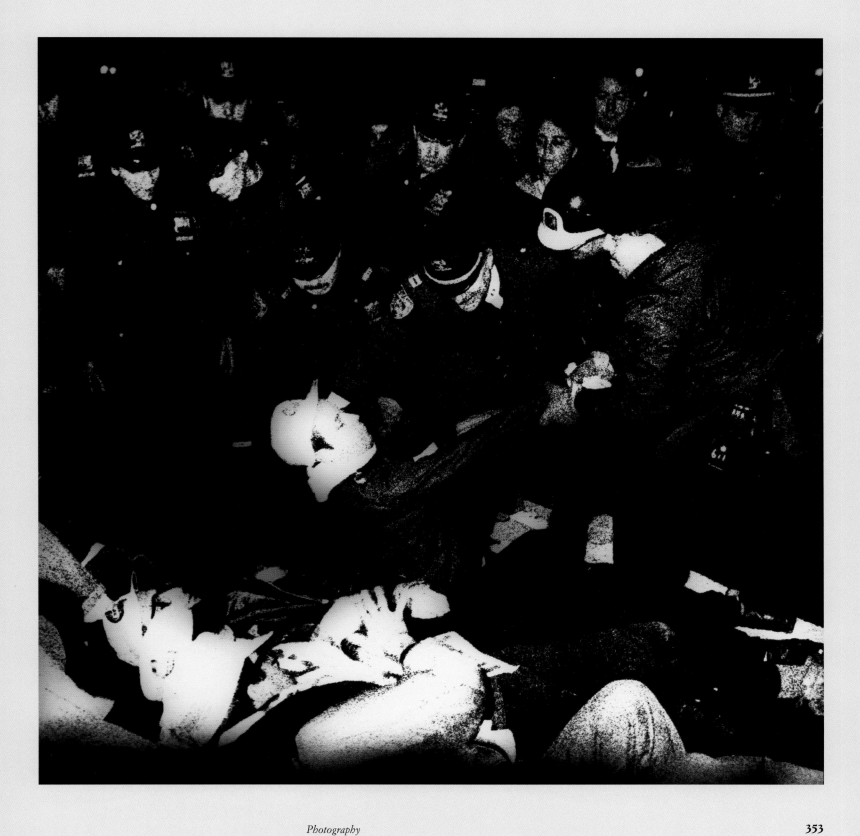

*308. *Act Up "Day of Desperation,"
42nd St. and Lexington Ave,
New York City*, 1991

David Wojnarowicz

Last night I took a man home from the subway where he had been standing against
a wall in the graffitti-covered car in black cowboy boots tight jeans and a
shirt openned to the third button and sleeves rolled up to reveal a workmans
arms and a couple of blue ink tatoo's and when we arrived back at my place I
sat on my bed and loosened his trousers with my teeth while pulling apart each
button on his shirt with my fingers and I slid my hands beneath the edge of his
T-shirt and let my hands slide over his hard and warm belly and as his T-shirt
rode up my arms with that motion there were two birds revealed tatooed in blue
ink flying the distances of his chest and my tongue moved back and forth
tracing wet lines across his belly and I slowly stood up and moved my tongue
over his pale sides as I lifted his T-shirt above his head and I could feel the
smell of his underarms as my face rose up towards them; my tongue taking in the
taste and then he laid me down on the bed and removed my shoes and pants while
I played with his hard dick through his pants and he bent and licked the inside
of my legs and thighs and under my balls and then laid on top of me pulling my
arms up and around his neck and he kissed behind my ears and licked across my
throat and across my face and down the bridge of my nose to my mouth where he
put his warm tongue in and I have the secondary stages of Aids and the man on
the T.V. who looks like he has a potatoe for a head is telling me and the rest
of the country that I must supress my sexuality - he talks about me in words
that makes me sound like an insect; "carrier" "infected" and when he shows
pictures or films of me I am always bedridden and alone and on the edge of
death and he says I must supress my sexuality whether I am a man or a woman
whether I am homosexual or heterosexual; whether I have aids or not.

The man on the T.V. is also the man in the newspapers; he has a replaceable
head - one day he can be a man and on another day he can be a woman; he can
have the face of a politician or the face of a doctor or the face of a research
scientist or the face of a health-care 'professional' or the face of a priest
with a swastika tatooed on his heart; and each and every one of these faces say
they are concerned for you because of my existence; and it is ironic when he
takes on the face of a family man who wants to protect his children because I
am his child and I have Aids and I don't think having Aids is something heavy;
it is the use of Aids as a weapon to enforce the conservative agenda that is
what is heavy. Homosexuals and intravenous drug users are expendable in this

For most people with Aids in this country their only alternative to the highly toxic AZT is the possibility of getting into a government/drug company sponsored drug trial - most women are excluded from these trials for no apparent reason; 1/3 of one percent of all women with Aids manage to gain access to these drug trials. Lesbians are completely excluded and even the government statistics on Aids will not recognize lesbians as either existing or vulnerable to the disease of Aids. Puerto Ricans, Blacks, Haitian and other people of color are excluded from these drug trials. The drug companies insist that in order to be eligible for inclusion in the drug trials one must have a private physician who can monitor the amounts of the drug you take. This automatically excludes the poor or those on welfare since their healthcare usually takes place in clinics where the doctors are constantly rotated. So this means that only white middleclass men have some chance of receiving drugs for the treatment of Aids if they are unable to handle the toxicity of AZT. Word is out that many poor minorities are unable to get a diagnosis of Aids from clinic doctors because if given a diagnosis then hospital beds have to be made available to them in the event of severe illness such as P.C.P. pneumonia. A poor person with P.C.P. stands a good chance of a clinic doctor telling them they only have the flu and being given ineffective antibiotics and told to come back later if it doesn't improve. Obviously this means they will die a short time later at home or in the hotel they live in or in the shelters.

Homeless men or women are not diagnosed even though city statistics acknowledge there are between five and ten thousand homeless people with Aids living on the city streets or in shelters where they are susceptible to the more than 300 opportunistic infections people with Aids can get. T.B. and pneumonia is rampant in the shelter sytem. Shelter doctors are likely to purposefully not diagnose homeless people with Aids because hospitals are overcrowded and the beds are saved for people with insurance or money. Intravenous drug users have to be completely clean of drugs for a period of seven years before they are elegible for drug trials. The waiting period for most addiction treatment centers is one to two years; so this means a drug-addict who has Aids has to kick his or her habit and then stay alive some how for seven years before being considered for the drug trials. It has taken eight years for the city government to begin information campaigns aimed at intravenous drug users and only recently have some small ads on the subway begun to use the spanish language even though an enormous amount of heterosexual people with Aids are from minority communities. They also say the homosexual community is so well informed that there need be no ad campaigns aimed at homosexuality and safe sex - once again this is nonsense; there are large percentages of men who engage in homosexual activity but because they simple fuck some guy or get blown by a guy they don't consider themselves homosexual. And although the gay baths in lower Manhattan were closed down the baths in harlem have been allowed to remain open and city health officials still won't acknowledge that Lesbians can get Aids.

*311-312. William Friedkin
French Connection, 1971

*313. Alan Pakula
Klute, 1971

*314. Sidney Lumet
Dog Day Afternoon, 1975

*315. Martin Scorsese
Taxi Driver, 1976

316. Marco Ferreri
Ciao maschio, 1978

317. Richard Donner
Superman, 1978

*318. Woody Allen
Manhattan, 1979

319. Martin Scorsese
Racing Bull, 1979

*320. John Carpenter
New York 1997, 1980

321. John Cassavetes
Gloria, 1980

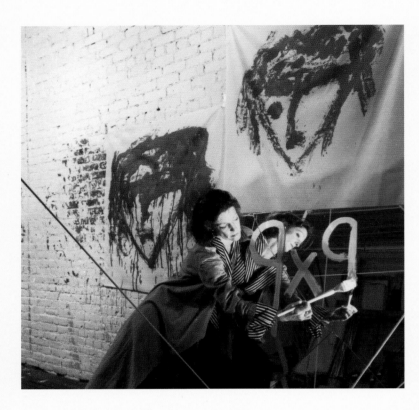

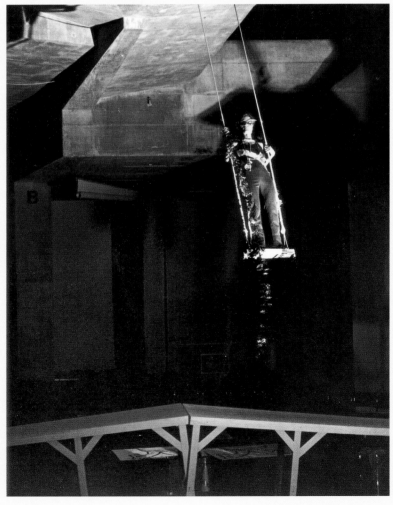

324. Joan Jonas
The Juniper Tree, 1978

325. Joan Jonas
Double Lunar Dogs, 1980

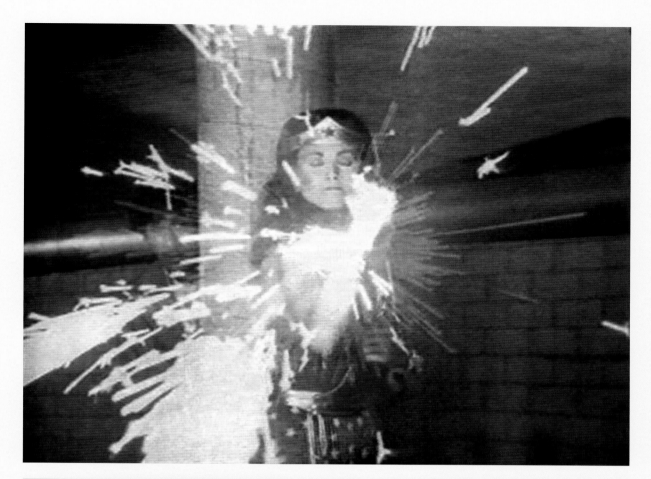

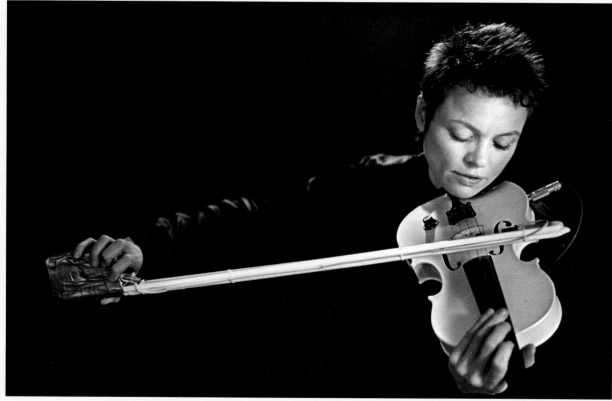

328-329. Diamanda Galas
Panoptikon, performed
at Brooklyn Academy
of Music, 1983

330. Eric Bogosian as Ricky Paula,
The Ricky Paula Show, performed
at White Columns, 1979

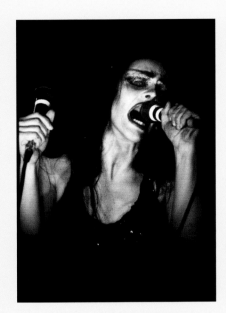

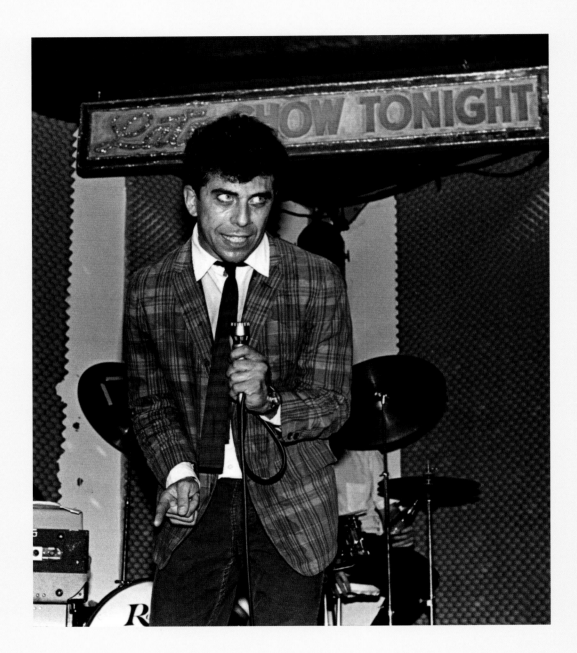

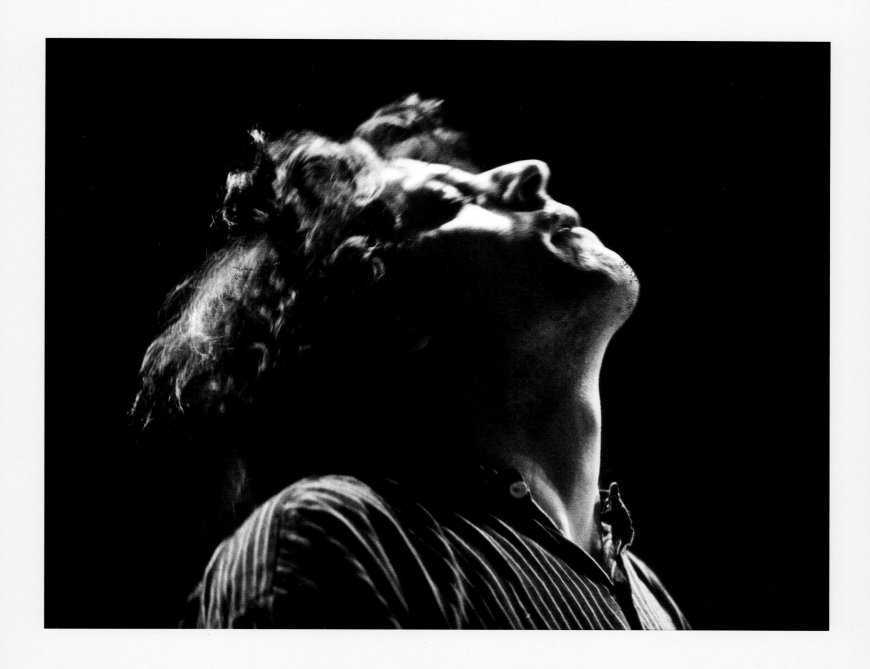

332. Grommet Art Theatre, 1982　　333. Tehching Hsieh
　　　　　　　　　　　　　　　　　　Performance, 1981-1982

September 26, 1981

STATEMENT

I, Tehching Hsieh, plan to do a one year performance piece.

I shall stay OUTDOORS for one year, never go inside.

I shall not go in to a building, subway, train, car, airplane, ship, cave, tent.

I shall have a sleeping bag.

The performance shall begin on September 26, 1981 at 2 P.M. and continue until September 26, 1982 at 2 P.M.

Tehching Hsieh

Tehching Hsieh

New York City

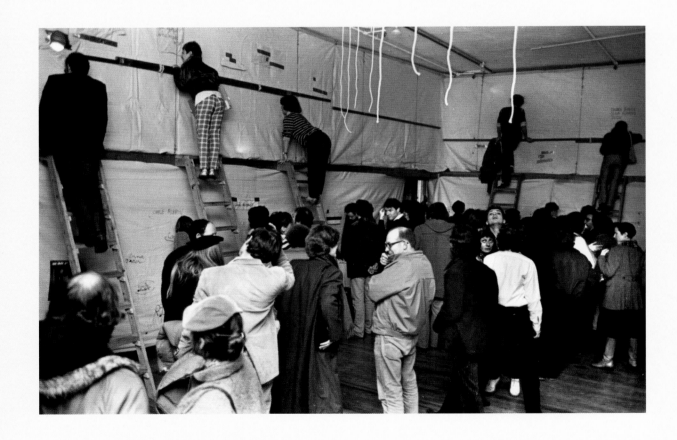

334. Peter Gordon, Bill T. Jones, Arnie Zane, Keith Haring, and Willie Smith at a performance of *Secret Pastures*, choreographed by Bill T. Jones in collaboration with Arnie Zane, Brooklyn Academy of Music, 1984

335. Bill T. Jones and Arnie Zane in rehearsal for *Valley Cottage*, The American Theater Laboratory, 1981. First performed at Dance Theatre Workshop, 1980

336. Bill T. Jones in the film *Two Moon July*, The Kitchen, 1986

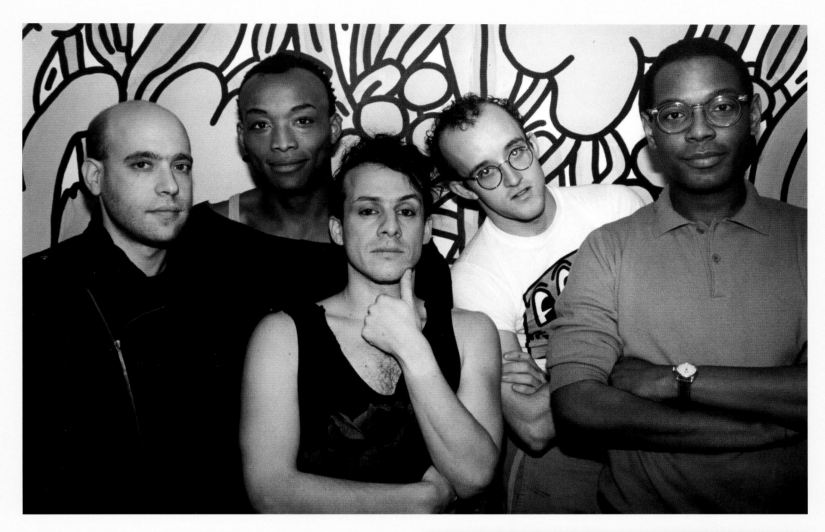

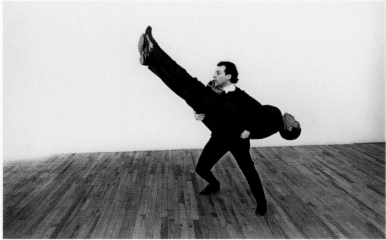

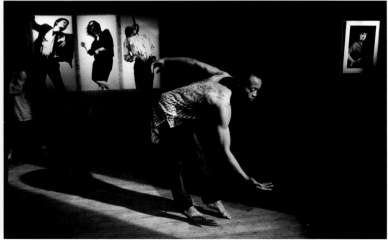

337. Menthol Wars performing
at Tier 3, New York, 1980

338. Ann Magnuson
Trial Dance, performed
at The Kitchen, 1984

339. Robert Longo
Iron Voices, performed
at The Kitchen, 1982

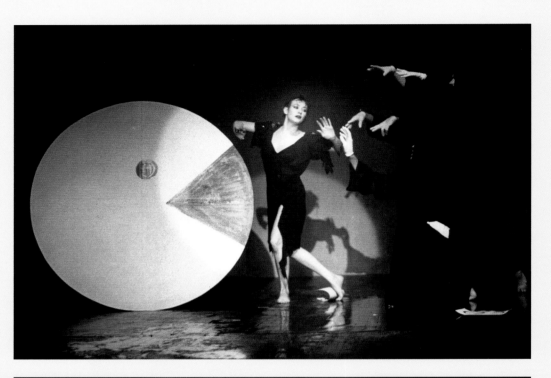

Performance and Video

340. The Rock Steady Crew,
performing at The Kitchen, 1981

341. Elizabeth Streb
Fall Line, performed
at The Kitchen, 1982

342. The Wooster Group
LSD (… Just the High Points…),
1984

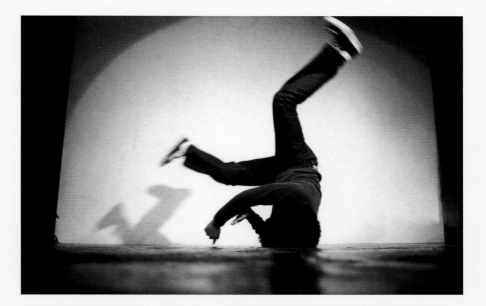

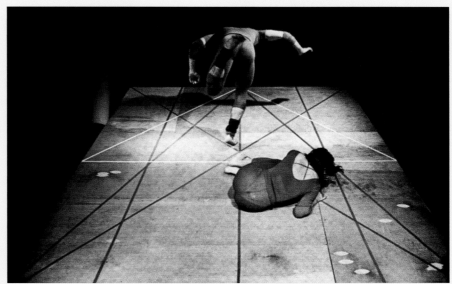

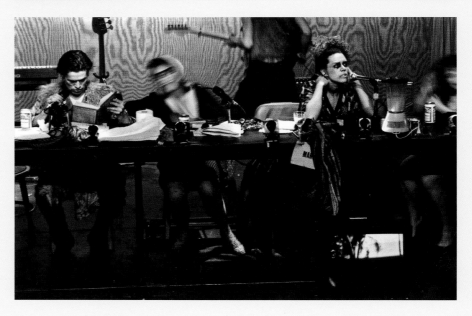

343. Minoru Yamasaki
& Associates, Emery Rothe & Sons
World Trade Center, New York,
1973

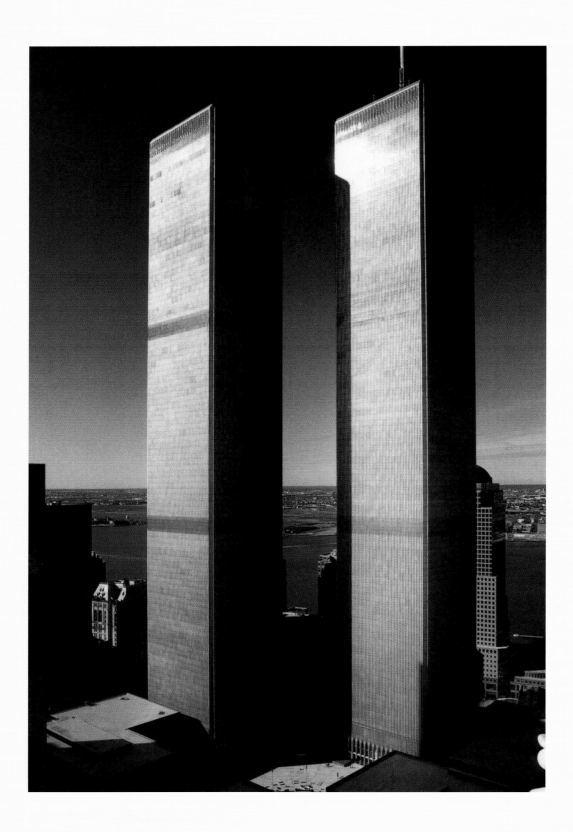

344. Philip Johnson & John Burgee
AT&T. Corporate Headquarters,
New York, 1978-1984

345. Philip Birnbaum, Philip
Johnson & John Burgee
1001 Fifth Avenue, New York, 1979

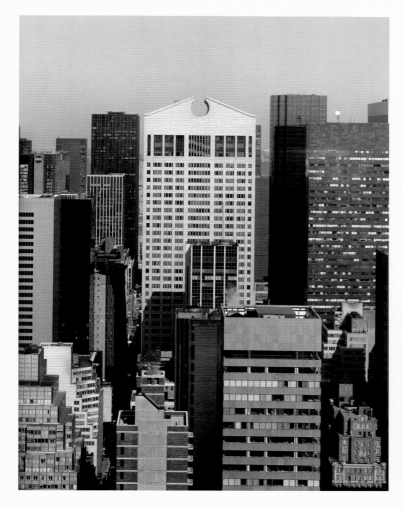

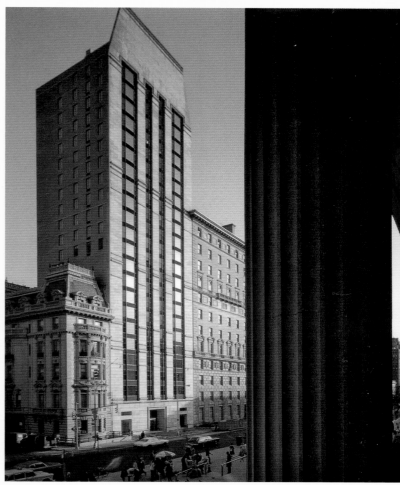

346-347. Philip Johnson
& John Burgee
33 Maiden Lane, New York, 1986

348. Philip Johnson & John Burgee
Lipstick Building, New York, 1986

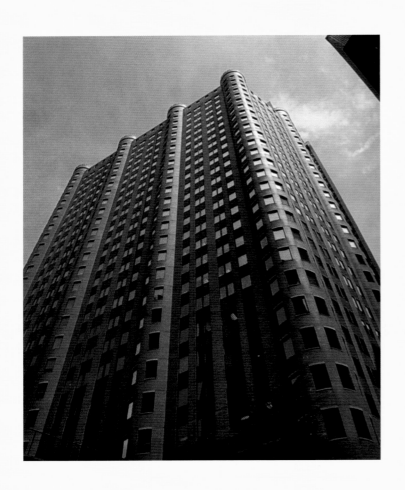

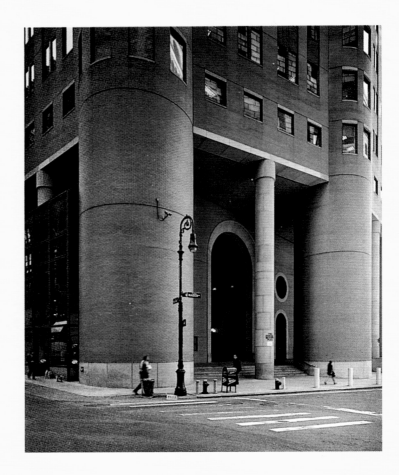

Architecture

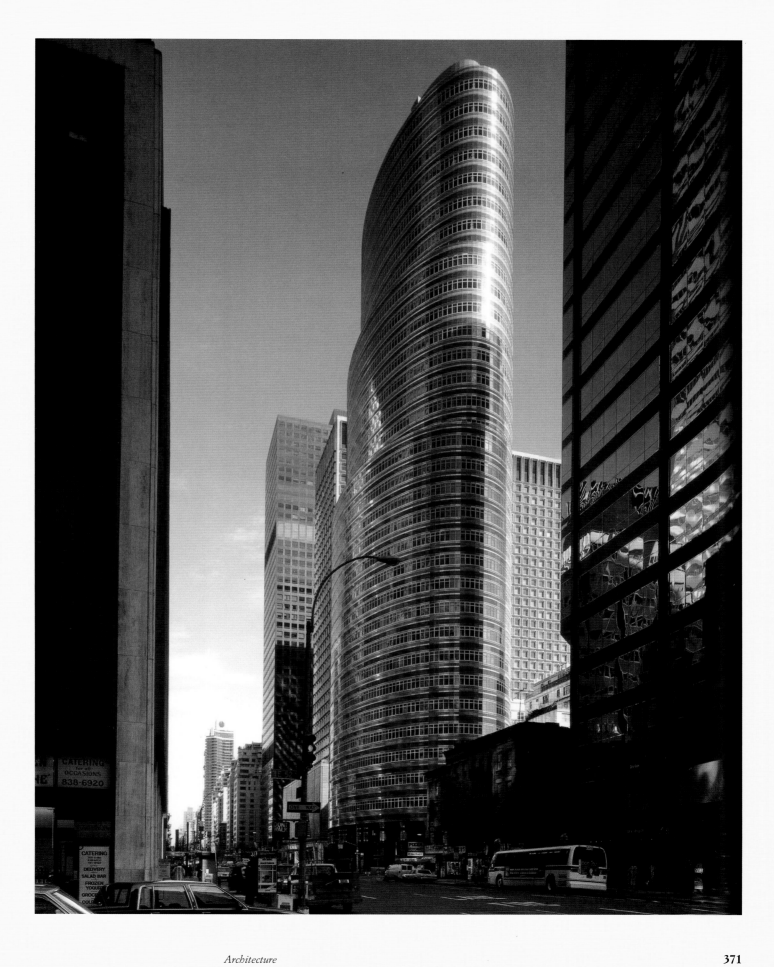

Vito Acconci

349-352. *Run off*, 1970

353-356. *Rubbing Piece*, 1970

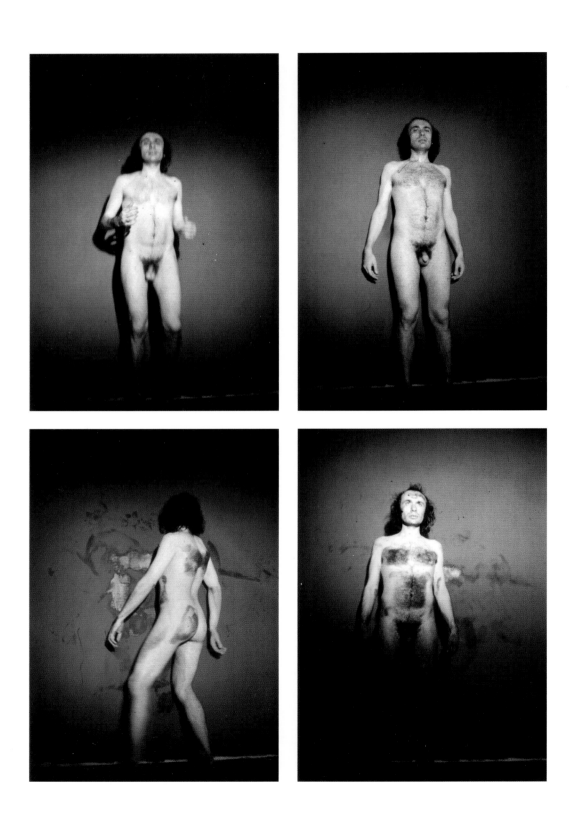

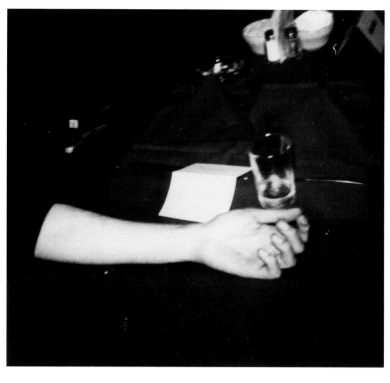 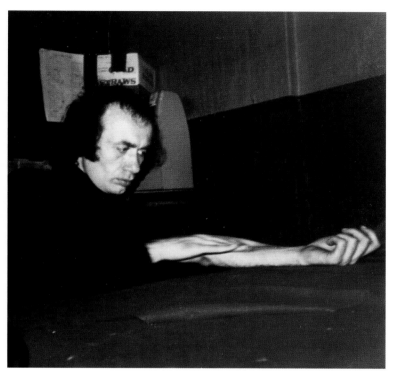

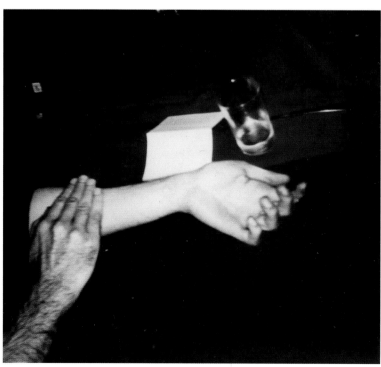

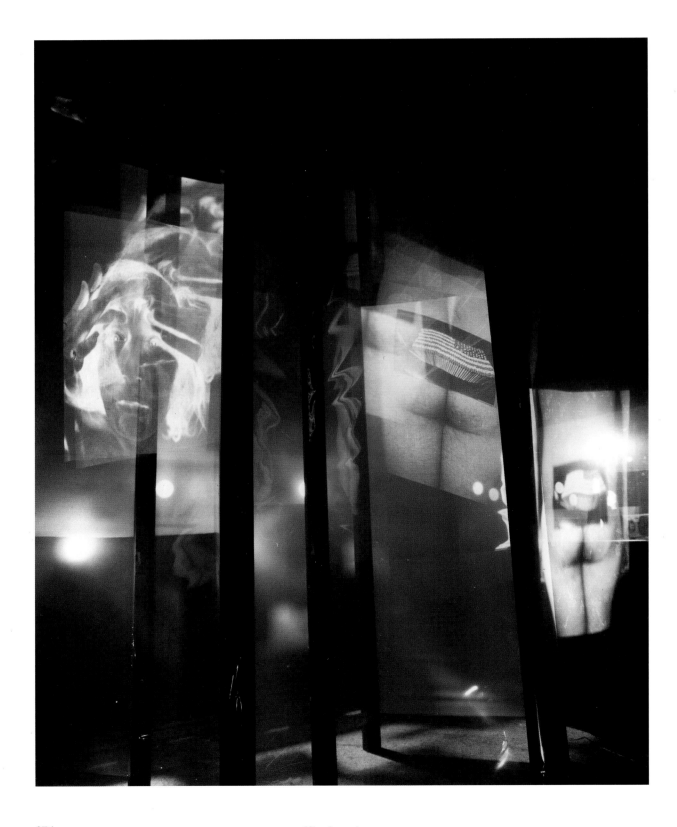

Vito Acconci

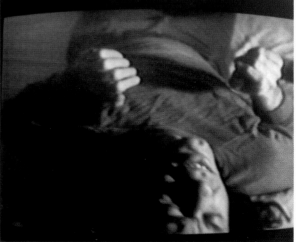

Walter De Maria

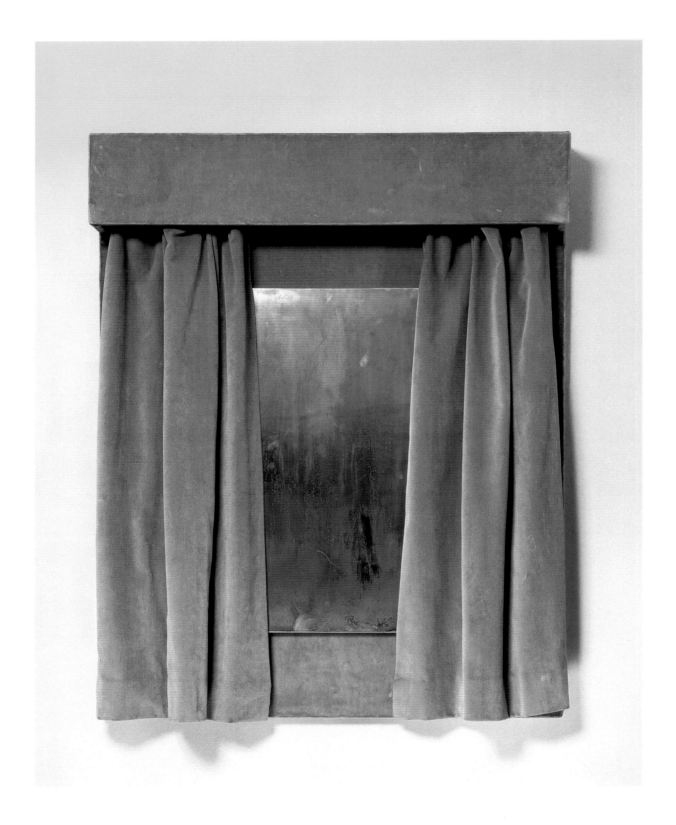

362. *The Color Men Choose When They*, 1968

THE COLOR MEN CHOOSE WHEN THEY ATTACK THE EARTH

*363. *Garbo Column*, 1968

Walter De Maria

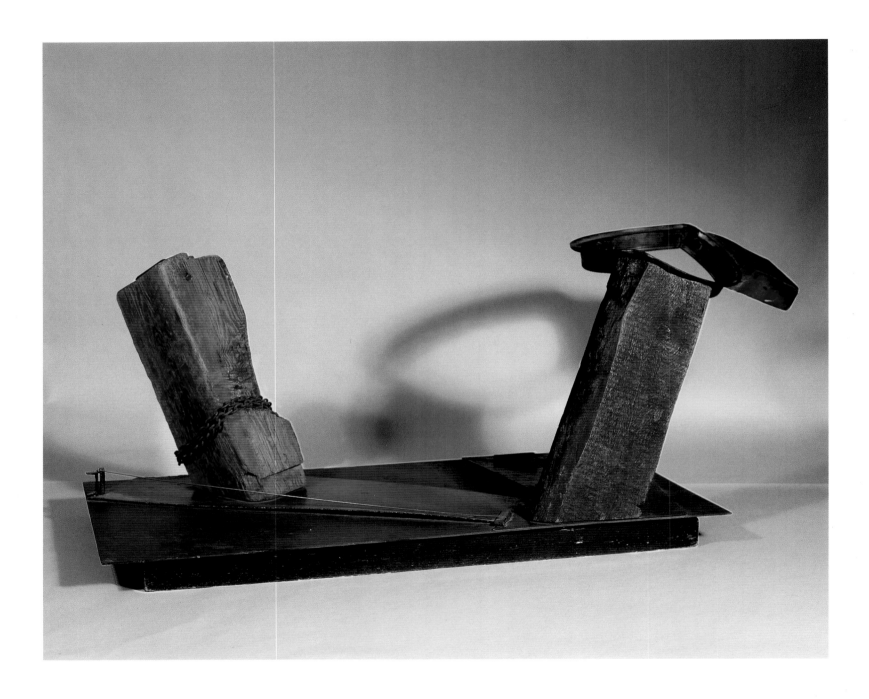

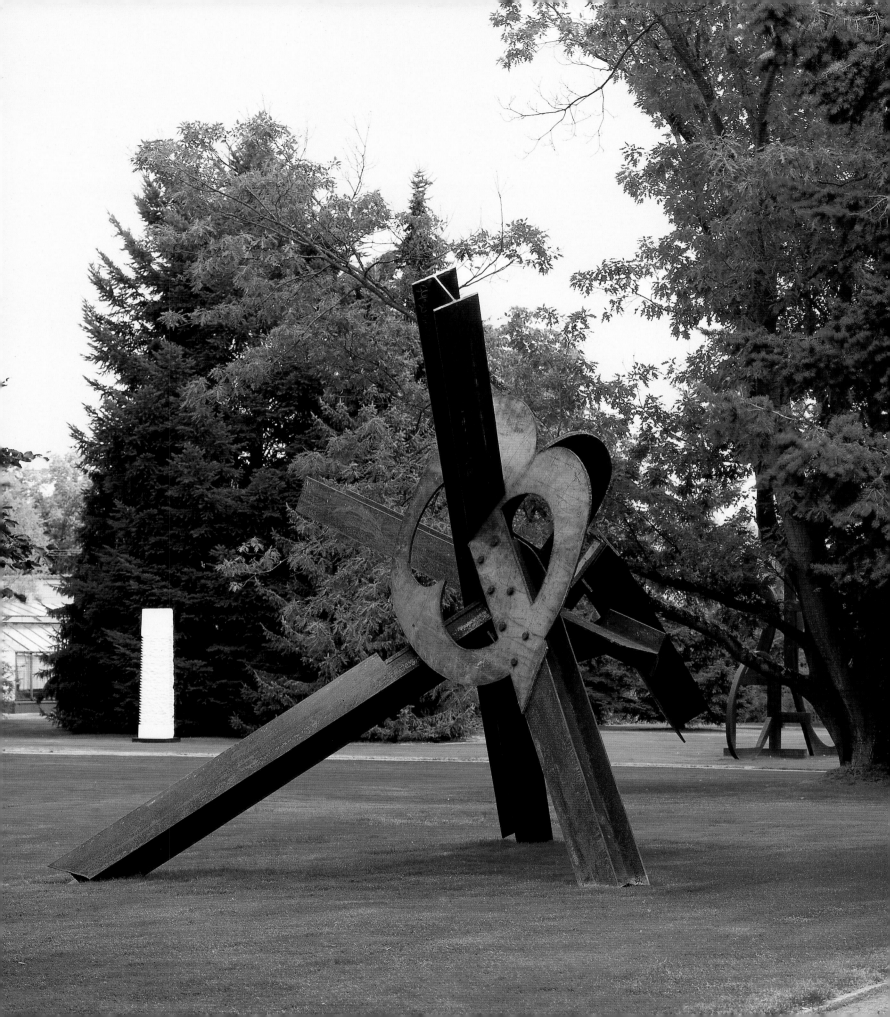

367. *Thought*, 1967

thought[1] (thôt). Pret. and pp. of *think*[1], *think*[2].
thought[2] (thôt), *n.* [AS. *thōht, gethōht, < thencan,* E. *think*[2].] The act or process of thinking; mental activity, esp. of the intellect; also, the capacity or faculty of thinking; also, the product of mental action, or that which one thinks (as, "Thou understandest my *thought* afar off": Ps. cxxxix. 2); also, the intellectual activity or the ideas, opinions, etc., characteristic of a particular place, class, or time (as, Greek *thought*); also, a single act or product of thinking; an idea or notion (as, to collect one's *thoughts*); a consideration or reflection (as, "In this *thought* they find a kind of ease": Shakspere's "Richard II.," v. 5. 28); also, often, consideration, attention, care, or regard (as, "Catherine . . . never took any *thought* for her appearance": Mrs. H. Ward's "Robert Elsmere," i.); meditation (as, lost in *thought*); intention, design, or purpose, or an intention or design, esp. a half-formed or imperfect intention (as, his *thought* was to avoid controversy; we had some *thoughts* of going); anticipation or expectation (as, I had no *thought* of seeing you here); a judgment, opinion, or belief (as, "What . . . are thy *thoughts* of the emperor?" Scott's "Count Robert of Paris," xxvii.); also, anxiety, trouble, or sorrow (obs. or prov.); also, a very small amount, or a trifle (as, "We're a *thought* before time," Eden Phillpotts's "Children of Men," Prologue, i.; "William de la Marck has been a *thought* too rough," Scott's "Quentin Durward," xxiii.).

noth-ing (nuth'ing). [Orig. two words, *no thing*.] **I.** *n*. No thing, not anything, or naught (as, to see, do, or say *nothing*; "I opened wide the door: Darkness there, and *nothing* more!" Poe's "Raven"); no part, share, or trace (*of*: as, the place shows *nothing* of its former magnificence; there is *nothing* of his father about him); also, that which is non-existent (as, to create a world out of *nothing*; to reduce something to *nothing*, as by a process of extinction or annihilation); also, something of no importance or significance (as, "Gratiano speaks an infinite deal of *nothing*," Shakspere's "Merchant of Venice," i. 1. 114; "The defeat itself was *nothing* . . . but the death of the Prince was a blow," Besant's "Coligny," ix.); a trifling action, matter, circumstance, or thing; a trivial remark (as, "In pompous *nothings* on his side, and civil assents on that of his cousins, their time passed": Jane Austen's "Pride and Prejudice," xv.); a person of no importance, or a nobody or nonentity; in *arith*., that which is without quantity or magnitude; also, a cipher or naught (0).

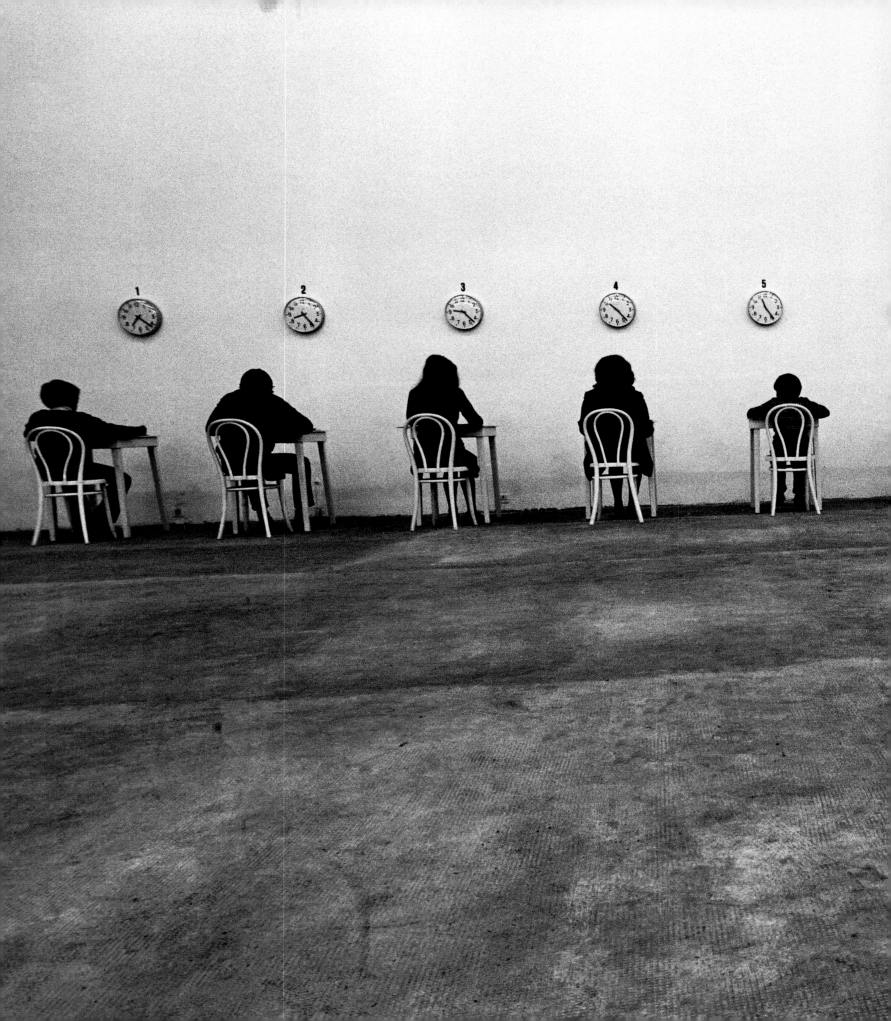

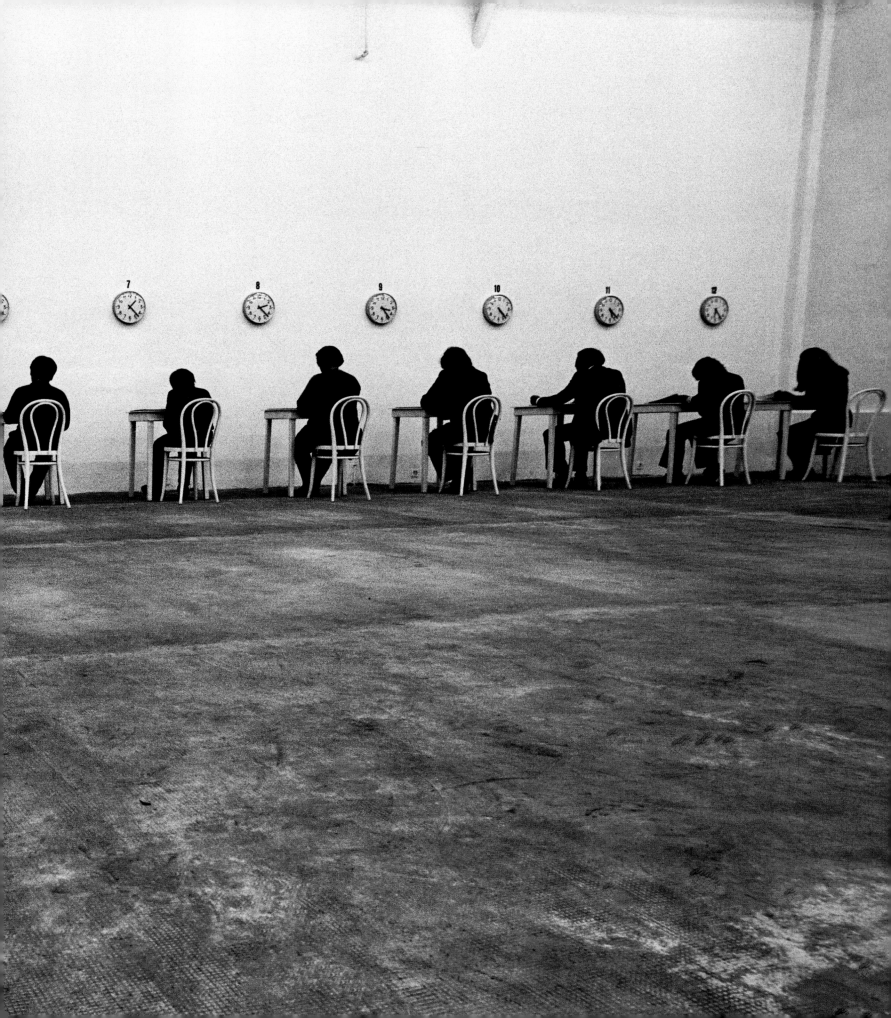

Bruce Nauman

*370. *Henry Moore Bound to fail,* 1967-1970

*371. *My Last Name exaggerated fourteen Times Vertically,* 1967

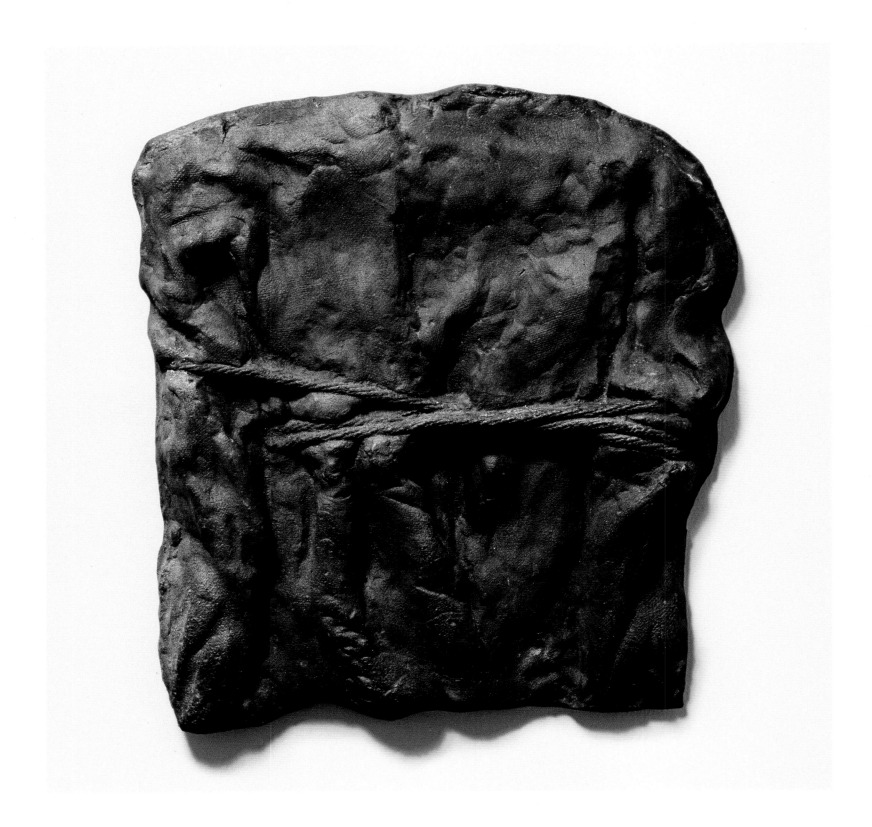

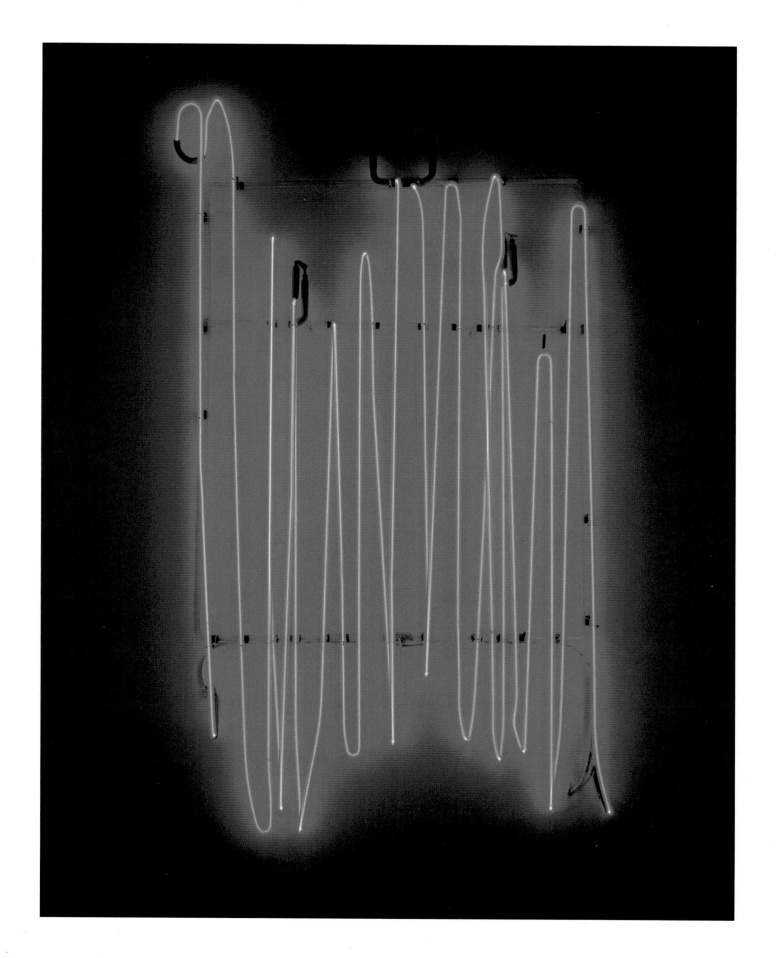

Bruce Nauman

372. *My Name as Though It Were Written on the Surface of the Moon*, 1968

Richard Serra

373. *White Neon Belt Piece*, 1967

*374. *House of Cards 1*, 1968-1998

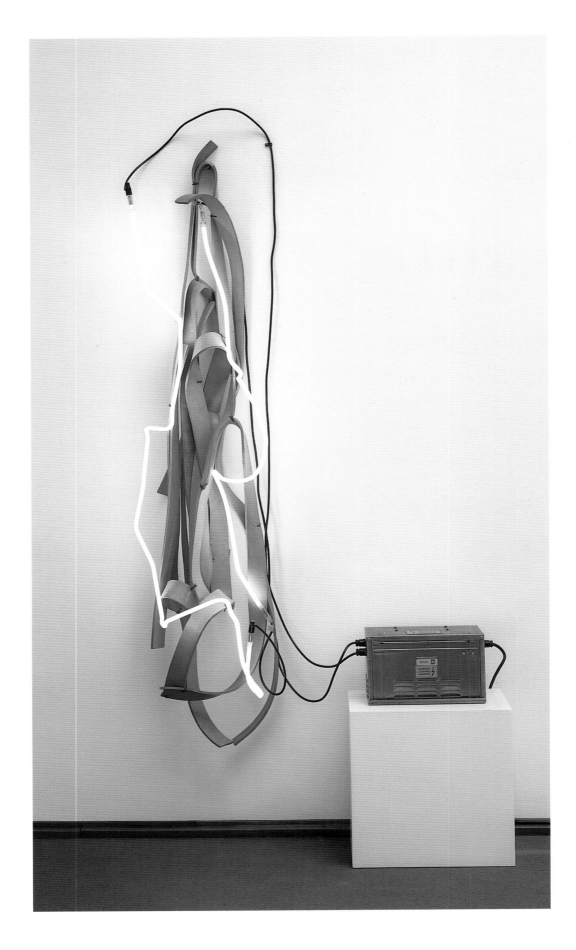

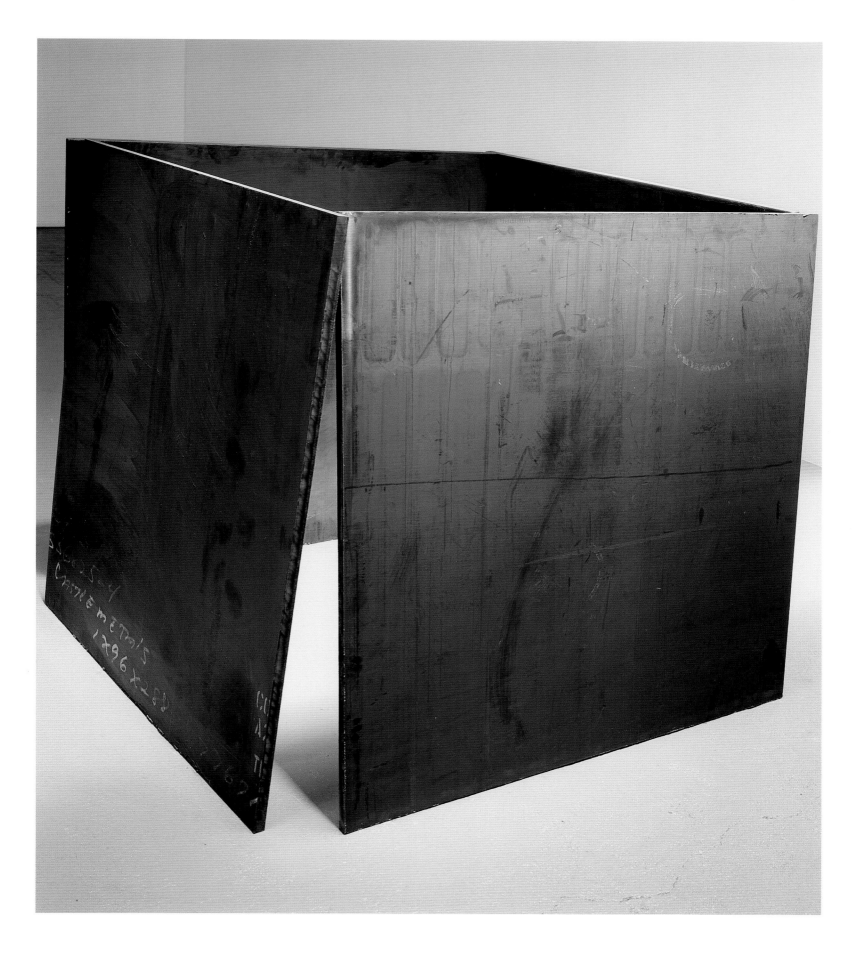

Richard Serra

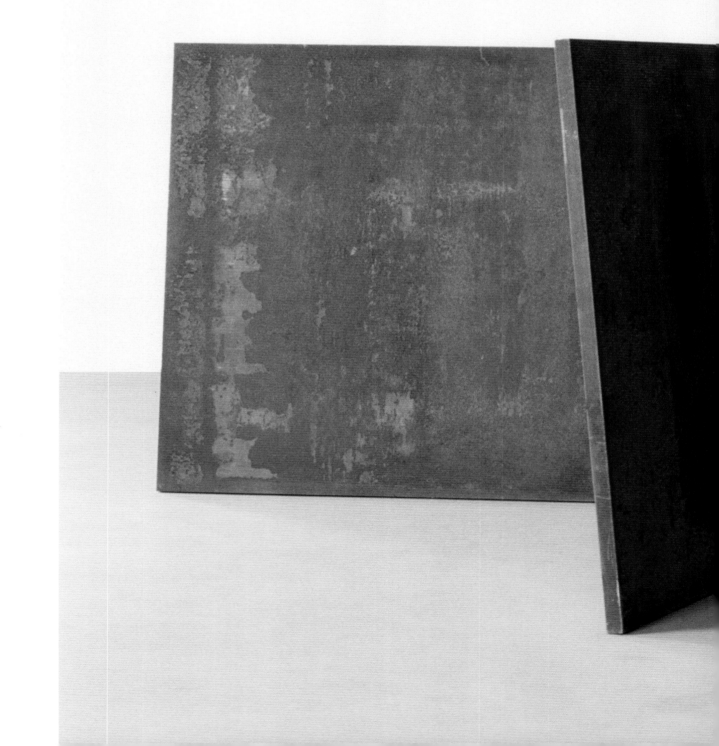

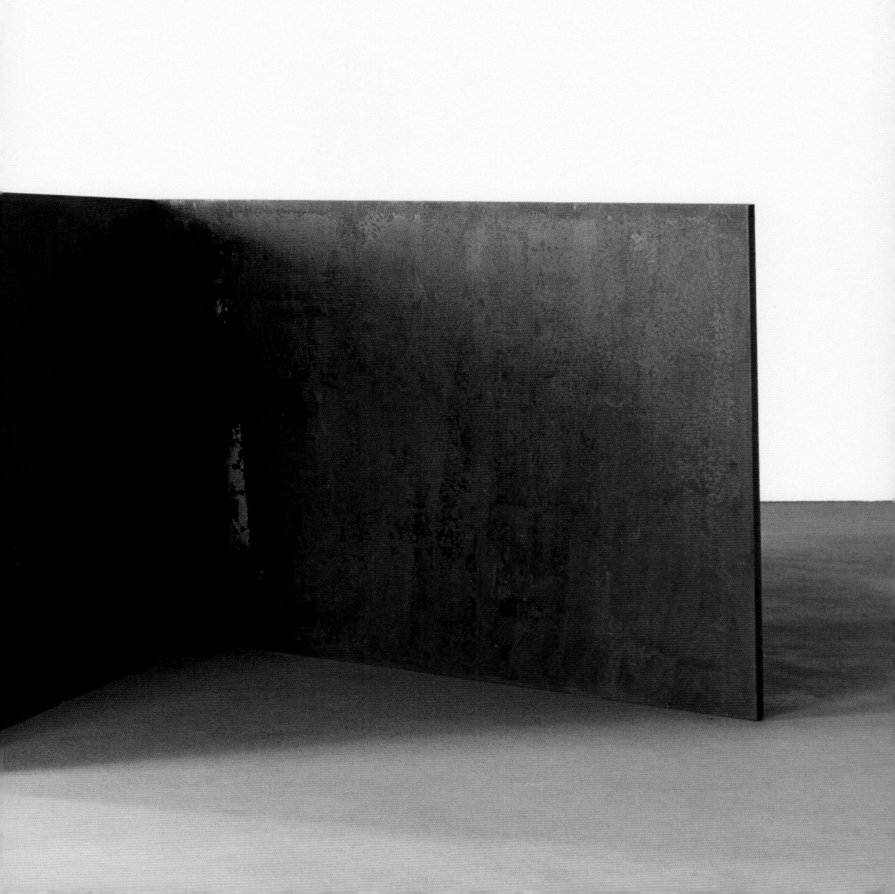

Robert Smithson

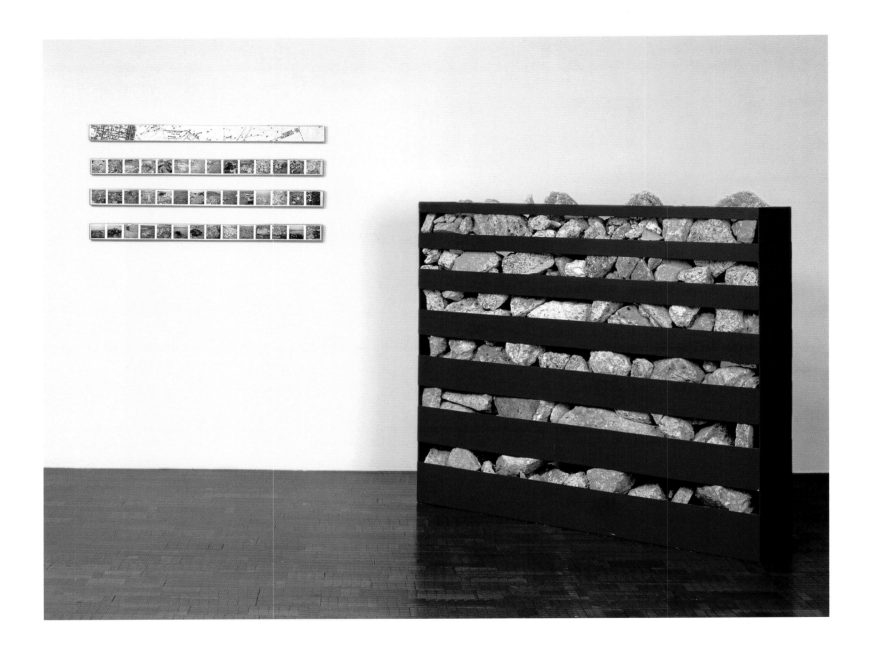

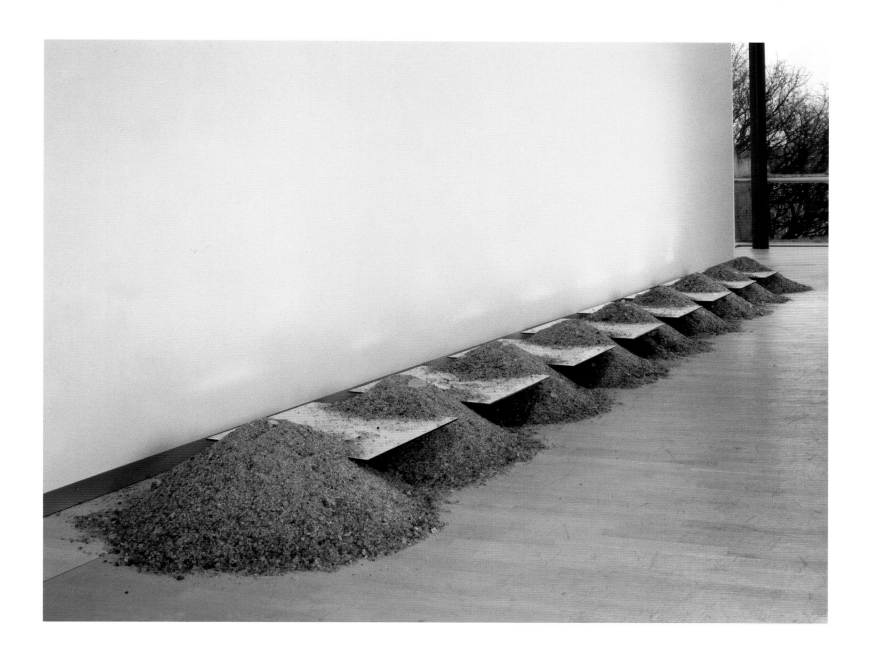

Richard Tuttle

378. *Genitron*, 1967

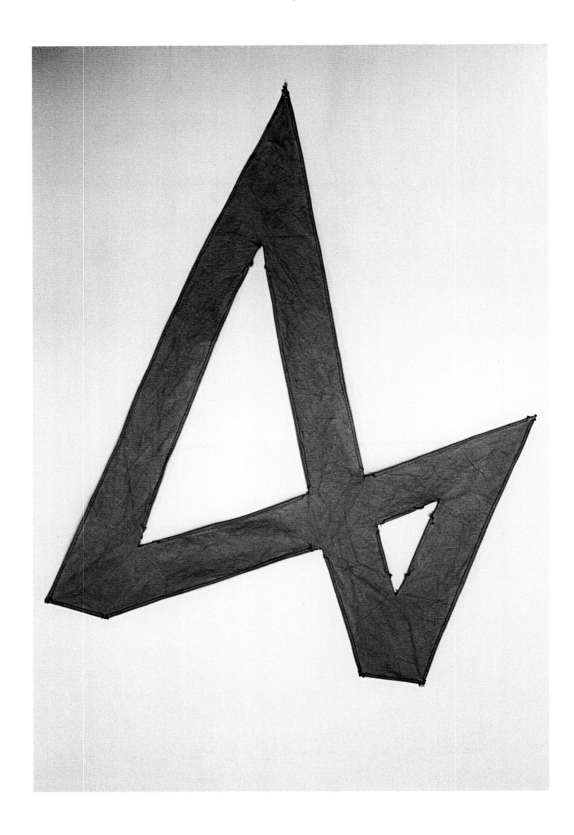

379. *Untitled (Wood Slat piece at Galleria Toselli)*, 1974

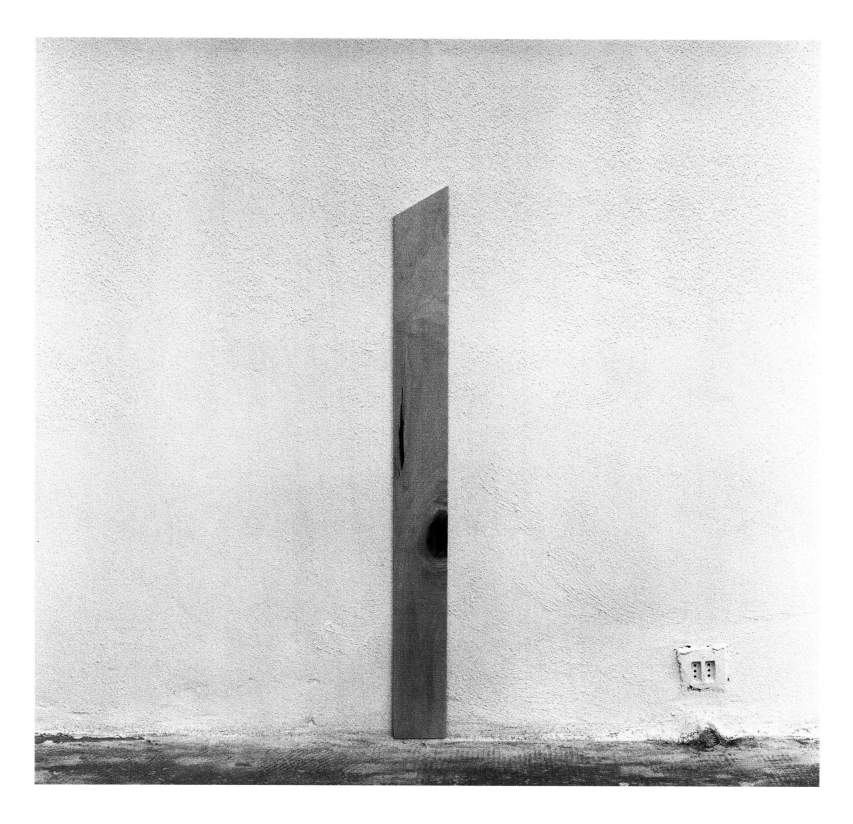

Richard Tuttle

397

Richard Tuttle

a rubber ball thrown on the sea

A STONE LEFT UNTURNED

Chuck Close

384. *Self Portrait*, 1977

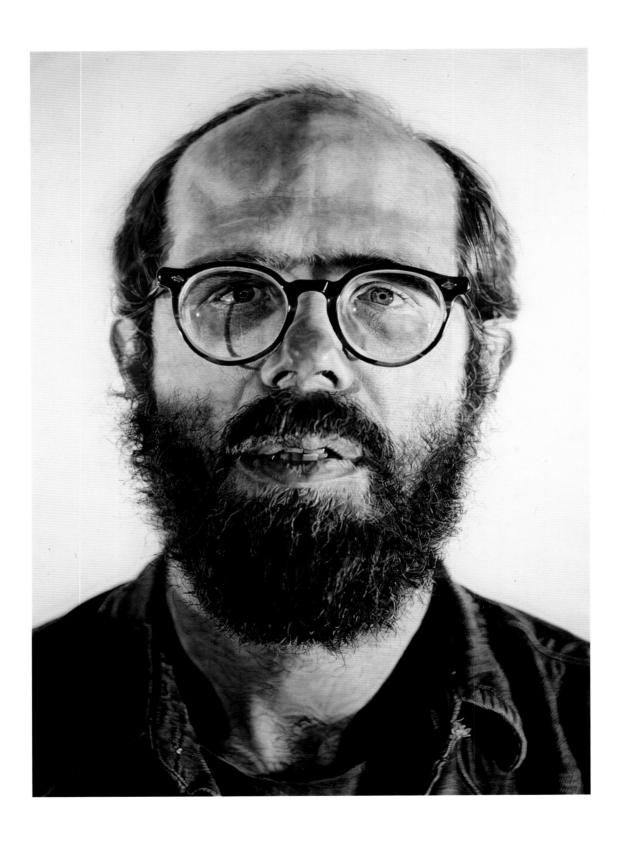

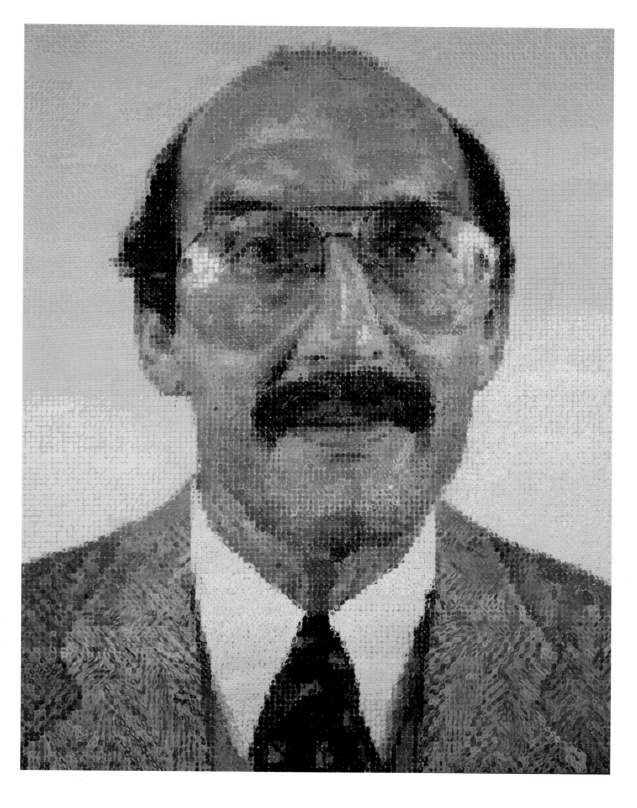

Chuck Close

Richard Estes

*386. *On the Staten Island Ferry
Looking Toward Manhattan,* 1989

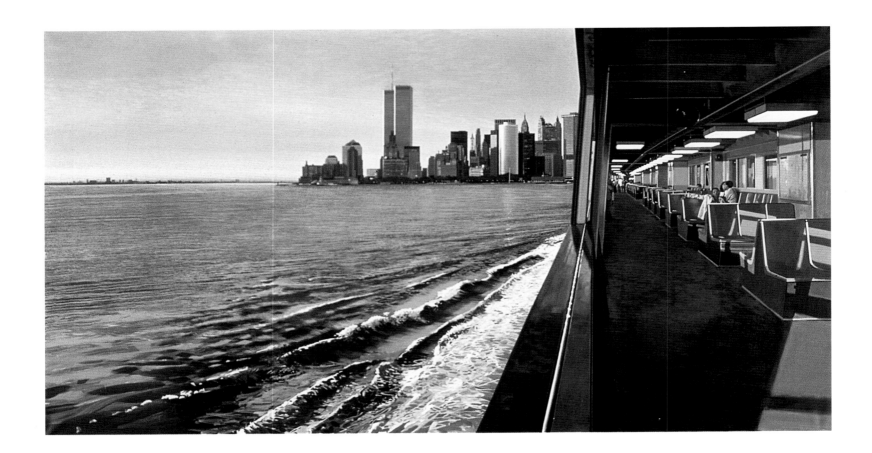

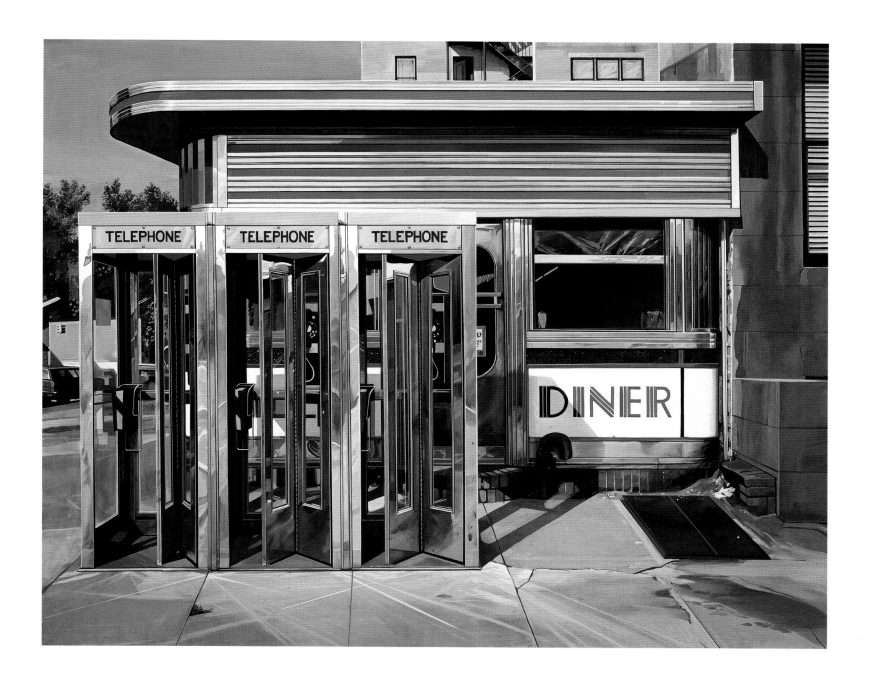

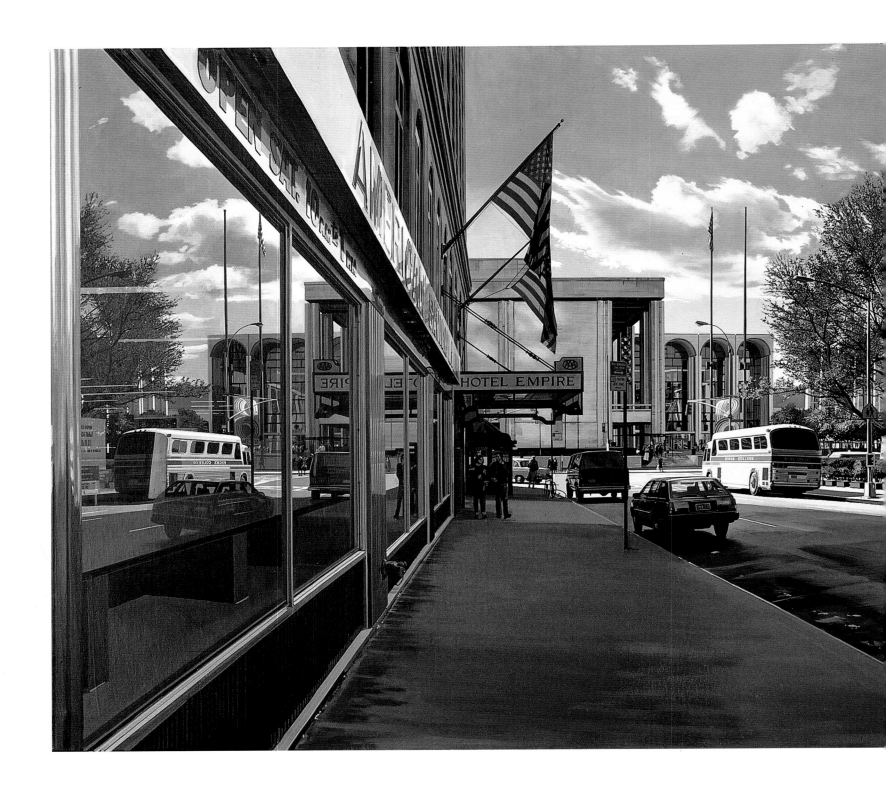

Richard Estes

Duane Hanson

*389. *Housewife*, 1969-1970

390. *Homeless*, 1991

Duane Hanson

391. *Paul Taylor*, 1959

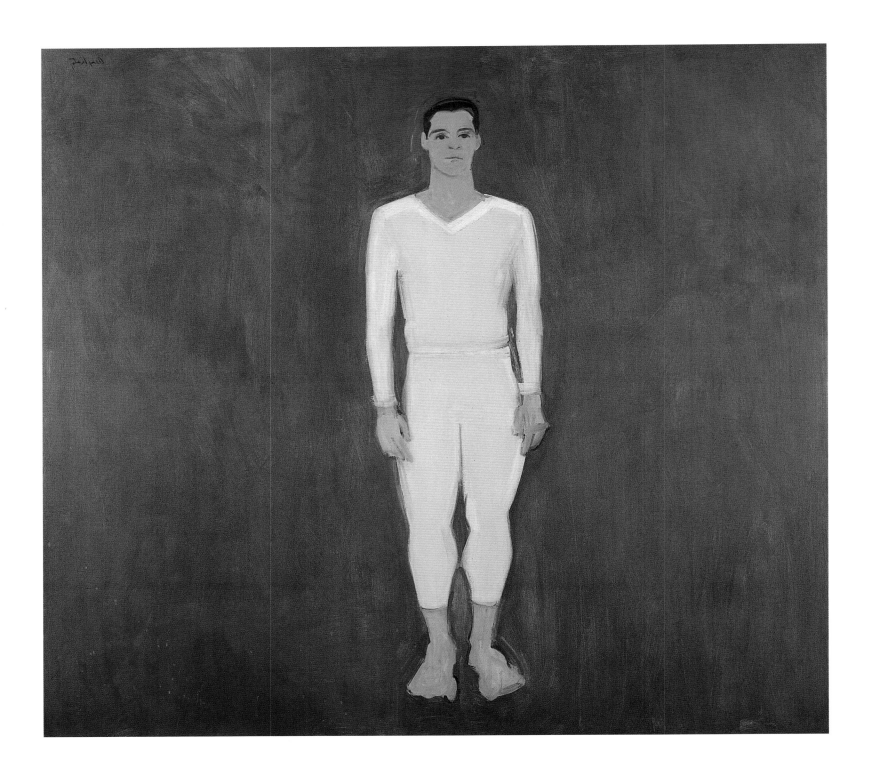

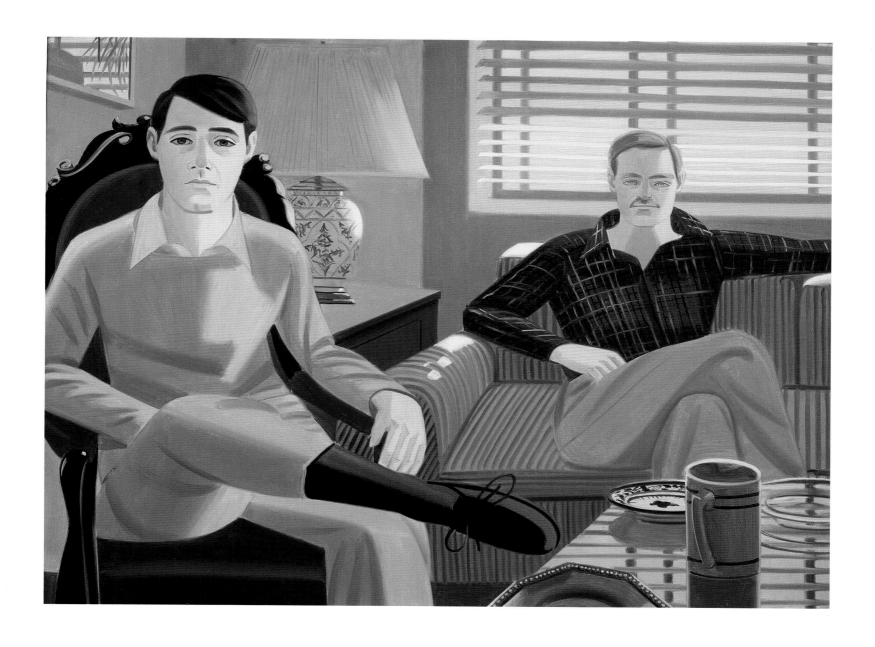

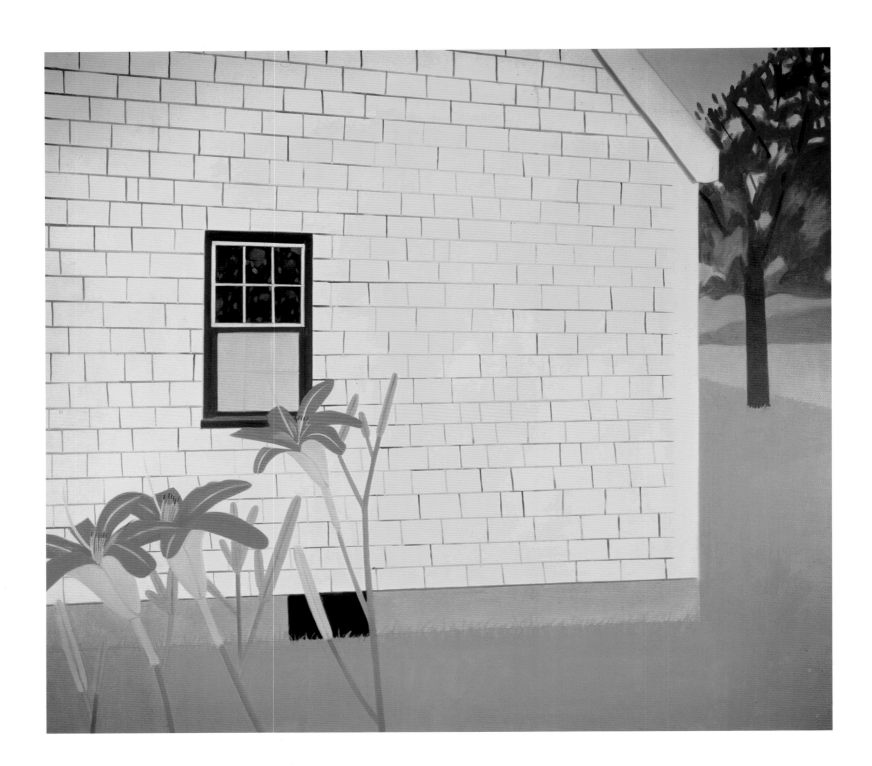

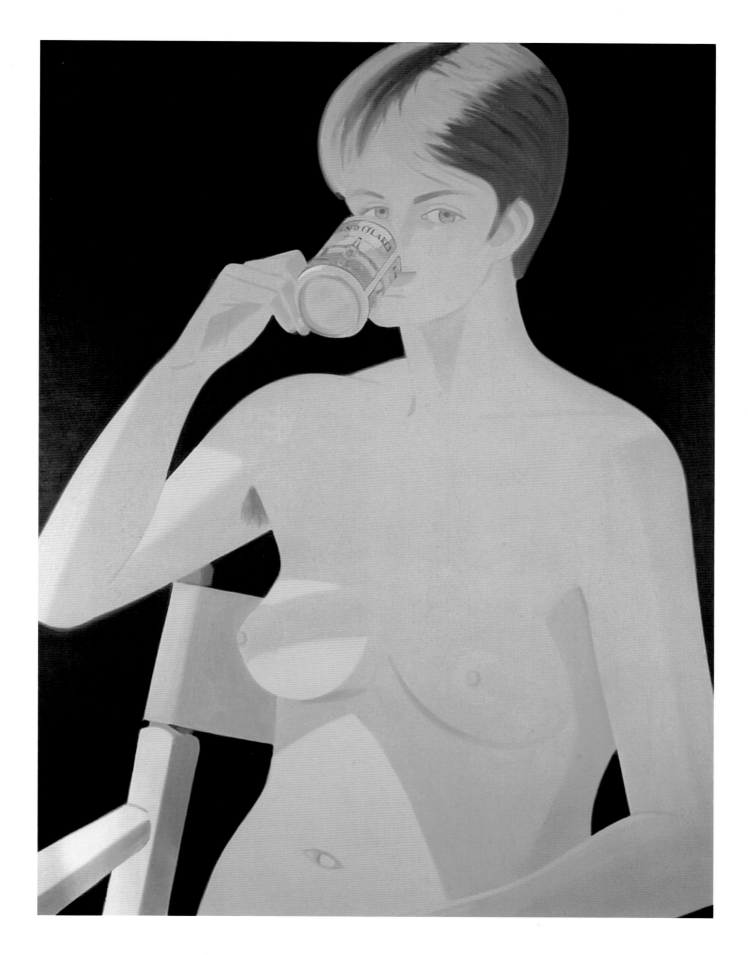

Alex Katz

James Casebere

Lois Conner

Gregory Crewdson

Photography

Philip Lorca diCorcia

*404. *Head #01* , 2001

*405. *Head #19*, 2000

*406. *Head #24*, 2000

*407. *Head #09*, 2000

Mitch Epstein

*408. *Untitled, New York
(from "The City")*, 1995

*409. *Vietnam Veteran's Parade,
New York City*, 1973 (2005)

Photography

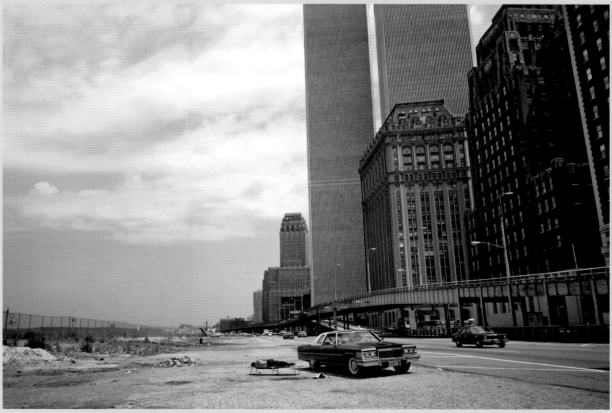

Donna Ferrato

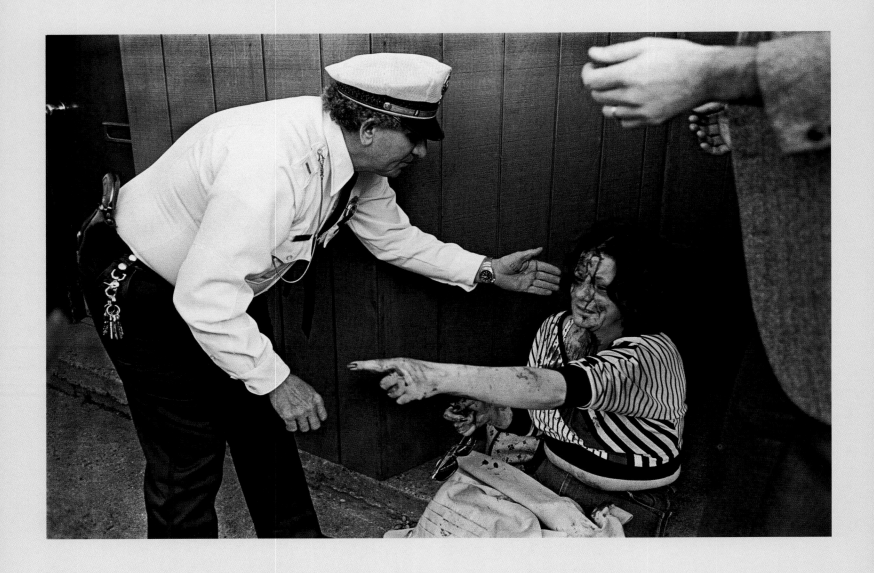

*412. A Pennsylvania policeman tried to console a woman who had been kicked in the head, 1983

*413. Early in the day, Garth tried to drag Lisa into the house because he couldn't find his cocaine pipe. Their three-year-old son cried so hysterically, that Garth let go of Lisa. He returned to the bedroom and stayed there brooding for the rest of the day…, 1982

*414. During the middle of the night, Garth cornered Lisa in their bathroom, still hunting for his cocaine pipe. Suddenly, enraged, he hit Lisa, 1982

Photography

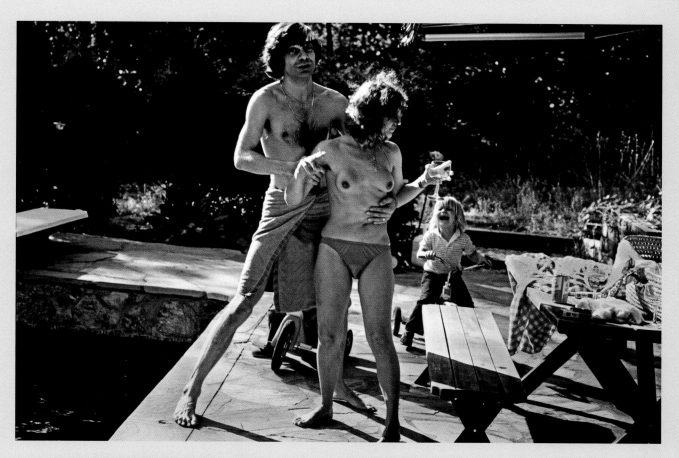

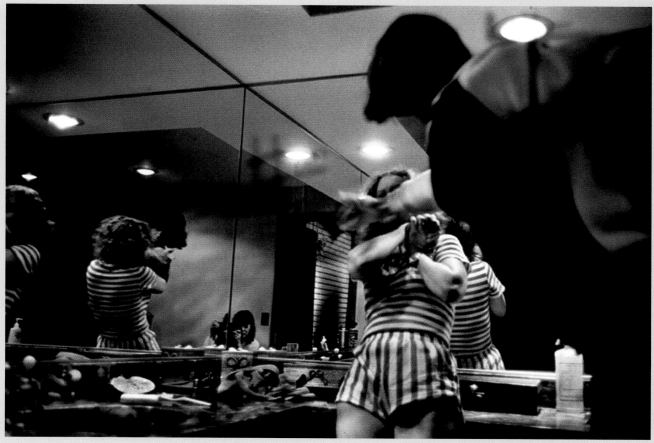

Andres Serrano

Laurie Simmons

Photography

*425. Tim Burton
Batman, 1989

*426. Spike Lee
Do the Right Thing, 1989

427. Woody Allen
Manhattan Murder Mistery, 1993

*428. Abel Ferrara
The Bad Lieutenant, 1993

429. Abel Ferrara
The Funeral, 1996

*430. Edo Bertoglio
Downtown 81, 1998

431. Spike Lee
Summer of Sam, 1999

Cinema

432. Amos Kollek
Fast Food Fast Women, 2000

433. Sam Raimi
Spider Man, 2002

434. Reza Abdoh
Law of Remains, 1992

435-436. Reza Abdoh
Quotations from a Ruined City,
1994

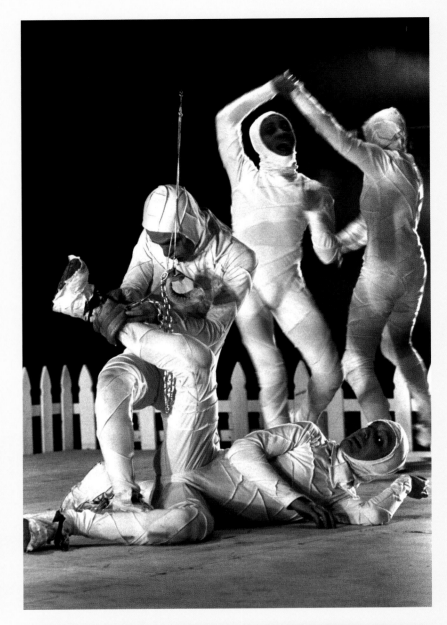

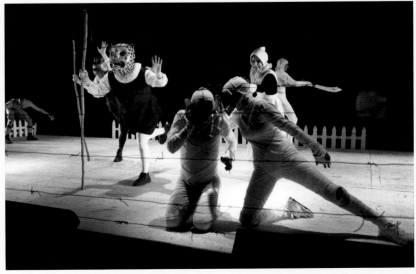

Performance and Video

437. DJ Spooky
Rebirth of a Nation, 2004

438. Gogol Bordello at the 2002
Whitney Biennal

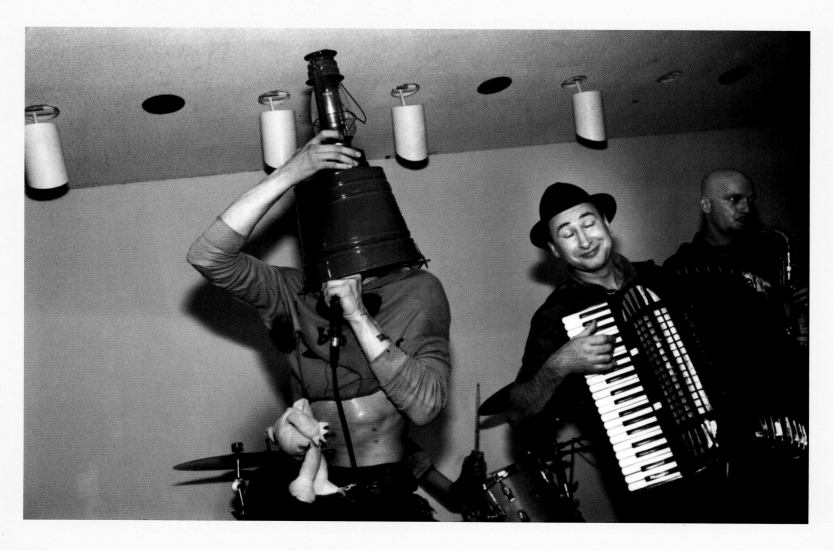

439. Karen Finley
Theory of Total Blame, 1988

440. Molissa Fenley
State of Darkness, performed
at the Joyce Theater, 1990. First
performed as a commission by the
American Dance Festival, 1988

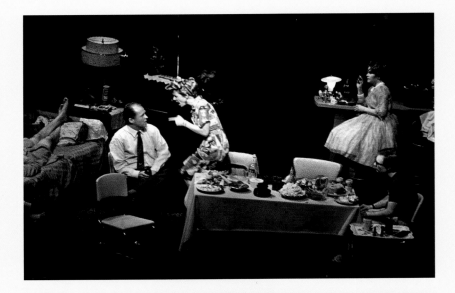

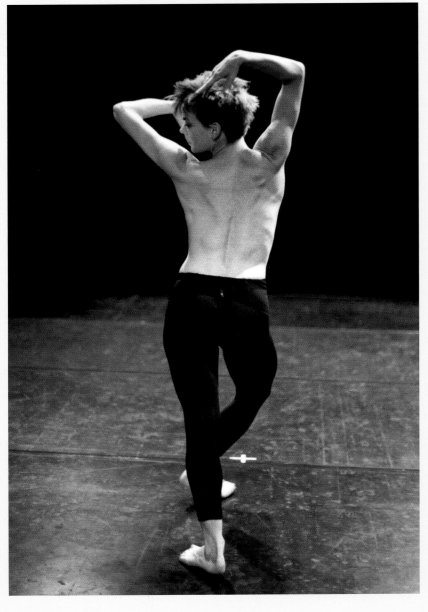

Performance and Video

441. John Kelly
Mona Lisa, 1986

442. John Jesurun
Shatterhand Massacre, 1987

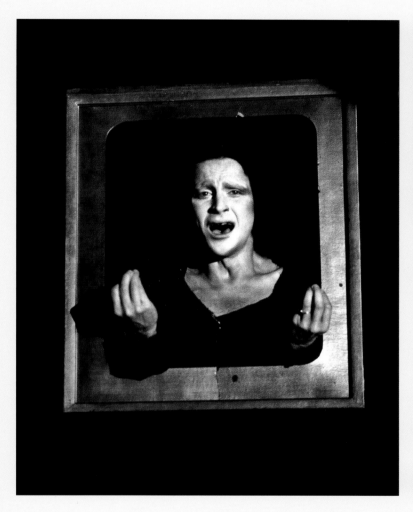

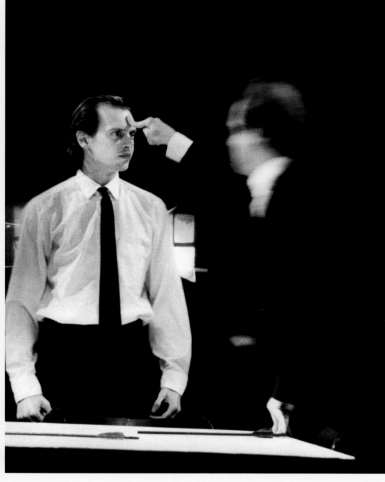

443-449. Lebbeus Woods, Michael
Sorkin, John Young
Time Square, New York, 1989

450. Renzo Piano
Morgan Library, New York, 2006

451. Raimund Abraham
Austrian Culture Forum,
New York, 1998-2001

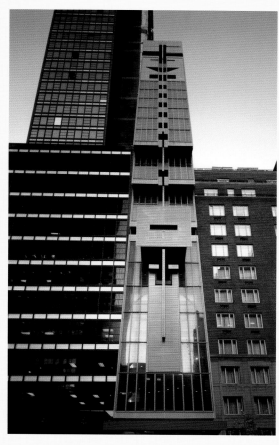

452. IM Pei & Frank Williams
Four Seasons Apartment House,
New York, 1993

453. Skidmore, Owings & Merrill
AOL Time Warner
Building/Colombus
Circle, New York, 1993

454. Pei Cobb Freed & Partners,
Henry N. Cobb
Guy Nordenson & Associates
The Seven Stems Broadcast Tower,
New York

455. Costas Kondylis & Partners
Trump World Tower at United
Nations Plaza, New York, 1997

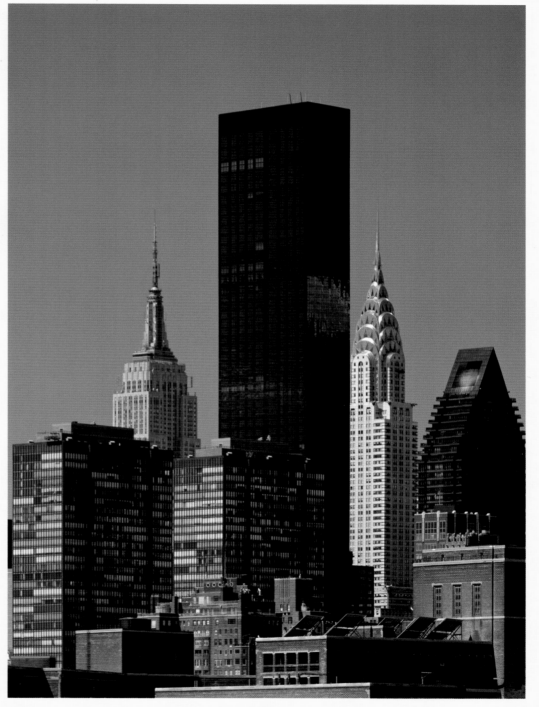

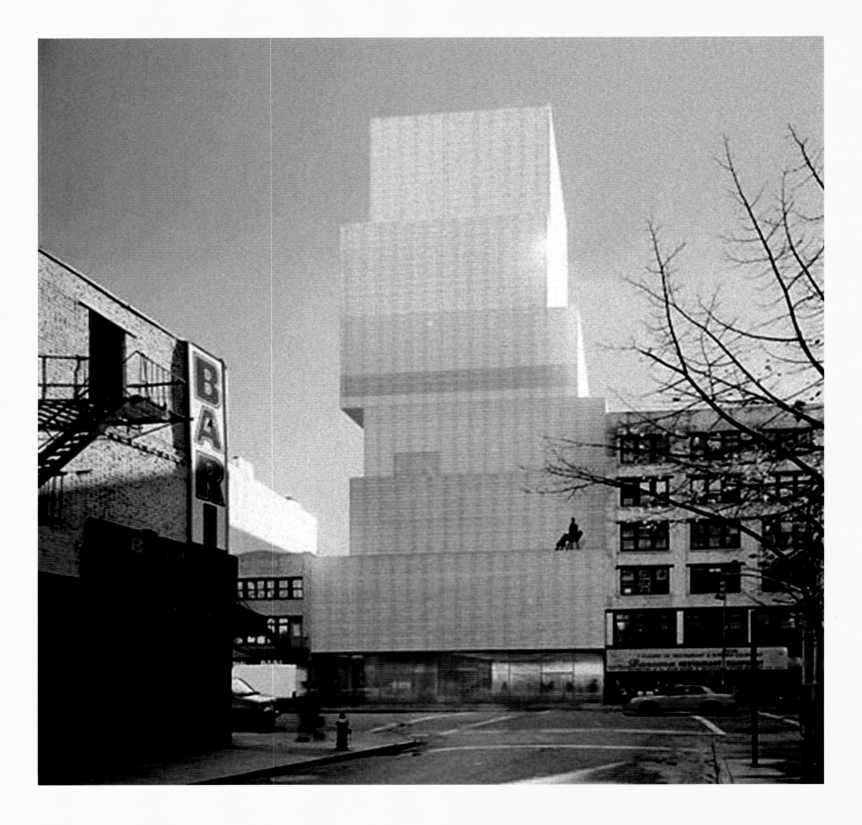

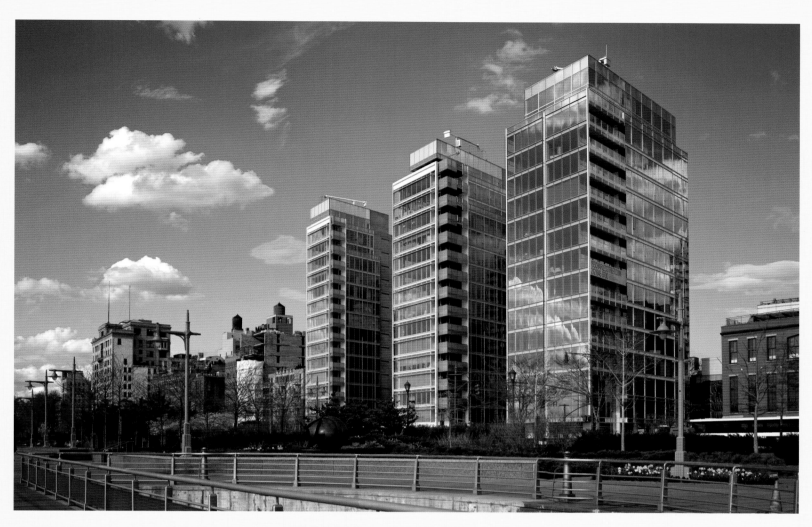

457. Richard Meier
Charles Street Apartments,
New York

458. Zaha Hadid
Installation view of "Zaha Hadid",
Solomon R. Guggenheim Museum,
New York, 2006

Laurie Anderson

460. *Still from video performance used for record cover "Bright Red",* 1994

Matthew Barney

461-464. *ENVELOPA: Drawing Restraint 7 (manual)*, 1993

*465. *The Cabinet of Harry Houdini*, 1999

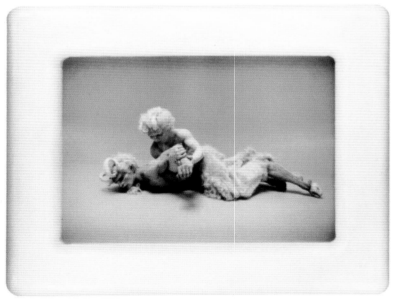

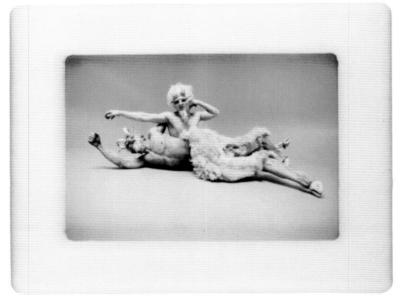

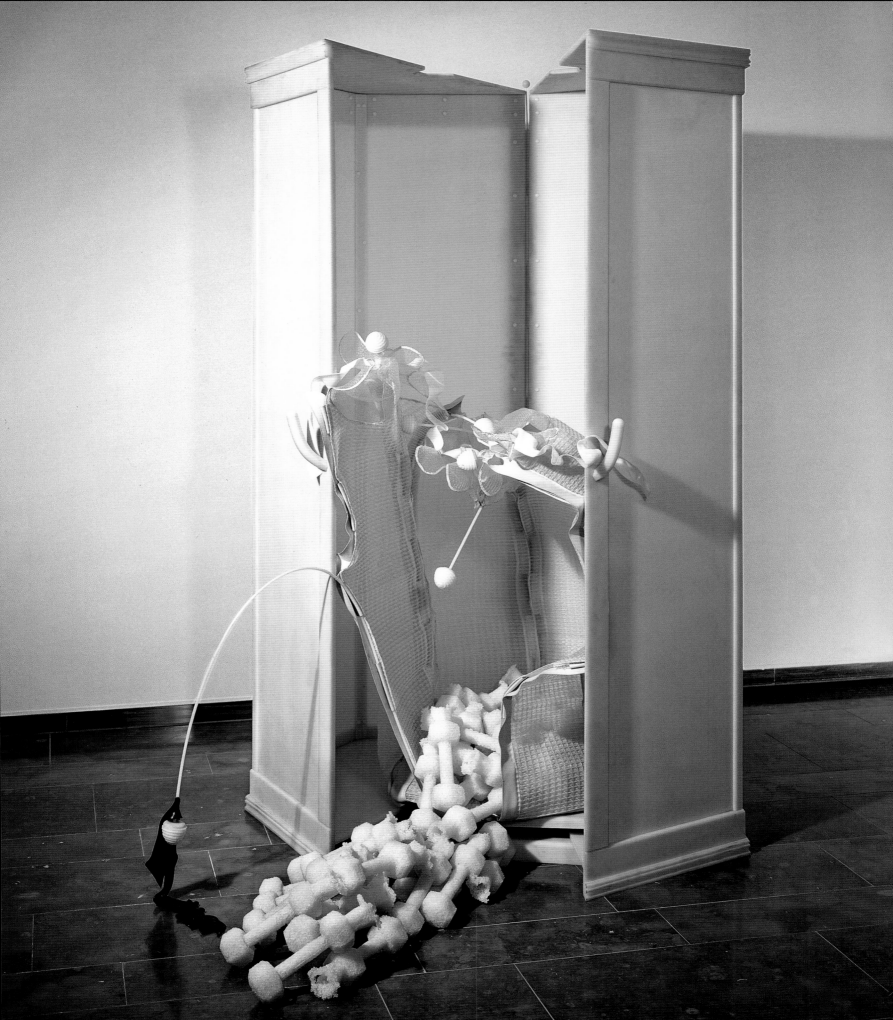

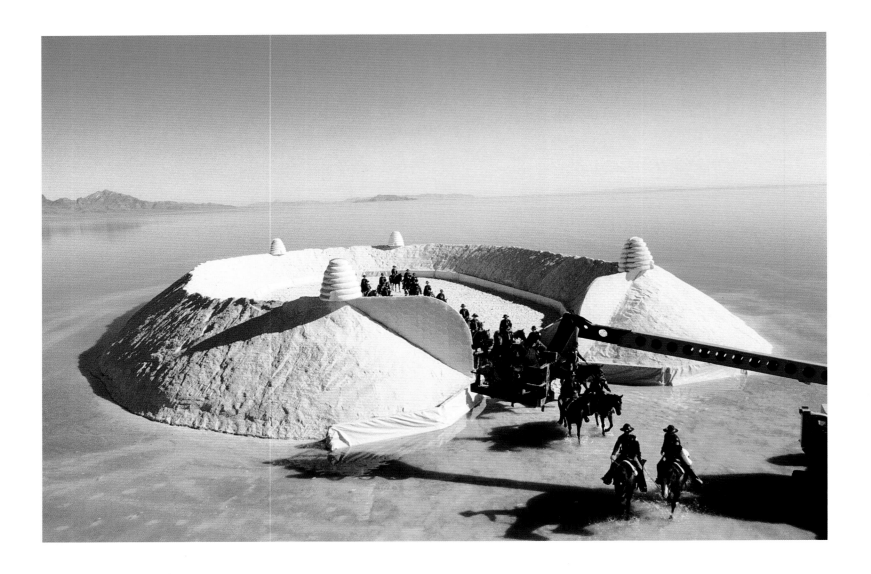

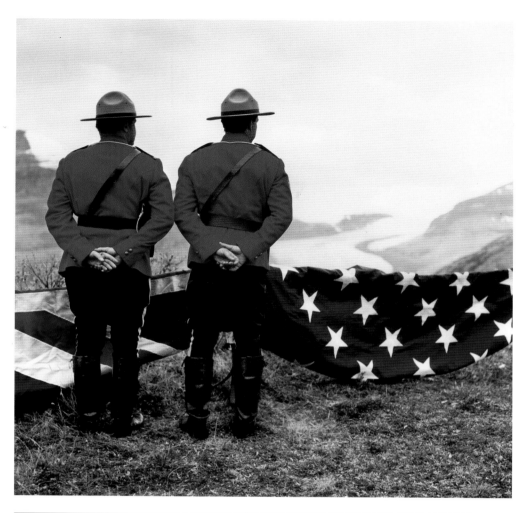

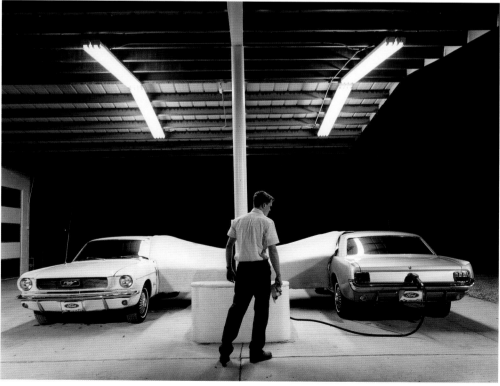

Matthew Barney

Jean-Michel Basquiat

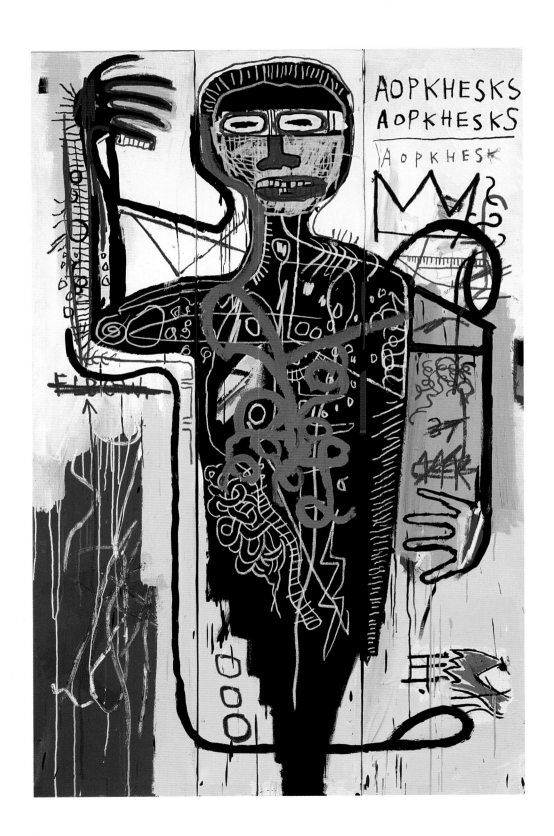

469. *Versus Medici*, 1982

470. *King of the Zulus*, 1984-1985

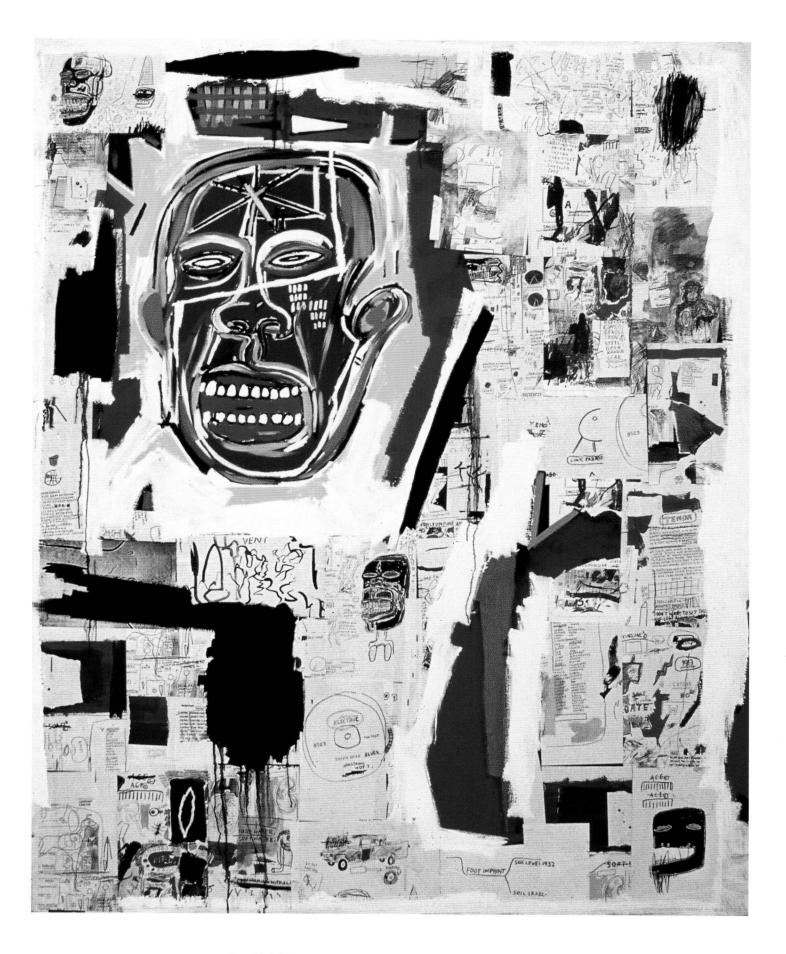

Jean-Michel Basquiat

*471. *Touissant l'Overture versus
Savonarola*, 1983

*472. *Zydeco*, 1984

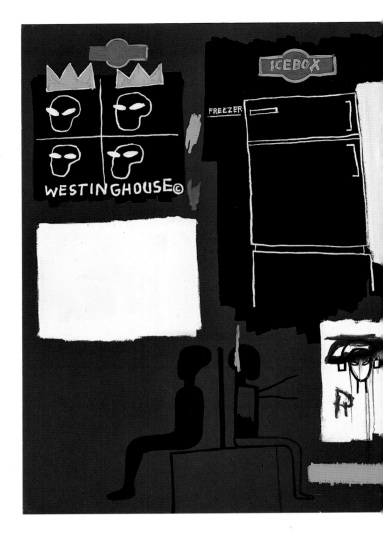

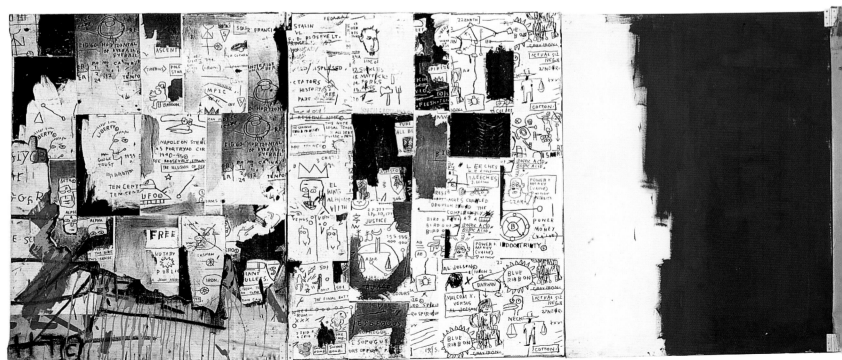

Jean-Michel Basquiat

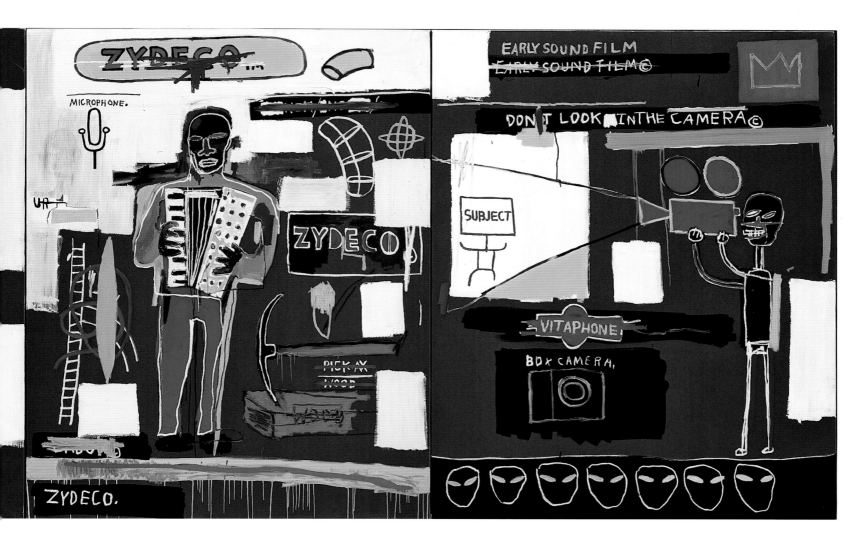

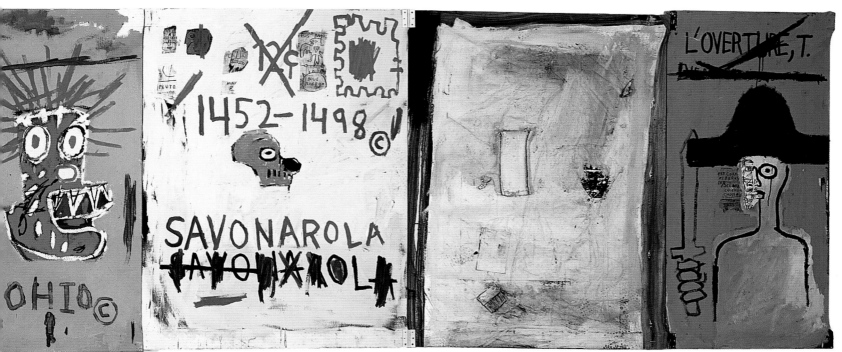

John Currin

John Currin

John Currin

477. *Sleepwalker*, 1979

Eric Fischl

Tom Friedman

*481. *White Cloud*, 1989

*482. *Inside-Out*, 1991-2006

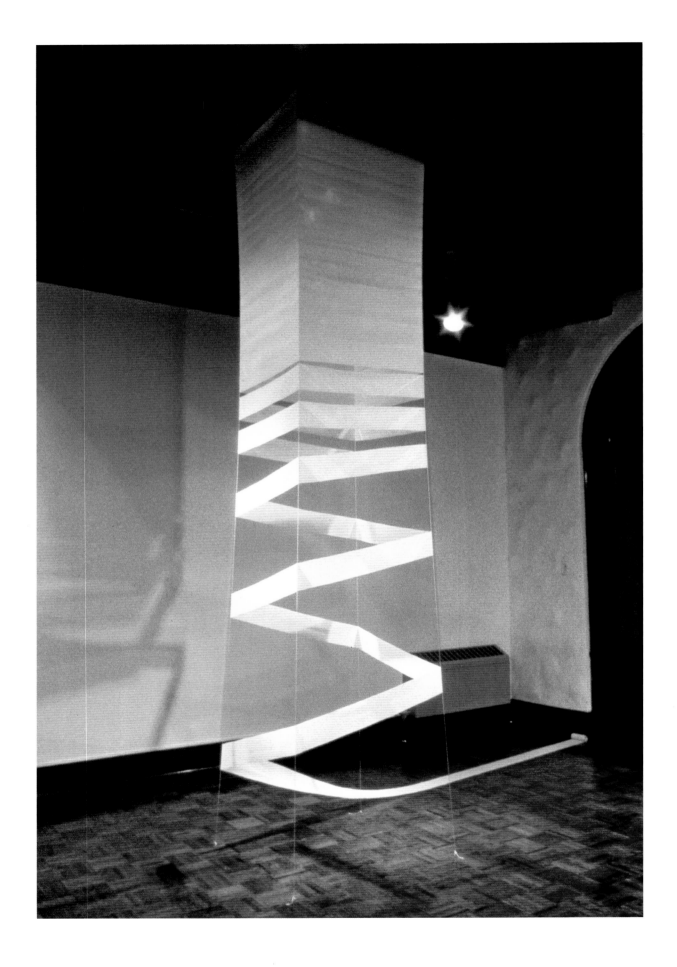

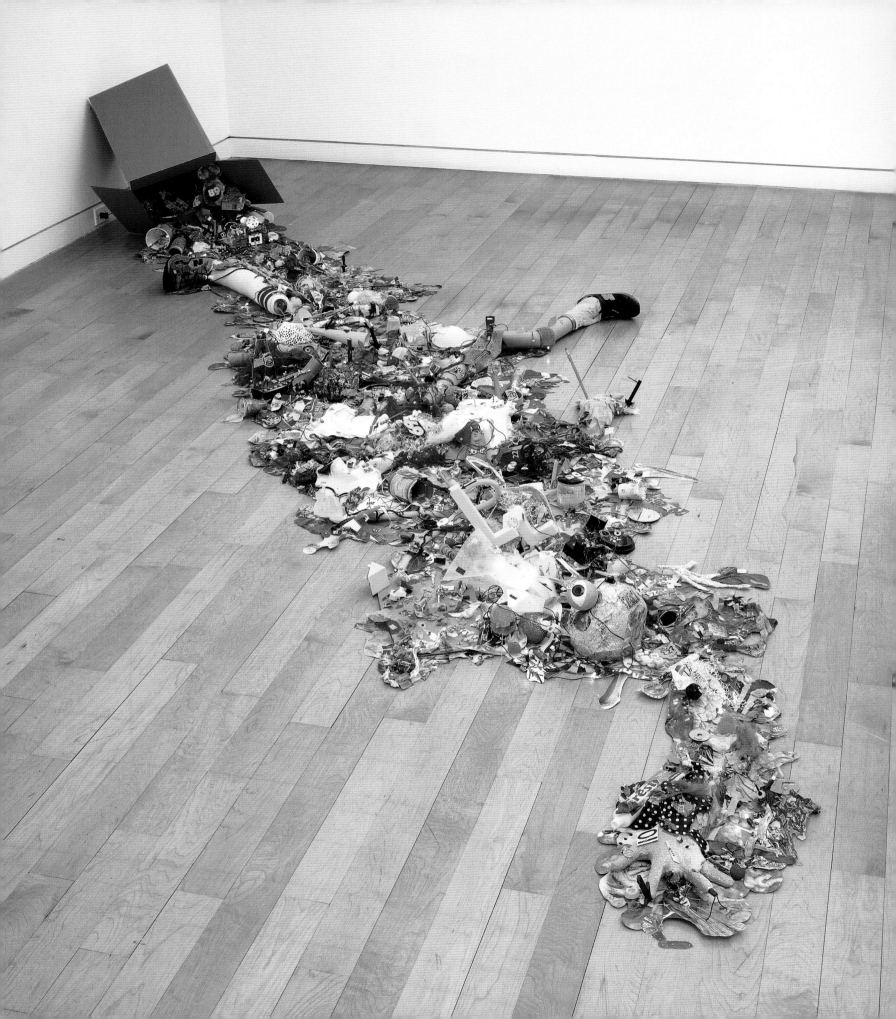

Robert Gober

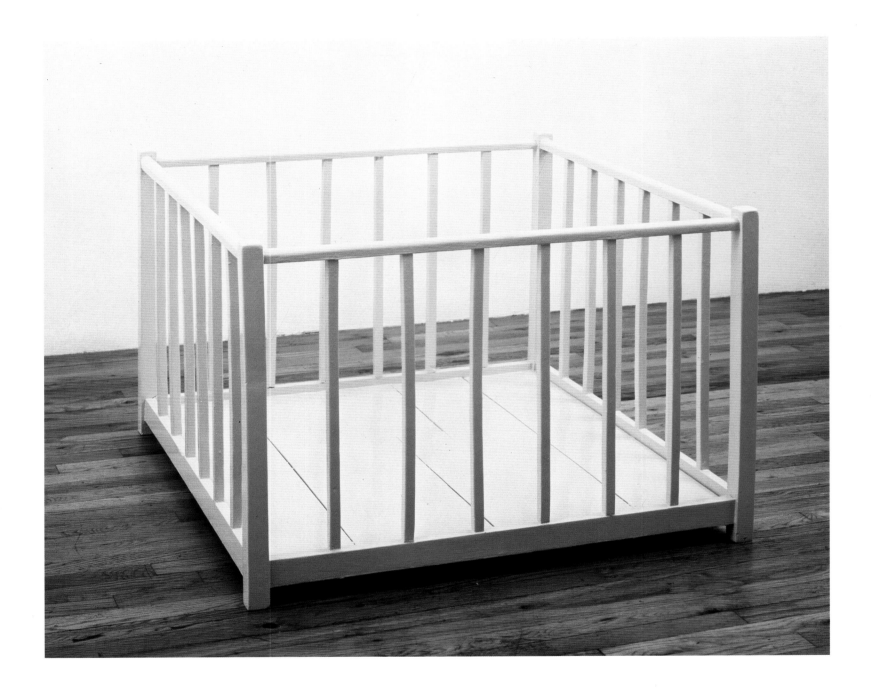

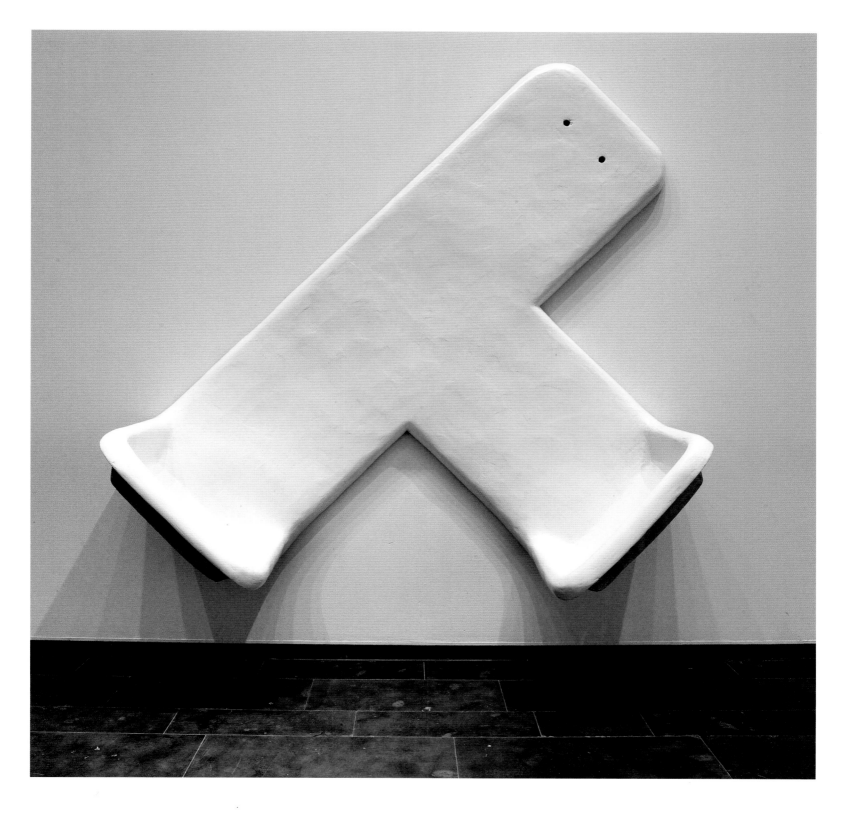

Felix Gonzalez-Torres

485. *"Untitled" (A Love Meal)*, 1992

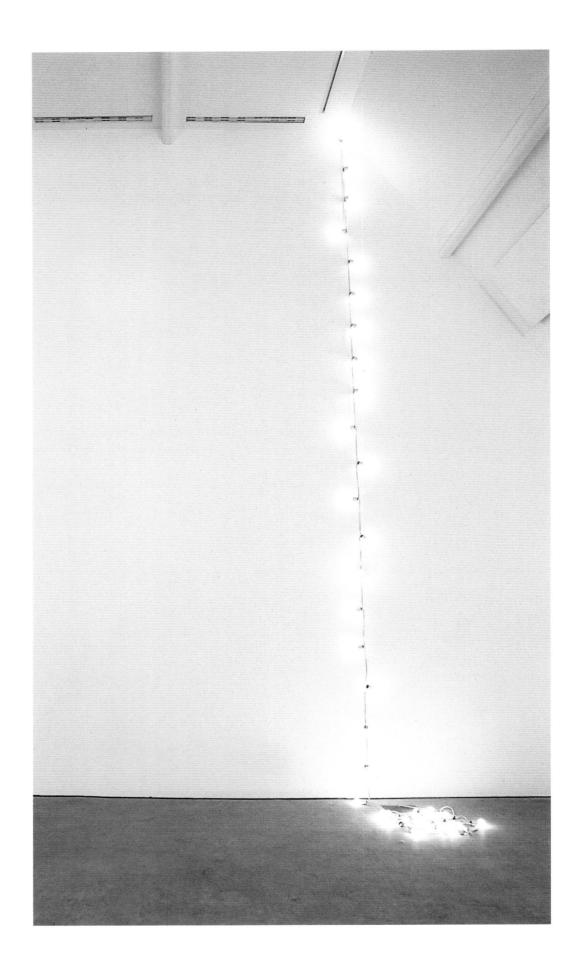

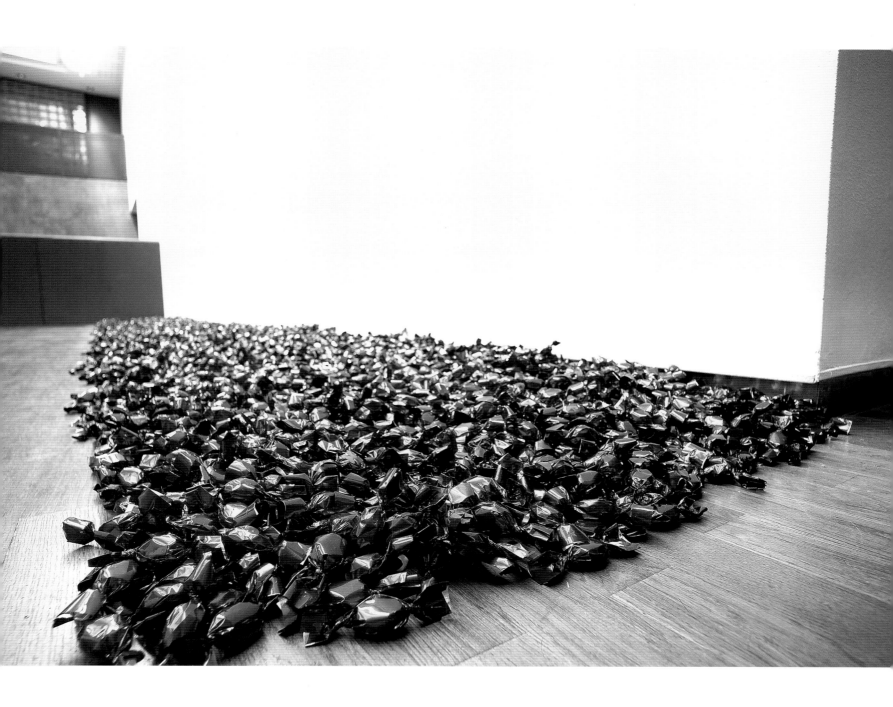

Keith Haring

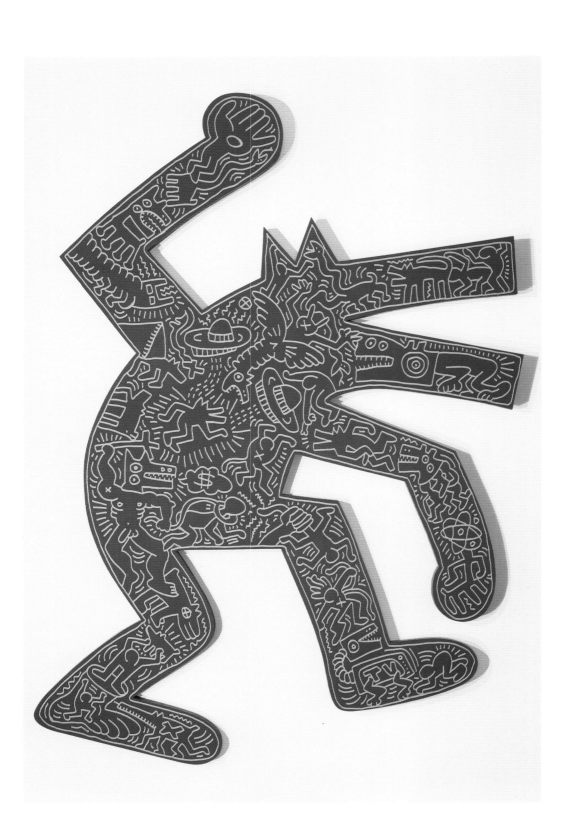

*488. *Untitled (June 5)*, 1984

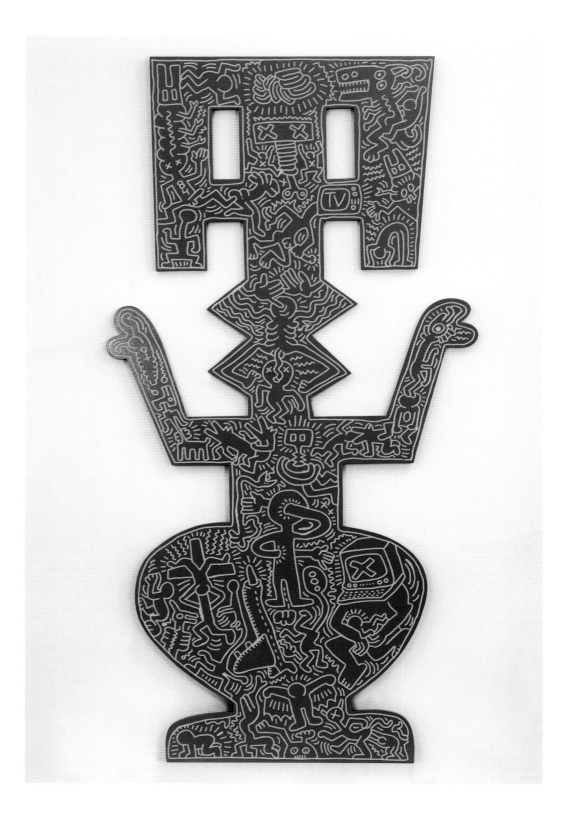

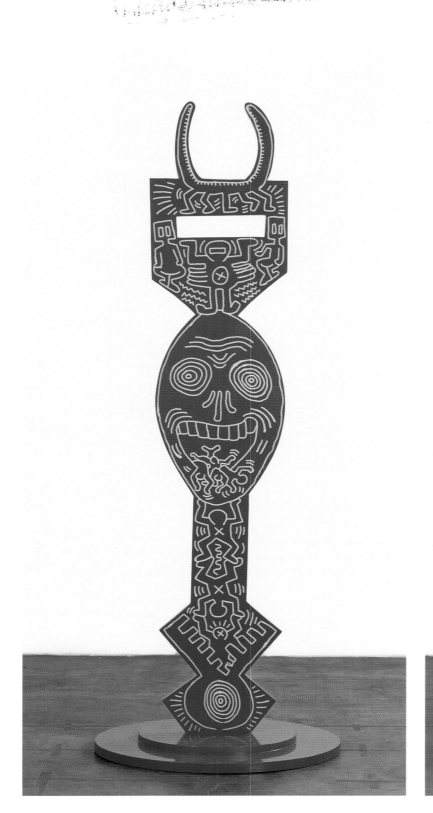

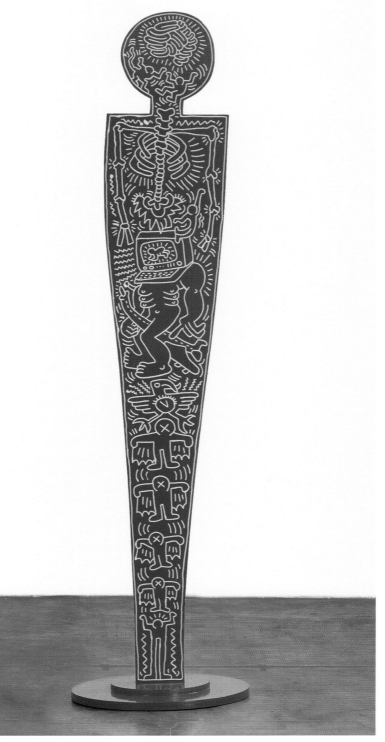

*491. *Untitled (June 5)*, 1984 *492. *Untitled (June 5)*, 1984

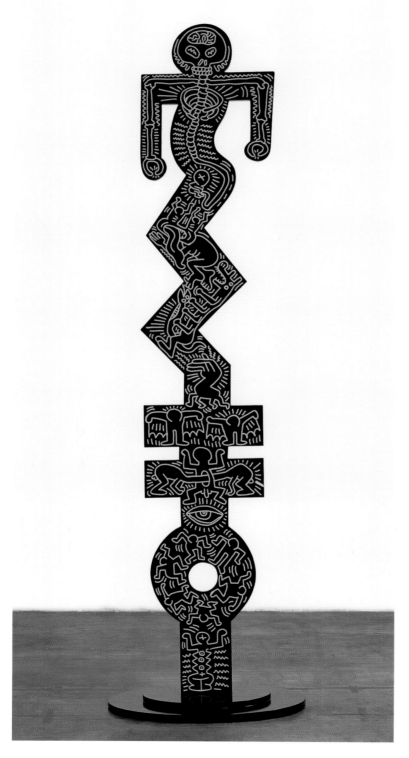
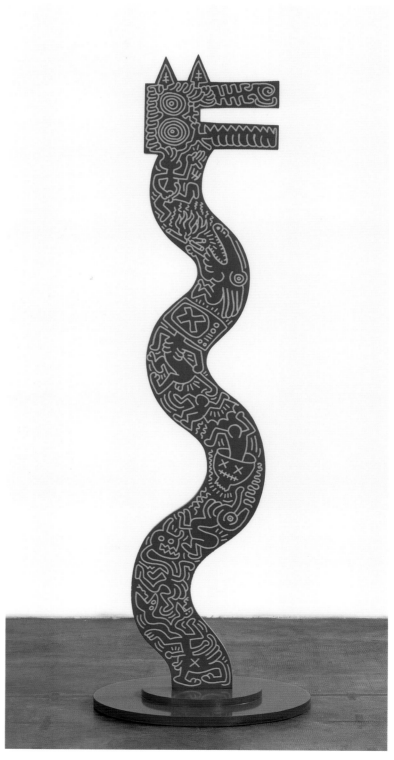

Keith Haring

473

Jenny Holzer

493. From *Truism*, 1996

*494. *Red and Yellow Looming*, 2004

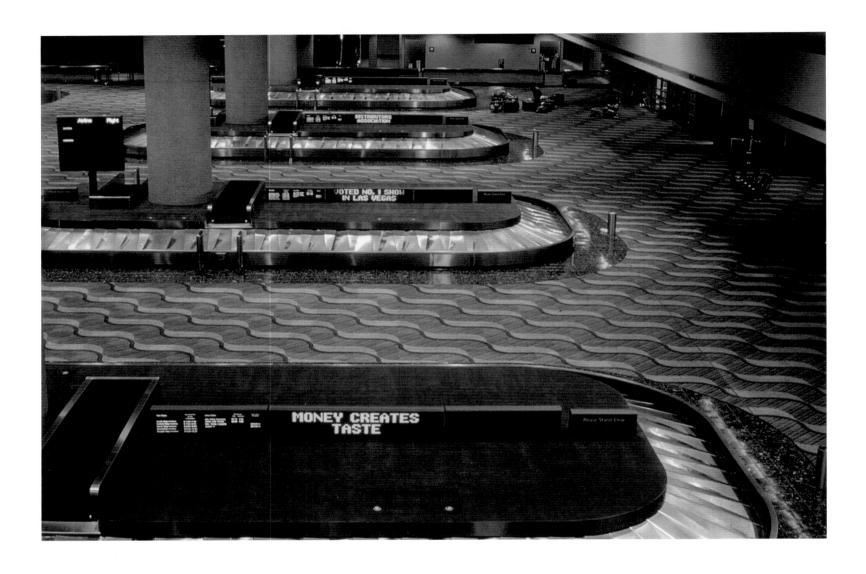

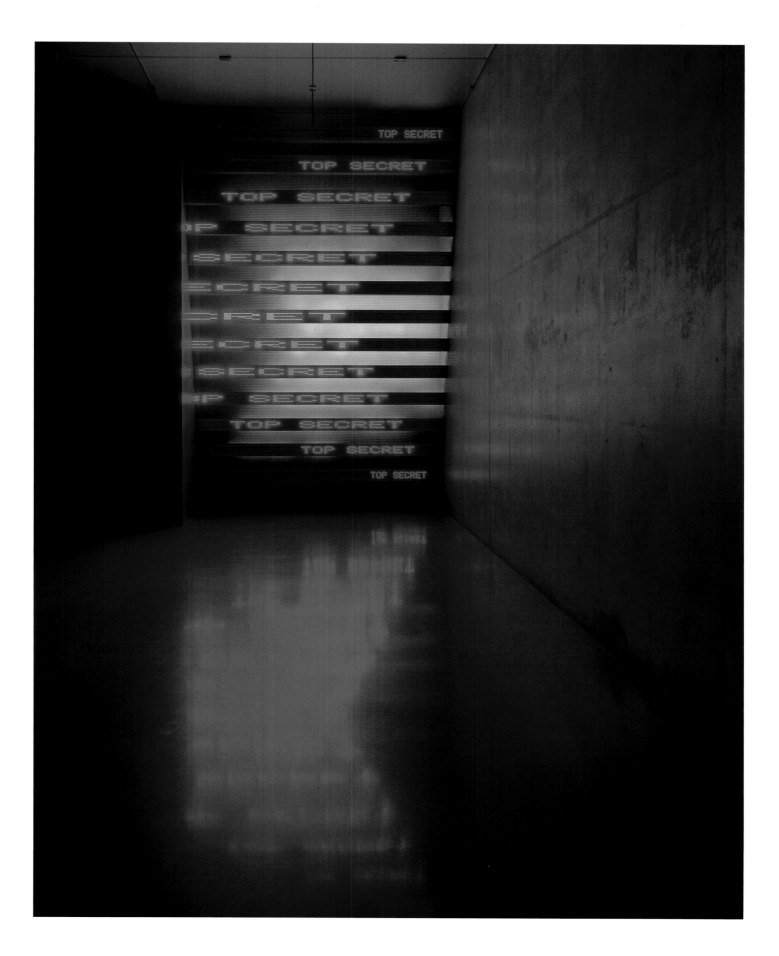

Jenny Holzer

Jeff Koons

*495. *Fisherman Golfer*, 1986

*496. *Mermaid Troll*, 1986

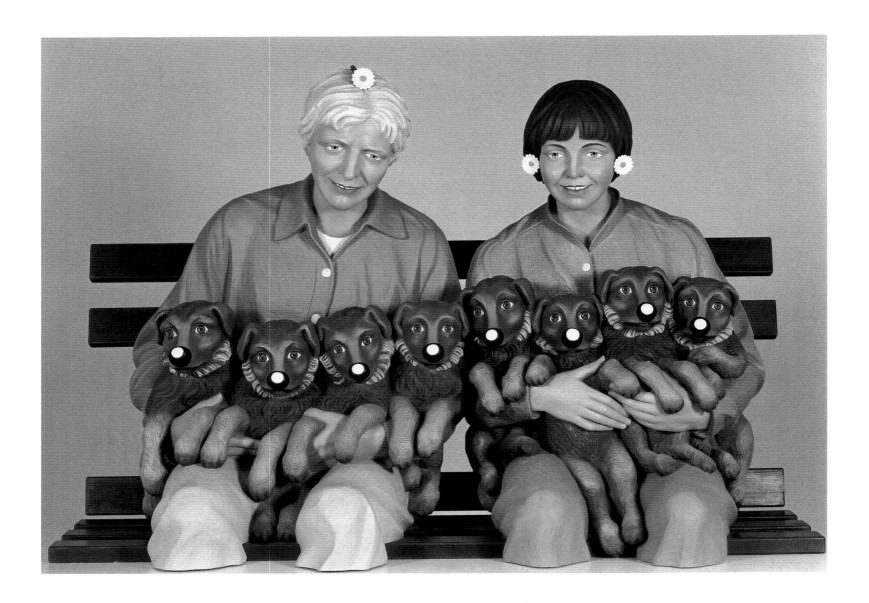

Jeff Koons

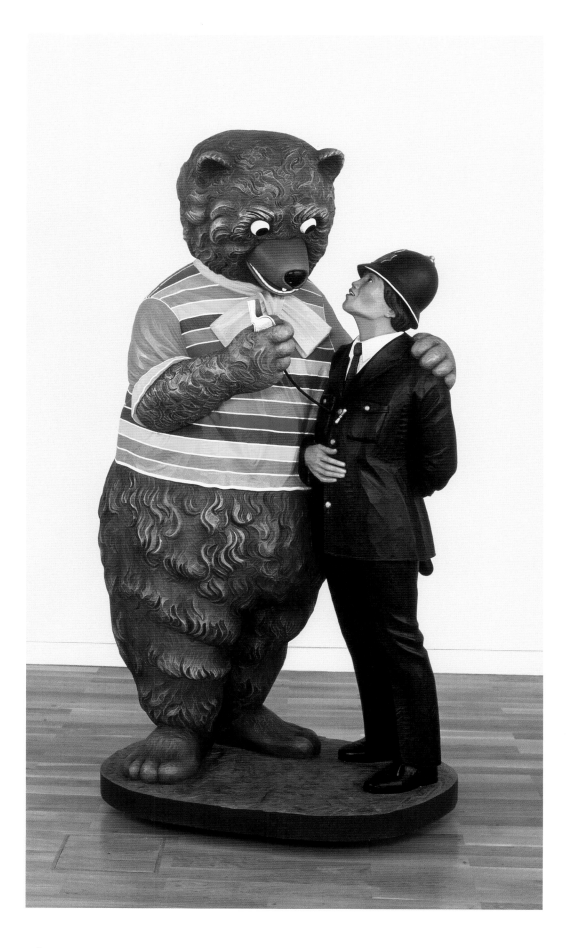

Robert Longo

*499-501. *Untitled (Men in the cities - 3 Erics)*, 1980-2000

Pages 482-483

502. *Pressure*, 1982-1983

*503. *Jerk Face*, 1985

Robert Longo

Robert Longo

Robert Longo

Tony Oursler

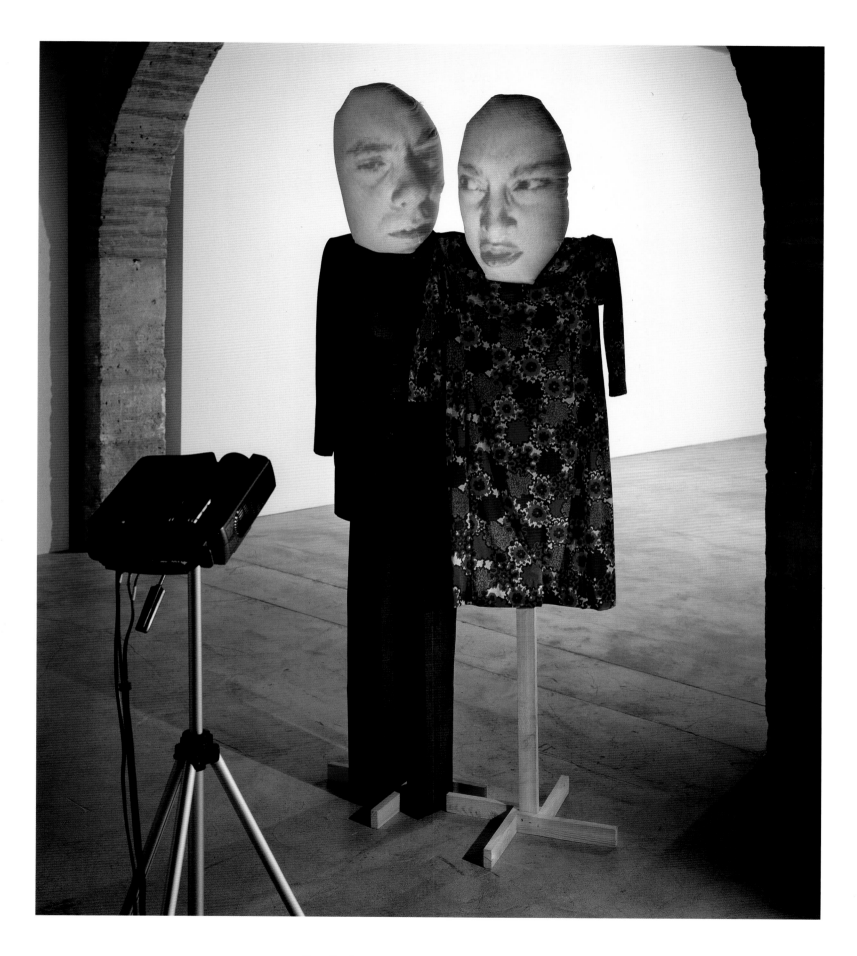

Tony Oursler

Richard Prince

*506. *Untitled (Cowboy)*, 1998

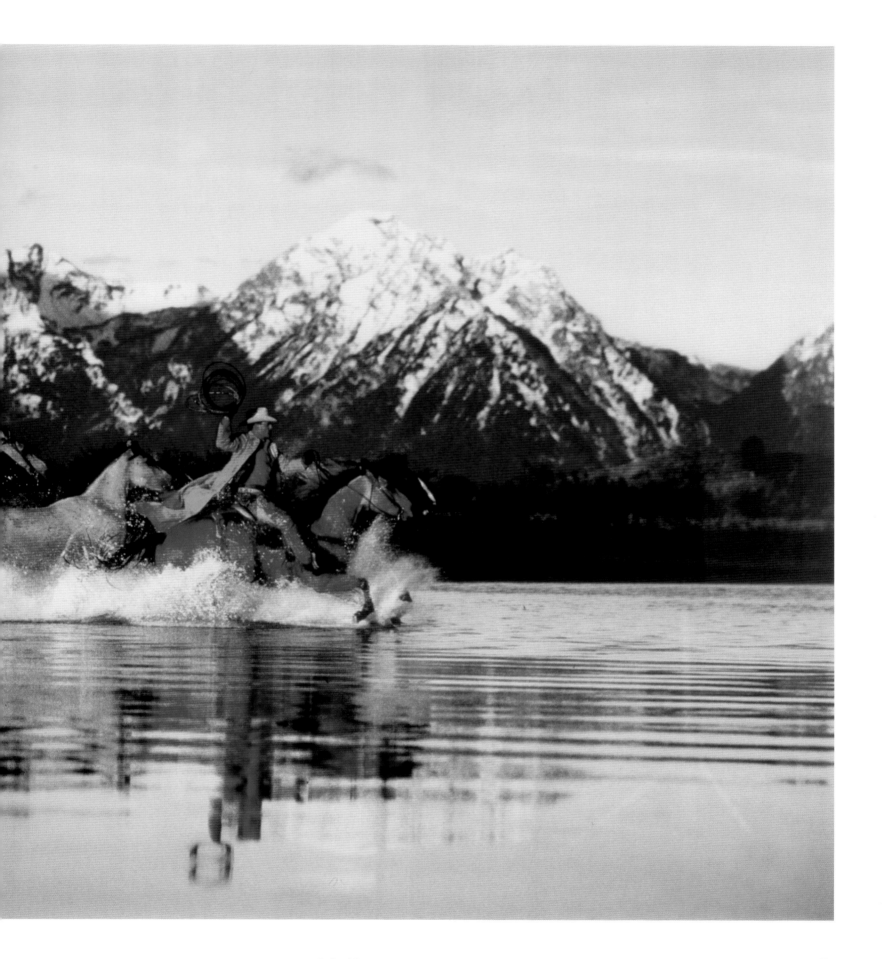

Richard Prince

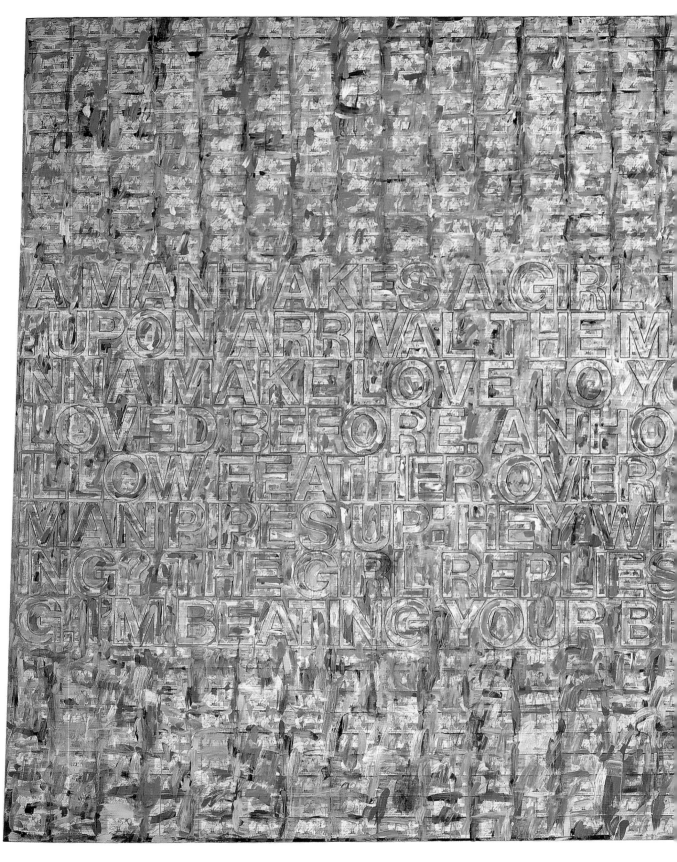

Richard Prince

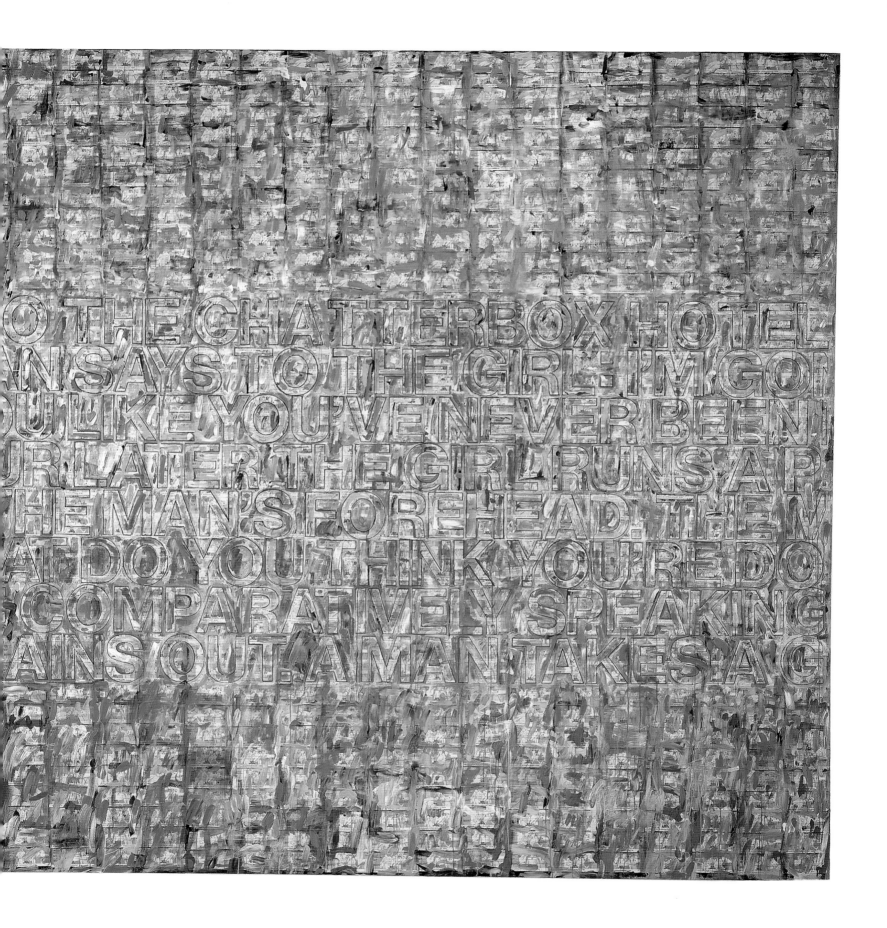

Richard Prince

Susan Rothenberg

Tom Sachs

*510-511. *Nutsy's 1/1 McDonald's v. 2*, 2003

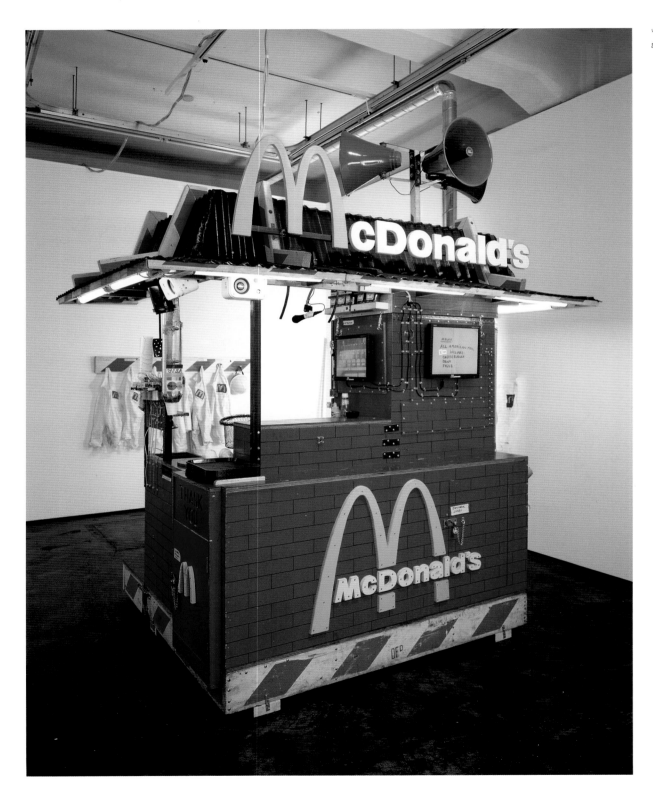

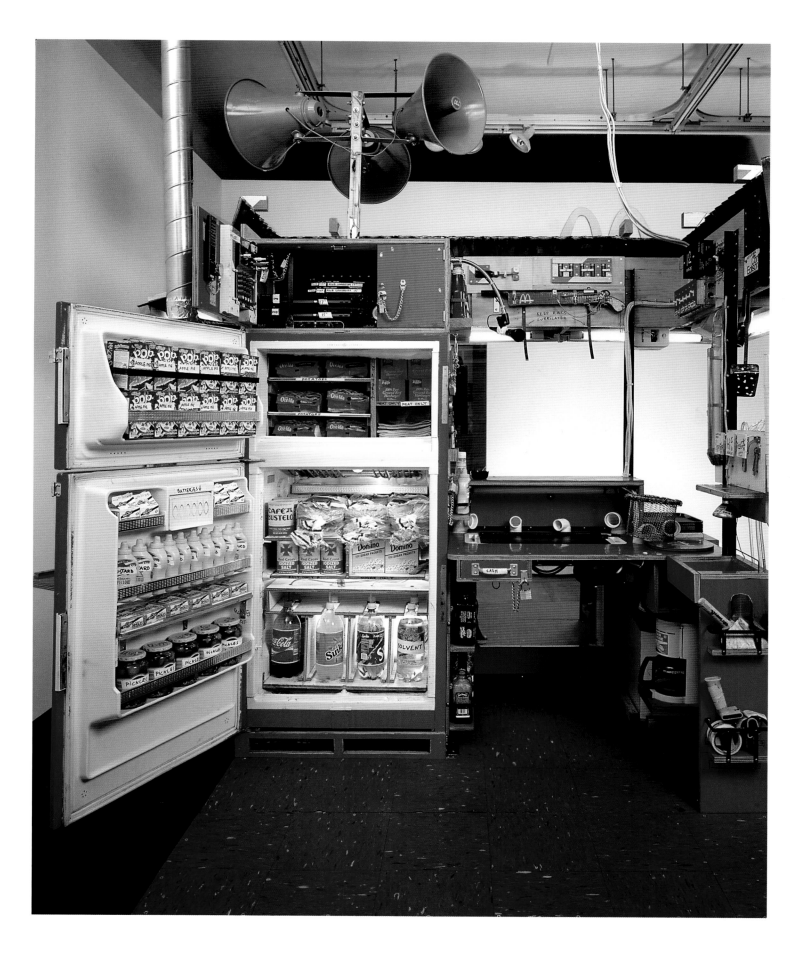

Tom Sachs

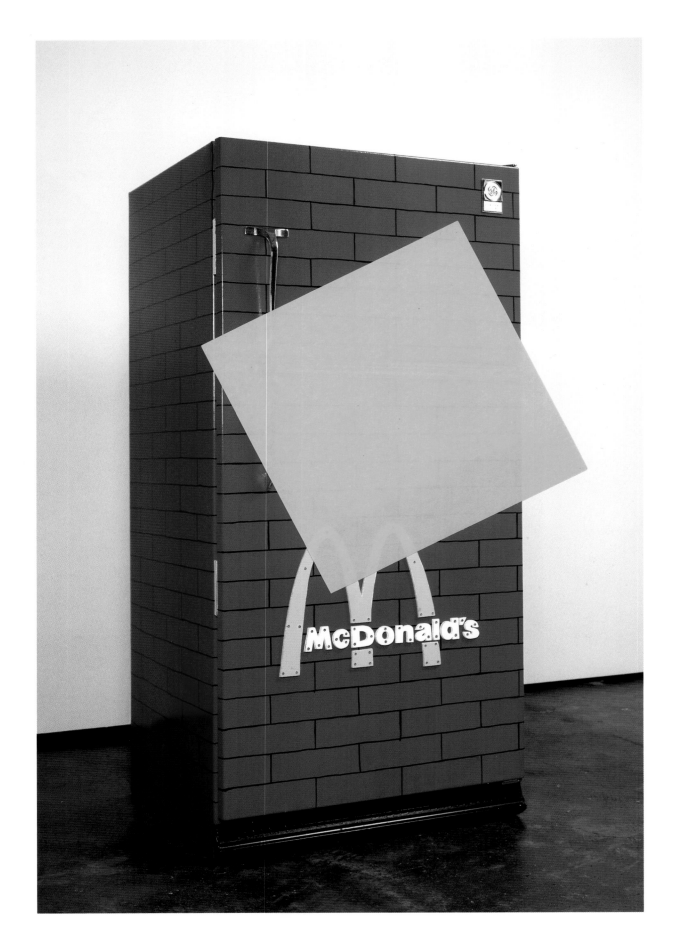

Tom Sachs

David Salle

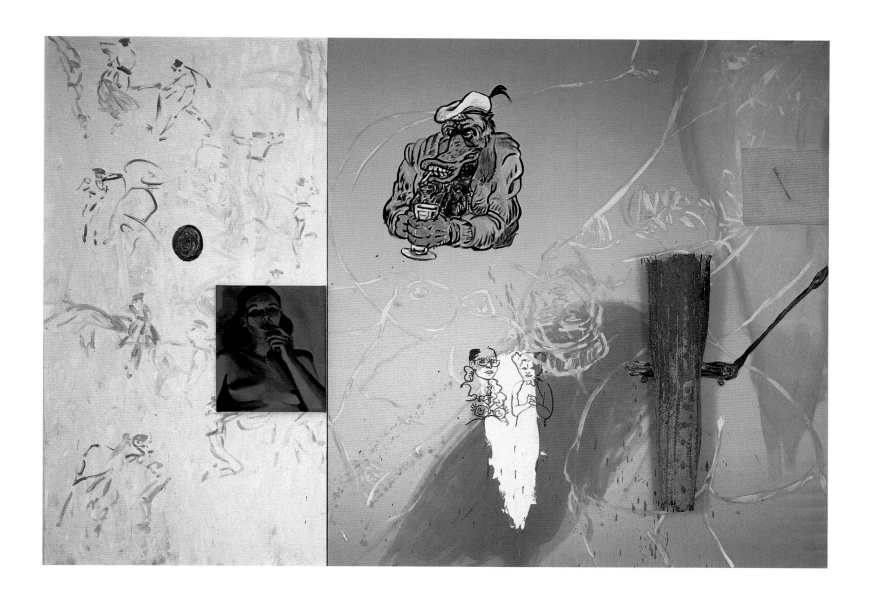

David Salle

516. *Ornamental Despair*, 1980 517. *Affection for Surfing*, 1983

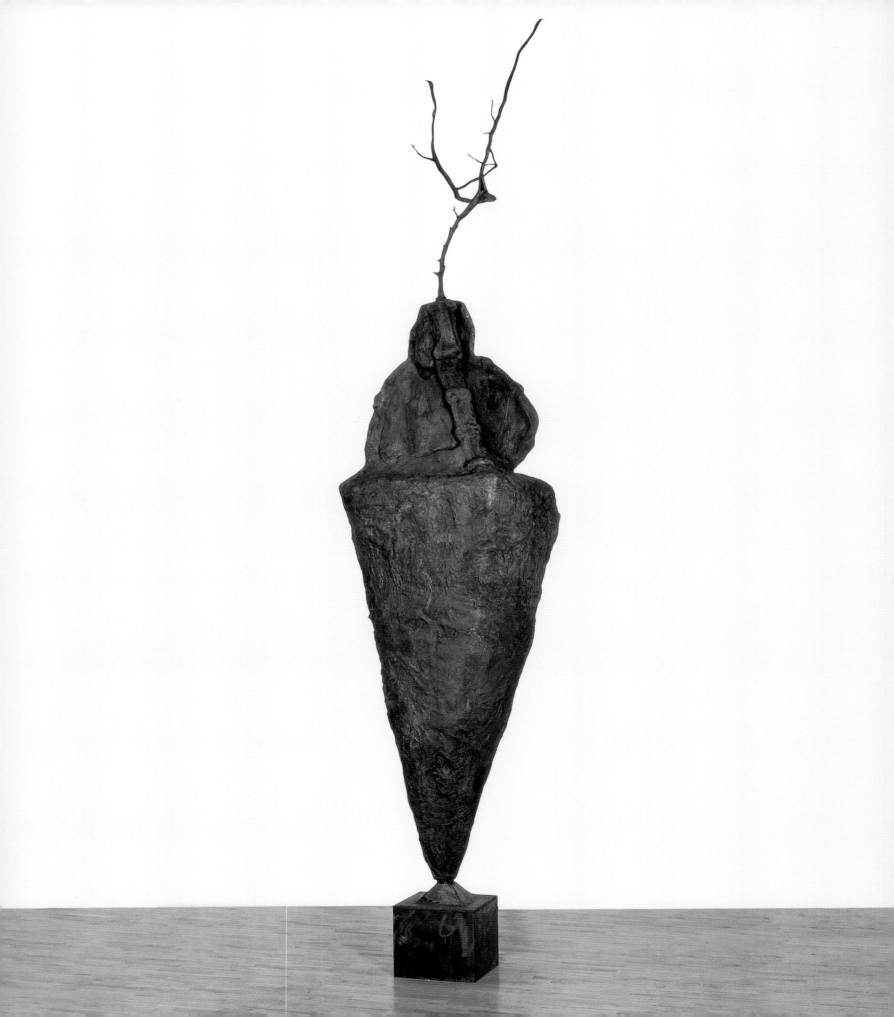

*518. *Balzac*, 1983

519. *Self-Portrait with Champagne Glass*, 1987-1990

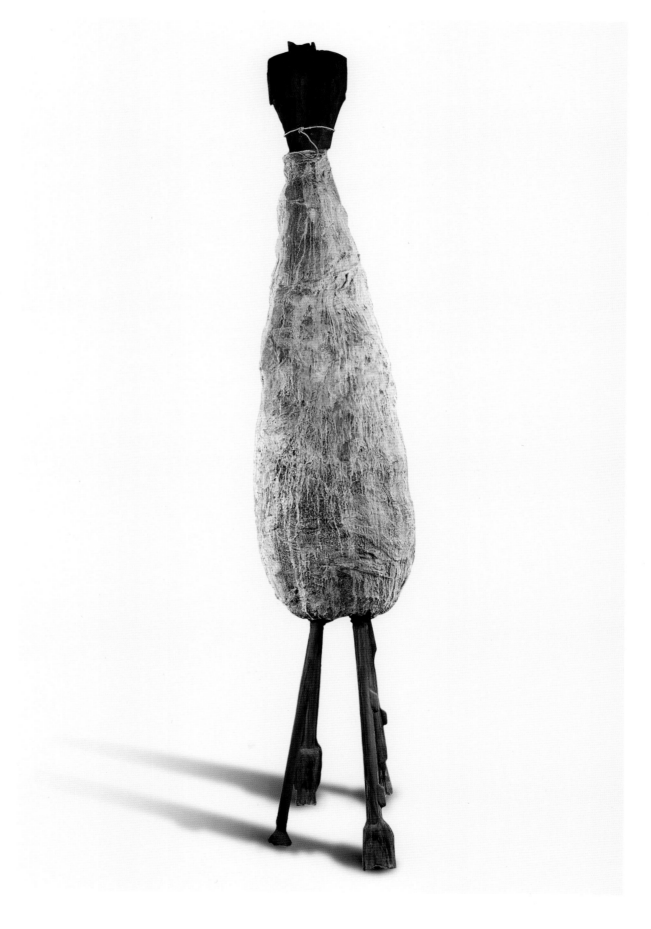

Julian Schnabel

Joel Shapiro

520. *Untitled*, 1975

521. *Untitled*, 1974

Joel Shapiro

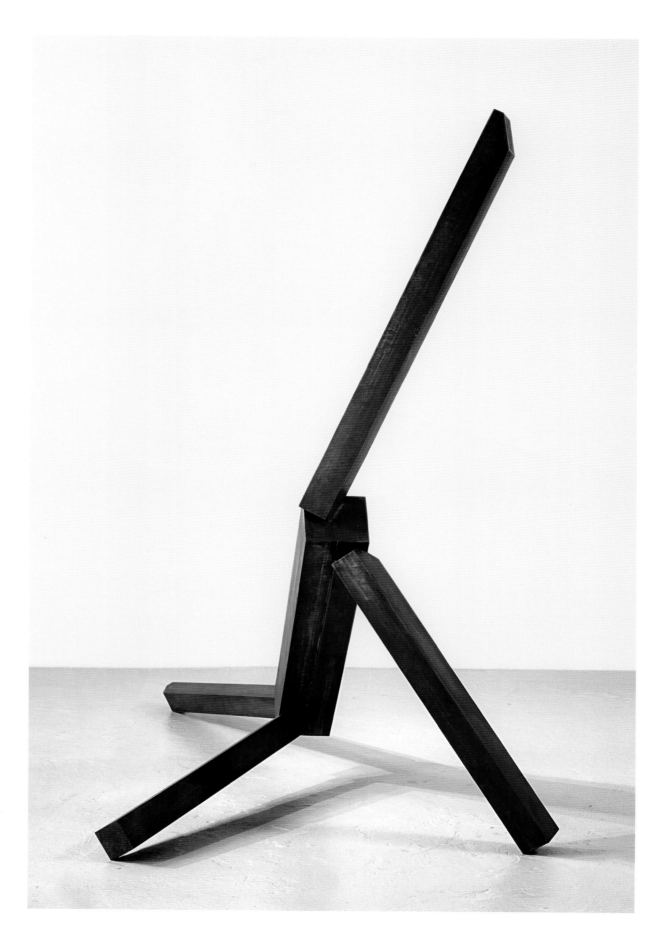

Joel Shapiro

Kiki Smith

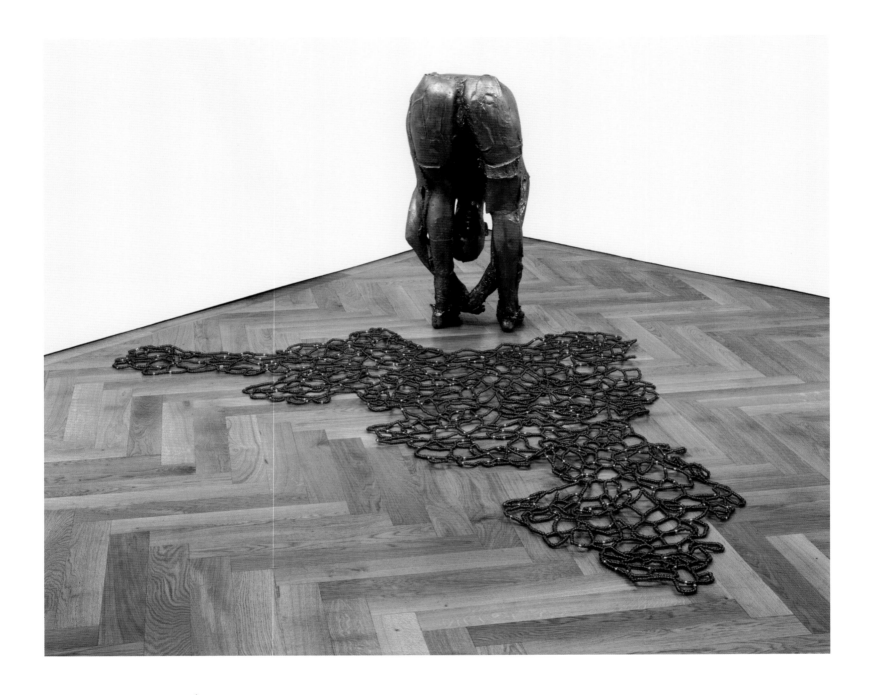

506

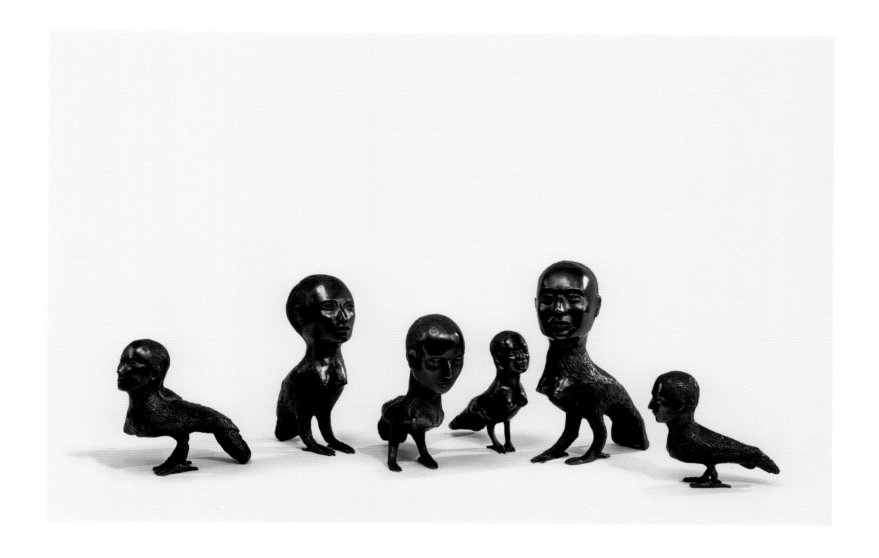

525. *Subtle Cork Brown*, 1984

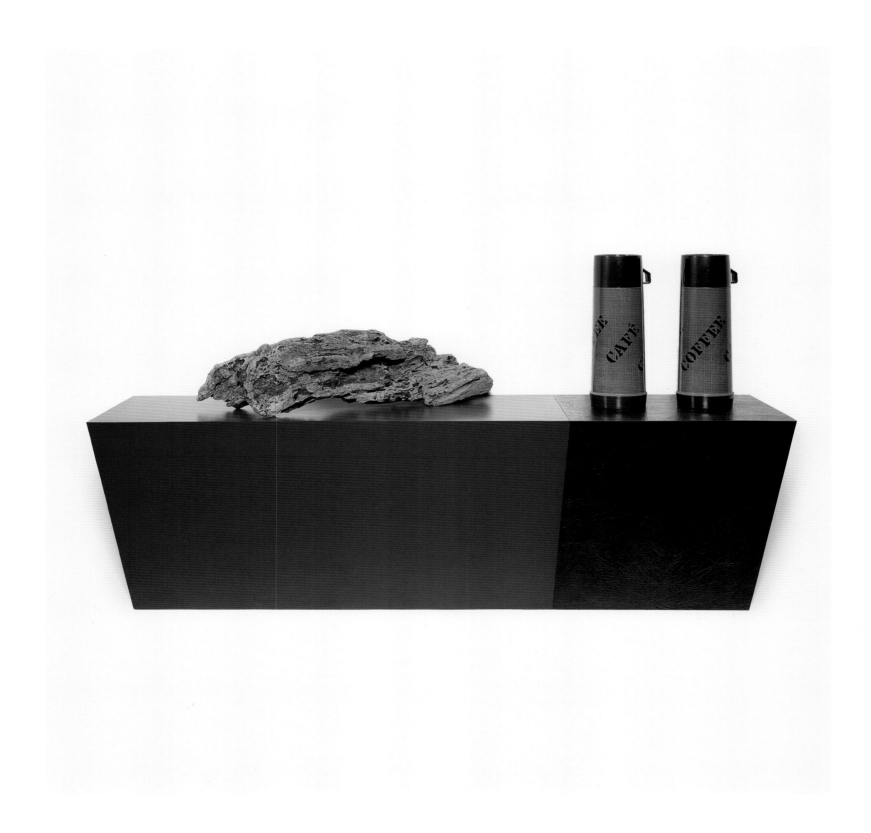

Haim Steinbach

Kara Walker

Sue Williams

Christopher Wool

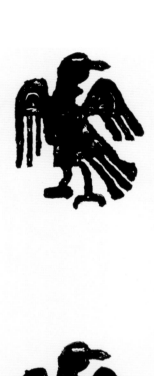
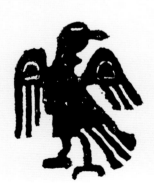

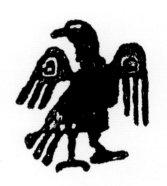
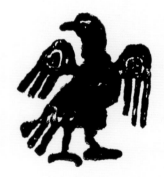
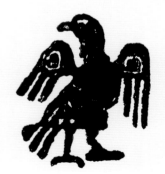

*531. *Untitled*, 1989

*532. *Untitled*, 1989

Christopher Wool

534. *Untitled*, 1989

List of Works in the Catalogue

*In the following list * indicates exhibited works*

Art

* Louise Bourgeois
Quarantania, 1947–53
bronze painted white and blue, 204.5 × 68.6 × 68.6 cm
Courtesy of the artist and Cheim & Read, New York
© Louise Bourgeois and Cheim & Read,
New York/Adagp, Paris 2006
(cat. no. 1)

* Louise Bourgeois
Spider Couple, 2003
bronze, silver nitrate patina, 228.6 × 360.7 × 365.8 cm
Collection of the artist
Courtesy Cheim & Read, New York
© Louise Bourgeois and Cheim & Read, New
York/Adagp, Paris 2006
(cat. no. 2)

Louise Bourgeois
Cell (Clothes), 1996
wood, glass, fabric, rubber and mixed media,
210.8 × 441.9 × 365.7 cm
Private collection
© Adagp, Paris 2006
(cat. no. 3)

Willem de Kooning
Two Figures in a Landscape, 1967
oil on canvas, 178 × 203 cm
Amsterdam, Stedelijk Museum
© The Willem de Kooning Foundation/Adagp,
Paris 2006
(cat. no. 4)

* Willem de Kooning
Large Torso, 1974
bronze, 95 × 91 × 70 cm
Baden-Baden, Museum Frieder Burda
© The Willem de Kooning Foundation/Adagp,
Paris 2006
(cat. no. 5)

* Willem de Kooning
Untitled, 1971
oil on canvas, 174 × 197.5 cm
Private collection
Courtesy Galerie Gmurzynska, Cologne
© The Willem de Kooning Foundation/Adagp,
Paris 2006
(cat. no. 6)

* Willem de Kooning
Untitled, XLIII, 1983
oil on canvas, 195.6 × 223.5 cm
New York, The Willem de Kooning Foundation
© The Willem de Kooning Foundation/Adagp,
Paris 2006
(cat. no. 7)

* Helen Frankenthaler
Walnut Hedge, 1971
acrylic on canvas, 305 × 195 cm
Collection of the Pennsylvania Academy of Art, PA
Courtesy Knoedler & Company, New York
© Helen Frankenthaler
(cat. no. 8)

Helen Frankenthaler
Vernal, 1976
acrylic on canvas, 90 × 126 cm
Courtesy Knoedler & Company, New York
© Helen Frankenthaler
(cat. no. 9)

Arshile Gorky
Waterfall, 1943
oil on canvas, 153.5 × 113 cm
London, Tate, Purchase with assistence from
the Friends of the Tate Gallery, 1971
© Adagp, Paris 2006
(cat. no. 10)

Arshile Gorky
One Year the Milkweed, 1944
oil on canvas, 94 × 119 cm
Washington DC, National Gallery of Art, Alisa
Mellon Bruce Fund, 1979.13.2
© Adagp, Paris 2006
(cat. no. 11)

* Arshile Gorky
Landscape Table, 1945
oil on canvas, 92 × 121 cm
Paris, Centre Pompidou, Musée national
d'art moderne/Centre de création industrielle
© Adagp, Paris 2006
(cat. no. 12)

Arshile Gorky
Charred Beloved I, 1946
oil on canvas, 136 × 101 cm
Adriana and Robert Mnuchin
© Adagp, Paris 2006
(cat. no. 13)

Adolph Gottlieb
Pictograph, 1944
oil on canvas, 91.4 × 63.5 cm
Promised Gift of The Judith Rothschild Foundation
© Adagp, Paris 2006
(cat. no. 14)

* Adolph Gottlieb
Charcoal, 1971
oil on canvas, 180 × 150 cm
The Adolph & Esther Gottlieb Foundation and
The American Contemporary Art Gallery, Munich
© Adagp, Paris 2006
(cat. no. 15)

* Philip Guston
Traveller II, 1960
oil on canvas, 166 × 186 cm
Barcelona, MACBA. Museu d'Art Contemporani
de Barcelona Foundation. Deposit of Onnasch
Collection
© The Estate of Philip Guston
(cat. no. 16)

* Philip Guston
Waking Up, 1975
oil on canvas, 170.2 × 327.2 cm
Courtesy McKee Gallery, New York
© The Estate of Philip Guston
(cat. no. 17)

* Hans Hofmann
Oriental Design, 1945
oil on panel, 74.3 × 99.7 cm
Stephen and Madeline Anbinder
© Adagp, Paris 2006
(cat. no. 18)

Hans Hofmann
Blue Interior, 1949
oil on canvas, 100 × 129 cm
Private collection
© Adagp, Paris 2006
(cat. no. 19)

Hans Hofmann
Jubilant, 1952
oil on canvas, 152 × 122 × 8 cm
New York, The Estate of Hans Hofmann
Courtesy The American Contemporary
Art Gallery, Munich
© Adagp, Paris 2006
(cat. no. 20)

* Hans Hofmann
Homage to the White, 1956
oil on canvas, 132 × 152 × 7 cm
New York, The Estate of Hans Hofmann
Courtesy The American Contemporary
Art Gallery, Munich
© Adagp, Paris 2006
(cat. no. 21)

Franz Kline
Herald, 1953
oil on canvas, 146 × 209 cm
Private collection
Courtesy Allan Stone Gallery, New York
© Adagp, Paris 2006
(cat. no. 22)

Franz Kline
Sabro, 1956
oil on canvas, 202 × 120.5 cm
Portugal, Berardo Collection
© Adagp, Paris 2006
(cat. no. 23)

* Franz Kline
Zinc Door, 1961
oil on canvas, 235 × 172.1 cm
Berlin, Onnasch Collection
© Adagp, Paris 2006
(cat. no. 24)

* Franz Kline
Mahoning II, c. 1961
oil on homosote, 2 pieces, 304.8 × 243.8 cm
Germany, private collection
© Adagp, Paris 2006
(cat. no. 25)

* Lee Krasner
Sun Woman II, 1957
oil on canvas, 176.5 × 288.3 cm
New York, Pollock-Krasner Foundation
Courtesy Robert Miller Gallery, New York
© Adagp, Paris 2006
(cat. no. 26)

Lee Krasner
Cat Image, 1957
oil on canvas, 100.3 × 147.3 cm
New York, Pollock-Krasner Foundation
Courtesy Robert Miller Gallery, New York
© Adagp, Paris 2006
(cat. no. 27)

Morris Louis
Burning Stain, 1961
acrylic resin on canvas, 220 × 183 cm
Courtesy Archivio Celant, Genoa
(cat. no. 28)

Morris Louis
Delta, 1960
acrylic resin on canvas, 260 × 381 cm
Courtesy Archivio Celant, Genoa
(cat. no. 29)

Morris Louis
Blue Veil, c. 1958–59
acrylic resin on canvas
© Fogg Art Museum, Harvard University
Art Museums, USA/Gift of Lois Orswell and Special
Uses Fund/The Bridgeman Art Library
(cat. no. 30)

Morris Louis
Gamma Epsilon, 1960
acrylic resin on canvas
Private collection/The Bridgeman Art Library
(cat. no. 31)

* Joan Mitchell
Untitled, 1956
oil on canvas, 185.4 × 195.5 cm
Courtesy of the artist and Cheim & Read, New York
© 2006 Estate of Joan Mitchell
(cat. no. 32)

* Joan Mitchell
Untitled, 1957
oil on canvas, 240 × 220 cm
Courtesy of the Joan Mitchell Foundation
and Cheim & Read, New York
© 2006 Estate of Joan Mitchell
(cat. no. 33)

* Robert Motherwell
Wall Painting n. III, 1953
oil on canvas, 137.1 × 184.5 cm
Barcelona, MACBA. Museu d'Art Contemporani
de Barcelona Foundation. Deposit of Onnasch
Collection
© 2006 Dedalus Foundation Inc./Adagp, Paris 2006
(cat. no. 34)

Robert Motherwell
Iberia Nr. 20, 1958
plywood, 56 × 76 cm
Munich, Pinakothek der Moderne
© 2006 Dedalus Foundation Inc./Adagp, Paris 2006
(cat. no. 35)

Barnett Newman
Uriel, 1955
oil on canvas, 243.8 × 548.6 cm
Hamburg, Hamburger Kunsthalle/The Bridgeman
Art Library
© Adagp, Paris 2006
(cat. no. 36)

Barnett Newman
Dionysius, 1949
oil on canvas, 176 × 122 cm
New York, Annalee Newman Collection
Courtesy Archivio Celant, Genoa
© Adagp, Paris 2006
(cat. no. 37)

* Barnett Newman
Now I, 1965
acrylic on canvas, 198 × 30.5 cm
Germany, private collection
© Adagp, Paris 2006
(cat. no. 38)

Barnett Newman
The Gate, 1954
oil on canvas, 236 × 192 cm
Amsterdam, Stedelijk Museum
© Adagp, Paris 2006
(cat. no. 39)

* Jackson Pollock
Square Composition with Horse, 1937
oil on masonite, 43.8 × 43.8 cm
Rome, Galleria Nazionale d'Arte Moderna
e Contemporanea
© Adagp, Paris 2006
(cat. no. 40)

Jackson Pollock
The Tea Cup, 1946
oil on canvas, 102 × 70.5 cm
Baden-Baden, Museum Frieder Burda
© Adagp, Paris 2006
(cat. no. 41)

Jackson Pollock
Watery Paths, 1947
oil on canvas, 114 × 86 cm
Rome, Galleria Nazionale d'Arte Moderna
e Contemporanea
© Adagp, Paris 2006
(cat. no. 42)

* Jackson Pollock
Composition 16, 1948
oil on canvas, 56.5 × 39.5 cm
Baden-Baden, Museum Frieder Burda
© Adagp, Paris 2006
(cat. no. 43)

Richard Pousette-Dart
Presence #10, 1949
oil on canvas, 104 × 80 cm
The Estate of Richard Pousette-Dart, New York and
The American Contemporary Art Gallery, Munich
© Adagp, Paris 2006
(cat. no. 44)

* Richard Pousette-Dart
Hieroglyph (White Garden), 1971
oil on canvas, 180 × 180 cm
The Estate of Richard Pousette-Dart, New York and
The American Contemporary Art Gallery, Munich
© Adagp, Paris 2006
(cat. no. 45)

* Ad Reinhardt
Untitled, 1952
oil on canvas, 127 × 50.8 cm
Courtesy Barbara Mathes Gallery, New York
© Adagp, Paris 2006
(cat. no. 46)

* Ad Reinhardt
Abstract Painting, 1956
oil on canvas, 203.2 × 127 cm
Barcelona, MACBA. Museu d'Art Contemporani
de Barcelona Foundation. Deposit of Onnasch
Collection
© Adagp, Paris 2006
(cat. no. 47)

* Mark Rothko
Untitled, 1959
oil on canvas, 142 × 137.5 cm
Monaco, private collection
© Kate Rothko Prizel and Christopher Rothko/
Adagp, Paris 2006
(cat. no. 48)

* Mark Rothko
N. 10, 1963
oil on canvas, 162.6 × 161.3 cm
Collection Christopher Rothko
© 1998 Kate Rothko Prizel and Christopher Rothko/
Adagp, Paris 2006
(cat. no. 49)

* David Smith
Construction on Star Points, 1954–56
stainless steel and steel painted wired
iron primer, 258.8 × 101.9 × 61.6 cm
The Estate of David Smith
Courtesy Gagosian Gallery, New York
© Adagp, Paris 2006
(cat. no. 50)

* David Smith
Tanktotem VI, 1957
painted steel, 263.8 × 53.3 × 68.6 cm
The Estate of David Smith
Courtesy Gagosian Gallery, New York
© Adagp, Paris 2006
(cat. no. 51)

* David Smith
Cubi II, 1963
stainless steel, 331.5 × 93.7 × 60.6 cm
The Estate of David Smith
Courtesy Gagosian Gallery, New York
© Adagp, Paris 2006
(cat. no. 52)

* David Smith
Dida's Circle on a Fungus, 1961
painted steel, 254 × 119.4 × 40.6 cm
The Estate of David Smith
Courtesy Gagosian Gallery, New York
© Adagp, Paris 2006
(cat. no. 53)

Clyfford Still
Untitled, 1964
oil on canvas, 289.6 × 190.3 cm
Baden-Baden, Museum Frieder Burda
(cat. no. 54)

Clyfford Still
Untitled, 1964
oil on linen, 259 × 222 cm
Bilbao, Guggenheim Bilbao Museoa
(cat. no. 55)

Photography

* Bruce Davidson
Untitled (from "Brooklyn Gang"), 1959
gelatin silver print, printed later,
21.6 × 32.4 cm
Courtesy Howard Greenberg Gallery, New York
& Bruce Davidson
© Bruce Davidson/Magnum
(cat. no. 56)

* Bruce Davidson
Untitled (from "Brooklyn Gang"), 1960
gelatin silver print, printed later, 28 × 35.6 cm
Courtesy Howard Greenberg Gallery, New York
& Bruce Davidson
© Bruce Davidson/Magnum
(cat. no. 57)

* Bruce Davidson
Untitled (from "East 100th Street"), 1966–68
gelatin silver print, 50.8 × 40.6 cm
Courtesy Howard Greenberg Gallery, New York
& Bruce Davidson
© Bruce Davidson/Magnum
(cat. no. 58)

* Elliott Erwitt
California, 1955
gelatin silver print, 40.6 × 50.8 cm
© Elliott Erwitt/Magnum
(cat. no. 59)

* Elliott Erwitt
Pasadena, California, 1963
gelatin silver print, 40.6 × 50.8 cm
© Elliott Erwitt/Magnum
(cat. no. 60)

* Elliott Erwitt
Versailles, France, 1975
gelatin silver print, 40.6 × 50.8 cm
© Elliott Erwitt/Magnum
(cat. no. 61)

* Elliott Erwitt
New York City, 1977
gelatin silver print, 40.6 × 50.8 cm
© Elliott Erwitt/Magnum
(cat. no. 62)

* Louis Faurer
Ritz Bar, New York, NY, 1947–48
gelatin silver print, printed 1980, 17.8 × 26.7 cm
Courtesy Howard Greenberg Gallery, New York
(cat. no. 63)

* Louis Faurer
Broadway Convertible, 1950
gelatin silver print, printed later, 21.2 × 31.5 cm
Courtesy Howard Greenberg Gallery, New York
(cat. no. 64)

* Louis Faurer
Deaf and Mute, c. 1950
gelatin silver print, printed later, 31.2 × 21.2 cm
Courtesy Howard Greenberg Gallery, New York
(cat. no. 65)

* Allen Ginsberg
Jack Kerouac, Staten Island Ferry dock,
New York, Fall, 1953
gelatin silver print, printed later, 28 × 35.6 cm
Courtesy Howard Greenberg Gallery, New York
(cat. no. 66)

* Allen Ginsberg
Rene Ricard, poet art critic, 1986
gelatin silver print, printed later, 28 × 35.6 cm
Courtesy Howard Greenberg Gallery, New York
(cat. no. 67)

* Allen Ginsberg
William Burroughs & Jack Kerouac in mortal combat
with snaky Morocan dagger and broomstick club
on my couch, 206 E. 7th. Street, Fall, 1953
gelatin silver print, printed later, 28 × 35.6 cm
Courtesy Howard Greenberg Gallery, New York
(cat. no. 68)

* Allen Ginsberg
Robert Frank at Kiev restaurant, 7th Str.
and Second Ave., March 7, 1984
gelatin silver print, printed later, 27.7 × 35.3 cm
Courtesy Howard Greenberg Gallery, New York
(cat. no. 69)

* Philippe Halsman
Martha Graham and Erick Hawkins, 1946
vintage gelatin silver print, 35.6 × 28 cm
Courtesy Philippe Halsman Archive
© Philippe Halsman/Magnum
(cat. no. 70)

* Philippe Halsman
Woody Allen, 1969
vintage gelatin silver print, 35.6 × 28 cm
Courtesy Philippe Halsman Archive
© Philippe Halsman/Magnum
(cat. no. 71)

* André Kertész
Disappearing Act, 1955
gelatin silver print, 25.4 × 20.3 cm
Courtesy Bruce Silverstein Gallery, New York
© Estate of André Kertész
(cat. no. 72)

* André Kertész
Flowers for Elizabeth, 1976
vintage gelatin silver print, 24.8 × 35 cm
Courtesy Bruce Silverstein Gallery, New York
© Estate of André Kertész
(cat. no. 73)

* William Klein
Group & Top Hat, Harlem, 1955
gelatin silver print, printed later, 40 × 50 cm
Courtesy Howard Greenberg Gallery, New York
© William Klein
(cat. no. 74)

* William Klein
Boys & See-Saw, Harlem, New York, 1955
gelatin silver print, printed later, 40 × 50 cm
Courtesy Howard Greenberg Gallery, New York
© William Klein
(cat. no. 75)

* William Klein
Severed Head, New York, 1955
gelatin silver print, printed later, 40 × 20 cm
Courtesy Howard Greenberg Gallery, New York
© William Klein
(cat. no. 76)

* William Klein
Boy on Swing & Smirking Girl, New York, 1955
gelatin silver print, printed later, 40 × 30 cm
Courtesy Howard Greenberg Gallery, New York
© William Klein
(cat. no. 77)

* William Klein
4 Heads, New York, 1954
gelatin silver print, printed later, 40 × 30 cm
Courtesy Howard Greenberg Gallery, New York
© William Klein
(cat. no. 78)

* William Klein
Stickball, New York, 1954
gelatin silver print, printed later, 50 × 40 cm
Courtesy Howard Greenberg Gallery, New York
© William Klein
(cat. no. 79)

* Gordon Parks
Emerging Man, Harlem, 1952
gelatin silver print, printed later, 28 × 35.6 cm
Courtesy Howard Greenberg Gallery, New York
© Gordon Parks
(cat. no. 80)

* Gordon Parks
Duke Ellington in Concert, c. 1960
vintage gelatin silver print, 23.8 × 34.2 cm
Courtesy Howard Greenberg Gallery, New York
© Gordon Parks
(cat. no. 81)

* Eugene W. Smith
Patient Annabelle Fuller carried to Maude Callen's
door to have dressing changed after a car accident,
S.C., 1951
vintage gelatin silver print, 34.3 × 26.7 cm
Courtesy Howard Greenberg Gallery, New York
© Eugene W. Smith/Magnum
(cat. no. 82)

* Eugene W. Smith
Nurse-midwife Maude Callen ministering
to patients outside on porch, S.C., 1951
vintage gelatin silver print, 33.7 × 23.5 cm
Courtesy Howard Greenberg Gallery, New York
© Eugene W. Smith/Magnum
(cat. no. 83)

* Eugene W. Smith
Nurse-midwife Maude Callen at the bedside
of pregnant woman, S.C., 1951
vintage gelatin silver print, 25.7 × 34.3 cm
Courtesy Howard Greenberg Gallery, New York
© Eugene W. Smith/Magnum
(cat. no. 84)

* Weegee (Arthur Fellig)
Fire Lieutenant rescues woman from fourth floor
of burning building, January 13, 1941
gelatin silver print, 16.5 × 11.7 cm
International Center for Photography,
Gift of Wilma Wilcox, 1993
© Weegee/International Center
of Photography/Getty Images
(cat. no. 85)

* Weegee (Arthur Fellig)
Fireman holding Torahs, saved from a fire, c. 1943
gelatin silver print, 24.1 × 19.7 cm
International Center for Photography,
Gift of Wilma Wilcox, 1993
© Weegee/International Center
of Photography/Getty Images
(cat. no. 86)

* Weegee (Arthur Fellig)
Madam Swift, 1941
gelatin silver print, 23.8 × 19.4 cm
International Center for Photography,
Gift of Wilma Wilcox, 1993
© Weegee/International Center
of Photography/Getty Images
(cat. no. 87)

* Weegee (Arthur Fellig)
"Bandit", August 11, 1941
gelatin silver print, 30.5 × 28.1 cm
International Center for Photography,
Gift of Wilma Wilcox, 1993
© Weegee/International Center
of Photography/Getty Images
(cat. no. 88)

* Weegee (Arthur Fellig)
Here is nurse accused of killing baby, 1942
gelatin silver print, 23.2 × 16.8 cm
International Center for Photography,
Gift of Wilma Wilcox, 1993
© Weegee/International Center
of Photography/Getty Images
(cat. no. 89)

* Helen Levitt
New York, 1982
gelatin silver print, printed later, 23.2 × 16.2 cm
© Helen Levitt. Courtesy Fraenkel Gallery,
San Francisco
(cat. no. 90)

* Helen Levitt
New York, c. 1940
gelatin silver print, printed later, 27 × 19 cm
© Helen Levitt. Courtesy Fraenkel Gallery,
San Francisco
(cat. no. 91)

Cinema

* Jules Dassin
The Naked City, 1948
Collection Les Cahiers du Cinéma / D. Rabourdin
© Universal Pictures
(cat. no. 92)

* Stanley Donen, Gene Kelly
On the Town, 1949
Collection Les Cahiers du Cinéma
(cat. no. 93)

* Samuel Fuller
Pick up on South Street, 1953
Collection Les Cahiers du Cinéma
(cat. no. 94)

Elia Kazan
On the Water Front, 1954
Collection Les Cahiers du Cinéma
(cat. no. 95)

Vincente Minnelli
The Bandwagon, 1953
Collection Les Cahiers du Cinéma
© MGM
(cat. no. 96)

Alfred Hitchcock
Rear Window, 1954
Collection Les Cahiers du Cinéma
(cat. no. 97)

* Billy Wilder
The Seven Year Itch, 1955
Collection Les Cahiers du Cinéma
© Twentieth Century Fox Film Corporation
(cat. no. 98)

* Stanley Donen, Gene Kelly
It's Always Fair Weather, 1955
Collection Les Cahiers du Cinéma
(cat. no. 99)

* Alfred Hitchcock
The Wrong Man, 1957
Collection Les Cahiers du Cinéma
(cat. no. 100)

John Cassavetes
Shooting of "Shadows", 1959
Collection Les Cahiers du Cinéma
© D.R.
(cat. no. 101)

* Blake Edwards
Breakfast at Tiffany's, 1960
Collection Les Cahiers du Cinéma
© Paramount Pictures
(cat. no. 102)

Performance and Video

Jackson Pollock at work on *One Number 31*, 1950
© Hans Namuth
(cat. nos. 103-104)

Claes Oldenburg
Ray Gun Theater, 1962
© Adagp, Paris 2006
(cat. no. 105)

Claes Oldenburg
Sports, 1962
© Adagp, Paris 2006
(cat. no. 106)

Jim Dine in *Vaudeville Collage: "Evening of: Sound-Theatre-Happenings"*, an evening
of performance held at the Reuben Gallery,
New York, June 11, 1960
© Adagp, Paris 2006
(cat. nos. 107-109)

* Carolee Schneemann
Meat Joy, 1964
16 mm film, 6 minutes, color, sound
Filmed in London, Paris, and New York
Courtesy of the artist and PPOW Gallery, New York
(cat. no. 110)

* Nam June Paik, John Godfrey
Global Groove, 1973
video, 28:30 minutes, color, sound
Courtesy of the artist and Electronic Arts Intermix,
New York
(cat. no. 111)

* Allan Kaprow
Comfort Zone, 1975
16 mm film, 17:50 minutes, black and white, sound
First enacted in 1975, Galeria Vandres, Madrid
Courtesy of the artist and Hauser & Wirth,
Zurich London
(cat. nos. 112-114)

Architecture

Skidmore, Owings & Merrill, Gordon Bunshaft
Lever Building, New York, 1952
© Esto
(cat. no. 115)

Skidmore, Owings & Merrill, Gordon Bunshaft
*Manufacturers Hanover Trust Building,
New York*, 1954
© Esto
(cat. nos. 116-117)

Frank Lloyd Wright
*Solomon R. Guggenheim Museum,
New York*, 1956–59
© Esto
(cat. no. 118)

Ludwig Mies van der Rohe
Seagram Building, New York, 1958
© Esto
(cat. nos. 119-122)

Art

Jasper Johns
Numbers in Colors, 1958–59
encaustic on canvas, 170 × 130 cm
Buffalo, Albright-Knox Art Gallery
© Jasper Johns/Adagp, Paris 2006
(cat. no. 123)

* Jasper Johns
Number 8, 1959
encaustic on canvas, 51 × 38 cm
Rovereto, MART, Museo di Arte Moderna
e Contemporanea di Trento e Rovereto
© Jasper Johns/Adagp, Paris 2006
(cat. no. 124)

Jasper Johns
Figure 5, 1960
oil on canvas, 183 × 137.5 cm
Paris, Centre Pompidou, Musée national
d'art moderne/Centre de création industrielle
© Jasper Johns/Adagp, Paris 2006
(cat. no. 125)

Jasper Johns
Target, 1967–69
oil on canvas, 152 × 152 cm
Vienna, MUMOK, Museum Moderner Kunst
Stiftung Ludwig
© Jasper Johns/Adagp, Paris 2006
(cat. no. 126)

* Louise Nevelson
Dawn's Wedding Chapel IV, 1959–60
wood, painted white, 276.7 × 221 × 34.3 cm
Courtesy PaceWildenstein, New York
© Adagp, Paris 2006
(cat. no. 127)

Louise Nevelson
Tropical Garden II, 1959
wood painted black, 180 × 333 × 30.5 cm
Paris, Fondation Nationale d'Art Contemporain
Lauros/Giraudon/The Bridgeman Art Library
(cat. no. 128)

Louise Nevelson
Homage to the Universe, 1968
wood, painted black, 275 × 900 × 90 cm
Courtesy Fondazione Marconi, Milan
© Adagp, Paris 2006
(cat. no. 129)

Nam June Paik
Klavier Intégral, 1958–63
piano and mixed media, 136 × 140 × 65 cm
Vienna, MUMOK, Museum Moderner Kunst
Stiftung Ludwig
(cat. no. 130)

Nam June Paik
T.V. Buddha, 1974
Buddha statue, camera, monitor, 160 × 215 × 80 cm
Amsterdam, Stedelijk Museum
(cat. no. 131)

* Nam June Paik
Play Piano for Ethiopia, 1989
vertical piano, 140 × 150 × 60 cm
Milan, Collection Fondazione Mudima
(cat. no. 132)

Nam June Paik
High Tech Baby, 1986
televisions, skeleton in aluminum,
203 × 108 × 51 cm
Private collection
(cat. no. 133)

Robert Rauschenberg
Kite, 1953
oil and silkscreen on canvas, 213 × 152 cm
Rovereto, MART, Museo di Arte Moderna
e Contemporanea di Trento e Rovereto
© Robert Rauschenberg/Adagp, Paris 2006
(cat. no. 134)

Robert Rauschenberg
Tideline, 1963
oil on linen, 213 × 152 cm
Denmark, Louisiana Museum for Moderne Kunst,
Kunst & Museum of Modern Art
© Robert Rauschenberg/Adagp, Paris 2006
(cat. no. 135)

* Robert Rauschenberg
Castelli Small Turtle Bowl, 1971
cardboard fragments stapled on cardboard,
240 × 368 cm
Collection of the artist
© Robert Rauschenberg/Adagp, Paris 2006
(cat. no. 136)

* Robert Rauschenberg
Balcone Glut (Neopolitan), 1987
assembled metal parts, 242 × 139 × 54 cm
Collection of the artist
© Robert Rauschenberg/Adagp, Paris 2006
(cat. no. 137)

* Cy Twombly
Untitled, 1958
mixed media on paper on canvas, 100 × 140 cm
Rome, Galleria Nazionale d'Arte Moderna
e Contemporanea
(cat. no. 138)

Cy Twombly
Rome (The Wall), 1962
oil, enamels, graffiti, and charcoal on canvas,
240.7 × 200 cm
Turin, Galleria Civica d'Arte Moderna
(cat. no. 139)

Cy Twombly
La caduta di Iperione (Second Voyage to Italy), 1962
mixed media on canvas, 264 × 300 cm
Rome, Galleria Nazionale d'Arte Moderna
e Contemporanea
(cat. no. 140)

* Cy Twombly
Untitled (New York City), 1968
oil based house paint and wax crayon
on canvas, 172.7 × 216 cm
Private collection
Courtesy Thomas Ammann Fine Art, Zurich
(cat. no. 141)

Photography

* Chuck Close
Torso Dyptich (MA), 2000
2 daguerreotypes, 21.6 × 16.5 cm each
© Chuck Close. Courtesy Pace/MacGill Gallery,
New York
(cat. nos. 142-143)

* Chuck Close
Ellen (Gallagher), 2000
daguerreotype, 21.6 × 16.5 cm
© Chuck Close. Courtesy Pace/MacGill Gallery,
New York
(cat. no. 144)

* Lee Friedlander
New York City, 2002
gelatin silver print, printed 2002, 38.1 × 35.6 cm
© Lee Friedlander, courtesy Fraenkel Gallery,
San Francisco
(cat. no. 145)

* Lee Friedlander
New York, New York, 2002
gelatin silver print, 38.1 × 35.6 cm
© Lee Friedlander, courtesy Fraenkel Gallery,
San Francisco
(cat. no. 146)

* Andy Warhol
Jon Gould with American Flag, 1976–86
gelatin silver prints sewn with thread, 69.9 × 54 cm
The Andy Warhol Museum, Pittsburgh Founding
Collection Contribution; The Andy Warhol
Foundation for the Visual Arts, Inc.
© Adagp, Paris 2006
(cat. no. 147)

* Andy Warhol
Statue of Liberty, 1976–86
gelatin silver prints sewn with thread, 69.9 × 54 cm
The Andy Warhol Museum, Pittsburgh, Founding
Collection Contribution; The Andy Warhol
Foundation for the Visual Arts, Inc.
© Adagp, Paris 2006
(cat. no. 148)

* Andy Warhol
*Unidentified Man and Window Sign ("Topless Bar
& Lounge")*, 1976–86
gelatin silver prints sewn with thread, 54.6 × 68.6 cm
The Andy Warhol Museum, Pittsburgh, Founding
Collection Contribution; The Andy Warhol
Foundation for the Visual Arts, Inc.
© Adagp, Paris 2006
(cat. no. 149)

* Garry Winogrand
*Kennedy-Nixon Presidential Campaign,
New York*, 1960
gelatin silver print, printed 1970s, 27.3 × 40.7 cm
Courtesy Fraenkel Gallery, San Francisco
© The Estate of Garry Winogrand
(cat. no. 150)

* Garry Winogrand
New York, c. 1970
gelatin silver print, printed 1970s, 21.9 × 33 cm
Courtesy Fraenkel Gallery, San Francisco
© The Estate of Garry Winogrand
(cat. no. 151)

* Garry Winogrand
Central Park Zoo, New York, 1967
gelatin silver print, printed c. 1980, 27 × 40.6 cm
Courtesy Fraenkel Gallery, San Francisco
© The Estate of Garry Winogrand
(cat. no. 152)

* Garry Winogrand
Political Demonstration, New York, 1969
gelatin silver print, printed 1970s, 27 × 40.6 cm
Courtesy Fraenkel Gallery, San Francisco
© The Estate of Garry Winogrand
(cat. no. 153)

Cinema

* Robert Wise
West Side Story, 1963
Collection Les Cahiers du Cinéma
© United Artists
(cat. no. 154)

Shirley Clarks
Shooting of "The Cool World", 1963
Collection Les Cahiers du Cinéma
(cat. no. 155)

Andy Wahrol
Empire, 1964
Collection Les Cahiers du Cinéma / Courtesy
Andy Warhol Film Project Whitney Museum
of American Art
© 1994 The Andy Warhol Foundation for the
Visual Arts / D.R.
(cat. no. 156)

Jonas Mekas
Shooting of "Guns of the Trees", 1964
Collection Les Cahiers du Cinéma
(cat. no. 157)

* Jim McBride
David Holzman's Diary, 1967
Collection Les Cahiers du Cinéma
(cat. no. 158)

* Roman Polanski
Rosemary's Baby, 1967
Collection Les Cahiers du Cinéma
© 1967 by Paramount Pictures
(cat. no. 159)

* John Schlesinger
Midnight Cowboy, 1968
Collection Les Cahiers du Cinéma
© Capital Cinema
(cat. no. 160)

Performance and Video

Yvonne Rainer
Terrain, 1963
Courtesy Archivio Celant, Genoa
(cat. no. 161)

Steve Paxton (with Barbara Lloyd) in *Trio A*
by Yvonne Rainer, 1966
Courtesy Archivio Celant, Genoa
(cat. no. 162)

Bruce Nauman
Flesh to White to Black to Flesh, 1968
© Adagp, Paris 2006
(cat. no. 163)

Robert Morris
Slow Motion, 1969
© Adagp, Paris 2006
(cat. no. 164)

* Bruce Nauman
Slow Angle Walk (Beckett Walk), 1968
© Adagp, Paris 2006
(cat. no. 165)

* Trisha Brown
Man Walking Down the Side of a Building, 1970
(cat. no. 166)

Steve Paxton
Contact Improvisations, 1968
Courtesy Archivio Celant, Genoa
(cat. no. 167)

Dance, 1979
Choreography by Lucinda Childs,
music by Philip Glass
Courtesy Archivio Celant, Genoa
(cat. no. 168)

Vito Acconci
Trademarks, 1969
Courtesy Archivio Celant, Genoa
© Vito Acconci
(cat. nos. 169-172)

Vito Acconci
Passes, 1971
Courtesy Archivio Celant, Genoa
© Vito Acconci
(cat. nos. 173-180)

* Gordon Matta-Clark
Clock Shower, 1973
16 mm film, 13:50 minutes, color, silent
Filmed at the Clock Tower Building, New York
Courtesy of the artist and Electronic Arts Intermix,
New York
(cat. no. 181)

* Hannah Wilke
Gestures, 1974
video, 35:30 minutes, black and white, sound
Courtesy of the artist and Electronic Arts Intermix,
New York
(cat. no. 182)

* Dan Graham
Performance/Audience/Mirror, 1975
video, 22:52 minutes, black and white, sound
Recorded at Video Free America, San Francisco
Courtesy of the artist and Electronic Arts Intermix,
New York
(cat. no. 183)

* Shigeko Kubota
Marcel Duchamp and John Cage, 1972
video, 28:27 minutes, black and white and color,
sound. Includes footage from *Reunion* (1968),
performed at the Ryerson Polytechnic Institute
in Toronto, and footage shot at the Duchamp
family plot in Rouen, France
Courtesy of the artist and Electronic Arts Intermix,
New York
(cat. no. 184)

Architecture

Eero Saarinen
TWA Terminal, New York, 1956–62
© Esto
(cat. no. 185)

Skidmore, Owings & Merrill
Pepsicola Building, New York, 1960
© Esto
(cat. no. 186)

Morris Lapidus, Harle & Liebman Architects
*Summit Hotel (Doubletree Metropolitan Hotel),
New York*, 1959–61
© Esto
(cat. no. 187)

Edwards D. Stone
*Gallery of Contemporary Art, 2 Columbus Circle,
New York*, 1964–65
© Esto
(cat. no. 188)

Kevin Roche, John Dinkeloo & Associates
Ford Foundation Building Location, New York, 1967
© Esto
(cat. no. 189)

Eero Saarinen
CBS Building, New York, 1961–66
© Esto
(cat. no. 190)

Marcel Breuer
Whitney Museum of American Art, New York, 1966
© Esto
(cat. no. 191)

Emery Roth & Sons, Pietro Belluschi
& Walter Gropius
Pan Am Building/Met Life, New York, 1958–63
© Esto
(cat. no. 192)

Davis Brody Bond
Waterside Plaza, New York, 1963–74
© Esto
(cat. no. 193)

Daniel Libeskind
Collage Rebus, New York, 1970
(cat. nos. 194-195)

Art

Richard Artschwager
Untitled (Girls), 1963–64
acrylic on celotex, 74.3 × 74.3 × 15.5 cm
Stuttgart, Froelich Collection
© Adagp, Paris 2006
(cat. no. 196)

* Richard Artschwager
Chair/Chair, 1965
formica and wood, 106.7 × 111.8 × 45.7 cm
Private collection
© Adagp, Paris 2006
(cat. no. 197)

Richard Artschwager
Piano II, 1965–79
plywood, formica, hair, 84 × 86.5 × 330 cm
Courtesy Archivio Celant, Genoa
© Adagp, Paris 2006
(cat. no. 198)

John Chamberlain
Trixie Dee, 1963
welded car parts, 138 × 76 × 135 cm
Vienna, MUMOK, Museum Moderner Kunst
Stiftung Ludwig
© Adagp, Paris 2006
(cat. no. 199)

* John Chamberlain
Untitled, 1965
painted and chromium-plated steel,
128 × 130 × 143 cm
Rome, Galleria Nazionale d'Arte Moderna
e Contemporanea
© Adagp, Paris 2006
(cat. no. 200)

John Chamberlain
Son of Dudes, 1977
mixed media, 182.9 × 132.1 × 96.5 cm
Private collection
Courtesy PaceWildenstein, New York
© Adagp, Paris 2006
(cat. no. 201)

* John Chamberlain
Remnant Gardens, 1986
enamel on chromium, plated steel,
274.3 × 152.4 × 101.6 cm
Courtesy PaceWildenstein, New York
© Adagp, Paris 2006
(cat. no. 202)

* Jim Dine
Car Crash, 1959–60
oil and mixed media on burlap, 152 × 163 cm
Courtesy PaceWildenstein, New York
© Adagp, Paris 2006
(cat. no. 203)

* Jim Dine
Flesh Chisel, 1962
oil on canvas, 213 × 153 cm
Berlin, Onnasch Collection
© Adagp, Paris 2006
(cat. no. 204)

* Jim Dine
Two Shovels, 1962
oil on canvas, two shovels, 122 × 213 cm
Private collection. Courtesy Kunstmuseum
Liechtenstein
© Adagp, Paris 2006
(cat. no. 205)

* Red Grooms in collaboration with
Mimi Gross and the Ruckus Construction Company
"Ms. Liberty" from Ruckus Manhattan, 1976
mixed media construction, 457.2 × 304.8 × 304.8 cm
Courtesy Marlborough Gallery, New York
© Adagp, Paris 2006
(cat. no. 206)

Red Grooms in collaboration with
Mimi Gross and the Ruckus Construction Company
"Brooklyn Bridge" from Ruckus Manhattan, 1976
mixed media construction
Courtesy Marlborough Gallery, New York
© Adagp, Paris 2006
(cat. no. 207)

* Roy Lichtenstein
Little Aloha, 1962
acrylic on canvas, 112 × 107 cm
Courtesy Sonnabend Gallery, New York
© Estate of Roy Lichtenstein, New York/Adagp,
Paris 2006
(cat. no. 208)

* Roy Lichtenstein
Large Spool, 1963
acrylic on canvas, 172.7 × 142.2 cm
Rovereto, MART, Museo di Arte Moderna
e Contemporanea di Trento e Rovereto
© Estate of Roy Lichtenstein, New York/Adagp,
Paris 2006
(cat. no. 209)

Roy Lichtenstein
Peace through Chemistry, 1970
oil on magna on canvas, 254 × 457.5 cm
Riehen (Basel), Fondation Beyeler
© Estate of Roy Lichtenstein, New York/Adagp,
Paris 2006
(cat. no. 210)

Roy Lichtenstein
Still Life with Playing Cards, 1974
oil and magna on canvas, 244 × 152.5 cm
Courtesy Archivio Celant, Genoa
© Estate of Roy Lichtenstein, New York/Adagp,
Paris 2006
(cat. no. 211)

Claes Oldenburg
Three Way Plug, 1966
painted cardboard, 100 × 64 × 49 cm
Private collection
(cat. no. 212)

* Claes Oldenburg
Alphabet/Good Humor Bar, 1975
painted fiberglass with bronzed metal base,
366 × 173 × 76 cm
Private collection
Courtesy PaceWildenstein, New York
(cat. no. 213)

Claes Oldenburg, Coosje van Bruggen
Spoonbridge and Cherry, 1988
painted aluminum with polyurethane enamel
and stainless steel, 900 × 1570 × 410 cm
Minneapolis, Minneapolis Sculpture Garden,
Walker Art Center
(cat. nos. 214a-b)

Claes Oldenburg, Coosje van Bruggen
Monument to the Last Horse, 1991
aluminum and polyurethane foam painted
on polyurethane steel, 600 × 518 × 376 cm
Marfa (Texas), The Chinati Foundation
(cat. no. 215)

James Rosenquist
I Love You with My Ford, 1961
oil on canvas, 210.2 × 237.5 cm
Stockholm, Moderna Museet
© James Rosenquist/Adagp, Paris 2006
(cat. no. 216)

* James Rosenquist
Blue Spark, 1962
mixed media on canvas, 121.5 × 152.5 × 42.5 cm
Valencia, IVAM, Instituto Valenciano de Arte
Moderno; Generalitat Valenciana
© Adagp, Paris 2006
(cat. no. 217)

* James Rosenquist
A Pale Angel's Halo, 1973
acrylic on canvas with marker on fabric
(tergal), 274.6 × 287 cm
Collection of the artist
© Adagp, Paris 2006
(cat. no. 218)

* James Rosenquist
Slipping off the Continental Divide, 1973
oil and acrylic on canvas, 259.4 × 668.3 cm
Collection of the artist
© Adagp, Paris 2006
(cat. no. 219)

* George Segal
Farmworker, 1963
mixed media, 243 × 243 × 107 cm
Barcelona, MACBA. Museu d'Art Contemporani
de Barcelona Foundation. Deposit of Onnasch
Collection
© Adagp, Paris 2006
(cat. no. 220)

George Segal
Cinema, 1963
plaster, metal, acrylic sheet
and fluorescent light, 300 × 244 × 76 cm
Buffalo, Albright-Knox Art Gallery
Courtesy Corbis
© Adagp, Paris 2006
(cat. no. 221)

* Andy Warhol
Cherry Marilyn, 1962
silkscreen on canvas and polymer
paint, 50.8 × 40.5 cm
Private collection
Courtesy Kunstmuseum Liechtenstein
© Adagp, Paris 2006
(cat. no. 222)

Andy Warhol
Orange Car Crash, 1964
acrylic resin and serigraphy on fabric, 220 × 210 cm
Turin, Galleria Civica d'Arte Moderna
© Adagp, Paris 2006
(cat. no. 223)

Andy Warhol
Mao 10, 1973
acrylic and silkscreen on canvas, 66 × 55.8 cm
Courtesy Sonnabend Gallery, New York
© Adagp, Paris 2006
(cat. no. 224)

* Andy Warhol
Statue of Liberty, 1986
synthetic polymer paint and silkscreen
on canvas, 183 × 183 cm
Courtesy Galerie Thaddaeus Ropac, Paris/Salzburg
© Adagp, Paris 2006
(cat. no. 225)

* Tom Wesselman
Still Life #45, 1962
mixed media, 91 × 122 cm
Courtesy Sonnabend Gallery, New York
© Adagp, Paris 2006
(cat. no. 226)

* Tom Wesselman
Bedroom Painting #36, 1978
oil on canvas, 213 × 206 × 3.5 cm
Monaco, private collection
© Adagp, Paris 2006
(cat. no. 227)

Tom Wesselman
Great American Nude #44, 1963
mixed media
Hamburg, Hamburger Kunsthalle/The Bridgeman
Art Library
© Adagp, Paris 2006
(cat. no. 228)

Carl Andre
Cross, 1978
wood, 30 × 30 × 90 cm
Courtesy Locksley Shea Gallery
© Adagp, Paris 2006
(cat. no. 229)

* Carl Andre
100 Magnesium Square, Düsseldorf, 1970
100 magnesium plates, 20 × 20 × 08 cm each
Rivoli (Turin), Castello di Rivoli Museo d'Arte
Contemporanea, Long term loan - Private
collection, Genoa
© Adagp, Paris 2006
(cat. no. 230)

Carl Andre
Magnesium-Steel Plain, 1969
magnesium and steel, 36 units square (6 × 6 cm),
18 plates of each metal alternating,
182.9 × 182.9 × 0.9 cm
Milan, Silvio Castelli
© Adagp, Paris 2006
(cat. no. 231)

Carl Andre
Steel Peneplain-Kassel-Cold Rolled Steel, 1982
300 plates cold-rolled steel, 100 × 100 × 0.5 cm each
© Adagp, Paris 2006
(cat. no. 232)

* Dan Flavin
Monument 12 for V. Tatlin, 1964
fluorescent daylight tubes, 220 × 62 × 10.5 cm
Rivoli (Turin), Castello di Rivoli Museo d'Arte
Contemporanea, Long term loan - Private
collection, Genoa
© Adagp, Paris 2006
(cat. no. 233)

Dan Flavin
Untitled (to Pat and Bob Rohm), 1973
red, yellow and green fluorescent light, 240 × 60 cm
Courtesy Archivio Celant, Genoa
© Adagp, Paris 2006
(cat. no. 234)

* Dan Flavin
Untitled (To Don Judd, Colorist) 1, 1987
pink fluorescent light, 6 units,
137.2 × 121.92 × 10.15 cm
Panza Collection
© Adagp, Paris 2006
(cat. no. 235)

* Dan Flavin
Untitled (To Don Judd, Colorist) 2, 1987
red and pink fluorescent light (4 red units, 2 pink),
137.2 × 121.92 × 10.2 cm
Panza Collection
© Adagp, Paris 2006
(cat. no. 236)

* Dan Flavin
Untitled (To Don Judd, Colorist) 3, 1987
yellow and pink fluorescent light (4 yellow units, 2
pink), 137.2 × 121.92 × 10.2 cm
Panza Collection
© Adagp, Paris 2006
(cat. no. 237)

* Dan Flavin
Untitled (To Don Judd, Colorist) 4, 1987
blue and pink fluorescent light (4 blue units,
2 pink), 137.2 × 121.92 × 10.2 cm
Panza Collection
© Adagp, Paris 2006
(cat. no. 238)

* Dan Flavin
Untitled (To Don Judd, Colorist) 5, 1987
green and pink fluorescent light (4 green units,
2 pink), 137.2 × 121.92 × 10.2 cm
Panza Collection
© Adagp, Paris 2006
(cat. no. 239)

Donald Judd
Untitled, 1966
plexiglass and stainless steel, 50.8 × 121.9 × 86.4 cm
Stuttgart, Froelich Collection
© Judd Foundation, licensed by VAGA, NY/Adagp,
Paris 2006
(cat. no. 240)

Donald Judd
Untitled, 1968
plexiglas and stainless steel, 10 units,
101.6 × 78.7 × 22.9 cm
Stuttgart, Froelich Collection
© Judd Foundation, licensed by VAGA, NY/Adagp,
Paris 2006
(cat. no. 241)

Donald Judd
Untitled, 1967
blue galvanized steel, 22.8 × 62.8 × 13.3 cm
Courtesy Sonnabend Gallery, New York
© Adagp, Paris 2006
(cat. no. 242)

Donald Judd
Untitled, 1974
anodized aluminum, 63.5 × 193 × 36 cm
Courtesy Archivio Celant, Genoa
© Adagp, Paris 2006
(cat. no. 243)

* Ellsworth Kelly
Two Panels: Black and White, c. 1970
oil on canvas, 71.1 × 406.4 cm
Germany, Collection Siegfried Weishaupt
Courtesy Gallery Hans Mayer, Germany
(cat. no. 244)

Ellsworth Kelly
Red Curve IV, 1973
oil on canvas, 254 × 254 cm
Musée de Grenoble
(cat. no. 245)

Ellsworth Kelly
Blue, Black, Red, Green, 2000
oil on canvas, 254 × 1219.2 cm
Riehen (Basel), Fondation Beyeler
(cat. no. 246)

* Sol LeWitt
Serial Project A1 5 9, 1966
enamel on steel, 81 × 208.9 × 52.1 cm
Courtesy PaceWildenstein, New York
© Adagp, Paris 2006
(cat. no. 247)

* Sol LeWitt
11 × 11 × 1, 1989
aluminum painted white, 378.5 × 63.5 × 63.5 cm
Courtesy PaceWildenstein, New York
© Adagp, Paris 2006
(cat. no. 248)

Sol LeWitt
Wall Drawing n. 260, 1976
white crayon, black wall
© Adagp, Paris 2006
(cat. no. 249)

Robert Mangold
Red Panel, 1964
oil on canvas on plywood on metal, 61 × 76 cm
Wiesbaden Museum
© Adagp, Paris 2006
(cat. no. 250)

Robert Mangold
W Series Central Diagonal II, 1968
acrylic on masonite, 122 × 244 cm
Private collection
© Adagp, Paris 2006
(cat. no. 251)

Robert Mangold
1/4 V Series, 1968
acrylic on masonite, 122 × 122 cm
Private collection
© Adagp, Paris 2006
(cat. no. 252)

* Robert Mangold
Untitled (Tan), 1977
acrylc, oil, and wax on linen, 244 × 426 cm
Barcelona, MACBA. Museu d'Art Contemporani
de Barcelona Foundation. Deposit of Onnasch
Collection
© Adagp, Paris 2006
(cat. no. 253)

Brice Marden
Rodeo, 1971
oil and wax on canvas, 244 × 244 cm
Los Angeles, Collection Lannan Foundation
© Adagp, Paris 2006
(cat. no. 254)

* Brice Marden
Blunder, 1969
oil and wax on canvas, 182.8 × 182.8 cm
Private collection
© Adagp, Paris 2006
(cat. no. 255)

* Agnes Martin
The Islands, 1961
acrylic and graphite on canvas, 182.9 × 182.9 cm
Private collection
Courtesy PaceWildenstein, New York
© Adagp, Paris 2006
(cat. no. 256)

Agnes Martin
Leaf, 1965
acrylic and graphite on canvas, 183 × 183 cm
Forth Worth (Texas), Collection of the Modern
Art Museum of Forth Worth, Museum Purchase,
Sid W. Richardson Foundation Endowment Fund
© Adagp, Paris 2006
(cat. no. 257)

Robert Morris
Untitled, 1967
16 steel boxes, 92 × 92 × 92 cm each
Courtesy Archivio Celant, Genoa
© Adagp, Paris 2006
(cat. no. 258)

* Robert Morris
Untitled (Felt), 1980
felt, 122.3 × 152.4 cm
Courtesy Sonnabend Gallery, New York
© Adagp, Paris 2006
(cat. no. 259)

* Robert Ryman
Untitled, c. 1961
oil on linen, 170 × 170 cm
Private collection
(cat. no. 260)

Robert Ryman
Windsor 20, 1966
acrylic on canvas, 194.5 × 194.5 cm
Private collection
(cat. no. 261)

Robert Ryman
General, 1970
enamel on cotton canvas, 139.7 × 139.7 cm
Private collection
(cat. no. 262)

Robert Ryman
Untitled (Surfeice Veil), 1970
oil on fiberglass panel, 50.5 × 50.5 cm
Private collection
(cat. no. 263)

Frank Stella
Abajo (Running V), 1964
metallic paint on canvas, 195 × 225 cm
Private collection
© Adagp, Paris 2006
(cat. no. 264)

Frank Stella
Valparaiso Flesh, 1964
painting metallic powder on canvas,
243.8 × 279.5 cm
Private collection
© Adagp, Paris 2006
(cat. no. 265)

Frank Stella
The Deck (Q-1), 1990
mixed media on aluminum, 280 × 240 × 150 cm
Courtesy Knoedler & Company, New York
© Adagp, Paris 2006
(cat. no. 266)

* Frank Stella
The Musket (C-2b, 2x), 1990
mixed media on aluminum, 360 × 420 × 180 cm
Courtesy Knoedler & Company, New York
© Adagp, Paris 2006
(cat. no. 267)

Photography

* Nan Goldin
Cookie at Tin Pan Alley, New York City, 1983
cibachrome, 76.2 × 101.6 cm
Courtesy Matthew Marks Gallery, New York
© Nan Goldin
(cat. no. 268)

* Nan Goldin
Nan one month after being battered, 1984
cibachrome, 76.2 × 101.6 cm
Courtesy Matthew Marks Gallery, New York
© Nan Goldin
(cat. no. 269)

* Nan Goldin
Jimmy Paulette and Tabboo! In the Bathroom, 1979
cibachrome, 76.2 × 101.6 cm
Courtesy Matthew Marks Gallery, New York
© Nan Goldin
(cat. no. 270)

* Nan Goldin
Cookie and Vittorio's wedding, New York City, 1986
cibachrome, 76.2 × 101.6 cm
Courtesy Matthew Marks Gallery, New York
© Nan Goldin
(cat. no. 271)

* Peter Hujar
David Wojnarowicz Reclining, 1981
gelatin silver print, 37.3 × 37.3 cm
Courtesy Matthew Marks Gallery, New York
(cat. no. 272)

* Peter Hujar
Peggy Lee, 1974
gelatin silver print, 36.9 × 37.5 cm
50.2 × 40.4 cm
Courtesy Matthew Marks Gallery, New York
(cat. no. 273)

* Peter Hujar
Self-Portrait (with string around neck), 1980
gelatin silver print, 37.5 × 37.8 cm
Courtesy Matthew Marks Gallery, New York
(cat. no. 274)

* Peter Hujar
Candy Darling on her Deathbed, 1974
gelatin silver print, 37.5 × 37.5 cm
Courtesy Matthew Marks Gallery, New York
(cat. no. 275)

* Barbara Kruger
I shop therefore I am, 1987
photographic silkscreen on vinyl, 284.5 × 287.5 cm
Private Collection
Courtesy Thomas Ammann Fine Art, Zurich
© Barbara Kruger. Courtesy Mary Boone Gallery,
New York
(cat. no. 276)

Barbara Kruger
Untitled (You delight in the loss of others), 1982
photography, 102 × 152 cm
Collection Nicole Klagsbrun
© D.R.
(cat. no. 277)

Robert Mapplethorpe
Patti Smith, 1979
gelatin silver print, 50.5 × 40 cm
New York, The Robert Mapplethorpe Foundation
© The Robert Mapplethorpe Foundation
(cat. no. 278)

* Robert Mapplethorpe
Brian Ridley and Lyle Heeter, 1979
gelatin silver print, 50.5 × 40 cm
© Robert Mapplethorpe Foundation
(cat. no. 279)

Robert Mapplethorpe
Larry and Bobby Kissing, 1979
gelatin silver print, 50.5 × 40 cm
New York, The Robert Mapplethorpe Foundation
© The Robert Mapplethorpe Foundation
(cat. no. 280)

Robert Mapplethorpe
Lisa Lyon, 1980
gelatin silver print, 50.5 × 40 cm
New York, The Robert Mapplethorpe Foundation
© The Robert Mapplethorpe Foundation
(cat. no. 281)

* Mary Ellen Mark
Putla on her bed with a crushed rose, Bombay, India, 1978
cibachrome print, 40 × 50 cm
Courtesy Marianne Boesky Gallery, New York
© Mary Ellen Mark
(cat. no. 282)

* Mary Ellen Mark
The Girl who is being made up was brought to the brothel by the people of her village because her husband had left her, Bombay, India, 1978
cibachrome print, 50 × 40 cm
Courtesy Marianne Boesky Gallery, New York
© Mary Ellen Mark
(cat. no. 283)

* Mary Ellen Mark
Falkland Road "cages". Madam: "Cage girls are the lowest - they only charge two rupees" (Seven Ruppes Equaled One Dollar), 1978
cibachrome print, 40 × 50 cm
Courtesy Marianne Boesky Gallery, New York
© Mary Ellen Mark
(cat. no. 284)

* Mary Ellen Mark
Champa, a transvestite, with his pet goat, getting dressed for the night, Bombay, India, 1978
cibachrome print, 40 × 50 cm
Courtesy Marianne Boesky Gallery, New York
© Mary Ellen Mark
(cat. no. 285)

* Susan Meiselas
First day of popular insurrection, Matagalpa, Nicaragua, August 26, 1978
cibachrome print, 50.8 × 61 cm
© Susan Meiselas/Magnum
(cat. no. 286)

* Susan Meiselas
Returning home, Masaya, Nicaragua, September, 1978
cibachrome print, 50.8 × 61 cm
© Susan Meiselas/Magnum
(cat. no. 287)

* Susan Meiselas
Market place, Diriamba, Nicaragua, 1978
cibachrome print, 50.8 × 61 cm
© Susan Meiselas/Magnum
(cat. no. 288)

* Susan Meiselas
"Cuesta del Plomo", a well-know site of many assassinations carried out by the National Guard, where people searched daily for missing persons, Managua, Nicaragua, 1981
cibachrome print, 50.8 × 61 cm
© Susan Meiselas/Magnum
(cat. no. 289)

* Duane Michals
The Poet Decorates His Muse with Verse, 2003–05
6 gelatin silver prints with hand applied text, each frame: 17.8 × 22.9 cm
© Duane Michals, Courtesy Pace/MacGill Gallery, New York
(cat. no. 290)

* Duane Michals
Christ in New York, 1981
6 gelatin silver prints, 12.7 × 19 cm each
© Duane Michals, Courtesy Pace/MacGill Gallery, New York
(cat. no. 291)

* Sylvia Plachy
Tom Waits, 1985
gelatin silver print, 40.6 × 50.8 cm
© Sylvia Plachy
(cat. no. 292)

* Sylvia Plachy
Lasker Pool, Harlem, 1982
gelatin silver print, 40.6 × 50.8 cm
© Sylvia Plachy
(cat. no. 293)

* Eugene Richards
Janine and Sam, Brooklyn, NY, 1988
gelatin silver print, 50.8 × 61 cm
© Eugene Richards
(cat. no. 294)

Eugene Richards
Shooting Cocaine, Brooklyn, NY, 1992
gelatin silver print, 50.8 × 61 cm
© Eugene Richards
(cat. no. 295)

* Eugene Richards
Young addicts in the early morning, Brooklyn, NY, 1988
gelatin silver print, 50.8 × 61 cm
© Eugene Richards
(cat. no. 296)

* Eugene Richards
Tom, New York City, 1988
gelatin silver print, 50.8 × 61 cm
© Eugene Richards
(cat. no. 297)

* Lucas Samaras
Figure, 6/29/78
polaroid polacolor II photograph, 27.6 × 21.6 cm
© Lucas Samaras, Courtesy Pace/MacGill Gallery, New York and PaceWildenstein, New York
(cat. no. 298)

* Lucas Samaras
Self-Portrait, 6/15/90
black and white polaroid and polacolor II collage, 27.3 × 22.3 cm
© Lucas Samaras, Courtesy Pace/MacGill Gallery, New York and PaceWildenstein, New York
(cat. no. 299)

* Lucas Samaras
Untitled (Self-Portrait), 7/6/90
color polaroid, 82.6 × 55.9 cm
© Lucas Samaras, courtesy Pace/MacGill Gallery, New York and PaceWildenstein, New York
(cat. no. 300)

* Lucas Samaras
Figure, 2/13/83
polaroid polacolor II photograph, 27.6 × 21.6 cm
© Lucas Samaras, Courtesy Pace/MacGill Gallery, New York and PaceWildenstein, New York
(cat. no. 301)

* Lucas Samaras
Figure, 8/19/78
polaroid polacolor II photograph, 27.6 × 21.6 cm
© Lucas Samaras, Courtesy Pace/MacGill Gallery, New York and PaceWildenstein, New York
(cat. no. 302)

* Cindy Sherman
Untitled #097, 1982
color photograph, 114.3 × 76.2 cm
Santa Monica, The Broad Art Foundation
Courtesy of the artist and Metro Pictures
(cat. no. 303)

* Cindy Sherman
Untitled #264, 1992
color photograph, 101.6 × 190.5 cm
Santa Monica, The Broad Art Foundation
Courtesy of the artist and Metro Pictures
(cat. no. 304)

* Cindy Sherman
Untitled #205, 1989
color photograph, 135.9 × 102.9 cm
Santa Monica, The Broad Art Foundation
Courtesy of the artist and Metro Pictures
(cat. no. 305)

* Mike & Doug Starn
Triple Christ, 1986
toned silver print, wood, glue, glass, aluminum, tape, 165.1 × 165.1 cm
USA, Collection of Mr. Randolfo Rocha
© 2006 Mike and Doug Starn/ARS, NY
(cat. no. 306)

* Brian Weil
Prince, Two-year-old with AIDS, New York City, 1986
gelatin silver print, 79.8 × 80.2 cm
University of Arizona, Collection Center for Creative Photography
(cat. no. 307)

* Brian Weil
Act Up "Day of Desperation," 42nd St. and Lexington Ave, New York City, 1991
gelatin silver print, 80.2 × 80.2 cm
University of Arizona, Collection Center for Creative Photography
(cat. no. 308)

* David Wojnarowicz
Untitled from "Sex Series (for Marion Scemama)",
1988–89
gelatin silver print, 88.3 × 94 cm
© The Estate of David Wojnarowicz. Courtesy
PPOW Gallery, New York
(cat. no. 309)

* David Wojnarowicz
Untitled from "Sex Series (for Marion Scemama)",
1988–89
gelatin silver print, 88.3 × 94 cm
© The Estate of David Wojnarowicz. Courtesy
PPOW Gallery, New York
(cat. no. 310)

Cinema

* William Friedkin
French Connection, 1971
Collection Les Cahiers du Cinéma
(cat. nos. 311-312)

* Alan Pakula
Klute, 1971
Collection Les Cahiers du Cinéma
© Warner Bros
(cat. no. 313)

* Sidney Lumet
Dog Day Afternoon, 1975
Collection Les Cahiers du Cinéma
© Warner Bros
(cat. no. 314)

* Martin Scorsese
Taxi Driver, 1976
Collection Les Cahiers du Cinéma
© Columbia Picture
(cat. no. 315)

Marco Ferreri
Ciao maschio, 1978
Collection Les Cahiers du Cinéma
(cat. no. 316)

Richard Donner
Superman, 1978
Collection Les Cahiers du Cinéma
(cat. no. 317)

* Woody Allen
Manhattan, 1979
Collection Les Cahiers du Cinéma
© United Artists
(cat. no. 318)

Martin Scorsese
Racing Bull, 1979
Collection Les Cahiers du Cinéma
(cat. no. 319)

* John Carpenter
New York 1997, 1980
Collection Les Cahiers du Cinéma
(cat. no. 320)

John Cassavetes
Gloria, 1980
Collection Les Cahiers du Cinéma
(cat. no. 321)

Sidney Lumet
Prince of the City, 1981
Collection Les Cahiers du Cinéma
© Warner Bros Pictures – Orion Pictures Corp.
(cat. no. 322)

Jim Jarmusch
Stranger than Paradise, 1984
Collection Les Cahiers du Cinéma
(cat. no. 323)

Performance and Video

Joan Jonas
The Juniper Tree, 1978
Courtesy Archivio Celant, Genoa
(cat. no. 324)

Joan Jonas
Double Lunar Dogs, 1980
Berkeley University Art Museum
(cat. no. 325)

* Dara Birnbaum
Technology/Transformation: Wonder Woman,
1978–79
video, 5:50 minutes, color, sound
Courtesy of the artist and Electronic Arts Intermix,
New York
(cat. no. 326)

Laurie Anderson
"Neon Duet" from her Show
"United States" Part I, 1980
Courtesy Paula Court
(cat. no. 327)

Diamanda Galas
Panoptikon, 1983
Performed at Brooklyn Academy of Music, 1983
Courtesy Paula Court
(cat. nos. 328-329)

Eric Bogosian as Ricky Paula,
The Ricky Paula Show, performed at White
Columns, 1979
Courtesy Paula Court
(cat. no. 330)

Philip Glass, 1980
Courtesy Archivio Celant, Genoa
(cat. no. 331)

Grommet Art Theatre, 1982
(cat. no. 332)

Tehching Hsieh
Performance, 1981–82
Courtesy Paula Court
(cat. no. 333)

Peter Gordon, Bill T. Jones, Arnie Zane, Keith
Haring and Willie Smith at a performance of *Secret
Pastures*, choreographed by Bill T. Jones in
collaboration with Arnie Zane, Brooklyn Academy
of Music, 1984
Courtesy Paula Court
(cat. no. 334)

Bill T. Jones and Arnie Zane in rehearsal for *Valley
Cottage*, The American Theater Laboratory, 1981.
First performed at Dance Theatre Workshop, 1980
Courtesy Paula Court
(cat. no. 335)

Bill T. Jones in the film *Two Moon July*,
The Kitchen, 1986
Courtesy Paula Court
(cat. no. 336)

Menthol Wars performing at Tier 3, New York, 1980
(cat. no. 337)

Ann Magnuson
Trial Dance, performed at The Kitchen, 1984
Courtesy Paula Court
(cat. no. 338)

Robert Longo
Iron Voices, performed at The Kitchen, 1982
Courtesy Paula Court
(cat. no. 339)

The Rock Steady Crew, performing
at The Kitchen, 1981
Courtesy Paula Court
(cat. no. 340)

Elizabeth Streb
Fall Line, performed at The Kitchen, 1982
Courtesy Paula Court
(cat. no. 341)

The Wooster Group
L.S.D. (... Just the High Points...), 1984
Courtesy Paula Court
(cat. no. 342)

Architecture

Minoru Yamasaki & Associates, Emery Rothe & Sons
World Trade Center, New York, 1973
© Esto
(cat. no. 343)

Philip Johnson & John Burgee
AT&T. Corporate Headquarters, New York, 1978–84
© Philip Johnson Alan Ritchie Architects
(cat. no. 344)

Philip Birnbaum, Philip Johnson & John Burgee
1001 Fifth Avenue, New York, 1979
© Philip Johnson Alan Ritchie Architects
(cat. no. 345)

Philip Johnson & John Burgee
33 Maiden Lane, New York, 1986
© Philip Johnson Alan Ritchie Architects
(cat. nos. 346-347)

Philip Johnson & John Burgee
Lipstick Building, New York, 1986
© Esto
(cat. no. 348)

Art

Vito Acconci
Run off, 1970
Body, sweat, blue tempera
Courtesy Archivio Celant, Genoa
Courtesy Gladstone Gallery
© Vito Acconci
(cat. nos. 349-352)

Vito Acconci
Rubbing Piece, 1970
Activity, arm, fingers, friction
Courtesy Archivio Celant, Genoa
Courtesy Gladstone Gallery
© Vito Acconci
(cat. nos. 353-356)

Vito Acconci
Voices for a Second Sight, 1974
Courtesy Archivio Celant, Genoa
Courtesy Gladstone Gallery
© Vito Acconci
(cat. no. 357)

Vito Acconci
Commando Performance, New York, 1974
Courtesy Archivio Celant, Genoa
Courtesy Gladstone Gallery
© Vito Acconci
(cat. nos. 358-360)

Walter De Maria
Silver Portrait of Dorian Gray, 1965
velvet on wood and silver, 104.5 × 79.1 × 10.8 cm
Private collection
(cat. no. 361)

Walter De Maria
The Color Men Choose When They, 1968
oil and stainless steel, 130 × 210 × 8 cm
Private collection
(cat. no. 362)

* Walter De Maria
Garbo Column, 1968
stainless steel, 182.9 × 10.8 × 10.2 cm
Private collection
(cat. no. 363)

* Walter De Maria
New York Eats Shit, 1970
pencil on white paper, 100 × 150 cm
Cologne, Speck Collection
(cat. no. 364)

Mark di Suvero
For Giacometti, 1962
wood and steel, 111.8 × 182.9 × 91.4 cm
Hartford, Wadsworth Atheneum Museum
of Art. Gift of an Anonymous donor
(cat. no. 365)

* Mark di Suvero
Quantum, 1986–87
steel sculpture, 405 × 610 × 535 cm
Germany, Collection Siegfried Weishaupt
Courtesy Gallery Hans Mayer, Germany
(cat. no. 366)

Joseph Kosuth
Thought, 1967
Courtesy Archivio Celant, Genoa
© Adagp, Paris 2006
(cat. no. 367)

Joseph Kosuth
Nothing, 1967
Courtesy Archivio Celant, Genoa
© Adagp, Paris 2006
(cat. no. 368)

* Joseph Kosuth
The Eight Investigation (A.A.I.A.I.), 1971 (first
installation)
12 texts, 12 clocks, small table and chairs, variable
dimensions
Bari, Angelo Raffaele Baldassarre Collection
© Adagp, Paris 2006
(cat. no. 369)

* Bruce Nauman
Henry Moore Bound to fail, 1967–70
cast iron, 64.8 × 61 × 6.4 cm
Rivoli (Turin), Castello di Rivoli Museo d'Arte
Contemporanea, Long term loan - Private
collection, Genoa
© Adagp, Paris 2006
(cat. no. 370)

* Bruce Nauman
*My Last Name Exaggerated Fourteen
Times Vertically*, 1967
pale purple neon tubing, 160 × 83.8 × 5.1 cm
Panza Collection
© Adagp, Paris 2006
(cat. no. 371)

Bruce Nauman
*My Name as Though It Were Written
on the Surface of the Moon*, 1968
neon, 28 × 635 × 5 cm
Rovereto, MART, Museo di Arte Moderna
e Contemporanea di Trento e Rovereto,
deposit of the Ileana Sonnabend Collection
© Adagp, Paris 2006
(cat. no. 372)

Richard Serra
White Neon Belt Piece, 1967
mixed media, 190 × 50 × 30 cm
Krefeld, Kaiser Wilhelm Museum
© Adagp, Paris 2006
(cat. no. 373)

* Richard Serra
House of Cards 1, 1968–98
four steel plates, 138 × 138 × 2.5 cm
Germany, private collection
Courtesy Gallery Hans Mayer, Germany
© Adagp, Paris 2006
(cat. no. 374)

Richard Serra
Five Plates Counter Clockwise Pentagon, 1987
steel, 170 × 250 × 5 cm
Weitmar, Galerie M. Bochum
(cat. no. 375)

Robert Smithson
*Non-Site: Line of Wreckage (Bayonne,
New Jersey)*, 1968
painted aluminum, broken concrete,
framed map and three photo panels, cage,
149.9 × 177.8 × 31.7 cm
Milwaukee Art Museum, Purchase, National
Endowment for the Arts Matching Funds
© Adagp, Paris 2006
(cat. no. 376)

Robert Smithson
Eight-Part Piece (Cayuga Salt Mine Project)
salt from rocks, mirrors and wood,
27.9 × 76.2 × 914.4 cm
Copenhagen, Statens Museum for Kunst
© Adagp, Paris 2006
(cat. no. 377)

Richard Tuttle
Genitron, 1967
canvas, 169 × 110 cm
Bari, Angelo Raffaele Baldassarre Collection
(cat. no. 378)

Richard Tuttle
Untitled (Wood Slat piece at Galleria Toselli), 1974
wood
(cat. no. 379)

Richard Tuttle
*Installation at the exhibition
"Pittura/Ambiente"*, 1979
installation, mixed media on paper
(cat. no. 380)

Richard Tuttle
*Installation at the exhibition
"Pittura/Ambiente"*, 1979
installation, mixed media on paper
(cat. no. 381)

* Lawrence Weiner
A Rubber Ball Thrown on the Sea, Cat. N. 146, 1969
cut letters stuck on wall, variable dimensions
Panza Collection
© Adagp, Paris 2006
(cat. no. 382)

Lawrence Weiner
A Stone Left Unturned, Cat. N. 150, 1970
language and the materials referred to,
variable dimensions
Panza Collection
© Adagp, Paris 2006
(cat. no. 383)

Chuck Close
Self Portrait, 1977
watercolor on paper mounted on canvas,
205.7 × 149.2 cm
Vienna, MUMOK, Museum Moderner Kunst
Stiftung Ludwig
© Chuck Close. Courtesy PaceWildenstein,
New York
(cat. no. 384)

* Chuck Close
Stanley, 1980–81
oil on canvas, 274.3 × 213.4 cm
New York, Solomon R. Guggenheim Museum.
Purchased with funds contributed by Mr. and Mrs.
Barrie M. Damson, 1981
© Chuck Close. Courtesy PaceWildenstein,
New York
(cat. no. 385)

* Richard Estes
*On the Staten Island Ferry Looking
Toward Manhattan*, 1989
oil on linen, painting, photorealism,
100.33 × 185.42 cm
New York, Louis K. Meisel Collection
(cat. no. 386)

* Richard Estes
Diner, 1971
oil on canvas, 110 × 130 cm
Washington DC, Hirshhorn Museum
and Sculpture Garden, Smithsonian Institution,
Museum Purchase 1977
(cat. no. 387)

Richard Estes
Hotel Empire, 1987
oil on canvas, 95.25 × 220.98 cm
New York, Louis K. Meisel Collection
(cat. no. 388)

* Duane Hanson
Housewife, 1969–70
fiberglass sculpture, 112 × 90 × 155 cm
Oslo, Astrup Fearnley Collection
© Adagp, Paris 2006
(cat. no. 389)

Duane Hanson
Homeless, 1991
mixed media, height 168 cm
Hamburg, Kunsthalle/The Bridgeman Art Library
/Alinari
© Adagp, Paris 2006
(cat. no. 390)

Alex Katz
Paul Taylor, 1959
oil on canvas, 170 × 187.5 cm
Courtesy Jablonka Gallery, Germany
© Adagp, Paris 2006
(cat. no. 391)

* Alex Katz
John and David, 1977
oil on linen, 182.9 × 243.8 cm
Courtesy PaceWildenstein, New York
© Adagp, Paris 2006
(cat. no. 392)

Alex Katz
The Yellow House, 1985
oil on canvas, 244 × 274 cm
Private collection
Courtesy Galerie Thaddaeus Ropac, Paris/Salzburg
© Adagp, Paris 2006
(cat. no. 393)

* Alex Katz
Morning Nude, 1982
oil on canvas, 243.8 × 182.9 cm
Courtesy Galerie Thaddaeus Ropac, Paris/Salzburg
© Adagp, Paris 2006
(cat. no. 394)

Photography

* James Casebere
Nevisian Underground #2, 2001
digital chromogenic print mounted to plexiglas,
edition of 3 with 1 AP, 195.6 × 121.9 cm each panel
Courtesy Sean Kelly Gallery, New York
(cat. no. 395)

* James Casebere
Georgian Jail Cages, 1993
dye destruction print, edition 3 of 5, 76.2 × 101.6 cm
Courtesy Sean Kelly Gallery, New York
(cat. no. 396)

* James Casebere
Converging Hallways From Left, 1997
cibachrome mounted on aluminum, edition
of 5 with 2APs, 122 × 170 cm
Courtesy Sean Kelly Gallery, New York
(cat. no. 397)

* Lois Conner
St. George's Hotel, New York, New York, 1991
gelatin silver print, 50.8 × 101.6 cm
© Lois Conner
(cat. no. 398)

* Lois Conner
New York, New York, 2004
gelatin silver print, 50.8 × 101.6 cm
© Lois Conner
(cat. no. 399)

* Lois Conner
Beijing, Tiananmen Square, China, 1998
gelatin silver print, 50.8 × 101.6 cm
© Lois Conner
(cat. no. 400)

* Lois Conner
Xizhimen, Beijing, China, 2005
gelatin silver print, 50.8 × 101.6 cm
© Lois Conner
(cat. no. 401)

* Gregory Crewdson
Untitled (Ophelia), 2001
digital cibachrome print, 121.9 × 152.4 cm
Private collection
Courtesy White Cube, London
© Gregory Crewdson
(cat. no. 402)

* Gregory Crewdson
*Untitled (Man in Living Room with Hole) 'Beneath
the Roses'*, 2005
digital cibachrome print, edition 6 of 6,
144.8 × 223.6 cm
Private collection
Courtesy White Cube, London
© Gregory Crewdson
(cat. no. 403)

* Philip Lorca diCorcia
Head #01, 2001
fujicolor crystal archive print mounted
to plexiglas, 122 × 152.4 cm
© Philip Lorca diCorcia, Courtesy Pace/MacGill
Gallery, New York
(cat. no. 404)

* Philip Lorca diCorcia
Head #19, 2000
cibachrome print on fuji crystal archive paper,
122 × 152.4 cm
© Philip Lorca diCorcia, Courtesy Pace/MacGill
Gallery, New York
(cat. no. 405)

* Philip Lorca diCorcia
Head #24, 2000
fujicolor crystal archive print mounted
to plexiglas, 122 × 152.4 cm
© Philip Lorca diCorcia, Courtesy Pace/MacGill
Gallery, New York
(cat. no. 406)

* Philip Lorca diCorcia
Head #09, 2000
fujicolor crystal archive print mounted
to plexiglas, 122 × 152.4 cm
© Philip Lorca diCorcia, Courtesy Pace/MacGill
Gallery, New York
(cat. no. 407)

* Mitch Epstein
Untitled, New York (from "The City"), 1995
fuji type C crystal archive, 101 × 124 cm
Courtesy Sikkema Jenkins & Co., New York
(cat. no. 408)

* Mitch Epstein
Vietnam Veteran's Parade, New York City, 1973
(from *"Recreation"*, 2005)
dye transfer print, 50.8 × 61 cm
Courtesy Sikkema Jenkins & Co., New York
(cat. no. 409)

* Mitch Epstein
Madison Avenue, New York City, 1973
(from *"Recreation"*, 2005)
dye transfer print, 50.8 × 61 cm
Courtesy Sikkema Jenkins & Co., New York
(cat. no. 410)

* Mitch Epstein
West Side Highway, New York, 1977
(from *"Recreation"*, 2005)
cibachrome print, printed 2006, 50.8 × 61 cm
Courtesy Sikkema Jenkins & Co., New York
(cat. no. 411)

* Donna Ferrato
A Pennsylvania Policeman Tried to Console a woman Who Had Been Kicked in the Head, 1983
silver gelatin print, 35 mm, 50.8 × 61 cm
© Donna Ferrato
(cat. no. 412)

* Donna Ferrato
Early in the day, Garth tried to drag Lisa into the house because he couldn't find his cocaine pipe. Their three-year-old son cried so hysterically, that Garth let go of Lisa. He returned to the bedroom and stayed there brooding for the rest of the day, 1982
silver gelatin print, 35 mm, 50.8 × 61 cm
© Donna Ferrato
(cat. no. 413)

* Donna Ferrato
During the middle of the night, garth cornered Lisa in their bathroom, still hunting for his cocaine pipe. Suddenly, enraged, he hit Lisa, 1982
silver gelatin print, 35 mm, 50.8 × 61 cm
© Donna Ferrato
(cat. no. 414)

* Andres Serrano
The Unknown Christ, 1984
cibachrome, silicone, plexiglas, wood frame, edition 1 of 10, 69.9 × 101.6 cm
Courtesy Paula Cooper Gallery, New York
(cat. no. 415)

* Andres Serrano
Pietà, 1985
cibachrome, silicone, plexiglas, wood frame, edition 5 of 10, 69.9 × 101.6 cm
Courtesy Paula Cooper Gallery, New York
(cat. no. 416)

* Andres Serrano
Budapest (The Model), 1994
cibachrome, silicone, plexiglas, wood frame, edition 5 of 7, 101.6 × 82.6 cm
Courtesy Paula Cooper Gallery, New York
(cat. no. 417)

* Laurie Simmons
Bending Globe, 1991
cibachrome print, 121.9 × 213.4 cm
Courtesy of the artist and Sperone Westwater, New York
© Laurie Simmons
(cat. no. 418)

* Laurie Simmons
The Instant Decorator (Pink Bedroom), 2001
flex print, 76.2 × 101.6 cm
Courtesy of the artist and Sperone Westwater, New York
© Laurie Simmons
(cat. no. 419)

* Laurie Simmons
The Instant Decorator (Plaid Living Room), 2004
flex print, 76.2 × 96.5 cm
Courtesy of the artist and Sperone Westwater, New York
© Laurie Simmons
(cat. no. 420)

* Lorna Simpson
Untitled (Yellow Hat), 2001
archival gelatin prints under semi transparent plexiglas with black vinyl lettering in wooden frame, edition of 3, 1AP, 155 × 104.1 cm
Courtesy Sean Kelly Gallery, New York
(cat. no. 421)

* Lorna Simpson
Untitled (Two Girls), 2001
Archival gelatin prints under semi transparent plexiglas with black vinyl lettering in wooden frame, edition of 3, 1AP, 155 × 104.1 cm
Courtesy Sean Kelly Gallery, New York
(cat. no. 422)

* Lorna Simpson
Untitled (Man on Bench), 2001
archival gelatin prints under semi transparent plexiglas with black vinyl lettering in wooden frame, edition of 3, 1AP, 155 × 104.1 cm
Courtesy Sean Kelly Gallery, New York
(cat. no. 423)

* Lorna Simpson
Untitled (The Bride or The Beloved), 2001
archival gelatin prints under semi transparent plexiglas with black vinyl lettering in wooden frame, edition of 3, 1AP, 155 × 104.1 cm
Courtesy Sean Kelly Gallery, New York
(cat. no. 424)

Cinema

* Tim Burton
Batman, 1989
Collection Les Cahiers du Cinéma
© 1989 DC Comics Inc
(cat. no. 425)

* Spike Lee
Do the Right Thing, 1989
Collection Les Cahiers du Cinéma / D. Rabourdin
© Universal Pictures
(cat. no. 426)

Woody Allen
Manhattan Murder Mistery, 1993
Collection Les Cahiers du Cinéma
© 1993 Tristar pictures Inc
(cat. no. 427)

* Abel Ferrara
The Bad Lieutenant, 1993
Collection Les Cahiers du Cinéma
© Odyssey Distributor
(cat. no. 428)

Abel Ferrara
The Funeral, 1996
Collection Les Cahiers du Cinéma
(cat. no. 429)

* Edo Bertoglio
Downtown 81, 1998
Collection Les Cahiers du Cinéma
© New York Beat Films
(cat. no. 430)

Spike Lee
Summer of Sam, 1999
Collection Les Cahiers du Cinéma
© Touchstone Pictures Company
(cat. no. 431)

Amos Kollek
Fast Food Fast Women, 2000
Collection Les Cahiers du Cinéma
(cat. no. 432)

Sam Raimi
Spider Man, 2002
Collection Les Cahiers du Cinéma
© Columbia Pictures
(cat. no. 433)

Performance and Video

Reza Abdoh
Law of Remains, 1992
Courtesy Paula Court
(cat. no. 434)

Reza Abdoh
Quotations from a Ruined City, 1994
Courtesy Paula Court
(cat. nos. 435-436)

DJ Spooky
Rebirth of a Nation, 2004
Courtesy of the Museum of Contemporary Art, Chicago
(cat. no. 437)

Gogol Bordello at the 2002 Whitney Biennal
Courtesy Paula Court
(cat. no. 438)

Karen Finley
Theory of Total Blame, 1988
Courtesy Paula Court
(cat. no. 439)

Molissa Fenley
State of Darkness, performed at the Joyce Theater, 1990. First performed as a commission by the American Dance Festival, 1988
Courtesy Paula Court
(cat. no. 440)

John Kelly
Mona Lisa, 1986
Courtesy Paula Court
(cat. no. 441)

John Jesurun
Shatterhand Massacre, 1987
Courtesy Paula Court
(cat. no. 442)

Architecture

Lebbeus Woods, Michael Sorkin, John Young
Time Square, New York, 1989
(cat. nos. 443-449)

Renzo Piano
Morgan Library, New York, 2006
© Artedia/Michel Denancé/Renzo Piano
(cat. no. 450)

Raimund Abraham
Austrian Culture Forum, New York, 1998-2001
© Esto
(cat. no. 451)

IM Pei & Frank Williams
Four Seasons Apartment House, New York, 1993
© Esto
(cat. no. 452)

Skidmore, Owings & Merrill
AOL Time Warner Building/Colombus Circle, New York, 1993
© Esto
(cat. no. 453)

Pei Cobb Freed & Partners, Henry N. Cobb
Guy Nordenson & Associates
The Seven Stems Broadcast Tower, New York
(cat. no. 454)

Costas Kondylis & Partners
Trump World Tower at United Nations Plaza, New York, 1997
© Esto
(cat. no. 455)

Sejima & Nishizawa / Sanaa
New Museum of Contemporary Art, New York, 2003
(cat. no. 456)

Richard Meier
Charles Street Apartments, New York
© Esto
(cat. no. 457)

Zaha Hadid
Installation view of "Zaha Hadid", Solomon R. Guggenheim Museum, New York, 2006
Courtesy of the Solomon R. Guggenheim
© SRGF, New York
(cat. no. 458)

Art

* Laurie Anderson
Jukebox, 1977
jukebox with 45 rpm records, photo-collage
written text in pencil on paper, 10 photo-collages,
76 × 57 cm
Courtesy of the artist and Sean Kelly Gallery,
New York
(cat. no. 459)

Laurie Anderson
Still from video performance used for record cover "Bright Red", 1993
4 of 7 photographs, 28.5 × 36.3 cm each
Courtesy Fondazione Prada, Milan
(cat. no. 460)

Matthew Barney
ENVELOPA: Drawing Restraint 7 (manual), 1993
graphite and synthetic polymer on paper in
prosthetic plastic frame, 47 × 49.5 × 3.8 cm
Courtesy of the Fischer Landau Center for Art,
New York
© 1993 Matthew Barney
(cat. nos. 461-464)

* Matthew Barney
The Cabinet of Harry Houdini, 1999
cast nylon, salt, epoxy resin, woven
polypropylene, prosthetic plastic and beeswax,
212.4 × 152.6 × 185.4 cm
Oslo, Astrup Fearnley Collection
© 1999 Matthew Barney
(cat. no. 465)

* Matthew Barney
Cremaster 2, 1999
production still
Courtesy Gladstone Gallery, New York
© 1999 Matthew Barney
(cat. nos. 466-468)

Jean-Michel Basquiat
Versus Medici, 1982
acrylic and oilstick on canvas, 213 × 136 cm
Bruckner Collection
© Adagp, Paris 2006
(cat. no. 469)

Jean-Michel Basquiat
King of the Zulus, 1984–85
acrylic, oilstick and xerox collage
on canvas, 208 × 173 cm
Marseille, Collection [MAC] Musée d'Art
Contemporain
© Adagp, Paris 2006
(cat. no. 470)

* Jean-Michel Basquiat
Touissant l'Overture versus Savonarola, 1983
acrylic, oilstick, and xerox collage on canvas,
122 × 584 cm
Zurich, Collection Bischofberger
© Adagp, Paris 2006
(cat. no. 471)

* Jean-Michel Basquiat
Zydeco, 1984
acrylic and oilstick on canvas, 218.5 × 518 cm
Zurich, Collection Bischofberger
© Adagp, Paris 2006
(cat. no. 472)

John Currin
The Neverending Story, 1994
oil on canvas, 121.9 × 96.5 cm
Private collection
© 2006 John Currin
(cat. no. 473)

* John Currin
The Cripple, 1997
oil on canvas, 111.8 × 91.4 cm
Hort Family Collection
© 2006 John Currin
(cat. no. 474)

* John Currin
The Old Fence, 1999
oil on canvas, 193.04 × 101.60 cm
Pittsburgh, Carnegie Museum of Art, A.W. Mellon
Acquisition Endowment Fund
© 2006 John Currin
(cat. no. 475)

* John Currin
Anna, 2004
oil on canvas, 61 × 45.7 cm
Santa Monica, The Broad Art Foundation
© 2006 John Currin
(cat. no. 476)

Eric Fischl
Sleepwalker, 1979
oil on canvas, 114.3 × 175.2 cm
© Eric Fischl. Courtesy Mary Boone Gallery,
New York
(cat. no. 477)

* Eric Fischl
Untitled, 1982
oil on canvas, 213.4 × 213.4 cm
Santa Monica, The Broad Art Foundation
© Eric Fischl. Courtesy Mary Boone Gallery,
New York
(cat. no. 478)

* Eric Fischl
Bayonne, 1986
oil on canvas, 2 panels, 259 × 336 cm
Private collection
Courtesy Thomas Ammann Fine Art, Zurich
© Eric Fischl. Courtesy Mary Boone Gallery,
New York
(cat. no. 479)

Eric Fischl
*Bedroom Scene #4 (You Leave Your Lover
to Answer the Phone)*, 2004
oil on linen, 187.8 × 274.32 cm
© Eric Fischl. Courtesy Mary Boone Gallery,
New York
(cat. no. 480)

* Tom Friedman
White Cloud, 1989
toilet paper and string, 457 × 122 × 122 cm
Courtesy Gagosian Gallery, New York
(cat. no. 481)

* Tom Friedman
Inside-Out, 1991–2006
mixed media, 66.7 × 472.4 × 139.7 cm
Courtesy Gagosian Gallery, New York
(cat. no. 482)

* Robert Gober
Playpen, 1986
enamel paint on canvas, 66.3 × 99 × 99 cm
Zurich, Daros Collection
(cat. no. 483)

* Robert Gober
Split-up Conflicted Sink, 1985
plaster, wood, chicken wire, steel, medium
gloss enamel paint, 207 × 296 × 64 cm
Oslo, Astrup Fearnley Collection
(cat. no. 484)

Felix Gonzalez-Torres
"Untitled" (A Love Meal), 1992
variable dimensions, 42 light bulbs, electric wire
Turin, Sandretto Re Rebaudengo Collection
© The Felix Gonzalez-Torres Foundation
(cat. no. 485)

* Felix Gonzalez-Torres
"Untitled" (Blue Placebo), 1991
candies individually wrapped in blue cellophan,
endless supply, variable dimensions
Oslo, Astrup Fearnley Collection
© The Felix Gonzalez-Torres Foundation
(cat. no. 486)

* Keith Haring
Untitled (June 4), 1984
enamel on wood, 216 × 200 cm
Private collection
Courtesy Galleria Salvatore + Caroline Ala, Milan
Keith Haring artwork © Estate of Keith Haring
(cat. no. 487)

* Keith Haring
Untitled (June 5), 1984
enamel on wood, 300 × 151 cm
Private collection
Courtesy Galleria Salvatore + Caroline Ala, Milan
Keith Haring artwork © Estate of Keith Haring
(cat. no. 488)

* Keith Haring
Untitled (June 5), 1984
enamel on wood, 330 × 100 cm
Private collection
Courtesy Galleria Salvatore + Caroline Ala, Milan
Keith Haring artwork © Estate of Keith Haring
(cat. no. 489)

* Keith Haring
Untitled (June 5), 1984
enamel on wood, 350 × 90 cm
Private collection
Courtesy Galleria Salvatore + Caroline Ala, Milan
Keith Haring artwork © Estate of Keith Haring
(cat. no. 490)

* Keith Haring
Untitled (June 5), 1984
enamel on wood, 350 × 100 cm
Private collection
Courtesy Galleria Salvatore + Caroline Ala, Milan
Keith Haring artwork © Estate of Keith Haring
(cat. no. 491)

* Keith Haring
Untitled (June 5), 1984
enamel on wood, 277 × 90 cm
Private collection
Courtesy Galleria Salvatore + Caroline Ala, Milan
Keith Haring artwork © Estate of Keith Haring
(cat. no. 492)

Jenny Holzer
From *Truism*, 1996
electronic signs, 245 × 395 cm each
installation, baggage, carousel
Las Vegas, McCarran International Airport, 1986
organized by Nevada Institute of Contemporary Art,
University of Nevada, Las Vegas
© Adagp, Paris 2006
(cat. no. 493)

* Jenny Holzer
Red and Yellow Looming, 2004
13 double-sided electronic signs with red and amber
diodes, 276.86 × 13.34 × 10.16 (each LED)
Courtesy Monika Sprüth, Philomene Magers,
Cologne, Munich
© Adagp, Paris 2006
(cat. no. 494)

* Jeff Koons
Fisherman Golfer, 1986
Stainless steel, 30.5 × 12.7 × 20.3 cm
Venice, Attilio Codognato
© Jeff Koons
(cat. no. 495)

* Jeff Koons
Mermaid Troll, 1986
Stainless steel, 51.2 × 21.6 × 21.6 cm
Venice, Attilio Codognato
© Jeff Koons
(cat. no. 496)

* Jeff Koons
String of Puppies, 1988
polychromed wood, 106.7 × 157.5 × 94 cm
Santa Monica, The Broad Art Foundation
© Jeff Koons
(cat. no. 497)

* Jeff Koons
Bear and Policeman, 1988
colored sculpted wood, 215 × 110 × 83 cm
Kunstmuseum Wolfsburg
© Jeff Koons
(cat. no. 498)

* Robert Longo,
Untitled (Men in the cities - 3 Erics), 1980–2000
flashe, graphite, charcoal on paper,
244 × 152 cm
Courtesy Galleria d'Arte Contemporanea Emilio
Mazzoli, Modena
© Robert Longo
(cat. nos. 499-501)

Robert Longo
Pressure, 1982–83
lacquer on wood, charcoal, graphite and ink
on paper, 258 × 229 × 96 cm
New York, Museum of Modern Art
© Robert Longo
(cat. no. 502)

* Robert Longo
Jerk Face, 1985
painted aluminum and light, 266 × 290 × 90 cm
Private collection
Courtesy Lia Rumma, Naples
© Robert Longo
(cat. no. 503)

Tony Oursler
White Trash & Phobic, 1993
video installation, 2 human scale figures in fabric,
video projector, variable dimension
Turin, Sandretto Re Rebaudengo Collection
© Tony Oursler
(cat. no. 504)

* Tony Oursler
Autochtonous Too High, 1995
video and mixed media, 195 × 210 × 120 cm;
video 11 minutes 16 seconds
Bordeaux, CAPC, Musée d'Art Contemporain
de Bordeaux
© Tony Oursler
(cat. no. 505)

* Richard Prince
Untitled (Cowboy), 1998
ektacolor photograph, 150.5 × 210.8 cm
Courtesy of the artist and Gladstone Gallery, New
York
© 1998 Richard Prince
(cat. no. 506)

* Richard Prince
I'm in a Limousine (Following a Hearse), 2005–06
acrylic on canvas with canceled
checks, 284.8 × 508 cm
Courtesy The Dakis Joannou Collection, Athens
© 2006 Richard Prince
(cat. no. 507)

* Susan Rothenberg
Bone Heads, 1989–90
oil on canvas, 195.6 × 386.1 cm
Santa Monica, The Broad Art Foundation
© Adagp, Paris 2006
(cat. no. 508)

Susan Rothenberg
Withall, 1982
oil on canvas, 165.5 × 312 cm
Amsterdam, Stedelijk Museum
© Adagp, Paris 2006
(cat. no. 509)

* Tom Sachs
Nutsy's 1/1 McDonald's v. 2, 2003
wood, metal, soda, hamburger, floor tikles, heat
lamp, fluorescent lights, 17" LCD monitor,
DVD player, Loudspeaker 2, 2 small speakers,
pornography, DVD 10 minutes,
264.2 × 208.3 × 264.2 cm
Belgium, private collection
Courtesy Tomio Koyama Gallery, New York
© Tom Sachs
(cat. nos. 510-513)

* David Salle
The Happy Writers, 1981
acrylic and oil on canvas, 183 × 366 cm
Zurich, Collection Bischofberger
© Adagp, Paris 2006
(cat. no. 514)

* David Salle
B.A.M.F.V., 1983
mixed media on canvas, satin, 257 × 372 × 38 cm
Zurich, Collection Bischofberger
© Adagp, Paris 2006
(cat. no. 515)

Julian Schnabel
Ornamental Despair, 1980
oil on velvet, 229 × 427 cm
Zurich, Collection Bischofberger
(cat. no. 516)

Julian Schnabel
Affection for Surfing, 1983
broken ceramics, bondo and oilpaint on wood
with woodpiece and bronze, 274 × 580 × 61 cm
Zurich, Collection Bischofberger
(cat. no. 517)

* Julian Schnabel
Balzac, 1983
bronze, 505 × 116.99 × 116.99 cm
Zurich, Collection Bischofberger
(cat. no. 518)

Julian Schnabel
Self-Portrait with Champagne Glass, 1987–90
bronze and oil, 388 × 113 × 75 cm
Zurich, Collection Bischofberger
(cat. no. 519)

Joel Shapiro
Untitled, 1975
metal
Collection of the artist
© Adagp, Paris 2006
(cat. no. 520)

Joel Shapiro
Untitled, 1974
iron
Milan, Galleria Salvatore + Caroline Ala
© Adagp, Paris 2006
(cat. no. 521)

* Joel Shapiro
Untitled, 1985
bronze, edition 3 of 3, 247.7 × 222.3 × 221 cm
Courtesy PaceWildenstein, New York
© Adagp, Paris 2006
(cat. no. 522)

* Kiki Smith
Untitled, 1994
white bronze, glass bead blanket, 84 × 44 × 49 cm,
blanket: variable dimensions
Greece, Dimitris Daskalopoulos Collection
© Kiki Smith. Courtesy PaceWildenstein, New York
(cat. no. 523)

Kiki Smith
Mermaids, 2001
bronze, variable dimensions
Courtesy Galleria Raffaella Cortese, Milan
© Kiki Smith. Courtesy PaceWildenstein, New York
(cat. no. 524)

Haim Steinbach
Subtle Cork Brown, 1984
plastic laminated wooden shelf, driftwood,
2 thermoses, 76 × 127 × 38 cm
Rivoli (Turin), Castello di Rivoli Museo d'Arte
Contemporanea, Long-term private loan
- Private collection, Genoa
(cat. no. 525)

Haim Steinbach
Gelded Eyes #4, 1987–90
plastic laminated wooden shelf, 2 latex masks,
5 ceramic eggs sculptures, 103.5 × 162.6 × 54.6 cm
Rivoli (Turin), Castello di Rivoli Museo d'Arte
Contemporanea, Long-term private loan
- Private collection, Genoa
(cat. no. 526)

* Haim Steinbach
Coat of Arms, 1988
mixed media, 297 × 427 × 148 cm
Rivoli (Turin), Castello di Rivoli Museo
d'Arte Contemporanea
(cat. no. 527)

* Kara Walker
Campton Town Ladies, 1998
cut paper and adhesive on wall, variable dimensions
Miami, Rubell Family Collection
(cat. no. 528)

* Sue Williams
Red Flouncy (Go Team), 1997
oil and acrylic on canvas, 208 × 264 cm
New York, Collection of Jeanne Greenberg Rohatyn
and Nicolas Rohatyn
Courtesy of the artist and David Zwirner, New York
(cat. no. 529)

* Sue Williams
Pale Orange and Red, 1996
oil and acrylic on canvas, 264 × 249 cm
Greece, Dimitris Daskalopoulos Collection
Courtesy of the artist and David Zwirner, New York
(cat. no. 530)

* Christopher Wool
Untitled, 1989
alkyd and acrylic on aluminum, 243.8 × 162.5 cm
Santa Monica, The Broad Art Foundation
Courtesy of the artist and Luhring Augustine,
New York
(cat. no. 531)

* Christopher Wool
Untitled, 1989
alkyd and acrylic on aluminum, 243.8 × 183 cm
Santa Monica, The Broad Art Foundation
Courtesy of the artist and Luhring Augustine,
New York
(cat. no. 532)

* Christopher Wool
I Smell a Rat, 1989–94
alkyd and acrylic on aluminum, 183 × 122 cm
Santa Monica, The Broad Art Foundation
Courtesy of the artist and Luhring Augustine,
New York
(cat. no. 533)

Christopher Wool
Untitled, 1989
alkyd and acrylic on aluminum, 228.6 × 152.4 cm
Courtesy of the artist and Luhring Augustine,
New York
(cat. no. 534)

List of Works in the Exhibition

Art

* Vito Acconci
Tests and Measures, 1972
5 black & white photographs, marker
and chalk on board (5 parts a, b, c, d, e)
99.1 × 50.8 cm (each framed)
Courtesy Gladstone Gallery, New York

* Carl Andre
81 Steel Cardinal, 1989
81 steel plates, total: 450 × 450 × 5 cm
Cologne, Speck Collection

* Richard Artschwager
Basket, Mirror, Window, Rug, Table, Door, 1985
acrylic on celotex, 136.5 × 142.9 cm
California, Frederick R. Weisman Art Foundation

* Richard Artschwager
Office Scene, 1966
acrylic on celotex with metal frame, 96.8 × 96.8 cm
Kunstmuseum Wolfsburg

* Jean-Michel Basquiat
Dustheads, 1982
acrylic and oil stick on canvas, 183 × 213.4 cm
Tiqui Atencio Collection

* Felix Gonzalez-Torres
"Untitled" (America), 1994–95
twelve lightstrings, each with 42 15-watt lightbulbs
and rubber sockets, variable dimensions
Whitney Museum of American Art. Purchase,
with funds from the Contemporary Painting
and Scultpure Committee

* Keith Haring
Untitled, 1983
vinyl paint on vinyl curtain, 307 × 307 cm
Milan, private collection
Courtesy Galleria Salvatore + Caroline Ala, Milan

* Keith Haring
Untitled (June 5), 1984
enamel on wood, 350 × 100 cm
Milan, private collection
Courtesy Galleria Salvatore + Caroline Ala, Milan

* Jasper Johns
Untitled, 1991
encaustic and sand on canvas
129.2 × 89.8 cm
Santa Monica, The Eli and Edythe L. Broad
Foundation

* Ellsworth Kelly
Blue, Red, Orange, 1964–65
oil on canvas, 190 × 180 cm
Sondra Gilman Collection

* Sol LeWitt
Wall Drawing Number 8, 1970
tissue paper cut into 4 cm squares, rolled
and inserted into holes in grey pegboard walls,
all holes in the walls are filled randomly. First
wall: white; second wall: white yellow; third
wall: white yellow red; fourth wall: white yellow
red blue, variable dimensions
Panza Collection

* Roy Lichtenstein
Girl with Tear III, 1977
oil and magna on canvas, 117 × 101.5 cm
Riehen (Basel), Fondation Beyeler

* Morris Louis
Beth Peh, 1958
acrylic on canvas, 240 × 340 cm
Courtesy Mr. & Mrs. David Mirvish, Toronto

* Brice Marden
Untitled N°1, 1986
oil on linen, 183 × 147 cm
Zurich, Daros Collection

* Robert Motherwell
Elegy to the Spanish Republic, 1970
acrylic on canvas, 200 × 480 cm
Courtesy Mr. & Mrs. David Mirvish, Toronto

* Bruce Naumann
Self-Portrait As Fountain, 1966
photography, 50.2 × 58.4 cm
Bari, Angelo Raffaele Baldassarre Collection

* Barnett Newman
The Name I, 1949
oil on canvas, 122 × 152.5 cm
Zurich, Daros Collection

* Claes Oldenburg
Three-Way Plug, 1969
wood and masonite, 149.9 × 99 × 72.4 cm
Courtesy Onnasch Collection, Berlin

* Nam June Paik
Andy Warhol Robot, 1968
mixed media, 300 × 287 × 76 cm
Kunstmuseum Wolfsburg

* Jackson Pollock
Untitled, c. 1949
Fabrics, paper, cardboard, enamel paint and
aluminum paint on pavatex, 78.5 × 57.5 cm
Riehen (Basel), Fondation Beyeler

* Robert Rauschenberg
Dylaby, 1962
"combines paintings": oil, metal objects, metal
spring, metal Coca-Cola sign, ironing board and
twine on un stretched canvas on tarp on wooden
support, 278 × 221 × 38 cm
Courtesy Sonnabend Gallery, New York

* Ad Reinhardt
Blue and Gray, 1950
oil on canvas, 152.4 × 91.44 × 5 cm
New York, Kojaian Ventures, LLC

* Mark Rothko
Untitled, 1947
oil on charcoal on canvas, 224 × 146.2 cm
Baden-Baden, Museum Frieder Burda

* Julian Schnabel
The Exile, 1980
oil, antlers, gold leaf and mixed media
on wood, 228.6 × 304.8 cm
Switzerland, Bischofberger Collection

* Julian Schnabel
Blue Nude with Sword, 1979–80
Broken ceramics, bondo, oil and wax on wood, 244
× 274. 5 cm
Switzerland, Bischofberger Collection

* Cindy Sherman
Untitled #22
Color photograph
Greece, Dimitris Daskalopoulos Collection

* David Smith
Euterpe and Terpsichore, 1946
bronze on artist's wood base,
bronze: 39.4 × 59.1 × 23.5 cm;
base: 10.2 × 45.1 × 17.8 cm
The Estate of David Smith, Courtesy Gagosian
Gallery

* Frank Stella
Bonne Bay I, 1969
acrylic on canvas, 305 × 610 cm
Berlin, Onnasch Collection

* Clyfford Still
1951-D
oil on canvas, 297.2 × 266.7 cm
Private collection

* Andy Warhol
Four Marilyn (Reversal series), 1979–86
Silskreen on acrylic on canvas
92 × 80 cm
Monaco, private collection

Photography

* Diane Arbus
A castle in Disneyland, Cal., 1962
gelatin silver print, 50.8 × 40.6 cm
Courtesy Robert Miller Gallery, New York

* Diane Arbus
Triplets in their bedroom, N.J., 1963
gelatin silver print, 50.8 × 40.6 cm
Courtesy Robert Miller Gallery, New York

* Diane Arbus
*Russian midget friends in a living room on 100th
Street, NYC*, 1963
gelatin silver print, 50.8 × 40.6 cm
Courtesy Robert Miller Gallery, New York

* Diane Arbus
Teenage couple on Hudson Street, NYC, 1963
gelatin silver print, 50.8 × 40.6 cm
Courtesy Robert Miller Gallery, New York

* Diane Arbus
*A young man and his pregnant wife in Washington
Square Park, NYC*, 1965
gelatin silver print, 50.8 × 40.6 cm
Courtesy Robert Miller Gallery, New York

* Diane Arbus
A family one evening in a nudist camp, Pa., 1965
gelatin silver print, 50.8 × 40.6 cm
Courtesy Robert Miller Gallery, New York

* Diane Arbus
A child crying, N.J., 1967
gelatin silver print, 50.8 × 40.6 cm
Courtesy Robert Miller Gallery, New York

* Diane Arbus
Four people at a gallery opening, NYC, 1968
gelatin silver print, 50.8 × 40.6 cm
Courtesy Robert Miller Gallery, New York

* Diane Arbus
Woman with a veil on Fifth Avenue, NYC, 1968
gelatin silver print, 50.8 × 40.6 cm
Courtesy Robert Miller Gallery, New York

* Diane Arbus
Man at a parade on Fifth Avenue, NYC,1969
gelatin silver print, 50.8 × 40.6 cm
Courtesy Robert Miller Gallery, New York

* Richard Avedon
*Bob Dylan, singer, 132nd Street and FDR Drive,
Harlem, November 4*, 1963
gelatin silver print (engraver's print), 50.8 × 40.6 cm
Courtesy The Richard Avedon Foundation

* Richard Avedon
*John Cage, musician; Merce Cunningham,
choreographer and Robert Rauschenberg, artist,
New York City, May 2, 1960*
gelatin silver print, 50.8 × 40.6 cm
Courtesy The Richard Avedon Foundation

* Richard Avedon
Beatles Portfolio, August 11, 1967
4 color coupler prints, 61 × 50.8 cm each
Courtesy The Richard Avedon Foundation

* Richard Avedon
The Mission Council, 1965
(Left to right: Hawthorne Q. Mills, mission
coordinator; Ernest J. Colantonio, counselor of
Embassy for Administrative Affairs; Edwards J.
Nickel, minister counselor for public affairs; John
E. McGowan, minister counselor for press affairs)
gelatin silver print, 101.6 × 25.4 cm
Courtesy The Richard Avedon Foundation

* Richard Avedon
*Malcolm X, black nationalist leader, New
York City, March 27, 1963*
gelatin silver print, 50.8 × 40.6 cm
Courtesy The Richard Avedon Foundation

* Richard Avedon
*Suzy Parker and Robin Tattersall, dress by Dior,
August 1, 1956, Place de la Concorde, Paris*
gelatin silver print, 61 × 50.8 cm
Courtesy The Richard Avedon Foundation

* Richard Avedon
*Anonymous woman, Harlem, New
York City, September 6, 1949*
gelatin silver print, 50.8 × 40.6 cm
Courtesy The Richard Avedon Foundation

* James Casebere
Winterhouse, 1984
gelatin silver print, 76.2 × 61 cm, edition 5 of 7
Courtesy Sean Kelly Gallery, New York

* James Casebere
Panopticon Prison #3, 1992
cibachrome, 114.3 × 91.5 cm, edition 5 of 5
Courtesy Sean Kelly Gallery, New York

* Chuck Close
Phil (Glass), 2001
daguerreotype, 21.6 × 16.5 cm
Courtesy Pace/MacGill Gallery, New York

* Lois Conner
Hangzhou, Zhejiang, China, 1995
gelatin silver print, 50.8 × 101.6 cm
Courtesy of the artist

* Lois Conner
Shanghai, China, 1999
gelatin silver print, 50.8 × 101.6 cm
Courtesy of the artist

* Lois Conner
Yuan Ming Yuan, Beijing, China, 2004
gelatin silver print, 50.8 × 101.6 cm
Courtesy of the artist

* Lois Conner
Yuan Ming Yuan, Beijing, China, 2005
gelatin silver print, 50.8 × 101.6 cm
Courtesy of the artist

* Gregory Crewdson
Untitled (Flower Beanstalk), 2001
digital cibachrome print, 121.9 × 152.4 cm
Private collection, Michael and Fiona King

* Gregory Crewdson
Untitled (Woman stain), 2001
digital cibachrome print, 121.9 × 152.4 cm
London, private collection

* Gregory Crewdson
Untitled (Bedroom Tree), 2001/2002
digital cibachrome print, 122 × 152cm
London, The Cranford Collection

* Bruce Davidson
Untitled (from "East 100th Street"), 1966–68
gelatin silver print, 40.6 × 50.8 cm
Courtesy Howard Greenberg Gallery, New York,
& Bruce Davidson

* Bruce Davidson
Untitled (from "Brooklyn Gang"), 1960
gelatin silver print, 40.6 × 50.8 cm
Courtesy Howard Greenberg Gallery, New York,
& Bruce Davidson

* Bruce Davidson
Untitled (from "Brooklyn Gang"), 1959
gelatin silver print, 40.6 × 50.8 cm
Courtesy Howard Greenberg Gallery, New York,
& Bruce Davidson

* Bruce Davidson
Untitled (from "Brooklyn Gang"), 1960
gelatin silver print, printed later, 28 × 35.6 cm
Courtesy Howard Greenberg Gallery, New York,
& Bruce Davidson

* Bruce Davidson
Untitled (from "East 100th Street"), 1966–68
gelatin silver print, 40.6 × 50.8 cm
Courtesy Howard Greenberg Gallery, New York,
& Bruce Davidson

* Bruce Davidson
Untitled (from "East 100th Street"), 1966–68
gelatin silver print, 35.6 × 28 cm
Courtesy Howard Greenberg Gallery, New York,
& Bruce Davidson

* Bruce Davidson
Untitled (from "East 100th Street"), 1966–68
gelatin silver print, 40.6 × 50.8 cm
Courtesy Howard Greenberg Gallery, New York,
& Bruce Davidson

* Mitch Epstein
Untitled, New York (from "The City"), 1996
fuji type c crystal archive, 101 × 124 cm
Sikkema Jenkins & Co.

* Mitch Epstein
Untitled, New York (from "The City"), 1997
fuji type c crystal archive, 101 × 124 cm
Sikkema Jenkins & Co.

* Mitch Epstein
Untitled, New York (from "The City"), 1998
fuji type c crystal archive, 101 × 124 cm
Sikkema Jenkins & Co.

* Elliott Erwitt
Huntsville, Alabama, 1974
gelatin silver print, 40.6 × 50.8 cm
Courtesy of the artist

* Elliott Erwitt
Saintes-Maries-de-la-Mer, France, 1977
gelatin silver print, 40.6 × 50.8 cm
Courtesy of the artist

* Elliott Erwitt
Pisa, Italy, 1976
gelatin silver print, 40.6 × 50.8 cm
Courtesy of the artist

* Elliott Erwitt
New York City (from "Personal Exposures"), 1974
gelatin silver print, 40.6 × 50.8 cm
Courtesy of the artist

* Louis Faurer
Penn Station, NYC, 1948
gelatin silver print, 35.6 × 28 cm
Courtesy Howard Greenberg Gallery, New York

* Donna Ferrato
*"I hate you! Never come back to my house,"
screamed an eight-year-old at his father as police
arrested the man for attacking his wife.* 1988
silver gelatin print, 35 mm, 50.8 × 61 cm
Courtesy of the artist

* Donna Ferrato
*Janice was part of the California Witness Protection
Program. She had come to them through the
underground shelter system. They knew that
she had witnessed a murder, that she had been
battered, and that she was pregnant.* 1988
silver gelatin print, 35 mm, 50.8 × 61 cm
Courtesy of the artist

* Donna Ferrato
*Still Raging, Garth threw Lisa on the Marble
Counter*, 1982
silver gelatin print, 35 mm, 50.8 × 61 cm
Courtesy of the artist

* Robert Frank
Detroit, 1955
gelatin silver print, 21.9 × 34 cm
Courtesy Robert Frank and Pace MacGill Gallery,
New York

* Robert Frank
Jehovah's witness, Los Angeles, 1955–56
vintage gelatin silver print, 28.9 × 19.7 cm
Courtesy Robert Frank and Pace MacGill Gallery,
New York

* Robert Frank
Cocktail party, New York City, 1955
gelatin silver print, 21 × 31.5 cm
Courtesy Robert Frank and Pace MacGill Gallery,
New York

*Robert Frank
Sandusky Ohio (Breakers Hotel), 1954
gelatin silver print, 35.4 × 21.6 cm
Courtesy Robert Frank and Pace MacGill Gallery,
New York

* Lee Friedlander
New Mexico, 2001
gelatin silver print, 50.8 × 40.6 cm
Courtesy Fraenkel Gallery, San Francisco

* Lee Friedlander
New York City, 2001
gelatin silver print, printed 2002, 38.1 × 35.6 cm
Courtesy Fraenkel Gallery, San Francisco

* Lee Friedlander
New Mexico, 2001
gelatin silver print, printed 2003, 38.1 × 35.6 cm
Courtesy Fraenkel Gallery, San Francisco

* Lee Friedlander
San Diego, 2002
gelatin silver print, 38.1 × 35.6 cm
Courtesy Fraenkel Gallery, San Francisco

* Lee Friedlander
Memphis, 2003
gelatin silver print, printed 2003, 38.1 × 36.9 cm
Courtesy Fraenkel Gallery, San Francisco

* Lee Friedlander
Chicago, 2003
gelatin silver print, printed 2003, 38.1 × 35.6 cm
Courtesy Fraenkel Gallery, San Francisco

* Lee Friedlander
Arkansas, 2003
gelatin silver print, printed 2003, 38.1 × 35.6 cm
Courtesy Fraenkel Gallery, San Francisco

* Lee Friedlander
Las Vegas, 2002
gelatin silver print, printed 2005, 38.1 × 36.9 cm
Courtesy Fraenkel Gallery, San Francisco

* Allen Ginsberg
Gregory Corso in his attic room, Paris, 1957
gelatin silver print, printed later, 35.6 × 28 cm
Courtesy Howard Greenberg Gallery, New York

* Allen Ginsberg
*Neal Cassady & Natalie Jackson conscious of their
Roles in Eternity, Market Street, San Francisco*, 1955
gelatin silver print, 35.6 × 28 cm
Courtesy Howard Greenberg Gallery, New York

* Allen Ginsberg
*Morning rooftop visit, Brahmin's house
on Dasasumedh Ghat, Benares, India*, 1963
gelatin silver print, printed later, 40.6 × 50.8 cm
Courtesy Howard Greenberg Gallery, New York

* Allen Ginsberg
Timothy Leary visiting Neal Cassidy who drove Prankster Bus to Millbrook Psychedelic Research Center, Election Year, 1964
gelatin silver print, printed later, 50.8 × 40.6 cm
Courtesy Howard Greenberg Gallery, New York

* Allen Ginsberg
Old-timer & survivor Herbert E. Huncke, 1993
gelatin silver print, 50.8 × 40.6 cm
Courtesy Howard Greenberg Gallery, New York

* Allen Ginsberg
Dorothy Norman, New York, January 3, 1987
gelatin silver print, printed later, 35.6 × 28 cm
Courtesy Howard Greenberg Gallery, New York

* Nan Goldin
Trixie on the cot, New York City, 1979
cibachrome, 76.2 × 101.6 cm
Courtesy of the artist and Matthew Marks Gallery, New York

* Nan Goldin
Nan and Brian in bed, New York City, 1983
cibachrome, 76.2 × 101.6 cm
Courtesy of the artist and Matthew Marks Gallery, New York

* Nan Goldin
Twisting at my birthday party, New York City, 1980
cibachrome, 76.2 × 101.6 cm
Courtesy of the artist and Matthew Marks Gallery, New York

* Nan Goldin
Brian on my bed with bars, New York City, 1983
cibachrome, 76.2 × 101.6 cm
Courtesy of the artist and Matthew Marks Gallery, New York

* Nan Goldin
Joey at the Love Ball, New York City, 1991
cibachrome, 76.2 × 101.6 cm
Courtesy of the artist and Matthew Marks Gallery, New York

* Nan Goldin
Gina at Bruce's dinner party, 1991
cibachrome, 76.2 × 101.6 cm
Courtesy of the artist and Matthew Marks Gallery, New York

* Philippe Halsman
Jerome Robbins, 1961
vintage gelatin silver print, 28 × 35.6 cm
Courtesy Philippe Halsman Archive

* Philippe Halsman
Jean Cocteau, 1948
vintage gelatin silver print, 28 × 35.6 cm
Courtesy Philippe Halsman Archive

* Philippe Halsman
Audrey Hepburn, 1955
vintage gelatin silver print, 28 × 35.6 cm
Courtesy Philippe Halsman Archive

* Philippe Halsman
Aldous Huxley, 1958
vintage gelatin silver print, 28 × 35.6 cm
Courtesy Philippe Halsman Archive

* Philippe Halsman
Edward Vilella, 1961
vintage gelatin silver print, 28 × 35.6 cm
Courtesy Philippe Halsman Archive

* Philippe Halsman
Alfred Hitchcock at home in Bel Air, 1974
vintage gelatin silver print, 31.6 × 26 cm
Courtesy Howard Greenberg Gallery, New York

* Peter Hujar
Edwin Denby, 1975
gelatin silver print, 37 × 37 cm
Courtesy Matthew Marks Gallery, New York

* Peter Hujar
Bruce de Saint Croix (standing), 1976
gelatin silver print, 36.9 × 37.5 cm
Courtesy Matthew Marks Gallery, New York

* Peter Hujar
Four cows, 1985
gelatin silver print, 37.3 × 37.3 cm
Courtesy Matthew Marks Gallery, New York

* André Kertész
Rainy day in Tokyo, 1968
gelatin silver print, 24.5 × 14.3 cm
Courtesy Bruce Silverstein Gallery, New York

* William Klein
6 O'Clock tea at Woolworth's, New York, 1955
gelatin silver print, 30 × 40 cm
Courtesy Howard Greenberg Gallery, New York

* William Klein
Elsa Maxwell's Toy Ball, NY (variant), 1955
gelatin silver print, printed later, 30 × 40 cm
Courtesy Howard Greenberg Gallery, New York

* William Klein
Men on corner, Chinatown, New York, 1955
gelatin silver print, printed later, 30 × 40 cm
Courtesy Howard Greenberg Gallery, New York

* William Klein
Woman & cigarette holder, New York, 1955
gelatin silver print, printed later, 40 × 30 cm
Courtesy Howard Greenberg Gallery, New York

* Barbara Kruger
Who is Free to Chose? Who is Photograph?
2 elements: each gelatin silver prints in artist's frame, 251.5 × 102.8 cm
Greece, Dimitris Daskalopoulos Collection

* Helen Levitt
New York, c. 1940
gelatin silver print, printed later, 23.2 × 16.2 cm
Courtesy Fraenkel Gallery, San Francisco

* Helen Levitt
New York, c. 1940
gelatin silver print, printed later, 26.7 × 17.8 cm
Courtesy Fraenkel Gallery, San Francisco

* Helen Levitt
New York, c. 1940
gelatin silver print, printed later, 42.9 × 28.9 cm
Courtesy Fraenkel Gallery, San Francisco

* Helen Levitt
New York, c. 1940
gelatin silver print, printed later, 29.9 × 20 cm
Courtesy Fraenkel Gallery, San Francisco

* Helen Levitt
Brooklyn, New York, c. 1942
gelatin silver print, printed later, 18.8 × 28 cm
Courtesy Fraenkel Gallery, San Francisco

* Helen Levitt
New York, c. 1942
gelatin silver print, printed later, 26.7 × 17.8 cm
Courtesy Fraenkel Gallery, San Francisco

* Helen Levitt
New York, 1985
gelatin silver print, printed later, 43.2 × 29.2 cm
Courtesy Fraenkel Gallery, San Francisco

* Robert Mapplethorpe
Larry and Bobby Kissing, 1979
gelatin silver print, 50.8 × 40.6 cm
Courtesy The Robert Mapplethorpe Foundation

* Robert Mapplethorpe
Lisa Lyon, 1980
gelatin silver print, 50.8 × 40.6 cm
Courtesy The Robert Mapplethorpe Foundation

* Robert Mapplethorpe
Man in polyester suit, 1980
gelatin silver print, 50.8 × 40.6 cm
Courtesy The Robert Mapplethorpe Foundation

* Robert Mapplethorpe
Marty and Veronica, 1982
gelatin silver print, 50.8 × 40.6 cm
Courtesy The Robert Mapplethorpe Foundation

* Robert Mapplethorpe
Patti Smith, 1976
gelatin silver print, 50.8 × 40.6 cm
Courtesy The Robert Mapplethorpe Foundation

* Robert Mapplethorpe
Self-portrait, 1978
gelatin silver print, 50.8 × 40.6 cm
Courtesy The Robert Mapplethorpe Foundation

* Robert Mapplethorpe
Thomas and Dovanna, 1986
gelatin silver print, 61 × 50.8 cm
Courtesy The Robert Mapplethorpe Foundation

* Mary Ellen Mark
Federico Fellini on the set of Satyricon,
Rome, Italy, 1969
gelatin silver print, 40 × 50 cm
Courtesy Marianne Boesky Gallery, New York

* Mary Ellen Mark
Contortionist with Sweety the puppy,
Raj Kamal Circus, Upleta, 1989
gelatin silver print, 40 × 50 cm
Courtesy Marianne Boesky Gallery, New York

* Mary Ellen Mark
Ram Prakash with his elephant Shyama, Great
Golden Circus Ahmedabad, India, 1990
gelatin silver print, 40 × 50 cm
Courtesy Marianne Boesky Gallery, New York

* Mary Ellen Mark
"Tiny" in her Halloween costume, Seattle,
Washington, 1983
gelatin silver print, 40 × 50 cm
Courtesy Marianne Boesky Gallery, New York

* Mary Ellen Mark
The Damm family in their car, Los Angeles,
California, 1987
gelatin silver print, 40 × 50 cm
Courtesy Marianne Boesky Gallery, New York

* Mary Ellen Mark
Brothers going to church, Tunica, Mississipi, 1990
gelatin silver print, 40 × 50 cm
Courtesy Marianne Boesky Gallery, New York

* Susan Meiselas
Soldiers search bus passengers along the Northern
Highway, North of San Salvador, El Salvador, 1980
cibachrome print, 50.8 × 61 cm
Courtesy of the artist

* Susan Meiselas
Wedding reception in the countryside, Santiago
Nonualco, El Salvador, 1983
cibachrome print, 50.8 × 61 cm
Courtesy of the artist

* Susan Meiselas
Firing range used by U.S.-trained Atlacatl Battalion,
Usulatan, El Salvador, 1983
cibachrome print, 50.8 × 61 cm
Courtesy of the artist

* Susan Meiselas
Taymour Abdullah, 15, the only survivor of
a mass execution, shows his wound, Arbil,
Kurdistan, Northern Iraq, December 1991
cibachrome print, 50.8 × 61 cm
Courtesy of the artist

* Susan Meiselas
Photograph of Kamaran Abdullah Saber, 20 years old,
held by his mother at Saiwan Hill Cemetery. He was
killed in July 1991 during a student demonstration
against Saddam Hussein, 1991
cibachrome print, 50.8 × 61 cm
Courtesy of the artist

* Susan Meiselas
Family living in the ruins of the village of Said Sadiq,
destroyed during Saddam's Anfal campaign against
the Kurds, Kurdistan, Northern Iraq, June, 1992
cibachrome print, 50.8 × 61 cm
Courtesy of the artist

* Duane Michals
The Kentucky Kid, 2001
10 gelatin silver prints, each 17.8 × 22.8 cm
Courtesy Pace/MacGill Gallery, New York

* Peter Moore
Untitled (Lucinda Childs in Carolee Schneemann's
"Chromelodeon", rehearsal, Judson Memorial Church,
NYC), 1963/2003
silver gelatin print, 14 × 11 cm
Courtesy Sonnabend Gallery, New York and Barbara
Moore

* Peter Moore
Untitled (Yvonne Rainer, "3 Seascapes", Sur+Dance
Theater: Exchange, NYC), 1964/2003
gelatin silver print, 11 × 14 cm
Courtesy Sonnabend Gallery, New York and Barbara
Moore

* Peter Moore
Untitled (Charlotte Moorman & Nam June Paik
performing John Cage's "26'1.1499 for a String
Player", Cafe Au GoGo, NYC), 1965/2003
gelatin silver print, 14 × 11 cm
Courtesy Sonnabend Gallery, New York,
and Barbara Moore

* Peter Moore
Untitled (Robert Morris, "Waterman Switch", with
Lucinda Childs, Judson Memorial Church, NYC),
1965/2003
gelatin silver print, 11 × 14 cm
Courtesy Sonnabend Gallery, New York,
and Barbara Moore

* Peter Moore
Untitled (Robert Rauschenberg, Carolyn Brown
& Alex Hay – hidden – in Rauschenberg's "Pelican",
Washington D.C.), 1965/2003
gelatin silver print, 14 × 11 cm
Courtesy Sonnabend Gallery, New York,
and Barbara Moore

* Peter Moore
Untitled (Trisha Brown's "Man Walking Down
the Side of a Building", performed by Joseph
Schlichter, NYC), 1967/2003
gelatin silver print, 14 × 11 cm
Courtesy Sonnabend Gallery, New York,
and Barbara Moore

* Peter Moore
Untitled (David Gordon, "Random Breakfast",
rehearsal, with Valda Setterfield, Judson Memorial
Church, NYC, 1963/2003
silver gelatin print, 11 × 14 cm
Courtesy Sonnabend Gallery, New York,
and Barbara Moore

* Peter Moore
Untitled (Deborah Hay, "All Day Dance With Two",
with Steve Paxton, Sur+Dance Theater, NYC),
1964/2003
gelatin silver print, 11 × 14 cm
Courtesy Sonnabend Gallery, New York,
and Barbara Moore

* Peter Moore
Untitled (Yoko Ono, "Morning Piece", NYC),
1965/2003
gelatin silver print, 14 × 11 cm
Courtesy Sonnabend Gallery, New York,
and Barbara Moore

*Peter Moore
Untitled (Merce Cunningham, "Night Wandering",
with Carolyn Brown, NYC), 1965/2003
gelatin silver print, 11 × 14 cm
Courtesy Sonnabend Gallery, New York,
and Barbara Moore

*Gordon Parks
Muhammad Ali, 1970
gelatin silver print, printed later, 28 × 35.6 cm
Courtesy Howard Greenberg Gallery, New York

* Gordon Parks
Red Jackson, 1948
gelatin silver print, printed later, 35.6 × 28 cm
Courtesy Howard Greenberg Gallery, New York

* Irving Penn
VOGUE, cover July 1948 (Yellow rose
Empire State Building)
Art Director: Alexander Liberman
31.7 × 24.13 cm
Collection Vince Aletti

* Irving Penn
VOGUE, spread pp. 32-33 "Elements in a party"
Art Director: Alexander Liberman
31.7 × 24.13 cm
Collection Vince Aletti

* Irving Penn
VOGUE, March 15, 1949, pp. 102-103 "French
in New York", portraits of Balthus and Barrault
Art Director: Alexander Liberman
31.7 × 24.13 cm
Collection Vince Aletti

* Irving Penn
VOGUE, December 1949, pp. 86-87, "Christmas
in Cuzco"
Art Director: Alexander Liberman
31.7 × 24.13 cm
Collection Vince Aletti

* Irving Penn
VOGUE, Oct. 1, 1950, pp. 154-155, "Paris fashions"
Art Director: Alexander Liberman
31.7 × 24.13 cm
Collection Vince Aletti

* Irving Penn
*VOGUE, July 1951, pp. 48-49, selections
from "America Inc."*
Art Director: Alexander Liberman
31.7 × 24.13 cm
Collection Vince Aletti

* Irving Penn
*VOGUE, Nabokov spread, December 1966,
pp. 224-225*
Art Director: Alexander Liberman
31.7 × 24.13 cm
Collection Vince Aletti

* Irving Penn
*LOOK, January 9, 1968, pp. 54-55 "The Outrageous"
motorcycle gang members*
Art Director: Allen Hurlburt
33.1 × 26.6 cm
Collection Vince Aletti

* Sylvia Plachy
The Louvre, 1985
gelatin silver print, 40.6 × 50.8 cm
Courtesy of the artist

* Sylvia Plachy
Maid, New York City, 1986
gelatin silver print, 40.6 × 50.8 cm
Courtesy of the artist

* Sylvia Plachy
Blacksmith on W. 38th St., NYC, 1986
gelatin silver print, 40.6 × 50.8 cm
Courtesy of the artist

* Sylvia Plachy
Miss W., Central Park, 1991
gelatin silver print, 40.6 × 50.8 cm
Courtesy of the artist

* Sylvia Plachy
Swann's Way, Prague, 1991
gelatin silver print, 40.6 × 50.8 cm
Courtesy of the artist

* Sylvia Plachy
Torch Song, Budapest Zoo, 1993
gelatin silver print, 40.6 × 50.8 cm
Courtesy of the artist

* Sylvia Plachy
"Creation of Adam", Sydney Zoo, 1997
gelatin silver print, 40.6 × 50.8 cm
Courtesy of the artist

*Sylvia Plachy
Reading "Eloise" on Broadway, 1998
gelatin silver print, 40.6 × 50.8 cm
Courtesy of the artist

* Eugene Richards
Boy flipping off a bare spring, Brooklyn, NY, 1992
gelatin silver print, 50.8 × 61 cm
Courtesy of the artist

* Eugene Richards
Donna high on crack, Brooklyn, NY, 1992
gelatin silver print, 50.8 × 61 cm
Courtesy of the artist

* Eugene Richards
Grandmother, Brooklyn, NY, 1993
gelatin silver print, 50.8 × 61 cm
Courtesy of the artist

* Eugene Richards
*Dust-covered snow globe of the city as it once
was, New York City*, 2001
gelatin silver print, 50.8 × 61 cm
Courtesy of the artist

* Eugene Richards
*The city's new skyline reflected in the Staten
Island Ferry, New York City*, 2002
gelatin silver print, 50.8 × 61 cm
Courtesy of the artist

* Eugene Richards
Crack Annie, Brooklyn, NY, 1988
gelatin silver print, 50.8 × 61 cm
Courtesy of the artist

* Lucas Samaras
Auto-Polaroid, 12/24/70
Polaroid with hand-applied ink image, 7.6 × 7.6 cm
Courtesy Pace/MacGill Gallery, New York
and PaceWildenstein, New York

* Lucas Samaras
Photo-Transformation, 2/9/74
Polaroid photo transformation, 7.6 × 7.6 cm
Courtesy Pace/MacGill Gallery, New York,
and PaceWildenstein, New York

* Lucas Samaras
Photo-Transformation, 6/21/74
Polaroid photo transformation, 7.6 × 7.6 cm
Courtesy Pace/MacGill Gallery, New York,
and PaceWildenstein, New York

* Lucas Samaras
Head Chest Liquid, 2002
iris print (pure pigment on paper), 71.8 × 56.5 cm
Courtesy of the artist and PaceWildenstein,
New York

* Andres Serrano
White Christ, 1989
cibachrome, silicone, plexiglas, wood frame,
152.4 × 101.6 cm
Courtesy Paula Cooper Gallery, New York

* Andres Serrano
Black Jesus, 1990
cibachrome, silicone, plexiglas, wood frame,
101.6 × 69.9 cm
Courtesy Paula Cooper Gallery, New York

* Andres Serrano
The Morgue (Jane Doe Killed by Police), 1992
cibachrome, silicone, plexiglas, wood frame,
151.1 × 152
Courtesy Paula Cooper Gallery, New York

* Andres Serrano
Budapest (Mother and Child), 1994
cibachrome, silicone, plexiglas, wood frame,
69.9 × 101.6 cm
Courtesy Paula Cooper Gallery, New York

* Andres Serrano
America (J.B., Pimp), 2003
Cibachrome, silicone, plexiglas, wood frame,
69.9 × 101.6 cm
Courtesy Paula Cooper Gallery, New York

* Laurie Simmons
The Boxes (Ardis Vinkler) Library, 2005
flex print, 116.5 × 208.6 cm
Courtesy of the artist and Sperone Westwater,
New York

* Eugene W. Smith
Untitled (Maude walking through mud), 1951
gelatin silver print, 35.6 × 28 cm
Courtesy Howard Greenberg Gallery, New York

* Eugene W. Smith
Women getting water (from "Spanish village"), 1951
gelatin silver print, 35.6 × 28 cm
Courtesy Howard Greenberg Gallery, New York

* Eugene W. Smith
A Man of Mercy (Bird and Bowl), 1954
vintage gelatin silver print, 26.7 × 34.6 cm
Courtesy Howard Greenberg Gallery, New York

* Eugene W. Smith
Untitled (Earl Hines with cigar at piano), 1960s
gelatin silver print, 28 × 35.6 cm
Courtesy Howard Greenberg Gallery, New York

* Eugene W. Smith
Minimata, 1971–75
vintage gelatin silver print, 25.7 × 35 cm
Courtesy Howard Greenberg Gallery, New York

* Eugene W. Smith
The Spinner (from "Spanish Village"), 1951
gelatin silver print, 32.4 × 23.2 cm
Courtesy Howard Greenberg Gallery, New York

* Andy Warhol
Male Nude, 1986 - 1987
six stitched gelatin silver prints, 80.3 × 69.5 cm
The Andy Warhol Foundation for the Visual Arts,
Courtesy Cheim & Read, New York

* Bruce Weber
Robert De Niro and Catherine Scorcese, NYC, 1990
photograph, archival gallery, 40.6 × 50.8 cm
Courtesy Little Bear Inc.

* Bruce Weber
Louise Bourgeois, NYC, 1997
photograph, archival gallery, 40.6 × 50.8 cm
Courtesy Little Bear Inc.

* Bruce Weber
Rickson and son Rawkson, Prainha, 1986
photograph, archival gallery, 40.6 × 50.8 cm
Courtesy Little Bear Inc.

* Bruce Weber
*The Duchess of Devonshire feeding
her chickens, England,* 1995
photograph, archival gallery, 40.6 × 50.8 cm
Courtesy Little Bear Inc.

* Bruce Weber
*The gang at Little Bear Ranch, McLeod,
Montana,* 1995
photograph, archival gallery, 40.6 × 50.8 cm
Courtesy Little Bear Inc.

* Bruce Weber
Stella Tennant in Yohji Yamamoto, NY, NY, 1999
photograph, archival gallery, 40.6 × 50.8 cm
Courtesy Little Bear Inc.

* Brian Weil
*Maria self-injecting experimental drugs,
Brooklyn, New York,* 1990
gelatin silver print, 77.2 × 76.5 cm
University of Arizona, Collection Center
for Creative Photography

* Weegee (Arthur Fellig)
"Pet Dog Joins Smoke - Poisoned Fireman",
December 24, 1942
gelatin silver print, 33.7 × 26. 7 cm
Courtesy International Center for Photography,
Gift of Wilma Wilcox, 1993

* Weegee (Arthur Fellig)
Mayor Fiorello La Guardia in a Police Car, c. 1943
gelatin silver print, 16.8 × 21.6 cm
Courtesy International Center for Photography,
Gift of Wilma Wilcox, 1993

* Weegee (Arthur Fellig)
*"… and the Living Suffer", Mrs. Vanta Supik, Wife
of the Dead Truck Driver,* September 7, 1944
gelatin silver print, 24.8 × 19.5 cm
Courtesy International Center for Photography,
Gift of Wilma Wilcox, 1993

Weegee (Arthur Fellig)
Runaway Bull, c. 1945
gelatin silver print, 24.8 × 18.9 cm
Courtesy International Center for Photography,
Gift of Wilma Wilcox, 1993

* Garry Winogrand
New York, c. 1968
gelatin silver print, printed 1970s, 34.3 × 22.9 cm
Courtesy Fraenkel Gallery, San Francisco

* Garry Winogrand
Hard-Hat rally, New York, 1969
gelatin silver print, printed 1970s, 27.3 × 40.6 cm
Courtesy Fraenkel Gallery, San Francisco

* Garry Winogrand
*Muhammad Ali - Oscar Bonavena press conference,
New York,* 1970
gelatin silver print, printed 1970s, 21.9 × 32.7 cm
Courtesy Fraenkel Gallery, San Francisco

* Garry Winogrand
*Opening, Frank Stella exhibition, The
Museum of Modern Art, New York,* 1970
vintage silver print, 27.3 × 40.6 cm
Courtesy Fraenkel Gallery, San Francisco

* Garry Winogrand
Central Park, New York, 1971
gelatin silver print, printed 1970s, 22.3 × 33.4 cm
Courtesy Fraenkel Gallery, San Francisco

* David Wojnarowicz
Untitled from "Sex Series (for Marion Scemama)",
1988–89
gelatin silver print, 93.98 × 88.27 cm
Courtesy PPOW Gallery, New York

* David Wojnarowicz
Untitled from "Sex Series (for Marion Scemama)",
1988–89
gelatin silver print, 93.98 × 88.27 cm
Courtesy PPOW Gallery, New York

* David Wojnarowicz
Untitled from "Sex Series (for Marion Scemama)",
1988–89
gelatin silver print, 93.98 × 88.27 cm
Courtesy PPOW Gallery, New York

* David Wojnarowicz
Untitled from "Sex Series (for Marion Scemama)",
1988–89
gelatin silver print, 93.98 × 88.27 cm
Courtesy PPOW Gallery, New York

* David Wojnarowicz
Untitled from "Sex Series (for Marion Scemama)",
1988–89
gelatin silver print, 93.98 × 88.27 cm
Courtesy PPOW Gallery, New York

* David Wojnarowicz
Untitled (Buffaloes), 1988–89
gelatin silver print, 102.7 × 121.92 cm
Courtesy PPOW Gallery, New York

* David Wojnarowicz
*Untitled from "Sex Series (for Marion
Scemama)",* 1988–89
gelatin silver print, 93.98 × 88.27 cm
Courtesy PPOW Gallery, New York

* David Wojnarowicz
Untitled (Sometimes I Come to Hate…), 1992
silver print with silk screened text, 96.5 × 66 cm
Collection of the New Museum of Contemporary
Art, New York, gift of Joel and Nancy Portnoy

Cinema

* James Agee/Helen Levitt
In the Street, 1953

* Woody Allen
Annie Hall, 1977
© MGM

* Peter Emmanuel Goldman
Echoes of Silence, 1967
© Cinédoc

* Henry Hills
Money, 1985

* Ian Hugo
Jazz of Lights, 1954

* Peter Jackson
King Kong, 2005
© Universal

* Ken Jacobs
Little Stabs at Happiness, 1960

* Jim Jarmusch
Permanent Vacation, 1980
© Bac Films

* Stanley Kubrick
Killer's Kiss, 1955
© MGM

* Richard Lester
Superman 2, 1980
© Warner

* Sidney Lumet
Serpico, 1973
© Paramount

* Alexander Mackendrick
Sweet Smell of Success, 1957
© MGM

* Jonas Mekas
Walden, 1969
© Re-voir

* Jonas Mekas
Scenes from the life of Andy Warhol, 1965–82/1991
© Re-voir

* Paul Morrissey
Flesh, 1968

* Donn Allan Pennebaker
Daybreak Express, 1953
© Jane Balfour Services

* Abraham Polonsky
Force of Evil, 1948
© Wild Side

* Sam Raimi
Spiderman 2, 2002
© Columbia

* Yvonne Rainer
Lives of Performers, 1972
© Zeitgeist Films

* Ron Rice
Chumlum, 1964

* Martin Scorsese
Mean Streets, 1973
© Warner

* Warren Sonnbert
The Tuxedo Theater, 1968
© Light Cone

* Stan Vanderbeek
A la mode, 1957
© Re-voir

Performance and Video

* Vito Acconci
Theme Song, 1973
video, 33:15 minutes, black & white, sound
Courtesy of the artist and Electronic Arts Intermix,
New York

* Laurie Anderson
O Superman, 1982
video, 8:40 minutes, color, sound
Courtesy of the artist and Sean Kelly Gallery,
New York

* Dara Birnbaum
Technology/Transformation: Wonder Woman,
1978–79
video, 5:50 minutes, color, sound
Courtesy of the artist and Electronic Arts Intermix,
New York

* Trisha Brown
Walking on the Walls, 1971 (excerpt)
16 mm film, 4:49 minutes, black and white, sound
Filmed at The Whitney Museum of American
Art, New York
Courtesy of Trisha Brown Dance Company,
New York

* Patty Chang
Fountain, 1999
video, 5:29 minutes, color, sound
Courtesy of the artist and Kustera Tilton Gallery,
New York

* Cheryl Donegan
Head, 1993
video, 2:49 minutes, color, sound
Courtesy of the artist and Oliver Kamm 5BE Gallery,
New York

* Joan Jonas
Good Night Good Morning, 1976
video, 11:38 minutes, black & white, sound
Recorded in New York and Nova Scotia
Courtesy of the artist and Electronic Arts Intermix,
New York

* Allan Kaprow
Warm-Ups, 1975
16 mm film, 14:20 minutes, color, sound
First enacted in 1975, Center for Advanced Visual
Studies, MIT, Cambridge, Massachussetts
Courtesy of the artist and Hauser & Wirth, Zurich

* Christian Marclay
Telephones, 1995
video, 7:30 minutes, black & white and color, sound
Courtesy of the artist and Paula Cooper Gallery,
New York

* Frank Moore and Jim Self
Beehive, 1985
16 mm film, 15:35 minutes, color, sound
Courtesy the Estate of Frank Moore, Jim Self,
and Sperone Westwater Gallery, New York

* Hans Namuth
Jackson Pollock Painting, 1950
16 mm film, 10 minutes, color, sound
Filmed at the artist's Long Island studio
and various New York City locations
Courtesy of the artist and the Museum of Modern
Art's Circulating Film and Video Library, New York

* Hans Namuth
Willem de Kooning the Painter, 1964
16 mm film, 13 minutes, color, sound
Filmed at the artist's East Hamptons and New York
City studios
Courtesy of the artist and the Museum of Modern
Art's Circulating Film and Video Library, New York

* Claes Oldenburg
Snapshots of the City, 1960
16 mm film, 9 minutes, black & white, mute
Filmed at Judson Church in Greenwich Village,
New York
Courtesy of the artist

* Yoko Ono
Cut Piece, 1965
16 mm film, 9 minutes, black & white, sound
Filmed at Carnegie Hall, New York
Courtesy of the artist and Studio One, New York

* The Performance Group
Dionysus in 69, 1968 (excerpt)
16 mm film, 20 minutes, black & white, sound
Filmed at The Performance Garage in SoHo,
New York
Courtesy of Richard Schechner

* Michael Smith
It Starts At Home, 1982
video, 24:58 minutes, color, sound
Courtesy of the artist and Christine Burgin Gallery,
New York

* Robert Wilson
Einstein on the Beach (excerpt), 1976
16 mm film, 15 minutes, black & white
and color, sound
Filmed at Théâtre Royal de la Monnaie, Brussels
Courtesy of the artist and the Byrd Hoffman Water
Mill Foundation

* The Wooster Group
Route 1 & 9, 1983 (excerpt)
video, 20 minutes, color, sound
Recorded at The Performing Garage in SoHo,
New York
Courtesy of The Wooster Group and Clay Hapaz

Architecture

Film projection on inflatables
2006
United architects; Greg Lynn form, Imaginary forces,
Kevin Kennon architects and UNstudio